LATE ANTIQUE,
EARLY CHRISTIAN
AND
MEDIAEVAL ART

LATE ANTIQUE, EARLY CHRISTIAN AND MEDIAEVAL ART

Selected Papers

MEYER SCHAPIRO

GEORGE BRAZILLER, INC. NEW YORK

Published in the United States in 1979 by George Braziller, Inc.

All rights reserved
For information address the publisher:
George Braziller, Inc.
One Park Avenue, New York 10016

Library of Congress Cataloging in Publication Data
Schapiro, Meyer, 1904—
 Late Antique, Early Christian and Mediaeval Art.

 (His selected papers; v. 3)
 Includes index.
 1. Art, Early Christian. 2. Art, Medieval.
I. Title. II. Series.
N7832.S26 709'.02 79–13333
ISBN O–8076–0927–7

Printed in the United States of America
First Printing
Designed by Allan Mogel Studios

Acknowledgments

The author and the publisher wish to extend their sincere thanks to all those listed below who graciously granted their permission, where necessary, for the reproduction of the material contained in this volume of *Selected Papers:*

The Art Bulletin, Vol. XXVII, no. 3, September 1945, "Muscipula Diaboli, the Symbolism of the Mérode Altarpiece," pp. 182–187. Reprinted by permission of the College Art Association of America.

The Art Bulletin, Vol. XLI, no. 4, December 1959, "A Note on the Mérode Altarpiece," pp. 327–328. Reprinted by permission of the College Art Association of America.

Israel: Ancient Mosaics, Preface by Meyer Schapiro, Introduction by Michael Avi-Yonah, (copyright © 1960 by UNESCO), published by The New York Graphic Society by arrangement with UNESCO: Meyer Schapiro, "Ancient Mosaics in Israel," pp. 5–13. Reprinted by permission of the publishers.

Gazette des Beaux-Arts, Vol. XL, Series 6, July 1952, "The Joseph Scenes on the Maximianus Throne in Ravenna," pp. 27–38. Reprinted by permission of the publisher.

Gazette des Beaux-Arts, Vol. XXXV, Series 6, March 1949, "The Place of the Joshua Roll in Byzantine History," pp. 161–176. Reprinted by permission of the publisher.

The Art Bulletin, Vol. XXXIV, no. 2, June 1952, "The Frescoes of Castelseprio," pp. 147–163. Reprinted by permission of the College Art Association of America.

The Art Bulletin, Vol. XXXIX, no. 4, December 1957, "Notes on Castelseprio," pp. 292–299. Reprinted by permission of the College Art Association of America.

The Art Bulletin, Vol. XXII, no. 4, December 1940, "The Carolingian Copy of the Calendar of 354," pp. 270–272. Reprinted by permission of the College Art Association of America.

The Art Bulletin, Vol. XXVI, no. 4, December 1944, "The Religious Meaning of the Ruthwell Cross," pp. 232–245. Reprinted by permission of the College Art Association of America.

The Art Bulletin, Vol. XLV, no. 4, December 1963, "The Bowman and the Bird on the Ruthwell Cross and Other Works: An Interpretation of Secular Themes in Early Mediaeval Religious Art," pp. 351–355. Reprinted by permission of the College Art Association of America.

Speculum, Vol. XLV, no. 4, October 1970, "Marginal Images and Drôlerie," pp. 684–686. Reprinted by permission of the Mediaeval Academy of America.

Scriptorium, Vol. XII, no. 2, 1958, "Decoration of the Leningrad Manuscript of Bede," pp. 191–207, pls. 23–25. Reprinted by permission of Gregg International, an imprint of Avebury Publishing Company, England.

Gazette des Beaux-Arts, Vol. XXXVII, Series 6, January 1950, "The Place of Ireland in Hiberno-Saxon Art," pp. 134–138. Reprinted by permission of the publisher.

Journal of the Society of Architectural Historians, Vol. XVII, no. 4, December 1959, "A Note on the Wall Strips of Saxon Churches," pp. 123–125.

The Art Bulletin, Vol. XXIV, no. 3, September 1942, "Cain's Jaw-Bone that Did the First Murder," pp. 205–212. Reprinted by permission of the College Art Association of America.

Gazette des Beaux-Arts, Series 6, March 1943, "The Image of the Disappearing Christ," pp. 135–152. Reprinted by permission of the publisher.

Ars Islamica, Vol. X, nos. 1–2, 1943, "The Angel with the Ram in Abraham's Sacrifice: A Parallel in Western and Islamic Art," pp. 134–147. Reprinted by permission of the editors of *Ars Orientalis.*

Essays in the History of Art Presented to Rudolf Wittkower, Douglas Fraser, Howard Hibbard, Milton J. Lewine, eds., copyright © 1967 by Phaidon Press Limited, "An Irish-Latin Text on the Angel with the Ram in Abraham's Sacrifice," pp. 17–19. Reprinted by permission of the publisher.

Artnews, Vol. 61, no. 9, January 1963, copyright © 1963 by Artnews, "The Beatus Apocalypse of Gerona," pp. 36, 49–50. Reprinted by permission of Artnews, 122 East 42nd Street, New York, N.Y. 10017.

Journal of the Warburg and Courtauld Institutes, Vol. XXIII, nos. 3–4, 1960, "An Illuminated Psalter of the Early Thirteenth Century," pp. 179–189, pls. 19–24. Reprinted by permission of the publisher.

Scritti di Storia dell'Arte in Onore di Lionello Venturi, Vol. I, M. Salmi, ed., Rome: De Luca, copyright © 1956 by Instituto grafico Tiberino di L. de Luca, "On an Italian Painting of the Flagellation of Christ in the Frick Collection," pp. 29–53. Reprinted by permission of the publisher.

The Bird's Head Haggada of the Bezalel National Art Museum in Jerusalem, Introductory Volume, M. Spitzer, ed., (copyright © 1967 by Beth David Salomons, Jerusalem), published by Tarshish Books (Dr. M. Spitzer): Meyer Schapiro, "The Bird's Head Haggada in the Bezalel National Art Museum in Jerusalem," Introduction to the text volume, pp. 15–19. Reprinted by permission of the publisher.

Contents

Illustrations

Fig. 13 Vatican City, Biblioteca Vaticana: Ms. Reg. gr. 1, Bible of Leo the Patrician, fol. 5.
Fig. 14 Munich, Bayerische Staatsbibliothek: Clm. 6224, fol. 191v. (Drawing by Professor Jacques Guilmain, after a photograph.)
Fig. 15 Durham: Cathedral. Coffin of St. Cuthbert.
Fig. 16 Dublin, Trinity College Library: Ms. A. 1.6, Book of Kells, fol. 114.
Fig. 17 Dublin, Trinity College Library: Ms. A. 1.6, Book of Kells, fol. 94. Letters *C U.*
Fig. 18 Florence, Biblioteca Medicea Laurenziana: Codex Amiatinus, fol. VII.

The Place of Ireland in Hiberno-Saxon Art

Fig. 1 Dublin, Royal Irish Academy: Cathach of St. Columba, s.n., fol. 6. Initial *N.*
Fig. 2 Milan, Biblioteca Ambrosiana: Ms. S. 45, sup., Atala Codex, p. 2. Initial *N.*
Fig. 2a Durham, Durham Cathedral: Ms. A. II. 10, Gospel, fol. 2. Initial.
Fig. 3 Paris, Bibliothèque Nationale: Ms. lat. 9389, Echternach Gospels, fol. 18v. *Imago Hominis*, Symbol of Matthew.
Fig. 4 Dublin, Trinity College Library: Ms. A. IV. 5., Book of Durrow. fol. 191v. Lion of John.
Fig. 5 London, British Museum: Incised bull from Burghead.
Fig. 6 Vatican City, Biblioteca Vaticana: Reg. lat. 1997, fol. 1v. Initial *I.*
Fig. 7 Vatican City, Biblioteca Vaticana: Reg. lat. 1997, fol. 116. Initial.
Fig. 8a Paris, Bibliothèque Nationale: Ms. lat. 12048, Sacramentary of Gellone, fol. 27.
Fig. 8b Paris, Bibliothèque Nationale: Ms. lat. 12048, Sacramentary of Gellone, fol. 22.
Fig. 9 Paris, Bibliothèque Nationale: Ms. lat. 9389, Echternach Gospels, fol. 75. Lion of Mark.

A Note on the Wall Strips of Saxon Churches

Fig. 1 Earls Barton, Northamptonshire: Tower.
Fig. 2 Tigzirt, Algeria: Basilica, (after Gavault).
Fig. 3 Maeseyck, Belgium: St. Catherine's Church, Aldeneyck Cloister Evangeliary, fol. 1, Evangelist.

"Cain's Jaw-Bone That Did the First Murder"

Fig. 1 Ghent, St. Bavo: Van Eyck. Altarpiece of the Adoration of the Lamb, detail of right shutter.
Fig. 2 New York, Pierpont Morgan Library: Ms. 43, Huntingfield Psalter, fol. 8, twelfth century.
Fig. 3 Cambridge, St. John's College: Ms. K. 26 (James Ms. 231), fol. 6a, late thirteenth century.
Fig. 4 Oxford, Bodleian Library: Ms. Junius 11, Caedmon Poems, eleventh century, fol. 49.
Fig. 5 Auxerre, Cathedral: Detail of relief from façade, end of the thirteenth century.
Fig. 6 London, British Museum: Cotton Ms. Tiberius C. VI. Descent into Hell. Psalter, eleventh century, fol. 14.

The Image of the Disappearing Christ

Fig. 1 London, British Museum: Ms. Galba A. XVIII, Athelstan Psalter.
Fig. 2 London, British Museum: Add. Ms. 49598, Benedictional of St. Aethelwold, fol. 64v. Ascension.
Fig. 3 Vatican City, Biblioteca Vaticana: Regina Ms. 12, Psalter from Bury St. Edmunds, fol. 73v. Ascension.
Fig. 4 Rouen, Bibliothèque Municipale: Ms. 274 (Y. 6), Missal of Robert de Jumièges, fol. 81v. Ascension.
Fig. 5 Vatican City, Biblioteca Vaticana: Regina Ms. 12, Psalter from Bury St. Edmunds, fol. 103.
Fig. 6 Paris, Bibliothèque Nationale: Ms. lat. 765, fol. 19.

The Angel with the Ram in Abraham's Sacrifice: A Parallel in Western and Islamic Art

An Irish-Latin Text on the Angel with the Ram in Abraham's Sacrifice

The Beatus Apocalypse of Gerona

An Illuminated English Psalter of the Early Thirteenth Century

On an Italian Painting of the Flagellation of Christ in the Frick Collection

The Bird's Head Haggada, An Illustrated Hebrew Manuscript of ca. 1300

Prefatory Note

Unlike the selected papers in Volumes I and II of this series, which are about the art of a single century, those in the present volume span a period of nearly a thousand years. Since they were not intended originally as parts of one book, they will appear unconnected in subject. Written during the course of more comprehensive study and teaching, mainly as research on problems concerning individual works and themes of religious art, I hope they will, by their approach and general ideas, bring one nearer to an understanding and enjoyment of that art as a whole. In interpreting an exceptional, unidentified subject or anomalous detail, I have tried to account for it not simply by searching for its ground in a congruent religious text, but through documents of secular, as well as religious life. For the roots of new unusual imagery, I have looked into social history, events, institutions, language, folklore, politics and law. I have assumed that religious art, like religious cult, is not just an expressive representation of sacred texts and a symbolizing of religious concepts; it also projects ideas, attitudes and fantasies shaped in secular life and given concrete form by imaginative, I may say, poetic minds. This is hardly a new notion in the study of art, yet the habitual concentration of scholars on the sources of imagery in religious texts has led them to neglect or underestimate the importance of the interactions of religious and secular life for interpreting that art. In the first essay of Volume I of this series ("The Aesthetic Attitude in Romanesque Art"), I have brought together the evidence of an autonomous aesthetic impulse and response during that period of supposedly strict religious programs in the art of the Church.

In this volume, the reader will find in the articles on the Joshua Roll, the Maximianus Throne, and the Glazier Psalter, accounts of the relations between religion and the contemporary state in the portrayal of biblical scenes; in the papers on the Frick Flagellation of Christ, the spontaneous response of a suffering people to a crisis during a civil war; in the first paper on the Ruthwell Cross, the reflections of a religious conflict among ethnic groups during a period of conquest; in the Sacrifice of Isaac, Cain's Jawbone, Ruthwell II, the Disappearing Christ, and the Mérode altarpiece, the emergence of vernacular,

folkloric and rationalistic conceptions in the art of the Northern peoples, with a new concreteness of fantasy. In all these papers I have noted characteristic processes of imagination in the new themes and their groupings.

In addition to these studies of content, I have included as many pages and papers that deal with the artistic aspect of works and the history of forms: Ancient Mosiacs in Israel, the Calendar of 354, The Place of Ireland in Hiberno-Saxon Art, the Leningrad Manuscript of Bede, Anglo-Saxon Wallstrips, the Frescoes of Castelseprio, the Gerona Apocalypse, and Marginal Images and Drôlerie.

As in Volumes I and II, I have corrected passages from the original texts without changing the sense. Exceptions are on pages 361 and 363, where I have re-written a paragraph to take account of an error. I have provided twenty-four illustrations for the article on the frescoes of Castelseprio (pp. 67-114, notes pp. 130-137) which was first published without any of them. It was addressed then to specialists who were engaged, like myself, in ardent discussions of those newly discovered frescoes. In that unillustrated form, the article would be, for the most part, unintelligible to readers unacquainted with those remarkable works and the associated Mediaeval and early Christian art. Additions to the text and references to later publications are marked by brackets.

I wish to thank the institutions and individuals named in the acknowledgments and permissions who have provided the photographs reproduced here. I am especially grateful to the libraries and librarians of Columbia University, the Union Theological Seminary and the Pierpont Morgan Library, and to the European libraries listed in the index. Their great collections of books and manuscripts have been indispensable resources in the investigations upon which many of these papers were founded. My former pupil, Dr. Miriam Bunim, has been an invaluable assistant. The index is the unstinting patient work of my wife, Lillian Milgram (M.D.), who has collaborated throughout in the preparation of this volume. I owe thanks also to the editorial staff of George Braziller, Inc. for their helpful suggestions and efforts in obtaining illustrations.

LATE ANTIQUE,
EARLY CHRISTIAN
AND
MEDIAEVAL ART

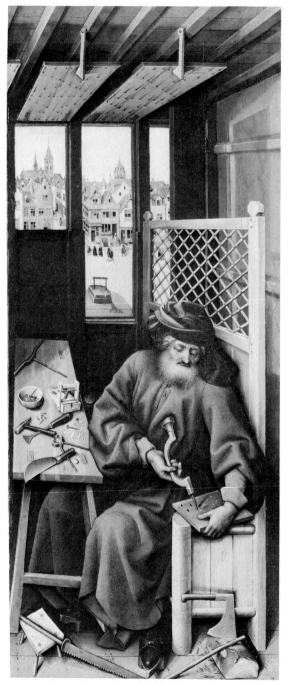

Fig. 1 New York, The Metropolitan Museum of Art, The Cloisters Collection: Flemish, *ca*. 1420–1430 Mérode Altarpiece by the Master of Flémalle (Robert Campin), right wing of the triptych. Joseph in his Carpenter's Shop.

"Muscipula Diaboli," The Symbolism Of The Mérode Altarpiece

(1945)

I

1.

In the Mérode altarpiece by the Master of Flémalle, the figure of Joseph appears in a wing beside the *Annunciation* as an artisan who fashions mousetraps (Fig. 1). Not only is the presence of Joseph in the context of the *Annunciation* exceptional in Christian art; we are surprised also that his craft of carpentry should be applied to something so piquant and marginal in his métier. The writers on Flemish painting have seen in this singular detail the mind of the author, who shows in other parts of his work an unmistakable disposition to the domestic, the intimate and tiny; his pictures represent a cozy, well-kept bourgeois world in which the chief actors are comfortably at home. He has been called the "Master with the Mousetrap,"[1] and a recent critic has regretted the now accepted name, since the former one is "prettier and more characteristic."[2]

I believe that this detail of the mousetrap is more than a whimsical invention of the artist, suggested by Joseph's occupation. It has also a theological meaning that was present to the minds of Christians in the Middle Ages, and could be related by them to the sense of the main image of the triptych. St. Augustine, considering the redemption of man by Christ's sacrifice, employs the metaphor of the mousetrap to explain the necessity of the incarnation. The human flesh of Christ is a bait for the devil who, in seizing it, brings about his own ruin. "The devil exulted when Christ died, but by this very death of Christ the devil was vanquished, as if he had swallowed the bait in the mousetrap. He rejoiced in Christ's death, like a bailiff of death. What he rejoiced in was then his own undoing. The cross of the Lord was the devil's mousetrap; the bait by which he was caught was the Lord's death."[3]

1

This metaphor appealed to St. Augustine as an especially happy figure of the Redemption; it occurs no less than three times in his writings.[4] In another sermon he says: "We fell into the hands of the prince of this world, who seduced Adam, and made him his servant, and began to possess us as his slaves. But the Redeemer came, and the seducer was overcome. And what did our Redeemer do to him who held us captive? For our ransom he held out his Cross as a trap; he placed in it as a bait his own Blood."[5]

The image of the mousetrap was only one of several metaphors of deception by which the theologians attempted to justify Christ's incarnation and sacrifice as the payment of a ransom owed to the devil, who held man prisoner because of the sin of Adam and Eve.[6] The conception of Christ's body as a bait on a divine fishhook which lures the demon to destroy himself was an older and more common figure, already used by Gregory of Nyssa and Cyril,[7] but was questioned by some writers as immoral. Anselm replaced the commercial transaction between God and the devil by the feudal idea of a wrong done by man to the honor of his superior, God, for which man as a finite creature was incapable of rendering due satisfaction (since the insult to God was infinite and required an infinite yet human penalty); and hence God in his infinite mercy offered his own incarnate Son as a voluntary sacrifice to atone for man's sin. Abelard, shortly after, devised a more ethical account of the sacrifice on the pattern of personal love, as a spontaneous, ultimate manifestation of Christ's love of man, which inspires the latter to a corresponding goodness and love. But the older view, with the authority of Augustine and Gregory the Great, persisted throughout the Middle Ages. Peter Lombard in his widely read *Sentences* repeats almost word for word Augustine's fable of the mousetrap and the deceiver deceived.[8] In the time of the Mérode altarpiece, the metaphor of the fishhook still appears in the writings of John Gerson expounding the Redemption.[9]

The connection of the mousetrap in the picture with the theological metaphor is strengthened by the extraordinary way in which the artist has rendered the *Annunciation* in the neighboring panel (Fig. 2). Instead of the Holy Spirit in the form of a dove, usual in images of the subject, he has represented a tiny naked figure of a child bearing a cross and descending toward the Virgin along beams of light which have just passed through a window. This homunculus Christ with the cross is fairly common in later mediaeval art,[10] although it appears to be contrary to dogma in showing the substantial human form of Christ before the moment of incarnation; it was criticized as unorthodox,[11] but the child was probably understood by the pious spectator as a symbol of the incarnation to come, just as the cross carried by this figure symbolized the Crucifixion and Redemption.[12] Here, too, as in the Joseph scene, doctrine, metaphor, and reality are condensed in a single object. The

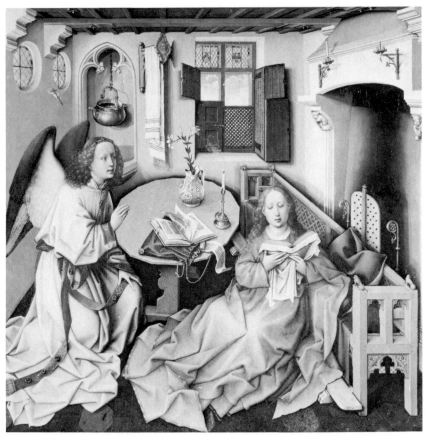

Fig. 2 New York, The Metropolitan Museum of Art, The Cloisters Collection: Mérode Altarpiece by the Master of Flémalle (Robert Campin). Central panel, Annunciation.

beams of light penetrating the window are not simply a phenomenal detail of everyday life, which later Dutch artists were to represent more subtly and picturesquely in their genre paintings of a woman reading or sewing in her room; the passage of the rays through the glass is a characteristic mediaeval image of the miraculous insemination and birth. In mediaeval poetry, in mystical literature, in hymns and mystery plays, in Latin and the vernacular, this simile recurs.

> As a ray of the sun
> Through a window can pass,
> And yet no hurt is done
> The translucent glass
>
> So, but more subtly,
> Of a mother untried,
> God, the son of God,
> Comes forth from his bride.[13]

In the Mérode panel, the mystery that takes place within the Virgin's body is symbolized in the space of the house; the various objects, all so familiar and tangible, the door, the window, the towel, the basin, the pot of lilies, the lighted candle, and perhaps others, possess a hidden religious meaning, focused on the central human figure. The theological sense of the mousetrap becomes more credible as an element of this symbolic whole. The imaging of the incarnation through the movement of the tiny soul-homunculus passing through glass along the rays of light belongs to the same mode of fantasy as the metaphorical mousetrap with its fleshy bait for the devil. Together they mark the poles of the human career of Christ.

2.

The image of the mousetrap depends, of course, on the presence of Joseph, who is a most unusual figure beside the *Annunciation*. In the two other examples that I know—a painting by Giovanni di Paolo,[14] contemporary with the Mérode panel, and a tapestry in Reims of about 1530[15]—the mousetrap is not rendered. In the first, Joseph simply warms himself by the fire; in the second, he is shown as a carpenter cutting wood and is part of an elaborate typological composition that includes *Isaiah*, the *Temptation of Eve*, and *Gideon's Fleece*. It is possible that in both works, Joseph and Mary were understood as counterparts of Adam and Eve; in the Italian work, the *Expulsion* adjoins the *Annunciation*.

In the Mérode triptych, which was probably made in the 1420s, the introduction of Joseph is peculiarly timely and local. This is a moment of strong

propaganda for the cult of Joseph, which is undeveloped before the end of the fourteenth century.[16] In 1399, the feast of Joseph (March 19) was adopted by the Franciscan order, and a little later by the Dominicans, but it did not enter the Roman breviary until 1479 and became obligatory for the entire church only in 1621. In the first decades of the fifteenth century, the leaders in the movement for the cult of Joseph were two eminent conservative reformers of the church who had held important religious posts in Flanders, the Cardinal Peter d'Ailly (1350–1425), Bishop of Cambrai, a diocese that embraced Hainaut, Brabant and Namur, and his pupil, John Gerson (1363–1429), who for a time after 1397 was dean of St. Donatian in Bruges. At the Council of Constance in 1416, they proposed that Joseph be elevated to a rank above that of the apostles and next to the Virgin's; they argued also for the institution of a universal feast of the Marriage of Mary and Joseph. Their effort was unsuccessful, but it contributed, no doubt, to the growth of the cult of Joseph. In the early fifteenth century, his feast appears in service-books of churches in Louvain, Liège, and Utrecht, and the feast of the Marriage is adopted toward 1430 in Bruges, Douai, and Arras. Gerson composed a number of works in honor of Joseph, including a sermon and a mass;[17] in his writings on the Annunciation and the Nativity, he dwells on the virtues of Mary's husband, whom he calls the *"chief et seigneur de la mère du chief et Seigneur de tout le monde."*[18] He pictures with great feeling the ideal relationship of the couple, their mutual trust, their chaste marriage, and, employing arguments that had been offered by an earlier theologian, Simon of Tournai, he justifies their relation as a true marriage, in spite of the perpetual virginity of the couple.[19]

It would be interesting to know why the cult of Joseph should spread at this time, and why the two men who were especially active in the unification and reform of the divided church should be its chief proponents. Here it is enough to observe that the cult of Joseph, when considered beside the worship of the apostles and the local saints who represent the authority and miracle-working powers of the church, places the human family of Christ in the foreground of devotion. It is essentially domestic and bourgeois, and celebrates the moral, familial virtues of the saint, rather than a supernatural accomplishment. Joseph belongs to the world as a husband and artisan, but he is also a model of continence. These aspects of his cult are in harmony with Gerson's nominalism and warm, emotional piety, his vernacular style, his concern with moral questions and desire for a simple faith freed from formal theological elaborations and subtlety. He turns from the mysterious, incomprehensible Trinity of dogma to the *"divinissima Trinitas Jesu, Joseph et Mariae."*

Although there is nothing about the mousetrap in his writings, Gerson's account of Joseph is not irrelevant to this detail of the Mérode panel. In the first place, he stresses Joseph's occupation as a carpenter (he calls him a

"charlier"—interesting for his personal enthusiasm for Joseph, since Charlier was Gerson's family name), and he disserts at length on the virtue of this humble craft which, together with the Virgin's labor as a weaver, assures his humility, his moral dignity, and livelihood.

> O what a marvel of deep humility—thus God's graciousness and humanity was such that he willed to be subject to a carpenter, a *charlier* or woodcutter, and to a poor weaver or silk worker.[20] [Joseph] devoted himself to work and toil, so as to be busied well and earn a just and honest living, and gain the blessing the Prophet speaks of when he says: "Because you eat the toil of your hands (that is, what your hands earn) you are blessed and it will go well with you" (Psalm 127). Thus Joseph in youth took to carpentry, to making carts or sheds or windows or ships or houses, though he was of an honorable and noble line in Nazareth, contrary to the men and women who don't want to work and think it shameful or slavery, and so are often poor and evil in the world and more to God, for such persons are commonly slaves to all the vices[21]

These arguments, it may be said in passing, anticipate the ascetic Protestant concept of the vocation and the religious value of industriousness, and should be taken into account in the problem of the origins of the Protestant ethic and bourgeois morality.

If this praise of Joseph as an artisan helps us to understand the pictures of the saint plying his craft, there is another aspect of the saint discussed by Gerson which refers to the theological concepts behind the metaphor of the mousetrap. He is deeply concerned with Joseph's role in the deception of the devil in the divine plan of Redemption, and in treating the question he alludes more than once to the artistic images of the saint. He observes that in ancient paintings Joseph is represented as a very old man with a big beard, and he attempts, like a modern student of iconography, to account for this type by historical considerations.[22] In the early period of Christianity, when the doctrine of the perpetual virginity of Mary had not yet taken firm root in the hearts of the faithful, it was necessary to combat heretics, who pointed to the Gospel passage about the brothers and sisters of Christ. The artists therefore rendered Joseph as an old man at the moment of Christ's birth, in order to indicate his incapacity for begetting a child. But Gerson remarked also that in more recent art, especially in Germany (where he had spent some time after the Council of Constance), Joseph was represented as a young man. The painters have a certain liberty, he says, quoting Horace:

> . . . Pictoribus atque poetis
> quidlibet audendi semper fuit aequa potestas.[23]

This newer version Gerson believes to be more in keeping with the divine plan. For if Joseph were too old, the devil would suspect the supernatural cause of

the birth of Christ and therefore not be deceived by the bait of the man-God.[24] On this question of the devil's awareness of the incarnation, theologians were divided.[25] Some, basing themselves on passages in the Gospels (Mark I,24 and Luke IV, 34, 41), believed that the devil, from the beginning, recognized the divine paternity of Mary's child; others, following Ignatius, whose opinion was read in the office of Christmas Eve in the Roman breviary, held that the Virgin was married to Joseph precisely in order to conceal the birth of Christ from the devil, who thought the child was begotten by Joseph. This last interpretation was widespread in the later Middle Ages and occurs in the writings of Bernard, Bonaventure, and Thomas, in the mystery plays, and the *Speculum humanae salvationis*.

The role of Joseph in the deception of the devil was therefore perfectly familiar in the time of the Mérode altarpiece. It may appear surprising then that Joseph is so often represented as an old man; but the theologians themselves were not strict in this whole matter. The same author, Jerome, or Thomas Aquinas, or Bridget of Sweden,[26] could give contradictory opinions on the question of the devil's knowledge of the incarnation, according to the context treated. By either type of Joseph, old or young, the spectator would be led to recall the homiletic teachings about Mary's virginity and the virtue of her chaste spouse. Local tradition undoubtedly had much to do with the type chosen, which, once established, became the vehicle of a growing mass of legend and belief implicit for the spectator in the mere presence of the customary image, however scant or inconsistent the attributes might be.

In the present case, what matters is the fact that Joseph was, for the religious fantasy of the later Middle Ages, the guardian of the mystery of the incarnation and one of the main figures in the divine plot to deceive the devil. Gerson, in meditating on the Redemption, does not employ the figure of the mousetrap. Instead, the fishhook and bait are the instruments, as I have remarked already. In his "Exposition on the Passion of the Lord," he addresses the devil as Leviathan who tried to bite the precious flesh of Jesus Christ with the bite of death. "But the hook of divinity that was concealed within and joined to the flesh, tore open the devil's jaws and liberated the prey, which you would imagine he held and devoured."[27]

3.

The double character of the mousetrap in the painting, as domestic object and theological symbol, suggests the following reflections on the art. In the early Middle Ages the notion that the things of the physical world are an allegory of the spiritual did not entail the representation of these things as the signs of a hidden truth. The symbolism of art was largely confined to

personifications and to the figures and episodes derived from the holy books; if animals were represented as symbols, they were most often the creatures named in the Bible, like the four beasts of John's and Ezekiel's visions, or the half-fabulous beings described and interpreted in the *Physiologus*. The introduction of nature and, with it, of the domestic human surroundings into painting can hardly be credited to a religious purpose. The mousetrap, like other household objects, had first to be interesting as a part of the extended visible world, before its theological significance could justify its presence in a religious picture. But even as a piece of still life, the mousetrap is more than just an object in a home; it takes its place beside the towel and the basin of water as an instrument of cleanliness or wholeness, and may therefore be regarded as an overt symbol of the Virgin's purity in the same sense as the others and, like them, independent of a theological text. The artist who inserts this object among the others feels its qualitative connection with them and creates a poetic unity, based on his love for the quality that attracts him. This love need not be religious in character, but a primary personal (or social) fact, which the religion absorbs and with which the artist himself may color the religious world.

If, now, we look at the mousetrap in this poetic manner as an attribute of Joseph or of Joseph and Mary together, we are led to another result. We have to consider its significance in relation to the human peculiarities of these two figures, who are man and woman, old and young, married yet chaste, in the context of a miraculous conception. In a poem about a beautiful maiden beside a pious old husband who is making a mousetrap, we would sense a vague, suggestive aptness in his activity, as if his nature and a secret relation to the girl were symbolized in his craft. The painter, in imagining a milieu for the Virgin and her guardian, Joseph, is unconsciously attracted by objects that project in some feature essential characters of the figures and vaguely resemble the hidden elements of the action. As we meditate on the labor of old Joseph who bores tiny holes with his drill, as we regard the objects in both rooms, the pair of mousetraps and the tools, the candles, the pot of lilies, the towel, the basin of water, the windows, the open books and the fireplace, they are drawn together in our minds as symbols of the masculine and feminine. The objects which are unified as fixtures and implements of the home and on another level as theological emblems are also coherent as metaphors of the human situation. The religious symbolism itself depends largely on the same basic properties of objects which make them relevant as psychological signs; the vessel, the window, or the door, for example, is common to dreams and to religious fantasy as an equivalent of the woman. It is difficult, of course, to fix precisely the meaning of a group of such sexual symbols in a painting. They are often ambiguous, and we lack, moreover, all knowledge of the life history of both the artist and the donor, who dictated perhaps the presence of Joseph and his

task. But the process of symbolization is a general one and may be adduced within limits in the decipherment of single works.

If the theological texts are an evidence for the religious meaning of the mousetrap in the Mérode panel, there exist documents no less explicit that point to a sexual significance. In popular magic and folklore, the mouse is a creature of most concentrated erotic and diabolical meaning.[28] It is the womb, the unchaste female, the prostitute, the devil; it is believed to arise by spontaneous generation from excrement or whirlwind; its liver grows and wanes with the moon; it is important for human pregnancy; it is a love instrument; its feces are anaphrodisiac; the white mouse is also the incarnation of the souls of unborn children. For aid against mice, Christians appeal to the Belgian virgin, St. Gertrude, a spinner and patron of spinners, and also to the Virgin Mary. This conception of the mouse as evil and erotic is shared by the folk and by learned men. In the Renaissance, scholars like Erasmus and Alciati write of the mouse as the image of the lascivious and the destructive.[29] To see the mousetrap of Joseph as an instrument of a latent sexual meaning in this context of chastity and a mysterious fecundation is therefore hardly arbitrary. What is most interesting is how the different layers of meaning sustain each other: the domestic world furnishes the objects for the poetic and theological symbols of Mary's purity and the miraculous presence of God; the religious-social conception of the family provides the ascetic figure and occupation of Joseph; the theologian's metaphor of redemption, the mousetrap, is, at the same time, a rich condensation of symbols of the diabolical and the erotic and their repression; the trap is both a female object and the means of destroying sexual temptation.

These symbols, whether religious or secular, presuppose the development of realism, that is, the imaging of the world for its own sake, as a beautiful, fascinating spectacle in which man discovers his own horizons and freedom of movement. The devoted rendering of the objects of the home and the vocation foretells the disengagement of still life as a fully secular sphere of the intimate and the manipulable. Religious thought tries to appropriate all this for itself; it seeks to stamp the freshly discovered world with its own categories, to spiritualize it and incorporate it within a scheme of other-worldly values, just as earlier, the church took over the dangerous critical method of dialectical reasoning for the demonstration of its dogmas. On the other side, the enlarged scope of individual vision makes this art increasingly a vehicle of personal life and hence of subconscious demands, which are projected on the newly admitted realm of objects in a vaguely symbolic and innocent manner. The domestic still life is claimed as a symbolic field by both the ascetic ideals and the repressed desires. The iconographic program of the period, in response to the social trend, favors this double process by placing in the foreground of art themes like the

Virgin and Child, the Annunciation, the Incarnation and the Nativity, which pertain to the intimate and hidden in private life and call into play this complex, emotional sphere. The religion tries to master the feelings by displacement to the imaginary holy persons, and in this it is aided by the realism of art, which is able to give to its figures a compelling vividness and familiarity. But in shaping a semblance of the real world about a religious theme of the utmost mysteriousness, like the Incarnation, the objects of the setting become significant of the unacknowledged physical realities that the religion aims to transcend through its legend of a supernatural birth. At the time of the Mérode panel appear also the first secular paintings of the naked female body, a clear sign of the new place of art in the contending, affective life of the individual.

It is interesting to recall that the same Gerson who spoke so knowingly of the proper rendering of Joseph (and criticized the allegorical *Roman de la Rose* as a lascivious, though beautiful poem) condemned the painting of the nude. He warned against the current confusion of mystical and erotic love and saw a danger even in contemplating the nudity of the crucified Christ.[30]

The new art thus appears as a latent battlefield for the religious conceptions, the new secular values, and the underground wishes of men, who have become more aware of themselves and of nature. Jan van Eyck's portrait of Arnolfini and his wife as a marriage document[31]—a significant theme at the time of the propagation of the cult of Joseph and the feast of his wedding with Mary—is a revealing example of this combat in which conflicting attitudes are made to coincide through the hidden allusions in the objects and through the reflection of the figures (including the painter) in a mirror. The latter is a beautiful, luminous, polished eye, encircled by tiny scenes of the life of Christ; it is both a symbol of the Virgin and a model of painting as a perfect image of the visible world. In accepting the realistic vision of nature, religious art runs the risk of receding to a marginal position, of becoming in turn the border element that secular reality had been. In the Arnolfini portrait, it maintains itself in the background and as a secret language in the small objects, in contrast to their ostensible domestic meaning and material charm; the more complete scenes of the life of Christ are a representation within a representation, a secondary reality forming a border around the reflecting glass.

At the end of the century this opposition comes out into the open and assumes a terrifying and melancholy form in the fantasies of Bosch, a master capable of enchanting tenderness in the painting of landscape. His works are a counter-offensive of the unhappy religious conscience against the prevailing worldliness in a period of the decay of the Church. The formerly marginal grotesques of Gothic art, minutely rendered embodiments of the aggressive and the erotic, invade the entire field, and are elaborated as monstrous symbols of

the desires, thrown together under the heading of the religious conception of sin. In these visions of a frightfully exasperated asceticism, more conscious of man than of God, there is neither the assurance of faith nor the refreshing beauty of the world. The mousetraps of the side-wing of the Mérode altarpiece, automatic mechanisms fashioned by the Virgin's bourgeois husband to catch the devil and overcome the passions, are forerunners of the ubiquitous Boschian instruments in which the diabolical, the ingenious, and the sinfully erotic are combined.

II

A Note On The Mérode Altarpiece
(1959)

In writing on the symbolism of the Mérode Altarpiece in 1945,[32] I left unexplained the wooden board in which Joseph is drilling holes (Fig. 1). I could not relate it to the mousetraps that he has already made, which I had interpreted through a sermon of St. Augustine: "The devil exulted when Christ died, but by this very death of Christ the devil was vanquished, as if he had swallowed the bait in the mousetrap The cross of the Lord was the devil's mousetrap; the bait by which he was caught was the Lord's death."[33]

Since then Professor Panofsky has supposed that the board is the perforated cover of a footwarmer,[34] and Miss Margaret Freeman has seen in it the tormenting spikeblock that hangs from Christ's waist in certain images of the Via Crucis.[35]

Another explanation is suggested by a painting in a Netherlandish manuscript of about 1440: the Hours of Catherine of Cleves, formerly in the collection of the Duke of Arenberg and now belonging to Alastair B. Martin (Fig. 3).[36] In a miniature at the bottom of page 171, a scene representing the trapping of fish, there appears a boatlike contrivance of which the upper surface is a perforated board of almond shape; the holes are no doubt a means of ventilation. The device is apparently a box for storing live fish as bait; it is attached by a cord to a stake on the shore. Nearby are other instruments of the fisherman: an openwork trap and two wicker baskets for preserving the caught fish in the water.

What makes the bait box especially relevant to the picture by Robert Campin is the scene in the miniature above. The Incarnation is represented there, with God the Father sending forth the naked Christ Child, who bears the cross in his arms; behind him flies the dove. The action is set on a starry eastern sky at early dawn above a rocky landscape; Christ and the dove descend toward a pond that fills the foreground. The absent Mary is perhaps implied in the star-filled eastern sky at dawn, a current metaphor of the Virgin.[37]

Here, as in the Mérode Altarpiece, the Incarnation is associated with a marginal image in which appear devices for trapping. The painter of the manuscript evidently knew the art of the Flémalle Master, since the latter's compositions for the Crucifixion and the Descent from the Cross are copied faithfully in this book.[38] As the Christ Child, with the bird of the Holy Spirit behind him, descends to the closed womb of the Virgin, bearing the cross with which to trap the devil, the fisherman below manipulates a long-handled net to draw the trapped fishes out of a round wicker basket floating in the pond. In representing an ordinary fishing scene, the miniaturist still holds to the

Fig. 3 New York, The Pierpont Morgan Library: Ms. 945, Hours of Catherine of Cleves, fol. 85. (Formerly collection of Alastair B. Martin).

connotation of the mousetrap. In the Middle Ages, in comments on Job XL, 19, 20 (Vulgate)—"Canst thou draw out Leviathan with a hook?"—Christ's body was described as a bait on a divine fishhook which lures the demon to destroy himself.[39]

In the Mérode Altarpiece the perforated board is rectangular, to be sure, rather than rounded as in the miniature. The rectangular bait box is common in our day and we may assume that it was known in the fifteenth century. The context of the miniature, as of the altarpiece, and the other connections between the two works lead us to believe that in the Mérode picture, too, the board on which Joseph is at work belongs to the same complex of trapping and bait associated with the Redemption.[40]

It may be objected that the genre scene in the manuscript is innocent of religious or other symbolism; as a representation of rural life on the lower margin of a page, it is like hundreds of other images of daily work in later mediaeval manuscripts—images that have no apparent connection with the content of the larger religious pictures on the same pages. Yet in some marginal scenes, one does notice a more or less obvious allusion to the major Biblical theme, as a parallel or parody drawn from the profane world. I have cited elsewhere a miniature of Cain killing Abel with a jawbone above which a monkey shoots a bird with a bow and arrow; the bestiality of man is compared with the cunning artifice of the beast.[41] Such spontaneous poetic transpositions of the main idea into a marginal image, unsupported by a text, are not infrequent and one may therefore look for a metaphorical content in the correspondences between the Incarnation above and the genre picture below in the page of the Book of Hours. The interpretation is, of course, only a plausible conjecture which owes what cogency it has to the relationships of the miniature with the Mérode Altarpiece where so many small elements are at the same time parts of a domestic world and mute symbols of a theological design. In the manuscript few of the miniatures are accompanied by marginal paintings—perhaps a half dozen of the sixty or more. Among these at least one alludes clearly to the religious scene above: on page 63 the painting underneath the *Visitation* represents the naked infant Christ in a net manipulated like a bird trap by another naked infant, undoubtedly John, who sits on the ground within a wicker enclosure.[42] On page 215, beneath a huge hell mouth where an angel comes to release the naked souls, a rustic suspends a wire between a post and a tree; two birds hover at the post and two others are caught in a cage, a reference perhaps to the state of man in purgatory and hell, although the image may be no more than a vaguely allusive genre scene inspired by the theme of enclosure and liberation in the miniature above.

By the fifteenth century the painter of manuscripts included in his repertoire many scenes of daily life suitable for the illustration of the calendars

of psalters, breviaries, and books of hours, which could also serve him for the margins of other leaves. The image of fishing and baiting is not strictly an invention of the artist designed for the context of the Incarnation above. We suspect that it was based on a picture of the labors of a month. In the Grimani Breviary, a scene of night fishing, with similar devices, illustrates the calendar page for March.[43] Since the Incarnation took place in that month, the choice of subject in the Hours of Catherine of Cleves seems altogether apt. A figure drawing eels (or fish) out of a weir or wicker basket is represented earlier on Romanesque capitals of Cluny[44] and Vézelay.[45] In Vézelay an accompanying figure blowing a bellows, a personification of the wind, indicates that the scene represents a month, probably March,[46] or at least has been copied from a cycle of the months—the wind is a common illustration of March in the Early Middle Ages.[47] But for a closer parallel to our miniature in the representation of the months one must turn to the poem of Wandalbert of Prüm in the early ninth century *(De mensium duodecim nominibus, signis,* etc.). In December, he writes:

> All kinds of water fowl are caught in nets;
> Here, too, in the fish-laden waters
> Wickerwork baskets are set
> And enclosures of faggots fixed at the banks
> Where the fords slacken the flow of the shallow stream
> And the nets capture an easy prey.[48]

I have not found this scene in Gothic calendars. But my knowledge of these is very incomplete. The images of the months in the later Middle Ages have yet to be collected and studied like those of the earlier period.

NOTES

1. By Bode, *Gazette des Beaux-Arts*, 2nd ser., XXXII, 1887, p. 218.

2. Fierens-Gevaert, *Histoire de la peinture flamande*, II, Paris, Brussels, 1928, p. 8. [He is now identified as Robert Campin.]

3. "Exsultavit diabolus quando mortuus est Christus, et ipsa morte Christi est diabolus victus, tanquam in muscipula escam accepit. Gaudebat ad mortem, quasi praepositus mortis. Ad quod gaudebat, inde illi tensum est. Muscipula diaboli, crux Domini: esca qua caperetur, mors Domini," Sermo CCLXIII, "De ascensione Domini," Migne, Patrologia latina, XXXVIII, col. 1210.

4. See also Sermo CXXX, *ibid.*, col. 726 (on John 5:5–14), and Sermo CXXXIV, *ibid.*, col. 745 (on John 8:31–34).

5. "Sed venit Redemptor, et victus est deceptor. Et quid fecit Redemptor noster captivatori nostro? Ad pretium nostrum tetendit muscipulam crucem suam; posuit ibi quasi escam sanguinem suum," Sermo CXXX, *ibid.*, col. 726.

6. On these doctrines see Hastings Rashdall, *The Idea of the Atonement in Christian Theology*, London, 1920, and Jean Rivière, *Le dogme de la rédemption au début du moyen âge*, Bibliothèque Thomiste, Section historique, XVI, Paris, 1934.

7. "The Deity was hidden under the veil of our nature, that so, as is done by greedy fish, the hook of Deity might be gulped down along with the bait of the flesh"—Gregory of Nyssa, *Oratio catechetica magna*, 24, cited by Rashdall, *op. cit.*, p. 305; for Cyril, see *ibid.*, p. 311, note 3; for Augustine, *ibid.*, pp. 330 ff.; and on these metaphors in the West, see Rivière, *op. cit.*, pp. 39, 40.

8. Lib. III, Dist. XIX, 1, Migne, Pat. lat., CXCII, col. 796; he repeats Augustine, Sermo CXXX, Migne, Pat. lat., XXXVIII, col. 726.

9. John Gerson, *Opera omnia*, III, Antwerp, 1706, col. 1199. See also p. 6 and note 27, p. 17, for the text.

10. See David M. Robb, "The Iconography of the Annunciation in the Fourteenth and Fifteenth Centuries," *The Art Bulletin*, XVIII, 1936, pp. 523 ff.

11. By St. Antoninus of Florence (1389–1459); for the text, see Robb, *op. cit.*, p. 526.

12. Cf. Charles de Tolnay, *Le Maître de Flémalle et les frères van Eyck*, Brussels, 1939, p. 15.

13.
> "Sicut vitrum radio
> solis penetratur,
> inde tamen laesio
> nulla vitro datur,
>
> Sic, immo subtilius,
> matre non corrupta,
> deus, dei filius,
> sua prodit nupta."

Mone, *Lateinische Hymnen des Mittelalters*, II, Freiburg i. Br., 1853, no. 370, p. 63 ("Sequentia de virgine Maria"). Cf. also the poem by a Spanish writer of the twelfth century, Peter of Compostela, which I have cited elsewhere in a parallel context (*The Art Bulletin*, "From Mozarabic to Romanesque in Silos," XXI, 1939, p. 349, note 122 [reprinted in *Selected Papers, I. Romanesque Art*, 1977, p. 88]):

> "Ut propriis solis radiis lux vitra subintrat,
> Sic uterum rector superum mox virginis intrat."

(See P. B. Soto, "Petri Compostellani De consolatione rationis libri duo," *Beiträge zur Geschichte der Philosophie des Mittelalters*, VIII, 4, Münster, 1912, p. 122.)

Another example is published by Mone, *op. cit.*, I, p. 63, in the hymn, "Dies est laetitiae in ortu regali . . ."; its special significance was discussed in an accompanying article by Millard

Meiss, whose questions about the motif of the light passing through the window in the *Annunciation* had been the occasion of my own consideration of the symbolism. Further examples are cited in the valuable book by Georges Duriez, *La Théologie dans le drame religieux en Allemagne au moyen âge*, Paris, Lille, 1914, p. 209 (German mystery plays; Amadeus; and St. Bridget, who seems to paraphrase the poems published by Mone), and by K. Smits, *De Iconografie van de Nederlandsche primitieven*, Amsterdam, 1933, p. 46, who connects this detail in Flemish painting with a corresponding mediaeval Netherlandish text.

14. Now in the National Gallery in Washington; see *Art Quarterly*, V, 1942, p. 316, fig. 2.

15. Ch. Loriquet, *Tapisseries de la Cathédrale de Reims*, Paris, Reims, 1882, pl. IX. These tapestries are now in the Municipal Museum.

16. On the history of the cult of Joseph, see O. Pfülf, "Die Verehrung des heiligen Joseph," *Stimmen aus Maria-Laach*, XXXVIII, 1890, pp. 137–161, 282–302, and the articles on St. Joseph in *The Catholic Encyclopedia* and the *Dictionnaire de théologie catholique*.

17. *Opera omnia*, III, Antwerp, 1706, cols. 842 ff. ("Considerations sur saint Joseph"), cols. 1352 ff. ("Sermo de annuntiatione B.M.V."), IV, cols. 729 ff. ("Exhortatio facta . . . Anno Domini 1413. Ut solemnizetur Festum Sancti Joseph virginalis sponsi beatae Mariae"), cols. 736 ff. ("Sequuntur quaedam quae opportune dicerentur in Festo s. Joseph"), cols. 740 ff. ("Officium Missae s. Joseph, etc."), cols. 743–783 ("Josephina carmine heroico decantata"). The date of the heroic poem is given by the text as 1417.

18. *Ibid.*, III, col. 844.

19. *Ibid.*, III, cols. 851 ff.; IV, col. 764.

20. *Ibid.*, III, col. 844.

21. *Ibid.*, III, col. 850. See also IV, col. 755.

"O quele merveille comme profonde humilité—: et se la benignité et humanité de Dieu fu tele qu'il ha voulu estre subget à ung fevre en bois, c'est à dire à ung charlier ou charon, ou à ung charpentier, et à une texceresse ou povre ouvriere en soye. [Joseph] se donna à labour et à mestier, tant pour soy bien occuper comme pour gaignier honnestement et justement sa vie, et pour acquerir la benediction de la quele parle le Prophete, quant il dit: 'Pour ce que tu mengeras les labeurs de tes mains, (c'est à dire que tes mains gaigneront); tu es benois et te fera bien' (Vulg., Ps. 127:2). Si se donna saint Joseph en son josne aage à estre fevre en boys, comme à faire charrettes ou huches, ou fenestres, ou nefs, ou maisons, jasoice fust il de tres honeste et noble lignée en la cité de Nazareth: et c'est contre ceulx ou celles qui ne veulent ouvrer, et reputent à honte ou à servage, si sont souvent povres et mechants quant au monde, et trop plus quant à Dieu; car teles personnes sont communement serves et subgetes à tous vices"

(I owe the translation to Professor Creighton Gilbert who reprinted the article in the volume *Renaissance Essays* that he edited for Harper and Row, New York, 1970, pp. 21–42.)

22. *Ibid.*, III, cols. 848, 1352.

23. *Ibid.*, III, col. 1352: ". . . Depictum tamen invenimus Joseph velut in aetate juvenili, qualem praediximus, sicut in hac Alemania crebro notavi. Vel dic illud Horatii"

24. *Ibid.*, III, col. 851; IV, col. 761.

25. The opinions are collected by Duriez, *op. cit.*, pp. 73, 74. See also *Dictionnaire de théologie catholique*, VIII, col. 1513.

26. Duriez, *loc. cit.*

27. *Op. cit.*, III, col. 1199 ("Expositio in Passionem Domini"): ". . . sed occultabatur intus et jungebatur divinitatis hamus, qui aperuit maxillas, et liberavit praedam quam opiniabaris tenere atque devorare."

28. I follow here the article, "Maus," by R. Riegler in the *Handwörterbuch des deutschen Aberglaubens*, ed. Bächtold-Stäubli, Berlin–Leipzig, 1934–35, VI, pp. 31–59.

29. Erasmus, *Adagiorum epitome*, Leipzig 1678 ("In deliciis"); A. Alciati, *Emblemata*, Leyden, 1591, pp. 306, 307, Emblema LXXIX ("Lascivia"); cf. also I. P. Valerianus,

Hieroglyphica, Cologne, 1631, pp. 161, 162 (cap. XXX–XXXV—note that the white mouse which is lascivious in cap. XXXIV is also "intaminata munditia" and a symbol of "intemerata castitas" in cap. XXXV).

30. *Op. cit.*, III, col. 610.

31. See Erwin Panofsky, "Jan van Eyck's Arnolfini Portrait," *Burlington Magazine*, LXIV, 1934, pp. 117–127.

II

The footnote reference numbers, as they appeared in the original publication, are found in parentheses after each footnote in the second section.

32. " 'Muscipula Diaboli,' The Symbolism of the Mérode Altarpiece," *The Art Bulletin*, XXVII, 1945, 182–187 [reprinted here, pp. 1–11]. (1)

33. Migne, Pat. lat., XXXVIII, col. 1210, (Sermo CCLXIII, "De ascensione Domini"). On this metaphor in Augustine's writing and its history, see J. Rivière, *Le dogme de la rédemption chez saint Augustin*, Paris, 1933, pp. 117 ff., 320–338. This book was not available to me in 1945. (2)

34. *Early Netherlandish Painting, Its Origins and Character*, Cambridge, Mass., 1953, p. 164. (3)

35. "The Iconography of the Mérode Altarpiece," *The Metropolitan Museum of Art Bulletin*, December 1957, p. 138. The same interpretation is now proposed by Charles de Tolnay, "L autel Mérode du Maître de Flémalle," *Gazette des Beaux-Arts*, VIe période, t. LIII, 1959, p. 75. (4)

36. The manuscript has been described by A. W. Byvanck, *La Miniature dans les Pays-Bas septentrionaux*, Paris, 1937, pp. 65, 117, 118. See also Panofsky, *op. cit.*, p. 398, note to p. 103. I wish to thank Mr. Martin for kindly permitting me to study this manuscript and to reproduce the page. (5)

37. Yrjö Hirn, *The Sacred Shrine*, London, 1912, pp. 465, 468. (6)

38. For the dependence of the Cleves master on Robert Campin, see Panofsky, *op. cit.*, pp. 104, 176, 177 and figs. 129, 130. (7)

39. Cf. Gregory, *Moralia in Job*, XXXIII, vii, 14; ix, 17 (Pat. lat., LXXVI, cols. 680, 682); and see Rivière, *op. cit.*, p. 336 n. 2 for other references. (8)

40. That mousetrap and fishing could be cited together as metaphors in an account of the Redemption is shown by a sermon in a breviary of the fourteenth century in Monte Cassino (Cod. XXXIV, p. 284). See Rivière, *op. cit.*, p. 321 n. (9)

41. "Cain's Jawbone that Did the First Murder," *The Art Bulletin*, XXIV, 1942, p.211 and fig. 6 [reprinted here, p. 257 and fig. 3]. (10)

42. The bird-hunter's net is also a symbol of the Crucifixion. Cf. Gregory, *Moralia in Job*, XL, xxiv (Pat. lat., LXXVI, cols. 691–692)—cited by Rivière, *op. cit.*, p. 337. (11)

43. *Le Bréviaire Grimani de la Bibliothèque Saint Marc à Vénise, avec une introduction de Giulio Coggiola*, Leyden, 1903–1908, fol. 4 (cf. also fol. 7). It is reproduced also by Paul Brandt, *Schaffende Arbeit und bildende Kunst*, II, Leipzig, 1927, fig. 5, p. 21. (12)

44. Brandt, *op. cit.*, I, fig. 242. (13)

45. *Ibid.*, fig. 243, and pp. 193 ff. The action and instrument of these figures were first recognized by Brandt. They are still misinterpreted in a recent description by J. Adhémar, in Francis Salet, *La Madeleine de Vézelay*, Melun, 1948, p. 184, no. 23 (Étude Iconographique par J. Adhémar). (14)

46. Brandt was puzzled by the figure with the bellows, and Adhémar, who recognized him as a wind, failed to see the connection with the month (*op. cit.*, p. 162 n. 1). (15)

47. On the Wind as March, see J. C. Webster, *The Labors of the Months in Antique*

and Mediaeval Arts to the End of the Twelfth Century, Princeton, 1938, p. 51, and my remarks in *Speculum*, XVI, 1941, pp. 135, 136. (16)

48. "Retibus hinc varias pelagi prensare volucres,
Amnibus hinc etiam piscosis ponere crates
Vimineas, densosque ad litora figere fasces,
Qua vada demisso tranquillant flumine cursum
Inventum, facilem capiant ut retia praedam"

E. Duemmler, ed., *Poetae Latini aevi Carolini*. I. Monumenta Germaniae Historiae, Berlin, 1884, pp. 615, 616. (17)

Ancient Mosaics in Israel:
Late Antique Art—
Pagan, Jewish, Christian

(1960)

The ancient floor mosaics in Israel—isolated arbitrarily, like so many ancient works elsewhere, as a group within modern state boundaries—are examples of an art practiced for centuries over a vast area from England to Mesopotamia in the Roman and Byzantine empires. The fact that in so large a region Roman or Greek culture was exposed to native peoples who maintained their own language and customs leads one to look for indigenous traits in this transplanted art.

Yet much that appears to be native may turn out on further study to be a common feature of late antique art. In all the provinces classic painting was submitted to a fairly uniform process of reduction by local craftsmen who approached the high forms of imperial art or the traditional style of the aristocracy as if from below, with a naive perception of their main aspects.

The technique of mosaic stamps all these works, metropolitan or provincial, with a family likeness (Figs. 1, 2 and 3). Through this technique the art of pavement mosaic as a type of painting has aesthetic characteristics of its own. Its physical nature, an assembly of cubes of colored stone set on a floor, enters in many hidden ways into the visual effect, whether the whole simulates natural forms or is made up of geometrical patterns. It may be described roughly as a technical rather than illusionistic pointillism—akin to the knotting in rugs, the beaded filigree in metal, or cells in enamel—in which discrete particles are fitted together into a continuous whole. We never lose sight here of the small unit of effect in a work which is conceived broadly in its larger forms. We sense everywhere the recurring cube and the cement joints; these are not only technical components but contribute an all-over network to the design. The background, even when a plain or barely toned white, has a pattern of squares and joints that often responds to the major shapes. No part of the surface is, strictly speaking, a neutral ground. From this uniformity of the tiny elements arises a typical texture and rhythm and a scale of proportions

of parts to the whole. Many objects—a petal, an eye, a nostril—are represented by a single cube which becomes a measure throughout. By their equal density and common structure the cubes and joints help to unify an extended horizontal field which we cannot easily see as a whole, but must grasp through successive views as we move around it. Important, too, are the characteristic hardness and opacity of the slightly lustrous medium, with its considerable range of stony and earthen tones; with the grayness of the joints they confer an aspect of the sober and subdued, a humble materiality that distinguishes the floor mosaics from the more colorful and luminous glass mosaics on the walls and vaults.

This art of the pavement, so commonplace in its time—applied universally in private and public buildings of every kind by pagans, Christians, and Jews alike—is basically a classic art, in the historical sense of the word; and although it presents a span of forms from the natural to the geometric, the symmetrical to the all-over pattern, which seem to correspond to different, even opposed, mentalities or cultures, both poles are found in Greco-Roman art side by side, often within the same work. They are modes, like the genres of poetry, equally accessible to the same artist, but not equally favored at all times and in all contexts. Because of its character as an extensive pavement covering the entire floor of a long room, the mosaic is particularly open to the strewn pattern and becomes a field for developing this type of form.

As an art practiced over so wide a region and in so many different kinds of buildings, the floor mosaic exhibits a range of quality from the most refined mastery of the human image to the crudest representation and to a purely artisan patterning with obvious geometrical motifs. In the rendering of the figure the mosaic is subject, like other fields of classic art in the late period, to what may be called the vernacularizing of the forms; it is like the *koine* or *vulgatum* of everyday speech compared with the cultivated language of poetry and artistic prose, and shows accordingly simplifications that remind us of an archaic art. But these more naive and rustic works—rustic even in some great centers when produced by unspecialized hands—will not be mistaken for the progressive archaic works of the earlier phases of classic art in which freshly observed natural forms have been simplified. We recognize in the first, across the folkloric simplicity of the images, many traces of a more advanced style. Broadly speaking, it is not nature but classic art of a complex kind that has been decomposed and reduced, although in certain works we are struck by elements of spontaneous imagination. The most rigid figures retain a vestigial pliancy and asymmetry that betray an origin in more highly articulated Greek forms. Even that aspect which seems most primitive, the full face, is a Greek view essentially foreign to the old Oriental styles of painting and relief sculpture, with their conventional profile heads; the schemas of the features

abbreviate a late classic modeling of the head. In the simple compositions, too, the modes of pairing, alternation, and contact of bodies come out of classic art.

In considering this reductive process, which is so widespread in late antiquity as to seem a historical law and is not easy to distinguish from the more positive aspect of the evolving styles, since these tend increasingly toward isolation and immobility of the figures, it must be remembered that certain of the traits attributed to this process—the plain background, the buildings and trees no larger than the human figures, the bodies separated from each other— were already part of ancient art in its naturalistic phase. Greek art never lost the tie with so-called conceptual forms, especially in representing depth, even when illusionism, in the impressionistic sense, was most advanced. The buildings, represented unforeshortened with two sides in full view, are typical even in the most skilled works. While discovering the apparent form and color in some aspects, Greek art preserved the conceptual object-form and color in others; it had never as thoroughgoing and consistent an illusionism as Western art of the post-Renaissance period.

There are two kinds of isolation in the art of the early Christian and Byzantine periods: a primitive distinctness of forms, such as one finds in the drawings of children and untrained adults and in many savage arts, which is independent of the content and is applied equally to plants, animals, geometrical motifs, and sacred themes; and a *represented* isolation often strongly expressive and symbolic, which is like that of ceremony in fixing attention on a sacred object, and is compatible with rich naturalistic detail. It is associated with symmetry and centered grouping and other types of composition, including the complex kinds with balanced movement and overlapping. In the first case, the isolation that marks the figure as a whole also applies to its parts which are drawn distinct from each other; in the second case, the parts are rendered in a more or less fused illusionistic way. In late antiquity and the early Middle Ages these two kinds of isolation—the one naively regressive and most often provincial or barbaric, and the other more deliberate and selective, an attempt to achieve a form adequate to a special content—these intersect and become difficult to disengage. The less trained provincial artist works with forms created in the centers; and the masters of the metropolis give up more and more the devices of naturalistic style as their content becomes more spiritualized and is tied to a theology that in its abstruse formulas minimizes nature and logic. There is also a concurrent change in society—in some respects a decline: in culture the vernacular and rustic displace the higher urban forms, and the traditions of Greek thought and art, already much contracted, are preserved most fully in a few favored centers like Constantinople.

But if the artists of the provinces appear to simplify a classical form which they cannot (rather than *will not*) assimilate in its whole complexity,

comparison of the results of the reductive process over several centuries shows that the models which have been reduced vary in style from period to period, and that the reductive works are the offshoots of a changing art. The high art does not stand still. In the pavements of the fourth to the sixth century we discern several complex features that arose in late antiquity. If figures are isolated and seem pieced together, interlace ornament displays a new intricacy which anticipates and prepares mediaeval art; the scroll forms are spread out richly with effects of endless twining and continuity in all directions, unknown to older classic art and in principle foreign to the methods of archaic design. In the simpler geometrical patterns, the spaces between the main motifs can also be seen as ornaments contending with the latter for dominance. In the large fields of ornament, there appears a degree of systematization, an accented framing, connectedness, and hierarchy in the allotment of spaces to the varied classes of elements, that reminds us of the planning of great architectural ensembles between the third and sixth century. Provincial art is able to reproduce faithfully those new motifs which are ornamental—that is, repetitive in structure—and therefore more accessible to an artisan mind. Besides, we recognize the dependence on an advanced style in the qualities of light and color: there is in the simplest pavements a multiplicity and nuancing of tones, a love of iridescence, of playful flicker, of sharp contrasts of pure colors, and abrupt modeling with light and shadow, that we see also in the great wall mosaics and manuscript paintings of the same period. A detail like the opposed local colors and light-values of the legs of the primitively drawn donkey of Beth-Alpha (Fig. 5) presupposes the audacities of color and light-dark in the most refined works of the fifth and sixth centuries in Ravenna and Constantinople, which spring from a tradition of illusionistic art. In the mosaic of Beth-Shean (Fig. 1) a head reminds us of the figure at Justinian's right in S. Vitale and intimates to us the existence of an art like the Ravenna mosaics in some Palestinian center (see Fig. 2 in Chapter 3).

In several pavements we feel the artist's considered response to the largeness of surface at his command and to its architecturally imposed boundaries. This is an advanced civilized attitude, far from the primitiveness of an art that proceeds from the object forms, juxtaposing them with little regard to the enclosing frame or the supporting surface. If in certain mosaics of this time the strewn elements seem to exist freely, like wild flowers in a meadow, they maintain a constant density throughout and in their randomness show some subtlety in the varied axes of the scattered motifs and in their adaptation to the shifting viewpoint of an observer who sees the floor from different sides of the room. Such devices are not to be compared with the arrangements of old Oriental ornament, which is limited and rigid in its axes, less varied in the themes combined within one field. The strewn ornament of late antiquity, it

Fig. 1 Beth-Shean, Monastery of Lady Mary: Pavement mosaic. Head.

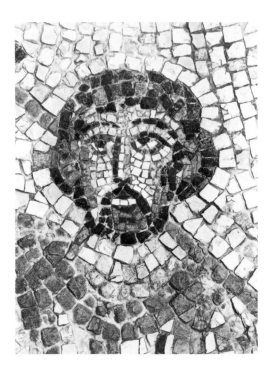

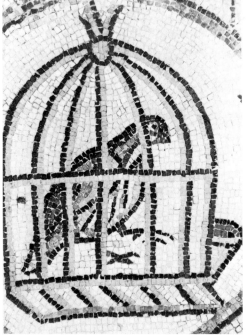

Fig. 2 Nirim, Synagogue of Ma'on: Pavement mosaic. Bird in Cage.

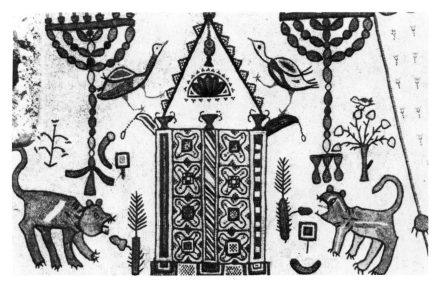

Fig. 4 Beth-Alpha Synagogue: Pavement mosaic. Ark of the Covenant.

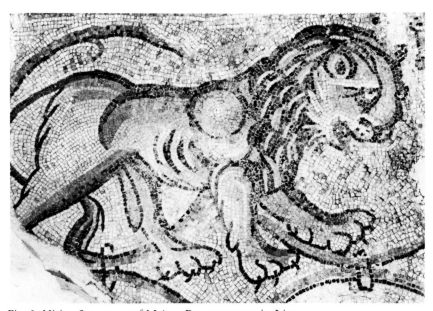

Fig. 3 Nirim, Synagogue of Ma'on: Pavement mosaic. Lion.

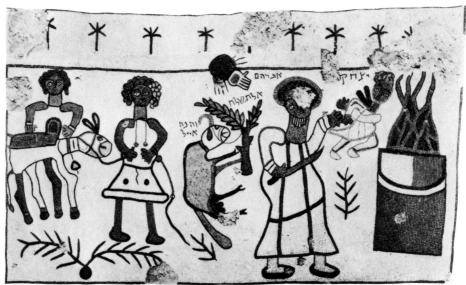

Fig. 5 Beth-Alpha Synagogue: Pavement mosaic. Sacrifice of Isaac.

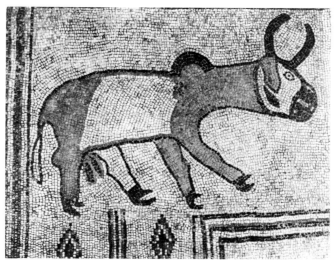

Fig. 6 Beth-Alpha Synagogue: Pavement mosaic. Bull.

must be said, rests on a tradition of Hellenistic naturalism. It may incorporate subjects taken from the Eastern world, like the Nilotic fauna and flora in so many Roman pavements, but the style is clearly Greco-Roman and can be traced to earlier classic art.

This strewn style is a perfected invention of skilled artists and not a passive trace or revival of old Oriental methods (Greek art had already absorbed those methods in the period before the sixth century B.C.). It is a solution particularly adapted to the decoration of floors, and for that reason, too, presents analogies to the Oriental carpet, of which we know, however, only much later examples. The opposed pictorial mosaic with depth is an artificial idea, an anomaly on the floor, and had a limited application, taking up only a small part of the field. It is infrequent after the fourth century. The all-over mosaic, with freely scattered figures, animals, plants, and household objects, far from being an innovation of the late period, had been common beside the framed picture mosaic before that time.

I have spoken of this art mainly as a provincial style, for with the destruction of the great basilicas and martyria in Palestine, no surviving works are known in that region which display the full artistic resources of the sumptuous pavements or wall mosaics of the imperial centers. But in certain examples a strong personality gives to the simplified forms an accent of originality. One should not ignore the difference between the regularity that comes from a passive repetition and the decorativeness which is inventive and depends on a vigorous imagination. Such is the enchanting bird in the cage of the mosaic at Nirim (Fig. 2) or the remarkable lion with plant-like outlines on the same pavement (Fig. 3).

Among the mosaics in Israel, one stands out through the uniqueness of its style and the interest of its religious ideas: the pavement of the synagogue of Beth-Alpha. It is so exceptional a work, so abundant in qualities and meanings, that I may be allowed to dwell on it in detail. It is one of the few mosaics in which we discover at work an original artistic mind belonging to a nonclassic culture.

Apart from the execution, it is distinctive already as an organized set of themes—the sacred objects of the Temple, the Cosmos with the sun, the heavens and the seasons, and *Abraham's Sacrifice*—together forming a definitely Jewish whole. If we had no inscriptions in Beth-Alpha and the panel with the Ark of Covenant (Fig. 4) were missing, we could infer that the pavement was a Jewish work from the care with which the artist has rendered the divided hoofs of the clean animals (after Leviticus 11) and has singularized in both the Zodiac (Fig. 8) and the Abraham panel (Fig. 5) the ram's horn, which was to be the horn (*shofar*) of the priesthood. The bull (Fig. 6) has two horns, other animals two ears; it is therefore not from primitive conceptual

representation nor from direct perception of the profile that the artist has omitted a horn of the ram.

The Jewish artists—Marianos and his son Hanina—have given these varied subjects a coherent form while preserving the distinctness of each, as the artists of Ravenna set out their interrelated Christian themes on the separate surfaces of the choir of S. Vitale. In Beth-Alpha, as in Ravenna, it is hard to find a key religious idea that explains all the parts; several concepts, I believe, have been combined to form a comprehensive whole. In the grouping of themes so different in character, yet so clearly coordinated in a divided field, this pavement (Fig. 7) announces the art of the Christian Middle Ages with its systematic programs of monumental theology. Jewish tradition by itself would not have provided such an art. Like the architecture of the synagogue—Beth-Alpha is a basilica—it belongs to a Judaism that has absorbed much from its Greek and Christian surroundings without giving up the basic practices and beliefs. The theme of *Abraham's Sacrifice* is an example of divine help, as well as the confirmation of God's convenant with Israel. The central field with the sun and moon, the stars, the zodiac, and the seasons, taken from pagan art, symbolizes the divinely governed order of nature. In the third panel, next to the apse, the Ark of Covenant, the candlesticks, the cult instruments and objects of the Temple, all common on Jewish gold glass, are grouped in a clear symmetry. Three great components of the religion are thus associated in one mosaic: the Shrine, the heavenly order and rule of the universe, and the intervention of God to save his chosen ones. Of the episode of *Abraham's Sacrifice* one can multiply interpretations without end. (Its occurrence on Mount Moriah, the site of the future Temple, connects it with the Temple objects in the third field and with the Messianic hope.) But the fact that in other synagogue pavements the sole narrative theme from the Old Testament is *Daniel with the Lions* or *Noah's Ark* permits us to think that in Beth-Alpha the element common to all three episodes underlies the choice: salvation through the Lord, God's help to His faithful ones in danger—although other values were undoubtedly felt. The same Old Testament figures were selected by Christians for funerary paintings and sculptures; they were cited in prayers by the Christians and by the Jews before them as examples of deliverance.

Most important to us in Beth-Alpha (and not sufficiently considered in the literature on the mosaic) is the artistic achievement. (I cannot say—not having studied the problem—what part was done by each of the two men, of whom one might have been the designer of the whole and the other might have helped him in the execution.) From the standpoint of classical canons of representation, they must seem ignorant and crude in drawing, pitifully innocent of the detailed structure of human and animal bodies. But forget the prejudice of classic style and look more closely at the forms. How strong and

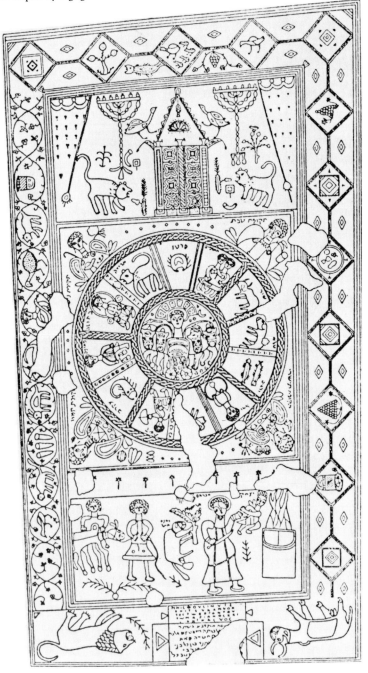

Fig. 7 Beth-Alpha Synagogue: Pavement mosaic.

sure are the lines! How freshly natural in their rhythms and correspondences, like the assonances and rhymes of a gifted folk poet! The artist draws and colors things neither quite as they are known to be nor as they are seen; his feeling for life, his warm interest in the individual objects, his sense of the pictorial whole, reshape with delightful freedom and taste the few elementary schemas delivered by memory. To penetrate this artist's power of drawing and composing, read the scene of Abraham and Isaac (Fig. 5) from figure to figure, observing the analogies and variations of form. Compared to the other panels, which are designed in a more legible symmetry, this one looks at first loosely ordered, without an axis or center. A more subtle disposition determines the unity of this scene in which an action rather than a fixed state of affairs has been rendered. The hand of God, directing the drama and its outcome, is placed in the center above the tree and the ram, so that what belongs to the last stage of the story is set in the middle—hardly a primitive procedure. The donkey (cut by the frame), the ram, and Isaac form a series of diminishing size and increasing compactness; each figure has another axis. The members of this series alternate with the series made up by the servants and Abraham, in which the figures become larger from left to right and also more active, more completely engaged in the crucial moment. Although every figure and object seems to be put together in the simplest way, each has its singularities of drawing and its peculiar liaisons with the neighboring objects. Observe how Abraham's arms and the stripes ornamenting his robe are related to the lines of the altar and the flames in a matching counterpoint of directions. Within this figure especially we admire the finesse in the network of the lines, their supple curves, their breaks and continuities. The division of colors in the altar brings us back to the surprising contrasted colors of the donkey on the other side; the same wavy forms define both Abraham and the animal's limbs. All this controlled fantasy in the shapes is not to be found in old Oriental compositions. It is something new in the East and rests upon the naturalistic dramatic narration in Greek art, which has been infused in late antiquity with a feeling for the pathetic and spiritual and has become more concentrated in form. (In its large conception, as in some details, the scene of *Abraham's Sacrifice* corresponds to the miniatures of the same subject in the Byzantine manuscripts of the Octateuch.) If there is an Oriental feeling here, it comes from a new Orient, not the old Egyptian, Babylonian, or Achemenid traditions. It is a development within the Hellenized and Christianized East and depends, as I have said, on an active transformation of the most advanced Greco-Roman art rather than on a revival of ancient native styles.

In the three panels of Beth-Alpha (Fig. 7), the artist has designed flexibly according to three distinct principles, all found in late classic art. Each field has its own mode of composition adapted to its content. In the middle, a radial

design centered in the circle of the Sun (Fig. 8), with figures set like the spokes of a wheel and with the corners filled symmetrically. The geometric framework is part of the representation, an image of the cosmic structure. In the upper rectangle (Fig. 4), preceding the apse, a lateral symmetry, with the central Ark flanked by animals, by two candlesticks and two curtains—almost everything is paired but not rigid. In the lower panel, at the entrance, a balanced narrative scene moving in the Greek manner from left to right (the Hebrew inscriptions read from right to left). Around the three fields runs a border of which the filling changes on three sides.

Some devices of composition tie each field to the others. In the Abraham scene (Fig. 5), the spotting of light and dark introduces a symmetry of the two sides sustained by the exact centering of the hand of God. In the middle panel, the strictness of the radial symmetry is broken or loosened: first, by the right-to-left direction of the signs of the Zodiac, beginning with the ram; second, by the irregular spacing of the individual fields in the Zodiac—there are no cardinal lines among them and the opposite spokes of the wheel fail to coincide as they approach the vertical and horizontal. The ornaments of these spokes are selected in a willfully lawless fashion, at once primitive and subtle—contrary to the systematic framework of the heavenly world. The guilloche braid that fills the borders of the inner and outer circles—and is therefore the most conspicuous motif—has been applied to the spokes in a counteraxial manner. In the central medallion (Fig. 8), with the Sun and the four horses, a similar randomness occurs in the irregular placing of the twenty-three stars. The uppermost panel of the Ark (Fig. 4) combines the symmetry of the central panel with an appearance of strewn forms, like the lowest field. In all three the paired or repeated figures are surprisingly varied. The central disk with the Greek conception of the personified Sun in his chariot is in this respect the most ingenious. Taken from a classic model with foreshortened elements, this image has a quality of the primitive organic, the cellular and compactly inlaid, which is completely un-Greek; for similar forms one must look at Merovingian art, at Mozarabic paintings in Spain, or at early mediaeval enamels. The free silhouetting of the shapes of the horses and the Sun, the studied variation in the design of the heads, these are superb and raise the work far above the artisan routines of mosaic pavements.

What is most astonishing in Beth-Alpha is that an artist with so little knowledge of natural forms should be able to carry out with so great assurance and expressive force the elaborate program of organized imagery in this pavement.

The father and son who signed this work with their names in Greek and explained the images in Hebrew knew that they belonged to two traditions. Their art, like the forms of folklore, seems outside history in the perennial

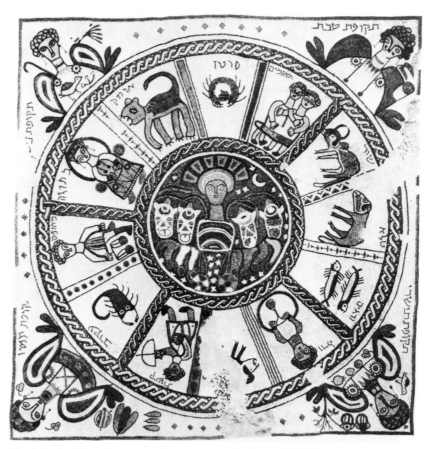

Fig. 8 Beth-Alpha Synagogue: Pavement mosaic. Sun and Zodiac.

simplicity of the untrained that pervades the drawing of the figures. One might regard the artistic power of their work as a unique accident due to the spontaneous response of an exceptionally gifted backwoods personality to the incompletely absorbed surrounding Byzantine culture within which the Jewish community was a small enclave. But we can hardly be sure since so little of the art of that period has come down. (What is unique and what is typical in the provinces will not be known until the entire body of surviving ancient pavements has been reproduced and studied.) There is a related program on the floor of a synagogue at Na'aran; but in its style the mosaic of Beth-Alpha remains until now an isolated work like the wall paintings of the synagogue of Dura which were made three centuries before. It is conceivable that other works of that kind were produced and that a continuous tradition of synagogue art in the Palestinian-Mesopotamian region gave to Jewish artists the tasks and experience which made possible the floor of Beth-Alpha. In that tradition, to judge by this mosaic, what counted was not the standard of Greek statuesque forms—still strong in the Byzantine world—but the power of decorative symbolization of the contents of Jewish faith, within a Christianized and Hellenized Oriental world, through the imaging of the Shrine, the Heavens, and the Promise.

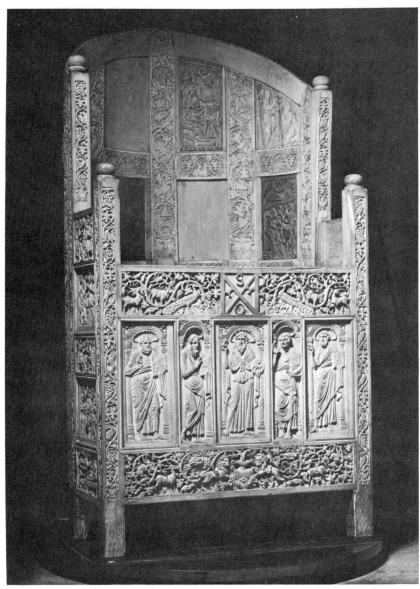

Fig. 1 Ravenna, Archiepiscopal Palace: Maximianus Throne.

The Joseph Scenes on the Maximianus Throne in Ravenna

(1952)

W hy was the story of Joseph represented on the great ivory throne of the Archbishop Maximianus (546–554) beside scenes from the life of Christ (Figs. 1, 4 and 5)? Until now the choice has been explained by the notion common among Christian theologians, from Tertullian to Pascal, that the patriarch Joseph was an antetype of Christ: betrayed by his brothers, lowered into the well and sold to the Ishmaelites, he was in the end the savior of the Gentiles and the Jews.[1] This striking parallel of Joseph to Christ does not account sufficiently, however, for the unique place of Joseph as a theme on a bishop's throne. Is it due, as some have supposed, to the origin of the throne in Alexandria where the story of Joseph had a singular value because of the Egyptian setting?[2] An Alexandrian origin has not been established and there are as strong, perhaps stronger, arguments for the view that the throne was made in Constantinople.[3] Besides, the Joseph story was not peculiar to the Christian art of Egypt; as many examples are known in Italy.[4]

In Ravenna itself, a writer of the early sixth century at the court of Theodoric, Helpidius Rusticus, composed *tituli* for paintings of concordant scenes of the Old and New Testament in a local basilica; among these was the episode of *Joseph Sold by his Brothers,* which was paired with *Christ's Betrayal by Judas.*[5] But more important for the Maximianus throne are the sermons of an earlier Bishop of Ravenna, Peter Chrysologus (432–450), who treated these symbolic relationships in a remarkably thorough way. In a sermon on the Nativity and the Virgin Birth, speaking of Saint Joseph as the spouse of Mary, he interprets him as a figure of Christ, the spouse of the Church; and to illustrate the concept of symbolic figuration, he enters into a detailed account of the patriarch Joseph as a figure of Christ's passion. "Joseph incurs jealousy because of his prophetic dreams, Christ provokes envy because of his prophetic visions; Joseph is lowered into the pit of death and emerges from it alive, Christ is delivered to the sepulchre and returns alive; Joseph is bartered, Christ is sold at a price; Joseph is brought to Egypt, it is to Egypt that Christ flees;

35

Joseph provides abundant bread to the hungering people, Christ satisfies the nations of the entire world with heavenly bread."

Behind these comparisons lies a theory of meaning: "Every dot, letter, syllable, word, name and person in the Gospels is a symbol of the divine."[6]

Besides this unexpected reference to the patriarch Joseph in a sermon on the Nativity of Christ and the Virginity of Mary—themes which occur on the ivory throne (all the front panels of the upper part of the throne are about the infancy of Christ)—Peter Chrysologus offers another which is of still greater interest for our problem. In a sermon on Saint John the Baptist, Joseph appears also as the figure of the Baptist, who is the central person among the four evangelists on the lower front of the throne (Fig. 1). "When he fled the adulteress, Joseph left his robe behind; John, in order not to see the adulteress, gave up his very body; Joseph, in order not to commit adultery, willingly accepted imprisonment; John, in order to denounce adultery, exchanged the desert for the jail; when Joseph interprets dreams, he escapes death; John, in order to foretell the Son of God, accepts death; when Joseph prepares the temporal bread, he earns the golden neck-chain (*torques*) and honor; John, to show believers the celestial bread, earns the bloody crown of martyrdom."[7]

The Bishop Peter Chrysologus begins his sermons on John the Baptist by speaking of himself as a shepherd; he will talk of the wolf Herod . . . and this brings him to John the Baptist.[8] In still another sermon, at the consecration of a bishop, he chooses as his subject the Virgin Birth, likening Joseph, Mary's spouse, to the bishop as the spouse of his bride the church.[9]

What is significant here is that the Ravenna author, in relating the patriarch Joseph to both Christ and John the Baptist and the latter to the bishop, points to the fuller context of the Joseph themes on the episcopal throne.

The connection with the bishop is clearer, more explicit, in the writings of a greater author, Saint Ambrose, Bishop of Milan. Like Peter Chrysologus, he observed the likeness between Joseph and Christ;[10] he composed some *tituli* in verse, describing paintings that illustrate the concordance of the Old and New Testament in these two figures.[11] Deeply attracted to the personality of Joseph, he pictures him as the model of the high civil servant and the bishop. In a treatise on Joseph,[12] he enumerates his virtues at length, and in another, more important, work of Ambrose, on the duties of the clergy—a Christian counterpart of Cicero's *De Officiis*—Joseph is held up as a paragon of the good priest, who combines religious and civil administrative virtues.[13] Joseph is liberal in distributing alms, just, prudent, and chaste—an ideal counselor; it is to a bishop with his qualities that the welfare of the community should be entrusted. In a letter to a newly elected bishop, Ambrose again recommends Joseph as a model of humility and modesty.[14] In his vision of the "saintly"

Joseph as a perfect administrator and statesman, Ambrose was perhaps inspired by the treatise of Philo on Joseph. There, the Biblical patriarch is pictured as the ideal ruler and his life as an allegory of the statesman or politician; his coat of many colors, for example, symbolizes the variability and multiplicity of political life. In the last line, Joseph is characterized as "a most admirable supervisor and arbiter in times both of famine and plenty."[15] The Biblical text (Genesis 41,42) offers to Ambrose one passage especially significant to a Christian of his time: the appointment of Joseph by Pharaoh as his chief minister, with the ring, the robe, and the gold necklace, is like the ceremonial ordination of a bishop. "For what does the ring placed on his finger mean, if not that the pontificate of faith has been awarded to him, so that he might himself designate others? Why the stole, which is the garment of wisdom, if not to show that the sovereignty of prudence has been granted him by the celestial king?"[16] In early Christian thought, the bishop's ring symbolized his role as the spouse or guardian of the church which is the spouse of God. As Saint Joseph was for Peter Chrysologus the chaste spouse and guardian of Mary, the bride of Christ, so the bishop was both spouse and guardian of the church.[17]

It is this richer conception of the patriarch Joseph as a figure of Christ and a model of the bishop who is both priest and statesman that underlies, I believe, the choice of the Joseph story for the symbolic decoration of the Maximianus throne.

The likening of the bishop to Joseph must be understood historically, that is, with respect to the character of the episcopal office in the sixth century. By that time, the bishop had advanced far from his earlier status as a presbyter to a position of great power, with civil as well as religious functions. The literal meaning of the "episcopus" (overseer, superintendent) was now resumed in its secular sense; the bishop was like Joseph, in Ambrose's words, the "superinspector," particularly when elevated on his throne.[18] He had not only to look after the continually expanding domains and interests of the church; he was also a functionary of the empire and took part in the administration of his city. With the decline of the Roman state, the bishop's role in secular affairs had increased immensely. The laws of Justinian assigned to the bishops important duties in the state; they were included among the notables who appointed the magistrates and the chief officials of the city; they took part in the maintenance of public buildings and were charged specifically with the repair of the city walls and the supervision of weights and measures; they controlled also the administration of municipal finances—the magistrates on leaving office had to render to the bishop an accounting of the use they had made of public funds. (In Ravenna the bishop presided over the commission of five citizens to whom the municipal authorities rendered their accounts.) Finally, the bishop was the

official protector of the poor, of prisoners, and slaves, and intervened in the courts where he enjoyed a high authority.[19] "In short, in the city as in the provinces, the episcopal authority intervened incessantly beside the administrative authority, and the governor, closely controlled by the Church, often had to yield to this ever-vigilant power which the civil law itself armed against him. In Italy in particular . . . the governor could hardly resist the all-powerful bishop, who spoke at the same time in the name of the Emperor from whom he drew his prerogatives and of God himself whose representative he was."[20]

The career of Ambrose at the end of the fourth century is a well-known example of the secular range of a great bishop's action. The son of a praetorian prefect and himself a civil governor of his province before his ordination, he was the adviser of three emperors while Bishop of Milan. For a theologian seeking an Old Testament prototype of the bishop active in civil affairs and close to the monarch as counselor, the patriarch Joseph, whom Ambrose called "sanctus," was a model figure. Like the bishop he was both a temporal ruler and a figure of Christ. Cassiodorus, who had been the minister of Theodoric in Ravenna a generation before Maximianus, called Joseph the first praetorian prefect and the originator of that office;[21] Joseph was a model prefect who saved the people and was designated *"patriarcha et nunc pater imperii"* by the king.[22] In the next century, when the Saxon King Ceadwalla appointed the Romanizing Bishop Wilfrid his chief minister, the latter was compared to Joseph: "He called for Bishop Wilfrid and made him supreme counselor over the whole kingdom, just as the King of Egypt, when Joseph had been taken from prison, made him, in the words of the prophet, 'Lord of his house . . . to teach wisdom'."[23]

We are led to see, then, in the imagery on the Maximianus throne not only the familiar likeness of Joseph to Christ, already well established in Ravenna and Milan, but a symbolization of the bishop's office, which was patriarchal in Joseph's sense and included civil as well as religious functions.

This combined religious and secular pattern of meaning in the Joseph scenes agrees with what we know of the life of Maximianus and the situation of Ravenna at this time. Maximianus was a poor deacon of Pola, who rose to a high position through his political adroitness. Having won the favor of the Emperor Justinian, he was appointed by him Archbishop of Ravenna in 546 (Fig. 2), against the wishes of the people. By shrewd maneuvers he overcame their opposition, and won their respect by his discretion, generosity, and great enterprises of church building and decoration.[24] Conscious of his humble beginnings, he said of himself, in two inscriptions on works of art he had donated, that he rose to power *"de stercore."*[25] We may suspect a personal identification in the choice of the fortunate Joseph as a figure among the images on his throne.[26]

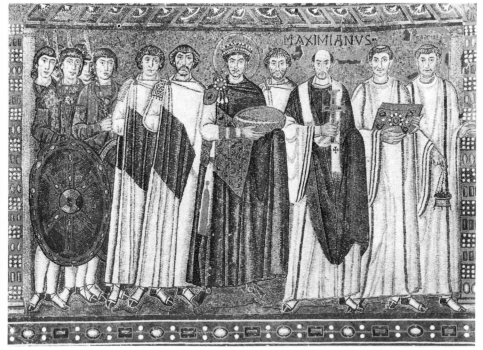

Fig. 2 Ravenna, San Vitale: Mosaic. Justinian and Maximianus.

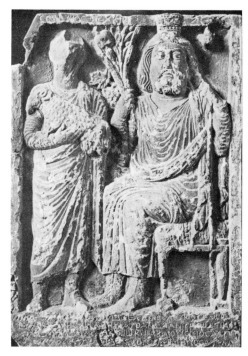

Fig. 3 Dura-Europos:
Zeus Kyrios, relief.

In the creation of the throne, with its unique symbolism, there was perhaps an attempt to rival Rome upon which the See of Ravenna depended.[27] Ravenna, recently conquered by the Byzantines, was then the new Western capital of Justinian's empire, and the importance of Maximianus was undoubtedly increased by the fact that all through his rule the Roman Bishop, Pope Vigilius, who had consecrated him, was a prisoner of Justinian in Constantinople. The attempt of Maximianus to bring the body of Saint Andrew, Peter's brother, from the imperial capital to Ravenna may be interpreted as a means of asserting Ravenna's autonomy with respect to Rome. In the mosaics of Ravenna since the early sixth century, Andrew is singled out very strikingly by unusual ray-like hair.

Our conception of the political meaning of the Joseph panels leads us to reconsider one of their details which has been interpreted as a purely religious element. It is Joseph's strange headgear in the scenes of his authority (Fig. 4 and 5), the high crown which several scholars have identified with the *modius* or bushel worn by the Hellenized Egyptian god Serapis (Osiris-Apis) in Greek and Roman sculptures as a symbol of abundance.[28] Since several early church fathers have written that Serapis was in origin none other than the deified Joseph, the savior of the Egyptian people,[29] it seems plausible that Joseph should be represented with the crown of the pagan god as the Serapis of the faithful. This would not, of course, prove an Alexandrian origin of the throne or its iconographic types;[30] the belief in the transformation Joseph-Serapis has been transmitted to us mainly by Latin writers and was probably well known outside of Egypt. Yet is it likely that Christians in the sixth century would have illustrated the conversion of an Old Testament patriarch into a pagan god? Moses had been identified with Musaios, the teacher of Orpheus, and likened to Hermes and Thoth, but we should be surprised to come upon a Christian image of Moses with attributes of the pagan divinities. For the Latin writer Paulinus of Nola, in the fifth century, the pagan god Serapis was a creation of the devil who, in assuming that name and form, took over the attributes of Joseph, including the bushel measure or *modius* which symbolized the patriarch's prevention of famine. Paulinus goes on to celebrate the destruction of the great temple of Serapis together with its immense idol by the Christians of Alexandria in 391.[31]

The *modius* was not, however, the exclusive property of Serapis, for it was worn by other pagan gods.[32] Besides, on the Maximianus chair, none of the three examples of this crown resembles the bushel with the symbolic sheaves of wheat, typical of the Serapis image; they are high, jeweled crowns, much closer to the crown worn by the Zeus Kyrios of Dura (Fig. 3)[33], and one of them has the form of a tower or city-wall with crenellations (Fig. 4 and 5).[34] The city-wall crown is also of pagan origin; it is the attribute of female divinities—

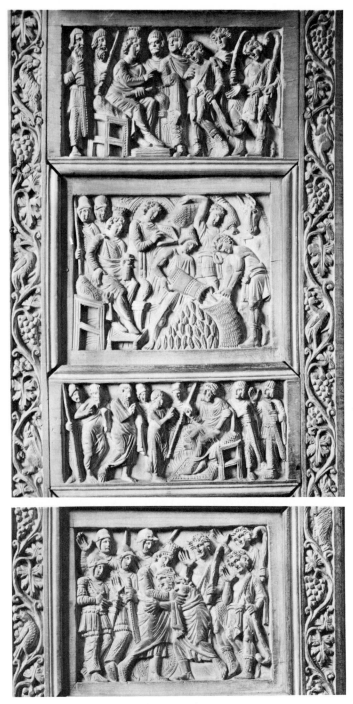

Figs. 4 and 5 Ravenna, Archiepiscopal Palace: Maximianus
Throne (detail). Scenes from the life of Joseph.

Cybele, Hera, Hygeia the Ephesian Artemis—and more particularly of the Tyches—who personify the great cities of the Eastern Greek world.[35] It has an apparent connection with fertility and good fortune, and therefore could well be transferred to the figure of Joseph.

There is still another context of the *modius* which is closer to the Maximianus chair than those we have mentioned. The Byzantine emperor possessed, in addition to the familiar diadem crown or tiara, a golden *modius* or *modiolus*.[36] Since this crown was given to the emperor by the senate and prefect of the capital city (as distinguished from the diadem offered by the patriarch), perhaps to show that the emperor's authority came from the will of the senate and the people, it may be regarded as the local Constantinopolitan form; it was similar to the crown worn by the Tyche of the city in a statue that existed in the forum in the Middle Ages.[37] The unique *modius* worn by Joseph on the Maximianus throne only after his elevation to power may therefore be an attribute of his secular office as the co-ruler of Egypt,[38] suggested by the secular investiture of the Byzantine emperor by the representatives of the city. Joseph would be imaged then as a Byzantine ruler rather than as an Egyptian god; and in this connection with civil authority, Joseph appears to us once more a likeness or prototype of the Bishop of Ravenna.

The *modius* of Joseph embodies then several ideas: the bushel measure as the instrument of his action in Egypt—according to one writer, Joseph upon his death was represented by the Egyptians with the *modius* as the symbol of his role in preventing famine,[39] and Eusebius records the belief that he was the inventor of weights and measures[40] (here too there is a possible relation to the bishop who distributes wheat and bread during famine); the *modius* as the crown of Tyche or Fortune; and the *modiolus* as the emperor's crown, offered by the city, and appropriate to Joseph as the ruler of Egypt.

In conclusion, some general remarks are in place here on the principles underlying the symbolism of the Joseph scenes on the throne. Besides the conception of Old Testament figures as antetypes of Christ through the parallel episodes in their lives and his, there was the no less important conception of Old Testament figures as antetypes of the rites of the Church. Abel sacrificing the lamb to God, Melchizedek offering bread and wine to the victorious Abraham, are cited in the mass as antetypes of the Christian priest performing the eucharistic sacrifice. But the non-sacramental functions of the Church also have their parallels in the Old Testament, and of this the relationship of Joseph to the bishop is an interesting example. In the Christian's effort to comprehend the whole of his world within a single system of thought, every new object and situation was submitted to a process of analogical interpretation. For late Antiquity and the Middle Ages, and particularly for religious thought, analogy was perhaps the most significant relationship between things. Since formal and

final causes, to use Aristotelean language, were the chief ones, and the material and efficient causes were more and more neglected, analogy and purpose became the key concepts in explaining the world. A similarity of form, even a purely verbal one in the names of things, was already a bond between things. Necessity was manifested in the formal resemblances of persons, objects, and events. These equivalences, which are the ground of symbolism, are not self-evident, given directly to the eye or the mind, but, like poetic symbols, are discovered through directing concepts and requirements which change with the human situation. The discovered analogies in turn serve a hidden purpose of the divine being. Every event or stage is an announcement and a preparation of a subsequent stage. Just as the plant is latent in the seed, so Christ's life is latent in Joseph's, and the secular authority of the bishop is already intended in Joseph's career. Symbolism thus includes purpose as well as analogy: the universe—nature and history—is saturated with Christian finality, everything points beyond itself to a formal system evident in the analogical structure of things, due to a divine intention working itself out in time. The predominance of analogy and purposefulness in much of mediaeval thinking is a primitive trait which we find among savage peoples and also in children and psychotics. But the mediaeval practice differs from the primitive in one important respect. The Middle Ages inherited the Greek and Roman rationality, deductive spirit, and encyclopedism, the search for completeness and order in knowledge, and applied these to the religious sphere with concepts largely restricted to the formal and teleological. Hence the play of analogy in Christian thought, while seemingly poetic and unconstrained, has a systematic, constructive character uncommon or less developed among primitives. On the Maximianus throne the selection of themes already possesses an articulation, a conceptual architecture, of its own, which anticipates the later mediaeval groupings of religious themes in art around one or more guiding concepts. There is a parallel in the contemporaneous mosaics of the choir and apse of San Vitale in Ravenna, where religious and secular figures have been represented together.

NOTES

1. Cf. Tertullian, *Ad Marcionem III*, 18, and Pascal, *Pensées*, part. II, art. IX, 2. For a list of the early texts, see P. Fabre, "Le Développement de l'histoire de Joseph dans la littérature et dans l'art au cours des douze premiers siècles," *Mélanges d'archeologie et d'histoire de l'école française à Rome*, XXXIX, 1921–1922, pp. 193–211. For recent literature on the Maximianus throne, see Carlo Cecchelli, *La cattedra di Massimiano ed altri avorii romani-orientali*, Rome, 1936–1940 (with extensive bibliography); Gunther W. Morath, *Die Maximianskathedra in Ravenna* (Freiburg theologische Studien, Heft 54), Freiburg i. Br., 1940; O. von Simson, *The Sacred Fortress*, Chicago, 1948, pp. 43 ff., 66 ff.

2. Cf. Cecchelli, *op. cit.*, pp. 121 ff., and C. R. Morey, review of Cecchelli in *American Journal of Archaeology*, XLV, 1941, pp. 145 ff.

3. Or by artists from Constantinople executing a program laid down in Ravenna. For the elements which point to Constantinople, see Morath, *op. cit.*, pp. 106 ff. Morath believes, however, that the iconography of the Joseph cycle goes back to an Egyptian source. But his citation of a passage by Moses of Greece as an evidence for Egyptian miniatures in the West is based on an incorrect dating and interpretation of this twelfth-century text.

4. Paintings and mosaics in Rome (St. Peter's, S. Paolo f.l.m., the Lateran basilica, Sta. Maria Antiqua) and Milan (S. Ambrogio). For a list of the early examples, see Fabre, *op. cit.*

5. Migne, Patrologia latina, LXII, col. 545.

6. Sermo CXLVI, Migne, Pat. lat., LII, cols. 592, 593.

7. Sermo CLXXIV, *ibid.*, col. 655. Other writers see a connection with John the Baptist in the herald who runs before Joseph; he is likened to John announcing Christ. Cf. Isidore of Seville, Pat. lat., LXXXIII, col. 274.

8. Sermo CLXXIII, *ibid.*, col. 650.

9. Sermo CLXXV, *ibid.*, col. 657.

10. Cf. "De Joseph patriarcha," Migne, Pat. lat., XIV, col. 646; "De Jacob et vita beata," *ibid.*, col. 662; "De benedictionibus patriarcharum," cap. xi, *ibid.*, cols. 686, 691; "De spiritu sancto," lib. III, *ibid.*, XVI, col. 806.

11. Garrucci, *Storia dell'arte cristiana*, I, p. 461.

12. "De Joseph patriarcha," *loc. cit.*, col. 642–672.

13. "De officiis ministrorum," Pat. lat., XVI, cols. 56, 116–118, 122–127. Cf. also Ambrose, Letters, Ep. XXXVII, to Simplicianus, Pat. lat., XVI, col. 1086, on Joseph's qualities and on wisdom as true liberty. Paulinus of Nola, speaking of Joseph and Christ, makes a digression to say that only a good man should rule the church:

> *"bonusque mentis vir gubernator suae*
> *et ecclesiae navem reget*
> *nam quomodo ille praesidebit proximis*
> *praeesse qui nescit sibi"*

—carmen XXIV, lines 765–768, Pat. lat., LXI, col. 629. Cf. also Gregory, "Homiliae in Ezechielem," lib. II, homil. ix, cols. 1054, 1055, on Joseph as a model for the priest, in his direction disciplining others.

14. Pat. lat., XVI, cols. 884, 885.

15. "De Joseph," in *Philo,* with an English translation by F. H. Colson (Loeb Classical Library), Cambridge, Mass., vol. VI, 1935, pp. 140–271, and particularly pp. 157 and 271.

16. "De Joseph patriarcha," cap. III, Pat. lat., XIV, col. 658. Cf. also Paulinus of Nola, carmen XXIV, lines 783–813 *(loc. cit.)* on the *stola*, the ring, the neck-chain, and the chariot as insignia of Christ; and Isidore of Seville, "Quaestiones in Genesim," Pat. lat., LXXXIII, col. 274 ff., on the ring and the "pontificatum fidei."

17. Cf. the Gregorian Sacramentary: *"Ad anulum digito ponendum. Accipe anulum fidei, scilicet signaculum, quatenus sponsam Dei, videlicet sanctam ecclesiam, intemerata fide ornatus illibate custodias."* Isidore *(loc. cit.)* interprets Joseph's Egyptian wife as the "Ecclesia ex gentibus." For the text of Peter Chrysologus, see Pat. lat., LII, col. 657 ff. (Sermo CLXXV).

18. *De dignitate sacerdotali*, cap. 6: "Nam quid aliud interpretatur episcopus, nisi superinspector? maxime cum in solio, in ecclesia editiore sedeat," cited by H. Menard, in notes on the bishop, in the Gregorian Sacramentary, Pat. lat., LXXVIII, col. 497 ff. Cf. also Sulpicius Severus, "Dialogus II," on the bishop as "quasi regio tribunali celsa sede residentem." Note that the Emperor Constantine already applied the name "bishop" to himself; he said, in addressing a banquet of bishops: "You are bishops of those within the Church, but I have been appointed by God bishop of those outside" ("Vita Constantini," VI, 24, Migne, Patrologia graeca, XX, col. 1171).

19. The juridical texts — passages from Justinian's *Codex* and *Novellae*— are cited in Charles Diehl, *Etudes sur l'administration byzantine dans l'exarchat de Ravenne*, Paris, 1888,

pp. 319 ff. See also H. J. Schmidt, "Die Kirche von Ravenna im Frühmittelalter 540-967," *Historisches Jahrbuch*, XXXIV, 1913, pp. 729-780.

20. Diehl, *op. cit.*, pp. 320 and 321.

21. See his *Variae*, VIII, 20, anno 527, 528, Monumenta Germaniae Historica Auct. Antiquiss., XII, p. 251.

22. *Op. cit.*, VI, 3. Formulae praefecturae praetoris, anno 511, p. 176: "Ipse primum huius dignitatis infulas consecravit."

23. See Eddius Stephanus, *Life of Bishop Wilfrid*, edited by B. Colgrave, Cambridge, 1927, cap. XLII, pp. 84 and 85.

24. On the life of Maximianus, see the Liber Pontificalis of Agnellus, XXVI, De sancto Maximiano, in *Rerum Italicarum Scriptores, Raccolta degli storici Italiani ordinata da L. A. Muratori, nuova edizione*, t. II, parte III, Bologna, 1924, pp. 186-211 (or Pat. lat., CVI, cols. 608 ff.). On Maximianus as a perfect bishop and shepherd, see p. 210.

25. "Memento mei peccatoris quem de stercore exaltasti in regno tuo." Professor Ernst Kantorowicz calls my attention to the fact that the phrase "de stercore," from Psalm 112:7, was read at imperial coronations.

26. Cf. Paulinus of Nola, carmen XXIV, lines 741-744, Pat. lat., LXI, col. 629, on Joseph's exaltation from slavery:

> *"Sic ille Joseph ante parvus factus est*
> *ut magnus esset, et nisi*
> *servus fuisset, non fuisset in sui*
> *tellure servitii potius."*

27. On the rivalry of Ravenna and Rome, see K. Brandi, "Ravenna und Rom," *Archiv für Urkundenforschung*, IX, 1926, pp. 1 ff., and O. von Simson, *op. cit.*

28. See P. David, in the appendix to W. de Grueneisen, *Sainte Marie Antique*, Rome, 1911, p. 501; Cecchelli, *op. cit.*, pp. 127 ff.; Morath, *op. cit.*, pp. 63 ff. The *modius* appears in the scenes of *Joseph's Brothers Buying Wheat*, the *Arrest of Simeon*, and *Joseph's Meeting with his Father*.

29. Cf. Tertullian, *Ad nationes*, II, 8; Julius Firmicus Maternus, De errore profanarum religionum, cap. XIV, Pat. lat., XII, col. 1011; Paulinus of Nola, carmen XIX, 98 ff. (*C.S.E.L.*, XXX, p. 122); Rufinus, Historia ecclesiastica, lib. II, cap. 23, Pat. lat., XXI, col. 532, who gives other derivations of Serapis (from Apis and Jove) and relates the *modius* to Jove. The connection of Serapis and Joseph is also asserted in Jewish literature; cf. Morath, *op. cit.*, pp. 66, 67, on the Midrashic texts — Joseph deified as the ox Apis.

30. As Cecchelli, *op. cit.*, p. 129 and Morey, *loc. cit.*, suppose.

31. *Op. cit.*, lines 98-111. A similar idea in Julius Firmicus Maternus, *loc. cit.* Joseph was not responsible if corrupt pagans allowed the demons to abuse the image of Serapis.

32. For examples, see S. Reinach, *Répertoire de la statuaire grecque et romaine*, I, pp. 186 and 187; II, pp. 18-20, 270; III, pp. 8, 226, and 227; IV, pp. 6, 10, and 11. Note that Rufinus, *loc. cit.*, derives the *modius* of Serapis from Jupiter, and speaks of the connection of Joseph and Serapis as only one of several pagan theories.

33. See M. I. Rostovtzeff, *Dura-Europos and its Art*, New York, 1938, p. XI; *Dura, Preliminary Report of the 7th and 8th Seasons*, New Haven, 1939, pl. XXXVII.

34. If we may trust the description by Cecchelli (*op. cit.*, p. 129), who has made a careful study of the ivories. In his photograph (pls. XXb, XXIa, XXIb), these *merli* look like a beaded or jeweled ornament of the upper edge. But the general effect is of a tower crown. Morath (*op. cit.*, p. 63) compares the *modius* of Joseph with the mural crowns of the personifications of cities and provinces.

35. See Reinach, *op. cit.*, I, p. 450; II, pp. 272 and 273; IV, pp. 163 and 324; Roscher, *Lexikon*, s.v. *Kybele*, col. 1647, and s.v. *Tyche*, col. 1682 ff.; J. M. C. Toynbee, *The Hadrianic School*, Cambridge, 1934, pp. 18, 24, and ff. In the Paris manuscript of the *Notitia Dignitatum*,

the personification of Palestine, unlike that of the other provinces, wears a *modius* with masonry joints, but no crenellations.

36. See P. Charanis, "The Imperial Crown 'modiolus' and its constitutional significance," *Byzantion*, XII, 1937, pp. 190 and 191; XII, 1938, pp. 377–383. F. Dölger (*Byzantinische Zeitschrift*, XXXVIII, 1938, pp. 240 ff.) and O. Treitinger (*ibid.*, XXXIX, 1939, pp. 194–202) have objected that the *modiolus* is not a crown worn by the emperor, but only the symbolic offering, the *aurum coronarium* of the Roman emperors, the gold measure of tribute. But the text of a Byzantine writer, Genesios, cited by Charanis, is clear evidence that the *modiolus* was a crown that was actually worn (the emperor's wife says, "It would be an awful thing indeed, if the wife of the tyrant Leo should wear the modiolus," Bonn ed., p. 6). See also Ducange, s.v. "*modiolus*," who says of the Greek term, "Vestis species est." Th. Klauser, who has studied the history of the *aurum coronarium* (*Römische Mittheilungen des deutschen archaeologischen Instituts, Römische Abtheilung*, LIX, 1944, Munich, 1948, pp. 129–153), doubts that the Byzantine *modiolus* was an *aurum coronarium* (*op. cit.*, p. 143, n. 3). R. Delbrueck (*Spätantike Kaiserporträts von Constantinus Magnus bis zum Ende des Westreichs*, Berlin, Leipzig, 1933, pp. 55 ff.) thinks of the *modiolus* as a true crown, possibly like that worn by the statues of the Tetrarchs; and in this opinion he has the support of Alföldi, who believes that the imperial *modius* was a survival of the pagan-Alexandrian symbolism of the ruler. I have not found a representation of a Byzantine emperor or empress with an unmistakable crown of this type, but in the illustrations of the Slavonic Manasses Chronicle, several of the old Oriental monarchs, as well as the Roman emperors, wear high flaring crowns of different shapes, recalling the *modius* (see B. D. Filow, *Les miniatures de la chronique de Manassès à la Bibliothèque du Vatican*, Sofia, 1927, pl. VII and *passim*). One can discern a similar type in a drawing of the destroyed column of Arcadius in Constantinople (A. Grabar, *L'Empereur dans l'art byzantin*, Strasbourg, 1936, pl. XIV) and on a textile in Bamberg (*ibid.*, pl. VII). In the Stuttgart Psalter, fol. 57v, a queen wears a jeweled crown with crenellations, which may be an echo of the Byzantine *modiolus;* she illustrates a passage from Psalm 44: "Astetit regina a dexteris tuis in vestitu deaurato" (see E. T. De Wald, *The Stuttgart Psalter*, Princeton, 1930, p. 45, and fol. 57v). Many of the miniatures in this manuscript seem to have been copied from a North Italian model.

37. On the *Tyche* of Constantinople, see Th. Preger, *Scriptores originum Constantinopolitanarum*, Leipzig, 1908, II, p. 205; J. Strzygowski, "Die Tyche von Konstantinopel," in *Analecta graeciensia*, Graz, 1893, pp. 144 ff.; R. Delbrueck, *Die kaiserliche Diptychen*, pls. 38, 49, and 65; and J.M.C. Toynbee, "Roma and Constantinopolis in Late Antique Art," in *Journal of Roman Studies*, XXXVII, 1947, pp. 135–144, pls. X and XI.

38. It should be observed that on the Maximianus chair, in the scene of *Joseph Explaining Pharaoh's Dream*, the king wears only a simple band or diadem, precisely like Joseph (cf. Cecchelli, p. 128 and pl. XXa). But in the miniatures of the Ashburnham Pentateuch (Paris, Bibliothèque Nationale ms. nouv. acq. latin 2334) a Latin work of the seventh century and of uncertain origin, a tall, brimmed headdress, somewhat like the *modius*, is given to both Pharaoh and Joseph. But it has not the precise form of the *modius* on the Maximianus chair in its three versions (although Joseph does wear a brimmed *modius*-crown in the scene of the *Meeting of Joseph with his Father*: Cecchelli, pl. XXIb); see O. von Gebhardt, *The Miniatures of the Ashburnham Pentateuch*, London, 1883, pls. 13 and 14.

That Joseph was not simply the chief minister of Pharaoh, but the co-ruler or ruler of Egypt, is a tradition reported by Josephus (*Antiquities*, II, chap. 7, 1, 3). Eusebius speaks of Joseph as the "despotes" of Egypt (*Praeparatio evangelica*, 1430a); for Julius Firmicus Maternus, he is the "particeps regni" (*loc. cit.*), for Paulinus of Nola "regiae princeps" (carmen XXIV, 783); in the apocryphal tale of Joseph and Asenath, Joseph becomes the sole ruler of Egypt after Pharaoh's death; in a Hebrew Midrashic text, he is called "cosmocrator" (L. Ginzberg, *Legends of the Jews*, V, p. 350, n. 234).

Professor André Grabar has called to my attention that the gold neck-chain (*torques*) given to Joseph, with the ring and purple robe (*stola*), was also part of the imperial Byzantine costume at the coronation and was worn by high officials.

39. Julius Firmicus Maternus, *De errore profanarum religionum*, cap. XIV, Pat. lat., col. 1011 ff.

40. *Praeparatio evangelica*, IX, cap. 23 (after Artapanus). Patrologia graeca, III, col. 1726.

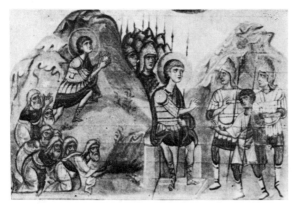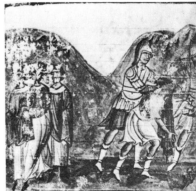

Fig. 1a and Fig. 1b Vatican City, Biblioteca Vaticana: Ms. gr. 746, Octateuch, fol. 448 and fol. 449. Achar Before Joshua, and The Stoning of Achar.

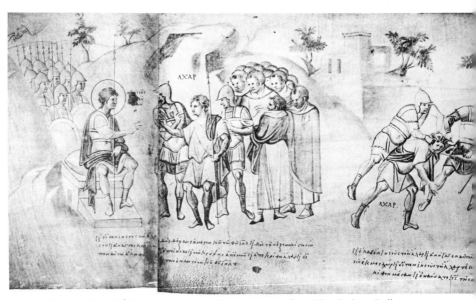

Fig. 2 Vatican City, Biblioteca Vaticana: Ms. palat. gr. 431, The Joshua Roll. Achar Before Joshua.

The Place of the Joshua Roll in Byzantine History*

(1949)

The Joshua manuscript in the Vatican library (Palatine gr. 431) is the unique surviving example of what is generally regarded as a late classical type of picture book, the horizontal roll with a continuous succession of narrative scenes explained by a text below (Figs. 2, 3A-B, and 8).[1] That it was copied from a roll of the early Christian period has been assumed by almost everyone who has written about it. Professor Morey has even supposed that the ultimate model was a picture book of the second century A.D., perhaps a Jewish Alexandrian work.[2]

The question that has not been raised so far in the literature, and that I propose to consider here, is: why was the Joshua Roll produced in the Middle Ages, centuries after the horizontal roll form had gone out of use? It is so contrary to mediaeval practice that a special complex of interests must have prompted the revival of the long outmoded form. In the period between the second and fourth centuries A.D., the codex had replaced the roll as the standard structure of the book. The illustrations of the ancient rolls were adapted then to the requirements of the codex form. Where they were continuous narrative pictures, like those of the Joshua Roll, they were cut up into small segments and sometimes framed.

This, at least, has been the common idea of the process until recently, when an Austrian scholar, P. Buberl, in the course of a study of the Vienna *Genesis*, denied that continuous roll illustrations were ever known in Antiquity.[3] The Joshua Roll, he thinks, is a new creation of the tenth century. He failed to take into account, however, the many evidences of the copying of an earlier model in the Roll, not simply in the costumes and buildings and other objects of an older type, but in the errors and omissions, of which some could be corrected through related works, the illustrated Octateuch manuscripts of the eleventh to the thirteenth centuries.[4] The text below the drawings in the Joshua

* This paper was read at the *Premier Congrès International Byzantino-Slave et Oriental*, held in New York, at the École Libre des Hautes Études on April 28, 1946.

Roll contains blank spaces, which can only be explained by the faintness or disappearance of parts of the writing in the ancient model before the eyes of the scribe. Since this text was a summary account of the action, excerpted from the Septuagint and specially adapted to the illustrations, the omissions can hardly have been due to the defects of a complete Bible manuscript which was consulted for this purpose in the tenth century.[5] Besides, in the scene of the hanging of the king of Ai on the forked gallows (furca), an ancient instrument, the soldier, whose whole posture indicates that he is attacking the king with a spear, has nothing in his hands.[6] In another scene there is a strange figure emerging from a tub in a landscape; comparison with the versions of the subject in the Octateuchs, in which the same figure appears as a carved relief bust on a classic tombstone, reveals that the artist of the Joshua Roll had misunderstood his model.[7]

These few details are enough to prove that the Roll is no original creation, but must go back to an older work with a corresponding cycle of images.

Moreover, the process whereby such a cycle was adapted to the codex form can be reconstituted through the related Octateuch manuscripts. The framed miniatures illustrating the Book of Joshua in these manuscripts agree so closely with each other and with the pictures in the Vatican Roll that they must all descend from a common archetype, although certain differences among them indicate that the five surviving illustrated Octateuch manuscripts were not copied directly from one work, and surely not from the Joshua Roll. It is apparent, however, that the archetype of the miniatures was a roll like the Vatican manuscript. The evidence for this is in the misunderstandings and peculiarities in several of the Joshua illustrations in the Octateuchs that must have arisen in the process of cutting up an originally continuous pictorial narrative into enclosed episodes.

In one such enclosure, the scene of the *Stoning of Achar* (Fig. 1B), there occurs at the left an unmotivated group of figures, detached and meaningless, which belongs to the preceding action (Fig. 1A).[8] The relationship to the latter is perfectly clear in the Joshua Roll where the group is properly placed (Fig. 2).

This kind of error was due in part to the fluid, continuous representation of groups in the model. In spite of the closure of some actions in the Joshua Roll by trees and rocks and elements of architecture—the *Meeting of Joshua and the Divine Messenger* is the clearest example—there remains a considerable overlapping of episodes. In the *Miracle of the Sun during the Battle with the Amorites* the moon is far to the left, above the preceding scene of the *Gibeonites begging Joshua's Help* (Figs. 3A and 3B). In the Octateuchs it has been brought within the same enclosed field as the sun (Fig. 4).[9]

The great diversity of the framed fields in the Octateuchs—some narrow, others broad and even including two or more incidents; still others divided into

distinct scenes by a vertical or horizontal line (sometimes with figures of different scale in adjoining episodes)—suggests that the miniatures of the Octateuchs owe their varied format to the varying breadth of the unframed scenes in the continuous cycle of the original roll.

We do not know when this cycle was broken up into the framed pictures preserved in the Octateuchs—perhaps already in early Christian times. It is possible, however, that the change took place as late as the ninth or tenth century,[10] if the original had not been copied in the intervening period. But after the fourth or fifth century it would certainly have been unusual to reproduce the roll model as such.

It is most surprising therefore to find in the Joshua Roll a reversion to the ancient form. Was the manuscript one of a larger corpus of rolls forming a complete Octateuch? Or was the Book of Joshua the only one singled out in this way for reproduction in a roll? Such questions cannot be answered with certainty; we are dealing with a unique surviving object of a class that might conceivably have been common. But I shall risk the hypothesis that only the Book of Joshua was reproduced in roll form.

In treating this problem, we must also recognize the difficulty in dating the Joshua Roll, which arises in part from the fact that it is a copy of a much older work. It has been placed in various periods, ranging from the fifth to the tenth century, by scholars of authority in the field of Byzantine art. The editor of the facsimile edition assigned the manuscript to the later seventh or early eighth century; but the growing consensus today is that the Roll belongs to the tenth.[11] That is the obvious date of the writing underneath (and sometimes within) the paintings, and the style of these paintings resembles most closely certain works of the tenth century.

In recent years Professor Morey has persistently argued for an earlier date.[12] He believes that the few uncial labels within the scenes are of the seventh or early eighth century and that the minuscule writing below is a much later addition to the Roll; in his eyes the miniatures are so similar in style to the frescoes of about 700 in the Roman church of Sta. Maria Antiqua that they might well be the work of the same group of Alexandrian artists (or their pupils) who, he conjectures, fled to Italy and Constantinople upon the Arab conquest of Egypt.[13]

It is impossible to examine these arguments exhaustively in a short paper, but the following objections seem to me sufficient.

The difference between the capital and minuscule writing is less decisive for the dating than has been supposed. In the Bible of Leo in the Vatican (Regina gr. 1),[14] a work which Morey believes to be of the early tenth century, we find just this combination of capital and minuscule inscriptions. It is worth noting also that in the Paris Psalter (Bibl. Nat., gr. 139), the text is in

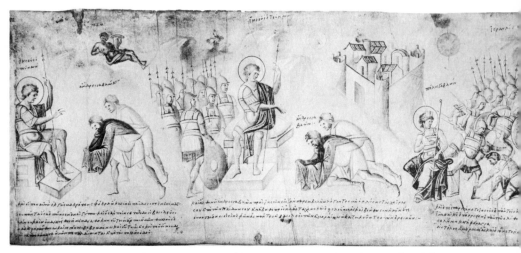

Fig. 3a and Fig. 3b Vatican City, Biblioteca Vaticana: Ms. palat. gr. 431, The Joshua Roll. The Gibeonite Messengers and the Miracle of the Sun.

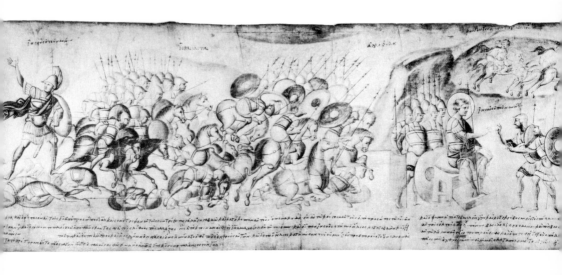

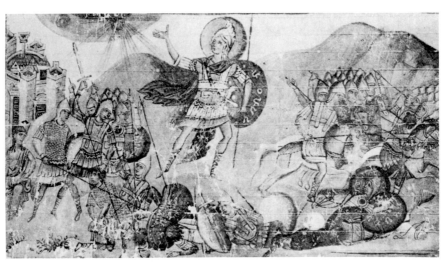

Fig. 4 Vatican City, Biblioteca Vaticana: Ms. gr. 746, Octateuch, fol. 453.
Joshua and the Miracle of the Sun.

minuscule writing, the headings are in capitals, and the labels of the miniatures in capitals alone,[15] a practice that is not uncommon in Middle Byzantine books. The uncial forms of the capital labels in the Roll and the Psalter are also employed for the text of Greek manuscripts all through the ninth and tenth centuries in varying styles.[16]

These uncials are most difficult to date, since they are archaistic types in an age when minuscule writing has become the chief book hand; a prudent paleographer would hesitate to assign an uncial label to a definite period without a most careful study. No one, to my knowledge, has thus far tried to determine the age of the uncials in the Joshua Roll by a systematic comparison with dated manuscripts or inscriptions. Their forms seem to me perfectly compatible with a date in the tenth century, though I would hardly venture to say that such uncials are absolutely excluded in the ninth or the eleventh.

According to Morey, the labels in the miniatures of the Paris Psalter are contemporary with those of the Joshua Roll. Yet they are quite different in style, the former being more decidedly mediaeval in character, more elaborately articulated, somewhat like the accompanying miniatures, with marked horizontal strokes across the top and bottom of certain letters (*alpha, beta, delta*). They are, in any case, less faithful to the ancient models than the capital writing in the miniatures of the Bible of Leo, which Morey accepts as a work of the tenth century.

His inference that the uncial labels of the Joshua Roll were written three hundred years before the minuscules underneath the same scenes has little to support it and seems, on the face of it, improbable. He has been too ready, I think, to break up works into parts and to separate these in time, in order to save a theory. He has done this not only with the Joshua Roll, but also with the Paris Psalter, of which he assigns the text to the tenth century and the miniatures to the seventh.[17] It is true that in the Joshua Roll the two writings appear different in the color of the ink (although not consistently), and that they are by at least two different hands. But was there an interval of almost three centuries between them?

Let us recall that the pictures would have been unintelligible without the inscriptions which Morey admits are of the tenth century. (The uncial labels are rather few and are restricted to less than half the scenes in the Roll.) This text is not the complete Septuagint version of Joshua, but an excerpted text and paraphrase which, with few errors, agrees with the illustrations and must have been conceived together with and for the illustrations of the model.[18] If Morey were right, we would have to assume that when the present roll was copied from its model, certain of the labels within the scenes were transcribed, but that the writer neglected to copy the most essential text of all, which was indispensable for the comprehension of the scenes; some centuries later, however, a reader or owner bethought himself to return to the very ancient

model which was still available and to transcribe the omitted writing, now rather faint and incomplete.

The resemblance of the Joshua Roll to the Paris Psalter and of both of these works to certain frescoes of Sta. Maria Antiqua in Rome is a more plausible argument for a date around 700. And indeed, by isolating elements from the Greek and the Roman works an arresting case can be constructed. But when we turn from such details of a head or a limb to entire compositions and consider the total aspect, the argument loses plausibility; nowhere in these frescoes of Sta. Maria Antiqua can be matched the landscape backgrounds of the Greek miniatures, the peculiar over-articulation of the statuesque figures, and the synthetic construction of the parts, already so remote from classical art in spite of the effort to recapture its spirit. On the other hand, in the details of the features, as in the landscape backgrounds, these Greek works are more sketchy and impressionistic.

Even the juxtaposition of the isolated heads from the Joshua Roll, the Paris Psalter, and Sta. Maria Antiqua (Fig. 5), on which Morey builds his case for their stylistic identity, is unconvincing.[19] In the Roman fresco, the eyes are immensely enlarged and the surmounting eyebrows joined in a winged line— an expressive schema which we recognize as a characteristic motif of Christian inwardness in the traditional Byzantine image of the face and which corresponds in an evident way to the spirituality of these self-constrained and dignified figures; whereas the eyes and brows in the Greek miniatures in question are more summary strokes, equivalents of shadow and light, without spiritual evocation, as if the artist had retained in the more lively technique the emotional opacity of the eyes of remote classical sculpture.

It is this hybrid and often clumsy play of the illusionistic, the linear, and the statuesque which is the distinguishing mark of the tenth century pseudo-classical art of the Paris Psalter and the Joshua Roll and which has led to the contradictory characterizations of this art as plastic and painterly. This much over-rated art, produced for the court or in connection with the court, naively strains to achieve effects of grandeur and force through statuesque postures, pedestals, and sumptuous backgrounds, but lacks a concentrating pattern and a pervasive incorporation of the forms in a general order such as determines the more deeply religious compositions of the preceding and later Byzantine art. Far from being a summit of mediaeval painting as often supposed, the Paris Psalter betrays a crisis in Byzantine art, a momentary deflection from its highest capacities and aims.

* * *

Let us assume then the correctness of the now more widely held view that the Roll is a work of the tenth century, and let us return to our first question:

Fig. 5 Heads from: a. The Joshua Roll; b. Sta. Maria Antiqua, Rome; c. The Paris Psalter (after Morey).

Fig. 6 Constantinople, Column of Arcadius (after Geoffroy).

why this Roll was produced in the tenth century, when the codex form was prevalent.

The answer is to be found, I believe, in the new meaning that the Book of Joshua acquired in Byzantium during the tenth century. This Book describes the reconquest of the Holy Land by the Jews, and the tenth century is the period of the Byzantine campaigns for the reconquest of the Holy Land and the other lost eastern provinces from the Arabs. In illustrating the Book of Joshua, the Byzantines were recalling their victories over the Saracens and expressing their hope for the ultimate restoration of the most precious province of Christianity to the Church and the Empire. Between 922 and 944, a Greek army conquered Asia Minor and northern Mesopotamia and reached Aleppo; in 969 Antioch was captured by the army of Nicephorus Phocas; in 975 John Tzimisces advanced through Syria and northern Palestine up to Jerusalem. He recounted his victories in a letter to the king of Armenia which has been preserved by an Armenian historian, Matthew of Edessa. Here he speaks of the conquest of all Syria and Palestine, although his army was incapable of controlling this whole territory and soon retired.[20]

Since we are unable to date the Roll more precisely in the tenth century, it is impossible for us to say whether it was made before or after the campaign of Tzimisces. Perhaps a careful investigation of the script or the discovery of new works of this time will some day help us.

But we may consider here the meaning of the roll form and of the Book of Joshua in the context of Byzantine history. The choice of the roll flows from the traditional imagery of triumph. In the Roman world the victories of the Emperors Trajan and Marcus Aurelius were monumentalized in triumphal columns on which their campaigns were represented in a continuous spiral band. This Roman practice was maintained in the early Byzantine empire. In 386 Theodosius had such a monument, with sculptured scenes of his triumphal return from a military campaign, set up in Constantinople. It was followed in 402 by the similar Column of Arcadius (Fig. 6). These two sculptured columns (now destroyed) once gave to the new imperial capital something of the aspect of Rome with its columns of Trajan and Marcus Aurelius. [21]

By the tenth century this practice had died out. For a long period, to be sure, the Byzantine emperors had few important victories to celebrate. But even Justinian and the great Heraclius and Basil I created no triumphal columns. The abandonment of the practice is part of the general disappearance of monumental stone sculpture in Byzantium after the fifth century. The same phenomenon may be witnessed in Latin Europe as well. There are no arches of triumph after Constantine who had to reemploy old reliefs of Hadrian and Marcus Aurelius for his own arch in Rome.

When, therefore, in the tenth century the Byzantines wished to celebrate a great victory against the Arabs, a substitute form was employed which was in accord with both the secular and religious symbolism of the Greek empire.

The resemblance of the Joshua Roll to the columns of triumph has often been remarked. The narrative relief winds around the column like the illustrated roll around its axial rod. The philologist Birt, in an excellent and fundamental work on the roll in art, has observed further that the column of Trajan, the first of its kind, was set up in a corner of the Forum between the Greek and Roman libraries that Trajan had founded.[22] He supposed that the direct inspiration of the historiated column was the roll picture-book with continuous scenes of a military campaign. But in his exhaustive survey of the surviving texts of antiquity which speak of book illustrations, Birt was unable to cite a single passage concerning a picture-book like the reliefs of the columns or like the Joshua Roll; these notices tell us rather of isolated images which help to clarify a text, but of nothing comparable to the pictorial roll that interests us here. If a Latin commentary on Jerome mentions historical pictures on papyri which have been brought from Egypt, the text is a work of the twelfth century.[23]

It has also been argued that such illustrated rolls must have existed prior to Trajan's column, because the idea of the spiral continuous relief "could hardly have occurred to an age that was not already used to the illustrated rotulus as a familiar form of bookmaking."[24] This argument has little weight; superposed banded reliefs were common on walls and even on columns, and there were also spirally fluted columns; the fusion of these two is conceivable, if we are to look for the origin of a new form in the combination of already existing elements. But what is most significant is that the oldest book illustrations of pagan epics that have come down to us, in the Vatican *Virgil* and the Ambrosian *Iliad*, are framed miniatures with no apparent traces of an origin in a continuous roll cycle.

If there were pictorial rolls like the Joshua manuscript before the second century A.D., the evidence for their existence is very weak. More likely, it seems to me, and more consistent with what we know, is the theory that the picture-book with continuous illustration, like the model of the Joshua Roll and perhaps the Vienna *Genesis*, originated *after* the creation of the first columns of triumph and was possibly influenced by these. To produce the reliefs of the columns required preliminary cartoons in continuous form; when copied for documentation or for sale (as we may surmise from the fact that details of these sculptures, hardly visible from below, were reproduced or described in subsequent literature and art),[25] these cartoons formed a pictorial roll, like the modern drawing, fifty-two feet long, of the reliefs of the Arcadius column, now

in the Louvre, and suggested perhaps similar pictorial rolls of biblical epic and history when Christianity triumphed.

In identifying a recent victory over the Arabs with the biblical campaign of Joshua, the Byzantines maintained an old indigenous tradition. At the very beginning of their history is the example of Eusebius who likened Constantine's defeat of Maxentius at the Milvian Bridge to the victory of Moses over Pharaoh on the Red Sea. "As in the days of Moses himself and the ancient and godly race of the Hebrews, 'Pharaoh's chariots and his host hath he cast into the sea, his chosen horsemen, even captains, were sunk in the Red Sea, the deep covered them' (Exodus XV, 4–5); in the same way also Maxentius and the armed soldiers and guards around him 'went down into the depths like a stone, when he turned his back before the God-sent power that was with Constantine ... So that suitably, if not in words, at least in deeds, like the followers of the great servant Moses, those who had won the victory by the help of God might in some sort hymn the very same words which were uttered against the wicked tyrant of old, and say: 'Let us sing unto the Lord, for gloriously hath He been glorified: the horse and his rider hath He thrown into the sea. The Lord is my strength and protector, He is become my salvation.' ... These things and such as are akin and similar to them, Constantine by his very deeds sang to God the Ruler of all and author of the victory, as he entered Rome in triumph."[26]

It is probably this conception of Constantine's victory as a Christian triumph that underlies the frequent choice of the Crossing of the Red Sea as a subject on the early Christian sarcophagi.[27] And we may ask whether the connection with the emperor does not account also for the rendering of the same subjects in the Paris Psalter, where the figure of Pharaoh being pulled into the sea is so prominent. The importance of the rod of Moses in this scene has been explained by the same Constantinian interest; for this rod was brought to Constantinople as a holy object during the reign of the emperor, who placed it first in a newly built church of the Virgin of the Rod and then had it transported to his own palace as a private relic.[28]

In the tenth century the Eusebian description was still alive in the minds of the Byzantines. The song of Moses and the Israelites upon their victory over Pharaoh,[29] which the historian puts into the mouth of Constantine, is prescribed by a later Constantine, the VII Porphyrogennetos, as the chant proper to an imperial triumph over the Arabs. This may be a literary reminiscence, but it expresses a real preoccupation of the time. The oldest surviving Greek manuscripts of Eusebius's *History* were copied in this period.

Such comparisons of the living monarch with the biblical hero are thoroughly in the spirit of mediaeval Christianity to which the Old Testament was the most secular part of the Bible, its pagan aspect. The New Testament,

composed at a time when the Jews had no independent state, is poor in positive secular precedents, while the books of the Old Law abound in examples of royal power, heroism, leadership, and divine aid. Melchizedek and Abraham, Moses and the Amalekites, Samuel and David, prefigure recurrent relationships of the mediaeval church and state.

Among these biblical figures, Joshua was the great antetype of the victorious general. Eusebius explains the name of Joshua as the Hebrew for "victory" and as the homonym of Jesus (Jeshua);[30] the Jewish hero was an image of the Savior, but also the object of a theophany when there appeared to him in battle the divine messenger with the sword.[31] An ancient equestrian statue in the Taurus forum in Constantinople was interpreted in the tenth century as Joshua commanding the sun to stand still at the battle of Gibeon.[32] The chronicler Cedrenus wrote of him as "that great and marvelous and admirable successor of Moses," and of his miracle of the sun as "greater than the miracles of Moses."[33] The pattern of the fall of Jericho reappears in a poetic account of the emperor Nicephorus Phocas at the siege of a Cretan city (in Arab hands) praying to God as his leader to destroy the walls of the town.[34] In the vernacular epic poem of the tenth century, *Digenis Akritas,* which was based on incidents and political relationships of the wars between the Byzantines and Arabs in the preceding period, the palace of the hero is decorated with mosaics of biblical and pagan heroes, terminating with "the glorious feats of Joshua."[35]

Among these mosaics are scenes from the stories of David and Moses, which recur in another creation of that time, the so-called aristocratic psalter, of which the Paris manuscript (Bibl. Nat., gr. 139) is the oldest example. The conception of a psalter of large format with full-page prefatory miniatures dominated by the royal figure of David and including the story of another king, Hezekiah, and the victory of Moses over the Egyptian Pharaoh, is characteristic for the culture of the tenth century, whatever the dates of the models of the particular scenes.[36]

The connection of the Joshua Roll with the secular sphere emerges finally in the choice of themes from the Book of Joshua on Byzantine ivory caskets of the tenth and early eleventh centuries. In general, such caskets are decorated with figures drawn from pagan mythology; they belong to a courtly world rather than to the church. It is interesting, therefore, to find on two of them, in the Metropolitan Museum, New York, and in the Victoria and Albert Museum, London, incidents from the story of Joshua,[37] and, on five others, isolated figures of soldiers which have been identified as copies from a Joshua cycle.[38]

On the casket in New York have been rendered the *Conquest of Ai*, the *King of Ai brought before Joshua*, and *Joshua Receiving the Gibeonite Envoys,*

themes which occur in the Vatican Roll in closely related compositions (Fig. 3); the second and third, especially, are nearer to the Joshua Roll than to the corresponding images in the Octateuchs, and in the first inscription, taken from the Septuagint, is a shortened text, which omits the same words as the Joshua Roll. Of the London casket, only one plaque has been preserved, with the *Gibeonite Envoys Before Joshua* (Fig. 7). The composition might have been copied from the Joshua Roll, but is truer to the Bible text than the miniatures, which are somewhat confused at this point. The subject is particularly suggestive for our hypothesis because of the importance of Gibeon in the letter of John Tzimisces announcing the conquest of the Holy Land.[39] He mistakenly identifies with the biblical site of Joshua's great miracle and victory a town on the Phoenician coast, and pretends to have found there the sandals of Christ and the hair of John the Baptist.

The reproduction of an ancient illustrated roll of the Book of Joshua, reminiscent of the columnar narratives of war and triumph, coincides with the general reversion to older models in Byzantine arts in the tenth century, especially in the court culture of this period. It is a time of revived interest in the past of Constantinople and the ancient monuments of imperial glory. The oldest surviving description of the antiquities of the capital city, the poem by Constantine of Rhodes on the church of the Holy Apostles, the burial place of the emperors, dates from 931 to 944.[40] It includes an account of the marvels of Constantinople in which the columns of Theodosius and Arcadius are mentioned.

The emperor for whom this poem was written, Constantine VII Porphyrogennetos, was a man deeply devoted to tradition, the most learned and bookish of Byzantine rulers and the instigator of the great enterprises of encyclopedic compilation of older literature, histories, and manuals which are the most characteristic works of this century.[41] In his own best-known work, the *Book of Ceremonies*, he reproduces details of the old Roman rituals of triumph, their acclamations and processions.[42]

I have already cited the chanting of the song of Moses to celebrate a victory at sea. There are passages more closely relevant to the Joshua Roll and frequent references to the Moslems. In celebrating a triumph, the emperor, before a statue of Constantine I, places his right foot on the head and his spear on the neck of the prostrated emir. Then the other captives fall prone to the ground and a psalm of David is sung by a choir. The celebration recalls the scene of Joshua's triumph over the five kings.[43] The representation of this subject in the Joshua Roll (Fig. 8), the final theme of the manuscript in its present state, is the culminating moment of the campaign.[44] Nowhere in the Roll is Joshua so pompous and triumphant. The five kings, prone at his feet, still wear their crowns, a detail not found in the same theme in the Octateuchs;

and at the right these kings are shown being dragged to the conqueror's throne, a scene absent from the Octateuchs and perhaps interpolated in the Roll in order to enrich the ceremonial of triumph.

The production of the Joshua Roll in the tenth century is significant in another respect. This is the great period of Byzantine military writing. The same emperor, Constantine VII, also collected the ancient books on strategy and siege and had them copied in an encyclopedic spirit. The greater part of classical literature on war has been preserved through the compilations of this time.[45] The frequent campaigns of the Byzantines against the Bulgars, the Slavs, and the Moslems gave this literature a high actuality.[46] The Book of Joshua, we may suppose, was also attractive to this time as the most detailed military chapter of the Old Testament. Scouting, reconnoitering, spying, ambushing, sieges, and open combat are described in its pages. In the Vatican Roll, only the military parts, chapters II to X, have been preserved. It has always been regarded as incomplete, but we may question whether the work was originally much longer, whether the triumph over the kings was not perhaps the concluding scene. The most remarkable and authentic scenes in the Roll are the battles; the expanded picture of the struggle with the Amorites, where Joshua commands the sun to stand still, has an epic force and movement that compel us to disregard the stiffness and confusion of details.

There is a literary work of the tenth century worth mentioning here, although artistically unimportant, because for years it was misdated, like the Joshua Roll, on account of its pseudo-classical character. I refer to the *Philopatris*, a dialogue once considered Lucian's and then attributed to the times of Julian and Heraclius, until its origin in the year 969 was established by a more discerning study of its content.[47] A speaker alludes to events of that year and comments also on the great naval victory of Nicephorus Phocas over the Arabs in Crete in 961. The dialogue is rich in classical reference—Homer, Aristophanes, and Euripides are quoted, and Hercules and Zeus invoked. While suggesting the most serious contemporary actualities, it pretends to be a work of early Christian times. The author ends by praising the emperor and foretells the final triumph over the Moslems and the conquest of Arabia and Egypt.[48]

This combination of the timely and the ancient, this archaistic play, reminds us of the Paris Psalter and the Joshua Roll, with their multiplied personifications, their elaborate backgrounds, pedestals and statuesque figures, and their ready passage from scenes of violent action to honorific groupings.

It is the political situation of Byzantium in the tenth century that perhaps accounts for the peculiarities of this art and the general pseudo-classical culture of the Byzantine court in this period. The military campaigns for the lost provinces which had belonged to Byzantium at its classic height, the wars against "barbarian" peoples, the Russians, Bulgars, and Arabs, the new concern

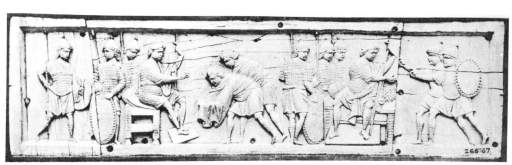

Fig. 7 London, Victoria and Albert Museum: Byzantine Ivory Plaque. Joshua and the Gibeonite Messengers.

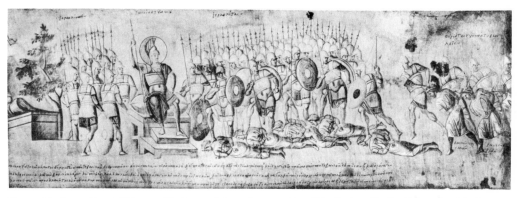

Fig. 8 Vatican City, Biblioteca Vaticana: Ms. palat. gr. 431, The Joshua Roll. Triumph of Joshua.

with the imperial heritage occasioned by the competing imperial revivals in the West in the ninth and tenth centuries and by the growing strength of the provincial nobility, all these helped to stimulate in the Byzantine court the consciousness of its own "Hellenism." Like the early mediaeval renaissances in the West, this one was imperial and ephemeral; it gave to its characteristic products in painting, the Joshua Roll and the Paris Psalter, their military and aristocratic aspect in a religious guise, and their unmatured, hybrid style.[49]

NOTES

1. It is reproduced in facsimile in *Il Rotulo di Giosué. Codices e Vaticanis Selecti*, V, Milan, 1905.

2. C. R. Morey, *Early Christian Art*, Princeton, 1942, p. 71. Cf. also J. Strzygowski, "Eine alexandrinische Weltchronik" in *Denkschriften der kaiserlichen Akademie der Wissenschaften (phil.-hist. Klasse)* LI, 2, 1906, p. 182.

3. P. Buberl, "Das Problem der Wiener Genesis" in *Jahrbuch der kunsthistorischen Sammlungen in Wien*. N. F., X. 1936, pp. 26, 27 and 40.

4. On the evidences of copying and the relation to the Octateuchs, see *Il Rotulo di Giosué*, pp. 13 ff.; J. Strzygowski, *Der illustrierte Octateuch in Smyrna*, appendix to *Der Bilderkreis des griechischen Physiologus (Byzantinisches Archiv*, Ergänzungsheft, II, 1899), pp. 113 ff.; G. Millet, "L'Octateuque Byzantin," in *Revue Archéologique*, II, 1910, pp. 71–80; and, more recently, H. Gerstinger, *Die Wiener Genesis*, Vienna, 1931, p. 163.

5. See H. Lietzmann, "Zur Datierung der Josuarolle," in *Mittelalterliche Handschriften, Festgabe zum 60. Geburtstage von H. Degering*, Leipzig, 1926, pp. 181 ff.

6. *Il Rotulo*, pl. XI.

7. Cf. *ibid.*, pl. I, and *Testo*, pl. B. 2, for the miniature in the Vatican Octateuchs (gr. 746).

8. For the example in Vatican gr. 746, see *Il Rotulo, Testo*, pl. D. 2; for the Smyrna Octateuch, D. Hesseling, *Miniatures de l'Octateuque Grec de Smyrne*, Leyden, 1909, pl. 85, No. 284; for the Constantinople manuscript, T. Uspensky, "The Octateuch of the Seraglio in Constantinople" (in Russian), in *Izviestiya* of the Russian Archeological Institute at Constantinople, XII, Sofia, 1907, p. 163 (fol. 484).

9. In Vatican gr. 746, *op cit.*, pl. E. 6; in the Seraglio ms., *op. cit.*, pl XXXVIII, No. 249; the Vatopedi ms., *ibid.*, No. 250; the subject is missing in the Smyrna ms.

10. As suggested by Millet, *Revue Archéologique*, II, 1910, p. 80.

11. This is the view of Weitzmann, Buchthal, Gerstinger, Buberl, Friend, Der Nersessian, Tikkanen, Wulff, Nordenfalk, *et al.*

12. See his "Notes on East Christian Miniatures," in: *The Art Bulletin*, XI, 1929, pp. 21 ff., 46 ff.; "The Byzantine 'Renaissance'," in: *Speculum*, XIV, 1939, pp. 139–159; *Early Christian Art*, Princeton, 1942, pp. 70 ff., 191 ff.

13. On this point he follows Prof. Myrtilla Avery, "The Alexandrian Style at Sta. Maria Antiqua," in *Art Bulletin*, VII, 1925, pp. 131 ff.

14. *Le Miniature dell Bibbia cod. Vat. Regin. gr. I e del Salterio, cod. Vat. Palat. gr. 381*, Collezione Palaeogr. Vaticana, I, Rome, 1905, especially pls. 7, 8, 10. See also Morey, in: *The Art Bulletin*, XI, 1929, pp. 35 ff. and his *Early Christian Art*, 1942, pp. 192, 193.

15. They are reproduced in H. Omont, *Miniatures des Plus Anciens Manuscrits Grecs de la Bibliothèque Nationale*, Paris, 1929, pls. I–XIV bis. and H. Buchthal, *The Miniatures of the Paris Psalter*, London, 1938.

16. See W. H. P. Hatch, *The Principal Uncial Manuscripts of the New Testament*, Chicago, 1939, for reproductions.

17. He had proposed a similar separation in the Etzschmiadzin Gospels of 989, where he interpreted the canon tables as reemployed pages of the sixth century which were not filled with writing until the tenth (*The Art Bulletin*, XI, 1929, p. 7), a theory that had been first put forward by Strzygowski in 1891 and then abandoned by him in 1911 (in *Huschardzan*, 1911, pp. 349, 350) after the observations of Millet (in Macler's article, *Nouvelles Archives des Missions*, XIX, fasc. 2, 1910, p. 123). Morey has now given up his opinion (*Early Christian Art*, 1942, p. 209, note 144) after the publication of Prof. S. Der Nersessian and Professor Weitzmann on this manuscript in 1933.

18. This has been clearly demonstrated by Lietzmann in the article cited in footnote 5 above. Professor Morey's attempts to answer him (*The Art Bulletin*, XI, 1929, pp. 46 ff., and *Speculum*, XIV, 1939, p. 141) do not meet his arguments.

19. In *Speculum, loc. cit.,* pp. 152 ff., and in his *Early Christian Art*, 1942, pp. 191 ff.

20. On this campaign, see Ernst Honigmann, *Die Ostgrenze des byzantinischen Reiches von 363 bis 1071*, Brussels, 1935, pp. 98 ff. and especially p. 103. The letter is translated by E. Dulaurier, *Chronique de Matthieu d'Edesse*, Bibliothèque Historique Arménienne, Paris, 1858, pp. 16 ff.

21. On the columns in Constantinople, see J. Strzygowski, "Die Säule des Arkadius in Konstantinopel," in *Jahrbuch des kaiserlichen deutschen archäologischen Instituts*, VIII, 1893, pp. 230–249; A Geffroy, *La Colonne d'Arcadius à Constantinople d'Après un Dessin Inédit*, Monuments Piot, II, 1895, pp. 99–130 and pls. X–XIII; Th. Reinach, "Commentaire Archéologique sur le Poème de Constantin le Rhodien," in *Revue des Etudes Grecques*, IX, 1896, pp. 75–80; *Second Report upon the Excavations carried out in and near the Hippodrome of Constantinople in 1928 on behalf of the British Academy*, London, 1929, pp. 57 ff., figs. 57, 58 (fragments of the column of Theodosius); E.H. Freshfield, "Notes on a Vellum Album Containing some Original Sketches of Public Buildings and Monuments, drawn by a German Artist who visited Constantinople in 1574," *Archaeologia*, LXXII, 1921–22, pp. 87–104, pl. XV–XXIII; Johannes Kollwitz, *Oströmische Plastik der theodosianischen Zeit*, Berlin, 1941, pp. 3 ff. and pls. 1–9.

22. *Die Buchrolle in der Kunst*, Leipzig, 1907, pp. 269 ff. See also his article, "Buchwesen und Bauwesen," in *Rheinisches Museum für Philologie*, N.F. 63, 1908, pp. 39–57.

23. *Die Buchrolle*, p. 307. Birt assigned this writing to the fifth century, although the first editor, Dom Pitra (1888), published it as an Irish work of the ninth. But Haskins has definitely identified the author, Moses of Greece, as the twelfth century Hellenist Moses of Bergamo (*Studies in the History of Medieval Science*, Cambridge, 1927, pp. 197–206). I am not sure, however, that the "papyratias texturas" mentioned by Moses are papyrus books; the reference is perhaps to "historiated" textiles, like those described in the Liber Pontificalis.

24. Morey, *Early Christian Art*, p. 71. See also Lietzmann, *op. cit.,* p. 185. Birt's theory that the illustrated roll was the source of Trajan's column has been criticized and rejected by K. Lehmann-Hartleben, *Die Trajanssäule*, Berlin, 1926, pp. 2, 3.

25. Birt, *op. cit.,* pp. 306, 307. Note also that in the third century Roman emperors (Septimius Severus, Maximinus) had paintings made of their campaigns and victories for public display (*Herodian*, III, 9; VII, 2).

26. Eusebius, *Historia Ecclesiastica*, IX, 9. I quote from the translation by J. E. L. Oulton (Loeb Classical Library), II, 1932, pp. 361, 363.

27. This has been well brought out by E. Becker, "Konstantin der Grosse, der 'neue Moses'," in *Zeitschrift für Kirchengeschichte*, XXXI, 1910, pp. 161–171. The same idea was developed independently by L. von Sybel, *Christliche Antike*, II, Marburg, 1909, pp. 191, 215.

28. E. Becker, *op. cit.*

29. See his "De Cerimoniis Aulae," II, 19, in Migne, Patrologia graeca, 112, col. 1138. Note also in the same work the frequent references to Moses's rod in processions and exhibitions of imperial treasures: I, 4 (cols. 103, 104), 11, 15 (cols. 1103, 1104), II, 40 (cols. 1187, 1188); it was kept in the oratory of St. Theodore in the imperial chapel.

30. *Historia Ecclesiastica*, I, 3, 4.

31. *Ibid.*, II, 11. This is a frequent subject in Byzantine art. Joshua appears also in the Menologium of Basil II on September 1 (Migne, Pat. gr., 117, cols. 21–24); the chief incidents in the summary account of his life are those of the Joshua Roll: Jericho, the Crossing of the Jordan with the People and the Ark, the Meeting with the Archangel, and the Miracle of the Sun.

32. See the anonymous account of the antiquities of Constantinople in *Scriptores Originum Constantinopolitanarum*, rec. Th. Preger, II, 1907, p. 176 and Migne, Pat. gr., 122, cols. 1215, 1216. The statue is also mentioned by Niketas Akominatas, Pat. gr., 139, cols. 1045, 1046, after the anonymous writer.

33. Migne, Pat. gr., 121, cols. 123, 124; a similar statement by George Hamartolus, Pat. gr., 110 cols. 193, 194.

34. Theodosius Diaconus, "Acroasis De Expugnatione Cretae," Pat. gr., 113, cols. 1001, 1002.

35. VIII, 2828 (ed. C. Sathas and E. Legrand, *Les Exploits de Digénis Akritas*, Paris, 1875, pp. 232, 233). For the historical content and tendency of the poem see the researches of Professor H. Grégoire, in: *Byzantion*, V, 1929-1930, pp. 328-340, VI, 1931, pp. 481-508, VII, 1932, pp. 287-302, and *Bulletin de l'Académie Royale de Belgique, Classe des Lettres . . .* 5e série, 17, 1931, pp. 463-493.

36. On the emperor as "another David," see "De Cerimoniis Aulae," I, 69, 73, Pat. gr., cols. 609, 663.

37. A. Goldschmidt and K. Weitzmann, *Die byzantinischen Elfenbeinskulpturen*, Berlin, 1930, I, Nos. 1–4, pl. I, and text, I, pp. 23 ff.

38. *Ibid.*, Nos. 8 (pl. III), 10 (pl. V), 11 (pl. III), 12, 20 (pl. VII, VIII), and text, I, pp. 25–29.

39. Dulaurier, *op. cit.*, p. 22, and p. 383, n. 14.

40. See Th. Reinach in *Revue des Etudes Grecques*, IX, 1896, pp. 66–103, and Krumbacher, *Geschichte der byzantinischen Literatur*, 1897, p. 723. Also of the tenth century is the more detailed description of the antiquities of Constantinople by an anonymous writer, later ascribed to Codinus. See note 32 above, and Krumbacher, *op. cit.*, pp. 423, 424.

41. On his literary activity see Krumbacher, *op. cit.*, pp. 252 ff. and A. Rambaud, *L'Empire Grec au Dixième Siècle, Constantin Porphyrogénète*, Paris, 1870, pp. 64 ff.

42. II. 19, Pat. gr., cols. 1134 ff.

43. *Ibid.*, cols. 1140–1142 (cf. also cols. 622, 623). In the Joshua Roll, the captains stepping on the necks of the kings illustrate the text of Joshua X, 24.

44. *Il Rotulo*, pl. XIV.

45. See Krumbacher, *op. cit.*, pp. 636, 638.

46. "De Velitatione Belli," *Pat. gr.*, 117, cols. 925 ff. refers often to the wars of Nicephorus Phocas with the Arabs.

47. See Krumbacher, *op. cit.*, pp. 459–460.

48. In the poem on the war in Crete (see note 34 above), there are frequent quotations of Homer and Plutarch, and allusions to Achilles, Alexander, Ajax, Ulysses, Scipio, and Sulla.

49. While this article was in press, there appeared the book of Professor Kurt Weitzmann on the Joshua Roll (Princeton University Press, 1948), too late for me to consider its conclusions here.

[At the congress of Byzantine studies where I presented this paper in 1946 (see page 49 note * above), Henri Grégoire suggested to me that the Roll might have been made to celebrate Heraclius's reconquest of the Eastern provinces of his empire from the Persians in 628/629. This date would be supported by the resemblance of certain features of the Roll to such works of the time of Heraclius as the Cyprus treasure. But the campaigns of Heraclius were not in the Holy Land. The re-acquisition of Jerusalem and other Biblical sites was the result of his victories in Persia and the death of Chosroes II in a palace revolt. This objection does not exclude the possibility that the roll in the Vatican was copied from a work of the seventh century.]

The Frescoes of Castelseprio

(1952)

I

All students of mediaeval and early Christian art are now aware of the problem of Castelseprio: are the beautiful frescoes which were recently discovered in this out-of-the-way Italian sub-Alpine site works of the seventh or the tenth century, are they of the so-called Middle Byzantine Renaissance, or do they belong to the preceding art of Greek-speaking Syria and Palestine (Fig. 1)? The different answers presuppose or imply a different picture of early mediaeval art and compel a reexamination of ideas about the character and development of Christian painting. At a meeting held in Castelseprio in September 1950, a poll of scholars from various countries showed an almost equal division of opinion between the datings in the seventh and the tenth century. A few thought the frescoes might be of the eighth or ninth. In an article in 1947 Toesca proposed a date around 600;[1] and before the inscriptions were made known, there was even a dating in the fourteenth century. This surprising uncertainty holds also for two important related works: the Paris Psalter (Bibl. Nat., Ms. gr. 139) (Figs. 6 and 10) and the Joshua Roll (Vatican, Cod. Palat. gr. 431),* both of which have been attributed to the seventh and the tenth century. The difficulty of decision reminds us how poor is our knowledge of the art of that long period, how few works have survived from the great Eastern centers, and on what unsure foundations have been built the general ideas about early mediaeval art. We know of not one fresco cycle in Istanbul from the first six centuries of Byzantine rule; not a single miniature can be surely assigned to the capital between about 520 and 880; we have no wall mosaics of the pre-Moslem period from Palestine or Syria or Egypt, except the much-restored ones on Mount Sinai. Apart from these great gaps, judgment is complicated by the fact that certain early forms and types reappear sporadically at intervals of centuries. We hardly know whether these are revivals or the elements of an unbroken tradition which has been imperfectly

* For illustrations of the Joshua Roll, see the chapter on this manuscript in the present volume—especially Fig. 5 in that chapter (pp. 48, 52, 53, 56, 63).

Fig. 1 Castelseprio, Sta. Maria: Frescoes of apse wall (drawing after Bognetti et al.)

 a: Annunciation and Visitation (Figs. 5 and 12)
 b: Trial by Water (Figs. 15, 8, and 17)
 c: Bust of Christ (Fig. 11)
 d: Dream of Joseph (Fig. 14)
 e: Journey to Bethlehem (Figs. 18 and 7)
 f: Hetoimasia
 g: Presentation to the Temple (Figs. 22 and 9)
 h: Nativity and Annunciation to the Shepherds (Figs. 2 and 16)
 i: Adoration of the Magi (Figs. 21 and 26)

TAV. XC

Schema dell'insieme visto dipinto sull'abside
e sul rovescio dell'arco trionfale

preserved. The student in other fields would appreciate the difficulties here if in a similar problem of later art he confronted a corresponding void in the art of mediaeval and Renaissance Rome or in modern French art.

The three Italian scholars who first published this great find of Castelseprio did not altogether agree.[2] D'Arzago, the historian of painting, placed the frescoes in the first half of the seventh century or about 650. Bognetti, a student of mediaeval Lombard institutions, thought they might be as late as 700, and the architectural historian, Chierici, lacking precise indications, accepted a broad dating in the seventh or eighth century. Common to the first two is the theory that the frescoes, so exotic in this abandoned Lombard chapel, are the work of an emigrant from the Hellenized Syro-Palestine coast, probably one of those orthodox monks who fled from the Moslem invaders, bringing with him a conservative artistic culture steeped in classic traditions, like the art of the great Palestinian sanctuaries. American readers are reminded of the theory of Professor Morey about the diffusion of classical forms to Italy, Salonica, and Constantinople by Alexandrian artists fleeing from the Moslem conquerors. The little building, of lobed-cross plan, with horseshoe forms and narrowed opening of the apse, of walls without moldings, is hardly classic in spirit or detail and points to the less Hellenized regions of Asia Minor and Mesopotamia. On the other hand, the inscriptions in the frescoes contain Greek elements, like the name "Emea" for the midwife at the Nativity (Fig. 16). The iconographic types are paralleled in Syria and Egypt, and the pictorial qualities of the paintings—the strong modeling, the free, sharp play of light and dark, the landscapes and elaborate buildings of the background—recall to the Italian writers works of the eighth century made for the Moslems: the paintings of Kuseir 'Amra and the mosaics of the great mosque of Damascus, which are an impressive evidence of the vitality of Hellenism in the late art of that region. They also observed resemblances of the frescoes of Castelseprio to the Joshua Roll and the Paris Psalter, which most scholars today believe to be works of the tenth century from Constantinople. But since these were copied from early models and have been identified with a "renaissance," Bognetti argued that the frescoes belong to the tradition of the models of the later Byzantine miniatures. D'Arzago, however, thought the Joshua Roll was of the late sixth or seventh century and the Psalter a copy made in the eighth or ninth from an original in the style of the frescoes.

It is precisely this resemblance to the Roll and the Psalter that has led Professor Weitzmann to place the frescoes in the second quarter of the tenth century.[3] He believes that the frescoes confirm not only the tenth-century dating of the two manuscripts—which is still denied by Professor Morey and some of his pupils—but also his older theory that the classicizing features of the Roll and Psalter were first introduced in the tenth century from pagan classical

models as an addition to a less decidedly classical Christian core. The frescoes were painted, he thinks, by a Greek artist from the same workshop in Constantinople that produced the Joshua Roll and the Paris Psalter; his model was a roll created in the imperial scriptorium early in the tenth century. Contrary to the Italian writers, Weitzmann maintains that no such style existed between the sixth and the tenth century. Although some iconographic elements in Castelseprio can be matched in the art of the sixth and seventh centuries, the thematic types are for him more characteristic of Middle Byzantine art. An important evidence for the limiting date of the murals is a graffito scratched into the wall of the frescoes; it refers to the ordination of a deacon under the Archbishop Ardericus of Milan, who ruled from 938 to 945. This is the oldest of several such inscriptions concerning the appointment of the clergy of the chapel, and implies that the frescoes existed in 945 and were created not long before. To account for the presence of these works in Castelseprio, so far from Constantinople, Weitzmann conjectures that they have some connection with the alliance, around 935, of the Greek Emperor Romanus Lecapenus and the Lombard King Hugo, whose seat was at Pavia. In 944 Hugo gave his daughter, Bertha, in marriage to a Byzantine prince, Romanus. The frescoes are perhaps the work of a Greek artist who accompanied one of the Byzantine embassies to Pavia.

The striking resemblance of the frescoes to the miniatures of the Joshua Roll and the Paris Psalter is Weitzmann's strongest argument. But it is in part an argument *ex silentio,* for it rests upon our ignorance of the painting of the seventh to the ninth century, and little is said, moreover, about important themes of the frescoes which have an early look and for which Weitzmann offers no Byzantine parallels—the medallion bust of Christ (Fig. 11), the angels and throne (Hetoimasia) on the arch, and the decorative band below the narrative scenes (Fig. 1). We are not at all sure that the classicizing elements common to the frescoes and miniatures did not exist before 900. Weitzmann's assumption that these were first introduced in the tenth century has still to be established. Nevertheless, I believe he is justified in placing the two manuscripts in the tenth century; among other reasons, they are close to the Leo Bible (Vatican, Cod. Regin. gr. 1), which is unquestionably of the early tenth century. Yet if Weitzmann is right in supposing that the Leo Bible is somewhat earlier than the Paris Psalter because in scenes common to both it is more consistent in form and truer to the old models, then it may be inferred from comparison of the common elements that the frescoes of Castelseprio are older than the Leo Bible and the Psalter—older also than the miniatures of the Paris Gregory (Bibl. Nat., Ms. gr. 510, painted about 880), if we may judge by the drapery forms and the relative purity of classical detail in works that belong to a common line of development. But how much older is hard to say.

If Weitzmann were strict in applying his theory about the formation of the renaissance art of the tenth century, he would have to consider more seriously the possibility that Castelseprio is an earlier work. In this new study, as in his previous writings, in characterizing the Roll and the Psalter (Figs. 6 and 10), he refers to the frequent use of personifying figures in the miniatures; he believes these are inventions of the Byzantine artists of the tenth century, characteristic additions in keeping with the Hellenizing spirit of that epoch. But such personifications are absent in Castelseprio, although the frescoes, according to Weitzmann, come from the same workshop in Constantinople as the two manuscripts and show the same artistic tendency. Is it because the Christian matter of the frescoes was less open to so pagan and classic a feature? Yet localities—the Jordan, Egypt, and Jerusalem—had been personified in images of the Gospels since the sixth century. The idea that the figures symbolizing human qualities in the Paris Psalter are innovations of the tenth century is also doubtful. Such moral personifications were in common use in Constantinople in the sixth century; they occur prominently in the miniatures of the Vienna Dioscurides, and churches in the capital bore the characteristic names of Hagia Sophia, Hagia Eirene, and Hagia Metanoia. Outside Byzantium such moral personifications appear in the paintings of Bagwat and Kuseir 'Amra. If they are so important in the Paris Psalter, it is not as original elements, but as old devices which have been revived in a self-conscious, retrospective, courtly art.

The theory of personifications failing here, Weitzmann turns to other features in Castelseprio as examples of an inveterate renaissance practice of amplification. He points to the columns, buildings, trees, and mountains in the frescoes as typical "insertions" of the tenth century designed to separate (or unite) in a newly devised continuous narrative the barer episodes, which go back to the Early Christian period.

Yet every one of these supposed insertions may be matched in works before the tenth century, and some of them even in older versions of subjects that occur in the Roll and Psalter. Such elements abound in the miniatures of the Paris Gregory (gr. 510) in scenes apparently copied from earlier art.[4] They occur also in the Vienna Genesis and the frescoes of Deir Abu Hennis.[5] In the latter—which include several of the themes of Castelseprio—mountains, towers, columns, buildings, and trees form a setting or frame for the action. The older examples show that these elements are not always devices for separating or linking the episodes of a continuous narrative, but are often means of closure in framed scenes as well. The sloping rock or mountain that separates the Nativity from the Annunciation to the Shepherds in Castelseprio (Fig. 2) and serves as a boundary between adjacent scenes in the Joshua Roll is used in the Paris Gregory to separate Joshua staying the sun from Joshua with the

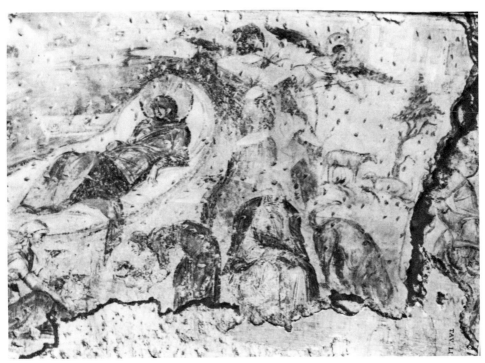

Fig. 2 Castelseprio, Sta. Maria: Nativity.

Fig. 3 Utrecht, University Library: Ms. 32, fol. 61v. Drawing in psalter.

angel[6]—scenes that are several chapters apart in the Bible text (Fig. 4). The Samson page in this ninth-century manuscript is rich in buildings, rocks, and hills used in the same way.[7] If one objects that Paris gr. 510 is already close in date to the Joshua Roll, there is the still earlier Utrecht Psalter—a Carolingian work surely based on an old model—where trees, rocks, and buildings separate the scenes, and the figures often emerge from behind the hills as in the Roll. In the Utrecht Psalter an isolated tree on the hill between two scenes (Fig. 3)[8] is in form remarkably like the tree between the Nativity and the Shepherds in Castelseprio (Fig. 2). Weitzmann's idea that the roll form of the Vatican Joshua manuscript is an invention of the tenth century is hard to accept; details that he explains as elements inserted in a formerly discontinuous series of scenes when these were united for the first time into a single horizontal band in the Joshua Roll are sometimes confused in the Roll and are represented more consistently and intelligently in the isolated, framed scenes of the Octateuchs.[9] I have little doubt that the Joshua Roll is a tenth-century work copied from an earlier roll which already possessed the devices of continuity and separation that Weitzmann attributes to the tenth century.

We can test his theory of insertion in a particularly instructive application to the scene of the Annunciation in Castelseprio (Fig. 5). Weitzmann tries to prove that the buildings represented in this painting were taken from a hypothetical illustrated manuscript of classical drama, and are like the architecture of the background of the scene of the return of David and Saul in the Paris Psalter (Fig. 6); and from the same classical manuscript he derives the maid behind Mary who makes a gesture of surprise—another insertion of the tenth century. If we study the buildings in the fresco and the Psalter miniature, we observe an uncommon construction—it is not at all typical of surviving mediaeval buildings, nor does it appear in the Pompeian works that Weitzmann cites as examples of the ultimate classical models,—a stilted lintel which resembles most of all the stilted colonnades of late Egyptian buildings, like the "kiosk of Trajan" at Philae. Precisely this form occurs twice in the well-known Bodleian ivory cover of about 800, with the central panel of Christ treading on the beasts (Fig. 13).[10] On the same ivory, in a series of scenes from the infancy of Christ, there appears behind the Virgin of the Annunciation the servant with her hand raised to her face, as at Castelseprio. In his discussion of the iconography of the Annunciation, Weitzmann regards the servant in this scene as an original invention of the tenth century; he knows of no example besides Castelseprio before the fresco of S. Urbano di Caffarella (1011). The Bodleian ivory is a work of the Ada school surely copied from an Early Christian model; certain of its scenes reproduce ivory carvings of the fifth century generally assigned to the school of Milan or Provence. It is obvious from this German panel that the elements which Weitzmann explains as

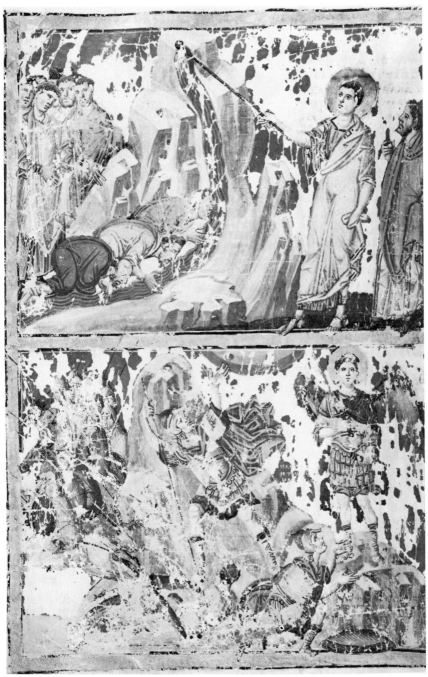

Fig. 4 Paris, Bibliothèque Nationale: Ms. gr. 510. Homilies of Gregory Nazianzen, fol. 226v. Upper scene: Moses Striking the Rock; lower scene: Joshua Staying the Sun; Joshua and the Angel.

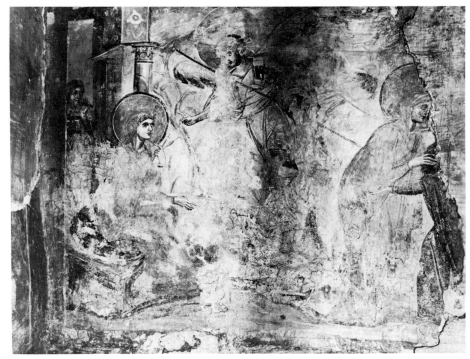

Fig. 5 Castelseprio, Sta. Maria: Annunciation and Visitation.

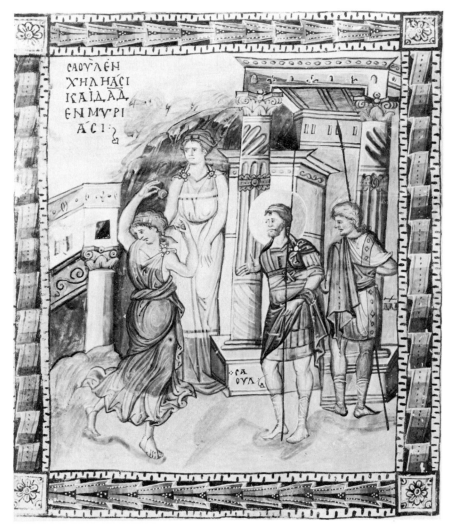

Fig. 6 Paris, Bibliothèque Nationale: Ms. gr. 139, psalter, fol. 5v. David and Saul.

classical types first introduced in the tenth century already existed in Western art by 800;[11] and we may ask whether they were not in the model of the ivory, a work perhaps made in Milan in the region of Castelseprio. The stilted lintel, which I believe existed in still older East Christian representations (though no longer preserved), is common enough in Carolingian art,[12] especially in Germany and Switzerland, regions close to the North Italian sphere. It is found also on the gold altar of S. Ambrogio in Milan in the scene of the Annunciation.

A related element of insertion for Weitzmann is the gate of which the arch springs from a column and a pier. He thinks this is an arbitrary invention of the Castelseprio master, since the supports of such a gate in classical art are either two columns or two piers. He has overlooked the presence of the same asymmetrical coupling of column and pier not only in the Paris Psalter,[13] but also in the Gregory manuscript.[14] It is no invention of the ninth century, however; we see it clearly represented on the magnificent pavement of *ca.* 500 in the Great Palace of Constantinople.[15]

Besides these insertions, Weitzmann observes peculiarities of costume, gesture, and details of drawing common to Castelseprio and to Greek miniatures of the tenth century. What he fails to consider are the elements of the frescoes which are not to be found in these Byzantine works but occur in Early Christian and Carolingian art. But even those which he singles out as typical of the Middle Byzantine school, like the tucked-in ends of the garment and the sash across the body, appear in the ivories and miniatures of the Ada group.[16] The jutting fold at the shoulder is, he admits, a classic Roman form; its use in S. Maria Antiqua tells us that it was not revived for the first time in the tenth century.[17]

* * *

If Weitzmann is mistaken in supposing that the elements he has cited in the frescoes and miniatures are peculiar to the tenth century, he may still be right in his dating of Castelseprio, though for other reasons. We must agree with him that if a work is a copy, it will betray the period of copying in intimate features of the copyist's own style. This is a principle that has been confirmed countless times in studies of literature and art. But to apply it successfully we must know what the copyist's own style is; and in the case of the Roll and Psalter this is still somewhat obscure. Weitzmann himself says of mediaeval art in general: "The style of the model has quite often a more powerful influence on a work of art than the individuality of the copyist." He believes that the minute differences by which one distinguishes mediaeval works are "rarely the characteristics of the individuality of an artist, but are in a broader sense those of a special workshop or a distinct locality at a given time." Taken together here, these principles are discouraging, if not puzzling;

but in practice, the "broader sense" may lead us to the truth, if we have enough evidence and a sufficiently searching analysis. Unfortunately, Weitzmann has not investigated the art of Castelseprio very far. He has isolated some details that occur also in the tenth-century manuscripts, without having established the actual range of those details in time. Admitting the artistic superiority of the frescoes—which he regards as a purely individual matter—he has done little to define their distinctive qualities. His characterization of their style as one of "nervous excitability and inner tension" is not specific enough to support his conclusion about their date. He would have us believe that this is the essential character of Middle Byzantine art, but it is scarcely intimated in his earlier accounts of the Psalter and Roll, where we find instead a reference to the classic qualities of this tenth-century "renaissance" style. But nervous expression and intensity—if we may use these vague terms—are, in varying nuance, more familiar in the art of the sixth century in the Near East (the Sinope Gospels, some pages of the Vienna Genesis, the Syro-Palestinian ivories, the Ezechiel figure in the mosaic of Hosios David in Salonica) and in Carolingian art. It is possible that Castelseprio belongs to a transitional stage between these two arts.

The art of Castelseprio—the work of a greater master—is much more refined than the art of the Roll and the Psalter. But while it is not easy to say what is personal and what belongs to the local or period style when we have so few works for comparison, and while it is conceivable that a level of quality may also be characteristic of a school, I believe that there is a difference here in the conventions, too, and this makes me doubt that the painter of the frescoes belongs to the same period and workshop as the artists of the two manuscripts. His brush stroke, his command of atmospheric perspective, of light and shade, of landscape and architectural forms—elements that in the hands of the best artists become increasingly schematic in the course of the ninth and tenth centuries in Byzantium—are much freer and more faithful to ancient tradition. His rocks and trees are less stylized. The lights, applied in vivid staccato strokes on beard and hair and face, form more active, varied patterns (Figs. 7–9). The buildings in several of the frescoes are seen diagonally and foreshortened. unlike the frontal representation of buildings in the Psalter. In no scene in the latter are the figures proportioned to the landscape and set so deeply within it as in the Nativity in the Italian cycle (Fig. 2); in the Psalter we feel more strongly the closeness of the figures to the frame and the foreground (Fig. 10). The foreshortened postures of the Virgin and the shepherd's dog in the Nativity are more natural than in the corresponding figures in the manuscript. At the same time, there is in Castelseprio a great ardor and conviction, an intense response to the human meaning of the subject, an effort to create images of distinct religious personalities, like the priests of the Trial and the Presentation

Fig. 7 Castelseprio, Sta. Maria: Joseph, detail of Journey to Bethlehem.

Fig. 8 Castelseprio, Sta. Maria: Priest, detail of Trial by Water.

Fig. 9 Castelseprio, Sta. Maria: Simeon, detail of Presentation in the Temple.

(Figs. 8 and 9), which we miss altogether in the manuscripts. Each scene has the quality of a fresh interpretation. The rhythmical sweep of line in the frescoes, the angels' outspread wings (Fig. 14), and the inwardness of the figures take us to another world than that of the military and courtly scenes of the Roll and the Psalter. If Castelseprio were a dated tenth-century monument, and we had to characterize the art of that time through these passionate, deeply felt frescoes, we would arrive at a quite different account than if we took as our standard the Joshua Roll and the Paris Psalter. We would not consider personifications and classical figure types so important then, nor would we think of the "renaissance" outlook as something self-conscious and artificial, expressed in stiff statuesque forms and awkwardly assimilated classic details.

There is in the Psalter a cluttered, confected quality, a literalness of the hand and of the mind, a lack of spontaneous feeling, which betrays the naive copyist in many details and in the aspect of the whole. I find none of this in Castelseprio, although the painter of the frescoes undoubtedly reproduces older forms and compositions. But he is not attempting the exact reproduction of a model over which he anxiously and pedantically bends his back. Whatever the models of the frescoes, he had to adapt them to a new surface, with its particular dimensions, curvature, and openings, and this he did with great sureness and expressive force, in full possession of his own means; whereas the miniaturists were more committed to close reproduction of their manuscript models. In the tenth century, the idea of copying, particularly from books, seems to have been an essential part of the spirit of imperial art, as it was of the literature of the time. The Emperor Constantine Porphyrogennetos, an encyclopedist and amateur painter, interested in old traditions, might himself have produced some of the miniatures of the Paris Psalter.

There is a motif common to Castelseprio, the Paris Gregory, and the Psalter which will permit us perhaps to gauge their relative positions in time. It is the knotted sash around a freestanding column beside the sleeping Joseph in the fresco (Fig. 14); in Paris gr. 510 it appears on the page with scenes from Gregory's life,[18] and in the Psalter we find it on the frontispiece with David playing the harp (Fig. 10).[19] Of the three versions, all probably based on Early Christian models, the fresco offers the most classic and freely natural form, the Psalter the most schematic one.

Another theme that may help us to locate the frescoes in time is the medallion bust of Christ with raised foreshortened right hand and a roll in his left (Fig. 11). This frontal Christ is conceived in another way than the narrative scenes, although surely contemporary with them; it is, we may say, in an iconic rather than dramatic or episodic mode, and should be considered alongside the corresponding examples of the seventh to the tenth century to determine its historical position. It is practically ignored in Weitzmann's book.

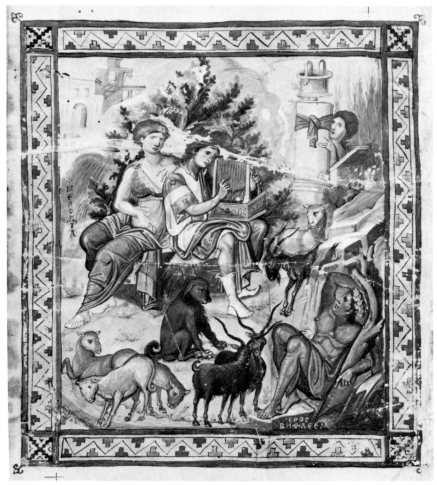

Fig. 10 Paris, Bibliothèque Nationale: Ms. gr. 139, psalter, fol. 1v. David as Harpist.

He has also ignored the architectural form of the frescoes, their relation to the wall. Designed for this building, the scenes are laid out in an "unconstructive" manner which reminds us more of Early Christian, and particularly of Italian, wall painting than of Middle Byzantine monumental decoration. The fields of the Hetoimasia and the Magi are irregular segments; the circular medallions, the arches of the original windows, and the great arch of the inner apse wall break the horizontal lines of the frescoes, as in Rome, Ravenna, and Parenzo (Fig. 1).[20] Medallions are similarly inserted in the narrative band in the early cycle of scenes from the infancy of Christ in Deir Abu Hennis in Egypt.

Also neglected by Weitzmann is the painted decoration below the pictures—a design of simulated niches with shallow arch segments and curtains suspended from a rod on which stand paired doves, the whole surmounted by a cornice of dentellated joists in perspective and by a heavy, ornamented horizontal rod issuing from trumpet-like tubes; around this rod winds a ribbon or garland, as on the borders of Roman mosaics (Fig. 1). Study of this decorative system will show, I believe, a close connection with Italian mural art of the fifth to the ninth century and with Carolingian works.[21]

* * *

If Weitzmann has failed to prove that the style of the frescoes was possible only in the tenth century, the arguments for a dating in the seventh still need the direct support of well-dated works of that period. There are, it is true, in Sta. Maria Antiqua frescoes of that time with astonishing classic qualities in the modeling and light and dark, especially in the heads. But these Roman paintings lack the landscape and architectural settings and the animated postures of Castelseprio. If contemporary with the latter, they belong to another tributary of the same classic stream—a current for which we have only indirect and approximate evidence. Perhaps the narrative paintings of the eighth century in Sta. Maria Antiqua, like the Adoration of the Magi and David and Goliath, with their landscape backgrounds and graded sky color, are reduced versions of this more picturesque classic art.

But is the absence of landscape and architecture and active figures in the seventh-century paintings of Sta. Maria Antiqua a sufficient reason for doubting that a style like that of Castelseprio could have existed beside the classic style of the Roman frescoes? Weitzmann himself supposes that in the tenth century there were in Constantinople mosaics and frescoes of an art like Castelseprio's besides the unclassic, iconic style of the surviving mosaics of Hagia Sophia. In the Paris Psalter are miniatures with statuesque isolated figures on a gold ground and others with idyllic or dramatic figures set in landscapes; in the sixth century the same duality appears in the paintings of the Vienna Genesis and

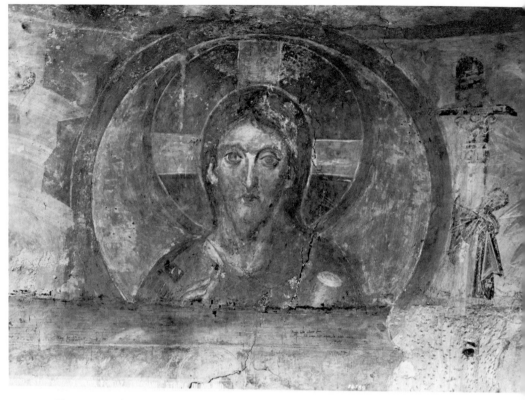

Fig. 11 Castelseprio, Sta. Maria: Bust of Christ.

the Dioscurides codex. Other examples from the earlier period are the ivory consular diptychs with formalized, ceremonial, and emblematic figures above and circus games rendered in a wholly different spirit below. It is a mistake to regard these opposed kinds of representation as personal or regional styles which necessarily imply different hands or places of origin. Although one or the other was favored in some centers and at certain moments, they were, in the late classic period, essentially modes—somewhat like the modes in music and the genres in poetry—which could be practiced by the same artist according to the subject-matter or purpose of the work, just as an artist of the Italian Renaissance could paint isolated monumental figures and scenes of action against quite different backgrounds and with contrasting accents in expression and touch.[22] In Castelseprio we observe just this range of modes in the difference between the narrative pictures and the Hetoimasia or the medallion with the head of Christ, the only frontal head in the entire fresco, a conception of icon-like character, subject perhaps to the spell of a venerated model (Fig. 11). The iconoclastic controversy may perhaps be regarded aesthetically as a conflict over the growing dominance of the latter mode in popular taste.

Landscapes and views of buildings were surely more common in Byzantine painting in the sixth to the eighth centuries than the surviving works suggest. The fortunately preserved examples of the eighth century in Damascus and Kuseir 'Amra were preceded by lost paintings of which we can form an idea through a contemporary description, like those of Gaza with their elaborate buildings, broad landscape, mountains, shepherds, flocks, and dogs, seen in the sixth century by Procopius of Gaza.[23] Weitzmann mentions as evidence of the purity of classic tradition in Constantinople the remarkable silver vessels of the sixth and seventh centuries, decorated with pagan themes in landscape settings. Can we believe that this art had no counterpart in painting or died out completely before 700? To judge from his account of the pavement mosaics of Antioch, which grow flatter, more schematic and oriental in the sixth century, works like the miniatures of the Syriac Bible in Paris (Bibl. Nat., Ms. syr. 341), the Damascus mosaics, and the frescoes of Kuseir 'Amra could not have been created after those pavements. For the practice of landscape in Byzantium in the eighth century there is the testimony of the historians of the iconoclastic period: the Emperors Leo III and Constantine V replaced religious paintings by landscapes and scenes of warfare and hunting. We know nothing about their style, but is it likely that they were less classic in spirit than works made for the Moslems in the same period, or than Carolingian paintings? Still, it must be said that we have no surviving works quite like Castelseprio from either the seventh or the tenth century. This is the real historical interest of the Italian frescoes—they offer something altogether unique and compel us to reconsider our ideas about early mediaeval art.

The building, too, is unique. Its date must be very close to that of the frescoes, since these were painted on a layer of plaster which covered the entire inner wall, and the first coat that pointed up the rough masonry bears traces of the artist's preliminary work, according to the observations of the Italian writers.[24] But although Chierici's study was inconclusive, I think Weitzmann underestimates the significance of the architectural evidence in stressing this negative fact. The coarse masonry of the building, the complete absence of the vaults, niches, and articulation of the walls characteristic of the buildings of the Milanese region in the ninth and tenth centuries, the general use of the horseshoe form in the plan and in the arches, point to the seventh or eighth century. The fact that no exact parallel can be found should not surprise us; so little is preserved of the architecture of Lombardy from this time that any conclusion must be tentative. But the elements of the church may be compared with those of buildings of the seventh century in England and Spain; there are also similarities to churches of Asia Minor and Mesopotamia of the sixth to the ninth centuries.[25]

The inscription naming Ardericus, the Archbishop of Milan between 938 and 945, which Weitzmann regards as a strong evidence for a date in the tenth century, seems to me to indicate the contrary. If the frescoes were made in the second quarter of the century, it would be surprising that a deacon appointed about 940 should scratch into the wall on the surface of these beautiful new frescoes a record of his appointment. Weitzmann also feels this difficulty, and therefore conjectures that the graffito was made a decade or two later in order to commemorate that occasion. But the now incomplete inscription (which calls the Archbishop "Dominus," as if he were still living) originally gave the day of the consecration; and the corresponding graffiti of the other consecrations, more completely preserved, also record the indictions—details which would be less available or relevant two decades after the event.

We must observe, too, that if Weitzmann's theory concerning the origin of the frescoes is correct, and if building and frescoes were made together, they could only have been created under this deacon, who would thus have to be the first deacon of this church.

Let us try to reconstruct the situation as Weitzmann has imagined it. In 935 an embassy from Constantinople to Pavia arranged an alliance of the Byzantine emperor and the Lombard king against a rival Italian prince. In 942 a second embassy to Pavia proposed the marriage of Hugo's daughter to a Greek prince. With one of these embassies came a great artist, a greater one than those of the same atelier that produced the miniatures of the Paris Psalter and the Joshua Roll for the imperial court. For some reason—it is useless to guess, there are so many untestable possibilities—this artist was sent by the Lombard king to a tiny village at the foothills of the Alps some thirty miles

away, to decorate a little chapel, a coarsely constructed new building, without capitals, moldings, or carved ornament—the apse has not even a vault. All this happened between 935 and 944, for the marriage of the Lombard princess was never consummated, the Emperor Romanus was deposed in December 944, a few months after the wedding, the friendly relations between Pavia and Byzantium lapsed forever, and the princess died in 949.[26] The little chapel was now resplendent with the wonderful frescoes donated by the king—a cycle of frescoes unique in Italy. The deacon who was appointed during this period, the first deacon of the church, then took it upon himself to scratch (not to paint) on the fresco of the apse (in the curtained field which includes the throne and the book that Weitzmann interprets as essential parts of the dogmatic conception of the whole cycle) an inscription to the effect that he was ordained deacon on a particular day during the rule of Dominus Ardericus, Archbishop of Milan—note that it is not the Bishop of Pavia. Succeeding priests continued this practice. We are accustomed to such graffiti in mediaeval village churches; but on the newly frescoed wall of an apse? Perhaps after some generations or centuries, hardly within a few years. It seems to me highly improbable that the frescoes can date from the lifetime of the literate deacon who inscribed a record of his appointment on the precious paintings. Let us add finally that we are not at all sure that this is the oldest of the graffiti on that wall.

This whole discussion of the graffiti ignores what is most important—the painted inscriptions of the frescoes themselves. They are of an uncial type that suggested a date in the sixth century to Professor Lowe, who judged the photographs at my request before he was acquainted with the problem of the frescoes. I do not insist upon this first impression of an expert in uncial writing; with all their painterly sketchiness and roundness, the letters have touches compatible with a dating in the seventh or eighth century.[27] The problem requires further study. But Professor Weitzmann, who is aware of the strikingly early aspect of the painted inscriptions and can cite no others like them in the tenth century, is content to say that painters often make inscriptions in a style earlier than the bookhand of their own day. Here he forgets the principle he calls upon in his study of the paintings: that copied forms always contain traces of the style of the copyist's time. This principle is evident in the capital letters of the legends in the miniatures of the Joshua Roll and the Paris Psalter, which are, I think, decidedly of the tenth century. For comparison with Castelseprio, he does not cite Latin painted inscriptions or uncial headings in manuscripts of the tenth century but three undated Greek inscriptions in the mosaics in Hagia Sophia. None would be taken for writing of the sixth or seventh century, none is sufficiently like the writing in Castelseprio to provide a ground for its dating, and Weitzmann considers them to be of the ninth century. Regrettably, he

reproduces no photographs of the inscriptions of Hagia Sophia, although he does illustrate many works to support his iconographic comparisons.

<p style="text-align:center">* * *</p>

The Italian editors gave great weight to the subject-matter of the frescoes, noting similar conceptions in works of the sixth, seventh, and early eighth centuries. Several scenes in Castelseprio resemble particularly those of Sta. Maria Antiqua and the lost mosaics of the oratory of Pope John VII at St. Peter's in Rome (705–707) (Fig. 20). Professor Weitzmann has taken pains to challenge this argument from iconography by a study of the types in which he tries to prove their Middle Byzantine origin. He doubts, however, that iconography is as sure a clue to the date of a work as its style; a theme may be represented for centuries in different styles with little or no change in the conception of the meaning. I believe that while this may be true for a particular subject, it is less likely for a whole cycle such as that in Castelseprio; where there are many themes, the contemporary interests and attitudes will tend to appear in at least a few details, even where an old cycle has been copied. Weitzmann's study shows in a number of elements considerable differences between the seventh and eleventh centuries in the iconography of the Virgin and the infancy of Christ. Since the conception is never quite stable and several variants exist side by side all through this long period, the judgment that a cycle is early or late depends on the weighing of the similarities and differences. I feel that in looking for parallels Weitzmann disregards too often the earlier examples. I shall comment on the single subjects, adding my own observations to those already made by d'Arzago and Weitzmann.

Annunciation: (Fig. 12) Weitzmann cites no example before the eleventh century of the maid behind the Virgin in this scene, an element foreign to older Byzantine art. She appears on the gold enclopium from Adana in the museum of Istanbul (sixth or seventh century);[28] the Genoels-Elderen ivory in Brussels (Fig. 19) (German, late eighth century);[29] the silver case of the enamel cross in the Sancta Sanctorum treasure in Rome (Italian, early ninth century);[30] and on a number of Carolingian works (Fig. 13).[31] In the Brussels ivory, the architectural setting is also interesting for the type in the fresco. The importance of the Parenzo mosaics of the Annunciation and Visitation (sixth century) for Castelseprio is underestimated by Weitzmann. For the persistence in North Italian art of the unusual elevated position of the angel, we have the drawing in the sacramentary of Ivrea (*ca.* 1000).[32]

Visitation: (Fig. 5) Weitzmann admits a close parallel to the embracing women in a fresco of the eighth century in the cemetery of S. Valentino in Rome. Here, as in Castelseprio, Elizabeth feels the Virgin's womb. But Weitzmann fails to analyze the elements of the resemblance, for he regards as

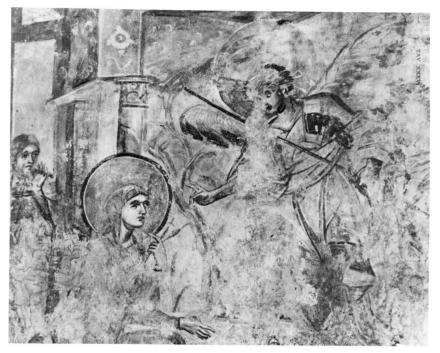

Fig. 12 Castelseprio, Sta. Maria: Detail of the Annunciation.

Fig. 13 Oxford, Bodleian Library: Ms. Douce 176, Ivory cover, detail.

the closest parallel a Greek miniature in Paris gr. 510 (*ca.* 880) which lacks this significant, traditional gesture of Elizabeth. He ignores the fact that precisely this gesture occurs in the Genoëls-Elderen ivory, which also includes the servant in the Annunciation, and in other Western works.[33] The example he illustrates from a Byzantine ivory (his fig. 52: a diptych in the Milan Cathedral), does not show the same gesture.

Trial by Water (Figs. 8, 15, 17): The closest parallels, as d'Arzago has shown, are in the tenth-century frescoes of Cappadocia (Qeledjlar, Toqale) where the priest offers the water in a beaker. This theme occurs in a number of ivories of the sixth century from the Syro-Palestinian and Egyptian milieu, but in a simpler form. The Cappadocian frescoes, according to Millet and de Jerphanion, the two scholars who have studied them most carefully (independently of the present problem), reproduce older Near Eastern types in a conservative way. Weitzmann thinks the model of the Cappadocian artists came from Constantinople. This is possible; but we are given no reason to regard the example in Castelseprio as a post-iconoclastic type. Its architecture is unique among all the versions of the scene.

Joseph's Dream (Fig. 14): Weitzmann finds "the closest parallel" in a Middle Byzantine lectionary, Dionysiu Ms. 740, and thus offers us a disconcerting criterion of similarity. The bare scene in the miniature lacks the architecture and landscape that appear in Castelseprio and the figures are conceived rather differently, the angel having little of the mobility and eagerness of the Italian example. In the miniature he stands beside Joseph; in the fresco he rushes in, with wings outspread as if flying. Joseph in the manuscript lies with his left thigh completely masked by the foreshortening; in Castelseprio his thigh is drawn out and fully visible, parallel to the other leg. The miniature is a reduced form of the type we see in the fresco; it is no more relevant than the fresco of the sixth century in Deir Abu Hennis in Egypt, where the two figures are set in architecture. Weitzmann thinks that the landscape in Castelseprio is a Middle Byzantine classicizing insertion or rather substitution for the architectural background of this scene in Early Christian art; but the scene is also set in a landscape in Paris, Bibl. Nat., Ms. copte 13, a manuscript of the twelfth century in which the frequent landscapes hardly depend on the influence of Middle Byzantine art but reflect Early Christian models. Here, too, the angel flies above Joseph.

Journey to Bethlehem (Fig. 18): Weitzmann cites the turned head of the Virgin, which represents her conversation with Joseph as described in the apocryphal gospel of the pseudo-Matthew, as a distinctive feature of the Cappadocian frescoes and the late Byzantine mosaic of Kahrie Djami. But he ignores this detail in a work of the sixth century—the Stroganoff ivory— though it is included among his examples of the subject. This ivory shares other

Fig. 14 Castelseprio, Sta. Maria: Dream of Joseph.

Fig. 15 Castelseprio, Sta. Maria: Trial by Water.

Fig. 16 Castelseprio, Sta. Maria: The Midwife Emea, detail of Nativity.

Fig. 17 Castelseprio, Sta. Maria: Hands of Mary and Priest, detail of Trial by Water.

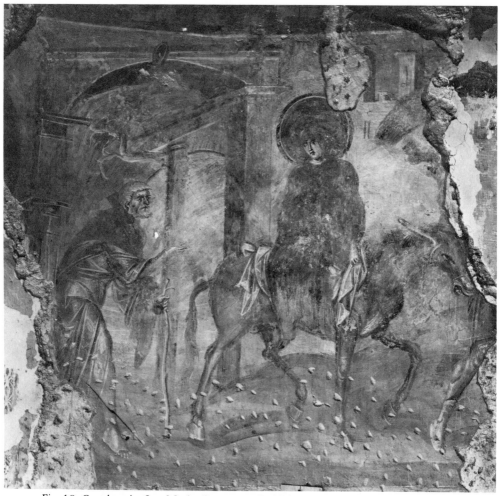

Fig. 18 Castelseprio, Sta. Maria: Journey to Bethlehem.

elements with the fresco: Joseph's mantle hangs from his left arm as in Castelseprio, and the ass is very similar to the creature in the fresco.[34] We may note that the rare landscape and buildings of this scene recur in the version in Deir Abu Hennis and in a later Italian ivory in Salerno, already cited by d'Arzago.

An interesting detail is the gem-like disk at the crown of the arched portal in this scene. There are examples in Roman art, but we are reminded also of the gemmed arches in Carolingian manuscripts of the Ada School.[35]

Nativity (Figs. 2 and 16): The scene is quite like the version in the lost mosaic of the oratory of John VII in Rome, which combines the birth, the bathing of the Child, the midwife with the miraculously withered arm and the Annunciation to the Shepherds (Fig. 20). There are many Middle Byzantine images of the Nativity with the bathing and the shepherds, but none is so close to Castelseprio as the mosaic of John VII and none includes the miracle of the doubting midwife. The latter theme does not occur even in Cappadocia, which preserves old types and where the Greek inscription for one of the nurses is H MEA; the article and noun reappear in Castelseprio in Latin (EMEA) as the name of the doubting midwife.[35a] Weitzmann nevertheless makes a heroic effort to save this fresco for Middle Byzantine art. He is happy to discover a later example of the midwife in the twelfth-century bronze door of Benevento—an Italian work which he thinks is under strong Byzantine influence. But he overlooks that she is not clearly the subject of the miracle and does not support a withered arm as does the apocryphal Salome of the Castelseprio fresco, the mosaic of John VII, the contemporary frescoes in Sta. Maria Antiqua and S. Valentino in Rome, and the ivories of the sixth and seventh centuries. In Benevento the woman's arms are both extended like the arms of the angels beside her; the original meaning has been weakened or lost. The true theme survived into Carolingian art,[36] but already in the fresco of the tenth century in Sta. Maria in Pallara the gesture is less precise than in Castelseprio and the early examples.[37] That the Virgin in Sta. Maria Antiqua raises her hand to the stricken midwife, while in Castelseprio her hand is relaxed, is for Weitzmann a reason for separating these works; but he says nothing of the fact that the Virgin's hand is also relaxed in this episode of the midwife in Bawit, in the oratory of John VII, on the Maximianus Chair, and on ivories in London and Manchester. On the other hand, I may note that Semele, in the lost classical composition of the Birth of Dionysus which Weitzmann ingeniously compares with the Virgin of Castelseprio, also raises her hand.

To strengthen the tenuous comparison with Middle Byzantine art, he characterizes the infant Christ of the bathing scene in the fresco as "a real babe, just like the infant Dionysus" on a Roman sarcophagus which he

reproduces (his fig. 48: a sarcophagus in the Capitoline Museum, Rome), whereas in the oratory of John VII and in S. Valentino the Child is a more formalized vertical figure, partly submerged, aware of his divine mission, and so forth. The truth is that the infant Christ in Castelseprio is one of the most formal of all, and in the mosaic of John VII, of which an original fragment with the Child and nurse is preserved, he grasps her arm and turns his head; at any rate, the bathing Child in Castelseprio is much closer to these works of the early eighth century than to the supposed classic model where the Child lies in the arms of the nurse, outside the basin (as in Kahrie Djami). I may mention also the fact that the scene of the bath occurs three times in the Utrecht Psalter;[38] the posture of Christ there is quite as in our fresco. The bathing of Christ, unknown in the Gospels and Apocrypha, probably goes back to Palestinian tradition. In the late seventh century, the Western pilgrim Arculf was shown in Bethlehem the water of Christ's first bath.

Of some interest for the style of Castelseprio is the arched form of the back of the standing midwife in the bathing scene. Her posture has a decidedly mediaeval aspect; it recalls to us both Carolingian art[39] and certain figures of the sixth and seventh centuries in the Near East (Codex Rossanensis, Syrian silver); but the strict profile of her head suggests a more classic style.

Important for Weitzmann's theory of the Middle Byzantine origin of the Nativity scene is the position of Joseph, who sits with his back to Mary. He believes that in the pre-Macedonian period, Joseph always faces the Virgin in the Nativity. While this is true for the very early examples, there is—prior to the Macedonian dynasty—the opposite testimony of Carolingian art, in which works probably copied from older models show Joseph with his back to the Virgin, e.g., the Drogo Sacramentary.[40] Joseph sits with his back to the Virgin in a Greek uncial fragment of the ninth or tenth century (Berlin, Staatsbibl., Hamilton Ms. 246) which Weitzmann has elsewhere judged to be a copy of an early model.[41] The similar position of Joseph in the Cappadocian frescoes may also reproduce an old type. Weitzmann insists further that in Castelseprio Joseph not only sits with his back to Mary but turns his head, as in the mosaic of Daphni from the end of the eleventh century. This interesting peculiarity seems to me less indicative than he supposes. I am not convinced that Joseph, who "is turning his back to the Virgin" in sorrow because he realizes "he is not the child's father," reverses his glance in order to witness the miracle of the Incarnation. The complex posture of Joseph may be compared with that of the prophet Habakkuk in the sixth century mosaic of Hosios David in Salonica;[42] he too sits in a landscape, within the profile of a rock, and holds his hand near his face. In the fifth-century mosaic of the Presentation in the Temple in Sta. Maria Maggiore, the standing Joseph has his back to the Virgin, but turns his head to see her. The bathing Christ Child in the mosaic of John VII turns his

head away from the midwife whose arms he grasps. On an Early Christian ivory plaque in Manchester, Joseph stands behind the Virgin in the Nativity and turns his head toward her.[43] We are dealing with a classical device of contrapposto, which has both a formal and expressive significance and was probably applied to the sitting Joseph in the Nativity before the Middle Byzantine period. In Castelseprio the divided posture of Joseph seems to serve as a compositional link between the Nativity and the Annunciation to the Shepherds. In asserting that this figure is like the one in Daphni and therefore belongs to Middle Byzantine art, Weitzmann overlooks that in Daphni Joseph's legs are crossed and his right arm is in a mantle sling, unlike the Joseph in the fresco, who is in these respects more like the Joseph in Carolingian art.[44] On the other hand, the crossing of the legs in Daphni might well come from an early source, for it already appears in the Athelstan Psalter (*ca.* 930).[45]

Concerning the Shepherds, Weitzmann accepts the view of Millet that the association of this episode with the Nativity, as it occurs in Castelseprio, is unknown before the Middle Byzantine period. This statement must be corrected: the two scenes, separated by a rock, are found together in one field in the mosaic in the oratory of John VII, which is known to us through old drawings (Fig. 20);[46] they are joined also, but without the rock, in Carolingian manuscripts from Tours—the Prüm Gospels and the Sacramentary of Marmoutiers in Autun.[47] In the latter, the angel, with a long wand, flies above the shepherds, and there is a great star in the sky. In the Drogo Sacramentary the Nativity, the Bathing of the Infant, and the Shepherds appear together in one initial, although without angel or rock.[48]

In discussing the types of the two shepherds, Weitzmann overlooks some early examples that resemble Castelseprio: on one of the Monza phials is the old shepherd, bearded and bald, lying on the ground;[49] on the Adana encolpium are two shepherds, one standing and one on the ground, as in the fresco.[50] The reclining shepherd with his arm bent over his head recalls the description of a reclining servant in a painting of about 500 in Gaza described by Procopius;[51] a reclining shepherd with raised, bent arm is represented in the Annunciation to the Shepherds beside the Nativity on a Carolingian ivory in the South Kensington Museum,[52] which probably reproduces an Early Christian model.

Before leaving the Nativity, I wish to discuss a small detail, ignored by Weitzmann, but of great interest for the problem of the frescoes. In the bathing scene, the arms of the cross at the Child's head project beyond the translucent nimbus (Fig. 2), as if issuing from its edge or from behind the nimbus. Grabar has observed that this is an un-Byzantine feature found also in Carolingian and Ottonian art.[53] It occurs, however, in the Cotton Genesis, a Greek manuscript of about 500,[54] and there is a variant form—the cross with a double traverse

Fig. 19 Brussels, Musées Royaux d'Art et d'Histoire: Ivory carving from Genoëls-Elderen. Annunciation.

Fig. 20 Vatican City, Biblioteca Vaticana: Ms. Barb. XXXIV. Destroyed mosaic of Oratory of Pope John VII, after a seventeenth-century drawing.

set in the nimbus and projecting from it—in a Byzantine miniature of the tenth century in Athens.[55] In these two Greek examples the cross is a solid, material object; in Castelseprio, as in the early Carolingian examples, it is a thin line, an effect more suggestive of the luminous and emanatory than of the instrument of the Crucifixion. It resembles the rays around the nimbus of the phoenix in Roman and Early Christian art and also certain representations of the sun.[56] In a sermon on the Nativity attributed to an early Christian author, Saint Zeno of Verona, Christ is likened to the sun and the apostles are twelve rays.[57] Was the use of such a cross nimbus in the Nativity perhaps influenced by the apocryphal account of the great light in the cave at the moment of Christ's birth? His halo corresponds broadly to the unusual pattern of the bands of light issuing from the nimbed star in the form of a cross above the scene. But a similar cross nimbus appears on Christ in the frescoes of the Magi and the Presentation as well (Figs. 21, 22, 26), and is therefore not to be explained by a particular episode. An alternative explanation suggests itself: in all these scenes the cross is formed by three rays—one is naturally reminded of the Trinity and one is led to ask whether the form of the cross nimbus, a circle of light from which issue three rays of light, may not have a theological basis. Is it perhaps an attempt to symbolize the divine nature or the Godhead in an image of the human Christ? In the writings of the pseudo-Dionysius the Areopagite, a Syrian mystic (*ca.* 500), the Godhead is often described through metaphors of light and emanation as the "superessential ray," "an originating beam," and "an overflowing radiance," and the persons of the Trinity as emanating essences from an undifferentiated superessence, like "different flames in the same indivisible brightness." God is a light that is multiplied without loss of unity and pours forth without diminution; in heaven, the saved will contemplate his "visible Theophany" amidst "blinding blissful impulsions of His dazzling rays."[58] These conceptions of the pseudo-Dionysius, whose language is so rich in imagery of light, were known in Italy in the seventh century, when his writings were quoted by Pope Martin I (649); in about 758 a copy was sent to Pepin by Pope Paul. Whether the origin of the radiant cross of the halo of Christ had to do with the theological controversies over the dual nature of Christ is a question for investigation. The Roman Council of 649, directed by Pope Martin I with the support of Greek monks and priests, many of them refugees from the East, in opposition to both the Monophysites and the discreetly orthodox Byzantine emperor, accepted as a dogma the doctrine of dyothelitism or two wills and two operations in the incarnate Christ—a sharpened distinction between the human and divine natures, designed perhaps as a means of extending the influence of Rome in the Eastern church.[59] In this controversy the intellectual leader of the Dyothelites was Maximus Confessor (d. 662), the greatest Greek theologian and philosopher of the century, a

Fig. 21 Castelseprio, Sta. Maria: The Magi.

disciple and commentator of the pseudo-Dionysius in other matters as well and, with the latter, the chief source of the great Carolingian thinker, John the Scot (Eriugena), who translated both Greek authors, aiming like them at a suprarational knowledge of God through theophanies and divine illumination.

Adoration of the Magi (Figs. 21 and 26): Weitzmann admits that the type of Magi, with their Persian costumes and their grouping in depth, is pre-iconoclastic, that the seated Joseph has a unique parallel in an Early Christian ivory—the cover of the Etzschmiadzin Gospels—and that the isolation of this subject as a separate scene is rare in Middle Byzantine art, where the Magi are usually part of the Nativity. Of the Virgin elevated on a rock above the other figures he knows only the example on the door of Sta. Sabina in Rome (*ca.* 500); but he observes that her seat is raised on a podium rather than on a rock and is therefore not a true parallel to the fresco. This podium looks to me like a stratified, stepped rock formation. If Weitzmann then proceeds to mention as a more relevant parallel the Virgin sitting on a rock in the Menologium of Basil II (975–1024), where she is on the same level as the Magi, I may be allowed to cite an Early Christian sarcophagus in Arles[60] where the Virgin sits similarly on a rock in this scene.[61] (Weitzmann states that "in early Christian times the Virgin always sits either on a throne with a back or at least on a chair," p. 60.) But equally important is the elevated Virgin before the Magi in the Drogo Sacramentary[62] and in a Carolingian ivory[63]—in the latter her throne is set on a rock. As an evidence that the conception of Castelseprio, with the Virgin in a landscape and with an architectural setting, existed as a separate theme at a time when the Magi still wore the robes of the Early Christian period, there is the fine drawing in a Homiliary of 1072 in Monte Cassino;[64] here the Magi still wear their archaic Persian hats and robes and are grouped in depth as in pre-iconoclastic examples. If copied from a Byzantine work, this drawing preserves a very old model which is one of the closest of all I have seen to Castelseprio. The architecture and trees of the fresco are no Middle Byzantine insertions; they appear in this subject on early Western sarcophagi.[65] Also common in Early Christian art in the West is the movement of the second Magus, who turns his head to speak to the third.[66] Besides the mosaic of the oratory of John VII, there are examples on sarcophagi in Ravenna and Tolentino,[67] and in ivories in Florence, Milan, and London.[68]

I note here that the unusual headdress of the Magi in the fresco is based on Iranian costumes of the late Parthian period. The high hat has a vertical ornamental stripe, and a slender band or strap hangs from the lower edge along the side of the face down to the jaw. Related forms can be seen in portraits of Parthian kings on their coins.[69] The last ruler to wear such a headdress is Ardashir I, the founder of the Sassanian dynasty (A.D. 226);[70] he abandoned it soon for the tiara with the mural crown. The high hat worn by attendants in

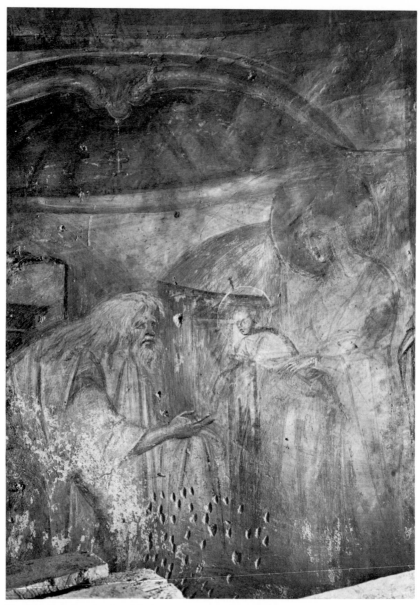

Fig. 22 Castelseprio, Sta. Maria: Presentation in the Temple.

later Sassanian images lacks the ornament and the hanging strap. The conception of the Magi's hats may go back then to an original work of the third century A.D.

Presentation in the Temple (Fig. 22): The painting seems to represent not so much the Presentation, which requires an altar, but the Hypapante or Purification of the Virgin and the Meeting with Simeon in the Temple.[71] Yet the gestures agree better with a Presentation. The setting is clearly an interior, a great apsidal space with a conch and two openings. Weitzmann explains these openings of the niche as "remnants of a stage architecture" which the painter "associated with the idea of an apse of a church, in spite of the openings in the wall which are irreconcilable with a church building." There may be some elements of stage architecture here, but openings in an apse are a well-known feature of Early Christian basilicas, especially where these adjoined a martyrium, to which direct access from the apse was necessary. A lampadarium in the shape of a basilica, once in the Basilewski Collection, reproduces an apse with three large openings; and an actual example survives in the church of St. George in Naples.[72] There were also openings in the apse of Sta. Maria Maggiore in Rome leading to a kind of gynecaeum. One should consider, too, the possibility that the painter in Castelseprio had in mind the openings of the choir space before the apse. But whatever the ultimate origin of the setting, it is probably no insertion of the tenth century, for a similar niche space with two openings and a conch serves as the background of the Wedding at Cana in the fresco of Deir Abu Hennis.[73]

Weitzmann would also derive from Middle Byzantine practice the two figures, probably the Virgin and angel of the Annunciation, painted on the spandrels of the niche. But their history may be traced far beyond the tenth century—beginning with a Greek page of the Nativity in Berlin (already mentioned *à propos* of the type of Joseph), which Weitzmann in another book has judged to be a work based on old models (it has uncial writing of the ninth or tenth century);[74] in a Carolingian manuscript of the Ada school;[75] in the still older figures in the spandrels of Syriac canon tables of the sixth century; beyond these, in the spandrel figures in the Calendar of 354;[76] and earlier still, in the frescoes of the synagogue of Dura (A.D. 245) where Victories stand at the haunches of a doorway arch.[77]

A detail of this setting in Castelseprio that has yet to be investigated is the little cross that hangs from the conch, an unusual element which might help us to date the work. Although the suspension of the cross in the apse is more typical of the pre-Carolingian period—the standing cross replaces it after this time—there is evidence that the older practice persists as late as the eleventh century.[78] The cross in Castelseprio, though faintly preserved, resembles in its type and proportions the cross of Adaloald in the Monza treasure,[79] perhaps

more closely several crosses of the eighth century, among them examples in Italian stonework.[80]

Also unusual are the steps behind or beside Simeon, but without an altar. They occur in the same scene, again without the altar, in a Byzantine portable mosaic of the fourteenth century in Florence.[81] From how old a model this feature derives is uncertain. We may refer to a similar structure in the scene of an apostle baptizing in Paris gr. 510.[82] The type in Castelseprio suggests the stepped sanctuaries and altars of the Old Orient, particularly in Asia Minor.[83]

Another rare detail in this subject is the conception of Simeon with one hand uncovered. Weitzmann considers this altogether un-Byzantine; but Mrs. Dorothy Shorr, in her valuable study of the Presentation, has reproduced an example from Karahissar Gospels in Leningrad (*ca.* 1265).[84] There is also a parallel in Carolingian art; in the Drogo Sacramentary[85] the right hand of Simeon appears to be unveiled. The singularity of this detail in Castelseprio will seem less significant, perhaps, if we observe that it occurs in other subjects. In a mosaic of the eleventh century in Hagia Sophia, Justinian offers the church to the Virgin and Christ with one veiled and one bare hand. It is common in Italian art of the sixth century to represent figures offering objects to Christ, or simply holding them in Christ's presence, with one hand unveiled. The books are held in one veiled hand on the Maximianus Throne and Justinian presents the gold vessel similarly in S. Vitale, and the angels beside Christ in the Codex Amiatinus (*ca.* 700) carry a scepter or wand in the unveiled hand.[86]

For the Middle Byzantine character of the whole scene, Weitzmann reproduces (his fig. 68) a miniature of *ca.* 1300 in a Greek-Latin Psalter from Cyprus (Berlin, Kupferstichkab., Cod. 78 A.9, fol. 265r) as decisive evidence. There Anna stands behind a block, a sort of repoussoir in the foreground, as in Castelseprio; the gesture of the Child, extending his hand to Simeon, is also like that in the fresco. This is an exciting discovery, especially since the manuscript is a psalter of the so-called monastic-theological type in which one has tried to distinguish various historical strata, before and after iconoclasm. Weitzmann thinks this miniature must be copied from a tenth-century model. But why not from a model that in turn repeats a type of the sixth or seventh century? Such repoussoir blocks occur in the Joshua Roll and the Octateuchs, not as fresh insertions but as elements taken from an older model; the motif is already awkward and misunderstood in the Joshua Roll, where Joshua emerges from behind a two-story building.[87] The fact is that we do have older examples. A woman stands behind such a block in the Samson page of Paris gr. 510,[88] and there is an example in the miniature of Lot and his daughters in the Vienna Genesis.[89]

Weitzmann finds another evidence of Middle Byzantine taste in this fresco in the extraordinary position of Anna's right arm, "placed under her

chin," and explains it as a sacrifice of the original prophetic attitude for the sake of a classic gesture (p. 63). If this is so, we must assume that the sacrifice had already occurred before the tenth century, since Anna, standing behind Simeon, makes a pensive gesture in the Utrecht Psalter (Fol. 89v) where the Child also extends his hands to the priest. But in a later chapter, Weitzmann describes the gesture of Anna differently: "The right arm is wrapped in a cloak and hidden so that it becomes clear that she is not speaking but merely contemplating Simeon's testimony. . . . It would seem to have been deliberate on the part of the Castelseprio artist to represent her not in the attitude of uttering a prophecy" (p.74). This was necessary because "her prophecy refers to the redemption of the world" rather than to the doctrine of the Incarnation, which Weitzmann thinks is the underlying thought of the entire cycle.

There remains a last theme, the angels and the throne above the arch of the apse, a more obviously symbolic, ceremonial subject (Fig. 1). Weitzmann observes that the attributes on the throne—the cushion, the cross, the imperial purple robe, and the crown—resemble the fifth century mosaic of Sta. Maria Maggiore; but he does not evaluate this similarity or reconcile it with his view that the frescoes, in the conception of their subjects, are closest to Middle Byzantine art; nor does he undertake to study this painting as he has studied the infancy cycle.

Let us note first of all that in Sta. Maria Maggiore the throne surmounts an arch of which the sides are decorated with scenes from the infancy of Christ, as in Castelseprio. In the latter, two angels beside the throne offer globes and scepters in homage. These flying figures recall the paired flying angels on sarcophagi, ivory book covers, ampullae, and mosaics of the sixth century, who carry a medallion with a cross or a bust of Christ; but they resemble most of all the flying angels with scepter and orb on the arch mosaic of St. Catherine at Sinai, a work of the same century.[90] The scepter and globe are attributes of the Byzantine emperor; in Castelseprio the homage to the symbolic throne of Christ, with the crown and the mantle, confirms the imperial sense of the whole image. The representations of the Byzantine rulers on their coins permit us to identify the particular combination of scepter and globe in the fresco with emblems on the coins of Justinian and Justin II (*ca.* 570);[91] the globe held by the ruler is surmounted by a simple cross as in the fresco and the scepters are of the same knobbed type. We observe this kind of globe-with-cross in the ivory carving of an empress of the early sixth century,[92] and the often illustrated archangel on the ivory in the British Museum bears a scepter and globe precisely like those of the fresco. In later art the scepter is enriched at the ends, and the cross acquires a second traverse or is transferred to the surface of the globe, or is omitted altogether. We can follow the history of these types in mosaics and paintings which have preserved the theme of the archangels

flanking Christ or the Virgin. In Byzantine art after the sixth century, they generally stand rather than fly, they wear a courtly costume, the scepter is sometimes replaced by a standard, and the forms of scepter and globe are changed as I have indicated. Examples of the later types are the mosaic of Chiti in Cyprus which is now attributed to the pre-Moslem period (i.e., before *ca.* 640),[93] the mosaic of Nicaea (late eighth century),[94] and numerous examples in the frescoes of Cappadocia.[95] Besides these works, the version in Castelseprio seems to be the earliest of all; if isolated from the other scenes, it would suggest a date in the sixth or seventh century. The form of the crown on the throne— a diadem band with two rows of jewels—and the surprisingly simple, unimperial step throne would support this dating. Since the crown is not worn by an historical figure—as in Paris gr. 510, where the miniatures reproducing models of different periods practically illustrate the history of the Byzantine crown—it is more likely to represent a contemporary type.[96] But Castelseprio is far from an imperial center, and we must allow the possibility that simple forms and perhaps local Italian forms persisted for centuries. A throne of equal simplicity, without a back, and limited in its decoration to a few jewels at the base, is represented on the silver cover of the enameled cross in the Sancta Sanctorum in Rome, a work of the early ninth century.[97]

What seems to me a strong indication of a limiting date and also a sign of the Western context of the whole work are the transverse clavi on the angels' thighs.[98] A frequent element in early Carolingian art, above all in the Ada School[99] and in the Italian art[100] of that period, yet exceptional in Byzantine painting, they point to a time not before the second half of the eighth century— if we can trust our scanty knowledge of the history of costume. The development of this decorative detail of costume, a segment of a finer material sewn on to the robe—it might at times have possessed a symbolic value as a sign of status or rank—may be reconstructed from representations since the first century A.D., beginning in the Greco-Syrian world. In Dura and Palmyra an H-shaped segment is applied at the knee or diagonally across the side of the robe;[101] but on figures painted in the temple of Zeus Theos in Dura,[102] it is placed transversely on the thigh—without spanning it, however, as in Castelseprio and in Carolingian art. This example in Dura seems to be the remote ancestor of a type we find in the early eighth century in Sta. Maria Antiqua (St. Quiricus in the chapel of Theodotus),[103] where two prongs from a rectangular segment on the side of the thigh end in little knobs or roundels, or a single knob is attached to each of two paired rectangular segments (St. Peter in the same painting, Isaiah in the earlier fresco of the story of Hezekiah).[104] The latter type, which is like the *paragaudae* applied in Byzantine costume at the breast and waist and lower hem, enters Carolingian art most probably from Italy. It should not be confused with the simple rectangular bands extending

across the thigh (sometimes in pairs), although they occur together in the same Carolingian works (the Stuttgart Psalter,[105] an ivory pyxis in the British Museum[106]), like different historical strata preserved by a copyist. In Carolingian art it is more common in the East Frankish schools, which seem to depend on the most recent Italian art; but it appears also in the original mosaic of the apse of Germigny-les-Près, paired on the angels' thighs.[107] Its occurrence on the costumes of the Lombard kings in the illustrated manuscript of Lombard Laws (La Cava, Badia Ms. 4),[108] although foreign to Byzantine and Carolingian imperial costume, suggests the possibility that it arose in Lombardy as a provincial adaptation of the appliqué borders on Greek costumes to the region of the thigh, where segments of another shape had been applied before.

Two interesting exceptions to this account must be noted: (1) a figure in the fifth- or sixth-century fresco of S. Paolo f.l.m. in Rome, as preserved in a drawing of the seventeenth century,[109] and (2) the painting of a nun in a late Cappadocian fresco at Karabach Kilisse.[110] Since the detail is unique in the Roman cycle, we may ask whether this figure of Moses is not perhaps a restoration made after the earthquake that destroyed the roof and damaged much of the church in 801. Moses' staff has a curved end in this scene, although perfectly straight in the others. The example in Karabach may represent a fashion in costume of the region in the thirteenth (?) century, which had no effect on religious narrative representation.

* * *

Having considered the scenes separately, Weitzmann tries to account for the series as an ordered whole. While d'Arzago interpreted this whole as a "theophany-vision" like the early cycles in the Palestinian martyria, the single scenes being divine manifestations or witnesses to the holy person, Weitzmann believes that in Castelseprio the directing concept is the dogma of the Incarnation for which the various episodes provide witnesses. The difference from d'Arzago's view is not altogether clear to me. Weitzmann asserts that "the leading dogmatic idea behind the program" is an evidence of the origin of the cycle in the tenth century and in Constantinople, as if this dogma were restricted in time and place. But he refers to no contemporary theological texts that speak of all these subjects as evidences or witnesses of the Incarnation. Several of the episodes come from the apocryphal gospels of James and the pseudo-Matthew (which is preserved only in Latin) rather than from the Evangels, and this fact should be considered in any interpretation. Even if the dogmatic idea construed by Weitzmann were the basic factor in the conception of the frescoes, it would hardly be adequate for characterizing the religious standpoint of those who selected the subjects or conceived the details. The importance of the intimate human elements, and particularly those drawn from

the apocryphal writings, would remain untouched by the dogmatic explanation. What does this combination of the vulgar-apocryphal and the canonical in the images of Castelseprio mean? To what phase of religious and social development does it correspond?

Weitzmann does refer to George of Nicomedia as an example of a homilist who uses apocryphal matter in his sermons; but this author wrote about 860, before the Macedonian period. The proto-Evangel of James rather than the pseudo-Matthew is his source, and not because his taste is too austere for the more fanciful elements in the pseudo-Matthew, as Weitzmann supposes. In Krumbacher's history of Byzantine literature, George's depiction of the story of Mary has been characterized as "unconstrained in fantasy."[111] I may add that the proto-Evangel of James was used in the preceding century by another Byzantine homilist, Epiphanius (*ca.* 780), who in his sermons on the Virgin tells the story of the doubting midwife at the Nativity.[112]

Important, too, for the origin of the frescoes is the history of the cycle as a whole and of the choice of just these themes for the decoration of an apse. On this, Weitzmann has little to say. It is a choice foreign to Middle Byzantine monumental painting and mosaic, though it occurs in Cappadocia on vaults and side walls, and would be out of place in a Byzantine apse of that period. But scenes from the life of the Virgin and the infancy of Christ do appear in frescoes of the sixth and seventh centuries in Bawit and Deir Abu Hennis in Egypt, about 705 in the oratory of Pope John VII in Rome, and in the seventh century in the apse of the Red Church of Perustica,[113] near the ancient Philippopolis, in Bulgaria. In the latter, they are associated with an Hetoimasia and with busts in medallions, as in Castelseprio. About 680, according to Bede, a series of pictures of the Virgin and the infancy of Christ was brought to Wearmouth from Rome—probably as models for wall decoration. In the early ninth century, an infancy cycle of ten scenes decorated the church of St. Gall, not far from the Italian frescoes.[114] The use of such themes in the apse continues in the West into the twelfth century; several examples survive in Catalonia.[115]

The reader will have noticed how many details and aspects which Weitzmann regards as exceptional, or foreign to the early period, or typical of Middle Byzantine art, occur in Carolingian and Italian works. One cannot overlook the resemblances to Roman painting about 700 and before, and to the art of the Rhineland and Northeastern France in the late eighth and early ninth centuries. Although the frescoes have been attributed to a Greek painter by the Italian scholars as well as by Weitzmann, they could only have been done in the West and probably in Italy. The fact that the inscriptions are in Latin is only one element in the Western aspect of the frescoes. The Italian editors have assumed (and Weitzmann agrees) that the Latin inscriptions

betray a Greek author in the words ZYMEON and EMEA (for H MAIA); but this conclusion is not rigorous. The Z for S before a vowel is a common North Italian phenomenon[116] and the fusion of noun and article in EMEA is as likely to be the act of an Italian as of a provincial Greek. The forms of the letters can all be matched in Latin writing; it is their accomplished character, the quality of the strokes, that suggests an early Greek script. D'Arzago was mistaken in assuming that after the fifth century uncial Є's (and other uncial capitals) must be due to a Greek influence; they are found in too many Latin inscriptions of the sixth to the tenth centuries, as well as in manuscripts, to warrant this assumption.[117] Greek inscriptions are common enough in Italian frescoes of the seventh and eighth centuries in Rome, and Greek letters are sometimes used among the Latin.[118] In Castelseprio, however, all the forms are native. A Greek artist might have used the C (sigma) for S in writing the name of Joseph and the P (rho) for the R in MARIA; such is not the case in our frescoes.

Between the seventh and ninth centuries, there was a great influx of Greeks and Syrians who took up permanent residence in Italy. The line of Eastern popes in Rome is the most familiar evidence of the power of this immigration. The Greek monks had their own quarter in Rome; they founded new monasteries, built churches and held important posts in the Roman hierarchy.[119] They were active also in the North and particularly in Lombardy.[120] We can hardly doubt that they were a powerful factor in bringing Eastern forms to the West in the seventh and eighth centuries.

Yet if the artist of Castelseprio was a Greek or Syrian, he was no newly arrived immigrant, but one who was already rooted in Italy and had assimilated some native traditions—to judge by the various elements that seem characteristically Italian and Western.

In reviewing the Italian publication on Castelseprio (*Magazine of Art*, December 1950), I suggested that the frescoes were an example of a current of Byzantine art in Italy which was the immediate starting-point of Carolingian painting during the last decades of the eighth century. Otherwise, we would have to explain the sudden appearance of illusionistic painting and of complex figure and drapery forms in the Palace and Ada schools as a revival by unpracticed German artists of a much older Mediterranean art that had died out in the South. If these Northern artists simply copied Greek and Syrian and Roman works of the fifth and sixth centuries, it is astonishing that they achieved a more faithful illusionistic quality than did the Greek painters of the tenth century, who are believed to have revived early models of about the same time. It seems to me improbable, however, that Northerners, trained in the schematic, ornamental styles of Merovingian and Hiberno-Saxon art, could assimilate the classic forms as fully as they did in the Schatzkammer Gospels,

the Leyden Aratus, the Vatican Terence, the Utrecht Psalter, the Drogo Sacramentary, the Madrid astronomical codex (3307), and in the many wonderful ivory carvings of the same period, unless they were taught by Southern artists who possessed at least to the same degree as the creators of these Carolingian works the technique and style of the models. It is hard to imagine the Frankish scribes undertaking to write uncial letters in gold on purple without instruction from experienced teachers; the technique is too risky for a self-taught hand, relying simply on the example of an ancient model. The artists of the Ottonian period who copied Carolingian, Early Christian, and contemporary Byzantine works—and their starting-point was a style more advanced than the Merovingian and Hiberno-Saxon—achieved a style much less illusionistic and classic in aspect than did the Carolingians; we must assume that the latter were in closer touch with classic forms and with artists who could transmit directly the methods of such an art. The name "Demetrius presbyter" inscribed in the Schatzkammer Gospels, together with the fact that the portraits of the Evangelists in this manuscript are unaccompanied by their symbols, has suggested to scholars that a Greek painter was the author of the surprisingly classic miniatures of this book. But although this would be a confirmation of the view proposed here—for it asserts the existence of such an art in the Greek world, where nothing of that kind has survived from the same period—I must say that the name is not evidently the painter's. It is an addition on the margin of the text, in no clear connection with the miniatures; I see nothing Greek in its script, which is by another hand than the text.[121] Besides, the style of these paintings, as of the ornament of the canon tables (and this holds for other manuscripts of the school), is more Italian than Byzantine. There is in the heads of the Evangelists, particularly of Matthew and Luke, something decidedly German.[122] The parallel work of the Ada school, less illusionistic but more complicated in posture, surface, and line, points to Italy as well, though to another stream in Italian art, also influenced by Eastern models.

We may assume, then, either a revival of the classic styles in Italy in the generation before about 780—and this might be connected with the iconoclastic controversy and the flight of Greek monks to Italy in the 760s, a view already expressed by Goldschmidt—or a persistent, if uneven, tradition of classic forms in Italy throughout the eighth century, which does not exclude a recurrent stimulus, especially in the last decades, from Byzantium. The close relationship of the frescoes of Castelseprio to the models of a later Constantinopolitan art— the Joshua Roll and the Paris Psalter—suggests a Byzantine rather than Syrian or Alexandrian source, although this, too, is uncertain. We have so few Italian works of this time, particularly in miniatures and outside Rome, that we can learn little from them about the art of the eighth century.

Luckily there survives in Italy a considerable cycle of frescoes of the ninth

century that indicates the existence in the preceding generations of a strong fresco art related to Castelseprio and the new forms in the North. The paintings of S. Vincenzo al Volturno are dated between 826 and 843 by the inscription that names the Abbot Epiphanius who is represented at the Virgin's feet. We cannot see the angel of the Annunciation[123] (Fig. 23) without thinking of Castelseprio; he has much of the sweep and force of the angel who addresses the sleeping Joseph in the latter, though the forms are more schematic (Fig. 14). In the background of the martyrdom of Lawrence[124] are foreshortened twin portals with a stilted rectangular opening above a paired column and pier, a typical motif in Castelseprio that I have already mentioned. There is also in S. Vincenzo an unexpected personification of Jerusalem in the scene of the Crucifixion, a crowned woman sitting on a rock in the landscape.[124a] We could not derive these elements from what we know of Italian painting of the seventh and eighth century; nor could we understand their existence in Volturno if we accepted Weitzmann's premise that such forms and types are inventions of the tenth century.

From Northern Carolingian works it is possible, I believe, to infer the existence of an art like that of Castelseprio in Italy during the seventh and eighth century. The Utrecht Psalter, for example, is based not simply on a work of the fourth or fifth century, but presupposes some intermediary Latin model that included the advanced iconographic types of the Nativity and the Anastasis which belong to the period about 700 or after.[125] The Stuttgart Psalter offers an extraordinary number of details of architecture, landscape, costume, and figures related to Castelseprio, although the style has lost the fluid atmospheric qualities of the frescoes. Certain buildings represented in the Psalter, with their horseshoe arches and paired windows,[126] seem to come from the same architectural tradition as the Lombard chapel. I had supposed before the discovery of the latter that the model of the miniatures of the Stuttgart Psalter was a work of the seventh or eighth century from the Milanese region. The initials[127] contain traces of Byzantine art which may be paralleled in Italian manuscripts of the eighth century.

Also interesting for the relation of Carolingian to North Italian art is the fine ivory book cover in the Bibliothèque Nationale in Paris,[128] with the Annunciation, the Magi, and the Massacre of the Innocents (Fig. 24). The action, restless and intense, takes place before an elaborate architectural setting; a tree emerges from one portico as in the Journey to Bethlehem in Castelseprio. The conception of the Massacre as a smashing of the innocents—this occurs also in the Stuttgart Psalter and in the Bodleian ivory—points to Milan. The Carolingian works that represent the scene in this way have been derived by Baldwin Smith from Provençal models, but Milan seems to me a more likely source.[128a] Unfortunately, we have little from Milan during the seventh and

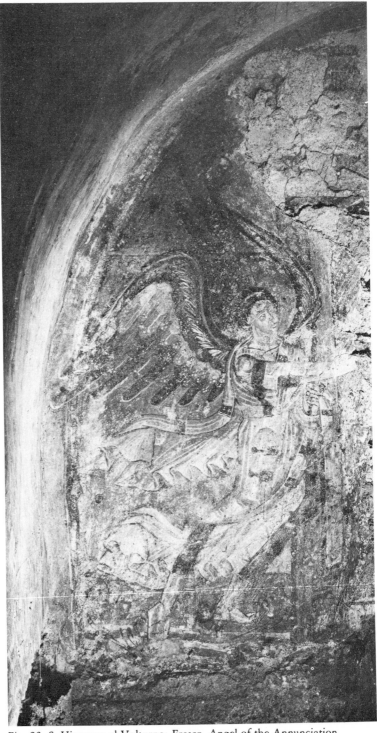

Fig. 23 S. Vincenzo al Volturno: Fresco. Angel of the Annunciation.

Fig. 24 Paris, Bibliothèque Nationale: Ms. lat. 9393, Ivory Book Cover.

eighth centuries. Yet one should not forget its great importance as the religious capital of Lombardy and as Charlemagne's center during his visits to North Italy, nor the evidences of its Greek culture. A psalter of the ninth century from S. Ambrogio was written there in Latin and Greek (Berlin, Staatsbibl., Hamilton 552).[129] Pavia, too, the seat of the Lombard kings, was a considerable center in the eighth century. Here were Paul the Deacon and Peter of Pisa, who had a notable influence on the culture of the first Carolingian generation in the North. The position of Castelseprio in the foothills of the Alps, on a road between Milan and the North, may be significant for the problem of the frescoes. Very close to this site is Olona, where the Lombard king, Liutprand, had a palace; the adjoining royal church of St. Anastasius was enlarged toward 730 and decorated with mosaics. The study of the local history during the eighth and ninth centuries, especially of the Carolingian relationships, if undertaken with the same thoroughness that Bognetti has applied to his account of this Lombard region during the seventh century, will perhaps bring us nearer to a solution of the Castelseprio problem.[130]

II

Notes on Castelseprio

(1957)

1. The Three-Rayed Nimbus

In an article in *Cahiers Archéologiques* (VII, 1954, pp. 157–159), Professor Grabar writes that in citing his observation of the peculiar symptomatic cross nimbus in the frescoes of Castelseprio, with the lines of the cross extending beyond the circle of the nimbus, "M. Schapiro a pensé pouvoir en réduire la portée en joignant aux exemples carolingiens et ottoniens de ce genre de nimbe crucifère deux exemples byzantins." He goes on to argue that these two examples are not at all relevant to the problem, for in one case—the Cotton Genesis (Fig. 25)[131]—the arms of the cross are broad bands and not thin lines as in the frescoes (Fig. 26), and in the other case—Athens Ms. 211, a work of the tenth century—there is not even a cross nimbus, but rather a candlestick in the form of a cross, independent of the nimbus and illustrating a sermon of St. John Chrysostom (Fig. 27).[132] Hence the detail at Castelseprio remains a Western peculiarity and an evidence of the late date of the frescoes, since it is found in this form only in Carolingian and Ottonian works.

I hope this detail will not seem too small and unimportant to warrant further study and the reader's attention; and I hope I shall be forgiven if I take this opportunity to restate my views on the subject of Castelseprio.

Although Professor Grabar links my name with Morey and Bognetti as proposing dates "sensiblement plus anciennes que l'époque carolingienne," the conclusion of my article was precisely that the fresco cycle could not be of the seventh century, as Morey and Bognetti believed, since it contains elements which are first known to us in the art of the Carolingian period. I regarded the type of cross nimbus as one of these elements, and in citing the two Greek examples I distinguished their form from the more specifically Western type of Castelseprio and the Carolingian parallels. I proposed further the view that the frescoes, though based on Byzantine art, were not of the tenth century, as Weitzmann and others maintained, but belonged rather to the second half of the eighth century at the earliest and probably to the late eighth century, because of the relations to early Carolingian art and to Italian works of the end of the eighth and the early ninth century.[133] This connection with the art of the Carolingian period I had already remarked in reviewing the book of Bognetti and de Capitani d'Arzago in 1950.[134]

In contrasting the form of the cross nimbus in the Greek and the Western examples, the first with a "solid, material" cross, the second with "a thin line

Fig. 25 Paris, Bibliothèque Nationale: Ms. fr. 9530, seventeenth-century copy of the destroyed miniature of the Cotton Genesis (London, British Museum: Cotton Ms., Otho B. vi). Creation, The Third Day.

Fig. 26 Castelseprio, Sta. Maria: Drawing after fresco. Adoration of the Magi.

[of the cross], an effect more suggestive of the luminous and emanatory than of the instrument of the Crucifixion," I wished also to offer an hypothesis to explain the distinctive features of the cross nimbus in the frescoes. I supposed that the three ray-like lines, resembling the rays issuing from the nimbus of the phoenix and the personified Sun in Roman and early Christian art, symbolized the emanatory aspect of the divine being, the threefold Godhead as a "superessential ray," "an originating beam," "an overflowing radiance"— metaphors found in the writings of the pseudo-Dionysius. But such imagery was not peculiar to this Greek writer; the underlying idea was common enough and had been expressed earlier and in a manner more pertinent to the frescoes by a Latin author, Tertullian, in speaking of the Logos and the Incarnation: "When a ray is projected from the sun it is a portion of the whole sun; but the sun will be in the ray because it is a ray of the sun; the substance of the sun is not separated but extended, as light is kindled from light So from spirit comes spirit, and God from God This ray of God, as had always been prophesied before, descended into a Virgin and having been incarnated in her womb was born a man-God" (*Apologeticum* xxi. 12–14).

Philo in the first century had already written of the Logos as "the radiant light of God"[135] and in the New Testament the Son is described as "the brightness of God's glory" (Hebrews i, 3). In the controversies during the fourth century over the consubstantiality of the Father and the Son, the relation of the ray to its source was the most cogent example of emanation and of distinct forms with a common substance.[136] Writing of the Trinity in the symbolic decoration of the church of Hagia Sophia, the poet Corippus exclaimed: "Subsistite, numina fulgent! Natus, non factus, plenum de lumine lumen."[137]

In the background of these theological metaphors was also the conception of Christ as the true Sun, replacing the pagan solar gods.

The heavy arms of the cross, in the two Greek examples I had cited, did not seem to me relevant to this explanation, although they extend, like the rays at Castelseprio, beyond the circle of the nimbus. But after reading Professor Grabar's comments on my article, it occurred to me upon further study that the massive crosses in the Greek examples also originated in a metaphor of God as light and that both types of cross nimbus—with broad or with thin ray-like arms extending beyond the circle—go back to early Christian models.

Grabar has observed that in the Athens National Library Ms. 211 the miniature showing a bust of Christ with three arms of a cross reaching beyond the nimbus (Fig. 27) renders very precisely the words of a sermon by St. John Chrysostom on the parable of the ten drachmas (Luke xv, 8–10). Christ, according to Grabar, is the tenth drachma and is held by Adam in a lamp; the other nine are the accompanying angels. The bust of Christ with the double

Fig. 27 Athens, The National Library: Ms. 211, Homilies of St. John Chrysostom, fol. 34v. The Tenth Drachma.

Fig. 28 London, British Museum: Engraved gem. Crucifixion.

traverse cross behind him illustrates the words of the homilist for whom Christ is the Divine Wisdom "which lights the lamp and placing it in the lampstand of the Cross, bears the light and leads the whole world to piety." Christ "comes from heaven, takes the clay lamp which is the body, lights it with the light of divinity, and sets up the candlestick of the cross." What I had taken to be a cross nimbus is therefore, in Grabar's opinion, quite another thing; the cross, symbolizing the candlestick and rendering literally the text of the accompanying sermon, "has nothing to do with the cross nimbus."[138]

I am not convinced by Professor Grabar's interpretation. Is not the tenth drachma Adam who holds the lamp?[139] And is not Christ the light by which Adam, the lost drachma, is found? In identifying the cross of Christ with the lampstand (*lychnia*) that bears the light, the author of the sermon describes a familiar object of his time: a candelabrum or stand in which the light is set above a cross.[140] The artist of the Athens manuscript, or perhaps the painter of his model, had another type of light in mind: one in which a cross surmounts a lamp.[141] The thought underlying this early Christian type is often expressed in the Greek phrase inscribed on the lamp: "The light of Christ shines for all."

In the Athens miniature the bust of Christ as well as the cross issues from the lamp in Adam's hand. The question is whether the cross here also belongs with the nimbus as an attribute of Christ or only symbolizes the metaphorical lampstand (or candlestick) of the homilist. If the latter were the case, it would be hard to understand why the cross should be set above rather than below the lamp and why the horizontal arms should extend beyond the nimbus; they scarcely look like parts of a stand or candlestick, and in any case the combination of lamp and candlestick seems strange. When the artist wishes on the same page to represent a candle in the hands of the angels, he draws it clearly enough, and where he wishes to depict a cross distinct from the nimbus, as in his drawing of the Holy Spirit on another leaf, the cross is set behind rather than within the nimbus, in passing beyond it.[142] Grabar interprets this cross as an actual metal object placed on an altar; but he ignores the material prototypes of the lamp in the miniature of the tenth drachma.

Is it not more plausible to suppose that the artist, in order to symbolize the illumination by Christ, "the light of the world," the "lucerna ardens et lucens" (Augustine), and to render the homilist's image of the cross as the lampstand or candlestick, has condensed the chain of metaphors in a cross nimbus of decidedly radiant aspect? The color reinforces this effect: the nimbus, the cross, and Christ's apparel are all painted yellow.

That light could be represented in this more solid form and even with a thickening of the rays or bands at the outer end is confirmed by the image of Helios in the recently discovered ceiling mosaic in the pre-Constantinian mausoleum underneath St. Peter's in Rome (Fig. 29).[143] The seven purplish

rays, forming massive bundles, extend beyond the halo as in the Cotton Genesis and the Athens manuscript.

But even without the testimony of this mosaic, one could have surmised the possibility from other works.[144] There is one especially, in which the connection of the cross with solid bands of emanating light is perfectly clear: the mosaic of the bema of the church of the Dormition at Nicaea.[145] Here eight broad bands of light issue from a cross set on the throne of the Hetoimasia; four of these prolong the arms and vertical members of the cross, the other four issue from the angles. They all traverse three great concentric circles which probably symbolize the Trinity. In the same church the mosaic of the apse repeats the theme of light in a more explicit Trinitarian sense: three rays in the form of bands issue from the hand of God, passing through two concentric circular segments into the semicircular golden space below.[146]

Let us note too that these unquestionable rays of light are of changing color: white, gray blue, and green blue in the first mosaic; rose, gray, and green in the second. Professor Bognetti has objected to the interpretation of the three lines of the cross nimbus in Castelseprio as rays or symbols of light that they are painted in a dark color.[147] This is due, I believe, to the fact that they are set on the light ground of the nimbus. In the mosaic below St. Peter's, as in the later mosaics in Nicaea and in many other works, rays of light are represented in dark tones (gray, blue, green, and purple).[148] Black rays are not uncommon in mediaeval images of the personified Sun.[149] The color of rays varies in mediaeval art just like the color of the nimbus, another symbol of light.

I may point out finally that in Carolingian art the solid cross with arms projecting beyond the nimbus is sometimes formed of parallel linear rays closely aligned.[150]

Hence from the point of view of theological meaning and origin—though not of style—the Carolingian examples of the nimbus with the linear ray cross need not be separated, as I once supposed, from the solid type. Both depend probably on models of the fourth or fifth century—the period during which the solar analogy was common and Helios was represented with rays issuing from the nimbus in the two forms that I have described.[151] The theologically significant choice of the three rays of Christ's halo may be likened to the seven rays of the sun in Mithraic art, also a theological attribute.[152]

The recurrence of the solid emanatory cross in the Creation scenes of the Cotton Genesis agrees with the theology that speaks of the divine light especially in connection with the Creation. In the same miniature (Fig. 25) the nimbus is marked with many small rays, a device that reappears in Carolingian art.

(I have assumed until now that the three rays are parts of the cross and

Fig. 29 Vatican City, St. Peter's: ceiling mosaic of underground mausoleum, Helios.

merely a variant of the "cross nimbus." But the facts presented here suggest another interpretation: that besides the true cross nimbus and monogram nimbus in which all four bars were more or less clearly drawn—as in the mosaics of Sta. Maria Maggiore and on the door of Sta. Sabina[153]—there existed very early a three-rayed nimbus of which the rays were at first conceived less as parts of a cross than as a symbol of the Trinity. In time this emblem was conflated with the cross in the familiar form in which the fourth part is covered by Christ's head. It is a remarkable fact that although Christian art develops from naturalistic to increasingly schematized and symbolic modes of representation and tends to present its symbols as distinct surface forms, the cross in the nimbus remains a symbolic object in real space overlapped and obscured by the head of Christ.)

The tiny stroke at the end of the rays in Castelseprio (and in several other Western works) seems to Bognetti incompatible with the interpretation of the lines as rays.[154] This is hardly a decisive objection since the rays in the image of Helios beneath St. Peter's in Rome (Fig. 29) are thickened at the end. In early Christian mosaics stars are often, if not usually, represented by radiating lines with knobbed ends;[155] this, in fact, is how the painter of Castelseprio has drawn the great star of Bethlehem in the scene of the Nativity. In pagan and Christian works the rays of the sun and of solar divinities end in dots or knobs that might symbolize the stars or planets,[156] a device which survives into the Middle Ages, especially in pictures of the Apocalyptic Woman "clothed with the sun" (Revelations xii).[157] On a medallion of the late fourth century in the Vatican Museum, the emblem of the sun accompanying a head of Alexander the Great is a circle from which radiate wheel-like spokes with short transverse lines at the ends (Fig. 30).[158] This schema for rays of light is not uncommon in Christian art. Similar nail-headed rays appear on the stars in the mosaic of Sta. Agnese in Rome[159] and in the frescoes of Civate and Saint-Savin;[160] they may be seen too in the personification of Day in the Gumpert Bible in Erlangen.[161] The nail-headed form in Castelseprio may therefore be regarded as a variant of an older convention for the luminous cross. Even if the end strokes are derived from a type of cross, the arms extended beyond the nimbus may still be interpreted as ray-like elements which owe their character to the theological metaphor of Christ as light.

I am not at all sure that the cross with projecting arms, whether solid or ray-like, was in every case designed to express the metaphorical luminosity of Christ. In some examples it might have been repeated as a fossilized type without thought of its figurative meaning, much like words of which the original sense has been lost. That the old meaning was still alive in the region of Castelseprio at the end of the eighth century seems evident, however, from the radiant aspect of the cross on the medallion bust of Christ in the Egino

codex, a manuscript of homilies of the Latin church fathers, which was written in Verona between 790 and 799.[162] The three bars of the cross passing beyond the circular frame are formed by bundles of rays. In another Lombard manuscript of the ninth century, the Homilies of Gregory in the Chapter Library of Vercelli (Ms. CXLVIII), an ordinary closed cross nimbus is inscribed LUX, with one letter on each of the three solid members of the cross.[163]

For the problem of the frescoes of Castelseprio—their date, their place in mediaeval art—it does not matter perhaps whether the ray-like form of the cross was conceived explicitly as a symbol of the divine light or was only an inherited convention maintained because of its congenial form. The rendering of the arms of the cross by a rapid stroke reaching beyond the nimbus seems to accord better with the impulsive sketchy style of the artist than would a massive form. In the medallion bust of Christ in the same series, the cross is of the more common type and is confined by the nimbus; but this painting of Christ already suggests another attitude of the artist—he is reproducing an iconic image, frontal and severe, and accepts the conventions of the canonical model which are in principle opposed to the forms of his own art.

Grabar believes, however, that the varieties of the rayed cross nimbus have some historical significance and provide a means of dating the frescoes. In another article in which he deals more specifically with the different types of cross that project beyond the nimbus, Grabar distinguishes not only between the thin and the solid form but also between the thin cross with the terminal stroke, like a nail head, as in Castelseprio, and the thin cross without this element.[164] Carolingian artists knew the latter, but Grabar has found examples of the Castelseprio type only in Ottonian works. He asserts that while Carolingian artists invented the projecting linear type, it was in the Ottonian period that the thin cross first acquired the terminal strokes. From this he concludes that although the painter of Castelseprio was strongly influenced by the art of Constantinople, these frescoes are related to the Ottonian Renaissance and must be more or less contemporary with the Ottonian miniatures in which the same type of cross appears.[165]

This is a surprising inference, since it would bring the date of the frescoes into the second half of the tenth century or even into the eleventh—the Salzburg manuscript which he has cited as the Ottonian parallel (Morgan Ms. 780) was made about 1070. Elsewhere he has spoken of the frescoes as works of the ninth century, and has admitted the possibility of a still earlier date in the Carolingian period.[166]

But it is unnecessary to go beyond his article in order to criticize his reasoning or the fluctuation in his dating of Castelseprio. For precisely this form of the nimbed cross with the nail-head ending of the rays occurs in

Fig. 30 Vatican City, Vatican Museum: Bronze medallion of Alexander the Great.

Fig. 31 Düsseldorf, Landesbibliothek: Ms. B 133.

Carolingian manuscripts: the Stuttgart and Utrecht Psalters, a fragment now in Düsseldorf which comes from the same center or school as the Utrecht Psalter (Fig. 31),[167] and, in the region of Castelseprio, the Canons of Councils in the Chapter Library of Vercelli (Fig. 32).[168] All these, except the latter, are listed by Grabar in his article, but he has overlooked the terminal strokes of the cross and classified the examples in these manuscripts with the plain Carolingian types.

The criterion on which Grabar built his conclusion should require him then to date the frescoes early in the Carolingian period. But it would be imprudent to base the dating on a single detail of which the history is still so little known. If the frescoes are to be placed in the later eighth century, as I have supposed, it is for a number of reasons beside the evidence of the rayed cross. The latter has some value, however, since of the many surviving works with the cross nimbus, none before the Carolingian period shows the peculiar form that occurs in Castelseprio, and the Carolingian works that present this form share other traits with the frescoes.

Future discoveries may disclose examples of this cross older than the Carolingian works. To Grabar's belief that the simple linear cross extending beyond the nimbus, but without the terminal strokes, was a Carolingian invention one can oppose an engraved gem in the British Museum attributed to the early Christian period (Fig. 28).[169] It is a red jasper found in Gaza, with a scene of the Crucifixion and an undeciphered inscription that Le Blant believed was of gnostic origin.[170] I cannot say more about this object; its date is uncertain and nothing decisive seems to have been added to the comments of de Longpérier and Le Blant published in 1867.[171] On the other hand, the broad-armed cross extending beyond the nimbus, as it appears in the Cotton Genesis, is less rare in the early Christian period than I had supposed. It is found also on two engraved gems in Cambridge and The Hague.[172]

2. The Clavus on the Thigh

I pass to another detail of the frescoes which has been a matter of dispute. In my article on Castelseprio I called attention to a peculiarity of costume that might serve as an indication of the date and perhaps throw light on the origin of the work. It is the transverse ornamental band sewn *across the middle of the thigh* on the long tunic or the mantle (Fig. 14), an element that is frequent in Carolingian and Italian art of the late eighth and ninth centuries.[173] It was preceded in the seventh and eighth centuries by a related form—the shorter *paragaudae*—that survived into the ninth century; it must be distinguished too from another ornament, the horizontal bands on hose.[174] Morey objected to my using this bit of costume as evidence of a date in the eighth century since he believed that it had already occurred in a work of the sixth.[175] But in the

Fig. 32 Vercelli, Biblioteca Capitolare: Ms. CLXV. Christ Enthroned.

figures of mounted Amazons on the silk fabric in the Cote Collection in Lyons which he has cited, I find no trace of such a transverse clavus across the thigh (Fig. 33). Morey has mistaken for the element I had described a simple hem at the lower edge of a short tunic that reaches to the thigh. The same form reappears in other silks with the same motif of the Amazons.[176] I do not regard as relevant Morey's observation that the clavus across the thigh in Castelseprio "is of the same character as the waist band worn by David in the miniature of the Penitence in the Paris Psalter."

One can hardly be sure that this peculiar band was first used in the eighth century; but until now I have found it in no works that can be securely dated before this time. It could have been a fashion in Constantinople (or some other center) for a short while in the eighth century, from which little of the art produced in the capital has come down; such a form might have persisted longer in the art of provincial regions, like Italy and France, where it had been accepted as a pictorial element rather than as part of a real costume. The fact that among surviving works the transverse clavus spanning the thigh first appears in the West after the common use there in the seventh and eighth centuries of an older Eastern type of appliqué on the thigh[177] seems to confirm its later origin.

As for the possibility that the Carolingian artists copied this detail from a much earlier model, there is some indication in a manuscript that I have cited: the illustrated Sedulius in the Musée Plantin in Antwerp (Ms. 126). The models of the miniatures in this book, according to Professor Wilhelm Koehler, our best judge in these matters, were Italian paintings of about 500.[178] But between the Italian prototypes and the Carolingian copy there were undoubtedly mediating versions of which one was preserved in England; an inscription in the Antwerp codex reproduced from an earlier copy names an owner Cuduuinus, whom Traube identified as the Bishop of Dunwich between 716 and 731.[179] The transverse clavus in these miniatures may belong to the model of 500 or to an Italian or insular copy—whatever its date—or it may have been introduced for the first time in the Carolingian version.[180] The initial *P* on Fol. 8 is clearly of the later eighth or ninth century and the furniture, too, points to this period. If the miniatures depend ultimately on prototypes of the early sixth century, this fact does not entail the same date for the ornament of the costume.

The same question arises for the Trier Apocalypse, a work attributed by Goldschmidt to the end of the eighth century.[181] The transverse thigh band occurs here often in the form which we observe at Castelseprio; and since the illustrations in this manuscript were copied from older models, perhaps of the sixth century, one must consider the possibility that this detail was part of the original work. There are two reasons, however, for doubting this. First, the

thigh band, so frequent in the Trier Apocalypse, does not appear in the Carolingian sister manuscript in Cambrai (386) which surely descended from the same prototype.[182] In the second place, the thigh band does occur on a flyleaf of the Trier manuscript in an early Carolingian drawing of Christ Treading on the Beasts, which is independent of the illustrations of the Apocalypse and by another hand.[183] It is close in style to the Genoels-Elderen ivory plaques in Brussels, where the same thigh band is rendered;[184] these ivory carvings are of the late eighth century and combine insular and Italian features—they have been commonly placed in or near the region of the Ada School.[185] I had noted before their relation in iconography to the frescoes of Castelseprio (Annunciation, Visitation);[186] to which may be added—as of some interest for the North Italian, as distinguished from the Roman, connections of Carolingian art—the resemblance of the drapery forms in these ivory panels, and particularly of Christ Treading on the Beasts, to the stucco figures of the eighth century in Cividale.[187]

There is a North Italian work which supports the possibility that the motif of the thigh band, as it appears in the Antwerp manuscript of Sedulius and the Trier Apocalypse, already existed in the first half of the eighth century. In the sculptured panels of the altar in Cividale, dedicated around 737 to the memory of Duke Pemmo (d. 734) by his son Ratchis, the transverse stripes on the robes of the angels[188] seem to represent triple bands of clavi like those on several figures in the Sedulius manuscript, and particularly on the flying angel in the scene of Daniel who in other respects betrays a family resemblance to the Cividale angels.[189] In the primitive relief carving of this altar, it is not easy to say what represents costume ornament and what is ornamental stylization of folds. But a connection with the clavi seems to me possible.

Earlier I had noted the occurrence of the clavus on the thigh in images of Lombard kings in a manuscript of laws in La Cava (Badia Ms. 4), apparently copied from a model of the ninth century.[190] This suggested the possible origin of the motif in royal costume. It is not at all characteristic of the dress of Byzantine or Carolingian rulers, though it does appear on the costume of kings and crowned Magi in Ottonian art. In Castelseprio and in Carolingian works the clavus is found more particularly on the thighs of angels. But in drawings of the ninth century in a native manuscript in Vercelli (Biblioteca Capitolare Ms. CLXV, Canons of Councils)[191] the clavus, decorated with dots or beads as in Castelseprio, is applied just below the knee on enthroned figures whose foreshortened thighs are not visible; these are the Emperors Constantine and Theodosius II (Fig. 34).[192] Here one may assume, I think, that the band below the knee has been transferred from the thigh. The transverse clavus in this manuscript is not limited to the emperors; two seated clerics at a council wear the same ornament.[193] What makes these drawings even more interesting for

Fig. 33 Lyons, Musée des Tissus: Silk textile. Mounted Amazons.

Fig. 34 Vercelli, Biblioteca Capitolare: Ms. CLXV. The Emperor Theodosius II.

the problem of Castelseprio is that Christ in one of the miniatures (Fig. 32) has a nimbus with nail-headed linear rays crossing the circle.[194] All the thrones are of the simple block type that appears in the painting of the Hetoimasia at Castelseprio. The drawings in this manuscript show that several distinctive motifs of the frescoes existed elsewhere in Lombardy in the ninth century.

It may be argued that the two elements considered in these notes—the rayed cross nimbus and the thigh band—occur in Ottonian as well as Carolingian art, and that the present study therefore points only to a probable *terminus post quem* for Castelseprio: the frescoes are not earlier than the eighth century and could well be of the tenth. If I incline to the view that the frescoes are of the eighth century, it is because their style fits better between the classical forms of Sta. Maria Antiqua and the classicism of the Carolingian schools than between the Byzantine miniatures of the tenth century and Ottonian art, where others have placed the frescoes; and this earlier dating is supported by a number of details, including the painted uncial inscriptions which seem so much older than the inscriptions recording the ordination of a priest, added in the tenth century, that a palaeographer like Lowe could date them in the sixth century.*

* After this paper was written, I observed what appears to be the motif of the transverse clavus on a work of the sixth century. It is the set of fragments of the ivory panel that originally formed the counterpiece of the leaf of the Murano diptych now in Ravenna. (See W. F. Volbach, *Elfenbeinarbeiten der Spätantike und des frühen Mittelalters*, 2nd ed., Mainz, 1952, p. 65 nos. 127–129, pl. 39, 40, 45.) The thigh band is most evident and most like the form in Castelseprio on the figure of Saint Anne (in the fragment in the Hermitage in Leningrad–Volbach, no. 129, pl. 40). But this detail belongs to the painted ornamentation of the ivory panel together with the gold stars on the background. Although the painting is old, there remains a doubt concerning its age; we are not sure that it is of the same time as the carving. The motif of the appliqué thigh band is not found in plastic form in other works of the same group or school of ivory sculpture. Yet on one of the fragments of the same diptych (formerly in the Stroganoff Collection and now in private hands in Paris) representing the Annunciation, the Trial by Water and the Journey to Bethlehem, of which the last two are uncommon themes and occur also in Castelseprio with some remarkable similarities of conception in the Journey(Volbach, no. 128, pl. 45), there are incised lines that may be interpreted as the thigh band in question, unless they are, as Dr. Volbach supposes (in a letter to the writer), simply schematic grooves representing folds; the photographs are not clear enough to permit a definite judgment.

NOTES

1. *Il Giornale d'Italia*, August 10, 1947.
2. G.P. Bognetti, G. Chierici, A. de Capitani d'Arzago, *Santa Maria di Castelseprio*, Milan, 1948. For a short statement, see A. de Capitani d'Arzago, "The Discovery at

Castelseprio," *Art News*, XLVII, 1949, pp. 16 ff. Bognetti has restated his views and answered objections in *Rassegna storica del Seprio* for 1949–50, fasc. IX–X, 1951, pp. 28–66.

3. *The Fresco Cycle of S. Maria di Castelseprio*, Princeton, 1951. Professor Weitzmann has also published a summary of his book in Italian in *Rassegna storica del Seprio, loc. cit.*, pp. 12–27. Bognetti's article in the same issue is largely an answer to Weitzmann and includes some valuable new observations.

4. H. Omont, *Fac-similés des miniatures des plus anciens manuscrits grecs de la Bibliothèque Nationale du VIe au XIVe siècle*, Paris, 1929, pls. XXII (cube on stepped platform), XXVII (vase on high pedestal, distant trees and buildings), XXXI (cylindrical tower between scenes), XXXIII, XXXVII (stepped structure with cube at side of scene), XLVII (portal with entablature on column and pier), LV (tree above column or pedestal), LX (freestanding column with knotted sash). Note also two freestanding columns flanking the Virgin in mosaic of the oratory of John VII in Rome (J. Wilpert, *Römische Mosaiken und Malereien vom IV.–XIII. Jahrhundert*, Freiburg i. Br., 1917, I, p. 390, fig. 128); and column with hanging drape, in Lateran painting of St. Augustine (late sixth century?), *ibid.*, I, fig. 37 and pl. 140.

5. *Die Wiener Genesis*, ed. W. Hartel and F. Wickhoff, Vienna, 1895, pls. X (column), XIII, XIV (personifications), XXX (column with knotted sash; rock between two scenes), XXXIV (column with betylion), XXXI, XXXV, XXXVIII, XLVII (terminal trees and buildings). For Deir Abu Hennis, see C. R. Morey, *Early Christian Art*, Princeton, 1942, fig. 75.

6. Omont, *op. cit.*, pl. XL.

7. *Ibid.*, pl. XLIX.

8 E. T. DeWald, *The Illustrations of the Utrecht Psalter*, Princeton, n.d., fol. 6Iv.

9. On this point, see my article, "The Place of the Joshua Roll in Byzantine History," *Gazette des Beaux-Arts*, March 1949, pp. 161–176, [reprinted here, pp. 49–66], and D. Tselos, "The Joshua Roll: Original or Copy?" *Art Bulletin*, XXXII, 1950, pp. 275–290.

10. A. Goldschmidt, *Die Elfenbeinskulpturen*, I, 1914, pl. III, no. 5.

11. His argument for the classical dramatic model of the scene of David and Saul in the Paris Psalter is presented more fully in "Euripides Scenes in Byzantine Art," *Hesperia*, XVIII, 1949, pp. 198 ff. It rests, I think, on the arbitrary assumption that the artist has tried to illustrate both I Samuel xvii, 54 and xviii, 6–7; i.e., both the triumphant return of David to Jerusalem and Saul's displeasure at the women acclaiming David upon Saul's return. Actually, only the second passage is illustrated here. The second woman "in a quiet attitude," who Weitzmann thinks cannot be explained by the text and must therefore be an insertion from the classical model, is obviously one of the women referred to in I Samuel xviii, 7 ("and the women answered one another . . . and said, Saul has slain his thousands, and David his ten thousands"), for precisely this text is written out above the woman, who wears, moreover, the same sleeveless costume as the dancer.

12. The cover to the Dagulf Psalter with scenes from the life of David (before 795), Goldschmidt *op.cit.*, I, 3, 4; Gospels in Würzburg, A. Goldschmidt, *German Illumination*, I, Florence, 1928, pl. 57; Gospels in Erlangen, *ibid.*, I, pl. 58; fresco in St. George at Oberzell, Reichenau (Raising of Lazarus). [Significant for our problem is the occurrence of the stilted lintel in the architectural frame of the colophon of a psalter of the ninth century (Berlin, Staatsbibliothek, Hamilton Ms. 552, fol. 1), with text in Greek and Latin, written in Milan by Simeon, a monk of S. Ambrogio, under Abbot Peter (851–897).] For Byzantine examples, cf. the Anointing of David in Vatican, Cod. Regin. gr. 1, *Le miniature della Bibbia cod. Vat. Regin. gr. I*, Rome, 1905, pl. 12; and Paris Psalter, Omont, *op. cit.*, pl. V. For an example in the Paris Gregory Ms., cf. *ibid.*, pl. L, but the form is on piers rather than columns. [The stilted lintel is common in the late Byzantine frescoes at Mistra—see G. Millet, *Monuments byzantins de Mistra*, Paris, 1910, pls. 70, 76, 77, 82, etc.]

13. *Ibid.*, pl. III.

14. *Ibid.*, pl. XXXVII.

15. *The Great Palace of the Byzantine Emperors*, Oxford and London, 1947, pl. 29.

16. Goldschmidt, *Die Elfenbeinskulpturen, op. cit.*, 1, 5, 13, etc.; Goldschmidt, *op cit., German Illumination*, I, pls. 37, 42.

17. Weitzmann, *op. cit.*, fig. 17 (Maccabees group, Eleazar); cf. also Lorsch Gospels, Goldschmidt, *German Illumination*, I, pl. 40. Note that in Castelseprio the hanging end of drapery of the Virgin in the Nativity, which Weitzmann compares with a Middle Byzantine example, occurs in the same context on a Carolingian ivory (Goldschmidt, *Die Elfenbeinskulpturen*, I, 24, pl. XIII) as well as in other themes (gold cover of the Codex Aureus, J. Braun, *Meisterwerke der deutschen Goldschmiedekunst*, I, Munich, 1922, pl. 6; painting of St. Augustine, Lateran, Wilpert, *op. cit.*, I, fig. 37, pl. 140); it is found in Byzantine silver of the sixth and seventh century (Matzulewitsch, *Byzantinische Antike*, Berlin, 1929, pls. 44, 46).

18. Omont, *op. cit.*, pl. LX.

19. *Ibid.*, pl. I.

20. Examples in Sta. Maria Maggiore, S. Michele in Affricisco (Ravenna), and, in the eleventh century, in Galliano.

21. Cf. Naples Baptistery, Wilpert, *op. cit.*, I, fig. 68, p. 216; SS. Silvestro and Martino, Rome, *ibid.*, I, figs. 105–107, pl. 206. For a Carolingian parallel in Switzerland, cf. the choir screen in Chur, S. Guyer, *Die christlichen Denkmäler des ersten Jahrtausends in der Schweiz*, Leipzig, 1907, figs. 20, 21 (rod with winding ribbon) [and also the ornament dividing the frescoes in the church of St. John at Müstair—see L. Birchler, "Zur karolingischen Architektur und Malerei in Münster-Müstair," *Frühmittelalterliche Kunst in den Alpenländern*, Akten zum III internationalen Kongress für Mittelalterforschung, Olten and Lausanne, 1954, pp. 167 ff., figs. 89, 93, 98.]

22. On this concept of "modes," see my article in *Review of Religion*, January 1944, pp. 181ff.

23. Paul Friedländer, *Spätantiker Gemäldezyklus in Gaza, Des Prokopius von Gaza Ekphrasis Eikonos*, Vatican City, 1939. The subject is the story of Hippolytus and Phaedra.

24. Bognetti et al., *op. cit.*, pp. 543, 625 ff.; cf. also Bognetti, *op. cit.*, 1951, pp. 30, 39 ff.

25. A larger section of the original pavement has recently been uncovered—a geometrical ornament in black and white, common in Milan and Rome between the sixth and ninth centuries (Bognetti, *op. cit.*, 1951, pl. XII, pp. 31ff.).

26. Steven Runciman, *The Emperor Romanus Lecapenus and His Reign*, Cambridge, 1929, p. 196.

27. E.g., the V-shaped strokes of the A cross the ∧ . For a clearer reproduction of one of the inscriptions, see Bognetti, *op. cit.*, 1951, pl. XIII, Fig 3, and our fig. 16, p. 93.

28. H. Peirce and R. Tyler, *L'art byzantin*, II, Paris, 1934, fig. 73b.

29. Goldschmidt, *Die Elfenbeinskulpturen, op. cit.*, I, 2.

30. H. Grisar, *Die römische Kapelle Sancta Sanctorum und ihr Schatz*, Freiburg i. Br., 1908, figs. 36–39.

31. Goldschmidt, *Die Elfenbeinskulpturen, op. cit.*, I, 5, 72, 75, 95. For a late Byzantine example, cf. Omont, *op. cit.*, pl. XCV, 17—Paris gr. 54, the Gospels in Greek and Latin.

32. Luigi Magnani, *Le miniature del sacramentario d'Ivrea*, Vatican City, 1934, pl. XII.

33. Cf. Goldschmidt, *Die Elfenbeinskulpturen, op. cit.*, I, 2, 95; Amiens, Bibl. municipale, Ms. 18, Psalter from Corbie, *ca.* 800, initial of "Ad te levavi." There is perhaps an older example in a Coptic embroidery (Dalton, *Byzantine Art and Archaeology*, Oxford, 1911, fig. 379), but it is unclear.

34. N. P. Kondakoff, *Ikonografia Bogomateri*, I, St. Petersburg, 1914, fig. 115.

35. A. Boinet, *La miniature carolingienne*, Paris, 1913, pls. VIII B, XIII B, XVII A, XIX A, etc.

[35a. See G. de Jerphanion, *Les eglises rupestres de Cappadoce*, Paris, 1925–1936, I, 2,

385, and album III, pls. 198, 203. In the archaic chapels like St. Eustathios, the noun MAIA appears without the article as a proper name—*ibid.*, I, 1, p. 77, n.2.]

36. Peirce and Tyler, *op. cit.*, II, pl. 160b; for the Carolingian date, see E. Gombrich, "Eine verkannte karolingische Pyxis," *Jahrbuch der kunsthistorischen Sammlungen in Wien*, N.F., VII, 1933, pp. 1–14.

37. Wilpert, *op. cit.*, II, p. 756, fig. 321. On the Hildesheim bronze door (*ca.* 1015), the woman beside the Virgin in the Nativity exposes her open left hand; in the Autun Sacramentary (Boinet, *op. cit.*, pl. XLI), she simply extends one arm; in the St. Mary Shrine in the Aachen Domschatz, one of the midwives bathing the Child has her right arm in a sling. An independent interpretation of the text of the pseudo-Matthew in a fourteenth-century North Italian miniature (Milan, Bibl. Ambrosiana, Ms. L 58 sup.) shows the midwife ("Solome") with paralyzed arm flexed at the elbow and wrist. The same gesture as in Benevento occurs in an ivory in the Musco Civico, Bologna (eighth century?—H. Graeven, *Frühchristliche und mittelalterliche Elfenbeinwerke aus Sammlungen in Italien*, Rome, 1900, n. 6), and a Carolingian ivory in Munich (Goldschmidt, *Die Elfenbeinskulpturen*, I, 67a).

38. DeWald, *op. cit.*, pls. LXVIII, LXXX, CXXXIX.

39. Cf. David in the Anointing scene, St. Gall, Ms. 22 (Boinet, *op. cit.*, pl CXLV), and God in the Creation page of the S. Paolo f.l.m. Bible (*ibid.*, pl. CXXII B). For a Byzantine parallel of more naturalistic type, cf. the ivory box in Sens (Goldschmidt and Weitzmann, *Byzantinische Elfenbeinskulpturen*, pl. 75, no. 124 p, t). Related to the more mediaeval conception is the Widow of Zarephath in the painting of Elijah's miracle in the Dura synagogue.

40. Boinet, *op. cit.*, pl. LXXXIX A.

41. *Die byzantinische Buchmalerei des IX. und X. Jahrhunderts*, Berlin, 1935, fig. 448.

42. Peirce and Tyler, *op. cit.*, II, figs. 65, 66. Morey dates it in the seventh century.

43. Dalton, *op. cit.*, fig. 114. Cf. also a Carolingian ivory in London (Goldschmidt, *Die Elfenbeinskulpturen*, I, 14) where the Virgin in the Nativity turns her head to see the Child; and a lost sarcophagus where the Virgin turns her head away from the Child (Le Blant, *Les sarcophages chrétiens de la Gaule*, Paris, 1886, p. 53).

44. E.g., the ivory in London, Goldschmidt, *op. cit.*, I, 14.

45. E. G. Millar, *English Illuminated Manuscripts*, Paris, 1926, pl. 2.

46. Reproduced in Bognetti et al., *op. cit.*, pl. LXXI, c; see also Bognetti, *op. cit.*, 1951, pp. 55, 56, for a detailed criticism of Weitzmann on this point.

47. Boinet, *op. cit.*, pl. XXXVII A, XLI A.

48. *Ibid.*, pl. LXXXVII A.

49. Garrucci, *Storia dell' arte cristiana*, pl. 433, no. 7.

50. Peirce and Tyler, *op. cit.*, II, fig. 73b.

51. Friedländer, *op. cit.*, pp. 47 ff. and pl. XI. Cf. also the shepherd in the mosaic of S. Aquilino, Milan (Wilpert, *op. cit.*, I, figs. 77, 78, pp. 264, 265).

52. Goldschmidt, *Die Elfenbeinskulpturen*, I, 14.

53. *Gazette des Beaux-Arts*, VIe pér., XXXVII, 1950, p. 112. As does Weitzmann, Professor Grabar believes that the frescoes belong to the Macedonian renaissance, like the Paris Psalter, but are a little earlier. In addition to the example of the cross nimbus reproduced by Grabar (a miniature in Morgan Library, Ms. 780, Salzburg, eleventh century), one may cite the Stuttgart Psalter, fol. 28 (ed. E.T. DeWald); Paris, Bibl. Nat., Ms. lat. 8850, fol. 180v (Miracle at Cana), Boinet, *op. cit.*, pl. XXII; and Düsseldorf, fragment (Reims school), reproduced in the Catalogue of the Bern Exhibition, *Kunst des frühen Mittelalters*, 1949, pl. 5 [illustrated here in Fig. 31, after p. 124]. The projecting cross of broader form occurs in Paris, Bibl. Nat., Ms. lat. 8850, fol. 124 (with rays), Gerona Beatus, frontispiece, fol. 2v (975), and in a fresco of the ninth century in the Sacro in Subiaco (Toesca, *Storia dell' arte italiana*, I, fig. 240).

54. British Museum Cotton Ms. Otho B.VI, fol. 3, The Creation of Eve and the Third Day of Creation. The latter scene was destroyed by fire and is known through the copy made in the 17th century for Peiresc, and preserved in Paris, Bibliothèque Nationale ms. fr. 9530; it is

reproduced by Omont, *op. cit.*, plate facing p. iv., [and reproduced here in Fig. 25, on p. 116].

55. Weitzmann, *Die byzantinische Buchmalerei*, fig. 381 (National Library, Ms. 211) [reproduced here in Fig. 27, on p. 118]. In a Byzantine ivory in London, the projecting cross is a modern restoration (Goldschmidt and Weitzmann, *op. cit.*, II, pl. LII).

56. Coins of Antoninus Pius, Calendar of 354 (Strzygowski, *Die Calenderbilder des Chronographen vom Jahre 354*, 1888, pl. IX), painting in apse of chapel in Catacomb of Massimo (Grabar, *Martyrium*, 1946, pl. XIX); for the sun with rays, cf. Cosmas Indicopleustes, Vatican Library, Ms. gr. 699 (ed. Stornajolo, 1908, pl. 51—rays inside medallion at the head, rays outside medallion below the bust), and the Calendar of 354 (Strzygowski, *op. cit.*, pl. XIII). In the Castelseprio frescoes and the Stuttgart Psalter, the rays end in a tiny transverse stroke; but this element is not found in the Soissons Gospels (Paris, Bibl. Nat., Ms. lat. 8850).

57. Migne, Patrologia latina, XI, col. 417 (lib. II, tract. ix).

58. *De divinis nominibus*, I, 2, 4; II, 4, 11; IV, 4, 6. I follow the translation by C. E. Rolt, *Dionysus the Areopagite on Divine Names and the Mystical Theology*, S.P.C.K., London, 1920.

59. A. Harnack, *History of Dogma*, IV, London, 1898, p. 258.

60. Garrucci, *op. cit.*, pl. 317, no. 4.

61. The conception in Castelseprio may be related to an Early Christian type of the Nativity, as in the ivory diptych in the Cathedral of Milan, in which both Joseph and Mary are sitting on rocks (A. Haseloff, *Pre-Romanesque Sculpture in Italy*, Florence, n.d., pl. 21).

62. Boinet, *op. cit.*, pl. LXXXIX B. In an initial in the Psalter, Boulogne 20, the Magi raise their gifts to the Virgin and Child who are elevated above their heads.

63. Goldschmidt, *Die Elfenbeinskulpturen, op. cit.*, I, 118.

64. G. Ladner, "Die italienische Malerei im XI. Jahrhundert," *Jahrbuch der kunsthistorischen Sammlungen in Wien*, V, 1931, p. 40, fig. 8 (Ms. 99 H).

65. Examples in Kondakoff, *op. cit.*, I, figs. 20 (Lateran), 21 (Tolentino), 26 (relief in Carthage).

66. Wilpert, *op. cit.*, I, p. 390, fig. 128.

67. Kondakoff, *op. cit.*, I, figs. 18, 21; H. Kehrer, *Die heiligen drei Könige in Literatur und Kunst*, II, Leipzig, 1909, fig. 29.

68. Kehrer, *op. cit.*, II, fig. 16 (London); Kondakoff, *op. cit.*, I, figs. 32–34 (Florence pyxis), and 112 (Milan ivory). Cf. also the silver case of the enameled cross in the Sancta Sanctorum, Rome (Grisar, *op. cit.*, figs. 36–39).

69. *A Survey of Persian Art* (ed. A. U. Pope and P. Ackerman), IV, London and New York, 1938, pls. 141 J, K, Q; 143 T; 144 X.

70. *Ibid.*, pl. 251 B. Note the hats, high but without straps, in the Adana encolpium, Paris, Bibl. Nat., Ms. copte 13, fol. 6, and Monte Cassino, Ms. 99 H.

71. Cf. Dorothy C. Shorr, "The Iconographic Development of the Presentation in the Temple," *The Art Bulletin*, XXVIII 1946, pp. 17 ff. The distinction between the two scenes is clear in Vatican Library, Ms. lat. 39, where both are represented (fols. 43v, 44).

72. R. de Lasteyrie, *L'architecture religieuse en France à l'époque romane*, 2nd ed., Paris, 1929, pp. 91, 92.

73. Morey, *Early Christian Art*, fig. 75, no. 2. Something of the tradition of the architectural setting in Castelseprio has perhaps survived in the Presentation scene in Magliano Pecorareccio, late eleventh century (Wilpert, *op. cit.*, II, p. 762).

74. See note 41.

75. Boinet, *op. cit.*, pls. XXI–XXIII (Gospels of St. Médard de Soissons, Paris, Bibl. Nat., Ms. lat. 8850).

76. Strzygowski, *op. cit.*, pl. IX.

77. Count Du Mesnil du Buisson, *Les peintures de la synagogue de Doura-Europos*, Rome, 1939, p. 33, fig. 29.

78. J. Braun, *Das christliche Altargerät*, Munich, 1932, pp. 467 ff.

79. Cabrol, *Dictionnaire d'archéologie et de liturgie chrétienne*, s.v. "Croix," III, 2,

fig. 3379; for a photograph, see Barbagallo, *Storia universale, Il medioevo*, III, Turin, 1935, p. 141; for reproductions of the cross in the fresco, see Bognetti, et al., *op. cit.*, pls. LVII–LIX.

80. Cross in Tournai (Cabrol, *op. cit.*, III, 2, fig. 3410), which has the twin terminal knobs at the ends of the cross, lacking in the Monza Cross. These knobs are a typical Byzantine form in the sixth century, although found on crosses of different type and proportions from the one in the fresco (cf. the Stroganoff silver dish, Diehl, *Manuel d'art byzantin*, I, 1925, fig. 160; the Cyprus silver treasure, Dalton, *op. cit.*, figs. 357, 360; wooden beams of Hagia Sophia, N. Åberg, *The Occident and the Orient in the Seventh Century, Part II: Lombard Italy*, Stockholm, 1945, fig. 53; a cross from Akhmin in Mainz, W. F. Volbach, *Metallarbeiten des christlichen Kultes*, Mainz, 1921, pl. VI). In Castelseprio, the knobbed ends project further, like the spiral finials of the crosses on the stone chancels of the eighth century, though not clearly spiral-shaped as in the latter (see G. T. Rivoira, *Lombardic Architecture*, I, Oxford, 1933, pp. 177, 180, 181). Cf. also the cross represented on the altar in the silver container in the Sancta Sanctorum treasure (Haseloff, *op. cit.*, pl. 57), a gift of Pope Pascal I (817–824).

81. M. Muratoff, *La pittura bizantina*, Rome, n.d., pl. CCXLI.

82. Omont, *op. cit.*, pl. LVI.

83. K. Galling, *Der Altar in den Kulturen des alten Orients*, Berlin, 1925, pl. 16.

84. *The Art Bulletin*, XXVIII, 1946, fig. 20, facing p. 30.

85. Boinet, *op. cit.*, pl. LXXXIX c.

86. E. H. Zimmermann, *Die vorkarolingischen Miniaturen*, Berlin, 1916, pl. 222.

87. Weitzmann, *Castelseprio*, fig. 28.

88. Omont, *op. cit.*, pl. XLIX.

89. Von Hartel and Wickhoff, *op. cit.*, pl. X.

90. Bognetti et al., *op. cit.*, pl. LXXVI.

91. W. Wroth, *Imperial Byzantine Coins in the British Museum*, I, London, 1908, pls. VIII, 3, 8; XII. For the types of scepter and globe, I am indebted to a study by Mr. Herschel Chipp in a seminar at Columbia University.

92. Dalton, *op. cit.*, fig. 128. The slender cross on the orb in Castelseprio is closer, however, to the cross on the throne in the same fresco.

93. Kondakoff, *op. cit.*, I, fig. 149, pl. V.

94. O. Wulff, *Die Koimesiskirche in Nicäa und ihre Mosaiken*, Strasbourg, 1903, pl. II.

95. G. de Jerphanion, *Les églises rupestres de Cappadoce*, Paris, 1925–33, pls. 40, 53, 59, 121, and I, p. 242, fig. 25. Cf. also Kondakoff *op. cit.*, II, figs. 64, 178, 184; and Dalton, *op. cit.*, figs. 165, 191, 236.

96. Cf. the crown of the Lombard Queen Theodolinda (*ca.* 600), the crowns of the prophets and Herod in the Sinope Gospels (Peirce and Tyler, *op. cit.*, II, pl. 150), and the martyrs' crowns in the mosaic of the Lateran Oratory (Wilpert, *op. cit.*, III, pl. III).

97. Reproduced in *Il tesoro della Capella Sancta Sanctorum*, Guida IV (Museo Sacro), Vatican City, 1941, fig. 8. Cf. also the Codex Amiatinus, Zimmermann, *loc. cit.*

98. They appear also on the angels of the Annunciation and Joseph's Dream and on Joseph in the latter scene.

99. Goldschmidt, *German Illumination*, I, pl. 31 (Paris, Bibl. Nat., Ms. lat. 8850); *Ars Sacra, Kunst des frühen Mitteralters*, Munich, 1950, fig. 5 (Paris, Bibl. Nat., Ms. lat. 8850); Trier Apocalypse, Goldschmidt, *Die Elfenbeinskulpturen*, I, p. 9, fig. 5 (other examples on fols. 2v, 5v, 76v of this manuscript); Bern Prudentius, R. Stettiner, *Die illustrierten Prudentius Handschriften*, Berlin, 1905, pl. 159; for examples, on ivories, see Goldschmidt, *ibid.*, I,2; I,6a. Cf. also the Stuttgart Psalter (ed. DeWald), fols. 5v, 13, 19v, 22, 22v, 23 31, 31v, 37, 53, 72v, etc., and the illustrated Sedulius manuscript in the Musée Plantin in Antwerp.

100. Cf. the announcing angel in the mosaic of SS. Nereo e Achilleo, Rome (795–816), M. van Berchem and E. Clouzot, *Mosaïques chrétiennes*, Geneva, 1924, fig. 286; the

executioner in fresco of Volturno, M. Avery, *The Exultet Rolls of South Italy*, Princeton, 1936, pl. CXCII.

101. Du Mesnil du Buisson, *op. cit.*, pls. XLVII–XLIX, LIV, etc; H. Seyrig, in *Syria*, XVIII, 1937, pp. 24, 25, fig. 16.

102. M. I. Rostovtzeff, *Dura-Europos and Its Art*, New York, 1938, pl. XIII and p. 117.

103. W. de Grüneisen, *Sainte Marie Antique*, Rome, 1911, pl. XCIV, 1.

104. *Ibid.*, pls. XXXVI, LV. Cf. also mosaics of S. Cecilia, S. Prassede, and the apse of the Lateran triclinium in Rome; for a later Cappadocian example, de Jerphanion, *op. cit.*, pl. 46.

105. Fols. 22v, 40 (ed. DeWald).

106. Goldschmidt, *Die Elfenbeinskulpturen*, I, 3, 6a.

107. J. Hubert, *L'art pré-roman*, Paris, 1938, pls. XIXc, XXe.

108. Avery, *op. cit.*, II, pl. CCII a, b.

109. Wilpert, *op. cit.*, II, fig. 273.

110. De Jerphanion, *op. cit.*, pl. 202, no. 2.

111. *Geschichte der byzantinischen Literatur*, 2nd ed., Munich, 1897, p. 166 (Ehrhardt).

112. Migne, Patrologia graeca, CXX, cols. 199 ff. I find no reference to the midwife or the bathing of Christ in the three sermons on the Nativity by the Emperor Leo the Wise, whose theological writings Weitzmann quotes for the dogmatic interpretation (Pat. gr., CVII, cols. 28 ff.).

113. A. Frolow, "L'église rouge de Perustica," *Bulletin of the Byzantine Institute*, I, Paris, 1946, pp. 15–42, pls. X–XIX.

114. J. Schlosser, *Schriftquellen zur Geschichte der karolingischen Kunst*, Vienna, 1896, p. 327, n. 931. We may note here that the St. Gall frescoes included the apocryphal Fall of the Egyptian Idols, a theme which Weitzmann conjectures was present in Castelseprio as part of the dogmatic program.

115. W. W. S. Cook and J. Gudiol Ricart, *Pintura e Imaginería Románicas* (Ars Hispaniae, VI), Madrid, 1950, figs. 26 (Mur), 62, 63 (Pedriñá), 66 (Barberá), etc.

116. Cf. "zulfuro" for "sulfuro." For information on this point I am indebted to my colleague, Professor Dino Bigongiari. In the inscription of Simeon's name, I read the second letter as a Latin Y because of a tail stroke at the *V*, visible in Weitzmann's reproduction (*op. cit.*, fig. 7), although not observable in the Italian publication. Cf. d'Arzago, *op. cit.*, p. 622.

117. Cf. the Ursus relief in Ferentillo, dated after 739, Haseloff, *op. cit.*, pl. 54.

118. For a later example, cf. the apse mosaic in S. Ambrogio in Milan.

119. See Fr. Dvornik, *Les Légendes de Constantin et Méthode vues de Byzance*, Prague, 1933, pp. 285 ff.

120. For a full discussion of the Greeks and Syrians in Lombardy, see Bognetti, *op. cit.*, 1948, pp. 203–319; *op. cit.*, 1951, pp. 50 ff.

121. For corroboration of the point, I wish to thank Dr. Fritz Novotny of Vienna.

122. The thesis of Dr. Hanns Swarzenski (*The Art Bulletin*, XXI, 1940, p. 23) that the style of the artist of the Schatzkammer Gospels was formed in copying the Xanten leaf (and its associated miniatures), which he attributes to the fourth century, seems to me unfounded. The long format of the book represented in the Xanten miniature, the arched supports of the chair, the lectern post, are obviously Carolingian features, for which Dr. Swarzenski has offered no true late antique parallels. The reference (his note 61) to the *Notitia Dignitatum* is in error; the "bench" in the latter is the wrapping of a book.

123. Avery, *op. cit.*, pl. CXCII; note also the transverse clavi, *ibid.*, pls. CXC, CXCII.

124. *Ibid.*, pls. CXCII, CXCIII.

124a. E. Bertaux, *L'Art dans l'Italie Méridionale*, I, Paris, 1904, pl. III.

125. Fols. 8, 88v, 90.

126. Fols. 16, 58, 152v, etc. [See the facsimile edition, *Der Stuttgarter Bilderpsalter Bibl. fol. 23*, Württembergische *Landesbibliothek*, Stuttgart, 1965–1966.]

127. Cf. the *E*, fols. 17v, 29v, etc. [On the North Italian model of the psalter, see now Florentine Mütherich in vol. II of the facsimile edition, pp. 196–202.]

128. Goldschmidt, *Die Elfenbeinskulpturen, op. cit.*, I, 72.

128a. Besides the large number of bones preserved in the cathedral of Milan as relics of the Innocents (oral information from Mgr. Cattaneo), I note that in the Stuttgart Psalter, fol. 152v (ps. 137)—the Massacre is represented as a smashing of the infants.

129. [See note 12 above on this manuscript.]

130. [The most recent literature on Castelseprio is listed, beside several older titles, at the end of the article by Patrik Reuterswärd, "Malingarna i Castelseprio," *Konsthistorisk Tidskrift*, 1978, offprint, pp. 1–26, with English summary on p. 26. Professor Reuterswärd favors a dating in the seventh century or beginning of the eighth. New in the studies of the problem is the discovery of the *sinopia* for a Flight into Egypt (his fig. 19) in the church of S. Salvatore in Brescia (a building begun in 753–54), "which presupposes the existence in Lombardy of a narrative art of Castelseprio's kind before the end of the eighth century." He writes that after this discovery "the arguments in favor of a later date have lost much of their weight."]

II

The footnote reference numbers, as they appeared in the original publication, are found in parentheses after each footnote in the second section.

131. After H. Omont, *Miniatures des plus anciens manuscrits grecs de la Bibliothéque Nationale du VIe au XIVe siècle*, Paris, 1929, pl. opp. p. iv. (1)

132. After A. Grabar, *Cahiers archéologiques*, VII, 1954, pl. LIV. (2)

133. *The Art Bulletin, XXXIV*, 1952, pp. 156, 160, 162, 163 [reprinted on pp. 97, 106–107, 109, 111 above]. (3)

134. *The Magazine of Art*, December 1950, pp. 312 ff. (4)

135. *De Somniis* i. 13, 72; cited by Harry A. Wolfson, *The Philosophy of the Church Fathers* (I, Faith, Trinity, Incarnation) Cambridge (Mass.), pp. 300, 301. (5)

136. On the analogy of light in early Christian theology and particularly in the doctrine of the Trinity, see besides Wolfson, *op. cit.*, pp. 300 ff., 359 ff., Cl. Bauemker, *Witelo (Beiträge zur Geschichte der Philosophie und der Theologie des Mittelalters*, III, 2), Münster, 1908, pp. 357–433 and especially pp. 371–379; G. P. Wetter, *PHOS*, Uppsala, 1914; Fr. J. Dölger, *Antike und Christentum*, I, 1929 ("Sonne und Sonnenstrahle als Gleichnis in der Logostheologie des christlichen Altertums"), pp. 271–290; *idem*, VI, 1940 ("Das Sonnengleichnis in einer Weihnachtspredigt des Bischofs Zeno von Verona. Christus als wahre und ewige Sonne"), pp. 1–56; R. Bultmann, "Zur Geschichte der Lichtsymbolik in Altertum," *Philologus*, XCVII, 1948, pp. 1–36.

Since the heretical Arians rejected the metaphor of light in explaining the Trinity (A. Harnack, *History of Dogma*, IV, London, 1905, pp. 15, 41), the three-rayed nimbus might be regarded as more characteristically Western in the fifth and sixth centuries, for Arianism was more important then in Italy and Spain than in the East; and the frequency of the three-rayed nimbus in the Carolingian period might be connected with the controversies over Adoptianism and the *Filioque* formula at that time, although these two questions were independent of the old Arian issue. (6)

137. For the whole text, see A. Heisenberg's article in *Xenia, Hommage international à l'Université nationale de Grèce*, Athens, 1912, p. 152. (7)

138. *Op. cit.*, p. 158. (8)

139. As the sermon clearly states (Migne, *Pat. gr.*, LXI, col. 781) and as Grabar recognized in his publication of the miniature in 1932: "Un manuscrit des homélies de Saint Jean Chrysostome à la Bibliothèque Nationale d'Athènes (Athenensis 211)," *Seminarium Kondako-vianum, Recueil d'études*, Prague, V, 1932, pp. 259–297, especially p. 272. Although attributed

to St. John Chrysostom in the manuscript, this sermon is published in Migne among the *spuria*. (9)

140. For an example see H. Leclercq, *Manuel d'archéologie chrétienne*, II, Paris, 1907, p. 570, fig. 379 (Cairo Museum). (10)

141. For examples see Cabrol, *Dictionnaire d'archéologie chrétienne et de liturgie*, s.v. "Lampe," cols. 1106 ff., 1202, 1209, 1210; Fr. J. Dölger, *Antike und Christentum*, V, 1936, pls. I, II. (11)

142. On fol. 56, cf. Grabar, *loc. cit.*, 1932, pl. XVIII, 2 and pp. 263, 278. Cf. for a similar effect the cross with a medallion bust of Christ in front of the cross in Paris, Bibl. Nat., Ms. gr. 20, fol. 7. (12)

143. See *Esplorazioni sotto la confessione di San Pietro in Vaticano*, ed. by B. M. A. Ghetti *et al.*, I, Vatican City, 1951, p. 41, pls. B, C (in color, II, pl. XI from which our Fig. 4 is reproduced); Jocelyn Toynbee and J. Ward Perkins, *The Shrine of St. Peter and the Vatican Excavations*, London, 1956, pp. 42, 117, pl. 32. Toynbee and Perkins date the mosaic in the mid-third century and call the figure Christus-Helios: "It may be no accident that the rays to right and left of his nimbus trace strongly accented horizontal lines, forcibly suggesting the transverse bars of a cross." (13)

144. For the same type of rayed nimbus as in the mosaic under St. Peter's, cf. the painting of Helios in the Vatican Virgil (lat. Ms. 3225), (*Fragmenta et picturae Vergiliana*, Rome, 1930, pl. 6); the pavement mosaic of the phoenix in Antioch (Doro Levi, *Antioch Mosaic Pavements*, II, Princeton, 1947, pl. LXXXIII); the mosaic of Christ on the arch of triumph of S. Paolo f.l.m. in Rome, which may be of the late eighth century (M. van Berchem and E. Clouzot, *Les mosaïques chrétiennes*, Geneva, 1924, figs. 100, 101, p. 89); the Romano-British relief of Sol Invictus in Corbridge (T. D. Kendrick, *Anglo-Saxon Art to A.D. 900*, London, 1938, pl. XIII, I: here the slender rays crossing the nimbus may be regarded as lines rather than as solid bands). More common are the solid pointed, i.e. peaked or convergent, rays passing the nimbus: the figure of Apollo in a Pompeian fresco (O. Brendel, *Römische Mittheilungen*, LI, 1936, p. 57, fig. 8); the relief of Mithras in Nimrud Dagh (Fr. Sarre, *Die Kunst des alten Persiens*, Berlin, 1923, pl. 56); the solar personifications in Mithraic art (Fr. Cumont, *Textes et monuments relatifs aux mystères de Mithra*, II, Brussels, 1894–1900, fig. 29, p. 202, no. 18, and *passim*); coins of Antoninus Pius (Daremberg et Saglio, *Dictionnaires des antiquités grecques et romaines*, s.v. "Nimbe," fig. 5321); for mediaeval examples, cf. the sun in Joshua's miracle of the sun in the Vatican Joshua Roll, the bust of the sun in Phillips Ms. 1830 (Thiele, *Antike Himmelsbilder*, Berlin, 1898, fig. 72). (14)

145. Theodor Schmit, *Die Koimesis-Kirche von Nikaia*, Berlin and Leipzig, 1927, pl. XII, p. 21; O. Wulff, *Die Koimesis Kirche in Nicäa und ihre Mosaiken*, Strasbourg, 1903, pl. I. For other examples of bands of light extending from the cross beyond the enclosing circle, cf. the fresco of the sixth century in the apse of the annex to the cathedral of Rusafa-Sergiopolis (J. Lassus, *Sanctuaires chrétiens de Syrie*, Paris, 1947, fig. 109); fresco in tomb chamber in Sofia, sixth century (E. K. Riedin, *The Christian Topography of Cosmas Indicopleustes*, in Russian, Moscow, 1916, fig. 2, p. 6); mosaic of Hagia Sophia in Salonica (van Berchem and Clouzot, *op. cit.*, p. 182); a newly uncovered mosaic in Hagia Sophia in Istanbul (*Dumbarton Oaks Papers*, IX and X, 1956, fig. 110, after p. 300). For the possible connection of the luminous cross in painting and mosaic with early Christian legends about the luminosity of the true cross and the miraculous appearance of a radiant cross in the sky over Jerusalem in 351 (or 353), see O. Wulff, *op. cit.*, pp. 241, 243 and A. Grabar, *Martyrium*, II, Paris, 1946, p. 276; for the occasion and date of Cyril's vision of the celestial cross, see J. Vogt, "Berichte über Kreuzerscheinungen aus dem 4. Jahrhundert n. Chr.," *Annuaire de l'Institut de philologie et d'histoire orientales et slaves* (Université Libre de Bruxelles) IX, 1949, pp. 593 ff. Visions of the luminous cross are also mentioned in Gnostic-Christian writings (Acts of John and Philip) (R. A. Lipsius, *Die apokryphen Apostelgeschichten und Apostellegenden*, I, 1883–1900, pp. 452, 523; III, pp. 9, 16, 37). In the Acts of John, which were read at the Council of Nicaea, Christ shows John a luminous cross which he calls Logos, Nous, Spirit, and Life, as well as Christ. (15)

146. Schmit, *op. cit.*, pl. XX, pp. 29, 30. (16)

147. See *Cahiers archéologiques*, VII, 1954, p. 143, n. 2. (17)

148. Cf. also the sun in the scene of Joshua's miracle in the mosaics of S. Maria Maggiore in Rome; the miniature of Joseph's Dream in the Vienna Genesis (Fr. Wickhoff, *Die Wiener Genesis*, Vienna 1895, pl. 29); the painting of Apollo in Pompeii cited in note 14 above; the bust of the sun in British Museum, Harley Ms. 647, fol. 13v (*Catalogue of Astrological and Mythological Manuscripts of the Latin Middle Ages, III, Manuscripts in English Libraries*, by Fr. Saxl and Hans Meier, edited by Harry Bober, II, London, 1953, pl. LVII, fig. 148); the sun in Madrid, Bibl. Nac. Ms. 19 (A. 16) (*ibid.*, I, fig. 9). (18)

149. Cf. the Leyden Aratus (Voss. 79) (Thiele, *op. cit.*, p. 121, fig. 46: three black and three gold rays); British Museum, Cotton Tiberius C. I (Saxl, Meier, and Bober, *op. cit.*, I, fig. 147). (19)

150. Cf. the Egino codex, Berlin Phillips Ms. 1676, fol. 24 (E. Arslan, *La pittura e la scultura veronese dal secolo VIII al secolo XIII*, Milan, 1943, pl. 42); the Lorsch Gospels (Boinet, *La miniature carolingienne*, Paris, 1913, pl. XVI, A); the Gospels of Soissons (Bibl. Nat. Ms. lat. 8850) (*ibid.*, pl. XX); the Smyrna Physiologus, bands of triple rays from the bust of the Sun (J. Strzygowski, *Der Bilderkreis des griechischen Physiologus*, Leipzig, 1899, pl. IV). Such bands are common in images of the Anastasis, issuing from Christ's body. Cf. the mosaic in the chapel of S. Zeno in Sta. Prassede, Rome (J. Wilpert, *Die römischen Mosaiken und Malereien*, Freiburg im Br., 1917, pl. 114, 4). (20)

151. For the Sun or Helios with single linear rays, cf. the Joshua scene in the Rabula Gospels, and the relief of the Sun in Corbridge cited in note 14 above. Both types of rays, the solid band and the linear, occur also in images of the phoenix: for the first, see the mosaic in Antioch cited in note 14; for the linear type, see examples I have cited in *The Art Bulletin*, 1952, p. 156 n. 56 [reprinted on p. 134, note 56, above]; for a list of examples on Roman coins, see L. Stephani, "Nimbus und Strahlenkranz," *Mémoires de l'Académie Impériale des Sciences de St. Pétersbourg*, 6e série (Sciences politiques, histoire et philologie), IX, 1859, pp. 444–446. For the nimbus with linear rays on solar figures carved on amulets, see Campbell Bonner, *Studies in Magical Amulets*, Ann Arbor, 1950, pl. XI, no. 236, pl. IV, nos. 83 and 86; and the same writer's article "Amulets chiefly in the British Museum," *Hesperia*, XX, 1951, pl. 97, no. 32. (21)

152. An interesting parallel to the three rays of Christ is the description by the Carolingian poet Sedulius Scottus (carmen 31) of an image of the personified Medicina painted in a hospital—she is represented with three rays issuing from her brow: "Haec regina potens rutilo descendit Olimpo. . . . Fronteque florigera cui lumina terna coruscant." (J. von Schlosser, *Schriftquellen zur Geschichte der karolingischen Kunst*, Vienna, 1896, pl. 381, n. 1027.) The analogy with Christ depended perhaps on the metaphor of Christ as *medicus* or *archiater* common since Origen. See R. Arbesmann, "The Concept of 'Christus Medicus' in St. Augustine," *Traditio*, X, 1954, pp. 1 ff. (22)

153. On the early types, see E. Weigand, "Der Monogrammnimbus auf der Tür von S. Sabina in Rom," *Byzantinische Zeitschrift*, XXX, 1929–1930, pp. 587–595, and especially p. 593. (23)

154. See *Cahiers archéologiques*, VII, pp. 143, 144. (24)

155. Cf. the mosaics of Sta. Maria Maggiore, Rome, *Adoration of the Magi* (van Berchem and Clouzot, *op. cit.*, fig. 51); Naples, Baptistry dome (*ibid.*, fig. 119); Albenga, Baptistery (*ibid.*, fig. 128); Ravenna, S. Apollinare in Classe (*ibid.*, fig. 202); the Cambrai *Apocalypse* (Boinet, *op. cit.*, pl. 106 B); the Milan gold altar of Wolvinius, *Nativity* and *Christ in Glory*; Codex Egberti, *Magi* (Goldschmidt, *German Illumination*, II, pl. 6). (25)

156. Cf. a Chnubis amulet reproduced by E. R. Goodenough, *Jewish Symbols in the Graeco-Roman Period*, III, New York, 1953, fig. 1096; a statue of Attis from Ostia in the Lateran Museum (F. Cumont, *Les religions orientales dans le paganisme romain*, 4th ed., Paris, 1929, pl. IV, opp. p. 66); a Gallo-Roman bronze figure of Dispater in the Walters Art Gallery (*The Journal of the Walters Art Gallery*, X, 1947, pp. 84 ff.); the nimbed bust of the Sun in

Vatican Ms. gr. 699, Cosmas Indicopleustes (C. Stornaiolo, *Le miniature della topografia cristiana di Cosma Indicopleuste*, Milan, 1908, pl. 52); Sacramentary of Henry II, Bamberg (A. Goldschmidt, *German Illuminations*, II, pl. 75); solar emblems on Gaulish coins (A. Blanchet, *Manuel du numismatique française*, I, 1912, fig. 107). F. Dölger, *Antike und Christentum*, VI, I, 1940, p. 31, interprets the end-points or knobs of the rayed nimbus or solar wheel as points of light (*apices*) rather than as stars. (26)

157. Cf. the Bamberg Apocalypse (H. Wölfflin, *Die Bamberger Apokalypse*, Munich, 1921, pls. 29, 31); Valenciennes, Bibl. mun. Ms. 99, fol. 23 (*Bulletin de la Société Française pour la Réproduction des Manuscrits à Peintures*, 6e année, 1922, pl. XXIII); Paris, Bibl. Nat., Nouv. Acq. lat. Ms. 1132, fol. 17. Cf. also angels with rayed nimbus and dots or little circles at the ends of the rays, in Trier Ms. 31 (Apocalypse), fol. 22, Cambrai Ms. 386 Apocalypse), fol. 13; Madrid, Bibl. Nac. HH58 (Beatus), fol. 96v, 97; *Annunciation* by Filippo Lippi, National Gallery, Washington, D.C. (rays with knobbed ends). (27)

158. See Andreas Alföldi, *Die Kontorniaten, Ein verkanntes Propagandamittel der stadtrömischen Aristokratie in ihrem Kampfe gegen das christliche Kaisertum*, I, Budapest, 1943, p. 133, no. 34, II, pl. XLIII, 7; Jocelyn M. C. Toynbee, *Roman Medallions* (*Numismatic Studies*, No. 5, The American Numismatic Society), New York, 1944, p. 236, n. 34, and pl. XXXIX, 5 (photograph). The same nail-headed rays appear on amulets of Chnubis, a lion-headed snake with solar affinities—see Bonner, in *Hesperia*, XX, 1951, pp. 339, 340, no. 65, and pl. 99, and copies in nos. 66, 67. Bonner regards all three as modern works based possibly on old models (see pp. 308 ff.). (28)

159. Van Berchem and Clouzot, *op. cit.*, fig. 247. (29)

160. In Civate, in the *Apocalyptic Vision of the Dragon*; in Saint-Savin, in the *Creation of the Sun and Moon*. (30)

161. Georg Swarzenski, *Die Salzburger Malerei*, II, Leipzig, 1914, pl. XXXIV, fig. 114. (31)

162. Berlin, Staatsbibliothek, Phillips Ms. 1676 (E. Arslan, *op. cit.*, pp. 42, 43). (32)

163. See Noemi Gabrielli, "Le miniature delle omelie di San Gregorio," *Arte del primo millennio* (Atti del II° Convegno per lo studio dell'Arte dell'alto medioevo, Pavia, 1950) Turin, n.d., pl. 149, pp. 301 ff. The same inscription LUX appears also in Vercelli, Bibl. capitolare Ms. LXII, fol. 22v, 103r. (33)

164. "Les fresques de Castelseprio et l'Occident," *Frühmittelalterliche Kunst in den Alpenländern* (Akten zum III. internationalen Kongress für Frühmittelalterforschung, September 9–14, 1951), Olten and Lausanne, 1954, pp. 85–93. (34)

165. *Ibid.*, p. 89. (35)

166. "Les fresques de Castelseprio," *Gazette des Beaux-Arts*, July 1950 (published in 1951), pp. 107–114, and especially pp. 113, 115. See also Grabar's book, *Byzantine Painting*, New York, 1953, p. 86. (36)

167. Landesbibliothek, Ms. 113, a fragment of Rabanus Maurus, *De institutione clericorum*; another example in a missal of the tenth century in the same library (Ms. D 3), in a drawing of the Crucifixion. Cf. also Carolingian examples in the Marmoutiers sacramentary, Autun, Bibl. mun. Ms. 19 bis (Boinet, *op. cit.*, pl. XLI), and Nancy evangiles (*ibid.*, pl. XXVII). For a clear example of the nimbus with nail-headed rays in the Utrecht psalter, see E. T. DeWald, *The Illustrations of the Utrecht Psalter*, Princeton, 1932, pl. XCI (fol. 57r). (37)

168. Ms. CLXV. Cf. N. Gabrielli, *op. cit.*, (note 33 above), pp. 303 ff. from which our figs. 7 and 11 are reproduced. (38)

169. See A. de Longpérier and E. Le Blant in *Mémoires de la Société des Antiquaires de France*, XXX, 1866, p. 111. The gem is now in the British Museum (no. 56231) and has been reproduced by Bonner, *op. cit.*, *Hesperia*, XX, 1951, pp. 336, 337, no. 54, pl. 98; for this information I am grateful to Mr. John Beckwith and Dr. A. A. Barb. Our Fig. 8 is from the engraving in Cabrol, *Dictionnaire*, s.v. "Gemmes," fig. 4945. (39)

170. A. de Longpérier and E. Le Blant, *loc. cit.* (40)

171. For later comment see, besides Bonner, *loc. cit.*, L Bréhier, *L'art chrétien*, 2nd. ed.,

Paris, 1928, p. 81; R. Zahn and J. Reil, "Orpheos Bakkikos," *Angelos*, II, 1926, pp. 63, 64; J. Reil, *Christus am Kreuz in der Bildkunst der Karolingerzeit*, Leipzig, 1930, p. 3. (41)

172. See Cabrol, *Dictionnaire*, s.v. "Gemmes," col. 846, fig. 5088 (The Hague Museum, *Entry into Jerusalem*), fig. 5090 (Lewis Collection, Corpus Christi College, Cambridge, *Crucifixion*). On the latter see also E. Babelon, *Bulletin de la Société des Antiquaires de France*, LVII, 1896, pp. 194, 195—he attributes the gem to Syria in the seventh or eighth century. Note also a trace of the same type of rayed cross nimbus in the encolpium of a gold cross in the Dzyalinska collection at Goluchow, an Italian work attributed variously to the sixth, seventh, and eighth centuries (Cabrol, *Dictionnaire*, s.v. "Assomption," col. 2993, fig. 1027). (42)

173. See *The Art Bulletin*, XXXIV, 1952, p. 160 [reprinted above, p. 106]. To the examples listed there should be added the Valenciennes *Apocalypse* (Ms. 99, fol. 3) and the recently discovered frescoes of the ninth century in St. John at Müstair (Switzerland) (L. Birchler, "Zur karolingischen Architektur und Malerei in Münster-Müstair," *Frühmittelalterliche Kunst in den Alpenländern*, Olten and Lausanne, 1954, pp. 167–252, fig. 96). An example in the Morgan Library *Beatus*, Ms. 644, fol. 9v (also fol. 181v), early tenth century, may go back to the model of the late eighth century. (43)

174. As on the hose of a Persian Magus in the Adoration scene in the Menologion of Basil II in Vatican Ms. gr. 1613 (Weitzmann, *The Fresco Cycle of S. Maria di Castelseprio*, Princeton, 1951, fig. 66), and as on the costume of lay figures in the tenth century Athens Ms. 211 (reproduced by Grabar in *Recueil d'études*, Seminarium Kondakovianum, V, Prague, 1932, pl. XVIII, 2). (44)

175. "Castelseprio and the Byzantine Renaissance," *The Art Bulletin*, XXXIV, 1952, p. 199, n. 70. (45)

176. Cf. the piece in Cologne—Peirce and Tyler, *L'Art Byzantin*, II, pl. 185, and also *Ars Orientalis*, I, 1954, pl. opp. p. 192 for an example in Dumbarton Oaks and one formerly in the Sangiorgi Collection. Dr. Florence Day (*ibid.*, p. 240) cites the shroud of St. Fridolin as the earliest example of the Amazon motif in silk, dating it in the sixth century, but notes that the type continues into the eighth century and into Islamic art. (46)

177. See *The Art Bulletin*, XXXIV, 1952, p. 160, for a brief account of its history [reprinted here, pp. 106–107]. (47)

178. "Die Denkmäler der karolingischen Kunst in Belgien," in *Belgische Kunstdenkmäler*, Munich, 1923, pp. 9, 19, figs. 8, 9. (48)

179. In the *Neues Archiv der Gesellschaft für ältere deutsche Geschichtskunde*, XXVII, 1901, pp. 267 ff. A. S. Cook has identified the name with another person ("Bishop Cuthwini of Leicester [680–691]," *Speculum*, II, 1927, pp. 253–257); but W. Levison, *England and the Continent*, 1946, pp. 133, 134, has rejected Cook's opinion and supported Traube. (49)

180. The form had already reached the North in the second half of the eighth century in late Merovingian art; it appears clearly in a manuscript of Corbie, Paris, Bibl. Nat. lat. 11627, fol. IV (E. H. Zimmermann, *Vorkarolingische Miniaturen*, Vol. II, Berlin, 1916–1918, pl. 109). (50)

181. *Die Elfenbeinskulpturen*, I, p. 9, fig. 5 (Staatsbibliothek Ms. 31, fols. 5, 6, 9, 17, etc.). On this manuscript see also W. Neuss, *Die Apokalypse des Hl. Johannes in der altspanischen und altchristlichen Bibel-Illustration*, I, Münster (Westphalia), 1931, 248 ff. [and most recently the facsimile edition: *Trierer Apokalypse* with commentary by Richard Laufner and Peter Klein, Graz, 1975]. (51)

182. See Neuss, *op. cit.*, pp. 248, 249. (52)

183. Reproduced by Goldschmidt, *loc. cit.* (53)

184. *Ibid.*, I, pl. 1 (the angel of the *Annunciation*). (54)

185. For the most recent reviews, see W. F. Volbach, "Ivoires mosans du Haut Moyen Age originaires de la région de la Meuse," in *L'Art mosan* (*Journal d'études*, Paris, February 1952), Recueil préparé par P. Francastel, Paris, 1953, pp. 43–46. (55)

186. *The Art Bulletin*, XXXIV, 1952, pp. 153, 154 [see pp. 88, 90, above]. (56)

187. A. Haseloff, *Pre-Romanesque Sculpture in Italy*, New York (1930?), pls. 48–50, and

articles by Hj. Torp and L'Orange in the *Atti del 2° Congresso internazionale di studi sull' alto medioevo*, Spoleto, 1953. (57)

188. C. Cecchelli, *I monumenti del Friuli del secolo IV all' XI*. I, *Cividale*, Milan and Rome, 194 , pl. I. (58)

189. Koehler, *op. cit.*, fig. 8. (59)

190. *The Art Bulletin*, XXXIV, 1952, p. 160 [see p. 107, above]. (60)

191. See Gabrielli, *op cit.* (note 163 above), pp. 303, 304, pls. CLVIII, CLIX. The author dates the manuscript in the last quarter of the eighth century, but the script points to the ninth. (61)

192. This detail does not appear on ecclesiastical or imperial dress in the painting of a council under Theodosius I (362) in Paris, Bibl. Nat. Ms. gr. 510 (Omont, *Manuscrits grecs de la Bibliothèque Nationale*, pl. L). (62)

193. Gabrielli, *loc. cit.*, pl. CLXIII (Council of Constantinople, 381). (63)

194. *Ibid.*, pl. CLXII. (64)

The Carolingian Copy of the Calendar of 354

(1940)

In an important article on the Calendar of 354, Dr. Carl Nordenfalk has shown with his usual acumen in matters of style the close relationship of figures in the Renaissance copies of this work to Roman art of the mid-fourth century, especially to the putti on the sarcophagus of Junius Bassus.[1] His analysis compels us to question the common view that the original Calendar belonged to the art of the Eastern Empire, if not to the Orient, as Strzygowski had maintained. However, Dr. Nordenfalk goes further and argues that the late copies by which we know the Calendar are better evidences of the original than has been supposed, for they were not made from a Carolingian copy of the lost original, but from the manuscript of 354 itself. The antiquarian Peiresc, who had the model of the Barberini copy in his hands in 1620, estimated its age as seven or eight hundred years; but Nordenfalk doubts that Peiresc was capable of judging correctly the antiquity of manuscripts, since Mabillon had not yet published his *De re diplomatica*, the first systematic work on paleography (1681).

It is the first time, to my knowledge, that the statement of Peiresc has been questioned. The opinion of Nordenfalk corresponds to the tendency among historians and paleographers to regard the judgments of script prior to Mabillon as necessarily worthless. It is easy to point to gross errors in the dating of manuscripts by editors of the sixteenth and seventeenth centuries—errors which are frequent enough in the eighteenth and nineteenth as well—but I believe it is a mistake to suppose that before paleographic knowledge had been systematized in a textbook, scholars like Peiresc (who had been trained in natural science and was accustomed to methodical observation and inference) could not form correct judgments about the antiquity of manuscripts.

For several reasons I am inclined to trust Peiresc in his estimate of the age of the model of the Barberini copy. In the first place, this copy includes minuscule writing that is apparently of Carolingian type (Fig. 1),[2] and in another copy (Vienna, Nat. Bibl. Ms. 3416, early sixteenth century) the base of a column in the image for the month of June has an unclassical, but

143

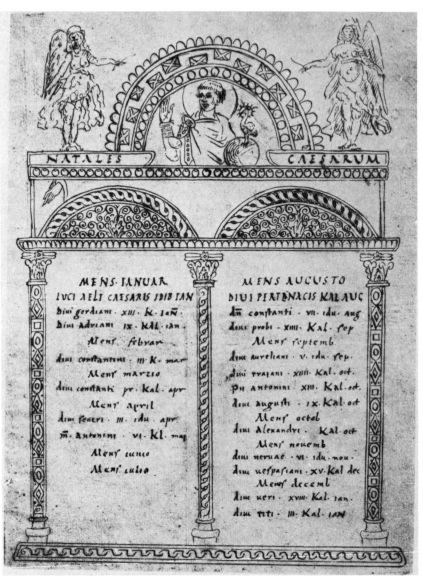

Fig. 1 Vatican City, Biblioteca Vaticana: Cod. Barberini lat. 2154, Calendar of 354, fol. 7. Natales Caesarum.

APORTA SCI PETRI USQUE AD
IND· circus flamineus·
Rotunda
Thermae commodianae
forum traiani &columna eius
Tiberis ARCUS
Sci hadriani
Scicyriaci FORUM
Sca agatha ibi imagines pauli & mariae· SUB
Therme constantini
Sci urbalis inuico longo ubi caual opt·
Sce eufemie inuico patricii
APORTA SCI PETRI USQUE AD POR
IN SINISTRA· PER AR
Sci apollinaris
Sci laurentii inlucina
Oboliscum FORMA UIRGI
Sci siluestri· ibi balneum
Sci felicis inpincis·

SCAM LUCIAM· INORTHEA·
INS· Sci laurentii indamaso·
Theatrum pompei· cypresus
Sci laurentii· capitolium·
Sci sergii· ubi umbilicu romae
SEVERI
Cauallus constantini
ROMANUM
URA·
pudentiana inuico patricii
laurentii informonso ubi ille assatusest
Iterum psubura· therme traiani adiuincula·
AM SALARIAM
CUM IND· circus flamineus ibi sca agnes·
Therme alexandrianae· & sca eustachii
Rotunda &therme commodiane
HIS· columna antonini
Sca susanna· &aqua deforma laterranense
Therme sallustiane &piramidem

Fig. 2 Einsiedeln, Stiftsbibliothek: Ms. 326, p. 397.

characteristically mediaeval, profile, with a high scotia.[3] In the second place, if Peiresc had been ignorant of the difference between classical and Carolingian scripts, he would more likely have regarded a Carolingian copy as antique than an antique work as Carolingian. The humanists in fact believed that there was a Roman minuscule book hand.[4] But the truth is that Peiresc, like other scholars before the time of Mabillon, was able to recognize late classical manuscripts. It was he who had the miniatures of the Cotton Genesis copied for reproduction; and in a letter on this manuscript he speaks of its "majuscules de la plus ancienne figure, qui se trouve dans les plus vieux manuscrits."[5] And although the opinion of his day referred it as far back as the time of Origen, he attributed the Genesis more correctly to a later time in Antiquity. Against Peiresc's judgment, Dr. Nordenfalk adduces the observations of lesser scholars of the Renaissance on the model of the Barberini copy: they refer to its "vetustissimis" and to its "antiquis plane characteribus." The presence of ancient capital forms in the Calendar surely did not escape the notice of Peiresc, who was one of the pioneers of classical epigraphy and had recognized the antiquity of the script of the Cotton Genesis. In the time of Peiresc, scholars already knew that classical forms had been reproduced in the Middle Ages. Toward 1620, the librarian of Robert Cotton, who dated the Canterbury Psalter (now British Museum Vespasian A 1) about A.D. 700, described its majuscules as "antiquo charactere."[6] The seventeen-year-old Grotius, editing in 1600 the text of the Leyden Aratus, a Carolingian manuscript of which the illustrations reproduce in part images of the Calendar of 354, said of its script: "Littera Romana, quam Capitalem vocant, multorum saeculorum praefert auctoritatem," but he observed also the corruption of the text—"miraberis quidem antiquitatem, sed ridebis turpissimos errores."[7] That some discernment of the differences between ancient and early mediaeval capital writing was possible before paleographic knowledge had been systematized in a treatise, we may judge from the fact that a layman like Montaigne could speak of mediaeval tendencies in the script of the late Roman Empire. In the account of his journey into Italy in 1581, he observes that a manuscript of Virgil in the Vatican has "those long thin characters which we see in the inscriptions of the time of the emperors; for instance, those of the period of Constantine which have begun to lose the square proportions of the antique Latin writings in the Gothic form." In this judgment, Montaigne was perhaps following critics like Erasmus for whom the majuscules on Roman coins were an "absolutissimum exemplum" and all else "Gothic."[8] But already in the middle of the sixteenth century, Pierre Hamon, the secretary of Charles IX, composed a book of specimens of ancient and mediaeval writing which was known to Mabillon and favorably cited by him in his *De re diplomatica.*[9]

Nordenfalk has argued that the faithful copying of so unique a work as a

calendar of the year 354 would be purposeless in the Carolingian period.[10] In saying this, he underestimates the interest of the scholars of the ninth century in Roman and early Christian antiquities. The celebrated Carolingian manuscript in the library of Einsiedeln, with the itinerary of Rome, contains not only topographical indications, but also a collection of pagan and Christian inscriptions of Rome (Fig. 2).[11] If the Carolingian manuscript were destroyed and we had only Mabillon's transcription and other seventeenth-century copies, we might be led to suppose by arguments such as Nordenfalk's that they were made from the original Roman inscriptions. There is another example of a late Roman secular manuscript reproduced in the Carolingian period and preserved for us through late Gothic and Renaissance copies of the mediaeval reproduction—the *Notitia Dignitatum Imperii Romani*. The evidences of a minuscule in the various copies of the lost codex of the cathedral of Speyer indicate that the antique original of the time of Theodosius was known only by way of a copy or descendant of the ninth century.[12]

If it is true, as Nordenfalk asserts, that the ornament of the copy of the calendar is thoroughly classical and shows no trace of an intermediate Carolingian hand (and this has still to be proved by investigation), it must be remembered that this ornament has a close resemblance to the architectural ornament of Carolingian manuscripts of the Palace school (e.g., the Schatzkammer Gospels in Vienna, the Gospels in the cathedral of Aachen),[13] which is also copied from late antique Italian works. The Leyden Aratus, a manuscript of the same school (or, at least, closely related to it), includes images of the months faithfully reproduced from the Calendar of 354,[14] and its paintings of the constellations, based on a model of the fourth or fifth century, are so classical in appearance that if they were known only through Renaissance copies, like the Calendar, it would be extremely difficult to detect the Carolingian intermediary through either script or miniatures. Nordenfalk reproduces figures of the Leyden Aratus beside the Barberini drawings to illustrate the stylistic kinship of the Carolingian work with the classic forms of the Calendar.

These facts strengthen the probability that the latter was indeed copied as a whole around 800. Together with the summary reclassicizing of the Carolingian model by the copyist of 1620, they would account for the rarity of obvious Carolingian traits in the Barberini version. Whether Peiresc's judgment was based on the script alone, or on the miniatures, or on some documentary evidence now lost, we cannot say. In any case, it is confirmed by Carolingian elements in the script of the copy. This conclusion does not weaken the force of Nordenfalk's comparisons of the Barberini copy with works of the fourth century; Carolingian artists were eminently capable of reproducing the forms of

that period. But it enables us also to account for the mediaeval traces in the Barberini manuscript.[15]

NOTES

1. *Der Kalendar vom Jahre 354 und die lateinische Buchmalerei des IV. Jahrhunderts* (Göteborgs Kungl. Vetenskaps . . . Saml. Handlingar, fol. v, ser. A., bd. 5, no. 2) Göteborg, 1936.

2. Professor Elias Avery Lowe of the Institute for Advanced Study, Princeton, is of the same opinion and writes me that "the minuscule is a humanistic version of the Caroline he (*sc.* the scribe) had before him."

3. Joseph Strzygowski, "Die Calenderbilder des Chronographen vom Jahre 354," *Jahrbuch des deutschen Archäologischen Instituts*, Ergänzungsheft I, Berlin, 1888, pl. XXIV; Nordenfalk, *op. cit.*, fig. 25.

4. Carl Wehmer, *Die Namen der gotischen Buchschriften*, Berlin dissertation, 1932, pp. 4, 5. Even Mabillon described the Caroline minuscule as "Romana minuta . . . quae a minutae Romanae forma paullum recedit" (*ibid.*, p. 10).

5. H. Omont, *Miniatures des plus anciens manuscrits grecs de la Bibliothèque Nationale*, 2nd ed., Paris, 1929, pp. 1 ff.

6. W. de Birch Gray, *The Utrecht Psalter*, 1876, pp. 83, 84.

7. Hugo Grotii Batavi, *Syntagma Arateorum*, 1600, "Notae ad Germanici Phaeno-mena," p.2.

8. Wehmer, *op. cit.*, pp. 3, 4.

9. H. Omont, *Le recueil d'anciennes écritures de Pierre Hamon 1566–1567* (Bibliothèque de l'École des Chartes, LXII), 1901, pp. 57–73.

10. *Loc. cit.*, pp. 7, 8. He believes that only a post-mediaeval copyist, with the peculiar historical consciousness of the modern period, would have reproduced the dedication page with the name of the scribe, Filocalus, and the patron, Valentinus. "It is a reasonable demand that if the model had really been a Carolingian manuscript, one must find in a more recent copy with the archaeological conscientiousness of the Barberini replica some traces, however slight, of Carolingian forms. These are completely lacking." The Barberini copyist was, incidentally, very attentive to the non-naturalistic conventions of perspective drawing in his model, and reproduced not only the broader aspects of the pre-Renaissance spatial forms of the miniatures before him, but also such details as the emphatically divergent lines of the parallels on the receding planes of the dice and the edicule-box on the table in the December page (*loc. cit.*, p. 13, fig. 3, and Strzygowski, *op. cit.*, pl. XXXII). It would be worth studying this page for light on the relations of classical and Carolingian styles as well as the Renaissance archaeological interpretation of these two.

11. Stiftsbibliothek Ms. 326. For the contents see P. Gabriel Meier, *Catalogus codicum manuscriptorum qui in bibliotheca monasterii Einsidlensis O.S.B. servantur*, I, 1899, pp. 297–300. Reproduced here in Fig. 2 after Bruckner (*Scriptoria medii aevi Helvetica*, I, Geneva, 1935, pl. XX) a page with rustic capitals and Caroline minuscule remarkably like the script pages of the Barberini Calendar.

Nordenfalk (*op. cit.*, p. 22, n. 1) has called attention to the fact that the text of the Calendar was copied in the ninth century, in the same Swiss region, in St. Gall Stiftsbibliothek, cod. 878.

12. Otto Seeck, *Notitia Dignitatum*, Berlin, 1876, "Praefatio." [It is attributed to the time of Arcadius by Professor Jonathan Alexander in a study of the copies in *British Archeological Reports: Supplemental Series 15*, 1976.]

13. *Der Trierer Ada-Handschrift* (ed. Janitschek et al.), 1889, pl. 18, 22.

14. Nordenfalk, *op. cit.*, pp. 28, 29; and more recently, James Carson Webster, *The Labors of the Months in Antique and Mediaeval Art*, Evanston and Chicago, 1938.

15. [See now in the thorough study of the Calendar by Henri Stern, *Le Calendrier de 354. Étude sur son texte et sur ses illustrations*, Paris, 1955, his comments, p. 19 and n. 4, on this article, with a letter of Wilhelm Koehler on the Carolingian model.]

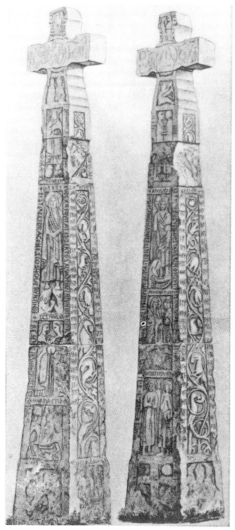

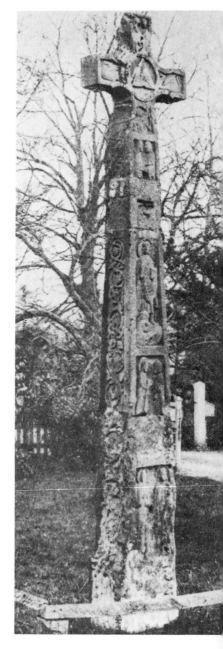

Fig. 1 Ruthwell: Cross, front (left) and back (right) from an old print in the church of Ruthwell.

Fig. 2 Ruthwell: Cross, back of Ruthwell cross.

The Religious Meaning
of the Ruthwell Cross

(1944)

I

1.

In the most thorough study that has been made of the Ruthwell Cross
(Fig. 1), the late Baldwin Brown came to the conclusion that this im-
posing work of the seventh century was erected to symbolize the triumph of the
cross.[1] His interpretation is supported by the Anglo-Saxon verses inscribed on
its side in runic characters, a poem of the *Dream of the Rood*, in which the
cross of Christ, speaking in the first person, recounts in passionate language its
own experience and testimony of the Crucifixion:

> Then the young hero, that was God almighty, stripped himself,
> Strong and steadfast; bold in the sight of many
> He mounted the high cross, that he might redeem mankind.
> I trembled when he clasped me; yet I durst not bow to the ground
> Or fall to the lap of earth, for I must needs stand fast[2]

Yet when we turn from these lines to the sculptured images beside them,
we find little that pertains directly to the poem. The *Crucifixion* is indeed there,
but is relegated to the lowest panel on the back of the Cross (Fig. 2); and the
subjects above it and in front hardly bear out Brown's interpretation. The
dominant theme is the figure of Christ standing on the heads of two beasts.
Above him is John the Baptist with the Lamb of God in his hands; below are
the hermit Saints, Paul and Anthony, dividing the loaf of bread brought by the
raven (Fig. 9). On the back, the central panel shows Mary Magdalen drying
the feet of Christ with her hair (Fig. 10). The other subjects (Fig. 1) from the
life of the Savior—the *Annunciation*, the *Visitation*, the *Flight into Egypt*, and
Christ Healing the Blind Man—are not arranged in a narrative sense or tied
together by any thought concerning the Crucifixion. The Passion of Christ, the
incidents preceding and following the Crucifixion, are absent. If these images

151

Fig. 3 Ruthwell: Cross, left, Christ Standing on the Beasts; Bewcastle: Cross, right, Christ Standing on the Beasts.

were designed to celebrate the cross, their choice and grouping are unique in mediaeval art.

The writers on the Ruthwell Cross have said little, if anything, about the integration of the religious themes of the carvings. Each of these has been studied in itself, identified, classified, and compared with other versions; but no one has inquired into the particular combination: why, for example, Christ with the beasts is linked with Sts. Paul and Anthony, and why the unusual subject of *Mary Magdalen at the feet of Christ* enjoys so prominent a place on the back of the Cross. If the unordered elements of a short narrative cycle of the life of Christ may be disengaged from the ten panels of the shaft, it is unclear why the *Flight into Egypt* has been chosen, but not the *Baptism* or the *Adoration of the Magi* or the *Entry into Jerusalem*, which are surely more important for cult. And why is the *Healing of the Blind Man* selected from among all the miracles of Christ? I have found no Early Christian work which might have served as the model for this general choice.[3]

If there was indeed the intention to represent the life of Christ by several momentous scenes of the Gospels, it must also be assumed that a second and parallel aim determined the selection of the other and more prominent subjects. The key to these will be found, I believe, in the sculpture of Christ and the beasts (Fig. 3). Its large size is already a judgment of its place in the total scheme and compels us to see the smaller surrounding panels in relation to it.

This dominating figure of Christ has always been regarded as an illustration of Psalm 91, 13: "Thou shalt walk upon the asp and the basilisk: and thou shalt trample under foot the lion and the dragon." ("*Super aspidem et basiliscum ambulabis, et conculcabis leonem et draconem.*"—Vulgate, Psalm 90, 13).[4] As such it is an emblem of Christ's power over evil and is often represented in English manuscripts of the early Middle Ages (Fig. 4). Its frequency in the North has to do perhaps with the primitive taste of the Anglo-Saxon tribes for imagery of heroic combats with wild beasts and monsters, as in Beowulf and the pagan legends.

But the inscription around the sculpture belongs to another world: IHS XPS: JUDEX AEQUITATIS: BESTIAE ET DRACONES COGNOVER-UNT IN DESERTO SALVATOREM MUNDI (Jesus Christ: the judge of righteousness: the beasts and dragons recognized in the desert the savior of the world). Unlike the verse in the ninety-first Psalm, there is no suggestion here of violent domination.

What is the source of this inscription?

I have found no passage precisely like it in the Bible. The initial words JUDEX AEQUITATIS are a frequent attribute of God in the Psalms ("judicas populos in aequitate"—Psalm 66, 5; cf. also 9, 9; 95, 10, 13; 99, 9), and the rest is undoubtedly an interpretation of Mark i, 13—"And Christ was in the

desert forty days and forty nights and was tempted by Satan; and he was with the beasts and the angels ministered to him." *("Et erat in deserto quadraginta diebus et quadraginta noctibus, et tentatus a Satana; eratque cum bestiis, et angeli ministrabant illi.")*

The sculpture represents, then, Christ with the beasts in the desert, according to Mark, although the pattern of the image is the familiar type of Christ treading on the lion and the dragon. The assimilation is not surprising, since there is an exegetical link between the two subjects. The motif of Christ in the desert belongs to the Temptation, which already in the Gospels is connected with Psalm 91. In the accounts of the episode in Matthew (iv, 6) and Luke (iv, 10, 11), the devil, in urging Christ to cast himself down from the pinnacle of the temple, quotes Psalm 91, 11, 12: "For it is written, He shall give his angels charge concerning thee: and in their hands they shall bear thee up, lest at any time thou dash thy foot against a stone." Jesus will not tempt the Lord, and the commentators celebrate his victory over the devil by quoting the next verse of Psalm 91, in which the feet of Christ trample on the monsters and wild beasts that symbolize the demon.[5] This passage is implicit for the commentators in the Gospel story and completes the episode of the Temptation; it reveals the deceit of the devil, who, in quoting scripture leaves out, like the heretics, the essential concluding lines that betray him.[6] In a number of mediaeval psalters, Psalm 91 is illustrated by a scene of the Temptation (Fig. 5),[7] and in one of them, a manuscript of the Carolingian period in Stuttgart, both the Temptation and the figure of a militant Christ on the beasts are represented on the same page of this text.[8]

On the Ruthwell Cross this connection has another sense, as appears already from the inscription; it is not the power over evil that matters here so much as the fact that the animals in the desert acknowledge the divinity of Christ. That the sculptor had this in mind is evident from the way in which he has changed the traditional type of Christ over the beasts in adapting it to his peculiar text.[9] In Ruthwell, Christ bears no cross, nor does he transfix the animals with a spear, and the attitude of the two creatures is not that of enemies which are being trodden underfoot and crushed, with inclined heads and twisted resisting bodies that convey the full malignity of the monsters; but the two beasts are reduced to identical anonymous heads, raised toward Christ, and with paws lifted in a gesture of adoration or acknowledgment, as implied in the adjoining inscription. They are more like the harmless ox and ass who recognize the infant Jesus in the Nativity, or the lions who lick the feet of Daniel, or the Symbols of the Evangelists turned toward the central figure of the Lord in early Western images.

This motif of Christ with the beasts in the desert is one of the rarest in mediaeval art.[10] The few examples that I have been able to find are not equally

Fig. 4 Vatican City, Biblioteca Vaticana: Regina lat. Ms. 12, Psalter from Bury St. Edmunds, fol. 98. Christ Standing on the Beasts.

Fig. 5 Boulogne-sur-Mer, Bibliothèque Municipale: Ms. 20, Psalter from St. Bertin, 989–1008, fol. 101. Temptation of Christ.

clear and show different interpretations of the biblical text. In a drawing of the first Temptation, in a psalter of the period around 1000 from the Abbey of St. Bertin, the tempted Christ stands on the lion and the dragon, the latter being adroitly assimilated to the tail of the initial Q which frames the scene—the first letter of Psalm 91 (Qui habitat ...) (Fig. 5). In appropriating literally the Gospel reference to beasts in the Temptation, the artist has fused into one image the two traditional ways of illustrating this psalm: by the figure of Christ on the beasts and by the Temptation; and in isolating the lion and the dragon, he has apparently followed the commentary on Mark by Jerome, who identifies the beasts of the Temptation with the lion and the dragon trodden by the Lord.[11] Although it is so much later than the Ruthwell Cross, the example is interesting as the product of a scriptorium on the English Channel, strongly influenced by Anglo-Saxon art.

The same thought appears in Romanesque art in another form. On a Spanish stone relief of the twelfth century in New York (Fig. 6), Christ stands on a single beast—apparently a lion—in each of the three Temptations.[12] The repetition of the theme of Christ on the beast gives to the series of episodes a primitive, incantatory character; the narrative is at once more schematic and yet more complete than the usual renderings of the incident.

On another Spanish tympanum, on the Portal of the Goldsmiths in Santiago,[13] the beasts are represented by a serpent coiled around a tree. Here there is the subtler thought, found also in the *Biblia Pauperum*,[14] that Christ's Temptation reenacts the Temptation of Adam and Eve and through his victory prepares the redemption of man. The desert becomes an ambiguous concept in this work, for it is both the fearful wilderness, uninhabited by man, and the earthly paradise where the first man lived in harmony with the beasts. This double sense confronts us again in an Italian drawing of the eleventh century in the Gospels of Matilda of Tuscany in the Morgan Library (Fig. 7),[15] in which the animals seem to be merely the inhabitants of the desert, a means of rendering the wild setting of the Temptation in a more concrete form, yet the birds and small creatures in the luxuriant shrubbery remind us more of an Eden than a desert; they are, in any case, far from the symbols of demonic evil discerned by the old commentators, who assigned a special significance to each of the four monsters listed in Psalm 91. In a Catalonian drawing of the same period in Gerona,[16] illustrating a homily on the Temptation, the scene of Christ among the beasts has been detached from the encounter with the devil as an independent subject. Here there is no wilderness of bushes, as in the Italian miniature, and the animals are grouped formally below Christ and the ministering angels, without any suggestion of conflict. Finally, and most explicit for our problem, there is a Catalonian painting of the later fourteenth century, in which the *Temptation of Christ*, illustrating Psalm 91, concludes with an

Fig. 6 New York, The Metropolitan Museum of Art, The Cloisters Collection:
Tympanum, Spanish, twelfth century. Temptation of Christ.

image of Christ in the desert among the adoring animals (Fig. 8), a peaceful congregation quite Franciscan in spirit.[17]

It is this conception of the phrase in Mark that the authors of the Ruthwell Cross had in mind in writing "bestiae et dracones cognoverunt in deserto salvatorem mundi." The inscription goes beyond the moral meaning of the Temptation into another religious sphere and draws upon an old Messianic wish that for centuries nourished the fantasy of hermit monks and religious reformers. It is expressed in the Apocalypse of Baruch, a Hebrew book contemporary with the Gospels: "And wild beasts shall come from the forest and minister unto men, and asps and dragons shall come forth from their holes to submit themselves to a little child" (lxxiii, 6).[18] This Messianic vision of the peaceful kingdom of God, a return to a primitive state of harmony with nature, inspired the legends of wild animals adoring the young Jesus during the flight into Egypt in the Latin apocryphal Gospel of the pseudo-Matthew, the same work that gave to mediaeval art the motif of the ox and the ass at his birth (chap. xiv). Dragons come out of a cave where the holy family is resting and adore the infant Jesus (chaps. xviii, xix); later, the lions and leopards worship him and accompany the family in the desert (chap. xxxv).[19] The remoter source of these legends is the eleventh chapter of Isaiah which concludes the supposed prophecy of the birth of Christ from the line of David ("And there shall come forth a rod out of the root of Jesse . . . "), with a promise of God's justice, in words like the inscription, "Judex aequitatis . . . ," and of the Messianic concord of the animal kingdom.[20] A passage in another chapter of Isaiah, that the ox knows his owner and the ass his master's crib (i, 3), perhaps supplied, directly or indirectly, the "cognoverunt salvatorem mundi"; the same verb appears also in the pseudo-Matthew as a description of homage and obedience.[21]

In Early Christian and mediaeval commentaries on the Temptation of Christ, this interpretation is exceptional.[22] It was undoubtedly more common in the earliest centuries of the church, to judge by the references to the Messianic kingdom in the writings of that time. Irenaeus in his treatise on heresies reports that old men who knew John had heard through him the words of Christ that animals shall be peaceable and in concord with one another, and subject to man with all obedience.[23] This was perhaps the original sense of Mark's phrase about the sojourn of Christ with the animals, and I may venture the theory that it was replaced after the establishment of the church as an authoritative, state-supported power by the familiar interpretation which affirms the triumph of Christ over his enemies and the militant strength of the Lord. But a phrase in the prologue placed before the Gospel of Mark in numerous manuscripts of the Latin Vulgate since the sixth century indicates that the ancient meaning was available throughout the Middle Ages. The unnamed author of the prologue, in a summary of the contents of Mark, after listing the expulsion of Christ to

Fig. 7 New York, Pierpont Morgan Library: Ms. 492, Gospels of Matilda of Tuscany, fol. 42v. Temptation of Christ.

Fig. 8 Paris, Bibliothèque Nationale: Ms. lat. 8846, English psalter, *ca.* 1200, fourteenth-century Catalonian miniature. Temptation of Christ.

the desert, the numbered days of fasting, and the temptation by the devil, speaks of the "fellowship with the beasts and the ministry of the angels" ("congregationem bestiarum et ministerium angelorum").[24] This phrase could hardly have signified the figures of evil; it is the same Messianic sense of the "congregatio bestiarum" that is clearly illustrated in the late Catalonian miniature (Fig. 8). The prologue is probably older than Jerome's translation of the Gospels, having been traced in part to a circle of Monarchian heretics in Rome in the later second or early third century A.D., a period when Messianic ideas were still alive. But in its mediaeval form, including the account of the Temptation, the prologue is believed, for reasons of content and style, to be the work of a Priscillianist heretic of the fourth century, perhaps Instantius.[25] As we shall see presently, this conception of Christ and the beasts, abandoned by the triumphant church of the fourth century, which adopted the interpretation offered by Eusebius, the panegyrist and historian of Constantine, survived through the Middle Ages among the hermit monks and the independent religious spirits, like St. Francis, who were possessed by a more spontaneous and lyrical Christianity and took as their model the Christ of the desert or the open country and the streets.

2.

This interpretation of the relief of Christ and the beasts permits us to understand the choice of the surrounding subjects.

The figure of Saint John the Baptist above is a prototype of Christian asceticism, the man who lived in the wilderness on locusts and wild honey. Below the fasting Christ in the desert are the hermits Paul and Anthony, sharing the bread delivered by the raven (Fig. 9).

For Anglo-Saxon tradition, those two fathers of the desert were the first monks and the founders of the first monastery. In a vernacular dialogue of the ninth century, *Salomon and Saturn*, the question is asked: "Tell me, what man first constructed a minister? I tell thee, Elijah and Elisha the prophets, and after Baptism, Paul and Anthony, the first anchorites."[26] Aldhelm, an older English author, contemporary with the Ruthwell Cross, had already named Paul and Anthony and John the Baptist as the founders of monastic life.[27] In the biography of Guthlac, an English hermit of the same period, the devils who wish to tempt him to excessive fasting, propose as models Moses, Elijah, Christ, and the Egyptian monks of the desert.[28] All these names had been associated already by Latin writers of the fourth and fifth centuries,[29] but in the early Middle Ages there is no country where this tradition appears to be as strong as in the British Isles. The name of the Egyptian Paul occurs regularly in the old English calendars with the phrase, "the first hermit."[30]

The particular incident chosen from the story of Paul brings us closer to the meaning of the central scene of Christ and the beasts. The inscription reads: SCS PAULUS ET ANTONIUS EREMITAE FREGER(un)T PANEM IN DESERTO. In his Life of Paul,[31] Jerome tells how the hermit saint was fed in the desert by a raven that brought him daily half a loaf of bread. But on the day that Anthony paid him a visit, the raven brought a whole loaf, and a dispute arising as to who should break the bread, the two hermits compromised and broke the bread together. It is this moment of the legend that is rendered, for the first time perhaps, on the Ruthwell Cross and repeated on Scottish and Irish crosses in the next centuries.[32] It is also the central episode in the paragraph devoted to Paul in an Anglo-Saxon martyrology.[33]

Besides the possible eucharistic significance of the miraculous provision of bread to the hermits who are far from the ministrations of priests, the story has another meaning. It belongs to a common and rich class of tales about the harmony of the saints with the animal world, in which beasts or birds submit or minister to the holy men and are in turn befriended by them. When Anthony visits the hermit Paul and finds the door closed, he asks, "You, who receive beasts, why do you keep out a man?"[34] The particular legend about the anchorite Paul undoubtedly comes from the story of Elijah fed by a raven in the wilderness.[35] Elijah is the prophet of the desert and is never far from the thoughts of the hermits; he is a holy man also for the Bedouins and the founders of Islam.[36] (Even the detail of the doubled ration for the visit of Anthony is in keeping with the character of Elijah as a sort of guardian of hospitality who tests the virtue of those on whom he calls in his wanderings.) The theme of the hermit and the raven occurs again in the Anglo-Saxon martyrology in the account of Saint Erasmus, a bishop "who went into the desert and lived there seven years; a raven brought him food there, and divers wild animals came and honored him."[37] This class of animal tales was propagated throughout Christendom in the writings about the Egyptian desert fathers[38] and received a fresh elaboration in the West in the lives of the British, Irish and Anglo-Saxon saints.[39] The monasticism of the islands in the sixth and seventh centuries was patterned on the example of the Egyptian anchorites. In an Irish poem attributed to Columbanus, Christ is called the "great abbot." The name "desert" was attached to a number of Celtic monastic establishments,[40] and Alcuin, in calling the Irish clergy "pueri egyptiaci," had in mind their strenuous emulation of the original desert fathers as well as their pretense that their unorthodox computation of Easter followed an Egyptian canon.[41] In retiring to the wilderness, the hermit monk returns to a state of nature; he attempts to attain the spiritual felicity of Adam before the fall. He lives with the beasts and is recognized by them as a friendly being rather than as the born enemy of the animal kingdom. This creature who strives to overcome his

Fig. 10 Ruthwell: Cross. Christ and Mary Magdalen.

Fig. 9 Ruthwell: Cross. Paul and Anthony Sharing the Bread.

impulses by constant self-deprivation comes to imagine his ascetic solitude as a recovery of the happy innocence of the first man in Eden. When he comments on Genesis (chap. i), Bede thinks of the hermit among his animals: "As a testimony of the first days of creation we read that the birds paid homage to the holy man who served God humbly and that the snarling of the beasts had ceased and that the serpent's poison could not harm the saints."[42] This idea had already occurred to the authors of the lives of the desert saints. An Eastern hagiographer, in telling the story of the lion who was relieved of a thorn in his paw by the hermit Gerasimus (in time, Jerome!) and who wept over the grave of his benefactor, writes that "all this was done, not because the lion had a rational soul, but because God wished to show how the first man held the beasts subject to himself, before his disobedience and his expulsion from Paradise."[43]

In the North, Cuthbert and Guthlac, the chief Anglian saints contemporary with the Ruthwell Cross, are described as heroic anchorites who exert a marvellous power over the beasts in the wild uninhabited regions where they dwell in religious contemplation. "And not only were the birds subject to Guthlac, but also the fishes and wild beasts of the wilderness all obeyed him, and he daily gave them food from his own hand, as suited their kind."[44] Cuthbert has his ravens who bring him swine's lard before his feet in penance for a sin. And when he comes out of the water, after a night-long vigil in the sea, and kneels in prayer, "two otters emerge from the depths, lie down on the sand before him, breathe upon his feet and wipe them with their hair; after having received his blessing, they return to their native element."[45]

This image of Cuthbert and the otters reminds us of the two central panels on the Ruthwell Cross, not only of Christ with the beasts but also of Mary Magdalen drying the feet of Christ with her hair (Fig. 10). The formal resemblance of these two reliefs, the analogy of Mary Magdalen and the beasts at the feet of Christ, suggests a parallel symbolism of the submission of the demonic and the sinful to Christ. But a more positive monastic sense underlies this relief as well as the first. Mary Magdalen, wiping the feet of Jesus with her hair (Luke vii, 37, 38), after having moistened them with her tears and anointed them with perfumes, is the traditional Christian figure of the contemplative life. In the Gospels it is not clear that the repentant sinner, Mary, at the house of Simon, and Mary Magdalen from whom Christ had expelled the seven devils (Luke viii, 2), and Mary, the sister of Lazarus, are one person; but Western commentators identified them as the same individual, who became in time the model of female asceticism and penitence. The words of Christ, "But one thing is needful, and Mary has chosen that good part, which shall not be taken away from her," in reply to Martha's complaint that Mary "sitting at his feet was not helpful and had left her to serve alone"

(Luke x, 41, 42), were cited as a basic justification for withdrawing from the world in tracts on the superiority of monastic life. John Cassian, the author of a widely read work on ascetic practice, in quoting this speech, remarked, "You see then that the Lord has placed the chief good in theory alone, that is, in divine contemplation."[46] This was also the thought of Jerome in his famous letter to Eustochium,[47] and of Pope Gregory[48] and Bede,[49] although Gregory, responsible for the church, qualifies the doctrine to preserve at least the value of practical affairs: "Martha is not reprehended," he says, "but Mary is indeed praised; for the merits of an active life are great, but those of a contemplative life still better."[50]

As a result of the studies of Duchesne,[51] the story of the Magdalen as a recluse is generally believed today to have been fabricated in the eleventh or twelfth century in order to maintain the pretensions of the monks of Provence and Vézelay that they possessed her bones. It is true that the legend was propagated and enriched by these interested groups; but it had existed already for centuries in England, where the story of Mary the Egyptian had been grafted on to the Magdalen's. In the Anglo-Saxon martyrology already cited, Mary is described as a repentant sinner who lived for thirty years in the desert. The episode from the Gospel, represented on the Cross, is also told here, in almost literal agreement with the inscription.[52] This vernacular martyrology is of the mid-ninth century, but it was copied from a native Latin work composed around 750.[53] The sculpture suggests that the legend had assumed its typical mediaeval form in England as early as the seventh century. The priority of England may be explained by the common English institution of the double monastery, often under the rule of an abbess.[54] It was at such a convent, governed by the famous Hilda, that the Synod of Whitby was held in 663. The importance of female ascetics in England perhaps inspired the elaboration of the legend of the Magdalen as an imposing prototype.

The remaining scenes of the shaft are not so readily comprised within this broad ascetic conception. The *Visitation* (Fig. 2), above the panel of Mary Magdalen, may be connected with the figure of John the Baptist on the same level on the front face; the meeting of Mary and Elizabeth foretells the meeting of John and Christ.[55] And the *Flight into Egypt* was placed under Paul and Anthony perhaps because of the common Egyptian setting of the two subjects.[56] We have seen before how the Flight is the occasion for typical eremitic miracles with beasts in the apocryphal pseudo-Matthew. Thus at least six of the ten panels of the shaft would belong to the central and dominant group of ascetic-monastic figures directly or by association. But it must be admitted that no inscription or text confirms the connection of the last two scenes with the more obviously ascetic types. It is chiefly the large central reliefs with the dominating figure of Christ which are the carriers of the eremitic idea. The narrative cycle

of Christ, if it may be called such, is a secondary matter subordinated to the first conception. The *Nativity* (which has been proposed as the subject of the illegible lowest panel on the front of the Cross) was conceivably connected with the latter through the ox and the ass; but it is so mutilated that we can no longer discern the beasts. If they were originally present in this scene, we could speculate on the remarkable fact that the front of the Cross has animal figures or a legend of animals in every field: the four Symbols of the Evangelists and the lamb at the top, the lamb of Christ in John's hands, the beasts at the feet of Christ, Paul and Anthony served by a raven, the donkey of the *Flight*, and the ox and the ass in the *Nativity*, whereas there are none in the religious reliefs on the rear.[57] Pre-occupied with the beasts who acknowledge the divinity of Christ, the authors are led to surround him with related objects; by a common process of poetic imagination, the central idea on the main panel attracts the themes with corresponding and reinforcing elements.

It will be asked whether a unifying source of the eremitic and Gospel subjects does not exist in the liturgy of the church in the Gospel lections or homilies for certain days. The question suggests itself since the account of the Temptation of Christ, who fasted forty days in the desert, is a common Lenten reading; Matthew iv, 1 ff. is the lection for Quadragesima in the pericope of the Lindisfarne Gospels.[58] Moreover, John xii, which describes Mary Magdalen anointing Christ, was the reading for the last Sunday in Lent in English manuscripts, so that the two central subjects of the Cross span the period of Lent. In a French manuscript of the thirteenth century in Lyons, the Temptation of Christ is illustrated in the initial *C* of the collect for the Monday of the first week in Lent and is followed by an initial *L* with Mary Magdalen wiping the feet of Christ with her hair at the house of Simon.[59] This parallel to the images on the Cross confirms the ascetic interpretation, suggesting at the same time a penitential nuance, but does not provide a particular liturgical source for the Cross as a whole or for a considerable group of subjects. I have found no liturgical or homiletic text in which a large number of the themes of the Cross appear together, or even the central group of ascetic subjects. On the other hand, the closest connection with the Crucifixion that I have been able to discover is in the chapter on Palm Sunday in the *Speculum ecclesiae* of Honorius of "Autun."[60] He begins with the citation of Psalm 91, 13, explaining the four beasts as sin, death, Antichrist, and the devil; Christ steps on the lion and dragon when he endures temptation humbly and persecution patiently. Honorius then turns to the Raising of Lazarus as an example of Christ's power over death and mentions the previous miracle of the healing of the boy blind since birth. He tells further of Mary anointing Christ's head with oil and of the objections of Judas. Four of the subjects of the Cross appear together here, although in discrepant texts, and all in the context of the

Passion. But this tie seems to me less significant and rich, less adequate for the Cross as a whole, than the ascetic idea which accounts also for John the Baptist, Paul and Anthony, Mary at Christ's feet, and the special content of the inscription around the central figure of Christ.

What is the relation of the ascetic subjects to Eastern monastic art? In some Byzantine psalters, Psalm 91 is illustrated by the *Flight into Egypt* and the *Temptation of Christ*,[61] but I am acquainted with no Greek or Coptic or Syriac work that corresponds more fully to the content of the Cross. Single figures and groups as formal types might have been copied from foreign art, but taken together they form through their content a unique religious ensemble, to which we cannot find even an approximation elsewhere. The one subject that represents an Egyptian legend, the story of Paul and Anthony, is already significantly Western in an essential detail. In choosing the incident of the miracle of the raven, the authors of the Cross isolated the moment of the sharing of the bread, an episode unknown in the Greek stories of the hermits, but recounted in the Latin Life of Paul by Jerome.[62] In a fresco of the sixth or seventh century on the walls of the ruined abbey of Deir-Abu-Makar in Egypt,[63] the raven brings the bread to Paul alone; as in Byzantine paintings of the feeding of Elijah, there is no hint there of the division of the bread with Anthony, or even of the meeting. The latter is probably a Western invention, or at least a theme adopted by the West because of its suggestion of communion and mutuality. The Coptic version represents a purely individual asceticism; the insular one, which appears also on the Irish crosses,[64] pertains to a more fraternal cenobitic ideal, however severe its discipline and passionate its longing for solitude. If Paul was the first hermit, Paul and Anthony together founded the first monastery, according to the Anglo-Saxon dialogue which I have quoted.[65] With all their fanatical admiration for the example of the Egyptian hermits, the early monks of the British Isles were finally molded into a more sociable, communal pattern, culminating in the rule of Saint Benedict.

3.

This interpretation of the eremitic content of the sculptures agrees, we shall see, with the conditions of the place and the historical moment.

The dating of the Cross has ranged from the seventh to the twelfth century, but its origin toward the end of the seventh is accepted today by an increasing number of students.[66]

Nothing seems to be known about the early history of the site. No written record permits us to understand why this great stone shaft was erected here. The Cross is indeed the only surviving document of the early history of Ruthwell.[67]

But if we consider the history of the region as a whole, the origin of the Cross in that part of Britain will be more intelligible.[68]

Ruthwell lies in Dumfriesshire, near the English-Scottish border, in the old Welsh kingdom of Strathclyde (Fig. 11), a section inhabited in the seventh century by British tribes who had been conquered by the Northumbrian Angles. The struggles between these Celtic natives and the Northumbrian rulers filled the entire century. They are recounted in Bede's *Ecclesiastical History*, of which the last paragraph (v, 23), written in 731, tells of the persistent enmity of the Britons.[69] They had been beaten at Chester between 613 and 616 by the Anglian king, Aethelfrith. A British king in turn defeated and killed his Northumbrian overlord, Edwin, in 632. In the following years, the Northumbrians, at first under Oswald and then under Oswiu (641–670), conquered Strathclyde; but the Northern Picts and the Britons rose against the latter's son and successor, Ecgfrith, and slew him in the battle at Nechtanesmere in 685. This was the end of Northumbrian power in that region and marks the beginning of the general decline of the kingdom. Since the Ruthwell Cross is in form an object of Northumbrian type, and is inscribed with a poem in an early Northumbrian dialect, it must precede that date. And this agrees with the date of the similar cross at Bewcastle (Fig. 3), which is in Anglian territory and commemorates by a vernacular inscription Ecgfrith's brother, Alcfrith, a local ruler who was active around 663.[70]

The struggle between Britons and Angles has also a religious aspect, no less interesting for the history of the Cross. The first wars between the northern Britons and the Angles, in the beginning of the seventh century, were battles between Christians and pagans. At Chester, the pagan king Aethelfrith massacred the British monks from Bangor who had come to pray for the victory of their people. The subsequent conversion of the Angles was effected by the Irish and Scottish monks from Iona and Augustine's Roman mission, two rival efforts which came into sharpest conflict in Northumbria. After the baptism of King Edwin by Paulinus of Canterbury in 627 and his defeat by the Britons in 632, the Angles in the North had been Christianized around 635 by monks from Scotland. The center of the Northumbrian church was the monastery of Lindisfarne, established by Aidan of Iona. In this Northumbrian Christianity, the Angles adopted the religious forms of the Celtic peoples whom they had subdued with the sword. The Northumbrian church in its beginnings was, like the Irish and British churches, a monastic movement led by abbots and monks inspired by the example of the desert fathers, and coinciding with a wave of most intense asceticism in the Celtic world. The chief Anglian saints of the seventh century, Cuthbert and Guthlac, were followers of Celtic ascetic practice. The Latin life of Guthlac written shortly after his death in 709, is patterned on the life of Anthony by Athanasius; his gruesome temptation by

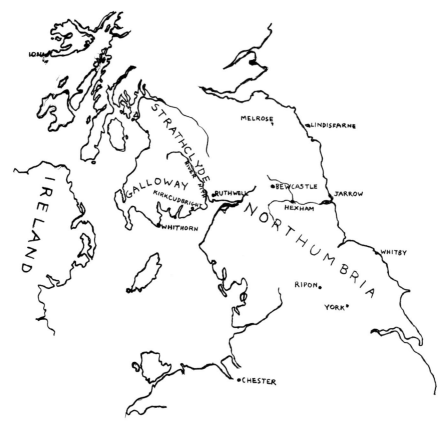

Fig. 11 Map of Northern England and Scotland.

the demons reenacts the temptation of the Egyptian hermit.[71] Cuthbert, who was called from solitude to serve as Bishop of Lindisfarne, retired again to the wilderness. In the early Northumbrian church the episcopal functions were secondary, and the monastery enjoyed a greater spiritual power than the secular church. It imposed a rigorous ascetic life, prolonged fasting, severe penance, and a strong discipline under the iron rule of the abbot. Its chief liberty was the traditional flight from the abbey for the solitude of wild places.

Toward 660, this native church had to contend with the growing force of the Roman rival in the south. Both churches were expanding then, the Northumbrians having sent successful missions to Middle Anglia and to Mercia. But the younger generation of the clergy in the north, some of whom had lived on the continent, was drawn to the Roman church. The high point of the religious struggle coincided with the farthest advances of the Northumbrian king into British and Pictish territory and his rising power in the whole Anglo-Saxon world. In the 650s Oswiu was overlord of the greater part of the southern English peoples. For a new and expanding kingdom, embracing several regions and peoples, the Roman organization, centered in the bishop and closer to practical life, was more adequate than the primitive ascetic forms of the loosely organized Celtic churches. King Oswiu and his sons, at first friendly to Iona, were won over to the Roman party. The new men of the Northumbrian church, Wilfrid and Acca, were organizers and builders who wished to draw the Anglo-Saxon world closer to the continent and the heritage of ancient culture.[72] Their work anticipates the Carolingian Renaissance, and the figure of Alcuin of York, a disciple of a disciple of Bede, is the bridge between these two phases in the Romanizing of northern Christianity. The art of Northumbria in the later seventh century, like its Latin writing, shows the reception of southern forms in numerous details.

The victory of the Roman party was not won without a struggle. The battle was fought on seemingly trivial issues, on points of doctrine and rite which cloaked or symbolized the more serious differences. In the histories and letters of the time, the method of cutting the hair of the clergy and the rules for fixing the date of Easter are the matters that divide the Roman and the native church. But the two institutions were also opposed in their liturgy, their mode of baptism and of ordaining bishops, and in the general conception of the structure and discipline of the church. In defending himself against his detractors at a synod in 704, Wilfrid listed as his accomplishments that he was the first to root out the poisonous weeds planted by the Scots, that he converted the whole Northumbrian race not only to the true Easter and tonsure, but also to the correct rite and chant, and that he introduced the Benedictine rule among them.[73] The conflict was finally between a particularist monastic church, shaped by the conditions of tribal society, and a church which aimed at

universality and the integration of local peoples into the larger ambient of European and Mediterranean life. Behind these religious differences lay the activating conflicts of the social and political sphere, brought on by the Anglo-Saxon conquest of the country and the formation of the Northumbrian state. At the Synod of Whitby (the ancient Streoneshalh) in the fall of 663,[74] the native clergy submitted to the Roman forms, although the Bishop and some monks of Lindisfarne left their holy place for Iona in protest. Shortly before Whitby, Eata, the abbot of the newly founded monastery of Ripon, had returned with his disciple, Cuthbert, to the Scottish abbey of Melrose, rather than adopt the foreign rules, and Ripon was then placed in the hands of Wilfrid. Cuthbert, who had been brought up in the older tradition and was by temperament drawn to the eremitic mode of life, afterwards accepted the change. The Celtic Easter and tonsure were maintained by rebellious British and Scottish elements into the eighth century, but the general trend was toward the Roman system and the Benedictine rule. In the 630s, well before the decision at Whitby, there was already a Romanizing faction in southern Ireland.

Nevertheless, the religious traditions of the native churches were not destroyed when their organizations declined. The penitential, which was composed not long after Whitby by Theodore, the foreign Archbishop of Canterbury and the chief representative of Rome in England, was based directly on the harsh Celtic system of penance. The Northumbrian church continued to produce ascetics who looked back to the example of Egypt and their Irish and British predecessors. In the arts, the models brought from Italy or other Mediterranean regions were soon transformed upon contact with the native styles, which were largely a fusion of Celtic and Germanic forms. In the monasteries of Northumbria at the end of the seventh century a short-lived attempt to reproduce the late classical handwriting of Italy gave way to the Hiberno-Saxon script, and runic writing persisted for several centuries in stone inscriptions. The coexistence of these opposed currents in England in the seventh and eighth centuries is responsible for the extreme complexity of its arts and the difficulty we have in giving a coherent account of their development. The difference between the images of the lion and the man in the Echternach Gospels illustrates the range of forms created upon the meeting of the native and the foreign styles. Works of one hand, they are alike in the precision and finesse of drawing, in the intricate juxtaposition of the object and the labyrinth frame; but the·lion (see fig. 9, page 239) is natural, organic, even elegant in movement, and clearly built on a southern model, while the *"imago hominis"* (see Fig. 3, page 233) is a rigid, abstract, denatured emblem, bearing the written word of God and held in place by the active compressing frame as by a

vise, a radical conversion of the body by which the ascetic conception of the human being is wonderfully expressed.[75]

What is the place of the Ruthwell Cross in this large historical movement of the seventh century?

According to a suggestion of Baldwin Brown,[76] it was set up in a hostile country by Ecgfrith, king of Northumbria and partisan of the Roman church, as a triumphal monument of the victory at Whitby. Hence the inscription of the Northumbrian poem of the *Dream of the Rood*, like Constantine's vision of the cross of victory; hence the classical and Anglian motifs in the ornament and the application of human figures in a style of continental or Mediterranean origin.

There is a little detail in the Latin inscriptions of the Cross, overlooked by Brown, which is pertinent to his view of the royal origin of the Cross: the phrase "Iudex aequitatis" on the border of the central Christ. I have already remarked its frequency in the psalter, a book of immense weight in the devotions of the insular church. But it is quoted in another passage of the Bible highly significant to Northumbrian Christianity. In Acts xviii, 31, Paul, addressing the Greeks in the Areopagus of Athens to convert them to Christianity, says: "He has appointed a day in which he will judge the world in righteousness." ("Statuit diem in quo iudicaturus est orbem in aequitate.") This is precisely the phrase that Bede puts into the mouth of the Northumbrian king Oswiu (the father of Ecgfrith), when he undertakes in 653 to convert the pagan ruler of the East Saxons, his friend Sigberct.[77] He tells him, as Paul told the Athenians, that sticks and stones and golden images could not be gods, that God's everlasting seat is in heaven rather than in vile and perishable metal, and that he governs and will judge the world in righteousness. Since Bede informs us that his account of Northumbrian history is built on contemporary documents and the reports of witnesses, as well as on personal knowledge,[78] this speech may represent in substance the arguments of Oswiu. As a Christian monarch with the supreme juridical power, he would be drawn to the conception of God as a righteous judge, a conception foreign to the old pagan religion.

Yet the theory of Brown, which must be respected for its historical intelligence, hardly touches on the religious conception of the Cross. The eremitic content of the main figures, the subordination of the theme of the crucified Christ, the absence of reference to the issues of Whitby, are at first sight incompatible with the presumed political aim. If the Ruthwell shaft is a monument of the newly established Northumbrian power on the Scottish border and of the decision at Whitby, its religious content belongs to the older native Celtic Christianity. In Strathclyde, it is intrusive as a commanding silhouette, as a piece of carving, and as a complex of decorative forms, and its vernacular poetic inscription is in a language foreign to the region; but the

native clergy could recognize in the images the most impressive models of their own religious will: the Christ of the desert, John the Baptist, the penitent Magdalen, Paul and Anthony, and the related Gospel subjects. In the choice of these figures, the Northumbrian authors of the Cross seem to adopt the point of view of the native church and the traditions which were being overcome in their own country. On the Bewcastle Cross, near Wilfrid's center at Hexham, the religious capital of the newly Romanized Northumbrian church, Paul and Anthony and Mary Magdalen are omitted. The dominating Christ, adapted from the Ruthwell sculpture (Fig. 3), no longer has the inscription which identifies him as the Christ of the desert, and he reverts in meaning to the original conquering type; only John the Baptist is preserved intact. Set up to commemorate Alcfrith, under-king of Deira who, together with his friend, Wilfrid, was instrumental in calling the Synod of Whitby, this Cross has little of the religious content of its slightly older or contemporary mate.[79]

Do these differences correspond then to the differences between the two regions in the ethnic and religious hostilities of the time, and do they indicate perhaps the strength of a native British resistance which imposed the concessions to the defeated church? Or is the eremitic aspect of the Ruthwell Cross no less Northumbrian in spirit, and the result, within the new order, of that persisting asceticism, more at home in the Celtic provinces to which the opponents of Whitby, Colman and Eata and Cuthbert, had at first retired?

If the Cross had been set up before the Synod of Whitby, when Ruthwell and Lindisfarne shared a common Celtic tradition, the problem would not arise (although we should then have the difficulty of accounting for the presence of southern forms on a monumental scale so far north at this early date). But we have seen that even after Whitby, the eremitic ideals survived in the literature of the Anglo-Saxon church, in the south as well as in the north, and in the practice of certain religious individuals who maintained the primitive habits of solitude, perhaps in reaction against the later decay of the church and the disorders of civil life,[80] after the Celtic religious institutions associated with these ideals had been suppressed. The martyrology and calendars and the biographies of saints preserved the memory of the old models of ascetic perfection, just as the Northumbrian art of the eighth century maintained Celtic forms of the sixth and seventh beside the Teutonic and Mediterranean elements. Nevertheless, it is difficult to imagine that a work with the content of the Ruthwell Cross could have been created in Northumbria itself. The arts of that region are indeed presupposed. The fresh resources and monumental forms, which depend on the new connections with Rome and the continent, are much less likely to have been developed in Ruthwell than in Hexham or Jarrow; but the central place given to the ascetic types indicates a more fully Celtic milieu. The theme of Paul and Anthony was known to Anglo-Saxon cult

and literature, yet it is chiefly, if not only, on the crosses of Scotland and Ireland that it appears in art.[81] This alone compels us to consider the location of the Cross in Ruthwell as a more than incidental fact.

The erection of such a cross cannot have been the work of individual hermits or of a group of monks living in isolation in a wilderness. It may celebrate the desert and the anchorite, but it is a product of power and monumental purpose. It represents the effort of a community, an organized church which thinks of its relations to the surrounding people in the present and the future; the eremitic imagery of the Cross is a collective religious conception, not the fantasy of a single anchorite who lives on the margin of the church. That is why the content of the Cross must be understood in terms of local institutions, whatever may have been the role of individuals in shaping the particular forms. To account for the complex nature of the Cross, with its Anglian poem on Celtic soil, its imagery of self-denial in a robust and richly decorated form, we may imagine hypothetically that there existed in Ruthwell in the second half of the seventh century a religious community of Britons and of Anglian settlers, ruled by Northumbrians who belonged to the older generation that owed its Christianity to the teachings of Aidan and Columba and its ecclesiastical privilege in hostile Strathclyde to the power of the Northumbrian king. Like Eata and Cuthbert at the monastery of Ripon, they rejected the new Roman forms, but unlike them had no need to retire to a more congenial Celtic site. (According to Bede, the northern Britons retained their old rites and Easter until about 703, and the monks of Iona until 715.)[82] And if they finally adopted the Roman rites, like the other recalcitrant monks, their adherence to the spiritual conception of the older church could be more public and effective and more significant in this British milieu which had also to endure the political authority of the foreign king. The Anglian element in Ruthwell was possibly larger and more rooted than we suppose. We learn from Bede that immediately to the West of Ruthwell in Pictish Galloway, which remained in Northumbrian hands after the defeat of 685, there were Anglian settlers in sufficient number to require the establishment of a new bishopric in Whithorn in the early eighth century.[83] This region had been evangelized by Cuthbert, whose activity has left its trace in the name of the county, Kirkcudbright, that borders on Dumfriesshire.[84] Our knowledge of the situation in Strathclyde at this moment is so slight that in speaking of the church and its people we are applying to them what we know of the Celtic and Anglian churches elsewhere and as a whole. More specific religious and political data fail us.

There is, however, a work of local hagiography that informs us of the early traditions here and has a remarkable bearing on the interpretation of the Cross. It is the *Life of Saint Kentigern (518–603)*, the apostle of Strathclyde,

written in the twelfth century by Jocelyn of Furness, but according to the author, based on older accounts, undoubtedly not far in time from the period of the Cross.[85] This *Life* is often cited for its reference to the practice of erecting stone crosses in this country as far back as the years around 600. But it contains another kind of evidence, more relevant to the imagery of the Ruthwell sculptures. Kentigern, a leader of the British church, lived and acted according to the models of Egyptian and Irish monasticism. "Following the footsteps of Elijah and John the Baptist and of the Savior himself, he retired to desert places every Lent"[86] for solitude and contemplation. Returning from the desert, "he washed with his own hands the feet of a multitude of poor men first, then of lepers, bathing them with his tears, wiping them with his hair"[87] on Maundy Thursday. The last words follow so closely the account of Mary Magdalen at the feet of Christ that we are led to ask whether the image on the Ruthwell Cross had not perhaps a penitential significance with respect to a practice of the local British church. In a homily for the Thursday before Easter, Eligius of Noyon (*ca.* 590–660) wrote: "As you have heard, this washing of the feet is the purgation of our sins: whence the reconciliation of penitents takes place not unfitly on this day, as the custom of the Church maintains."[88] Since the middle of the seventh century, the period from Ash Wednesday to Maundy Thursday was a period of public penance marked by the exclusion of penitents from the church at the beginning of Lent and their readmission on Holy Thursday.[89] But this practice of public penance during Lent in the continental church was apparently unknown in the British Isles before the second third of the eighth century, when it is described in the Pontifical of Egbert of York.[90] The Archbishop Theodore of Canterbury (668–690) expressly asserts that the Roman usage is foreign to England and that he maintains the local Celtic system of private penance in his own penitential.[91] Most likely the account of Kentigern's quasi-penitential fasting, seclusion, lamentation, and kneeling before the faithful, insofar as it is fixed in the period of Lent, does not belong to his own time; but the reference to the ascetic prototypes of fasting and the implicit parallel to the penitent Magdalen is of the tradition of insular monasticism of the sixth and seventh centuries.

Like the Egyptian hermits, Kentigern had a miraculous power over animals and realized the Messianic prophecies of the concord of man and the beasts. He brought back to life a pet redbreast. He yoked untamed bulls who carried a corpse to its pre-ordained but unknown burial place; he also yoked together a wolf and a stag to draw a plough, and explained to the marveling people that before man's disobedience, all the animals obeyed him.[92]

Another miracle of Kentigern's, recorded in a document of the twelfth century, is the restoration of sight to a blind king.[93] This incident recalls the scene of Christ healing the blind man on the Ruthwell Cross, where it has no

apparent connection with the thought determining the central themes. But the same choice comes to mind again when we read Bede's account of the first disputes in 603 between the Roman and native British parties over the celebration of Easter (lib. II, cap. 2). The Roman missionary, Augustine, proposed that a blind man of the English race be brought, and that the faith and practice of those by whose prayers he would be healed, were to be looked upon as acceptable to God and be adopted by all. The priests of the Britons were unsuccessful; the blind man received sight only upon the prayer of Augustine, who "was declared by all, the preacher of divine truth."

Augustine's master, Gregory, had written of the healing of the blind man in the Gospel of Luke that his blindness was of the whole human race ("caecus quippe est genus humanum") and that Christ's miracle was an illumination of the Gentiles.[94] This thought was repeated by Bede in his commentary on the Gospel of John.[95] The importance of the incident for the English church may be gauged from the fact that it is told again in the few lines on Augustine in the Anglo-Saxon martyrology.[96]

Kentigern's miracle of the blind king is perhaps a reply of the British church to the legend of the Roman missionaries, and although no conclusive evidence connects either his own or Augustine's miracle with the choice of the subject of Christ healing the blind on the Cross, we may ask whether the sculpture of the Gospel scene does not depend on the religious conflict between the local and the foreign church and possess a special meaning in Strathclyde.[97]

Kentigern lived before the Roman missionaries came to Northumbria, but in the *Life* by Jocelyn traces of the conflicts of the seventh century may be discerned in details of the story which link the Saint with Columba and Gregory, the great contemporary protagonists of Celtic and Roman Christianity. The meeting of Kentigern and the Irish apostle to Scotland is an elaborate and affecting ceremony; they exchange pastoral staves as a gesture of friendship, and the staff of Columba is ultimately placed in Wilfrid's abbey of Ripon.[98] But Kentigern also visits Rome seven times to receive the counsel and blessings of Pope Gregory who exempts him from episcopal control.[99]

Like the ascetic details in the *Life of Kentigern*, these reflections of the struggles of the seventh century suggest that the source of the biography must lie, at least in part, in the period after Whitby when the Celtic churches, having submitted to the new forms, undertook to maintain the spiritual prestige of their great founders. At the Synod of 663, Wilfrid, the new abbot of Ripon, expressed complete ignorance of Columba.[100] We are therefore inclined to wonder about the ecclesiastical significance of Columba's staff at Ripon. Even the stone crosses set up by Kentigern to mark his success as a missionary are suspect as later accretions to his legend, inspired by the rivalry with the Romanized Northumbrian church, which erected many such monuments.

The life of the Strathclyde saint nevertheless gives us some insight, unprecise to be sure, into the native religious world and its traditions, and supports our reading of the eremitic symbolism of the sculptures in showing the prevalence of these ascetic types and ideals in the region of Ruthwell. We cannot draw a sharp line between Anglian and British asceticism nor distinguish nuances in their common devotions which will help to elucidate the origins of the Cross; nor can we judge to what extent the program of sculptures is a reaction against the outcome of the conflicts at Whitby. Whichever of the possibilities is accepted, one conclusion is clear, that the content of the sculptures is based largely on the eremitic conception of the native churches of the British Isles in the sixth and seventh centuries. The Cross is Anglian and classic in its forms, mainly Celtic in its religious content.[101]

II

The Bowman and the Bird on the Ruthwell Cross and Other Works: The Interpretation of Secular Themes in Early Mediaeval Religious Art
(1963)
1.

In interpreting works of mediaeval religious art, the question often arises whether all figures represented in them are properly understood as religious in content. There is one class in particular that is uncertain in meaning: the animals and associated humans—the hunters, bowmen, and struggling figures engaged with beasts. For a student who is convinced that all in mediaeval art is symbolic or illustrates a religious theme, it is not hard to find a text that seems to justify a moral or spiritualistic interpretation of the hunter and the beasts. But there is also the famous letter of St. Bernard denouncing the fantastic sculptured capitals of the Cluniac cloisters as completely devoid of religious significance. This powerful, vehement statement of a great churchman, who was also a poet, confirms the view that Romanesque art includes much that was not designed as symbol or as illustration of a sacred text.[102] There are, however, examples to which Bernard's strictures might not apply and where our intuition about a possible religious content of the animal image leads us to inquire further into the criteria of interpretation. Sometimes we observe that the images of animals and hunters, whether in the main or marginal field, resemble neighboring themes which have an undoubted religious sense. But even this resemblance is not decisive, for the problematic theme may elaborate freely an extra-religious aspect of the religious representation as in images of violence from the Old Testament bordered by scenes of animal and human combat in the frame. Thus on one of the Meigle stones in Scotland, Daniel with the Lions is surrounded by hunters, hounds, a centaur with two axes, a man with a club, and a dragon fighting a horned beast.[103] Centuries later, and no doubt independent of insular tradition, above a capital in the cloister of Moissac with the story of Daniel in the Lions' Den, is an impost carved with droll figures of little men fighting with birds, beasts, and monsters.[104]

On the twelfth-century bronze doors of Augsburg, a man struggling with a lion is probably Samson, since on a nearby panel the same figure wields a jawbone against a crowd of smaller figures who can only be the Philistines.[105] But there is also a scene of a bear at a tree with birds, a lion devouring a calf, a youth and a snake, and a centaur shooting a lion.[106] Are these to be taken as religious symbols too? According to the late Adolf Goldschmidt, one of the keenest and most sober students of mediaeval art, the figure of Samson is a type

of Christ and an example of the triumph over sin; his presence here points then
to the meaning of the less obvious scenes with animal figures.[107]

Could one not reverse the order of interpretation and, proceeding from
the manifest meaning of the unbiblical scenes of animal force, see the two
themes from the story of Samson as a biblical equivalent of the profane
subjects? For Samson is a legendary figure of human force, a hero who
overcomes beasts and human enemies, as in so many literatures of primitive and
barbaric peoples. As such he is named together with David, Hercules, Achilles,
and others in the citation of exemplary heroes by the storytellers of the time.[108]
It may be that for the priest or monk who commissioned the artist, the choice
of Samson in this context of animal violence could be justified by the exegetical
notions of the schools. But these would not explain the particular choice of the
antetype of Christ from among so many others offered by the Old Testament,
nor would they illuminate the obvious unity of Samson and the surrounding
scenes of animal life. There would remain, of course, for the reading of the
profane imagery of force the problem of discerning the specific sense of the
animals chosen—the interest in the bear, the snake, the lion, and the centaur.
For these nuances of meaning we must return to secular literature, to legends
and folklore, and to the conditions of everyday life in the Germanic world of
the eleventh century, just as we consult the religious beliefs and practices for
the decipherment of the sacred themes.

A text of the twelfth century throws an unexpected light on the
equivalences of the sacred and the secular with respect to themes of force. In the
famous *Schedula Diversarum Artium*, the monk-author Theophilus Rogerus,
writing about the proper decoration of *repoussé* gold and silver vessels, counsels
the craftsmen to represent on them "horsemen fighting against dragons, the
image of Samson or David tearing the jaws of the lion, also single lions and
griffins strangling a sheep, or anything you please that will be suitable and
appropriate to the size of the work" (Book III, ch. 77).[109] What unites all
these varied subjects is the content of force embodied in nameless fighting men,
biblical heroes, and voracious beasts.

2.

These reflections on the animal themes bring me to a problem raised in a
recent article in *The Art Bulletin* by Professor Ernst Kantorowicz on the
meaning of the archer and the bird on the top of the Ruthwell Cross.[110] His
interpretation of the figure as Ishmael, founded on the resemblance to the
drawing of Ishmael shooting a bird in the manuscript of Aelfric's Paraphrase
of the Heptateuch (Figs. 12, 13), seems to confirm and to draw some support
from my own paper on the religious meaning of the sculptures of the Cross.[111]
Ishmael as a figure of the desert would belong with the central eremitic content

of the scenes and figures below: Christ with the beasts in the desert, John the Baptist, Paul and Anthony, and Mary Magdalen.

It would be agreeable to accept his view, but I am not convinced by it. I shall set forth here the reasons for my doubt, which have a bearing on the interpretation of a large class of mediaeval images of the hunter and the beast.

In his argument Professor Kantorowicz treats the bowman as if he were a unique figure in Hiberno-Saxon art, whose meaning is to be grasped through the connection with neighboring subjects on the Cross. The fact is that he occurs in several other works where the interpretation as Ishmael would appear farfetched. The same conception of a bowman and a bird appears on Saxon stone sculptures at Hexham, Halton, Sheffield, and elsewhere.[112] On some of these the arrow is not pointed exactly at the bird, which merely surmounts the archer as on the Ruthwell Cross.[113] In a psalter from Corbie, *ca.* 800, strongly influenced by English art, an archer aiming at a bird fills the initial *B* of Beatus in Psalm 1 (Fig. 14).[114]

At a later time, in the twelfth century, a bowman in another posture is represented repeatedly on the bronze doors of southern Italy. He occurs twice on the same door at Trani and in a field that elsewhere is reserved for images of hunters, riders, and archers, whom we cannot easily connect with the religious scenes beside them.[115] Such figures from secular life are extremely common in Romanesque art.[116]

But already in the seventh and eighth centuries, they have a prominent place in the art of the British Isles, even on monuments with religious scenes, including the stone slabs and crosses.[117] On the Bewcastle Cross a figure with a falcon is carved at the base.[118] In Scotland, not far from the region where stand the Bewcastle and Ruthwell Crosses, are many representations on stone of hunters and riders.[119] They seem to express the interests and mode of life of the native rulers and nobility for whom these religious monuments were made and perhaps preserve motifs which in pagan times had some significance as marks of rank or as symbols of virile qualities.

It was because of the frequency of the hunter in the sculptures of the seventh to the ninth centuries in the islands, in varied contexts and compositions which seemed incompatible with a religious explanation, that in writing on the Ruthwell Cross I interpreted the archer there as a secular figure.[120]

Professor Kantorowicz supposes that since I call it a "secular figure" I regard it as "purely decorative."[121] If by that he means to say that I deny to the figure any value or significance beyond the contribution of its form to the rhythm of lines and of light and dark on the Cross, he misunderstands me. I believe that such motifs of decoration, especially since they represent a human or animal figure, have moving connotations and qualities for the people of their time, even when they are not symbols of status.[122] The alternatives are not, as

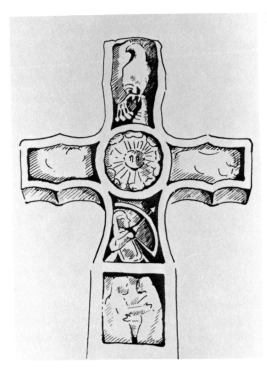

Fig. 12 Ruthwell: Cross, uppermost section. (Drawing by Miss A. C. Esmeijer).

Fig. 13 London, British Museum: Cotton Ms. Claudius B. IV, fol. 36v. Ishmael with Hagar and His Egyptian Wife.

is often supposed, religious meaning or no meaning, but religious or secular meanings, both laden with affect. Like metaphor in poetry, such marginal decoration is also a means of dwelling in an enjoyed feeling or desire.

As I have said before, we are not always able to distinguish these two fields of meaning, since the choice of religious figures is influenced by their secular interest,[123] and themes chosen at one time for their qualities of force may be interpreted later as moral and religious symbols.

Is it surprising that the barbarian Christians, for whom the chase was a virile and noble sport and had also an economic value, should delight in images of the falconer, the hunter, and the rider?[124] These were important figures for the imagination of the new masters of Western Europe in the early Middle Ages.[125] All that pertained to human and animal force seems to have attracted them. The frequency of animal themes on the portals and doors of churches, as in the examples of Augsburg and Trani, may be connected with the place of this imagery on the exterior of the church, which is turned to the secular community. The barbarian Christians could also find many such representations in the last works of classic art. The fowler had appeared already in pagan calendars and in verses on the months as typical for October and November.[126] Scenes of the hunt are rendered on pagan tombs where they have a possible religious significance.[127]

It is remarkable that in illustrating the story of Ishmael in the manuscript of Aelfric's Paraphrase of the Heptateuch (Fig. 13), a later Anglo-Saxon artist approached the pattern of the archer and bird in the Ruthwell Cross. But the Bible text about Ishmael's hunting—"he grew and dwelt in the wilderness, and became an archer" (Genesis xxi, 20)—written on the margin of the scene, already accounts for the presence of the archer; and the artist who had to represent this subject shared a tradition at least 300 years old in the rendering of an archer aiming at a bird. The same conception may be found in the already mentioned psalter at Amiens of about 800, in the decoration of the initial *B*, which has been strongly influenced by English art (Fig. 14).[128]

That Ishmael was a figure of the desert makes it conceivable that he could be associated with Christian hermits. But for other reasons this association is improbable on the Ruthwell Cross. For although Professor Kantorowicz can cite a church father, John Chrysostom, on Ishmael as a pious man living in the desert under God's protection, by the end of the seventh century Ishmael stood for the Moslems who were Christendom's greatest enemies. While the truly eremitic figures of Christ in the Desert, John the Baptist, Paul and Anthony, etc., on the Ruthwell Cross are often named in early insular writings, I have yet to find a mention of Ishmael as a model of ascetic life in that literature. Bede, who was a younger contemporary of the sculptor of the Ruthwell Cross, speaks of Ishmael in a very different sense, as the ancestor of the Saracens—homeless

and destructive heathens, the "lues Sarracenorum."[129] What Christian of the seventh century, reading Genesis, could forget the angel's prophecy to Hagar: "He shall be a wild man; his hand will be against all men, and all men's hands against him" (xvi, 13)?[130]

<center>**3.**</center>

As an early example of the use of the extremities of sacred objects as marginal fields for an imagery of force, the archer of the Ruthwell Cross reminds us how many features common in Romanesque art arose in insular sculptures and manuscript decoration of the seventh to the ninth century.

There is an interesting parallel to this problem in the interpretation of two figures on the Romanesque tympanum of the abbey church at Andlau in Alsace.[131] Flanking a central Christ who gives the keys to Peter and the book to Paul, one figure aims an arrow at a bird on a tree (Fig. 15); his counterpart on the other side of Christ wields a sling directed at a bird above him. Several scholars have interpreted the trees as those of Paradise, the birds as human souls, and the hunters as symbols of evil. I incline instead to view them as a heraldic of force drawn from the profane world, like other figures on the same portal. Most of the sculptures of Andlau are of beasts: there are lions, dragons, a centaur shooting with a bow, an elephant, a griffin, fighting horsemen, a banquet scene, a butcher, the combats of David and Goliath, and of Samson and the lion.[132] No doubt, a cleric of the time invited to comment on these figures would have found in them an occasion to speak of good and evil, the soul and Satan. But it seems to me unlikely that such was the thought of the artist (or even his directing patron) in selecting these particular figures.

All this should not be taken to mean that the bowman and the bird are always a purely secular theme. I may cite here an example from a mediaeval psalter in which a picture of the shooting of a bird serves to symbolize a religious concept. In the Canterbury Psalter (Paris, Bibl. Nat. Ms. lat. 8846), Psalm 89 (90) which speaks of the shortness and miseries of man's life is illustrated by a series of figures representing the seven stages of life.[133] A child plays with a top, a youth aims his arrow at a bird on a tree, a more mature figure with a falcon rides a horse, etc. Here the connection with the text and the adjoining themes makes the meaning explicit. "We spend our years as a tale that is told; the days of our years are three-score and ten; and if by reason of strength they be four-score years, yet is their strength labor and sorrow; for it is soon cut off, and we fly away" (lines 9, 10). It is interesting, too, that the naturally pagan worlds of childhood and youth are symbolized by games and the hunt, and the later years by an elderly man reading a book and an ancient sitting and praying.

Fig. 14 Amiens, Bibliothèque
Municipale: Cod. 18, fol. 95.
Initial *B*.

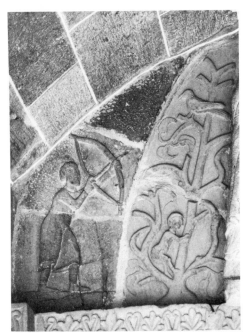

Fig. 15 Andlau, Abbey Church: West porch,
Tympanum, detail.

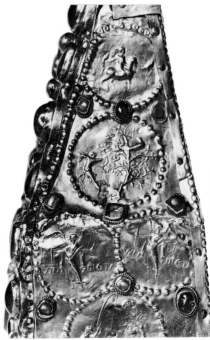

Fig. 16 Vienna, Kunsthisto-
risches Museum, Schatzkam-
mer: Reliquary of St. Stephen,
detail.

Fig. 17 Vienna, Kunsthisto-
risches Museum, Schatzkam-
mer: Reliquary of St. Stephen.

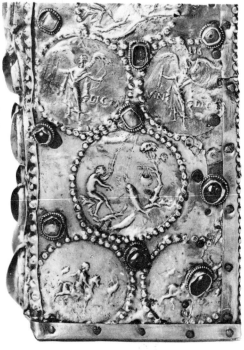

4.

In proposing to interpret the archer of the Ruthwell Cross as an image of force, with a poetic and emotional significance, I have ignored one familiar sense of such figures. Since the archer and bird are at the top of the Cross, they may be seen as apotropaic, like the lion heads and other emblems of force on the cornices or pediments of buildings.[134] There the repetition of an element, while contributing to the rhythmical order of the whole, does not exclude a symbolic meaning and may even reinforce it. For the archer and the bird there is a mediaeval parallel in a context with an inscription that speaks directly of protection from evil powers. On the famous gold bursa with the relic of St. Stephen in the treasure of the Holy Roman Empire in Vienna, a North French work of the ninth century closely related to the art of Reims, the two narrow sides are stamped twice with a tiny medallion image of a bowman aiming at a bird (Fig. 16).[135] Beside this figure appear the images of a fisherman four times and of a horseman six times (Fig. 17). The meaning of these medallions is intimated by a fourth subject: an angel with the inscription MALIS VINDICTA (Figs. 16, 17). This medallion occurs eight times and may be the key to the whole. It is not clear why the angel who protects against evil should be accompanied by the rider, the bowman, and the fisherman. Are they, in some vague sense, emblems of virile occupations, suited to a noble? One can cite texts from the Bible, and especially the psalter, that speak of the bowman as a figure of evil and also of the fowler with his snares, and others in which the bird is the soul.[136] But for comprehending these ornaments as a whole, the most relevant texts, I believe, are those of mediaeval magic prayer. In a manuscript of the ninth century (Paris, Bibl. Nat., Ms. lat. 1979), I find on the last page (fol. 250v) an inscription: "Nec malus omo, nec mala linga, nec mala fantasma, non in campo, nec ad arma, neque a bastone, non insidiat me." An incantation against the three-fold ubiquitous evil one occurs in a different form in a later manuscript from Grasse (Paris, Bibl. Nat. Ms. lat. 5231, fol. 129v), also at the end of the book: "Non in silva, non in agro, non in domo, . . ." It follows a series of prayers for protection against evil and includes examples from the Old Testament of divine aid *in extremis*, as in the prayers for the dying. These incantations suggest that the repeated images on the bursa in Vienna, with their order of frequency—two, four, six, culminating in the eight medallions of the angel—represent the three elements or fields in which evil is to be averted: air, water, and earth, symbolized by the archer, the fisherman, and the rider.[137] This interpretation is, of course, a conjecture and it may be, as Marc Rosenberg has said, that of all the medallions only those with the angels have a religious sense.[138]

That the archer on the Ruthwell Cross is an apotropaic figure is hardly

certain. A more extensive study of the examples and the texts would be needed for testing this interpretation. But I believe that the view advanced earlier— that the archer belongs to the class of secular figures of force congenial to a barbarian and emerging feudal society—is the most consistent with the variety of contexts in which the hunter appears in mediaeval art, although it may acquire in particular works an apotropaic and even a moral-religious sense.

NOTES

1. G. Baldwin Brown, *The Arts in Early England*, V, London, 1921, p. 314.

2. The inscription is only of verses 39–49a, 56b–65a, of the poem, which is preserved *in toto* in the Vercelli codex. For the original text, the runic forms, and the historical significance of the poem, see A. Blyth Webster, in Brown, *op. cit.*, V, pp. 203 ff. My translation of lines 39–43 is taken from Webster's with some slight changes (*ibid.*, pp. 219, 220).

3. In a Greek-Latin Gospel manuscript of the ninth or tenth century in St. Gall (Stifsbibliothek 48), there are inscriptions for unexecuted paintings after a Greek model, of which those before Matthew indicate some resemblance to the Gospel series on the Ruthwell Cross; Mary Magdalen and Christ, the Visitation, the Flight into Egypt, the Nativity, the Healing of the Blind, and the Crucifixion are included. But there are other subjects not found on the Cross and the relationship is vague. For this manuscript, see S. Beissel, *Geschichte der Evangelienbücher*, Freiburg im Br., 1907, pp. 238 ff.

4. For the most recent discussion of this subject on the Cross, see F. Saxl and R. Wittkower, *Guide to an Exhibition of English Art and the Mediterranean*, London, 1942, pp. 20, 21. Dr. Saxl has in press an article on the sources of the Ruthwell Cross.

5. See Jerome's *Tractatus in Marcum*, I:13, in *Sancti Hieronymi presbyteri tractatus sive homiliae in psalmos, in Marci evangelium aliaque varia argumenta*, ed. D. Germanus Morin, Anecdota Maredsolana, III, pars II, Maredsoli, 1897, pp. 328 ff.; Bede, *Expositio in Lucae evangelium*, Migne, Patrologia latina, XCII, col. 369. Similarly, the commentators on the Psalms interpret Psalm 91, 13 (Vulgate 90, 13) with reference to the Temptation of Christ. For the Greek examples, cf. Eusebius, *Commentaria in psalmos*, Migne, Patrologia graeca, XXIII, cols. 1153–1156 (also 1143, 1144, 1161, 1162), and his *Demonstratio Evangelica*, lib. IX, Pat. gr., XXII, cols. 674 ff., and the excerpts from the later Greek writers in Balthasar Corderius, *Expositio patrum Graecorum in psalmos*, II, Antwerp, 1642, pp. 886, 887. For an early Latin example, see Jerome, *De psalmo XC*, ed. Morin, *loc. cit.*, p. 118, and *ibid.*, pars III, 1903, p. 71.

6. Cf. John Cassian, *De incarnatione Christi (Contra Nestorium)*, lib. VII, 16.2, Pat. lat., L, cols. 234, 235, and *Corpus scriptorum ecclesiasticorum Latinorum*, XVII, p. 372.

7. The Stuttgart Psalter, the Psalter of St. Bertin (Boulogne, Bibl. Mun., Ms. 20), the Chludoff Psalter, Pantocrator 61, Barberini Gr. 372, the Psalter of 1066 in the British Museum (Add. Ms. 19352), the Bristol Psalter (British Museum, Add. Ms. 40731), Paris, Bibl. Nat., lat. 8846, etc.

8. See Ernest T. DeWald, *The Stuttgart Psalter*, Princeton, 1930, pp. 79, 80 (fol. 107v).

9. For the early types and the variety of renderings, see E. Baldwin Smith, *Early Christian Iconography and a School of Ivory Carvers in Provence*, Princeton, 1918, pp. 146 ff., and Heinz Köhn in *Reallexikon zur deutschen Kunstgeschichte*, I, Otto Schmitt, ed., Stuttgart, 1937, cols. 1147 ff.

10. The only reference that I have found to it in the literature is an article by Robert Eisler, "Jesus among the Animals by Moretto da Brescia," in *Art in America*, XXIII, 1935,

pp. 137–140, on a painting in the Metropolitan Museum. He knows only one example in the Middle Ages, the drawing in Gerona, described below.

11. *Op. cit.*, p. 328; see note 5 above.

12. There is a similar conception in the scene of the *Baptism* on the wooden door of S. Maria im Kapitol in Cologne, where Christ stands on a dragon; see R. Hamann, *Der Holztür von S. Maria im Kapitol*, Berlin, 1926, pl. XIX.

13. See A. Kingsley Porter, *Romanesque Sculpture of the Pilgrimage Roads*, VI, Boston, 1923, ills. 678, 679; G. Gaillard, *Les débuts de la sculpture romane espagnole*, Paris, 1938, pls. XCVII–XCIX.

14. See G. Heider, *Beiträge zur christlichen Typologie aus Bilderhandschriften des Mittelalters*, Vienna, 1861, p. 57.

15. The drawing precedes the text of Mark, but is part of a fuller rendering of the *Temptation*, including the incidents mentioned only in Matthew and Luke. For a description and facsimile of the miniatures, see Sir George Warner, *Gospels of Matilda, Countess of Tuscany 1055–1115*, London, 1917. The animals in the third scene of the *Temptation* (pl. XV) represent the riches of the world, as feudal property (cattle, horses). These occur often in this sense in the *Temptation*, e.g., Drogo Sacramentary, Winchester Psalter (British Museum, Nero C. iv, fol. 18), etc.

16. Reproduced by W. Neuss, *Die altkatalanische Bibelillustration*, Leipzig, 1922, fig. 160. The text of the manuscript is identified in the literature as the Homilies of Bede, but I doubt the correctness of this title. The passages available in the photographs of the drawings do not agree with the text of the published homilies of Bede (see *Opera*, J.A. Giles, ed., London, 1843–44, V, *Homilies*, and the corrections by Ch. Plummer in the introduction to his fine edition of Bede's *Opera historica*, I, Oxford, 1896, p. cliii); the manuscript is more likely a collection of homilies by various authors, including Bede. The particular miniature of Christ with the beasts is at the head of a homily on the Temptation, beginning with the passages Mark i, 12, 13, which are not quoted in Giles's edition of Bede's homilies. Where Bede does comment on Mark i, 13 (see Migne, Pat. lat., XCII, col. 140), he compares the beasts with the bestial manners of men ("bestiales hominum mores"); and in quoting Mark i, 13 in his commentary on Luke iv, on the Temptation (*ibid..* col. 366), he omits the phrase about the beasts. For a description of the manuscript and its miniatures (it is in the Colegiata of S. Feliu), see S. Sanpere i Miquel, *La pintura mig-eval catalana*, I, *L'art barbre*, Barcelona, n.d., pp. 80–89; J. Sacs, "El llibre de los homilies del venerable Beda en Gerona," *Vell y Nou*, V, 1919 (not available to me); W. Neuss, *op. cit.*, pp. 109 ff., 129 ff.; and R. Eisler, *loc. cit.* The date of the manuscript, to judge by the script, may be as late as 1100.

17. The manuscript (Paris, Bibl. Nat., lat. 8846—reproduced by Omont, *Psautier du XIIIᵉ siècle Bibliothèque Nationale*, Paris, n.d., fig. 99) is an English psalter of the end of the twelfth century of which the illustration was not completed until the fourteenth. The Catalonian origin of the later paintings was first pointed out by Millard Meiss, "Italian Style in Catalonia," *The Journal of the Walters Art Gallery*, IV, 1941, pp. 45–88, especially pp. 73–76.

[A charming example from the late fourteenth century is a miniature in the *Petites Heures of Jean de Berry* (Paris, Bibl. Nat. lat. 18014, fol. 208), showing Saint John with beasts in the wilderness. The Baptist sits at the entrance of a cave, with his left arm caressing a lion and with a panther at his right knee; around him are birds, monkeys, a goat and rabbit. See M. Meiss, *French Painting in the Time of Jean de Berry, The Late Fourteenth Century*, Phaidon, London, 1969, fig. 167.]

18. See Robert H. Charles, *The Apocrypha and Pseudepigrapha of the Old Testament*, II, Oxford, 1913, p. 518. The passages in Jewish apocryphal literature which pertain to this conception of Mark i, 13 have been listed by R. Bultmann, *Die Geschichte der synoptischen Tradition*, 2nd ed., Göttingen, 1931, pp. 271 ff., 301.

19. See *Evangelia apocrypha*, ed. C. Tischendorf, Leipzig, 1853, pp. 77, 81; M.R. James, *The Apocryphal New Testament*, Oxford, 1926, pp. 75, 78. [It is a compilation of the

eighth or ninth century, based on an older Latin work; most of it is already in the proto-Evangel of James, a Greek work that may be as early as the second century.]

20. *"Sed judicabit in justitia pauperes, et arguet in aequitate pro mansuetis terrae* (xi, 4) . . . *Habitabit lupus cum agno: et pardus cum haedo accubabit: vitulus et leo* . . . (xi, 6) *Et delectabitur infans ab ubere super foramine aspidis* . . . " (xi, 8).

21. *"Cognovit bos possessorem suum, et asinus praesepe domini sui: Israel autem me non cognovit"* (Isaiah i,3). Cf. also the Old Latin version of *Habakkuk* (iii, 2): *"In medio duorum animalium cognosceris,"* and the poem sometimes prefaced to the psalter and attributed (falsely) to Damasus and Jerome:

> . . . virtus regit omnia Christi,
> qui varias iunxit uno sub carmine linguas,
> ut pecudes volucresque deum cognoscere possint.

(*Damasi epigrammata*, ed. M. Ihm, Leipzig, 1895, p. 66, and praef., p. xiv). In the pseudo-Matthew (cap. XXXV), Christ says to the people: "How much better than you are the beasts which know me and are tame, while men know me not"

22. For a rare example, see the commentary on Mark, falsely attributed to Jerome; Migne, Pat. lat., XXX, col. 595, on Mark i, 13 ("and then the beasts will be at peace with us, when in the shrine of our souls, we tame the clean and the unclean animals, and lie down with the lions, like Daniel"). This comparison with Daniel reappears in the *Biblia Pauperum*; cf. Heider, *op. cit.*, p. 115.

23. *Contra haereses*, v. 33.3, cited by M. R. James, *op. cit.*, p. 36, who refers also to similar Messianic statements by Hippolytus and Papias (p. 37). [Origen, in commenting on Psalm 73, 19—"O deliver not the souls trusting in Thee to the beasts" Pat. gr., XIII, col. 1531—cites Job v, 23: "The wild beasts shall be peaceful with Thee." E. T. DeWald adduced these texts in explaining the representation of the two lions licking Christ's feet in the miniature illustrating that passage in the Stuttgart Psalter, fol. 87. See his edition, Princeton 1930, p. 67.]

24. John Wordsworth and Henry J. White, *Novum Testamentum Latine secundum editionem Sancti Hieronymi*, Oxford, 1889–98, p. 172. For a list of early manuscripts containing this preface, see S. Berger, "Les préfaces jointes aux livres de la Bible dans les manuscrits de la Vulgate," *Mémoires présentés à l'Académie des inscriptions et belles-lettres*, Ser. i, XI, 2, 1904.

25. For the attribution of the whole prologue to the Monarchians, see Peter Corssen, *Monarchianische Prologe zu den vier Evangelien*, Texte und Untersuchungen zur Geschichte der altchristlichen Literatur, ed. O. von Gebhardt and A. Harnack, XV, I, Berlin, 1897, p. 63. For the Priscillianist origin, see Dom John Chapman, *Notes on the Early History of the Vulgate Gospels*, Oxford, 1908, pp. 238 ff. For the relations of the older Monarchian and the Priscillianist layers in the prologue, see Dom Donatien de Bruyne, "Les plus anciens prologues latins des évangiles," *Revue Bénédictine*, XL, 1928, pp. 193–214, a reference which I owe to the kindness of Dom Anselm Strittmatter, O.S.B. The Spanish source of the Priscillianist text may account for the relative frequency of our motif in Spanish art.

26. John M. Kemble, *The Dialogue of Salomon and Saturn*, London, 1848, pp. 190, 191. The same question and answer occur also in the Latin dialogue of Adrian and Epictus, *ibid.*, p. 213.

27. *De virginitate*, Monumenta Germaniae historica, *auctorum antiq.*, XV, Berlin 1909, pp. 253, 264, 265.

28. C. W. Goodwin, *The Anglo-Saxon Version of the Life of St. Guthlac, Hermit of Croyland*, London, 1848, pp. 32, 33. It is based on the Latin life by Felix, written shortly after the death of the Saint.

29. For example, by Jerome, *"Ep. XXII ad Eustochium,"* Migne, Pat. lat., XXII, col. 421, and Loeb Classical Library, *Select Letters of St. Jerome*, trans. F. A. Wright, 1932, p. 143: "The founder of the system was Paul, and Anthony made it famous: going back, the first example was given by John the Baptist." Cf. also the speech of Anthony in Jerome's *Vita Pauli*: "Woe to me, a sinner who falsely bears the name of monk: I have seen Elijah, I have seen John

in the desert and I have truly seen Paul in Paradise" (Migne, Pat. lat., XXIII, col. 26) and John Cassian, *Collationes*, XVIII, vi, Migne, Pat. lat., XLIX, cols. 1100, 1101, on the anchorites as imitators of John the Baptist and of Elijah and Elisha (on Anthony, Elijah, and Elisha, see also *Collationes*, XIV, cap. iv, col. 957), and the same author's *De coenobiorum institutis*, lib. I, *ibid.*, cols. 61 ff. For the Irish references to John and Paul and Anthony, see A. Kingsley Porter, *The Crosses and Culture of Ireland*, New Haven, 1931, pp. 19 ff., and 85–87.

30. See Francis Wormald, *English Kalendars before A.D. 1000, I, Texts* (Henry Bradshaw Society), London, 1934, pp. 2, 16, 44, 58, etc.

31. Migne, Pat. lat., XXIII, col. 25.

32. On the Irish and Scottish examples, see Porter, *op. cit.*, pp. 85–87, and Françoise Henry, *La sculpture irlandaise*, Paris, 1935, pp. 133, 134.

33. See *An Old English Martyrology*, introd. and notes by George Herzfeld (Early English Text Society, no. 116), London, 1900, p. 17.

34. See note 31.

35. The story of the raven feeding Elijah in the wilderness occurs also in the dialogue of Adrian and Ritheus, Kemble, *op. cit.*, p. 203.

36. On the legends of Elijah, see A. Maury, *Croyances et légendes du moyen-âge*, p. 117, and P. Saintyves, *Essais de folklore biblique*, Paris, 1922, pp. 237, 238.

37. *Op. cit.*, p. 91, June 2.

38. For the numerous examples in the lives of the desert fathers, see Migne, Pat. lat., LXXIV, index, col. xxiii, *s.v.* "Bestiae." For an early transmission to the West, cf. Sulpicius Severus, *Dialogus I, 13–15* (toward 400), of which an early copy exists in the Book of Armagh.

39. See C. Plummer, *Vitae sanctorum Hiberniae*, Oxford, 1910, I, pp. cxli ff., and II, p. 371, index. Cf. also Jonas, "Vita S. Columbani," Migne, Pat. lat., LXXXVII, cols. 1020, 1021, 1028; "nor should you wonder why beasts and birds were obedient to the rule of the man of God"

40. On "disert" or "disart" as a name and on the flight to the desert, see John Ryan, *Irish Monasticism*, London, New York, 1931, pp. 195 ff.

41. "Ep. LXXXII" (to Charlemagne, 798), Migne, Pat. lat., C, cols. 266, 267.

42. *Opera*, ed. Giles, VII, *Commentarii in librum Genesis*, p. 27.

43. John Moschus (writing about 620), "Pratum spirituale,", lib. X of the *Vitae patrum*, Migne, Pat. lat., LXXIV, col. 174 (cited by H. B. Workman, *The Evolution of the Monastic Ideal*, London, 1927, p. 36, n. 1).

44. See Goodwin, *op. cit.*, pp. 50–53.

45. Bertram Colgrave, *Two Lives of Saint Cuthbert. A Life by an Anonymous Monk of Lindisfarne and Bede's Prose Life*, Cambridge, 1940, pp. 80, 81, 190, 191; on the ravens, see pp. 102, 103. When Cuthbert is fed miraculously on a journey, Bede compares him with Elijah fed by the ravens.

46. Collationes, I, cap. VIII, Migne, Pat. lat., XLIX, cols. 490 ff.

47. Migne, Pat. lat., XXII, col. 410.

48. *Moralia in Job*, VI, cap. 28.

49. *Opera*, ed. Giles, XI, *Comm. in Lucan X*, pp. 129–131.

50. *Loc. cit.*

51. L. Duchesne, *Fastes épiscopaux de l'ancienne Gaule*, 2nd ed., I, Paris, 1907, pp. 321 ff., 346.

52. *Op. cit.*, p. 127 (July 22): the text and the inscription are paraphrases of Luke vii, 37, 38. The inscription reads: A(ttulit alaba) STRVM VNGVENTI ET STANS RETRO SECVS PEDES EIVS LACRIMIS COEPIT RIGARE PEDES EIVS ET CAPILLIS CAPITIS SVI TERGEBAT (see Brown, *op. cit.*, V, p. 137).

53. See Herzfeld, *op. cit.*, pp. xxvii ff. On the probable Northumbrian origin of the Latin source, see Dom John Chapman, *op. cit.* p. 159.

54. On the double monasteries, see Workman, *op. cit.*, pp. 178 ff.

55. On the Genoels-Elderen ivory in Brussels (A. Goldschmidt, *Die Elfenbeinskulpturen*,

I, Berlin, 1914, pls. I, II, nos. 1,2), of the end of the eighth century, the subject of Christ on the beasts is accompanied by the *Annunciation* and *Visitation*; the work is apparently influenced by insular art, but the iconographic connection is not clear.

56. In his commentary on Luke, Bede, in discussing the Temptation, refers to the Flight into Egypt as an example of flight from evil, in accord with Christ's words in Matthew x, 23 ("and when they shall persecute you in this city, flee into another"); Migne, Pat. lat., XCII, col. 369.

57. I do not believe that the archer and the bird on the back of the little cross above the main shaft have a definite religious sense; I have not undertaken to discuss this theme, because it would carry us too far from the main problem into a field which has not yet been adequately studied. It is one of the oldest mediaeval examples of secular imagery at a terminal point of a religious monument, and is paralleled by the falconer at the base of the Bewcastle Cross and the numerous figures of riders, huntsmen, and combatants on the bases or lower areas of the Irish and Scottish crosses. [See pp. 177 ff., above.]

58. For these readings, see S. Beissel, *Die Entstehung der Perikopen des römischen Messbuches*, Stimmen aus Maria-Laach, no. 96; Freiburg im Br., 1907, p. 113 and *passim*. Psalm 91, 13 was sung in the mass of the first Sunday of Lent.

59. See V. Leroquais, *Documents paléographiques, Bibliothèque de Lyon*, I, Lyons, 1923, pl. XIII. The manuscript is a psalter from Jully-sous-Ravières (Yonne).

The choice of the *Temptation of Christ* and the *Arrest of Christ* as the unique subjects of Gospel illustration in the Book of Kells (allowing for the incomplete state of the manuscript) may be connected with the liturgical importance of the period from Quadragesima to Holy Thursday. See above, pp. 173–174, on this period in relation to public penance.

60. Migne, Pat. lat., CLXXII, cols. 913 ff.

61. The Psalter of 1066 in the British Museum (Add. Ms. 19352), the Chludoff Psalter, and Barberini Gr. 372.

62. See A. Kingsley Porter, *Crosses and Culture*, pp. 85–87. The Coptic and Syriac lives of Paul seem to have been derived from Jerome; see Workman, *op. cit.*, p. 96, note 3.

63. It was first published by Porter; see *op. cit.*, fig. 140, and pp. 86, 87. For a description of the monastery, see A. J. Butler, *Ancient Coptic Churches of Egypt*, I, London, 1884, p. 304.

64. From certain peculiarities of the examples on the Irish crosses, Porter concluded that the type based on Jerome's text, which we see on the Ruthwell Cross, was replaced in Ireland in the ninth or tenth century by a new version derived more directly from the Egyptian source. On the Ruthwell Cross and on the early Irish cross at Moone Abbey, the two hermits are shown actually dividing the bread, whereas in the later Irish works, according to Porter (p. 86), only the scene of the raven bringing the bread is rendered, as in the Coptic fresco. That a version of the story, simpler than Jerome's existed in the British Isles, may be inferred from the fact that Aldhelm speaks only of Paul and the raven (Mon. Germ. hist., *auctorum antiq.*, XV, p. 265). But a careful examination of these Irish crosses shows that even where the breaking of the bread is not explicitly represented, the image refers to the story as told by Jerome: the figures are turned in profile toward a large loaf suspended by the raven between them (Castledermot, North Cross, Porter, fig. 134); the saints grasp the bread (Castledermot, South Cross, fig. 133); their staves are crossed to indicate contention (Muiredach Cross, Monasterboice, fig. 135, Kells Market Cross, fig. 137); they make gestures toward the bread (Kells, Cross of Patrick and Columba, fig. 136). Some of these variants occur also on the continent in later art: in a fresco in Limburg, Paul and Anthony are seated, symmetrically confronted, and a bird descends vertically between them with the bread in its beak (P. Clemen, *Romanische Monumentalmalerei in der Rheinlande*, Düsseldorf, 1916, fig. 358); in an earlier wall-painting in the narthex of S. Angelo in Formis, the two saints share the bread; on a window in Chartres, they grasp the bread with crossed arms (Y. Delaporte and E. Houvet, *Les vitraux de Chartres*, I, Chartres, 1926, pl. XXXVII). For a late Gothic example of this subject, see Rose Graham, "A Picture-book of the Life of Saint Anthony the Abbot, Executed for the Monastery of Saint-Antoine de Viennois in 1426," *Archaeologia*, LXXXIII, 1933, pl. X, fig. 3 (on a manuscript in the public library of

Valletta in Malta); the seated saints grasp the split bread suspended from the raven's bill. Porter's theory has been accepted nevertheless by Françoise Henry, *op. cit.*, pp. 133, 134.

65. See above, p. 160.

66. The dating in the seventh century or the beginning of the eighth has been supported by Brown, Strzygowski, Gardner, R. Smith, Kendrick, Clapham, Porter, Lethaby, Brøndsted, Saunders, Baum, F. Henry, Kitzinger, and Saxl. For the history of the older opinions, see Albert S. Cook, "The Date of the Ruthwell and Bewcastle Crosses," *Transactions of the Connecticut Academy of Arts and Sciences*, XVII, 1912. Cook attempted, with extremely doubtful arguments, to place the crosses in the twelfth century; his opinion was shared by the Italian scholar, Rivoira, but in the second edition of the latter's book, *Lombardic Architecture*, II, Oxford, 1933, p. 209, his translator, G. McN. Rushforth, has accepted the common view. Professor Morey, in his new book, *Mediaeval Art*, New York, 1942, p. 187, ignoring the work of the last thirty years, proposes a Romanesque date for the crosses and repeats the old incorrect arguments that have been sufficiently refuted by Brown and Brøndsted, *Early English Ornament*, London and Paris, 1924, pp. 74–79. He finds in both the ornament and the figure style "a mature stage" of Romanesque art; the form of the crosses is for him Irish, in spite of Brown's careful demonstration of its Anglo-Saxon origins; he finally regards the crosses as products of Celtic art, *via* Iona, in the twelfth century.

67. On the site, its topography and history, see Brown, *Arts in Early England*, V, pp. 290 ff.

68. The chief ancient source is Bede's *Historia ecclesiastica*, ed. C. Plummer, *Bedae Opera Historica*. For the most recent account of this period, see F. M. Stenton, *Anglo-Saxon England*, Oxford, 1943, chap. III. An excellent survey by various authors is *Bede, His Life, Times, and Writings*, ed. A. Hamilton Thompson, Oxford, 1935.

69. Cf. also the statement in the Anglo-Saxon *Life of St. Guthlac*, "The British nation, the enemy of the Anglian race" (Goodwin, *op. cit.*, pp. 42, 43).

70. For these inferences, see Brown, *op. cit.*, V, pp. 294, 313, and 314.

71. See B. P. Kurtz, "From St. Anthony to St. Guthlac, a Study in Biography," *University of California Publications in Modern Philology*, XII, 2, 1926, pp. 103–146.

72. On Wilfrid, see *The Life of Bishop Wilfrid by Eddius Stephanus*, text, translation, and notes by Bertram Colgrave, Cambridge, 1927.

73. *Ibid.*, chap. XLVII, pp. 98, 99.

74. For the arguments at the Synod, see Bede, *op. cit.*, lib. III, chap. 25. In dating it in 663, rather than 664, I follow Stenton *op. cit.*, p. 129.

75. Paris, Bibl. Nat. Ms., Lat., 9389. An interesting example of the later juxtaposition of the opposed traditions is the presence of relics of Benedict, Anthony, and Columba on the altar of St. Benedict in the abbey of St. Riquier near the English Channel. See J. Schlosser, *Quellenschriften zur karolingischen Kunstgeschichte*, Vienna, 1892, pp. 254, 255.

76. *Op. cit.*, V, pp. 313, 314.

77. This has escaped Plummer (*op. cit.*, I, p. 172), who mistakenly refers the phrase "iudicaturus esset orbem in aequitate" (lib. III, chap. 22) to Psalm 95, 13, which reads "iudicabit orbem terrae in aequitate."

78. On Bede's veracity and concern with first-hand information, see Wilhelm Levison, "Bede as Historian," in *Bede, His Life, Times, and Writings*, ed. A. Hamilton Thompson, Oxford, 1935, pp. 132 ff.

79. On the Bewcastle Cross and its inscriptions, see Brown (and Webster), *op. cit.*, V, pp. 197 ff., 245 ff.

80. On this point, see Thompson, *op. cit.*, p. 87.

81. For the examples, see Porter, *op. cit.*, pp. 85–87.

82. *Historia ecclesiastica*, lib. V, chaps. 15, 21.

83. *Ibid.*, chap. 23. Note also that Wilfrid was restored to office in 705 by a synod held near the River Nith, the boundary between Galloway annd the kingdom of Strathclyde, close to Ruthwell; *ibid.*, chap. 19.

84. See W. F. Skene, *Celtic Scotland*, II, Edinburgh, 1887, pp. 208, 209.

85. It is published by A. P. Forbes in *The Historians of Scotland*, V, Edinburgh, 1874, pp. 29–133, 159–252.

86. Cap. XVII, p. 61.

87. *Ibid.*, p. 62.

88. Migne, Pat. lat., LXXXVII, col. 609, quoted by O. D. Watkins, *A History of Penance*, II, London, 1920, pp. 523, 524.

89. Watkins, *op. cit.*, II, pp. 577 ff.

90. T. P. Oakley, *English Penitential Discipline and Anglo-Saxon Laws in Their Joint Influence*, New York, 1923, pp. 79 ff.

91. *Ibid.*, pp. 74 ff.; Watkins, *op. cit.*, II, pp. 650 ff.

92. Forbes, *op. cit.*, chap. XX, pp. 66–68.

93. *Ibid.*, p. lxxx. He makes the sign of the cross on the king's eyes.

94. "Homiliae in evangelia," lib. I, *Hom. in Lucam*, XVIII, 31–44, Migne, Pat. lat., LXXVI, col. 1082.

95. Pat. lat., XCII, cols. 757–762.

96. *Old Eng. Martyrology*, p. 87 (May 26). It is worth remarking that in Bede's account, the miracle of Augustine is followed by the visit of the British bishops to a holy hermit to consult him as to whether they should forsake their traditions.

97. It should be noted, in any case, that the inscription around the panel, "ET PRAETERIENS VIDI (t hominem caecum) A NATIBITATE ET SA (navit eum ab infi) RMI (tate)," indicates that it is the blind man of John ix at the pool of Siloe who is in question on the Cross. This figure is for Christian commentary an image of conversion and baptism.

98. Forbes, *op. cit.*, chap. XL, p. 109.

99. *Ibid.*, chap. XXVII, pp. 84, 85.

100. Bede, *Historia ecclesiastica*, lib. III, chap. 25. See also Skene, *op. cit.*, II, p. 196.

101. I am indebted to my pupil, Miss Selma Jónsdóttir, for her generous assistance in verifying several quoted texts.

II

The footnote reference numbers, as they appeared in the original publication, are found in parentheses after each footnote in the second section.

102. For Bernard's text, see Migne, Patrologia latina, CLXXXII, cols. 914–916; for a translation, see G. Coulton, *Life in the Middle Ages*, 3rd ed., IV, New York, 1935, pp. 174 ff. I have commented at length on this text in an article: "On the Aesthetic Attitude in Romanesque Art," *Art and Thought, Essays in Honour of A. K. Coomaraswamy*, London, 1947, pp. 133 ff. [reprinted in my *Selected Papers*, I, *Romanesque Art*, New York, 1977, pp. 6 ff.] (1)

103. See Stewart Cruden, *The Early Saxon and Pictish Monuments of Scotland*, Edinburgh, 1957, p. 16, and pls. 26, 27. (2)

104. See M. Schapiro, "The Romanesque Sculpture of Moissac," *The Art Bulletin*, XIII, 1931, p. 334, fig. 79. [reprinted in my *Selected Papers*, I, *op. cit.*] (3)

105. A. Goldschmidt, *Die deutschen Bronzetüren des frühen Mittelalters*, Marburg, 1926, pls. LXIII ff. (4)

106. *Ibid.*, pls. 67 ff. (5)

107. *Ibid.*, pp. 29 ff. (6)

108. For a late example, cf. the Provençal poem, *Flamenca*, lines 618 ff. See *The Romance of Flamenca, A Provençal Poem of the Thirteenth Century*, translated by M. J. Hubert, Princeton, 1962. (7)

109. *Theophilus De Diversis Artibus*, translated from the Latin with Introduction and Notes by C. R. Dodwell, London 1961, p. 141 (lib. III, cap. 78). (8)

110. "The Archer on the Ruthwell Cross," *The Art Bulletin* XLIII, 1960, pp. 57–59. (9)

111. "The Religious Meaning of the Ruthwell Cross," *ibid.*, XXVI, 1944, pp. 232–245. [reprinted above, pp. 151–176] (10)

112. See A. W. Clapham, *English Romanesque Architecture before the Conquest*, Oxford, 1930, pp. 70–72, for examples of "archers carved at the base of the shafts, shooting at the birds and beasts above"; pl. 21 shows example at Bishop Auckland (Durham); fig. 18, at Bradbourne and Sheffield (now in the British Museum). See also W. G. Collingwood, *Northumbrian Crosses of the Pre-Norman Age*, London, 1927, p. 40, on this motif, and the examples at Hexham (fig. 28), Halton (fig. 92), and Sheffield (fig. 93). Other representations of the archer aiming at a bird or beast are cited by A. S. Cook, "The date of the Ruthwell and Bewcastle Crosses," *Transactions of the Connecticut Academy of Arts and Sciences*, New Haven, Conn., XVII, 1913, pp. 274 ff. These are at Bakewell and Camuston (Scotland) and in later Romanesque art in England and France. (11)

113. I write loosely in describing the archer as aiming at the bird. It is possible, however, that there were birds on the missing (now restored) horizontal arms of the Ruthwell Cross, as on the cross-head at Cropthorne (Yorkshire), Clapham, *op. cit.*, I, pl. 16. (12)

114. The example has been noted and reproduced by Clapham, *op. cit.*, pl. 23. For the connection of the ornament of this initial with insular art, see my article: "The Decoration of the Leningrad Manuscript of Bede," *Scriptorium*, XII, 1958, pp. 192, 196, [reprinted below, pp. 199–224]. (13)

115. See A. Boeckler, *Die Bronzetüren des Bonanus von Pisa und des Barisanus von Trani*, Berlin, 1953, figs. 97, 100, 101, 126, 127, 131, 151, for the examples at Trani, Ravello, and Monreale, and p. 64 n. 199, on the ancestors of this motif in the Byzantine ivory caskets and classic hunting scenes. Two bowmen aiming at a bird on a tree between them are represented on the lid of a sarcophagus of 1179 with relics of the soldier saints, Sergius and Bacchus, in the Museo Civico at Verona—see Hans Decker, *Romanesque Art in Italy*, New York, 1959, fig. 256.

The theme of the archer and bird is discussed, *a propos* of the archer aiming at a squirrel on the bronze door of Gniezno, in the magnificent publication of this important monument: *Drzwi Gnieźnieńskie*, edited by Michael Walicki, Wroclaw, 1959, 3 volumes, with French summaries, in the chapters by Lech Kalinowski, "The ideological and esthetic content of the Door of Gniezno" (in Polish), II, pp. 91 ff., 156, and by Zdsistaw Kepiński, "The symbolism of the Gniezno Door," II, pp. 161 ff., 290 ff. (14)

116. Cf. musicians, acrobats, dancers and horsemen on the archivolts of doorways in southwest France. Many instances of the archer fighting with wild beasts in English Romanesque sculpture are listed by A. S. Cook, *op. cit.*, pp. 274, ff. (15)

117. Cf. the sculptures of Breedon (Leicestershire), attributed to the late eighth century by Clapham, *op. cit.*, pls. 27 ff., and the crosses mentioned in note 112 above. (16)

118. See G. Baldwin Brown, *The Arts in Early England*, V, London, 1921, pl. XII, and pp. 132 ff., 281 ff. (17)

119. See Stewart Cruden, *op. cit.*, pls. 5, 7–10, 13, 18–20, 27. On p. 12 the author calls the Pictish crosses "a huntsman's art." (18)

120. See my note 57 on page 190. This was also the view of G. Baldwin Brown, *op. cit.*, V, p. 125, who compares the archer with the falconer on the Bewcastle Cross: "he is treated in quite a secular spirit." (19)

121. *Op. cit.*, p. 59, the last paragraph. (20)

122. I have written about this aspect of mediaeval decoration in the article cited in note 1 above. (21)

123. An example in Romanesque art is the choice of figures on the portal of Santa Maria in Carrión de los Condes (Palencia), the seat of the counts of Carrión, famous in the epic of the Cid. Herod is placed in the center, enthroned and frontal among the Magi, above the crown

of the arch; in the spandrils below are Samson on the Lion and the equestrian Constantine (A.K. Porter, *Romanesque Sculpture of the Pilgrimage Roads,* Boston, 1923, fig. 773). A later example of a selection of religious themes unified by their common reference to a secular interest is Rubens's altarpiece in Mechlin. On the central panel is painted the Miraculous Draught of Fish; on the left wing, Tobias and the Angel; on the right wing, Peter Finding the Coin; on the predellas, Jonah Thrown into the Sea, and Christ Walking on the Water. One may seek a theological common denominator for all these subjects, but more obvious and plausible is the connection with those who commissioned and donated the triptych: the Fishermen's Guild. (22)

124. On fowling in the pre-Christian North European world, see J. G. D. Clark, *Prehistoric Europe. The Economic Basis,* London, 1952, pp. 37 ff. (23)

125. For an example of hunters, riders and bowmen in pre-Christian Germanic art, see the drawings of the lost golden horns from Gallehus (Slesvig) in H. Shetelig and Hj. Falk, *Scandinavian Archaeology,* Oxford, 1937, p. 208, pl. 36. (24)

126. See the admirable book of Henri Stern, *Le Calendrier de 354, Etude sur son texte et sur ses illustrations,* Paris, 1952, pp. 246 ff., 355, 366, 367, on the fowler as the figure for October or November in classical, Byzantine, and early mediaeval Western literature and art. Note also on classical engraved gems the related figure of Hercules shooting the Stymphalian birds— S. Reinach, *Pierres Gravées des Collections Marlborough et d'Orléans et des recueils d' Eckhel, Gori, Levesque . . . ,* Paris, 1895, pl. 19, no. 38, and the frequent isolated bowman in A. Furtwängler, *Die antiken Gemmen,* Leipzig, Berlin, 1900, pl. VIII, 48; IX, 21; XV, 22, 23; LI, 6, 10, 11, 14. (25)

127. See Franz Cumont, *Le symbolisme funéraire des Romains,* Paris, 1942, pp. 439 ff. Also E. LeBlant, *Les Sarcophages Chrétiens de la Gaule,* Paris, 1886, p. 68, pl. 19, 38, 39, and J. Baum, *La Sculpture figurale en Europe à l'époque mérovingienne,* Paris, 1937, pl. 63, for scenes of the hunt on Christian sarcophagi in Spain and Italy from the sixth to the eighth century. (26)

128. See note 114 above. (27)

129. *Historia Ecclesiastica,* V, 23 (ed. Plummer, I, p. 349; II, pp. 338, 339)—"*Quo tempore gravissima Sarracenorum lues misera caede vastabat.*" See also Bede's comment on Genesis, xvi, 13 (the prophecy about Ishmael's descendants) in his *Hexaemeron,* lib. IV, (Pat. lat. XCI, col. 159): [it] "signifies that his seed will dwell in the desert, that is, the homeless Saracen nomads who raid all the peoples bordering on the desert and are fought by all of them. . . . Today, indeed, his hand is against everyone and everyone's hand is against him, as they oppress all Africa with their sway and hold the greater part of Asia and much of Europe, hostile and hateful to all" Again, in his Commentary on the Pentateuch (Pat. lat. XCI, cols. 241–243), interpreting Paul's contrast of Ishmael and Isaac in Galatians iv as symbolizing the Old and the New Law, Bede observes that Hagar with Ishmael in the desert signifies the Synagogue and its people expelled from its land, without a priesthood and ignoring the path of Christ. Moreover, that Ishmael is called a bowman is not inappropriate to the Jewish people; it refers to the killing of sacrificial victims under the Old Law.

Already before Islam the Bedouins were described by St. Jerome as Saracens and Ishmaelites who attack a caravan of Christians and enslave them. See his "Vita Malchi Monachi Captivi" (Pat. lat. XXIII, col. 57). The story is retold by an Anglo-Saxon contemporary of the Ruthwell sculptor, the poet Aldhelm, in his "De Laudibus Virginitatis" (Pat. lat., LXXXIX, col. 129— "a Saracenis praedonibus et Ismaelitis grassatoribus obvia quaeque atrociter vastantibus"). (28)

130. Dr. Kantorowicz, on pp. 58 ff. of his article, with reference to Galatians iv, 22–31 and the patristic interpretations of these lines of St. Paul, also entertains the possibility that the archer aiming at the bird is Ishmael, the son of Abraham *secundum carnem,* persecuting Isaac, the son *secundum spiritum* or the *sursum Jerusalem.* (29)

131. See Robert Will, *Repertoire de la Sculpture Romane de l'Alsace,* Strasbourg, 1955, pp. 8 ff., and pl. VIII; Julius Baum, "The Porch of Andlau Abbey," *The Art Bulletin,* XVII, 1935, pp. 492–505, fig. 8. (30)

132. Will, *op. cit.,* pp. 5–9. In explaining the bowman and the bird as "symbolic of the

devil's attempt to gain possession of the soul, which remains unharmed because it is under the protection of Christ," Baum (p. 498) ignores the other figures of combat and animal force. (31)

133. It is reproduced by H. Omont, *Psautier du XIIIe siècle, Bibliothèque Nationale*, Paris, n.d., fig. 98. The manuscript was written at the end of the twelfth century, but certain of the miniatures, including the illustration of Psalm 89 (90), were painted in the fourteenth century in Catalonia, as Millard Meiss has shown ("Italian Style in Catalonia," *Journal of the Walters Art Gallery*, IV, 1941, pp. 73–76). (32)

134. On the same themes in Greek buildings, see the important article by Emanuel Löwy, "Ursprünge der bildenden Kunst," Vienna, 1930 (from the *Almanach*, Akademie der Wissenschaften in Wien, Jhrg. 80). (33)

135. It was a reliquary of the blood of St. Stephen and was said to have belonged to Charlemagne, though the decoration is surely later than his time. For the fullest account of this work, see Marc Rosenberg, "Das Stephansreliquiar im Lichte des Utrechtpsalters," *Jahrbuch der preussischen Kunstsammlungen*, XLIII, 1922, pp. 169–184. (34)

136. Cf. Psalm 91, 3–5: "Surely he shall deliver thee from the snare of the fowler. . . . He shall cover thee with his feathers, and under his wings shalt thou trust; his truth shall be thy shield and buckler. Thou shalt not be afraid for the terror by night; nor for the arrow that flieth by day. . . ." On the symbolism of the fowler in mediaeval literature and its biblical sources, see B. G. Koonce, "Satan the Fowler," *Mediaeval Studies*, Toronto, XXI, 1959, pp. 176–184. (35)

137. For related magic prayers, exorcisms, and incantations with elements grouped in threes, see Eugène de Rozière, *Recueil général des formules usitées dans l'empire des Francs du Ve au Xe siècle*, II, Paris, 1859, and particularly p. 885, no. 626: "*non per aurum, non per argentum, neque per lapidibus praeciosis* [*sic*]"; "*nec dormientem, nec sedentem, nec ambulantem*"; "*coelum et terram, mare et omnia quae in eis sunt.*" Cf. also the formula in the fictitious letter of Christ to Abgar, that was used as an apotropaic incantation: "sive in mare, sive in terra, sive in die, sive in nocte, sive in locis obscuris, si quis hanc epistolam habuerit securus ambulet in pace"—cited by E. von Dobschütz, "Charms and Amulets (Christian)," in J. Hastings, *Encyclopaedia of Religion and Ethics*, III, New York, 1911, p. 425. My friend, the late Ralph Marcus, professor at the Oriental Institute in Chicago, called my attention many years ago to the spell published by A. Dieterich (*Abraxas*, 1891, p. 139) from the Greek magical papyrus, Paris 3009, adjuring the demons of the air, the earth, and under the earth, which recalls Paul, Philippians ii: 10—"at the name of Jesus every knee should bow, of things in heaven, and things in earth, and things under the earth." (36)

138. *Op. cit.*, p. 181. (37)

Fig. 1 New York, The Metropolitan Museum of Art, The Cloisters Collection: Hours of Jeanne d'Evreux, before 1328. Man carrying his severed head; man carrying fawn; and nude musician.

Fig. 2 Verdun, Bibliothèque Municipale: Ms. 107, Breviary Part II, for Marguerite de Bar, before 1304, fol. 89. Hare astride lion fighting snail-man.

Marginal Images and Drôlerie

(1970)

The hundreds of illustrations in Dr. Randall's book* and the index of themes—190 pages of two columns, listing alphabetically over 10,000 examples—arouse our wonder at the prodigious fertility of this art. One marvels, too, at the author's industry and feels grateful to her for this immense labor. It is an amazing world of everyday life as well as of humor and fantasy that she has catalogued and reproduced in her book. Besides the scenes of work, which will delight the social historian and student of technology, it includes the pictured proverbs, metaphors, fancies, parodies, jokes, and obscenities current in Western Christendom during the thirteenth and first half of the fourteenth century, mainly in England, France, and the Netherlands. Most of these images are found in manuscripts made for private devotion, but one can match many of the subjects in the choir stalls and other sculptured and painted fields in the churches of the same period. The margins of books committed to a most disciplined spirituality were open to primitive impulses and feelings, and in a context of exquisite writing these miniatures, which are whimsical and often gross in idea, compete for the reader's attention. Though scattered capriciously on the margins, they are done with the same precision of detail and calligraphic finesse as the richly framed religious imagery on the same page (Figs. 1 and 2). They are a convincing evidence of the artist's liberty, his unconstrained possession of the space, which confounds the view of mediaeval art as a model of systematic order and piety. There is also in these images a sweetness and charm which seem to arise from the truly miniature scale—a scale that is not just a consequence of the small format of the book made for private reading and prayer; it is a quality of the objects represented. The humans here play, fight with, and dwell among tiny creatures whose minuscule size they assume without loss of their own essential humanity. In the sureness with which these painters draw hares, apes, mice, cats, birds, snails, insects, and flowers, they are equalled only by their contemporaries in the Far East. By reducing man to the scale of these creatures, by a hybrid mingling of

* Lilian M. C. Randall, *Images in the Margins of Gothic Manuscripts*, California Studies in the History of Art, Vol. IV, Berkeley and Los Angeles, 1966.

bodies which form together an undemountable dwarf, a monstricule, the artist strips man of his privilege and supremacy; we see him in these strange re-embodiments as a being among the others in nature, and sharing in his movements and passions the instinctive mobility of the animal world. This art is a boundless reservoir of humor, spirited play, and untamed vitality. The ape is everywhere, inviting the viewer to recognize the animal core of human behavior in the easy translation of all the higher forms of social life—learning, religion, law—into simian games. It is a process of desublimation through which the distance between the natural and the civilized is abolished. No other art in history offers so abundant an imagery of the naked and clothed body as a physical engine. Free from classic norms, the artist experiments with the human frame as the most flexible, ductile, indefatigably protean, self-deforming system in nature. He anticipates with irreverent playfulness the more sober study of the human body by Renaissance artists.

The author's introductory essay, which summarizes the essential facts, is much too short as an account of this wonderfully rich collection of images. But she deserves our warmest thanks for assembling and ordering a matter that invites reflection on so many aspects of art and mediaeval life; her book will undoubtedly inspire alert students to make new discoveries.

Dr. Randall believes that investigation will disclose symbolic meanings in many of the seemingly nonsymbolic pictures. This is a likely guess; but I think it would help the search for meanings if one recognized that we are not limited to the alternatives: symbolic or decorative. There are other kinds of meaning (as in metaphor, parody, and humor) which need not be symbolic in the coded manner of mediaeval religious symbolism, even where there is an obvious tie of the drôlerie with the adjoining text or its illustration, as in Dr. Randall's figure 229—a hare holds a disk underneath a picture of the fool with the bauble (or cheese) in his mouth at the beginning of the psalm: *Dixit insipiens*. In a fourteenth-century breviary from Chalons (not illustrated by Dr. Randall) a game of ninepins is drawn under a scene of the Conversion of Paul who is falling from his horse. The sense of such analogies is not easily found in religious commentaries; they call for another and essentially poetic approach.

There is a text of the thirteenth century quoted by Bédier (*Les Fabliaux*, 4th ed., 1925, p. 408) from a debate between two jongleurs (*Deux borderus ribauz*) that may be added to those given by Dr. Randall as examples of a similar fancifulness in the literature of the time. One jongleur boasts that besides knowing how to sing all the great epic *gestes* and love poems he can bleed cats, leech cattle, cover houses with fried eggs, make a harness for cows, gloves for dogs, hats for goats, hauberks for hares, so strong they will no longer be afraid of dogs.

The Decoration of the
Leningrad Manuscript of Bede

(1958)

B efore the facsimile of the Leningrad manuscript of Bede's *Ecclesiastical History* (Q. v. I. 18) was published,[1] students of art knew only the one initial reproduced in Zimmermann's corpus of pre-Carolingian miniatures (Fig. 1). From study of its style, Zimmermann had concluded, with some doubt, that the manuscript was produced in the south of England about 800. In his account of insular art, it occupied an insignificant marginal place.[2]

With Lowe's dating of the Bede in 731 to 735—which seems to me plausible—together with his proof that it was written in the twin abbeys of Jarrow and Wearmouth, the decorated initials of this manuscript assume an important position in the history of insular art.[3]

The *h* of Book II (fol. 26v) becomes the oldest dated "historiated" initial that we know of (Fig. 1).

The enclosed half figure of a tonsured saint with book and cross is labeled AUGUSTINUS, the name of the Roman missionary to England whose story is told in the following text. The drawing seems to be contemporary with the initials in the undated Canterbury Psalter (British Museum, Cotton Ms. Vespasian A. 1) which contain episodes from the life of David (Fig. 2); most students place these in the middle or first half of the eighth century.[4] In the subsequent Carolingian art the religious image set within a letter is a more common motif, mainly in manuscripts of the Tours and Ada schools which were strongly influenced by insular art.

The historiated initial, a basic type in mediaeval art, may thus be an English invention.[5] But the earliest insular examples, it should be noted, occur in works from Jarrow and Canterbury, centers with important Italian relations. In its manner of combining the image and the letter, the historiated initial of the Anglo-Saxon artists presupposes the classic practice of framed illustration (although classic art could not easily admit the asymmetrical forms of letters, except the *O*, as a proper frame).

There is, in mediaeval art, another kind of historiated initial, one in which the figures themselves form the body of the letter. This type, somewhat

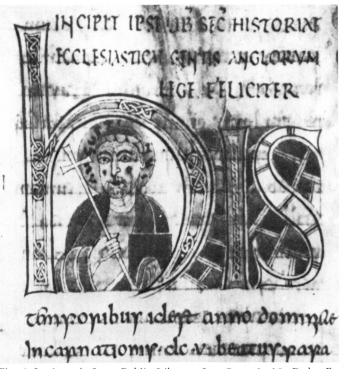

Fig. 1 Leningrad, State Public Library: Lat Q. v. 1. 18, Bede, *Ecclesiastical History*, fol. 26v. Letters *H I S* with portrait of St. Augustine of Canterbury.

Fig. 2 London, British Museum: Cotton Vespasian A. I., fol. 53.

Fig. 3 Paris, Bibliothèque Nationale: Ms. lat. 4884, fol. 1. Initial with Temptation of Eve.

Fig. 4 Leningrad, State Public Library: Lat. Q. v. I. 18, Bede, *Ecclesiastical History*, fol. 3v. Initial *B*.

more recent, and different in aesthetic principle from the insular type I have described, seems to have arisen independently on the continent where the letter had been assimilated earlier to human as well as animal forms, at first without a religious meaning. Developing along different paths in England and in Frankish Gaul, these two types of historiated initial occur together in a psalter of *ca.* 800 from Corbie, Ms. 18 in the library of Amiens.[6] It appears from both ornament and figures that much in the style of the fantastic initials of this book—remarkable calligraphic drawings anticipating Romanesque art—depends on insular models of the eighth century, which incorporated elements of Italian art of the period. In an earlier manuscript from the same region of Corbie, the so-called Scaliger Barbarus (Paris, Bibl. Nat. Ms. latin 4884),[7] a world history, written in the second half of the eighth century, the sole decorated initial shows a fusion of the two types: the serpent's body in the scene of the Temptation (Fig. 3) forms the bow of the *P* which in turn encloses the figure of Eve. The unfinished interlace filling of the column of the *P* is an insular pattern; it supports the view that this early example of a historiated letter on the continent follows insular art.[8]

In drawing a figure of some religious significance within a major initial, the Anglo-Saxon artist of the Leningrad Bede departed from the usual practice of the painters of manuscripts both in England and on the continent. The first ornament of the initial—in the sixth and seventh centuries—was a decoration of the body of the letter either through linear markings and appendages or through a transformation of this body into a living creature. Only later, as in the Leningrad Bede, did the initial become the enclosing frame of a scene, a figure, or a decorative pattern. Between these two stages lies another which might easily be confused with the second and which perhaps prepared the way for the latter: the filling of the inner background of the initial with a dense ornament, as in the Lindisfarne Gospels and the Book of Kells. But these elaborate fillings were not always conceived as distinct forms bounded by the initial; they extend or transpose the terminal and bodily ornament of the letter beyond as well as within the space enclosed by the initial—a complex milieu in which the letter itself seems to be embedded. The occasional human and animal figures inserted in this environment of the letter can hardly be viewed as primary objects framed by the initial. On the other hand, one should not overlook in the fabulous repertoire of the artists of the Book of Kells the exceptional angel snugly fitted into a tiny *O*.[9] It is less often in the surviving works of the Celtic Northumbrian style and rather in manuscripts with a hybrid Italo-Saxon or Frankish-Saxon character that we observe the filling of the inner ground of initials with birds, plants and profane figures as distinct units—a practice that emerges also in the continental schools in the eighth century.

Such is the character, too, of the only other large initial in the Leningrad

manuscript, the *B* on fol. 3v (Fig. 4). It is remarkable as an initial of which the foliate ornament is in several respects independent of the structure of the letter: two large plants issue inorganically and unarchitecturally from the corners of their fields, at a sharp angle to the main axes of the initial. They neither continue the rounded arcs of the *B* nor do they spring from them as from a base. I know of no similar design in early insular book art, although the principle is consistent with the tendency of the painters to contrast the axes or divisions of frame and field.

The form is distinctive, too, in the sheer variety of motifs. The upper theme is a tree-like shrub with symmetrically branching stems from which grow different elements: a pointed or heart-shaped leaf, a trefoil, a kind of berry or seed; the outer stems also produce unlike growths. The lower plant, with its fleshy, lobed leaf, recalls an antique palmette. The variation is surprising; the more common practice at that time was to repeat the same plant form in a symmetrical counterpart. The two growths belong to different species of ornament, although they seem to rise from a single root and are subject to the same large scheme of design that retraces the curves of the *B*, while opposed to one another in the contrast of slender and fat, of involuted and spreading forms.

The elements of this initial and even the peculiarities of their design may be found in other works. What is unique is the combination of details.

The diagonal axes of the plants are typical in relief carvings on sarcophagi of the seventh century in southern France.[10] There the rectangular panels of the front faces of the coffins are filled with ivy and trefoils somewhat like the plant in the upper half of our initial (Fig. 5). They are designed in deliberate contrast to the static grouping of the vine scrolls or palmettes in neighboring panels.

The plant grows diagonally from the corner of the field in another Northumbrian book in Leningrad, on the bases of a canon table (Fig. 6);[11] but the sloping axis is rare in surviving Anglo-Saxon initials. I do not doubt, however, that such initials were common in the eighth century. Their frequency in Carolingian manuscripts of the school of Tours, which shows many insular features, probably depends on Anglo-Saxon practice.[12]

Most often in Carolingian and later Anglo-Saxon art the foliage that fills the inner space of a *B*, as on the Beatus page of psalters, tends to prolong the curves of the *B* as a spiral scroll.[13] The plant in the Leningrad initial is essentially an arborescent rather than winding, vine-shaped form in spite of its spiral details—a difference that points to a particular tradition of design. The slender plants that fill the corners of the silver portable altar of Saint Cuthbert in Durham (*ca.* 700 A.D.) are a simplified version of the same motif.[14] The dominance of the tree structure, with two pairs of branches from one stalk, recalls old Oriental types, like the "tree of life," which were maintained in

Fig. 5 Narbonne: Sarcophagus.

Fig. 6 Leningrad, State Public Library: Lat. F. v. I. 8, Gospels from Northumbria, fol. 13v. Canon table.

Fig. 7 Bewcastle, Church of St. Cuthbert: Cross.

Fig. 8 Croft, Church of St. Peter: Cross.

later Eastern art beside the classic rinceau.[15] Northumbrian and other Anglo-Saxon examples may be cited on stone sculptures of the late seventh and eighth centuries,[16] on metal work[17] and in several manuscripts.[18] For the transmission of this motif to the West, the gold cross of the Emperor Justin II (565–578) at St. Peter's in Rome is an important document.[19]

The forms of the leaves and other growths also point to the East and especially to Coptic[20] and Sassanian art.[21] They are types distinct from the common Mediterranean vine and acanthus, but appear in England beside the vine, often on the same work, as on the Ruthwell and Bewcastle crosses (Fig. 7). The peculiar detachment of the two berries from the lance-shaped leaf along the stem is found mainly in Northumbrian works, e.g., on the cross at Croft (Fig. 8),[22] on the Ormside Bowl (Fig. 9),[23] and in another manuscript of Bede—Bodleian 819.[24] Closely related to these are the plant forms on a stone relief of the ninth century in Jarrow.[25]

The lower plant—a sprung palmette of which the middle lobe is replaced by a flower with a central bud and two pointed leaves on a long stem—is exceptional in early insular art. Like the plant above, and even more clearly, it is a Near Eastern type. The compact rounded lobes preserve the archaic aspect of the ancient Assyrian form;[26] most often in later art the lobes are pointed and curled. There is a precedent for the whole plant in Greek art on the Scythian side of the Black Sea,[27] and the fleuron has striking analogues in early continental Celtic work which had absorbed much from classic art.[28] But the context, as well as the details of form, make it clear that we have to do here with a later line of tradition. The distinctive central flower, set like a trefoil in the palmette, is familiar in Sassanian art[29] and the neighboring schools (Byzantine, Syrian, Coptic and Moslem) in more or less complex elaboration, above all in textiles.[30] But the closest parallel I have found to the simple treatment in the Bede is on the repoussé bronze sheathing of the tie rods in the Dome of the Rock at Jerusalem (692).[31] Whether the motif got to England directly from the East or by way of continental art, I do not venture to guess. Related, though not precisely similar, forms may be cited in Western Europe in the seventh century; on the stone sarcophagi of southern France they appear beside a diagonal growth which resembles the upper plant of our initial.[32] They show that this family of ornament, if not the species, was already established in the West prior to our manuscript. If the palmette with the fleuron in its specific form in the Bede is unique among surviving Anglo-Saxon works, it was no doubt more common in its time. An adaptation of the motif may be discerned in an initial *B* in the Corbie Psalter (Amiens Ms. 18).[33] In studying a more complex variant on the Durham stole (909–916), a Winchester work, Dr. R. Freyhan has already traced its history through Sassanian, Coptic and Byzantine art.[34] Since the initial of the Leningrad Bede was still unknown when he wrote,

he concluded that the Near Eastern form came to England in the early tenth century on a wave of Byzantine art. We can be sure now that the type was already there in the first half of the eighth century, although the richer version on the stole depends perhaps on a later model. The presence of the fleuron of our initial, in almost identical pattern, on the Jedburgh slab[35] makes it probable that the palmette as a whole had reached England by about 700.

We conclude from these comparisons that the plant ornament of the *B* is an adaptation of elements from the Near East in a new context and with a newly developed relationship of the ornament to the frame. No other insular work shows all these details; in none is the palmette with the fleuron so distinctly Eastern; but the closest parallels are found in Northumbrian sculpture and mainly in works in which the Northern elements are associated with other motifs of Mediterranean type. The initial *B* is an evidence that the characteristic plant ornament of Northumbrian sculpture existed also in contemporary manuscript art in a pure form and particularly in the Romanizing center of Jarrow-Wearmouth where, it is well known, the abbots had brought works of art from Italy and artists from Gaul.

Let us consider next the geometric ornament of the capital letters and especially of the large majuscules that accompany the initials.

The interlace with intermittent knotting on the *B* (Fig. 4) will be recognized at once, from the resemblance to the Lindisfarne Gospels, as a Northumbrian type. Even small details in the varied construction of the knots can be duplicated in Northumbrian manuscripts.

Note also the line inside the bow of the *R*, with two concave arcs forming together with the bow what may be called roughly a triangle with curved sides—a habitual design in the majuscules of the Lindisfarne Gospels and the related books of Durrow, Chad and Kells. It is an ornament undoubtedly derived from native British art. Such concave scalloping along a rounded edge recalls the Celtic bronze mirrors of the first century A.D.;[36] but more likely the calligraphers of the Christian period borrowed this congenial curve from the pagan art of the sixth century. It appears especially on the enameled escutcheons of the hanging bowls,[37] Celtic works found in Saxon graves, and has been plausibly interpreted as a development from the pelta motif in Roman-British art.[38] The connection of this form in the manuscripts with the immediately preceding native metal style is confirmed by the little almond or lozenge drop set between the arched lines—an element common to the manuscripts and the enameled disks.[39]

Apart from this minor, though revealing, detail, the ornament of the majuscules—a sustained and complex decoration—is distinct from any that we find in the Lindisfarne group.[40] This alone would lead us to suspect that the Leningrad Bede comes from a Northumbrian center with a different tradition.

In these majuscules (Figs. 1, 4) the body of the letter is marked transversely with bands of triple lines—the middle one thicker—at a right angle to the contour of the letter; and the reserved space of the background is divided densely by oblique lines—also triple, but of uniform thinness—into an irregular, in places skewed, pattern of plaid-like colored spots (in one ground, red, yellow, blue and white, in the other, white and red), the linear bands always remaining uncolored. The letters, too, are uncolored, except for three compartments in the *NIA* of *BRITANNIA*.

The resulting interplay of letter and ground recalls the method of design of the native enamelists and metalworkers. It is the rhythmical "coloristic" assertion of the intervals of the background that Alois Riegl described long ago as an essential goal common to late antique and barbarian art. Here it is applied with a fresh ingenuity and freedom in varying the contrasts.

The lines and colors are so disposed and the cells so proportioned and cut, that in no two interspaces of the letters do we find the same pattern. The effect is of a two-part ornament, a visual counterpoint in which the more stable and continuous forms of the letters are opposed to the zigzag, broken, flickering, relatively chaotic, colored ground, which is strong enough to distract or unsettle our perception of the word. Also, each part itself contains rival patterns: in the ground, the network of lines against the marquetry of color; in the letters, the transverse banding against the large vertical forms. But letter and ground share a number of elements and are closely adapted to each other, apart from the obvious recurrence of the tripled lines in both; e.g., the *T* of the upper row of majuscules (Fig. 4) seems to determine the slope of the colored bands around it, and other lines of the ground correspond to the larger diagonals of certain letters. We observe finally as an aspect of complexity that the main initial has a different kind of ornament than the counterposed letters which it balances.

The transverse banding of the letters occurs in other insular manuscripts in Northumbria and the South.[41] Since it is found more often in continental initials of the fifth to eighth century,[42] one may view the practice in England as a foreign, perhaps Italian, feature, in spite of parallels in native metal work.[43] But nowhere has it been applied in so sustained a way as in the Leningrad Bede.[44]

An analogous ornament on the surviving porch of Wearmouth, believed to be of the time of Benedict Biscop, the founder of the abbey in 674, may have some bearing on the origin of our manuscript. The columns on the porch (Fig. 10) and at the window openings on the west wall are grooved transversely with parallel lines, spaced like the bands on the letters. It may seem far-fetched to draw conclusions from the use of so obvious an ornament as a repeated set of parallel lines, which might arise independently anywhere and at any time. The fact is, however, that this columnar decoration is a distinct local type, apparently

Fig. 9 York, Yorkshire Museum: Ormside Bowl.

Fig. 10 Wearmouth, Abbey: Porch.

unknown outside the region of the twin abbeys; about fifty similar shafts are preserved in Wearmouth, Jarrow and Durham.[45] Although produced by the lathe, this ornament on stone is hardly to be explained as a simple result of the technique of turning the shafts. The baluster shafts elsewhere in England and on the continent are convex in profile and lack these finely grooved transverse lines. Whatever its ultimate source, the application of this ornament to both letters and columns seems to be a feature of the art of Wearmouth and Jarrow.

The banding of the background, I have said, follows another principle: the thin lines, in sets of three, enclose cells of color—an effect like that of inlay or enamel bounded by the lines of the cloisons. Among the smaller initials of the first two books are some, however, in which the background divided by these lines remains entirely uncolored. In several, only the parallel diagonal bands are drawn;[46] in one, some perpendiculars are added to create an effect like that of masonry joints;[47] in another (Fig. 11), the banded lines at right angles to each other are staggered in a less regular fretwork. The development, or at least the stages in the construction of the more complex design, are preserved in the series of smaller initials.

This singular treatment of the ground has precedents in older native work. It may be regarded as a local variant of the widespread taste in Hiberno-Saxon art for the articulation of the background interspaces as a contrasting ornament. In the pre-Christian Celtic art of Britain, especially on the bronze mirrors, the intervals of the main pattern were sometimes scored with a hatching of lines on a diagonal axis, though with units of smaller scale—the "basket-pattern" filling which survives into mediaeval art.[48] Early Anglo-Saxon metal work, too, is full of banding and compartmenting of colored fields in which the lines form a pattern of their own with a rhythm distinct from that of the enclosed colored units, but finally coordinated with them.[49]

Of the constituent elements of this background ornament in the Leningrad Bede, each one can be found elsewhere in isolation from the others. In the Codex Amiatinus the uncolored inner ground of an initial Q is divided by a knotted band of double lines forming an X within a circle.[50] In the Lindisfarne Gospels the artist has traced in dotted lines behind and between the majuscules a horizontal band or a diagonal diaper, but without the cloisonné structure and coloring; or he has drawn a system of doubled lines of key or fret pattern.[51] A diagonal stepped design with a colored wash decorates the inner ground of certain initials, but where color is used in the background of majuscules in the Lindisfarne book, each painted inner field of a letter has a single tone, unlike the polychromy of the similar spaces in the Bede. In the Vespasian Psalter (Fig. 2) the background of varied color is a strictly rectangular checkered field and lacks the essential banding, the triple lines that form the unstable grid in the Jarrow manuscript. A similar checkered effect appears in manuscripts attributed

to northern France.[52] There is, however, a Northumbrian book, Cambridge Corpus Christi College 197, with a rectangular system of reserved bands enclosing the painted cells.[53] A cruder form of this treatment occurs later in north French manuscripts of the eighth century, the Laon Orosius (Ms. 423)[54] and Paris, Bibl. Nat. latin 12168 (Fig. 12),[55] a sign that insular art had penetrated that region. In those Merovingian works the cells of color form for the most part a horizontal and vertical system, though some inner lines are diagonal. The practice in France seems to be an unskilled reduction of the insular device to a simpler, coarser form. The same tendency to the horizontal and vertical in this motif is found in Ireland, too, in the Book of Mulling[56] and in much later insular work of provincial quality.[57]

I have not been able to localize the early practice of this form in a particular center. The oldest surviving example seems to be the Northumbrian Gospels of about 700: Durham Cathedral Library Ms. A. II. 17, with which have been bound, before the tenth century, some leaves from a codex written in Jarrow.[58] It does not appear, so far as I can learn from the available reproductions, in the books of Durrow, Chad, Echternach or Lindisfarne. It is a surprise then to find it in an embryonic form in the Book of Kells.[59] There, most often, the colored inner ground of certain initials is simply divided by parallel sloping lines, without the perpendiculars which, in the manuscript of Bede, create a complex grid. But we have seen that this simpler form occurs also in the Bede. It is the stage, in the elaboration of this ornament, represented in the Durham book with which Kells has other elements in common. The more advanced form can be found, however, in another copy of Bede's History, with the same red, yellow and blue fillings, and with the same style of writing as the Leningrad codex: British Museum, Tiberius A XIV, fol. 4v.[60] In this manuscript, which most probably comes from the same scriptorium, are also several initials with an inner ground decorated in the simpler manner of the Book of Kells.[61]

In studying this Northumbrian ornament, one should consider also the possibility of a Mediterranean, even Byzantine, factor in the design. There is an interesting analogue of the linear grid in an initial of a manuscript from Constantinople, the Bible of Leo the Patrician, Vatican Reg. gr. 1 (Fig. 13). Double lines or bars divide the uncolored ground of an *E*, as in an *E* of the Leningrad Bede (Fig. 11), without solid filling of color or cloisonné effect. A similar treatment is found in the sister manuscript of the Bede, Tiberius A XIV, and also in the Book of Kells. The Greek manuscript, dated 886–911, seems too late to serve as an evidence of a connection between insular art and earlier Byzantine forms, although other features of the ornament of this Bible appear in Merovingian books and in the Stuttgart Psalter, a Carolingian work copied from an older model. The diagonal pattern in question occurs already,

Fig. 11 Leningrad, State Public Library: Lat. Q. v. I. 18, Bede, *Ecclesiastical History*, fol. 9. Initial *E*. (Drawing by Professor Jacques Guilmain, after a photograph.)

Fig. 12 Paris, Bibliothèque Nationale: Ms. lat. 12168, St. Augustine, Heptateuch, fol. 1, (detail).

Fig. 13 Vatican City, Biblioteca Vaticana: Ms. Reg. gr. 1, The Bible of Leo the Patrician, fol. 5.

Fig. 14 Munich, Bayerische Staatsbibliothek: Clm. 6224, fol. 191v. (Drawing by Professor Jacques Guilmain, after a photograph.)

however, on the body of an initial in an Italian or Illyrian manuscript of the seventh century, the Valerianus Gospels in Munich (lat. 6224—Fig. 14). In its relative simplicity this example suggests an earlier stage of the Greek type. But the insular form might have been developed independently from native ornament which is so rich in key and fret patterns.[62]

Whatever the origin of the single elements of the background ornament of the Leningrad Bede, it is clear that the letters themselves are based on continental art. The forked endings of several of the majuscules (*R, A, N*) are a common feature in Merovingian script, especially in Luxeuil and northern France.[63] Also Merovingian is the type of *A* with a curved cross bar extending outside the left slope of the *A*.[64] These are not typical insular or classic forms, and hence their presence in the Leningrad Bede implies a direct contact with recent book art on the continent. One might refer to the artists who came to Wearmouth from Gaul in 675 to decorate Benedict Biscop's church, although we do not know whether such craftsmen also practiced the arts of the book. But from a remark in Bede's History we are led to suppose that his abbey possessed manuscripts from northern France: in describing the visions of Fursa, an early Irish saint (649), Bede speaks of a little book of the saint's life as his source;[65] it was perhaps a manuscript from the Irish foundation at Péronne, near Corbie, where the saint was buried.

I have put off to the end the analysis of what is most important for the Northumbrian origin of the decoration: the image of Saint Augustine of Canterbury in the *b* (Fig. 1).

It is a delicate, precise and pretty drawing with decorative charm. The lines, which follow rhythmically in clear repeats, are fitted neatly to the adjoining contours of the *b*, a frame with corresponding straight and curved forms. The scalloped silhouette of the halo and the body join the inner bow of the *b* to form that curved triangular pelta shape which we have noted in the *R* beside the other initial (Fig. 4) and which is an old theme in native British art. We discern here the underlying unity of representation and ornament in this artist's style. The diagonals of the cross, the folds with their reserved white borders, are like the banded lines that make up the grid of the background in neighboring letters. The book is a member of the same family of shapes as the colored cells nearby. Their tones of red, yellow and blue reappear in the halo, the costume and the book.[66] The human and the abstract, the figure and the ground ornament, with their many secret echoes and conjunctions, disclose to scrutiny a surprising likeness of form. Yet something of the living individual is caught in the drawing of the face. The artist steers a middle course between the pictorial manner of Mediterranean art and the fantastic artifice of Northern ornament. If we knew nothing of the origin of the manuscript, the resemblance of this half-figure to well-known Northumbrian works—the coffin of Saint

Fig. 15 Durham: Cathedral. Coffin of St. Cuthbert.

Cuthbert in Durham (698) and the Lindisfarne Gospels (698–721)—would compel us to place the Leningrad drawing in a neighboring center. The relation to the apostles and angels incised on the coffin is particularly clear (Fig. 15). The tonsured, beardless Augustine, with book and cross, is patterned, with some religious intent, on the type of the Roman Peter of the Durham work, which remained traditional in Anglo-Saxon art.[67] The smooth linear forms, quite regular and grouped in closed sets in the folds of the costume, resemble those of the Lindisfarne evangelists (Fig. 15). On the Cuthbert coffin these elements, vigorously cut in wood, are coarser and more schematic, but depend no doubt on the same types of models and local style as the drawing in the Bede. Note especially how the lines of the costume are joined in both works, e.g., on the shoulder and right arm, and the remarkably similar drawing of the folds and the book.[68] An interesting detail confirms the connection: the vertical ridges of the upper lip, an element of the facial schema found not only in the Gospels, the initial, and on the coffin, but in other works of the Northumbrian school.[69] (Dr. Kitzinger, in his admirable study of the coffin,[70] has overlooked this detail in tracing the facial schema of its figures to a Provençal type where it is lacking.) It comes, very likely, from a Mediterranean style in which this feature was more definitely marked than in the Gospels of Saint Augustine in Cambridge where it appears in a less decided form and then only in the large figure of Saint Luke[71]—it is omitted altogether in the small accompanying scenes. Already part of a rudely stylized face on the Durham coffin, it occurs in the initial of the Bede manuscript[72] beside other features more naturalistic even than those in the Lindisfarne Gospels; the drawing in our initial thus provides a clearer view of the character of the common prototypes. The Mediterranean source is indicated also in the modeling of the brow by accented furrows,[73] as in the Lindisfarne Gospels and the Vatican manuscript Barberini 570.[74] Like the Lindisfarne master, the artist of the Bede initial renders the color of the cheeks by two spots; he also models the face with purple touches on the side of the nose and under the eyebrows. But his drawing of the eyes is more faithful to nature and to classic norms than the severely schematic eyes of the Lindisfarne or Durham figures. The lids, carefully distinguished, are unequal in length; they overlap at the outer side and are joined at the inner angle by the rounding of the tear duct. This is close to the form of the eye in Italian paintings of the seventh and eighth centuries and in early Carolingian manuscripts which follow Italian practice.[75] The Leningrad drawing is an evidence that the more natural form had been transmitted to England already before the Carolingian period.[76] The same type of eye in the Corbie Psalter (Amiens 18) comes perhaps from English models rather than directly from Italy or from early Carolingian art.

The drawing of Augustine, in its studied articulation of the features, is an

example of a stage in the development of insular style which lies between the Southern models and the Lindisfarne Gospels, although the manuscript of Bede is later than the Gospels and shows a somewhat more schematized form in the lines of the costume. There existed in Northumbria and most probably in Jarrow, before the middle of the eighth century, artists who did not carry the ornamentalizing of the figure as far as the miniaturists of Lindisfarne, but like the contemporary painter of the Vespasian Psalter retained more of the Mediterranean natural form, at least in certain details of the face. The development of insular art proceeded then, even within the same region, along several diverging lines.

Our new knowledge of the Leningrad Bede throws some light on the Book of Kells.

In the magnificent group of manuscripts with which it is classed, including the Gospels of Durrow, Lindisfarne, Echternach and Saint Chad, the Book of Kells alone possesses foliate ornament.[77] This fact has been cited more than once as an argument for a late date (*ca.* 800) and for probable dependence on Carolingian art.[78] But no one has yet found a convincing Carolingian model for the plant forms in Kells (Fig. 16).

Zimmermann, who placed the manuscript in the years about 700, referred this ornament to an Eastern source, citing, with some reservation, the gold cross of the Emperor Justin II in the treasure of St. Peter's in Rome as an example of the parent style.[79] The decoration of this work of the later sixth century has, indeed, a resemblance to the plant forms in the Book of Kells, though not enough to permit one to answer the question concerning its date and models. Other writers have thought of insular and Merovingian prototypes.[80]

The initial *B* of the Leningrad codex, neglected by Zimmermann,[81] provides the best evidence from manuscript art of what one may reasonably regard as an early stage of the foliate ornament of Kells. The trefoils, the pointed leaves, the round berries or seeds at the stem, detached from the leaf— all these are clearly represented in our initial in forms more natural and less stylized than those of the Book of Kells.

That the ornament of the latter has some connection with the school that produced the Leningrad Bede is confirmed by an initial of Kells which combines several features of the ornament of the Bede. In a *CU* on fol. 94v (Fig. 17) we observe not only the characteristic elements of plant form proceeding from an inclined stalk within the enclosed space of the initial,[82] but also that diagonal banding of the inner ground which I have already discussed as a peculiarity of the manuscript of Bede and which is unknown in the books of Durrow, Echternach and Lindisfarne.

This mode of filling the inner ground of the initials is common, we have seen, in the Book of Kells. Most often it appears in a more primitive form:

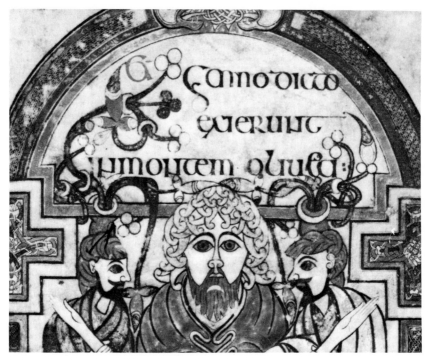

Fig. 16 Dublin, Trinity College Library: Ms. A. 1.6, Book of Kells, fol. 114.

Fig. 17 Dublin, Trinity College Library: Ms. A. 1.6,
Book of Kells, fol. 94. Letters *C U*.

simple parallel diagonal zones separated by paired lines, without the perpendicular, masonry-like or fretwork divisions used in several letters of the Bede. But there is also in the Book of Kells a more developed stage in which the middle band is subdivided by a central cell with an ✕-pattern of intricate, stepped design—perhaps an independent elaboration of the common parent form.[83]

The foliate ornament of the Book of Kells, it now appears, was derived from one stream of Northumbrian art, which issued from or passed through Wearmouth and Jarrow. The same forms have long been known in the stone sculptures of that region; it was these in fact that led Brondsted to attribute Kells to the Northumbrian school and to suppose that the same plant motifs had existed in other arts of the region.[84] But these elements of plant ornament had been observed also as a distinctive type in the sculptures of the west of Scotland, nearer to Iona. Anderson in 1881[85] and Baldwin Brown,[86] more recently, had noted that beside the typical vine scrolls which come from Eastern art, the Scottish crosses include lancet and trefoil motifs of another origin. It is these that are revealed for the first time in Northumbrian manuscript art through the publication of the facsimile of the Leningrad Bede, a work produced in a center that was a port of entry of foreign art. The initial *B*, like the *h*, permits a further insight into one of the sources of the Book of Kells— the Italo-Saxon current in Northumbrian art.

These observations accord with recent discoveries concerning the Book of Kells. P. McGurk has shown that its canon tables probably depend on a Northumbrian model and that the division of its text agrees with that of Northumbrian Gospel manuscripts—a division ultimately based on an Italian work.[87] The connection of Kells with Northumbria has also been confirmed by Kitzinger's study of the image of the Virgin and Christ on the Cuthbert coffin, so similar in type to the painting in the Book of Kells.[88]

If the study of the ornament confirms the Northumbrian origin of the Leningrad Bede, an origin inferred already from the language and script, it should be observed that certain elements of the Jarrow style, whether native, continental or Eastern in source, were known in other Romanizing centers like Canterbury and probably York, and were in time diffused throughout the islands. For lack of data we are unable to trace the process of invention and borrowing; the gaps are too great and lead us to misjudge, perhaps, the singularity and importance of surviving works. The association of Latin and Northern forms is no less evident in the fragments of the great cross at Reculver in Kent than in the Ruthwell and Bewcastle crosses in the North. In the Codex Aureus in Stockholm, usually assigned to Canterbury in the mid-eighth century, the ornamented majuscules of the *XPI AUTEM* page resemble the capitals of the Leningrad Bede in their arrangement and broad type and in small details of decoration; the figures, too, have something in common with the drawing in

Fig. 18 Florence, Biblioteca Medicea Laurenziana: Codex Amiatinus, fol. VII.

the Bede. Similarly, the Book of Cerne, a later work of uncertain origin, attributed to Mercia, offers interesting parallels in its majuscules and figure types to those of the Leningrad book. But all these are hardly close enough in character and detail to justify attribution to the same center or region as the Bede, although they lead us to seek a connection. We recognize again what has often been noticed, that the polarity of the Celtic and the Roman within insular art, like that of Lindisfarne and Jarrow—the differences corresponding to the larger opposition of Celtic and Roman Christianity in the islands— does not exclude the rich interplay of the opposed traditions in the same works, as in the church itself, although one or the other may dominate in the most individual achievements.

We have seen that Jarrow-Wearmouth, the home of the Codex Amiatinus, was also open to Celtic forms. From the many references to Irish scholars, monks and saints in Bede's History and other writings, it is clear that the Irish church was well known and its members respected in the Romanizing center at Jarrow. We cannot regard the Leningrad Bede as a sufficient example of the art of Jarrow in the generation after the Amiatinus; it is an historical text, not a book of liturgical use, and the initials correspond in their limited size and richness to the secondary initials of the Lindisfarne Gospels—those which mark the beginnings of the prologues rather than of the evangiles themselves. Who can imagine what surprises a sumptuous gospel manuscript from Jarrow would bring! There were surely motifs and types of composition in use at Jarrow which found no place in the Bede and which are perhaps preserved in a radically transformed aspect in works of more elaborate Hiberno-Saxon character, like the Book of Kells. A little noted page in the Codex Amiatinus, with Hilary's account of the contents and divisions of the Bible,[89] grouped in an ornamented structure of medallions, arch, crosses and tabellae ansatae (Fig. 18), might well be an example of the forms that underlie as models the most complex frames on certain pictorial pages of the Book of Kells (fols. 32v, 114r, 291r).[90]

NOTES

1. O. Arngart, *The Leningrad Bede, an Eighth Century Manuscript of the Venerable Bede's Historia Ecclesiastica Gentis Anglorum in the Public Library, Leningrad*, Early English Manuscripts in Facsimile, Vol. II, Copenhagen, 1952.

2. E. H. Zimmermann, *Vorkarolingische Miniaturen*, Berlin, 1916, pp. 145, 309, 310, and plate 332a.

3. E. A. Lowe, "Some Observations on the Leningrad Manuscript of the Historia Ecclesiastica Gentis Anglorum—a key to Bede's Scriptorium," *Scriptorium*, 1958, pp. 182–190 and: "An Autograph of the Venerable Bede?," *Revue Bénédictine*, 1958, pp. 200–202. [Lowe's conjecture that the colophon was signed by Bede himself (†735) has been doubted by P.

Meyvaert (*Revue Bénédictine*, 1961, pp. 274–286) and D. H. Wright (*ibid.*, pp. 265–273), and is not mentioned by Lowe in his subsequent account of the manuscript in *C.L.A.*, XI, 1966, no. 1621, where he dates it after 731 (when Bede completed the book) and before 746, when a scribe noted in the margins of the text the number of years that had elapsed since the events Bede had recapitulated in annalistic form at the end of his text.]

4. E. H. Zimmermann, *op. cit.*, pl. 286–288, pp. 131, 133, 134, 289–291 (third quarter of the eighth century). For most recent discussion, see K. Sisam, "Canterbury Lichfield, and the Vespasian Psalter," *Review of English Studies*, VII, 1956, pp. 1–10, 113–131, and the unpublished doctoral dissertation of David H. Wright, *The Vespasian Psalter and the 8th century Renaissance*, Harvard University, 1956. [See now Wright, *The Vespasian Psalter*, Early English Manuscripts in Facsimile, Vol. XIV, Copenhagen, 1967.]

5. A. Schardt, *Das Initial*, Berlin, 1938, pp. 48 ff., attributes to the Ada school the invention of the enclosing historiated initial.

6. A. Boinet, *La Miniature Carolingienne*, Paris, 1913, pl. 148, 149; V. Leroquais, *Les Psautiers Manuscrits des Bibliothèques Publiques de France*, I, Paris, 1937 p. 6, II, pl. III–VI; J. Porcher, "L'évangéliaire de Charlemagne et le psautier d'Amiens," *Revue des Arts*, VII, 1957, pp. 50–58. For the earlier Merovingian type, cf. Cambrai, Ms. 470; Lowe, *C.L.A.*, VI, no. 740.

7. This important manuscript, ignored by Zimmermann, has been described by J. Strzygowski, "Eine alexandrinische Weltchronik," *Denkschriften der kaiserlichen Akademie der Wissenschaften in Wien*, phil.-hist. Klasse, LI, 1906, pp. 133 ff. and fig. 1.

8. There was perhaps an earlier illustrated copy of this text in Northumbria. Several episodes of ancient secular history included in this chronicle and designed for illustration in the adjoining unfilled reserved spaces—the Capture of Jerusalem by the Romans, the story of Romulus and Remus—are represented on the Franks ivory casket, a Northumbrian work of *ca.* 700. This has been noted by Strzygowski and discussed further by Baldwin Brown, *The Arts in Early England*, VI, part 1, pp. 27 ff. The serpent's temptation of Eve, an unusual subject, is also a separate scene in the Caedmon manuscript in Oxford.

9. *The Book of Kells*, Urs Graf Verlag, Bern, 1950, fol. 48r. Cf. also St. Gall Ms. 731 (Zimmermann, *op. cit.*, pl. 152b); in several Italian and Frankish manuscripts a head or a cross is inserted in the closed space of an *O, P,* or *Q* (*ibid.*, pl. 14d, 31a, 35a, 45a, c, 60a, etc.).

10. E. Le Blant, *Les sarcophages chrétiens de la Gaule*, Paris, 1886, pl. 32, 34, 36; J. B. Ward Perkins, "The Sculpture of Visigothic France," *Archaeologia*, 87, 1937, pl. XXXII, 1, 2, XXXV, 2, 3. Cf. also the symmetrically diverging diagonal plants at the base of a cross on a sarcophagus in S. Apollinare in Classe, Ravenna (A. Haseloff, *Pre-Romanesque Sculpture in Italy*, Florence and New York, 1931, pl. 3); a single diagonal spray in an *F* in Milan, Ambros. F. 84 sup. (Zimmermann, *op. cit.*, pl. 18d). These examples should be distinguished from the plants issuing diagonally from the four corners of a square towards an inscribed circle or lozenge, as in Italian altar panels of the ninth century (Haseloff, *op. cit.*, pl.67 [Sorrento, Rome], though here the palmette with central fleuron suggests some family relation to the ornament of the initial of the Bede. For an analogue of the diagonal stalk in the East, though less marked, cf. a relief of the seventh century near Safa, in Syria (R. Cattaneo, *Architecture in Italy from the sixth to the eleventh century*, London, 1896, fig. 24).

11. Public Library, Ms. F. v. I. 8. For the whole page see Zimmermann, *op. cit.*, pl. 323. Zimmermann attributes it to South England, but T. D. Kendrick, *Anglo-Saxon Art to A.D. 900*, London, 1938, pp. 144 ff., G. Micheli, *L'enluminure du haut moyen âge et les influences irlandaises*, Bruxelles, 1939, p. 28, and F. Henry, *Irish Art in the Early Christian Period*, London, 1940, p. 134, place it in Northumbria. Note also the diagonal plant on the stone frieze at Breedon on the Hill (Leicestershire), *Archaeologia*, LXXVII, 1927, pl. XXXI, 4, ninth century.

12. W. Koehler, *Die karolingischen Miniaturen I. Die Schule von Tours*, I, Berlin, 1930–33, pl. 18 d (Bible in Bern), pl. 57 (Bamberg Bible), pl. 89 (Paris, Bibl. Nat. lat. 1, Bible of Charles the Bald), pl. 120e (Paris, Bibl. Nat. lat. 261, Gospels of Le Mans). Cf. also

the Bible of S. Paolo f.l.m., Rome (Boinet, *op. cit.* pl. 130B), and Wolfenbüttel Ms., life of St. Gall (Schardt, *op. cit.*, p. 97.)

13. F. Wormald, "Decorated Initials in English Manuscripts from A.D. 900 to 1100," *Archaeologia*, XCI, 1945, p. 108 and pl. 1, and T. D. Kendrick, *Late Saxon and Viking Art*, London, 1949, pl. XXVII, LXXIV.

14. Baldwin Brown, *op. cit*, V, pl. XLII, 2, and VI, part 1, pl. III and fig. 1, p. 17; C. F. Battiscombe, ed., *The Relics of Saint Cuthbert, Studies by Various Authors*, Oxford, 1956, p. 333, fig. 3.

15. Cf. the rock relief at Taq-i-Bustan, A. U. Pope, ed., *A Survey of Persian Art*, IV, London and New York, 1938, pl. 167, 168; stuccoes from Ctesiphon in New York, *ibid.*, pl. 172D; a bronze ewer in the Hermitage, J. Orbeli and C. Trever, *Orfèvrerie Sasanide*, Moscow and Leningrad, 1935 pl. 70; a Coptic wood panel in Cairo, E. Kitzinger, "Anglo-Saxon Vine-Scroll Ornament," *Antiquity*, X, 1936, 61–71, pl. IVA.

16. Cf. L. Stone, *Sculpture in Britain: the Middle Ages* (Pelican History of Art), London, 1955, pl. 4B (Jedburgh), pl. 11 (Codford St. Peter).

17. Cf. the Björkö pail in Stockholm (F. Henry, *Irish Art*, fig. 30).

18. Leningrad, F.v.I.8 (Zimmermann, *op. cit.*, pl. 321, 322); Vatican, Barberini lat. 570 (*ibid.*, pl. 315b); the Vespasian Psalter (*ibid.*, pl. 288).

19. H. Peirce and R. Tyler, *L'art byzantin*, Paris, 1933–34, pl. 136, 199b, and Zimmermann, *op. cit.*, Text, fig. 22. One should note also the Western variants outside England: Paris, Bibl. Nat. lat. 2110, *ibid.*, pl. 134; the Mozarabic Codex Vigilanus in the Escorial (A. Riegl, *Stilfragen*, Berlin, 2nd ed., 1923, fig. 176); a sarcophagus in Narbonne (J. B. Ward Perkins, *op. cit.*, pl. XXXV, 2); the reliquary of Pepin in Conques (J. Hubert, *L'Art préroman*, Paris, 1938, pl. XVIe); and many Carolingian manuscripts (Boinet, *op. cit.*, pl. 5, 17, 41, 130B).

20. Cf. J. Strzygowski, *Koptische Kunst*, Vienna, 1904, fig. 50 (no. 7299), 175 (no. 8777), for examples in the Cairo Museum; also E. Kitzinger, *op. cit.*, p. 66, on the Coptic factor in Anglo-Saxon ornament.

21. For a striking parallel, cf. the bronze ewer in the Hermitage, reproduced in *A Survey of Persian Art*, IV, pl. 236, especially for the pointed leaf with the detached berries. Orbeli, *ibid.*, I, p. 765 places it in the Western part of the Sassanian empire and notes a strong Syrian influence in both the ornament and the figural themes.

22. Cf. also the cross at Cropthorn (Yorkshire)—Baldwin Brown, *op. cit.*, VI, part 2, pl. CVI, and A. W. Clapham, *English Romanesque Architecture*, I, Oxford, 1930, pl. 16.

23. See Baldwin Brown, *op. cit.*, V, pp. 318 ff. and pl. XXX, and T.D. Kendrick, *Anglo-Saxon Art to A.D. 900*, pp. 150 ff. The bowl seems to me a native work of the first half of the eighth century, if not *ca.* 700; I fail to recognize the Carolingian influences that have induced Kendrick to place it in the ninth century.

24. *Beda in Proverbia Salomonis* (Lowe, *C.L.A.*, II, no. 235). Cf. also another Bede manuscript: British Museum, Tiberius C. II (Zimmermann, *op. cit.*, pl. 291–292.

25. A. K. Porter, *The Crosses and Culture of Ireland*, New Haven, 1931, fig. 155.

26. A. Riegl, *Stilfragen*, fig. 39.

27. S. Reinach, ed., *Antiquités du Bosphore Cimmérien* (1854), Paris, 1892, pl. II, diadem from Kul Oba, near Kertch.

28. P. Jacobsthal, *Early Celtic Art*, II, Oxford, 1944, pl. 274, no. 365, 371, 376.

29. *Survey*, IV, pl. 223 B, 224 B, 247 (the ewer of St. Maurice, which is perhaps Byzantine).

30. N. Åberg, *The Occident and the Orient in the Art of the Seventh Century*, Part II, *Lombard Italy*, Stockholm, 1945, p. 53, fig. 53 (wooden beams, S. Sophia, Constantinople); M.S. Dimand, "Studies in Islamic Ornament," *Ars Islamica*, IV, 1937, p. 319, fig. 41 (a Syrian alabaster capital, eighth century, New York); cf. also the wood door of Qaryatayn, now in Beyrouth, Omayyad, published by H. Stern, *Ars Orientalis*, I, 1954, pl. I, opp. p. 122; fabrics from Antinoë in Egypt—Peirce and Tyler, *op, cit.*, II, pl. 48a.

31. K. A. C. Creswell, *Early Muslim Architecture*, I, *Umayyads*, A.D. 622–750, Oxford, 1932, I, pl. 25c, 26a, d; cf. also the mosaics of the Dome, *ibid.*, pl. 19.

32. Cf. Ward Perkins, *op. cit.*, pl XXXV, 3, and Le Blant, *op. cit.*, pl. XXXVI, 1, and XLVI, 1.

33. In the *B* of psalm 102; and in several other initials—cf. Marburg Institute photo 32209. Cf. also a remarkably similar palmette with central fleuron in Vienna Ms. 1007, early ninth century, from Salzburg, with insular elements, (G. Swarzenski, *Die Salzburger Malerei*, Leipzig, 1908, pl. VI). Cf. also the Carolingian examples in Boinet, *op. cit.*, pl. 46, 49, 95, 99, etc. and Koehler, *op. cit.*, I, pl. 108. In Italy, the form appears on carved stones of the ninth century (A. Haseloff, *Pre-Romanesque Sculpture in Italy*, Florence and New York, 1931, pl. 67 A, B. (Sorrento, Rome). In these two examples the palmette is set downward and obliquely, as in our manuscript, but the details are less purely Oriental.

34. R. Freyhan, "The Stole and Maniples," in C. F. E. Battiscombe, ed., *The Relics of Saint Cuthbert*, Oxford, 1956, pp. 418 ff.

35. L. Stone, *op. cit.*, pl. 4b.

36. Cf. the Birdlip mirror in Gloucester (E.T. Leeds, *Celtis Ornament in the British Isles down to A.D. 700*, Oxford, 1933, fig. 9).

37. *Ibid.*, opp. p. 150, color plate III, and T.D. Kendrick, *op. cit.*, pp. 56, 57, figs. 9–11, pl. XXVII, 3-5. Note also the red, yellow and blue color of the escutcheons as in the initials of the Bede.

38. Kendrick, *op. cit.*, pp. 36 ff., 56 ff.

39. The original pelta form appears in the oldest ornamented insular manuscript that is preserved: the Cathach of Saint Columba (F. Henry, *Art Irlandais*, Dublin, 1954, pl. 7b). But in this Irish work, it is distinct from the type we are discussing and lacks the lozenge or almond drop.

40. I must mention here the *IN* initial on fol. 29v of the Leningrad Bede, which terminates below in a bird head of the Lindisfarne type, with curved beak and foliate crest.

41. Northumbrian school: Book of Durrow, the opening pages of Luke and John; Durham A. II. 10 (Lowe, *C.L.A.*, II, no. 147, p. 9). South England: Bodleian, Hatton Ms. 48 (Lowe, *C.L.A.*, no. 240); Bodleian, Selden sup. 30 (*ibid*, no. 257); Codex Aureus, Stockholm (Zimmermann, *op. cit.*, pl. 284); Boulogne, Bibl. mun. Ms. 74 (Lowe, *C.L.A.*, no. 738); British Museum, Add. Ms. 36929 (Zimmermann, *op. cit.*, pl. 216).

42. Italy: Vatican lat. 3256 (Virgil) Zimmermann, *op. cit.*, Text, fig. 2; Munich, lat. 6224 (*ibid.*, pl. 7); Milan, Ambros. D. 23 sup. (Lowe, *C.L.A.*, no. 328 [Bobbio]; Milan, Ambros. S. 45 sup (*ibid.*, no. 365 [Bobbio]); Vatican lat. 3836 (*ibid.* no. 18b); Monte Cassino, Archivio della Badia Ms. 753 (*ibid.*, no. 381); Rome, Vitt. Emman. Sessor. 128 (*ibid.*, no. 426). France: Munich lat. 22501 (Zimmermann, *op. cit.*, pl. 38); Paris, Bibl. Nat. lat. 17655 (*ibid.*, pl. 89); Bibl. Nat. lat 12155 (*ibid.*, pl. 108); Vatican Reg. lat. 316 (*ibid.*, pl. 135, 136 [Gelasian Sacramentary]); Spain: Paris, Bibl. Nat. lat. 2269, fol. 36. There seems to be the same form in Vatican Reg. gr. 1 (Bible of Leo) on fol. 115v, and a simpler form in another initial reproduced by W. Stassoff, *L'ornement slave et oriental*, St. Pétersbourg, 1887, pl. 123, no. 35.

43. As on the frame of the gold purse lid found at Sutton Hoo.

44. It is not found in the Lindisfarne Gospels apparently; and in the Book of Kells it occurs only on the arched frame of the canons on fol. 3v, 4r. But this use may reflect the Italian tradition behind Jarrow, for the ornament is also found on the arches of canons in Munich lat. 6212, a South German manuscript copied from a Ravenna codex of the sixth century—see C. Nordenfalk, *Die spätantiken Kanontafeln*, Goeteborg, I, 1938, p. 151, fig. 17—and also on the arched frame of the title page of a North French manuscript of the early ninth century in Vienna—H. J. Hermann, *Die frühmittelalterlichen Handschriften des Abendlandes* (Wien, Nationalbibliothek), Leipzig 1923, p. 74, fig. 52—of which the text is the penitential of Theodore of Canterbury.

45. Baldwin Brown, *The Arts in Early England*, II, new ed., 1925, pp. 257 ff., and fig. 101.

46. Fol. 4v, 10r, 8v.

47. Fol. 29r.

48. Cf. the Desborough mirror (*Guide to Early Iron Age Antiquities*, British Museum, 1925, pl. X and fig. 133, p. 123).

49. *A Guide to the Anglo-Saxon and Foreign Teutonic Antiquities*, British Museum, 1923, pl. I; Kendrick, *op. cit*, pl. XXIV.

50. Lowe, *C.L.A.*, III, no. 299.

51. E. G. Millar, *The Lindisfarne Gospels*, British Museum, 1923, pl. 3, 22, 26, 31, 32, 35.

52. Cf. the gospels of *ca.* 800 in the Essen Münsterschatz (A. Schardt, *op. cit.*, p. 30).

53. Zimmermann, *op. cit.*, pl. 259b.

54. *Ibid.*, pl. 147.

55. *Ibid.*, pl. 149 for the whole page. The same treatment of the ground appears also in a manuscript of the same group in Cambridge, Corpus Christi College 334, fol. 1r (Origen).

56. Lowe, *C.L.A.*, II, no. 277—the date is probably *ca.* 800 or later, rather than the late seventh century to which it has been attributed.

57. Vatican Pal. 65, from Coupar-Angus, Scotland, twelfth century (F. Ehrle and P. Liebaert, *Specimina codicum latinorum Vaticanorum*, Bonn, 1912, pl. 24).

58. The best examples of the cloisonné effect are on fols. 45v, 79v; in the S of fol. 28, the inner ground is polychrome. Note also the example in another Northumbrian manuscript—Leningrad F. v. I. 8 (Zimmermann, *op. cit.*, pl. 326.).

59. *The Book of Kells*, Bern, 1950, fol. 8, 17v, 19, etc.

60. As already noted by Arngart, *op. cit.*, p. 24; the text is close to that of the Leningrad Bede (*ibid.*, p. 35).

61. On fols. 6, 6v, 16v.

62. In both the Leningrad Bede and Tiberius A. XIV (fol. 4v) the pattern of some sections of the grid, with an irregular staggered spacing of the perpendicular bands, recalls Near Eastern wood work—e.g., a panel from Cairo in the Victoria and Albert Museum, reproduced by Lethaby, *The Archaeological Journal*, LXIX, 1912, p. 109, fig. 16; cf. also the imitation of such wood forms in a more regular pattern on a stone sarcophagus from Ravenna in the Berlin Museum (O. Wulff, *Die altchristliche und byzantinische Kunst*, I, Berlin, 1916, fig. 253).

63. Cf. Zimmermann, *op. cit.*, pl. 44 ff. (Luxeuil) and Lowe, *C.L.A.*, nos. 300, 497, 525, 459, 839, 894, 924.

64. Zimmermann, *op. cit.*, pl. 73, 75, 153, and Lowe, *C.L.A.*, nos. 300, 614, 679, 715, 781, 841, 924. Note also the example in the Book of Cerne (Zimmermann, *op. cit*, pl. 293, 294).

65. *Hist. Eccl.*, III, cap. xix.

66. Dr. Arngart describes the color as follows: red nimbus, yellow cassock, blue pallium, purple book, pink face, purple on cheeks, forehead, side of nose, and under eyebrows (*op. cit.*, pp. 23, 24).

67. That is how Peter looks in a vision reported by Bede (*Hist. Eccl.*, IV, cap. xiv, ed. Plummer, I, p. 235): "adtonsus erat, ut clericus," while Paul in the same vision "barbam habet prolixam."

68. The book held horizontally on its long side in the veiled hand is a distinctive type, found in other Anglo-Saxon images: the Ruthwell Cross, the half-figure at Breedon on the Hill, the Book of Cerne, the Codex Aureus in Stockholm (the Matthew symbol). It is not very common in Italy, but appears especially in Ravenna—the mosaics of S. Apollinare in Classe (M. van Berchem and H. Clouzot, *Mosaïques chrétiennes*, Geneva, 1924, fig. 203–206); S. Apollinare Nuovo, a figure above the Palatium mosaic; and on the Maximianus Chair.

69. Cf. Durham Cath. Ms. A. II. 16, fol. 37 (Zimmermann, *op. cit.*, pl. 327) The

Durham Cassiodorus, *ibid*, pl. 248; the Echternach Gospels, Paris. Bibl. Nat. lat 9389; the Book of Kells, *passim*.

70. "The Coffin Reliquary," in *The Relics of Saint Cuthbert*, Oxford, 1956, pp. 290–292.

71. F. Wormald, *The Miniatures in the Gospels of St. Augustine*, Cambridge, 1954, pl. II.

72. It is not clear in the photographs of the initial whether the ridges are actually drawn as lines or reserved through the modeling of the cleft. If the latter is the case, the Bede is even closer to the Saint Luke of the Gospels of Augustine in Cambridge.

73. Cf. the heads of Peter and Paul in the mosaics of S. Vitale in Ravenna (van Berchem and Clouzot, *op. cit.*, p. xx, fig. viii).

74. Zimmermann, *op. cit.*, pl. 313, 314, 316b; cf. also the Book of Cerne, *ibid.*, pl. 296b, where the faces share other peculiarities with the Northumbrian types.

75. Cf. the Godescalc evangelistary, Paris, Bibl. Nat. Nouv. Acq. lat. 1203 (Boinet, *op. cit.*, pl. 3, 4).

76. Cf. also the Matthew of the Codex Aureus in Stockholm and the evangelists in Barberini 570. (Zimmermann, *op. cit.*, pl. 316); I believe these manuscripts are independent of the Carolingian movement.

77. *The Book of Kells*, Bern, 1950, fol. 32v, 114r and *passim*; Zimmermann, *op. cit.*, pl. 169, 170.

78. By J. A. Bruun, *An Enquiry into the art of the Illuminated Manuscripts of the Middle Ages*, I,*Celtic Illuminated Manuscripts*, Stockholm, 1897, pp. 80, 81; A. M. Friend, Jr. "The Canon Tables of the Book of Kells," in *Mediaeval Studies in Memory of Arthur Kingsley Porter*, II, Cambridge, Mass., 1939, pp. 611, 612; F. Masai, *Essai sur les origines de la miniature dite irlandaise*, Bruxelles, 1947, p. 80; and by F. Henry, *Art Irlandais*, Dublin, 1954, pp. 49, 53.

79. Zimmermann, *op. cit.*, pp. 22, 29, and fig. 22 (text volume).

80. J. Brøndsted, *Early English Ornament*, London and Copenhagen, 1924, pp. 85 ff., on the Northumbrian origin of the plant forms in Kells; F. Henry, *La Sculpture irlandaise*, I, Paris, 1953, pp. 109 ff. on Merovingian sources by way of south England; Zimmermann, *op. cit.*, p. 22, on resemblance to Ruthwell and Bewcastle crosses.

81. He writes (*op. cit.*, p. 310) "the codex contains only one other initial, on fol. 3v, which offers no figural decoration and no new forms."

82. The crossed scrolls of this initial are related to the ornament on the leather binding of the Stonyhurst Gospel of John, a manuscript associated with Cuthbert and Bede and very probably written in Jarrow (T. D. Kendrick, *op. cit.*, pl. XLIII, and Lowe, *C.L.A.*, no. 260). Cf. also the relief in Jarrow (Porter, *op. cit.*, fig. 155), and the ornament of the square *P* in Bodleian 819, a Northumbrian work (*C.L.A.*, no. 235).

83. Fols. 17, 163v, 167, 170, 177v, 178v, 180v, 182v, etc.

84. See n. 80 above.

85. J. Anderson, *Scotland in Early Christian Times*, Second Series, Edinburgh, 1881, pp. 130, 131.

86. *The Arts in Early England*, VI, part 2, 1937, p. 256, on the pointed leaf.

87. P. McGurk, "Two Notes on the Book of Kells and its relation to other insular Gospel books," *Scriptorium*, IX, 1955, pp. 105–107.

88. "The Coffin-Reliquary," *The Relics of Saint Cuthbert*, Oxford, 1956, pp. 262–264.

89. Fol. VIIr, reproduced by H. Quentin, *Mémoire sur l'établissement du texte de la Vulgate*, Rome, 1922, p. 443, fig. 76.

90. I wish to express my gratitude to the Warburg Institute in London for the opportunity to prepare this article in its admirable library. I am indebted also to Dr. Jacques Guilmain for his drawings of the initials reproduced in Fig. 11 and Fig. 14.

The Place of Ireland in
Hiberno-Saxon Art
(1950)

During the last thirty years the traditional view that the manuscript art of the British Isles between the seventh and ninth century was an essentially Irish product has undergone much revision. Study of the ornament has disclosed the importance of Anglo-Saxon, Scandinavian, Oriental and Latin forms in the constitution of this art; it has shown also that the fusion of these foreign styles with the older native Celtic art took place not in Ireland, but in Northumbria and Scotland. The great Irish works of the seventh and eighth centuries depend therefore on the artistic development in the neighboring island. The earliest of the richly decorated insular manuscripts, the Book of Durrow, with its questionable colophon referring to Patrick and Columba, has been attributed by students of text and script as well as of art to Northumbria. Some writers have nevertheless affirmed the primary role of Ireland in the face of the new investigations; but the more common tendency of students has been that of A. W. Clapham, who wrote in 1934: "We must thus conclude that Hiberno-Saxon art was in origin in no sense Irish but that the Irish perhaps welded its component parts into one style; that this welding probably took place in Northumbria in the second half of the seventh century, and that it was transmitted thence to Ireland and from Ireland across half of Europe."[1] If the Irish did not create this art, it was the Irish missionaries in Northumbria and Scotland who were responsible for its flowering.

M. Masai, who is the first writer to apply these findings to a survey of the manuscripts as a whole, has boldly risked a more radical conclusion.[1a] The greater part of his vigorous book is devoted to the polemical thesis that the Irish had little if anything to do with the formation of this art and were merely weak, belated imitators of the Northumbrian Saxons who were its true creators. The oldest Irish manuscript art of certain date belongs to the ninth century and is technically and esthetically crude. The masterpieces of insular art, the gospel books of Durrow, Echternach, Lindisfarne, Lichfield and Kells, and the lesser manuscripts of the same "metallic" style, he is convinced, were all written in Northumbria after 700 and probably in the same center, which can only be

225

Lindisfarne. Their common majuscule script, still used today as a symbolic national style in Eire, was a Northumbrian invention. Where continental art has an insular aspect, England rather than Ireland supplied the models; indeed the insular style is much less widespread on the continent than has been supposed. M. Masai denies that it was known in the continental Irish foundations in the seventh and eighth centuries; and he finds no direct influence of insular art on French Carolingian art or on the Spanish manuscripts of the pre-Romanesque period. All these conclusions are accompanied by a judgment of the general inferiority and backwardness of Irish culture during this entire period, contrary to the common view about the civilizing mission of the advanced Irish monks and scholars.

If M. Masai is right, it will be necessary to speak of insular art as Celto-Saxon or Britanno-Saxon rather than as Irish or even Hiberno-Saxon, and we shall have to revise still more drastically the historical picture of the art of this period. The book is not altogether convincing, however, although it is so searching and critical and so concerned with the solidity of the foundations. The systematic studies which alone can decide these issues are not yet advanced enough to allow a reliable reconstruction of the development. Much that M. Masai says is probably right and his effort is important as an incitement to fresh research and revaluation. But his main thesis rests on a number of assumptions that are contradicted by evidence which he ignores: 1) that we have a good sample of the original works of the seventh and eighth centuries, 2) that the art of manuscript ornament and imagery in the islands begins about 700 with the Book of Durrow, 3) that all the artistically important manuscripts before 800 could have been produced only in a single center. It is with the help of these propositions that he is able to exclude the Irish so completely from the formation of insular manuscript art.

For the first assumption, he argues that had there been fine manuscripts with decoration produced before 700 (and outside Northumbria in the eighth century), some would have been preserved, since liturgical books were piously guarded as treasures in the abbeys and churches. Even the Danes, who ravaged England during the ninth century, pillaging and burning monasteries, were not wholly indifferent to the value of manuscripts; the Codex Aureus, now in Stockholm, was brought from the heathen invaders and presented to the Church of Canterbury by a Saxon earl in the ninth century; and the preservation in Durham of manuscripts from the libraries of Wearmouth and Lindisfarne shows that the pillaging had its limits. Lastly, the fact that the surviving books with rich ornament all belong to the period after 700, although the invasions began at the end of the eighth century, suggests that there were no such works from the years before 700 to preserve.

The weakness of this reasoning lies in the belief that the conditions of

survival of works of art are fairly uniform everywhere and at all times. This belief will hardly withstand examination. A comparison of mediaeval library catalogues with the actual remains would quickly open our eyes to the very uneven distribution of surviving manuscripts from the early Middle Ages. If from the Cluniac abbey of St. Martial at Limoges we have a remarkably rich collection of biblical and liturgical manuscripts written before 1150, we do not possess a single gospel, psalter, or sacramentary of this early period from the great library of Cluny itself. Does there exist even one of the seventy-two volumes that the Archbishop Maximianus gave to the church of Ravenna in the sixth century?[2] Where are the psalters so prominent in the devotions of Irish saints and ascetics of the sixth and seventh centuries? Or the service-books, psalters, evangeliaries and Bibles of the Church of Canterbury and its diocese before the mid-eighth century? The manuscripts of the great library at York celebrated in verses by its alumnus Alcuin? The books made for the Bishop Wilfrid, including the magnificent gospels in purple and gold, written for the church of Ripon in the 670's and mentioned in his epitaph? The entire library of Hexham, formed by Bishop Acca between 709 and 732, which Bede described as *"amplissima ac nobilissima,"* was destroyed by the Danes in 875. Bede speaks also of the intense study of the prophets, gospels and apostolic writings at Iona in the seventh century (*Hist. eccl.* III, c. 4), but no existing manuscript of these texts can be referred to Iona at this time. Other sources, notably Aldhelm, tell us of an active production and exchange of books in Ireland, England and Scotland before *ca.* 725, as well as of the importation of books from the continent; but from this period only a few scattered volumes and fragments survive. It is a remarkable fact, to which the late Wilhelm Levison has called attention, that many Latin writings by Anglo-Saxon authors of the seventh and eighth centuries have been preserved only in continental manuscripts.[3]

With all these indications of lost manuscripts of the seventh and eighth centuries, it is surely imprudent to infer so positively and narrowly the original state of affairs from the few surviving objects. But it should be said that M. Masai does not hold strictly to his assumption, for he believes that the great decorative pages of the Northumbrian manuscripts were copied directly from metallic book covers, although no example of such a cover has come down from that period.

As for the second assumption, that there was no manuscript decoration in the islands before the very end of the seventh century, the history of insular book art, contrary to M. Masai's belief, does not begin in Northumbria around 700, but at least a hundred years earlier and in Ireland. He has overlooked several Irish works in which may be traced the primitive stages of this art: the Cathach of St. Columba in the Royal Irish Academy in Dublin, an Orosius

Fig. 1 Dublin, Royal Irish Academy: Cathach of St. Columba, s.n., fol. 6. Initial *N*.

Fig. 2 Milan, Biblioteca Ambrosiana: Ms. S. 45, sup., Atala Codex, p. 2. Initial *N*.

manuscript from Bobbio in the Ambrosiana in Milan (D.23 sup.), and the Atala codex in the same library (Ambrosiana S.45 sup.). All these have been described and reproduced in part, most recently.[4] The first, a psalter[5] which belongs probably to the second half of the sixth century contains the oldest known insular manuscript ornament, with the characteristic set of three or more initial letters of graduated, decreasing size, the motif of "ingression" into the text which is so magnificently developed in the later manuscripts (Fig. 1). Their ornament is exceedingly simple, with terminal spirals and bordering dots and an occasional fish form that points to some connection with the stylistically different contemporary Italian work. Initials with similar spiral endings and dots and the same principle of graduated letters occur in the Bobbio Orosius, together with simple interlace (C.L.A., III, 328; Lowe thinks the decoration may be a later addition to the script which he dates in the seventh century, but the forms seem to me contemporary with the writing; similar ornament is found in other manuscripts of the seventh century from Bobbio). The Atala codex[6] (Jerome on Isaiah) is inscribed with the name of the second abbot of the Irish foundation of Bobbio, Columbanus's successor who died in 622, and is therefore significant as a dated work. A large initial N, reproduced by Lowe, has a more complex, although crude, spiral and fish ornament (Fig. 2).[6a] It recalls the initial N of an important gospel manuscript in Durham cathedral (A.II.10) probably executed in an Irish foundation in Northumbria (Fig. 2a), but overlooked by M. Masai, although it has been described and reproduced by Lowe[7] and Mynors.[8] The N here is much larger, descending the page, and has beast heads and knotting, undeveloped in the previous Irish works. I do not believe that this manuscript can be much later than the middle of the seventh century.[9] It marks the transition to the new and more elaborate insular art of the type of the Echternach Gospels (Paris, Bibl. Nat. lat. 9389) and the Book of Durrow, which M. Masai would place around 700 and Mr. T. D. Kendrick in the mid-seventh century. In both manuscripts are initials which are clearly built on the preceding Irish types and which lack the Germanic elements employed in other parts of the same books (Durrow, e.g., fol. 15, the X). We have at present no means of dating these two books accurately, but if the Lindisfarne Gospels are of the period 698–721 (at the latest, for these are the dates of the Bishop Eadfrith who was the scribe, and he might have done this work before becoming bishop in 698), the less advanced manuscripts of Durrow and Echternach might well be a generation older. Their canon-tables are of the most primitive schematic type, without the arches and columns of the Lindisfarne Gospels. In trying to account for the great difference between the figures in these two manuscripts and in the Lindisfarne, M. Masai supposes that the former were copied from already well-established and frequently reproduced old types, whereas the Lindisfarne artist had before him a freshly

Fig. 2a Durham, Durham Cathedral: Ms. A. II. 10, Gospel, fol 2. Initial.

imported Italian work related to the model of the portrait in the Codex Amiatinus; hence the more radical stylization of the first two works and the greater naturalism of the last. But apart from the unacceptable explanation of styles as phenomena of pure copying, independent of an already fixed disposition and practice of the copying artist, this theory admits what M. Masai had elsewhere denied; namely, that there had been a continuous tradition of ornament and imagery in manuscripts in the British Isles before 700, perhaps for several generations. One might deduce as much also from his theory that the pages of pure ornament in the Durrow Gospels and related manuscripts, and even certain of the figures, like the Virgin and Child in the Book of Kells, are simple transpositions of metal book-covers. If covers of such richness existed prior to the Book of Durrow, is it at all likely that the pages they enclosed were wholly devoid of decoration?

There is within the Book of Durrow itself interesting evidence of an earlier Irish tradition of manuscript painting in the peculiar matching of the gospel texts with the symbols of the evangelists: the man with Matthew, the eagle with Mark, the bull with Luke, and the lion with John. Lawlor has observed (Chapters on the Book of Mulling, 1897, pp. 18 ff.) that the order of the symbols here corresponds to the pre-Vulgate, so-called Western, order of the gospels (Matthew, John, Luke and Mark), which is found in the oldest Irish Latin gospel manuscripts, whereas the Durrow text follows the order of the Vulgate (Matthew, Mark, Luke and John). He concluded that the scribe of Durrow had before him two manuscripts, a Vulgate from which he transcribed his text and an old Latin copy from which he took other elements, including the order of the symbols of the evangelists. Lawlor was able to demonstrate the survival of this older conception of the symbols in poems about the evangelists in Irish Vulgate manuscripts of the eighth to the tenth centuries. Now we know from Bede (*Hist. eccl.* V 19) that when Wilfrid, the great opponent of Celtic particularism in Northumbria, first visited Rome in 654, he learned, besides the Roman method of computing Easter, the correct "order" of the Gospels which he had not known in his own country (*"in patria nequiverat"*). Around 670, the same Wilfrid gave to the church of Ripon a luxurious gospel manuscript in gold, purple and gems, described as written *"in ordine,"* a fact which was considered worth recording in his epitaph (Bede, *loc. cit.*). The Book of Durrow, with its Vulgate order of the Gospels and older Western order of the symbols, belongs then to the period of transition from the old Irish order to the newly introduced Roman one, i.e. after the Council of Whitby (663 or 664) and before the eighth century when the symbols follow the canonical grouping. The paintings of the Durrow symbols were apparently copied from a manuscript written prior to the mid-seventh century. The origin of the Echternach Gospels, slightly later in this same transitional period, is

perhaps reflected in the clear (and exceptional) Roman tonsure given to the image of the man (Fig. 3) and in the explicit reference in the colophon to the correction of the text with the help of a manuscript that had belonged to St. Jerome.

M. Masai denies, however, that there is any evidence for a comparable art in Ireland before 800, the earliest date at which, in his opinion, the forms of continental or Near Eastern imagery could have reached Ireland from Northumbria. Here he overlooks the important testimony of an Irish writer, Cogitosus, who died toward 670. In his *Life of St. Brigid* (*ca.* 500), he describes in her church and shrine at Kildare wall paintings, panel pictures and a splendid sculptured ciborium of precious metal.[10] We have not the faintest idea of the character of this imagery and ornament and it would be useless to speculate about their relation to the books of Durrow and Echternach. But their mere existence compels us to doubt M. Masai's assumption that there was no Irish practice of figure art and rich ornament before 800.

To judge by the few traces, there was apparently a continuous development from the Irish works of the sixth and early seventh centuries to the art of the middle and later seventh century in the Northumbrian and Scottish region, which owed its Christianity to Irish monks. At some time in the course of the seventh century and probably in Northumbria this art received an impetus to rapid growth and was immensely enriched by new themes from Saxon, Latin and Near Eastern art. Did all this happen in Northumbria around 670 after the Irish missionary church was displaced by the new wave of Roman Catholicism supported by the Saxon rulers? Or should one distinguish two stages, the first toward 650 when Iona, Lindisfarne and other centers dominated by the Irish missionaries were patronized by the Saxon kings, and there took place the great union of Celtic and Germanic forms that we see somewhat later in the Book of Durrow; the second, in the last quarter of the century or toward 700, when so many Roman works were brought to Northumbria and the Codex Amiatinus was written here? M. Masai believes that the entire art of Northumbria, including the Book of Durrow, depends directly on the impulse from Canterbury and Italy. The practical absence of Roman artistic forms in the Echternach and Durrow manuscripts makes this hard to accept.

These questions bring us to M. Masai's third assumption, that the important early manuscripts were all written in Northumbria and in one center, Lindisfarne. In spite of the similarities of script (which have yet to be studied thoroughly for this problem) and many common details of ornament, these works do not give students the impression of being products of a single scriptorium. Without documentary clues, it is not easy to effect a convincing distribution of such isolated works, now preserved in different regions. Besides

Fig. 3 Paris, Bibliothèque Nationale: Ms. lat. 9389, Echternach Gospels, fol. 18v *Imago Hominis*, Symbol of Matthew.

the connections with Northumbria, there are also striking relationships to Ireland and Scotland. I have mentioned the Irish order of the symbols of the evangelists in the Book of Durrow. In this manuscript (Fig. 4) and in the Echternach Gospels, the drawing of the animals, which is amazingly refined and precise in the details, includes a characteristic spiral, voluted design of the haunches and other parts, very similar to the animals of the incised stones of Scotland during this period, and unknown, it seems, in Ireland and Northumbria (Fig. 5).[11] The peculiar convention of repeated profile feet in an otherwise strictly frontal symmetrical figure—the man in the Book of Durrow—is again a Scottish feature[12] which occurs also in Ireland.[13] The *"millefiori"* ornament of the costume of the same figure is a specifically Hiberno-Scottish element.[14] We have to consider then the possibility that the Durrow and Echternach Gospels, which are undoubtedly products of a common tradition, were written somewhere in Scotland rather than in Lindisfarne, or were decorated by artists from Scotland who brought their native forms to a Northumbrian scriptorium. Since the peculiar animal style appears a century later in the Book of Kells, an unfinished work which came to Ireland from the Irish settlement of Iona on the West coast of Scotland, the activity of Scottish centers seems more likely. In any case, M. Masai's assumption that the Gospel manuscripts of Durrow, Echternach, Lindisfarne, Durham, Lichfield and Kells, and still others of the eighth century, could only have been produced in Lindisfarne and that their style was unavailable elsewhere before 800, is exceedingly doubtful. Just as the themes of animal ornament and richly knotted, broken interlace introduced and developed by the Germanic invaders in England in the mid-seventh century appear also in native metal-work of high quality in Ireland and Scotland by 700, so we are inclined to believe that the corresponding style was also practiced in manuscript decoration in these same regions.

M. Masai's restriction of the manuscript art to Northumbria until the end of the eighth century has as one of its logical consequences the view that its forms could not have been known on the continent until this late period. I doubt very much that this opinion will be sustained by research. The example of the Atala codex from Bobbio is an indication to the contrary, although it belongs to the period prior to the Book of Durrow. In order to sustain his principle, M. Masai examines an initial *L* (Fig. 6) in an Italian manuscript (Vatican Reg. lat. 1997) which has been cited as an example of insular forms on the continent, and concludes that its knotwork is really an instance of the Mediterranean models of the northern interlace, rather than a copy of the latter. But if there is some uncertainty about the insular aspect of this initial, other ornamented letters in this same manuscript (ignored by M. Masai) are clearly Hiberno-Saxon in their hairspring spirals and knotted terminal bands (Fig. 7):[15] the beast-head, too, is insular in conception and drawing.[16] Similarly,

Fig. 4 Dublin, Trinity College
Library: Ms. A. IV. 5, Book
of Durrow. fol. 191v. Lion of John.

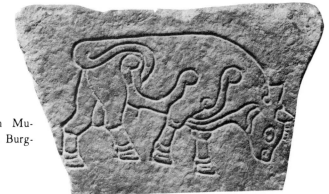

Fig. 5 London, British Mu-
seum: Incised bull from Burg-
head.

Fig. 6 Vatican City, Biblioteca Vaticana: Reg. lat. 1997, fol. 1v. Initial *I*.

Fig. 7 Vatican City, Biblioteca Vaticana: Reg. lat. 1997, fol. 116. Initial.

he is mistaken in denying any trace of insular art in the Gellone Sacramentary, which, in spite of its evident Merovingian figures and animals, does contain some initials of unmistakable insular character (Figs. 8a and 8b).

There are two problems of another order treated by M. Masai: the causes of this art and its relative value as art, problems on which surprisingly little has been said by previous students. On the first, he offers the theory that the roots of insular manuscript art are social and not at all ethnic, as is sometimes said; arising in a pre-commercial primitive society, this art is necessarily irrational, abstract and decorative, just as classic art, arising in a commercial urban society is rational and naturalistic. The defect of so broad an explanation, which is certainly an advance on the racial theories about a Celtic spirit or Northern "form-will," is that it tells us nothing concrete about the social conditions peculiar to insular art. Even with the added factors of heritage and foreign influence, it does not enable us to understand the difference between this art and any other "primitive" art with geometric ornament, for example, the Islamic. Nor does it account for the intense development of this art during the short period between the Book of Durrow and the Book of Kells, and the great difference between these works and the manuscripts produced at the same time in southern and central England, in the regions dominated by the Church of Canterbury. M. Masai assumes that manuscripts like the Cotton Psalter and the Codex Aureus in Stockholm, with their more naturalistic figures, are late works already affected by the Carolingian Renaissance. But their dates are uncertain and it is likely that some of them are before 781, the date of the Godescalc evangelistary in Paris, the oldest known manuscript of the Ada school. And since the stone crosses and other carvings in England show a continuous use of Mediterranean figures and foliate ornament from the seventh to the ninth century, it is reasonable to suppose that the manuscripts of Canterbury and Mercia, in which a corresponding figure art occurs beside a classical uncial script, belong to a local tradition going back to the seventh century, from the period of the Roman missions in southern England. This art had surely reached Northumbria by 700—witness the Codex Amiatinus and the evangelists' portraits in the Lindisfarne Gospels; it had been applied together with the new Hiberno-Saxon ornament on the great crosses at Ruthwell and Bewcastle in the far north in the last third of the seventh century. (M. Masai believes that these monuments are after 740 and 780 respectively, but he offers no evidence against the views of those who have studied the crosses most minutely—eg. Baldwin Brown.) Hence no explanation of insular art is adequate that does not take into account the coexistence of two unlike styles in this art and sometimes within the same object during the seventh and eighth centuries. The opposition of these two styles, the dominance of one or the other in certain localities and moments, their occasional fusion and reconciliation, can hardly be understood

Fig. 8a Paris, Bibliothèque Nationale: Ms. lat. 12048, Sacramentary of Gellone, fol. 27.

Fig. 8b Paris, Bibliothèque Nationale: Ms. lat. 12048, Sacramentary of Gellone, fol. 22.

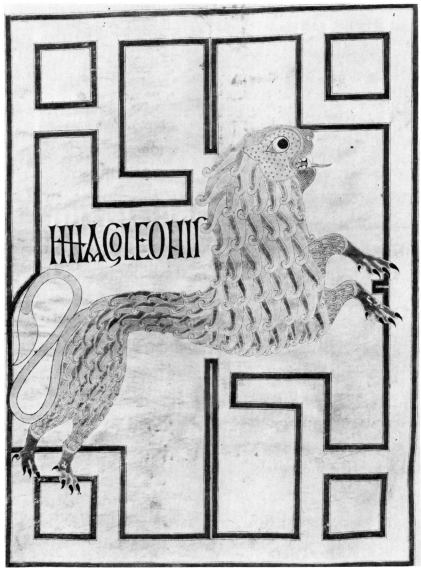

Fig. 9 Paris, Bibliothèque Nationale: Ms. lat. 9389, Echternach Gospels, fol. 75v. Lion of Mark.

without reference to the great religious and social antagonisms during this period, the struggles between the Celtic and Roman churches, the policies of the Saxon kings striving to dominate a conquered people and to achieve unity among Britons, Picts, Irish and Anglo-Saxons through religious as well as legal institutions.[17] But aside from these institutional factors, the explanation of the peculiarity of insular manuscript art must consider the functions and content of this art and the relations of these to the peculiar religious standpoint of the native church, its intensely ascetic spirit and the extraordinary role, sometimes fetishistic and magical, of the written word, the book and the scribe in Hiberno-Saxon Christianity. M. Masai denies, however, that the decoration of these manuscripts has any spiritual connection with the text, in spite of the unmistakable concentration of fantasy on the symbols and portraits of the evangelists, the canon-tables, the frontispiece cross pages and the great initials of the Gospels.

On the question of the artistic value of this art, he draws a sharp line between the ornamental forms and the representations: the first he considers truly fine works, the second are clumsy and artless. I do not believe that this judgment will be sustained by careful critical observation of the manuscripts. The drawings of the figures, animal and human, in the Echternach Gospels are as finely controlled, as sensitive and precise, as any of the interlace patterns or animal ornament of this period; they are astoundingly delicate in detail with a wonderful fantasy of line in the bodily forms (Figs. 3 and 9). Because of a dogmatic norm of naturalism, foreign to this art, and an arbitrary separation of ornament and figures, M. Masai is able to speak of the "stylization" of the latter as "excessive," inartistic and absurd. This standard of nature is an obstacle to critical insight into the art as a whole.

NOTES

1. "Notes on the Origins of Hiberno-Saxon Art," *Antiquity*, VIII, 57.

1a. Masai, *Essai sur les Origines de la Miniature dite Irlandaise*, Bruxelles, Anvers, 1947.

2. Migne, Patrologia latina, CVI, col. 610.

3. *England and the Continent in the VIII Century*, 1946, pp. 146–147.

4. In E. A. Lowe's *Codices Latini Antiquiores*, vols. II, 1935, and III, 1938, [For a survey and reproductions of these manuscripts and their predecessors on the continent, see Nils Åberg, *The Occident and the Orient in the Art of the Seventh Century, The British Isles*, Stockholm, 1943, pp. 88 ff.]

5. *Ibid.*, II, 266.

6. *Ibid.*, III, 365.

6a. [P. Engelbert (*Revue Bénédictine*, LXXVIII, 1968, pp. 235, 237) believes that initials of that style did not exist before the second half of the seventh century, and dates the ornament and script of the codex at the end of the century.]

7. *Ibid.*, II, 147.

8. *Durham Cathedral Manuscripts to the End of the XII Century*, Oxford, 1939, pl. 4.

9. This initial, together with another ornamented page of the Durham manuscript, has been reproduced and carefully studied in an article that I have just received from Dr. Carl Nordenfalk, after this one was written ("Before the Book of Durrow," *Acta Archaeologica*, XVIII, Copenhagen, 1947, pp. 141–174). Dr. Nordenfalk reproduces also many initials from the psalter of St. Columba and offers a critique of Masai's thesis which parallels my own. This article is a basic work on insular art and is one of the most important recent contributions to our knowledge of early mediaeval art.

10. Chapt. 37. See: Mesnard, "L'église Irlandaise de Kildare," *Rivista di Archeologia Cristiana*, IX, 1932, pp. 37–50.

11. For a splendid example in Burghead, Elginshire, see the *British Museum Guide to Anglo-Saxon Antiquities*, 1923, p. 127, and the article by C. L. Curle and F. Henry, *Gazette des Beaux-Arts*, 6 série, XXIV, 1943, pp. 258 ff., fig. 4a; other examples in: J. Anderson, *Scotland in Early Christian Times*, II, figs. 50, 51, 83, 107.

12. Anderson, *Op. cit.*, II, figs. 39, 102.

13. F. Henry, *Irish Art*, fig. 23.

14. T. D. Kendrick, *Anglo-Saxon Art*, pp. 104 ff.

15. They are reproduced in: E. Carusi and V. de Bartholomaeis, *Monumenti Paleografici degli Abruzzi*, I, pl. I–V, especially the initial on fol. 1vo.

16. Cf. Durham Cathedral Ms. A. II. 16, Lowe, *Op. cit.*, II, 148A.

17. On this point, cf. my article, "The Religious Meaning of the Ruthwell Cross," in the *Art Bulletin*, XXVI, 1944, pp. 232–245, [reprinted here, pp. 151–176].

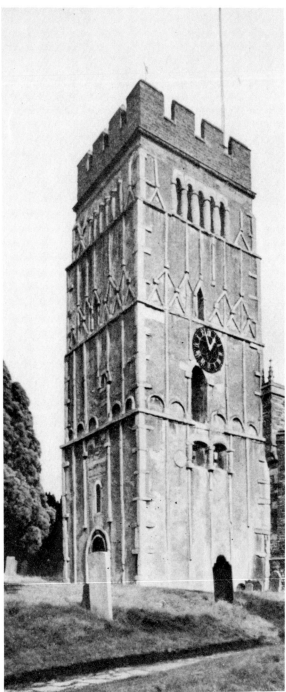

Fig. 1 Earls Barton, Northamptonshire: Tower.

A Note on the Wall Strips
of Saxon Churches

(1959)

One of the distinctive features of Saxon architecture of the tenth and eleventh centuries is the pattern of thin strips of stone applied in relief to the walls of church towers. The examples at Earls Barton (Fig. 1) and Barton-on-Humber are the most striking and familiar. The older students assumed that these strips were translations of native half-timbered work into stone.[1] But the researches of Baldwin Brown have led to another view, that the Anglo-Saxon builders had imitated the pilasters of Carolingian and Ottonian churches of the Rhineland, forms that had been brought there from Italy and that ultimately descend from Roman and old Oriental buildings.[2] In his now standard book on English mediaeval architecture, the late A. W. Clapham wrote that "this derivation seems fully established."[3] The common use of the words *Lisenen* and *lesene* in describing these wall strips indicates the tendency to refer this English form to a foreign source.

The idea of a wood prototype is nevertheless so obvious and compelling that the older theory continues to attract scholars. One is not surprised to learn that J. Strzygowski, the defender of Nordic originality, was among these.[4] Even Clapham was inclined to make an exception of the tower of Earls Barton. "There can be little doubt," he wrote, "that the builders, while employing traditional methods, were consciously imitating timber constructions."[5]

More recently this question has been revived in the histories of English mediaeval art published by D. Talbot Rice[6] and Geoffrey Webb.[7] While recognizing the resemblance of the network of stone strips at Earls Barton to half-timbered construction, both writers acknowledge an influence from the stone pilasters of Rhenish buildings. It was in Germany, they say, that the primitive wood form was first converted into stone; and from the Rhineland it was carried to England. The lack of any sign of such forms in England before the Carolingian period excludes an explanation by native practice in wood.

In his discussion of this motif, Baldwin Brown isolated only one aspect, the thin pilasters ending in mitre arches. Having found this form in German buildings on the Carolingian and Ottonian periods, he was content to accept

the latter as models. Strzygowski, however, has drawn attention to the use of oblique strips as braces of the verticals, a quite different form which is undocumented, so far as I know, in the Rhenish churches. This is clearly a device of wood construction, difficult to explain in stone except as a transferred decorative element. The vertical pilasters rise from the apexes of the converging oblique strips in an unconstructive manner (Fig. 1). One can point to an example in stone in the sixth century in the basilica of Tigzirt in North Africa (Fig. 2); but this is an exceptional instance which the scholar who first reported and reproduced it denounced as a bizarre inversion of architectural common sense.[8] The uncanonical mounting of a column on the crown of an arch recurs nevertheless in later mediaeval buildings, even on the south tower of Chartres cathedral, which is generally admired as a masterpiece of architectural reason. Before the Romanesque period, only in Saxon England do we find pilasters set above arches in this way; they form an elaborate grid or truss-like structure on the surface of the wall, independent of the main enclosing and supporting masonry.

I wish to bring into this discussion a neglected English work in which the form in question appears almost two centuries before the oldest surviving architectural examples. In a miniature inserted in a gospel book from Aldeneyck (in Belgian Limburg) preserved in the treasury of the church of Maeseyck, the wooden seat of the Evangelist is formed like the wall strips of Earls Barton (Fig. 3). The resemblance is too detailed and complex, the forms are too uncommon, for us to regard this design as unconnected with the patterns of wall strips on the Saxon towers. It seems to me clear evidence that woodworkers in England already employed these forms in the eighth century at a time from which no trace of them has survived in stone and well before the presumed contact with Carolingian and Ottonian art in the Rhineland.

This miniature unfortunately cannot be dated precisely or placed in a definite scriptorium. But its Anglo-Saxon origin is evident enough from the ornament of the border. Like the accompanying canon tables, the miniature has been bound with a later manuscript that an uncritical tradition ascribed to native Belgian saints in Aldeneyck. Zimmermann placed the older inserted leaves in southern England and in the last quarter of the eighth century,[9] a dating with which Wilhelm Koehler has agreed.[10] More recently Carl Nordenfalk, to whom we owe important studies of manuscript art, has ventured to place the miniature in York and close to the year 700, as a work connected with the Romanizing policy of Saint Wilfrid.[11] It would be extremely interesting to fill the gap in our small knowledge of the art of Wilfrid's circle by a surviving manuscript.[12] But Nordenfalk's arguments have not convinced me. The forms of the ornament resemble most of all those of Vatican, Barberini Ms. lat. 570, which is probably a work of the second half of the

Fig. 2 Tigzirt, Algeria: Basilica, (after Gavault).

Fig. 3 Maeseyck, Belgium: St. Catherine's Church, Aldeneyck Cloister Evange-
liary, fol. 1, Evangelist.

eighth century.[13] As for the place of origin of the Maeseyck pages, it is still a puzzle. Barberini 570 is attributed by Zimmermann to the south of England,[14] by some students—notably T. D. Kendrick—to Mercia.[15] And other manuscripts in which are found elements related to our miniature—such works as the Prayer Book of Cerne (in Cambridge) and the Codex Aureus in Stockholm—have also been assigned to both Mercia and the South.[16] From the distribution of examples of the timber-like patterns in Saxon churches, one would infer that the manuscript is more probably from southern Mercia than from York. The buildings that show forms related to those on the Evangelist's chair are all south of the Humber.[17] Although Barton-on-Humber is not far from York, it is the northernmost example. There the wall strips are a simplified variant of the form on the tower of Earls Barton (which is in Northamptonshire) and lack the essential oblique trussing that is common to the latter and the chair.[18]

If we accept the miniature as an evidence of the practice of wood construction in England in the eighth century with trussed patterns that served as the models of the stone forms on the towers, we must still recall the surprising analogy offered by the ruined basilica of Tigzirt (Fig. 2). How it is related to the Saxon examples I cannot say. It is a reminder that our knowledge of the history of architecture is extremely fragmentary, and that the connections between works are more complex and obscure than our ideas about types and developments imply.

NOTES

1. John Henry Parker, *An Introduction to the Study of Gothic Architecture*, Oxford and London, 1849, p. 25.

2. G. Baldwin Brown, *The Arts in Early England*, vol. II, *Ecclesiastical Architecture in England from the Conversion of the Saxons to the Norman Conquest*, London, 1903, pp. 58 ff.

3. A. W. Clapham, *English Romanesque Architecture before the Conquest*, Oxford, 1930, pp. 108 ff. and pls. 39,40,41.

4. Josef Strzygowski, *Early Church Art in Northern Europe*, London, 1929, p. 98.

5. Clapham, *English Romanesque*, p. 109.

6. D. Talbot Rice, *English Art 871–1100*, Oxford, 1952, pp. 52–56.

7. Geoffrey Webb, *Architecture in Britain: The Middle Ages*, Baltimore, 1956, pp. 21–23.

8. P. Gavault, *Études sur les ruines romaines de Tigzirt*, Paris, 1897, p. 39 and fig. 14, p. 73.

9. E. H. Zimmermann, *Vorkarolingische Miniaturen*, I, Berlin, 1916, pp. 142 ff. and pls. 318–320. On page 303 the manuscript is dated "c. 770."

10. In *Belgische Kunstdenkmaeler*, ed. Paul Clemen, Munich, 1923, I, 3.

11. Carl Nordenfalk and André Grabar, *Early Medieval Painting*, New York, 1958, pp. 121–122.

12. For Wilfrid see my remarks in *Gazette des Beaux-Arts*, January 1950, pp. 135–136, [reprinted here on pp. 227, 231].

13. See Zimmermann, *Miniaturen*, pls. 313 ff.

14. Zimmermann, *Miniaturen*, p. 140.

15. T. D. Kendrick, *Anglo-Saxon Art to A.D. 900*, London, 1938, pp. 145–148; also G. L. Micheli, *L'enluminure du haut moyen âge et les influences irlandaises*, Brussels, 1939, p. 28.

16. For the attribution to Canterbury, see Zimmermann, *Miniaturen*, pp. 294–295 (Book of Cerne), pp. 286 ff. (Codex Aureus). Kendrick, *Anglo-Saxon Art*, p. 165, places the Book of Cerne in Mercia and on pp. 159–160 the Codex Aureus in Canterbury. Sherman Kuhn, "From Canterbury to Lichfield," *Speculum*, XXIII (1948), 591–629, argues for the Mercian origin of the Codex Aureus. He has been refuted by Kenneth Sisam, "Canterbury, Lichfield, and the Vespasian Psalter," *The Review of English Studies*, N.S. 7 (1956), pp. 1–10, 113–131. I note that F. Masai, *La Miniature dite Irlandaise*, Brussels, 1947, p. 115, n. 95, attributes the Maeseyck manuscript to Echternach, but offers no reasons for his opinion.

17. See Clapham, *Romanesque*, p. 109, for a list of examples.

18. For Barton-on-Humber, see Baldwin Brown, *The Arts*, figs. 123, 126.

"Cain's Jawbone That Did The First Murder"

(1942)

1.

I n the graveyard scene in *Hamlet*, the prince says: "That skull had a tongue in it, and could sing once: how the knave jowls it to the ground, as if it were Cain's jawbone that did the first murder! It might be the pate of a politician, which this ass now o'er-reaches; one that would circumvent God, might it not?" (Act V, Scene I, 83–87).

In this playfully ambiguous image, the poet draws on an old Anglo-Saxon tradition, as several writers have shown.[1] The jawbone is not Cain's, but the ass's with which Cain slew Abel. Since the ninth century, the weapon of Cain in English vernacular accounts of the first murder is the jawbone of an ass.[2] Even the alternative meaning, that Cain bit Abel to death, is implied in another English legend: in the verse *Life of Adam and Eve*, Eve dreams of the blood of Abel in his brother's mouth.[3]

How did the jawbone come to replace the usual club or agricultural implement as the weapon of Cain? Is this simply a transposition from the story of Samson, or are there other factors peculiar to England which account for the change? Before I attempt to answer these questions, I shall consider the history of Cain's jawbone in art.

This peculiar conception has been observed in continental paintings of the fourteenth to the sixteenth century.[4] It appears on the *Petrialtar* by Master Bertram in Hamburg (1379) and in the Van Eyck retable in Ghent (Fig. I).[5]

There is no doubt that these examples are derived from England. Bonnell, the only scholar to discuss the relation of the English texts to the images, supposed that the English conceptions were disseminated through the mystery plays, since the jawbone, which is not mentioned in the theological writings or Latin Bible commentaries, is found in the Towneley and Hegge cycles.[6] But the only continental mystery play he could cite is a much later Celtic Breton work of *ca.* 1550.[7] He was unaware that there exists a whole series of English illustrations of the murder of Abel with the jawbone from the eleventh to the sixteenth century (Figs. 2 and 3).[8]

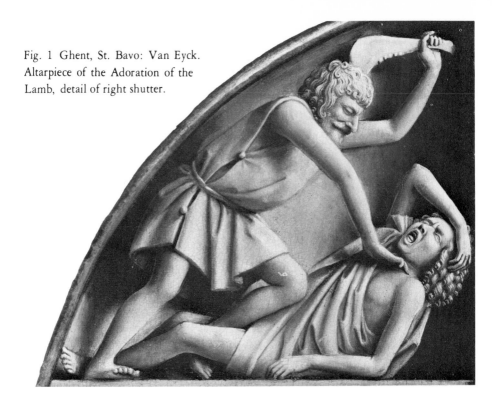

Fig. 1 Ghent, St. Bavo: Van Eyck.
Altarpiece of the Adoration of the
Lamb, detail of right shutter.

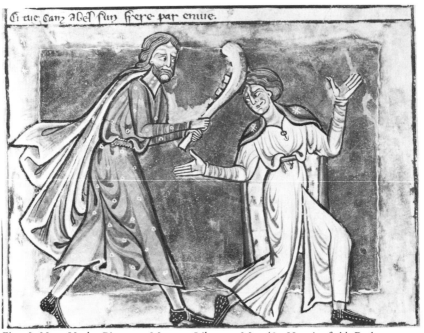

Fig. 2 New York, Pierpont Morgan Library: Ms. 43, Huntingfield Psalter,
fol. 8, twelfth century.

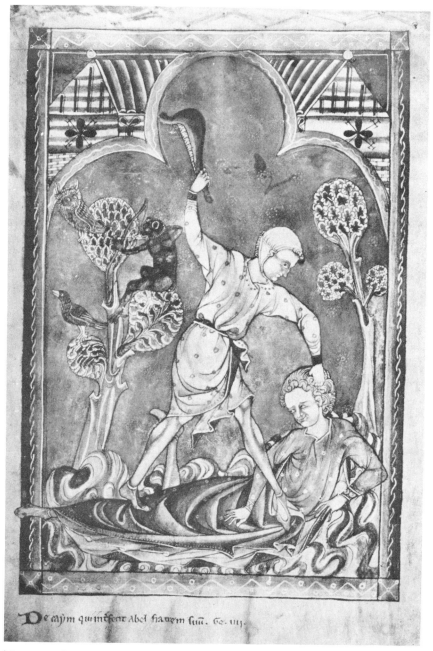

De caym qui intfent Abel fratem suu. Ge. iiij.

Fig. 3 Cambridge, St. John's College: Ms. K. 26 (James Ms. 231), fol. 6a, late
thirteenth century.

The oldest example is a miniature in the manuscript of Aelfric's Paraphrase of the Heptateuch, probably of the second quarter of the eleventh century.[9] The text of Aelfric, faithful to the Bible, specifies no instrument of murder.[10] The painter was apparently inspired by vernacular tradition or by an image from another source. In a drawing in the Caedmon manuscript of Junius (Fig. 4),[11] somewhat earlier in the eleventh century, Cain strikes Abel with a club, although here too the text is silent about the weapon. The only Anglo-Saxon writing prior to the ninth century that speaks of a weapon is a passage in *Beowulf*, where a sword is mentioned—Cain is called the sword-slayer of his brother.[12]

There is one other region in which the jawbone of an animal is the instrument of Cain. I refer to Ireland, where Arthur Kingsley Porter observed it on several stone crosses of the tenth century.[13] The form of the weapon is unclear on these ancient weathered monuments, and Porter was able to identify it by means of a passage in the Book of Lecan, an Irish compilation of the early fifteenth century: "Cain took in his hand the jawbone of a camel, so that he slew Abel." The camel is so obviously an exotic beast in Ireland that we are led to suspect an Eastern tradition. The story of Samson might have suggested the jawbone of an ass, but the camel is more specifically Eastern than the ass.[14] Yet I have found no Eastern account or image of the murder, Christian, Islamic, or Jewish, in which the jawbone appears.[15]

What is the relation of the English and the Irish versions? The jawbone is not the only weapon in the English images or literary versions of the story, but its frequency in England and rarity on the continent before the fourteenth century, indicate a direct connection between the English and the Irish examples. So singular a detail could hardly have been imagined independently in two adjacent islands, remote from the original sources of Christian iconography. Porter was not aware of the English artistic or literary tradition and therefore conceived of the jawbone as an Irish peculiarity. If we followed his general assumptions about the precedence of Irish art, we should have to infer that this detail came to England from Ireland (whatever its ultimate source), since the oldest preserved image that can be dated with any certainty is an Irish work of the early tenth century, the Muiredach Cross in Monasterboice.[16] But in spite of the greater antiquity of the crosses, the Irish text adduced by Porter points in the opposite direction. It includes a sentence which he neglected and which is a valuable clue to the source of the Irish examples. The account of Abel's murder is followed by these words: "The learned tell us that these stones have not grown since the blood of Abel touched them."[17] But no stones are mentioned in the preceding sentence. A commentator on the passage, Mr. St. John Seymour, has therefore inferred that the Irish is a confused, derivative version.[18] "The Irish writer has here blundered his original which appears as follows in the Anglo-Saxon prose *Salomon and Saturn*—'Tell

me why stones are not fruitful? I tell thee, because Abel's blood fell upon a stone when Cain slew him with the jawbone of an ass'."[19] This Anglo-Saxon text of the ninth century is older than the Irish sculptures of the subject, and is the most ancient literary source of the jawbone as Cain's weapon.

In Anglo-Saxon art, not only the jawbone but the blood falling upon the stone is represented. In a drawing in the Caedmon manuscript, Abel's bleeding head is shown striking a rock (Fig. 4),[20] and in a later manuscript in Eton College,[21] Abel lies prostrate on a green rock beneath Cain with the jawbone.

In its explanation of the barrenness of the rocks, the Anglo-Saxon text is based on apocryphal Jewish accounts of Abel's death. If the jawbone is unknown in the latter, the notion that Abel's blood fell on a stone echoes the blood sacrifices of the Semitic East. The Arab sanctuaries in pagan times usually consisted of sacred stones which were smeared with the blood of the victims.[22] It was believed that rain, dew, and vegetation were regulated at their source, the holy rock in Jerusalem, from which all the sweet waters issued and spread over the earth.[23] According to Jewish tradition, the place of Cain's and Abel's offerings was the very spot where the altar of Jerusalem was to stand.[24] In one Jewish legend, "God showed Cain the place where he had killed Abel, where the blood bubbled and where nothing grows till this day."[25] The blood remained clinging to the wood and stones without becoming absorbed, and the earth, originally a level surface, became mountainous as a punishment for having received Abel's blood. God cursed the ground that it might not yield fruit to Cain. The ground changed and spoiled at the very moment of Abel's violent end; trees and plants refused to yield at this spot.[26]

The confusion of the Irish text betrays its derivative character. In the period of the oldest Irish sculptures, the conception was already established in Anglo-Saxon literature and probably in art.[27]

2.

The jawbone of Cain, we have seen, was not confined to the British Isles. In the later Middle Ages it appears frequently on the continent and in such great works as the Ghent retable (Fig. I). This extraordinary detail may be regarded as a specifically English symptom in European art, one of the means of tracing that broad current of insular art on the continent during the Gothic period.[28]

The motif first seems to take root in the Low Countries, where it persists to the present day. My colleague Professor Adrian Barnouw has independently traced the same theme from the Anglo-Saxon to the vernacular literature of the Netherlands.[29] The jawbone of an ass is Cain's weapon in the thirteenth century in the rhymed Bible of Jacob van Maerlant (ca. 1235–1300).[30] With this text and the continuous pictorial tradition in England, we do not have to

Fig. 4 Oxford, Bodleian Library: Ms. Junius 11, Caedmon Poems, eleventh century, fol. 49.

Fig. 5 Auxerre, Cathedral: Detail of relief from façade, end of the thirteenth century.

appeal to the mystery plays as the source of the continental representations. I have found no examples in the Low Countries between the verses of Jacob van Maerlant and the Ghent altarpiece,[31] but the jawbone is common in the fifteenth and sixteenth centuries in manuscripts, paintings, and engravings.[32] In the seventeenth century, it appears in a drawing by Rembrandt[33] and in Dutch popular Bible imagery,[34] and survives into the nineteenth century in Belgian Sunday-school teaching.[35]

Are the German examples of the fourteenth and fifteenth centuries[36] copied from Netherlandish models or are they based directly on English works? I do not venture to decide. That German Gothic art depends to some extent on England has long been known.[37] But the mediation of the Netherlands in this detail is also possible, since the artistic relations of the latter with Germany were so close during those two centuries.

The jawbone is rare outside of this North European zone, which corresponds roughly to the regions of dialects most closely related to Old English. We know that English art was copied in France in the Royal Domain in the thirteenth century; there are miniature paintings like those in the Psalter of Ingeborge and the Leyden Psalter of St. Louis of which the French or English origin was for many years difficult to determine. In the Leyden manuscript,[38] now established as an English work of the end of the twelfth century,[39] Cain's weapon is the jawbone. Since the Psalter belonged to St. Louis, later king of France, and a great lover of manuscripts, the diffusion of this element in France is readily conceivable. I have found only one work in the Royal Domain in which it appears, a relief of the later thirteenth century on the façade of the cathedral of Auxerre (Fig. 5). The sculpture is mutilated, and in the scene of the Murder of Abel only the scar of the weapon remains—a curved silhouette, thickened at one end, like the jawbone in the English images. In the adjoining panel of the Lord reproaching Cain, where the weapon is better preserved, the form of the jawbone is somewhat clearer.[40]

Another possible example of the influence of the English tradition is the painting of the Murder in a remarkable Hebrew manuscript of the fourteenth century from Catalonia, the Sarajevo Haggada. The weapon, which the editors have described as a sword, is not clear; in any case, it does not resemble the swords represented in other pages of the book, but seems to be a femur of a short-legged beast.[41]

3.

Why was the jawbone chosen as the weapon of Cain in England? The common explanation by the analogy of Samson's slaying the Philistines with the jawbone of an ass does not account for the origin of this detail in England.

In Byzantine art a stone is usually indicated, [42] in the West, a club[43] or some agricultural instrument, a hoe or a scythe, proper to the biblical conception of Cain as a farmer;[44] in rare instances, Cain kills his brother with his bare hands.[45] The choice of a stone and even of a club shows some degree of ethnological insight, since the Bible story refers to a primitive period of mankind, before the invention of the metal arts by Tubal-Cain. In the same manner, the Byzantines represent Adam and Eve in untailored skins when they are cast out of Paradise,[46] while western artists often show them in tunics,[47] like contemporary Europeans. Is the choice of the bone a corresponding historical judgment of the primitive character of the first murder? Is there a connection with the Bone Age culture of Denmark and northern Germany?[48] Animal bones were still used as implements in the northern world during the Middle Ages and were important in folklore and popular traditions;[49] in England, especially, bone-carving was intensively practised by the Anglo-Saxons.[50] In a relief of the tenth century (?) from Inchbrayock in Scotland, a fighter in an undeciphered secular subject is represented armed with a jawbone.[51]

Is the jawbone perhaps an interpretation of an unclearly drawn sickle, an implement appropriate to Cain as a farmer? The sickle is familiar as a weapon in ancient mythology, for example as the instrument of Hercules and Perseus.[52] They have a common shape, and in Egyptian hieroglyphic writing the sign for jawbone is a pair of sickles.[53] Maspero supposed that the primitive Egyptian sickle with wooden frame and inset toothed flints was preceded by an animal jawbone.[54] In the Middle Ages the toothed sickle was still in use, as we know from representations.[55] But the sickle is so rare as the weapon of Cain in mediaeval literature and art (I have found no English examples)[56] that the hypothesis of a substitution of the jawbone for the sickle is extremely weak. It seems unlikely that the sharply pointed sickle form, familiar to everyone in the agricultural society of the Middle Ages, would be misunderstood as the clubbed jawbone in an image of the farmer Cain.

I believe a more adequate explanation of the jawbone as Cain's weapon than the survival of prehistoric traditions is to be found in the vernacular linguistic context of the story. In the oldest Anglo-Saxon reference to Cain's use of the jawbone, the Anglo-Saxon prose *Salomon and Saturn*, it is called the *cinbán*.[57] Now Cain in the same literature is called the *bana*,[58] i.e., the slayer or bane of his brother. When he uses the sword to kill him, Cain is the *ecg-bana*,[59] or "sword-bane," of Abel. Is it not likely that the words *Cain bana* suggested *cinbán*? This is a linguistic process that has been observed in different cultures in the formation of legends, and is most evident in the elaboration of the biblical stories. Everyone knows how the attributes and powers of certain saints are derived from their names; St. Claire and St. Augustine are invoked

for eye troubles, and St. Ouen for the deaf, St. Genou heals the knee, Vincent carries the pruning-knife of the vine-dressers, St. Expédit facilitates traffic and shipments, etc.[60] The Hebrew legend that Cain killed Abel with a rod is based on the resemblance of the Hebrew *Kain* and the word for rod, *kaneh*;[61] and the same coincidence suggested to Josephus that Cain invented weights and measures.[62] Even the jawbone used by Samson owes its origin to a similar linguistic play; for jawbone in Hebrew is *lechi*, which is also the name of the place where the author of Judges (xv,14) locates the fight with the Philistines.[63] If an ass's jawbone is specified, it was perhaps because the ass was a sacred animal of the Philistines,[64] so that in triumphing over his enemies, Samson uses the carcass of their protecting divinity. When they applied Samson's weapon to the story of Cain, the Anglo-Saxons were directed by the same process that underlies the Hebrew invention.

But such an explanation is incomplete without another factor, the expressive value of the jawbone in the larger context of the story of Cain and in the Anglo-Saxon fantasy. The choice of a jawbone is highly imaginative and rare, unlike the familiar everyday weapons in the other versions, and implies a peculiar style of fantasy. As the instrument of animal voracity, the jaw is a constant theme in mediaeval art in the expression of overwhelming force; the beast-head with open jaws is often isolated on archivolts, corbels, capitals, initials, and borders in early mediaeval art, especially in England. On the portal of the church of Kilpeck, the arch is decorated with a succession of beasts and beast-heads, some of them devouring the parts of their victims.[65] The animal jaw is the most powerful sign of violence and destructiveness. The representation of hell as the open jaws of a monster (Fig. 6) is a typical English motif;[66] most of the examples before the twelfth century are English works.[67] English artists who represented Cain with the jawbone sensed the bestiality implied in the use of this weapon; in a painting of the late thirteenth century in the Psalter in St. John's College, Cambridge, the artist has placed above the figure of Cain a monkey who shoots at a bird with bow and arrow (Fig. 3). By this *drôlerie*, characteristic of the time in its marginal inversion and parody of the central theme,[68] he reminds us of the crossing of the human and the animal in the main incident. In a Hebrew legend of the Middle Ages, which has its parallel in England, Cain is described as biting Abel to death.[69] Shakespeare's ambiguity in speaking of Cain's jawbone carries something of the same force. Cain is, indeed, for Jewish and Christian legend a half-animal creature, a hairy wild man of the woods;[70] in the story of his own death, often told and represented in England, he is mistaken for a beast in the woods and shot by his own kin, Lamech.[71] In the Anglo-Saxon *Beowulf*, the terrible monster Grendel, who crunches the bones of his human victims, is described as a descendant of Cain.[72] Cain is mentioned twice in the epic, and his story is the only clear biblical

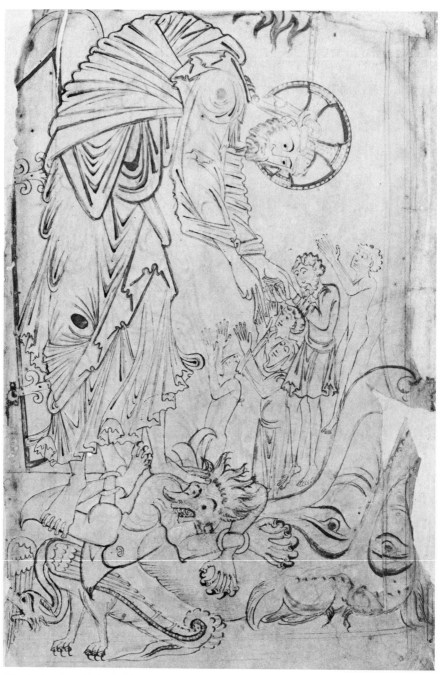

Fig. 6 London, British Museum: Cotton Ms. Tiberius C. VI, psalter, eleventh century, fol. 14. Descent into Hell.

allusion in the poem.[73] His violence has something demonic in it, and the jawbone as his instrument recalls to us that in English, as in older Christian and Jewish tradition, Cain is the son of the devil.[74] In an early mediaeval allegorizing lexicon, once attributed to Rabanus Maurus, the jawbone is the devil's malice,[75] bone in general being a symbol of diabolical cunning.[76]

There is a work of the Renaissance that shows the same connection of envy with half-human, half-animal violence and weapons of bone as the story of Cain in England—the engraving of the battling marine monsters by Mantegna.[77] To illustrate how Envy can create discord even among the most peaceful creatures, he represents the ichthyophagi, sea-centaurs reputed for their freedom from all passion, fighting with each other, armed with the bones of wild beasts.[78]

The invention of the jawbone as Cain's weapon in England was not only inspired by the vernacular play of words peculiar to England. The affective connotations of both Cain and the jawbone for demonic and animal violence in English fantasy probably helped to fuse these two elements into a single image. This expressive aspect underlies also the chain of contrasted images in Shakespeare's willfully ambiguous lines. Hamlet hears the grave-digger sing and recalls that the skull had a tongue in it and could sing once; the jaw belongs to man and ass; it is an instrument of both murder and speech, of the animal and the rational, the alternatives that obsess Hamlet himself, who must kill his own kin. But the skull which he imagines might be Cain's or a politician's, a courtier's or a lawyer's, is doubly dead, for it is "chapless," that is, without a jaw. It can neither bite nor talk, and is therefore the complete image of his own extinction.[79]

NOTES

1. W. W. Skeat, "Cain's Jaw-bone," *Notes and Queries*, 6th series, II, 1880, 143; R.R., *ibid.*, 1880, 162; *ibid.*, III, 1881, 4; W. Pengelly, *ibid.*, IV, 1881, 245; Oliver F. Emerson, "Legends of Cain, Especially in Old and Middle English," *Publications of the Modern Language Association*, XXI, 1906, 851 ff.; J. K. Bonnell, "Cain's Jaw-Bone," *ibid.*, XXXIX, 1924, 140–46. [See also Sir George Warner, *The Queen Mary's Psalter*, 1912, p. 13]

2. The chief examples are the prose *Salomon and Saturn* (J. M. Kemble, *The Dialogue of Salomon and Saturn*, London, 1848, p. 187), *The Master of Oxford's Catechism* (*ibid.*, p. 219), the Northumbrian poem *Cursor Mundi* (Early English Text Society edition, line 1073), the prose *Life of Adam and Eve*, Caxton's *Game of the Chesse* (*ca.* 1474), the Towneley and Hegge plays.

3. Emerson, *loc. cit.*, pp. 851, 852. For the Jewish sources of this work and the particular legend, see Emerson, p. 837, and below, note 69.

4. Bonnell, *loc. cit.*, pp. 143 ff.

5. Bonnell lists also the following examples: a woodcut of 1494 in the Lübeck Bible, two etchings by Lucas van Leyden, and a woodcut by H. S. Beham.

6. *Ibid.*, pp. 143 ff.

7. *Ibid., loc. cit.*

8. Cf. British Museum, Cotton Ms. Claudius B. iv, fol. 8v (Aelfric, Paraphrase of the Heptateuch), eleventh century; British Museum, Cotton Ms. Nero ca. iv, fol. 2 (Winchester Psalter), twelfth century; New York, Pierpont Morgan Library, Ms. 43, fol. 8 (Huntingfield Psalter), twelfth century (Fig. 2); Leyden University, Ms. latin 76 (Psalter of Saint Louis—see H. Omont, *Miniatures du psautier de saint Louis à Leyde*, Leyden, 1902, pl. 4); Dyson Perrins collection, Ms. I, fol. 9 (miniatures from a Psalter of the late twelfth century; see *Catalogue*, ed. Warner, 1920, p. 6, no. 4); Kingsdown Church (Kent), fresco, E. W. Tristram and W. G. Constable, *English Medieval Wall Painting*, I, *The Twelfth Century*, London, 1944, pl. 27; Dyson Perrins collection, Oscott Psalter, fol. 16v, thirteenth century; Cambridge, Fitzwilliam Museum, De Brailles Psalter, *ca.* 1240 (see E. Millar, *English Illuminated Manuscripts from the Xth to the XIIIth Century*, Paris, 1926, pl. 75a); Eton College, Ms. 177, fol. 2 (Bible miniatures), thirteenth century; Cambridge, St. John's College, Ms. 231 (Psalter, end of thirteenth century) (Fig. 3); British Museum, Royal Ms. 2. B. vii (*The Queen Mary's Psalter*, ed. Warner, 1912, pl. 8), early fourteenth century; Holkham Hall, Ms. 666 (picture-book of the Bible, fourteenth century—published by M. R. James in the *Walpole Society Annual*, XI, 1922–23, pl. II); British Museum Add. Ms. 39810, fol. 7 (East Anglian Psalter, fourteenth century—see *Reproductions from Illuminated Manuscripts*, British Museum, Series IV, 1928, pl. XXVI); New York Public Library, De la Twyre Psalter, fourteenth century; woodcut in printed Bible, Day and Serres, 1549, cited by R.R. in *Notes and Queries*, 6th series, II, 1880, 162, and in English printed Bibles of 1572 and 1578 (Stuart Collection, New York Public Library).

9. British Museum, Cotton Ms. Claudius B. iv, fol. 8. Aelfric's dates are *ca.* 955 to 1020(?).

10. S. J. Crawford, *The Old English Version of the Heptateuch. Aelfric's Treatise on the Old and New Testament and his Preface to Genesis* (Early English Text Society, no. 160), London, 1922, p. 92.

11. Oxford, Bodleian Ms. Junius II, fol. 49; reproduced in C. W. Kennedy, *The Caedmon Poems*, 1916, and I. Gollancz, *The Caedmon Manuscript of Anglo-Saxon Biblical Poetry*, London, 1927.

12. Lines 1261, 1262; the text is of the seventh century, the only manuscript *ca.* 1000.

13. *The Crosses and Culture of Ireland*, New Haven, 1931, p. 121. He cites examples on the crosses of Muiredach at Monasterboice, of Durrow, Moone, Castledermot, Camus, Donoughmore, and Arboe, but the jawbone is clear only in Monasterboice (fig. 239) and fairly clear in Durrow (fig. 241). A more recent writer, Françoise Henry, *La sculpture irlandaise*, Paris, 1933, ignores Porter's identification of the weapon, and although she recognizes the scene of Cain and Abel in Durrow beside Adam and Eve, interprets the corresponding scene of Monasterboice as "des combats qui font peut-être allusion à la vie de David ou à celle de Samson" (I, pp. 156, 157).

14. Asses and camels are mentioned together in the Old Testament—Gen. xii, 16 and Exod. ix, 3—but it is possible that the connection of the ass and the camel as symbols of the giant descendants of Cain in the Book of Enoch is a factor in this substitution. For the passage in the Book of Enoch, lxxxvi, 4, see Charles, *Apocrypha and Pseudepigrapha of the Old Testament*, Oxford, 1913, II, 250.

15. In the *Jüdisches Lexikon* (ed. Herlitz and Kirschner), Berlin, 1927, I, 14, the jawbone is listed among the instruments of Cain in Jewish tradition, reference being made to the jawbone of an ass used by Samson (Judges xv, 15–17). But the writer has simply misquoted V. Aptowitzer, *Kain und Abel in der Agada, der Apokryphen, der hellenischen, christlichen und muhammedanischen Literatur*, Leipzig, 1922, p. 51, who states after Fabricius, *Codex Pseudoepigraphicus*, I, 113, that most painters show Cain with a jawbone.

16. It is dated by inference from the inscription naming Muiredach, who died in 924 or 925. See Henry, *op. cit.*, I, p. 16.

17. St. John D. Seymour, "The Book of Adam and Eve in Ireland," *Proceedings of the Royal Irish Academy*, XXXVI, 1922, 129.

18. *Ibid., loc. cit.*

19. J. M. Kemble, *The Dialogue of Salomon and Saturn*, London, 1848, p. 187.

20. See note 11 above.

21. Ms. 177, fol. 2 (biblical images), thirteenth century.

22. W. Robertson Smith, *The Religion of the Semites*, new ed., London, 1914, pp. 201, 205, 233 ff.

23. D. Feuchtwang, "Das Wasseropfer und die damit verbundenen Zeremonien," *Monatsschrift für Geschichte und Wissenschaft des Judentums*, N.F. XVIII, XIX, 1910; A. J. Wensinck, "The Ideas of the Western Semites concerning the Navel of the Earth," *Verhandelingen der Koninklijke Akademie van Wetenschapen te Amsterdam, Afdeeling Letterkunde*, Nieuwe Reeks, XVII, 1916.

24. Louis Ginzberg, *The Legends of the Jews*, I, Philadelphia, 1909, 107.

25. *Ibid.*, V, 1925, 140.

26. *Ibid.*, I, 110, 112; V, 142. See also J. G. Frazer, *Folk-Lore in the Old Testament*, I, London, 1919, 101, 102, on the danger of uncovered, unabsorbed blood, and on Ezek. xxiv, 8: "that it might cause fury to come up to take vengeance, I have set her blood upon the bare rock, that it should not be covered."

27. On the literary connections of England and Ireland in the early Middle Ages, see C. H. Slover, "Early Literary Channels between Britain and Ireland," *University of Texas Studies in English*, VI, 1926, 5–52; VII, 1927, 5–111; St. John D. Seymour, *Irish Visions of the Other-World*, London, 1930, p. 122; and V. E. Hull, in *Speculum*, IV, 1929, 95 ff.

28. For an excellent account of the influence of English on continental art in the Middle Ages, and reference to the older literature, see A. Goldschmidt, "English Influence on Mediaeval Art," *Mediaeval Studies in Memory of Arthur Kingsley Porter*, II, Cambridge, 1939, 721 ff.

29. In an unpublished manuscript which he has kindly permitted me to read.

30. See *Rymbybel van Jacob van Maerlant*, ed. J. David, I, Brussels, 1858, 41, lines 864–867:

> The fiend came from hell
> And gave him counsel
> To strike him dead
> With the jaw-bone of an ass.

The poem is dated 1271. Professor Barnouw cites also a passage in a later Dutch History-Bible that Abel was killed "with a bone of an ass's head."

31. The murder of Abel is not illustrated in the richly illuminated manuscript of Jacob van Maerlant's *Rijm Bijbel* by Michiel van der Borch, dated 1332, in the Hague (Museum Meermanno-Westreenianum, Ms. 10. B. 21). It is possible, however, that the jawbone was familiar to Netherlands artists before Van Maerlant's time. [There is an example in a Bible manuscript of the second half of the thirteenth century, Brussels Bibl. Royale Ms. 10730, fol. 5v.] In a miniature of the murder in a manuscript from St. Bertin of *ca.* 1200 (Hague, Royal Library, Ms. 76. F. 5, fol. 2v) the asymmetrically dented, thickened end of the curved club in Cain's hand may be a vestigial trace of a jawbone in the model. Other miniatures in the same manuscript show English types—the Hell Mouth, the Ascension with only the legs of Christ visible, etc.

32. Cf., besides the examples cited by Bonnell (note 5 above), Van Eyck, *Van der Paele Madonna*, 1436, on the right arm of the Virgin's throne; Dirk Bouts, architectural frame of the *Descent from the Cross* in Valencia (M. Friedländer, *Die altniederländische Malerei*, III, pl. V), and of the *Annunciation* in the Prado (*ibid.*, pl. I); Petrus Christus, *Nativity*, sculpture of the enframing arch, in the National Gallery, Washington (*ibid.*, XIV, nachtr. pl. III); Munich, Staatsbibliothek, Deutsche Hs. 1102, Old Testament in Netherlandish, dated 1439 (Th. Ehrenstein, *Das alte Testament im Bilde*, Vienna, 1923, p. 89); a manuscript in the Royal

Library in Copenhagen, s. 1605, of about 1500 (*ibid.*, p. 89); a Netherlandish Bible, dated 1473–1474, in the British Museum, Add. Ms. 16951, fol. 23 (A. W. Byvanck and G. J. Hoogewerff, *La miniature hollandaise dans les manuscrits des 14e, 15e et 16e siècles*, The Hague, 1925, pl. 98); Master of the Beatitudes, early sixteenth century, in spandrel of a painting of Christ as a child in the Temple, in the Rijksmuseum, Amsterdam; Master of the Last Supper, sixteenth century, Brussels, Musée Royal, no. 107, painting of the Last Supper, wall medallion; Madrid, Old Royal Collection, Flemish tapestry of the sixteenth century (Calvert, *The Spanish Royal Tapestries*, London, 1921, pls. 128, 129); woodcut attributed to Jan Gossaert (Mabuse) (G. Hirth and R. Muther, *Meister-Holzschnitte aus vier Jahrhunderten*, Munich, 1893, pls. 122, 123).

33. W. Valentiner, *Rembrandt, Des Meisters Handzeichnungen* (*Klassiker der Kunst*), I, no. 3, 4. There is also a seventeenth-century painting of Cain with the jawbone, attributed to Martin de Vos, in the Cathedral of Seville (Mas photo 81758–C).

34. Cf. an Amsterdam print reproduced by E. H. Van Heurck and G. J. Boekenoogen, *Histoire de l'imagerie populaire flamande*, Brussels, 1910, p. 547, and *L'Ymagier* (ed. by Alfred Jarry and Remy de Gourmont), I, Paris, 1894, 45.

35. Emerson, *loc. cit.*, p. 859, n. 2, says that a colleague of Belgian origin had heard the story of the jawbone in Sunday-school.

36. For the examples listed by Bonnell, see note 5 above; for the woodcut in the Lübeck Bible of 1494, M. Friedländer, *Die Lübecker Bibel*, Munich, 1923, fig. 2.

37. In Master Bertram's *Petrialtar* of 1379, another panel besides the Cain and Abel is ultimately English in iconographic conception: the first of the Creation scenes shows the fall of the rebel angels, a specifically English theme since about the year 1000. In Bertram's Passion Altar, the Hell Mouth of the *Anastasis* and the disappearing Christ of the Ascension are based on English art. For reproductions of these works, see Alexander Dorner, *Meister Bertram von Minden*, Berlin, 1937, and A. Stange, *Deutsche Malerei der Gotik*, II, Munich, 1936, fig. 166.

38. Leyden University Library, Ms. lat. 76 (H. Omont, *Miniatures du psautier de saint Louis à Leyde*, pl. 4).

39. By James Carson Webster's publication of the paintings of the calendar (omitted in Omont's book), which are almost identical with those of another English Psalter, St. John's College, Cambridge, Ms. 233 (*The Labors of the Months in Antique and Mediaeval Art*, Evanston and Chicago, 1938, pls. LIX, LXI).

40. There is perhaps a vestige of the jawbone in the bone-like club of Cain in a miniature by the "Maître aux Boqueteaux" in the French Livy of Charles V in the Bibliothèque S. Geneviève, Ms. 777, fol. 7 (H. Martin, *La miniature française*, Paris, pl. 51).

[In the destroyed Hours of Turin (from the *Très Belles Heures* of the Duke Jean de Berry), in a miniature on the lower margin of fol. 36, a jawbone lay on the grave of Abel; Adam and Eve sat nearby in the landscape (P. Durrieu, *Heures de Turin*, Paris, 1902, pl. XXI). Paul Perdrizet (*Étude sur le Speculum Humanae Salvationis*, Leipzig, 1907, p. 155) supposed that this scene was based on a miniature in the *Speculum*, e.g., Paris, Bibl. Nat. Ms. fr. 6275; there Adam and Eve are shown sitting in a hut while the killing takes place in the background.]

41. See D.H. Müller and J. von Schlosser, *Die Haggadah von Sarajevo*, Vienna, 1898, fol. 4. For precise renderings of knife and sword, see fol. 13 and 27.

Knowledge of the English conception by Jewish scribes and artists is not excluded, since the illustration of Old Testament themes in Hebrew manuscripts is sometimes so close in composition and iconographic type to Christian works. It is worth mentioning here that a leaf in the Leyden Psalter of St. Louis (fol. 11v) has traces of four lines of partially erased Hebrew writing, apparently of the twelfth century.

42. As in the Octateuchs, the Pesaro ivory casket, and Paris, Bibl. Nat., Ms. gr. 74, fol. 46v, etc. [For an example in Romanesque art, see the capital with this subject in the cloister of Huesca (Aragon).] The stone is also the weapon in Islamic art: cf. the Morgan Manafi-al-Hayawan (Ms. 500) and Paris, Bibl. Nat., Ms. suppl. Persan 1313, fol. 15. In some Greek

manuscripts (Homilies of James, Vatican Ms. gr. 1162, Paris, Bibl. Nat., Ms. gr. 1208), a knife is used.

43. The bronze doors of Hildesheim and Monreale, the mosaics of Monreale, the drawings in the Junius Caedmon manuscript, a relief on the west front of Modena cathedral, wall-painting in S. Angelo in Formis, etc.

44. A hoe in a window in Chartres cathedral, the altar of Nicholas of Verdun in Klosterneuburg, and a North French manuscript in the John Rylands Library, Manchester (French Ms. 5); a mattock in Paris, Bibl. Nat., Ms. Fr. 22912–13, Augustine, *Cité de Dieu, ca.* 1376; a spade in the Psalter of St. Louis, Bibl. Nat., Ms. lat. 10525, and in the Belleville Breviary, Bibl. Nat., Ms. lat. 10483, fol. 24v; a scythe in the *Bible Moralisée*, Bodleian Ms. 270b, fol. 8, and on a baptismal font in Östra Eneby, Östergötland; an axe in the Ashburnham Pentateuch, the narthex mosaics of S. Marco in Venice, the mosaics of the Palace Chapel in Palermo, the fresco from Mur in the Boston Museum, etc. [In the twelfth-century play *Jeu d'Adam*, Cain's weapon is a pot.] In a modern Negro song, *Darky Sunday School*, it is the leg of a table:

> The good book says Cain killed his brother Abel,
> He hit him on the head with the leg of a table.

For the literary traditions about the instrument of Cain in Jewish and Early Christian writings, see the work of Aptowitzer, cited above in note 15 (pp. 50 ff.).

45. In the paintings of the palace of Ingelheim, described by Ermoldus Nigellus: "Perculit, haud gladio, sed manibus miseris."

46. In the Octateuchs and in the narthex mosaics of S. Marco, Venice.

47. Cf. the Carolingian Bibles of Bamberg, Moûtier-Grandval (British Museum, Add. Ms. 10546), the Junius Caedmon, a Josephus manuscript in Brussels (Bibl. Royale, Ms. 3062, fol. 3v), a capital in the cloister of Moissac, a drawing from Moissac (Paris, Bibl. Nat., Ms. lat. 2077), etc.

48. The so-called Maglemose Culture; see Shetelig and Falk, *Scandinavian Archaeology*, Oxford, 1937, chap. III.

49. See E. Cartailhac, *L'âge de pierre dans les souvenirs et superstitions populaires,* Paris, 1877, pp. 96 ff.; and J. Déchelette, *Manuel d'archéologie préhistorique, celtique et gallo-romaine*, I, Paris, 1924, 575, esp. fig. 218, for amuletic use of animal teeth and jawbone.

50. Bone objects of late antiquity and of the early Middle Ages in England are reproduced in the *British Museum Guide to Early Iron Age Antiquities*, 1925, the *Guide to Anglo-Saxon Antiquities*, 1923 and the *Guide to Mediaeval Antiquities*, 1924. For English bone and ivory carvings see also A. Goldschmidt, *Elfenbeinskulpturen*, vol. IV.

51. J.R. Allen, *The Early Christian Monuments of Scotland*, Edinburgh, 1903, fig. 235b; W. Anderson, in *Seminarium Kondakovianum, Recueil d'études*, 1937, pl. X, 3.

52. On its use as a weapon in ancient representations, see the article "Falx" by S. Reinach, in Daremberg and Saglio, *Dictionnaire des antiquités grecques et romaines*. p. 970.

53. See H. Maspero, in *Revue critique d'histoire et de littérature*, I, 1892, 270.

54. *Ibid.* Cf. also Ranke, in Ebert, *Reallexikon der Vorgeschichte*, XII, 73, s.v. "Sichel": "die Urform ist vielleicht ein Esels-oder Rinderkinnbacken mit künstlich nachgeschärften Zähnen." For reproduction of a primitive Egyptian wooden sickle with flint teeth and the hieroglyphic sign, see J. de Morgan, *La préhistoire orientale*, II, Paris, 1926, fig. 107.

55. Cf. the harvest scene in the Beatus manuscript, Morgan Library Ms. 644, and in the Gerona cathedral Beatus.

56. It is cited, however, by Irenaeus in commenting on the story of Cain; see Aptowitzer, *loc. cit.*

57. " . . . da hine Chain his broder ofslóh mid ánes esoles cinbáne" (J.M. Kemble, *op cit.* in notes 2, and 19 above).

58. *Beowulf*, lines 1261, 1262.

59. *Ibid., loc. cit.*

60. H. Delehaye, *Les légendes hagiographiques,* Brussels, 1927, pp. 45 ff., and K. Nyrop (and H. Gaidoz), "L'étymologie populaire et le folk-lore," *Mélusine,* IV, 1889, 505-24, V, 1890, 12-15, 148-52.

61. L. Ginzberg, *op. cit.,* V, 139, n. 20. For a similar origin of the reed as Cain's weapon in rabbinical tradition, see R. H. Charles, *The Apocrypha and Pseudepigrapha of the Old Testament,* II, Oxford, 1913, 138 n.

62. L. Ginzberg, *op. cit.,* V, 144, 145, n. 41.

63. *Ibid.,* VI, 207, n. 119.

64. See D. B. Stade, *Biblische Theologie des Alten Testaments,* Tübingen, I, 1905, 141, and W. Robertson Smith, *op. cit.,* p. 468.

65. A. Gardner, *A Handbook of English Medieval Sculpture,* Cambridge, 1935, fig. 61.

66. The oldest example I know is the ivory carving of *ca.* 800 in the Victoria and Albert Museum; see M. H. Longhurst, *Catalogue of Carvings in Ivory in the Victoria and Albert Museum,* London, 1927, Part I, pl. XLV, no. 253-1867. Goldschmidt (*Elfenbeinskulpturen,* I, 178) tentatively assigns it to Tours, but the associated ornament is clearly of insular type. The Anglo-Saxon taste for the Hell Mouth was perhaps influenced by the northern pagan myth of the Crack of Doom and the battle with the wolf, who devoured Odin. The wolf's great jaws are broken by Odin's son, Vidar, who is later identified with Christ. The latter scene is illustrated on the Gosforth Cross, about 900, according to H. Colley March, *Rending the Wolf's Jaws,* Manchester, 1894.

67. Cf. the Junius manuscript (Kennedy, *op. cit.,* p. 199); British Museum, Cotton Ms. Titus D. xxvii, fol. 75v (E. Millar, *op. cit.,* pl. 24b); Stowe Ms. 944, *Liber Vitae* of Newminster, Winchester (*ibid.;* pl. 25b); the Anglo-Saxon psalter, Paris Bibl. Nat., lat. 8824; Cotton Ms. Tiberius C. vi, fol. 14, Winchester Psalter, first half of the eleventh century (Fig. 6); Victoria and Albert Museum, ivory carving of the tenth or eleventh century, no. 1-1872, German (?), (Longhurst, *op. cit.,* pl. LII, and p. 74); and from the other side of the Channel, close to English art—Morgan Library Ms. 333.

68. On parody and inversion as forms of *drôlerie* and in marginal decoration, see my remarks in *Mediaeval Studies in Memory of A. Kingsley Porter,* 1939, p. 377, and in *The Art Bulletin,* XXI, 1939, 339 ff. [reprinted in my *Selected Papers,* I, 1977, pp. 6, 10, 42, 83n., 81, 123, 127n., 14, 249; see also, in the present volume, pp. 196-198.]

69. In the *Zohar* and in earlier Jewish literature (Targum to Gen. iv, 7, Sanhedrin), cited by Aptowitzer, *op. cit.,* n. 219, 219b, and Ginzberg, *op. cit.,* V. 139, n. 20. [It is illustrated in the Hebraizing Bible of the Duke of Alba (*ca.* 1430), where Cain lies on Abel's fallen body and seems to bite his heart—see J. Dominguez Bordona, *Manuscritos Miniados,* I, p. 497, fig. 415.] In the Apocalypse of Moses, cap. 2, Eve dreams of seeing the blood of Abel flowing in Cain's mouth. This is also found in the *Vita Adam et Evae,* cap. XXII, 4, which was well known to Anglo-Saxon writers (Charles, *op. cit.,* II, 138 and Emerson, *op. cit.,* pp. 851 ff.).

70. Emerson, *op. cit.,* pp. 866 ff. In the Chester Creation play, Cain lives among the beasts; in the Cornish Creation play he is described as covered with hair; and in the Middle English poem, *Ywaine and Gawain,* a monster of the wood, human but with partial likeness to animals, his teeth like bare tusks, is of Cain's race (*ibid.,* p. 885). This figure, according to Kittredge, is of English origin, since it is missing in the French original. [My colleague Roger Sherman Loomis wrote me in 1942: "The wild man of *Ywain and Gawain* is in the original Chrétien's *Ivain.* He is not of English origin but of Celtic. Cf. my chapter on the Giant Herdsman in *Celtic Myth and Arthurian Romance.*"]

71. On the Lamech story in England, see Emerson, *op. cit.,* pp. 876 ff.

72. Lines 104 ff., 1258-1266.

73. On Cain and his descendants in *Beowulf,* see Emerson, *op. cit.,* pp. 878 ff.

74. In the Jewish and Early Christian writings, explicitly; in the English, metaphorically— Emerson, *op. cit.,* pp. 833-35.

75. *Allegoriae in Sacram Scripturam,* Migne, Pat. lat., CXII, 977, —s.v. "maxilla."

76. *Ibid.,* col. 1013, s.v. "os." [Earlier, Pope Gregory, in his *Regula Pastoralis,* (III,

ch. 10), in speaking of Cain and Abel, quoted Proverbs xiv, 30: "Envy is the rottenness of bones" ("Putredo ossium invidia").]

77. B. 17. See T. Borenius, *Four Early Italian Engravers*, London, 1923, Mantegna, no. 5.

78. For this interpretation, based on a passage in Diodorus Siculus, see R. Förster, "Die 'Meergötter' des Mantegna," *Jahrbuch d. preussischen Kunstsammlungen*, XXIII, 1902, 205–14. [The jawbone of a beast is also a weapon in the two engravings of Hercules by Dürer (*Dürer*, Klassiker der Kunst, 4th ed., edited by F. Winkler, Stuttgart, pp. 119, 230). In one it is held by a satyr, in the other it is the jawbone of an ass wielded by a furious naked old woman. In Gruenewald's Temptation of Saint Anthony, the demon that pulls the saint's hair brandishes a long jawbone.]

79. [For other proposed explanations of Cain's jawbone, see the articles by G. Henderson in *Journal of the Warburg and Courtauld Institutes*, XXIV, 1961, pp. 108–114, and A. A. Barb in the same periodical, XXXV, 1972, pp. 386–389.]

Fig. 1 London, British Museum: Ms. Galba A. XVIII, Athelstan Psalter.

Fig. 2 London, British Museum: Add. Ms. 49598, Benedictional of St. Aethelwold, fol. 64v. Ascension.

The Image of the Disappearing Christ

The Ascension in English Art Around The Year 1000

(1943)

1.

In rendering the Ascension of Christ, the artists of the early Christian period imagined the scene in one of two ways. Christ stands or sits in the sky, with attributes of his divinity and glory, above the apostles; or he ascends actively, as if climbing, toward the extended hand of the Father. The first type is more emblematic, exhibiting the divine Christ triumphant in the heavens, while the second shows better the transitive episode of ascension, the last moment of his human incarnation. These types have been referred to different regions of origin, the static, theological version presumably coming from Syria and Palestine, and the naturalistic conception from the more Hellenized Mediterranean centers.[1] The former belongs then to oriental art, the latter betrays the typical processes of Greek imagination. But since the oriental type appears in works of Greek style, this view of their respective origins remains hypothetical. However, the artists of the Eastern provinces tend to favor the so-called oriental type; the static, emblem-like version was more congenial to the retarded margins of the early Christian world.

Whatever their ultimate sources, both types were widely diffused in the West; but in England, where they occur together (Figs. 1, 2), a new variant arose toward the year 1000. Only the legs or feet of Christ were represented, the rest of the body disappearing in the cloud (Fig. 3). It is as if the artist wished to show Christ as he looked to the apostles who observed from below his disappearance into the heavens. Even the mandorla that encloses Christ in some of the English miniatures (Figs. 3, 4) is cut by the clouds, a strange phenomenalizing of an abstract theological attribute. When we reflect how constantly early mediaeval art preserves the full form of Christ, or at least the emblematically sufficient head and bust (Fig. 5), and how remote this art is from an optical or phenomenal conception of the episodes of the Bible, the English innovation seems astonishingly precocious. It is independent of ancient

267

Oum difcernit caeleftif regef fup eam·
niue dealba buntur infelmon
monf dei monf pinguif·
Monf coagulatuf monf pinguif· utquid
fufpicamini montef coagolatof·
Monf inquo bene placitum eft deo·habi
tare ineo·&eni dnf habitabit infinem·
Curruf dei decem milib: multiplex milia
l&antium dnf meif infyna infancto·
Afcendifti inaltum cepifti captuitate·
accepifti dona inhominibuf·
Etenim noncredentef inhabitare
dominum deum·
Benedictuf dnf die cotidie·pfpum facit
nob df falutarium noftrorum·
Df nr df faluof faciendi
&dni domini exituf moftif·
Verumtamen deuf confring& capita
inimicorum fuorum uerticem capilli
per ambulantium indelictiffuif·
Dixit dnf exbafan conueftam·
conueftam inpfundum marif·
Ut tintin guatur pef tuuf infanguine

Fig. 3 Vatican City, Biblioteca Vaticana: Regina Ms. 12, Psalter from Bury St. Edmunds, fol. 73v. Ascension.

Fig. 4 Rouen, Bibliothèque Municipale: Ms. 274 (Y. 6), Missal of Robert de Jumièges, fol. 81v. Ascension.

Fig. 5 Vatican City, Biblioteca Vaticana: Regina Ms. 12, Psalter from Bury St. Edmunds, fol. 103.

illusionism and goes beyond the most advanced naturalistic classical represen-
tations of ascension and disappearance. We are not surprised that Emile Mâle,
unaware of the early English examples, incorrectly derived this type from the
performance of the late mystery plays in which a figure could be observed
ascending from the stage;[2] and more recent students of the iconography of the
Ascension, who know the early date of the first examples, still designate them
as a Gothic type.[3]

<div align="center">

2.

</div>

How did the English artists come to imagine the Ascension in this new
and apparently unmediaeval manner?

It is foreshadowed in the tenth century in a vernacular account of the
same incident. In the Anglo-Saxon *Blickling Homilies*, commenting on Acts
(i, 9) ("And when he had spoken these things, while they beheld, he was taken
up; and a cloud received him out of their sight"),[4] the sermonist describes the
Ascension in the following way: "The cloud did not make its appearance there,
because our Lord had need of the cloud's aid at the Ascension; nor did the
cloud raise him up, but he took the cloud before him, since he hath all
creatures in his hand, and by his divine power and by his eternal wisdom,
according to his will, he orders and disposes all things. And he, in the cloud,
disappeared from their sight and ascended into heaven, as a sign that from
thence in like manner he will on Doomsday again come on earth in a cloud,
with hosts of angels."[5]

What is most striking in this passage is that the author feels the need to
explain Christ's physical relation to the cloud. He seems to be correcting an
interpretation not explicit in the text of Acts, but apparently followed by artists
who showed Christ supported by a cloud. This is the form of the Ascension in
some continental works of the period around 1000: miniatures in the pericope-
book of Henry II in Munich[6] and in a troper from Autun.[7] It is perhaps
present also on a mutilated Northumbrian stone cross of the ninth century from
Rothbury.[8] In the Bible itself, the cloud is a frequent element in real or
visionary appearances of a sacred person, and the sermonist recognizes this
function of the cloud when he adds that the Savior will return to earth in a
cloud on Doomsday. Yet he is led into obscurity by his concern with the cloud;
for if the cloud does not carry Christ, but Christ takes the cloud before him,
what sense is there in saying that he will again come on earth in a cloud "in
like manner," words repeated literally from Acts, unless he means that the
cloud envelops Christ without supporting him, as the atmosphere enveloping
the earth is carried along in the latter's motion. In any case, he contradicts the
Jewish-Christian tradition which makes the cloud the true vehicle of the

heavenly being. In the prophecy of Daniel (vii, 13) and in the preaching of Christ and Paul, the Son of Man is described as coming on the clouds.[9] The account of the Ascension in Acts speaks of the cloud as taking up Christ, and although the expression "nubes suscepit eum" may be interpreted as an ascension *through* a cloud within which he disappeared like the Homeric heroes, the Old Testament was cited by commentators in favor of the notion that a cloud was his vehicle, and actually bore him up. In a sermon on the Ascension, the Englishman Bede invokes Psalm 103, line 3, in which the Lord "maketh the clouds his chariot" ("qui ponit nubem ascensum"), and Isaiah (xix, 1): "Behold the Lord rideth upon a swift cloud" ("Ecce Dominus ascendet super nubem levem").[10] This is the sense also in the earliest apocryphal accounts of the Ascension and the Transfiguration;[11] and centuries later, John Donne, perhaps inspired by the painting of his time, pictures the ascending Christ upon the clouds:

> Behold, the Highest, parting hence away,
> Lightens the dark clouds, which He treads upon.[12]

The Anglo-Saxon homilist could not accept this state of affairs, in which the Lord had to be supported by a cloud, and reversed the relation in a curious way. But in doing so, he looked for a theological justification, and found it, strangely enough, in the idea of God's power over all created things, which had formerly suggested the image of the Lord riding on the clouds. Already in the sixth century, Gregory had distinguished the Ascension of Christ from previous Ascensions by the fact that while Enoch, *ante legem*, was carried up by angels and Elijah, *sub lege*, rose with the help of a chariot, Christ, who had made all things, was borne up by his own strength ("nimirum super omnia sua virtute ferebatur"); "he was neither translated, nor carried up, but he penetrated the ethereal heaven by his own power."[13] For the Anglo-Saxon homilist the fact of self-elevation was evidently of real moment, since he speaks of it a second time in describing the Descent of Christ into Hell: "Then the Lord, with the spoil that he had taken from hell, immediately went living from the tomb, *raised by his own power*, and afterwards clothed himself with his unspotted body."[14]

But to the older writers, unlike the homilist, this belief in the miraculous self-elevation of Christ did not contradict the belief in the ascension on a cloud. The same Bede who spoke of the cloud as the vehicle of the Lord also wrote that Christ was not supported but only escorted by angels in his assumption to heaven.[15] The comment of the Blickling homilist therefore suggests that the image of the Ascension had become problematic and was about to be revised. He rejects as inconsistent with the divine power the notion that a cloud carried up Christ, and proposes instead an image that seems to anticipate the new

English miniatures of the Ascension: "he took the cloud before him . . . and he, in the cloud, disappeared from their sight and ascended into heaven."

From this interest in the means of support to the new type of disappearing Christ there is, however, a great leap. In both, the material reality of the miracle is central, but the first belongs to statics, the second to the phenomenal and psychological world of perception. The question whether the cloud carried Christ or vice versa could be answered through a schema of the supporting and supported objects, whereas the new Ascension is an image of a crucial transition, the penetration of the heavens or a cloud as seen from the viewpoint of a specially placed observer. It is this reference to the earthly observer that constitutes the far-reaching originality of the English invention, and distinguishes it so radically from the parallel type of Christ standing on a cloud that was conceived at the same time. The last moment of the Ascension was also interesting to the early commentators, but not as a visual experience of the witnessing apostles. In describing the transitive aspect of the Ascension, they distinguish the localities through which Christ passes instead of dwelling on the moment and phenomenon of disappearance. Bede, in a commentary on Acts, explains that the angels point to Christ as really going up to heaven and not merely in the sky, like Elijah ("ut vere in caelum illum ire monstrarent, et non quasi in caelum sicut Eliam");[16] and Gregory, before him, distinguished the two Ascensions accordingly, Elijah having been carried up in the sky of the birds and the air (caelum aereum), while Christ had ascended to heaven itself (caelum aethereum)[17]—a distinction which corresponds to that between the Roman Caelus and Polus, the sky and the summit of heaven. Even after the English invention of the new type, continental artists of the eleventh and twelfth centuries who attempt to render the diminishing visibility of the ascending figure still preserve the absolute theological predominance of the head of Christ. On a tympanum of the Royal Portal of Chartres, the feet of Christ are covered by the cloud and the body rises from it in clear transcendance; on a relief in Santo Domingo de Silos only the head emerges from the clouds which are carried by angels.[18] In neither case does the form of Christ correspond to the optical experience of the apostles who look up from below; the convention of disappearance in the clouds lacks the phenomenal and subjective aspect of the English type.[19]

For the Blickling homilist, the disappearance "from their sight" is not only linked with Christ's independence of the cloud; it is elaborated further as a moment in the awareness of the apostles that was reenacted in the contemporary religious cult. He goes on to describe at great length[20] the church built on the Mount of Olives where Christ ascended, and observes the unerasable last footprints of Christ and their miraculous properties. The roof is open above them, so that the pilgrims may look up to the sky, like the apostles,

from the very point where Christ ascended. "Our Lord would that to the eyes of those men who believingly came thither and visited the holy place, the way might always become familiar to look up to heaven, whither they knew that the Lord had bodily ascended."[21]

The account of the church on the Mount of Olives follows closely the description of the site in the work of Adamnán of Iona on the holy places of Palestine. This Irish abbot of the latter part of the seventh century had taken down the oral report of a pilgrim, Arculf, to record it in a book that he presented to the Anglo-Saxon King Aldfrid: "On the whole Mount of Olives the highest point is the one from which our Lord is said to have ascended to heaven; here stands a great round church with three concentric porticos all roofed over. The inner chamber of the round church, having no roof, is exposed to the sky, but in its eastern part there is an altar, protected by a narrow roof. The inner space has no room above it, so that from the spot where the Lord left his holy footprints when he was carried up to heaven in a cloud, the way is always open, and those who pray there may look up and see the sky directly"[22]

Although the tradition of the footprints fulfills the prophecy of Zacharias xiv, 4 ("And his feet shall stand that day upon the Mount of Olives"), and although the legendary imprint of Christ's feet was known to the early writers of the Church, it is only in England that the site on the Mount of Olives becomes a substance for religious and literary imagination. The text of Adamnán had an extraordinary appeal. Bede paraphrased it in two of his most widely read works, the *Liber de Locis Sanctis* (cap. vi) and the *Historia Ecclesiastica* (lib. V, cap. xvii).[23] In the sermon on the Ascension already quoted, he retold the story according to this contemporary experience of the site, as if the apostles were pilgrims of his own day. "They worshipped on the spot," he says, "where Christ's feet had stood, after moistening with their profuse tears the footprints he had just implanted."[24]

Later in the eighth century, the vernacular poet Cynewulf imagined the Ascension itself according to these native texts: "Our Lord departed through the temple roof even as they beheld, the chosen thanes who in that meeting-place gazed on the last footprints of their well-loved Prince. They saw the Lord, the Son of God, ascending up on high from earth"[25] (Fig. 6).

The imaginative reenactment of the Ascension through the footprints and the open roof is therefore a specifically English tradition, which provided the English artists a material ground for their bold conception of the disappearing Christ. That the cult of the sacred mountain-top and of the feet of Christ was a factor in forming the new image may be supposed also from the miniature in the Hereford troper (British Museum, Caligula A.XIV, fol. 18) (Fig. 7). In this painting, not only is the mountain outlined beneath the feet of Christ, but

Fig. 6 Paris, Bibliothèque Nationale: Ms. lat. 765, fol. 19.

Fig. 7 London, British Museum: Ms. Caligula A. XIV, Troper, fol. 18.
Ascension.

Fig. 8 New York, Pierpont Morgan Library: Ms. 333, Evangeliary of St. Bertin, fol. 85.

it is inscribed MONS OLIVETI. In the Benedictional of Ethelwold (Fig. 2), two hills diverge from the hollow center, contrary to the tradition about the mountain summit. The account in Acts (i, 9) does not specify directly an ascent from a mountain-top; only later is the Mount of Olives mentioned as the place from which the apostles returned to Jerusalem (i, 12). Luke (xxiv, 50, 51) simply reports how Christ led the apostles to Bethany and ascended from that place. In naming Mount Olivet, the painter of the Hereford manuscript reveals his acquaintance with the tradition about the holy places of the East. It is most unusual to find this name in an image of the Ascension in the early Middle Ages. But the footprints themselves are not rendered in the surviving English examples of the Ascension of the eleventh and twelfth centuries; and in spite of the existence of later English and continental versions in which both the footprints and the disappearing Christ are shown,[26] I do not believe that these two motifs were originally joined in English art. There are enough Gothic examples of the full figure of Christ with the footprints[27] and of the disappearing type without them[28] to make the theory of a primitive connection doubtful. The footprints are a specifically Gothic element. They belong to the later, more developed cult of the physical person of Christ, the relics, and the instruments of the Passion. For the English artists around the year 1000 the vision of the disappearing Christ is the chief meaning of the Ascension. Nevertheless, the account of the church on the Mount of Olives in the Blickling homily, with its extensive description of the site, the footprints, the miracles, the furniture, and the cult of the holy place, indicates that already by the tenth century English religious imagination was disposed toward the concrete and tangible, and elaborated the reports of the sacred moments with a material fullness that anticipates the piety of the end of the Middle Ages, with its demand for participation, reenactment, and visibility.

3.

The probability of the English origin of the new type of Ascension is limited by the existence of two continental examples of very early date. The oldest work with the new type that I have been able to discover is a miniature in a Gospel manuscript in the Pierpont Morgan Library (Ms. 333, Fol. 85) (Fig. 8). From the resemblance to the great psalter in the library of Boulogne-sur-Mer (Ms. 20), it was apparently made in the same center, the abbey of St. Bertin at St. Omer in northern France, under the rule of Odbertus (986–1008).[29] It is a product of the so-called Channel school, which was deeply impregnated with Anglo-Saxon tradition in both the forms and the subjects. The Morgan manuscript depends in so many respects on English art that I have

no hesitation in deriving this already subdued, marginal example of the new Ascension from an English model of the same period.

The second example is a miniature in the Evangeliary of Bernward in the cathedral of Hildesheim.[30] In this work of the early eleventh century, the disappearing Christ is represented above the evangelist John and his eagle. The example is not only isolated in German art of the period—the frequent German versions of the thirteenth century are admittedly copied from English models[31]—but is also unique as a rendering of the subject. There are no apostles or angels; the feet of Christ rest on the earth, while the head is veiled by the concentrically patterned segment of the sky; and the connection with the eagle and John raises the question whether the conception of Christ has not been fused somehow with the attributes of John. For John is the eagle evangelist who flies highest and reaches heaven with his theological insight, as in the verse of Alcuin: "John, in writing, you penetrate heaven with your spirit" ("Scribendo penetras caelum tu mente Johannes").[32] In the absence of the apostles looking upward, the image lacks just that empirical moment of vision of the disappearing Christ which is the core of the English invention. It is later than the first English examples, if we can trust the opinion of scholars who place it around 1010, contemporary with the South German works of analogous style.[33] It is conceivably a reduction of some English model, although an independent origin is not excluded. The Bishop Bernward, according to his biographer,[34] collected works of English art; and we know that, through other channels, richly decorated English manuscripts were accessible in Germany.[35]

The text of the Blickling homily and the native tradition behind it strengthen the probability of the English invention of the type. The homily on the Ascension was written in 971,[36] a generation before the oldest surviving versions of the new Ascension image. It is possible that earlier examples, literary and pictorial, have been lost, but most likely the first images were later than the Blickling text, since the Ascension in the most advanced English art of the same moment follows a traditional type. In the Benedictional of St. Ethelwold (*ca.* 975–980) the full-length Christ is represented mounting the heavens (Fig. 2). In the Athelstan Psalter (Fig. 1), he sits in a mandorla held by angels.[37] The same type reappears in the sculpture of Rothbury already cited,[38] but here the mandorla seems to be of a wavy, cloud-like form.

The new sign for ascent and disappearance created by the English artists was soon detached from its original place and applied to other contexts in which the same phenomenon was present. Contemporary with the earliest examples of the disappearing Christ is the drawing of the Translation of Enoch in the Junius manuscript of Caedmon,[39] where the patriarch disappears like Christ in the clouds, but with the aid of angels who lift his body. The fact that the motif of disappearance existed so early in connection with Enoch and the

supporting angels would lead one to doubt the relevance of the theological distinctions cited above. But the image of Enoch was borrowed from a prior Ascension of Christ: his disappearance in the sky is witnessed by twelve figures, unmentioned in the biblical text, and evidently inspired by the apostles of the Ascension. We see through this work how the disappearance-form has become a general formula. In a later English manuscript, the Albani Psalter, the same schema of the legs is employed to represent Christ vanishing from the table at Emmaus.

4.

The text of the Blickling homily is not enough to account for the new pictorial conception. The literary elements were available to English artists for several centuries before the first images of the disappearing Christ. The comments of Gregory and Bede telling how Christ rose unaided and penetrated the sky, the tradition about the Mount of Olives, were no doubt well known throughout the English Church since the eighth century. Yet these texts seem to have had no effect on the manner of conceiving the Ascension until the period around the year 1000. There is, moreover, a certain vagueness in these literary parallels, which are, indeed, compatible with a variety of pictorial interpretations, like the original account in Acts, although they would not be adequately rendered by the traditional forms. How shall we account, then, for the revision of the older types in England at this moment?

In answering such a question about a new type of mediaeval image, we are accustomed to look into two different fields for the answer: the theological ideas which often supply artists with the materials of their conceptions, and the common disposition of the fantasy of artists at this moment, as revealed in their style and manner of conceiving the most varied subjects. We have hardly exhausted the religious meanings in this special form of the Ascension, but let us consider this second source, which, it should be said, is more accessible than the theological literature of the same time, since so many drawings and paintings of that period have been preserved. It has been neglected by writers on this problem, no less than the vernacular texts.[40] Of course, theology and the style of imagination are not self-generated things, and are themselves subject to the compulsions of social life which lead men to revise their ideas and their ways of thinking and feeling. In comparing the culture of England and France during this time, we cannot help asking to what extent the more advanced state of English art in the tenth and early eleventh centuries and its special characteristics are due to the earlier political unification of England and the accompanying religious reform. But to search the deeper causes of the new type of image would require an extensive study of the whole art and history of

the time. It would be worth undertaking if we were concerned with a larger problem than the Ascension; for the present purpose, it is enough, I think, to consider the direct connections with the religious ideas and the processes of imagination.

For the latter, it is important to observe that in other subjects beside the Ascension, the traditional conceptions were radically transformed in England around the year 1000 in favor of more concrete and active types. I have indicated this elsewhere[41] in discussing the remarkable richness and realism of the English calendar drawings of the occupations of the months in the early eleventh century. Where artists of the preceding period and throughout the twelfth and thirteenth centuries, with few exceptions, represent the months by a single figure engaged in the month's characteristic activity, in English calendars of the early eleventh century complex genre scenes, with landscape and whole groups of cooperating figures (sometimes as many as five or six), are introduced.[42] The Anglo-Saxon artists imagined the temporal theme in a wholly fresh manner and brought into the old symbolic conception new elements drawn from first-hand experience and inspired by a hearty interest in secular life. We have to wait until the fourteenth century, on the eve of Renaissance art, for the next examples of such detailed illustration of the months. Indeed, those of the Queen Mary's Psalter, the first subsequent work with a corresponding sentiment of reality in the calendar images, were copied from an English manuscript of the eleventh century, as Olga Koseleff has shown.[43] This revised conception of the months in Anglo-Saxon art is marked not only by an abundance of new observation, but by an enthusiastic activizing of the figures. This trait appears already in the second half of the tenth century in the very style of drawing with energetic, sketchy lines, impulsive movements, and complicated contrasts of folds, silhouettes, and irregular spaces. The taste for pen drawing with its spontaneous, cursive lines and direct projection of the artist's excitement is part of the new tendency. But while this vehemence of style may be independent of any special attachment to nature—it suggests rather a mood of exaltation—in the period around 1000 it is linked with discoveries of descriptive detail, with wonderful improvisations of bodily movement, and with just this intensified concreteness in rendering the transitive and dynamic aspects of the old religious scenes.

English art shows then two striking characters: an intense expressiveness, through the movement of linear forms and surface patterns, and a fresh naturalism in the conception of the subjects. The first is so powerful an impulse that it goes beyond the demands of the subjects: the same vivacity, excitement, and sweeping energy dominate the mobile and static, the ceremonious and intimate themes. The Nativity, the Baptism, and the Ascension are caught in the same whirlwind of feeling. Like the older Anglo-Saxon poet Cynewulf,

who pictures the life of Christ as a series of six great leaps, from the Incarnation to the Ascension,[44] the Anglo-Saxon artists represent the successive episodes of a cycle as actions of an equally powerful momentum. The fact that the frames are not mere enclosures, but terminal regions of intensified centrifugal movements of curling plants, shows how pervasive is this desire for mobility, this enthusiasm. But the same artist who disregards the original sense of the subject in imposing his own sentiment as a constant of exaltation is also attentive to incidental, suggestive meanings of the story; he discovers little touches that make it more human and familiar, and he enriches it with observations, often tender and amiable, of a living actuality. Certain of these details, if they appeared in modern painting, would be merely anecdotal elements without much value for the work as a whole; and indeed, painters today are bound to suspect as trivial and inartistic the modern works in which they appear. But in mediaeval art, when a text imposes its conditions on the artist's fantasy, such details are bold inventions that reflect the power of the individual imagination, otherwise fettered by its assigned tasks and by established symbols. They denote a real emancipation of art, a widening of its scope and possibilities, since each of these little details stands in contrast to the older method of envisaging the material of the artist and marks a fresh conquest of experience.

In the Missal of Robert of Jumièges, the nurse places a cushion under the head of Mary at the Nativity (Fig. 9);[45] the child reaches out its arms to a bird on a tree during the Flight into Egypt (Fig. 10); at the Ascension (Fig. 4), the Apostles form themselves into an asymmetrical group with a displaced axis, like a living crowd in excitement. In the beautiful drawing in the Bury Psalter in the Vatican (Fig. 3), the Apostles, who are profoundly stirred by the sight of Christ disappearing in the cloud, turn in all directions to see him; they leap up, twist their bodies, and raise their arms, with a multiplicity of reactive postures unparalleled in other versions of the scene. It is noteworthy that in these early English examples, the legs of the disappearing Christ are in profile, climbing, moving upward; in the later English and continental adaptations, the legs are more often frontal and inert, as if the static Eastern type of ascending Christ had merely been clipped of its upper part. There are even Gothic examples in which angels carry the mandorla of the disappearing figure.[46] But looking at the Bury drawing, we relive both the visual and emotional experience of the original apostles, like the pilgrim on the Mount of Olives, who, gazing through the open roof, imagines the disappearing Christ above his head.

Of this conception of dramatic reenactment as a norm of imagery there is a revealing example in another work of the same school. In a psalter in the British Museum, Tiberius C.VI, the artist has drawn the Washing of Feet according to a contemporary rite; unlike the Byzantine and older Western

images, where the standing Christ preserves his sovereign dignity while washing the feet of Peter, the English drawing represents Christ kneeling, as a model of the humility that he comes to teach. This change, for which the biblical text provides no source, has been inspired by the Easter ceremony in which the abbot washes the feet of the monks or the poor; for the inscription above the scene reads: "Hic fecit Ihs mandatum cum discipulis suis," instead of "dedit mandatum," as if Christ's mandate ("mandatum novum do vobis") (John xiii, 34) to love one another were something done rather than spoken, an action rather than a teaching, like the corresponding ceremony of the *mandatum* in the Middle Ages, which has given its name to Maundy Thursday. One thinks here of the empiricism and pragmatic aspect of English philosophy, already so striking in the Middle Ages. In calling attention to this, I do not mean to imply that the powerful disposition toward the concrete and active in the art of the pre-Norman period is an inherent racial character. It is unknown for centuries in English representations before this time—the figures in English art of the seventh to the mid-tenth centuries are among the most schematic in European art—and during the thirteenth and fourteenth centuries, when England is the fountain of empiricist thought, this realism appears with greater force in the arts of other countries.

Within this general tendency, the English type of Ascension has a special place. For what distinguishes it above all from other subjects which have been enriched or recast by new details drawn from the living world is the importance of the act of seeing as an objective moment of the story. The scene is conceived from the viewpoint of the apostles as eyewitnesses of the Ascension ("why stand ye gazing, men of Galilee?"); it is their real vision of the disappearing Christ which replaces the visionary and theological image of the triumphantly ascending Lord. Even Renaissance art rarely ventured to show Christ in this way, although it possessed to an immeasurably higher degree the power of rendering the perspective phenomenon of Christ's disappearance. But one should not overestimate the optical realism of the English innovation. It is not at all a question of foreshortening or atmospheric effects, which would lie outside the scope of this art. Instead of representing the entire distant figure on a smaller scale, the English artists showed a small part of the entire figure, and thereby captured the disappearance itself as a transitive phenomenon. The disappearance rather than the distance had to be materialized. The visible extremities were drawn as segments of the more conventional ascending form; they were not redesigned to suit a perspective conception of the disappearing body. The passage through the cloud, the optical relation to the witnesses below, were substantialized in the new sign for disappearance. The phenomenal moment in this view of the Ascension is only a partial motif within a larger, typically mediaeval whole in which the elements remain clearly isolated,

Fig. 9 London, British Museum: Add. Ms. 49598, Benedictional of St. Aethelwold, fol. 15v. The Nativity.

Fig. 10 Rouen, Bibliothèque Municipale: Ms. 274 (Y. 6), Missal of Robert de Jumièges, fol. 33. The Flight Into Egypt.

symbolical, and independent of a relativizing perspective system. Not that a perspective view was impossible to some extent in the Middle Ages. The optical experience of the Ascension was suggested already in the twelfth and thirteenth centuries by an appreciable diminution of the full figure of Christ, contrary to the hierarchical principles which govern the relative sizes of objects in mediaeval art. There is an example in a mosaic in Monreale,[47] and in the mid-thirteenth-century French miniature in a manuscript of the Life of St. Denis (Bibliothèque Nationale, Paris, *Nouv. Acq. fr.* 1098),[48] the standing Christ in the sky is less than a third as big as the apostles below. But these are exceptional works, which render the distant presence and transcendance of Christ rather than his disappearance. In the few Renaissance examples of the latter (for instance, in Dürer's woodcut),[49] not the cloud but the upper frame of the image cuts the body of the rising Christ. The disappearance no longer depends on the penetration of the cloud, but is due to the limits of the visual field and the relation of Christ to the eye-level of the apostles; when he reaches a certain height, only his lower extremities are visible. Through these works we can grasp better the limitations of the optical moment in the mediaeval type and the importance of the cloud, which appears also as a materialized segment and symbol of the otherwise intangible sky.

It remains surprising, however, that so early in the Middle Ages, before the developed town life of the thirteenth and fourteenth centuries, and at a time when the folk-wanderings still shape the history of Europe and the apprehensions of the year 1000 occupy the literate (including the author of the Blickling homily),[50] the subjective, individual side of religious feeling should emerge in art in this daring realistic form. It is a sign of advanced conditions in England, favorable to so precocious an individuality in art, and of the progressive character of English culture at the end of the tenth century. This culture is wonderfully rich in vernacular elements. The Anglo-Saxons had produced since the seventh century a vernacular literature, epic, lyrical, and religious, unparalleled on the continent; and around 1000, the illustration of vernacular works like Caedmon's *Genesis* and Aelfric's *Paraphrase of the Old Testament* is one of the distinguishing marks of Anglo-Saxon art, a measure of the extent to which secular life had penetrated the Latin culture of the Church. It indicates the weight of the popular, the individual, the contemporary, the novel, and the local, as against the stabilized institutional forms. We may even speak of the image of the disappearing Christ, in a broad sense, as a vernacular achievement in art, not only because of its relation to the Blickling homily, but because of its essentially empirical attitude to the supernatural religious objects. When we compare it with the traditional types, weighted with theology and classical recollections, it has the freshness and spontaneity of the lyrical passages in Anglo-Saxon writings. The empirical and the vernacular here are not

identical, however, with the secular, by which they are so largely conditioned, nor are they antithetic to the religious as such, although opposed to certain of its forms; for it is within religious art and religious life that these new attitudes operate. If the impulses in Anglo-Saxon art toward observation of human movement and an effusive, exalted expression of an overflowing excitement and ecstasy seem to be incompatible with each other, we should remember that in the Middle Ages an intense religious individualism is often associated with an empiricist attitude: the mystics who repudiate logic, rites, and systematized dogma for the higher evidence of individual religious experience are also drawn to the concrete and singular within the living world which correspond to their lyric mood and nourish it. The emotionality and realistic perceptiveness of this art, in contrast to the more abstract and formalized styles, are finally united, as in the religious sphere, through their still embryonic common element of direct experience, which becomes in time the criterion of certitude for both the inner and the outer eye.

NOTES

1. On the types of the Ascension, see S. H. Gutberlet, *Die Himmelfahrt Christi in der bildenden Kunst von den Anfängen bis ins hohe Mittelalter,* Strassburg, 1934; Hubert Schrade, "Zur Ikonographie der Himmelfahrt Christi," in *Vorträge der Bibliothek Warburg* (1928–1929), 1930, pp. 66–190; Ernest T. DeWald, "The Iconography of the Ascension," in *American Journal of Archaeology,* second series, XIX, 1915, pp. 277–319.

2. In *L'art religieux de la fin du moyen âge en France,* 1908, p. 53.

3. See Schrade, *op. cit.,* pp. 184 ff.; Gutberlet, *op. cit.,* pp. 243 and seq. The first writer to isolate the early English examples of the new type seems to have been Otto Homburger, *Die Anfänge der Malschule von Winchester im X. Jahrhundert,* Leipzig, 1912, pp. 20, 21.

4. The Vulgate reads: "Et cum haec dixisset, videntibus illis, elevatus est: et nubes suscepit eum ab oculis eorum."

5. *The Blickling Homilies of the Tenth Century,* edited with a translation by Rev. R. Morris, London, 1880 (Early English Text Society, Series I, no. 73), pp. 120, 121. I am quoting the editor's translation.

6. Staatsbibliothek, C.l.m. 4452 (Cim. 57), dated 1002–1014. It is reproduced, together with another example of the same type in the Bamberg Apocalypse, by H. Wölfflin, *Die Bamberger Apokalypse,* Munich, 1921, pl. 61, 56.

7. Paris, Bibliothèque de l'Arsenal, Ms. 1169, fol. 40; it is dated 996–1024.

8. See: W. G. Collingwood, *Northumbrian Crosses of the Pre-Norman Age,* London, 1927, fig. 94, p. 76; and for a photograph, C. C. Hodges, "The Ancient Cross of Rothbury," in *Archaeologia Aeliana* (Society of Antiquaries of Newcastle-upon-Tyne), Fourth Series, I, 1925, pp. 159–168, pl. XXII; and T.D. Kendrick, *Anglo-Saxon Art,* London, 1938, pl. 64.

9. See Mark xiii, 26; xiv, 62; Luke xxi, 27; Thessal. iv, 17; and on this theme in general Loisy, *Les Actes des Apôtres,* 1920, p. 161.

10. See Migne, Patrologia latina, XCIV, col. 178. In another passage, in a commentary on Acts, Bede interprets the function of the cloud as a homage to Christ: "Everywhere the created pays homage to its creator. The stars indicate his birth and darkness his crucifixion; clouds take him up when he ascends and will escort him when he returns for judgment" (Pat. lat., XCII, col. 941).

11. Cf. the *Epistle of the Apostles*, second century: "There appeared a light cloud which bore him up"—M.R. James, *The Apocryphal New Testament*, p. 503; the *Apocalypse of Peter*, second century: "and then came a great and exceeding white cloud over our heads and bare away our Lord and Moses and Elias"—*ibid.*, p. 519.

12. See *Poems of John Donne*, edited by E. K. Chambers, I, London, New York, 1896, p. 155 (*Divine Poems*).

13. *Homiliae in Evangelia*, lib. II, hom. 29, Pat. lat., LXXVI, cols. 1216, 1217.

14. *Loc. cit.*, pp. 88, 89.

15. Pat. lat., XCIV, col. 180.

16. Pat. lat., XCII, col. 942. This text has been edited more recently by M. L. Laistner, *Bedae Venerabilis Expositio actuum apostolorum et retractatio* (Mediaeval Academy of America), Cambridge, Mass., 1939, p. 9.

17. Pat. lat., LXXVI, col. 1216 ff. The distinction probably depends on the Jewish belief that Elijah did not ascend to heaven, but only to its close vicinity; see Louis Ginzberg, *The Legends of the Jews*, V, Philadelphia, 1925, pp. 322, 323, n. 32.

18. See A. K. Porter, *Spanish Romanesque Sculpture*, I, Florence, 1928, pl. 37.

19. A French painter of the end of the twelfth century, in a psalter in Amiens (Public Library, Ms. 19), attempted to unite these opposed conceptions by showing the entire figure behind a cloud which covers the legs, but not the feet or the upper body. There is a related solution in the *Somme Le Roi* in the British Museum, Add. Ms. 28, 162.

20. *Loc. cit.*, pp. 124–129.

21. *Loc. cit.*, p. 124.

22. For the original text, see P. Geyer, *Itinera Hierosolymitana, saeculi IIII–VIII (Corpus Scriptorum Ecclesiasticorum Latinorum*, vol. 38), Vienna, 1898, pp. 246–251 (Adamnanus, *De Locis Sanctis*, lib. I). For a copy of Adamnán's plan of the building, see Geyer, p. 250.

23. See *Bedae Opera Historica*, ed. Plummer, I, Oxford, 1896, pp. 318, 319. The open roof is also mentioned by the Anglo-Saxon pilgrim Willibald, who visited Jerusalem in 723; see T. Wright, *Early Travels in Palestine*, London, 1848, p. 19.

[Arculf's account of that church, with its open roof and the footprints, is cited too in an Anglo-Saxon martyrology of the eighth century ("the way was always open to heaven for the eyes of the people who prayed there"): *An Old-English Martyrology*, edited by G. Herzfeld (Early English Text Society, no. 116), 1900, p. 75.]

24. Pat. lat., XCIV, col. 177: "adoraverunt in loco ubi steterunt pedes eius, postquam vestigia quae novissime fixit lacrimis rigavere profusis."

25. See Charles W. Kennedy, *The Poems of Cynewulf translated into English prose*, London, New York, 1910, p. 167.

[An English artist of the fourteenth century pictured literally Christ rising "through the temple roof" in a miniature of the Fitzwarin Psalter (fig. 6), Paris, Bibl. Nat. lat. Ms. 765, fol. 14. See Francis Wormald, "The Fitzwarin Psalter," *Journal of the Warburg and Courtauld Institutes*, VI, 1943, pp. 77–78 and pl. 23a.]

26. Cf. a miniature in a Gradual of Seligenthal (mid-thirteenth century): Hanns Swarzenski, *Die lateinischen illuminierten Handschriften des XIII. Jahrhunderts in den Ländern an Rhein, Main und Donau*, II, Berlin, 1936, fig. 403; paintings in Ramersdorf and Mainz: P. Clemen, *Die gotischen Monumentalmalereien der Rheinlande*, I, 1930, figs. 177, 284; English woodcuts of the fifteenth century: E. Hodnett, *English Woodcuts*, Oxford, 1935, figs. 179, 331, 348.

27. Cf. the Landgrafen Psalter in Stuttgart (dated 1211–1213): Löffler, *Der Landgrafenpsalter*, Leipzig, 1925, pl. 16, and Schrade, *op. cit.*, pl. XIX; other examples in H. Swarzenski, *op. cit.*, figs. 259, 575, 1084.

28. Cf. H. Swarzenski, *op. cit.*, figs. 19, 149, 668.

29. See *The Pierpont Morgan Library Exhibition of Illuminated Manuscripts held at the New York Public Library*, New York, 1934, pp. 12, 13 (catalogue by B. Da C. Greene and

M.P. Harrsen), for the opinion of Professor A.M. Friend that it is a companion volume to the unfinished Gospels in the library of St. Omer (Ms. 56).

30. Ms. 18 of the cathedral treasure. See A. Goldschmidt, *German Illumination*, II, Florence, pl. 100; and Schrade, *op. cit.*, pl. XV, fig. 30.

31. See Schrade, *op. cit.*, pp. 184, 185.

32. Quoted by Gutberlet, *op. cit.*, p. 244.

33. On the date, see H. Josten, *Neue Studien zur Evangelienhandschrift des hl. Bernward in Hildesheim*, Strassburg, 1909, p. 87.

34. See Thangmar, "Vita S. Bernwardi," Pat. lat., CXL, col. 397. Bernward made a collection of manuscripts and promoted all the arts, including painting, sculpture and metalwork—"et quicquid elegantius in huius modi arte excogitare poterat, numquam neglectum patiebatur, adeo ut ex transmarinis et ex Scotticis vasis, quae regali majestati singulari dono deferebantur, quicquid rarum vel eximium reperiret, incultum transire non sineret."

35. Cf. William of Malmesbury, "Vita Wulfstani," Pat. lat., CLXXIX, cols. 1738, 1739, 1745, for the story of Canute's presentation of a finely decorated English sacramentary and psalter to Cologne.

36. The date is given in the text of the sermon on the Ascension, *loc. cit.*, pp. 118, 119.

37. The miniatures added in this manuscript of older date are commonly attributed to the time of Athelstan, *ca.* 925–940.

38. See note 8 above.

39. See C.W. Kennedy, *The Caedmon Poems*, London, New York, 1916, p. 229.

40. Professor Schrade mentions, in passing, Arculf's account of the open church and the footprints on the Mount of Olives as of basic importance for Christian art in general (*op. cit.*, p. 116, no. 1), but is unaware of its relation to the English vernacular texts. Elsewhere he observes cleverly that "the new type of Ascension might be described as a transposition of the footprints of Christ to the sky" (*ibid.*, p. 168).

41. *Speculum*, XVI, 1941, pp. 136, 137.

42. British Museum Ms. Tiberius B.V. and Julius A.VI. For reproductions see J.C. Webster, *The Labors of the Months in Antique and Mediaeval Art*, Princeton, 1938, pl. XVII–XX.

43. In the *Gazette des Beaux-Arts*, November 1942, pp. 77–88 (with reproductions of Julius A.VI).

44. See Kennedy, *The Poems of Cynewulf*, pp. 174, 175.

[The leaping Christ is a theme in Christian exegesis of the Song of Songs ii, 8 ("The voice of my beloved! Behold, he cometh leaping upon the mountains, skipping upon the hills"), ever since Hippolytus (*ca.* 200 A.D.). It appears in the writings of Ambrose and Pope Gregory, and later in Honorius' *Speculum Ecclesiae*. See Hieronymus Frank, "Zur Geschichte von Weihnachten und Epiphanie," *Jahrbuch für Liturgiewissenschaft*, XIII, 1935, pp. 17–18.]

45. I have reproduced the earlier example of the same motif in the Benedictional of Ethelwold, which was written, according to a recent investigator (J.B.L. Tolhurst, "An Examination of Two Anglo-Saxon Manuscripts of the Winchester School: the Missal of Robert of Jumièges and the Benedictional of St. Ethelwold," *Archaeologia*, LXXXIII, 1933, pp. 27–44) at Ely, in the same center as the Rouen missal (1006–1023).

46. Cf. Morgan Library, Ms. 699: H. Swarzenski, *op. cit.*, fig. 1046; and a missal in Seitenstetten, Ms. 15: E. Winkler, *Die Buchmalerei in Niederösterreich von 1150–1250*, Vienna, 1923, fig. 55.

47. See P. Muratoff, *La Pittura Bizantina*, pl. CXXX.

48. Henri Martin, *La Miniature Française*, pl. 2

49. See *Dürer, L'oeuvre du Maître* (Les classiques de l'art), p. 246.

50. In the homily on the Ascension, *loc. cit.*, pp. 116, 117.

Fig. 1 Durrow: Stone cross, tenth century.

Fig. 2 Arboe: Stone cross,
tenth century. Sacrifice of Abraham.

The Angel with the Ram in Abraham's Sacrifice: A Parallel in Western and Islamic Art

(1943)*

I

1.

In the sacrifice of Abraham the ram appears miraculously, "caught in a thicket by his horns," and is taken by Abraham and is "offered up for a burnt offering instead of his son" (Genesis xxii, 13). How did the ram come to this place of sacrifice? The Bible does not say, and both the Jewish and the Christian artists of the early period and the Middle Ages, who represented this incident, were satisfied to show the ram beside or in the bush.

In several works, however, an angel is represented bringing the ram. The late Arthur Kingsley Porter[1] was the first to observe this peculiarity to which he called attention in examples on the Irish crosses of the tenth century in Durrow, Arboe, and Monasterboice (Figs. 1 and 2). Although he was deeply interested in the relations between Irish, continental, and Eastern art, the significance of this detail escaped him; he compared the Irish versions of the Sacrifice with Byzantine miniatures in which the angel is lacking.

The same unusual conception appears also in a few continental works of the eleventh and twelfth centuries: a drawing in the Catalonian Farfa Bible,[2] and Romanesque sculptures in León,[3] Bordeaux,[4] Souillac (Fig. 3),[5] Parthenay,[6] Autun,[7] Parma,[8] and Capua.[9] On two capitals in León[10] and Jaca[11] the ram is held by a wingless figure, perhaps a misunderstanding of a model in which an angel had been rendered.

These examples of the angel carrying the ram are so concentrated geographically and so few in number beside the usual types that one is inclined to suppose a direct connection between the Irish and the continental versions. Since the Irish examples are at least a century older than the others, it is

* For the seventieth birthday of Professor Louis Ginzberg.

Fig. 3 Souillac: Trumeau, twelfth century. Sacrifice of Isaac.

conceivable that this type was diffused in France, Spain, and Italy from Ireland. Porter had already argued that various elements in continental art were brought from Ireland, and he attempted to trace an Irish current in the theme of the wrestling men on the same trumeau of Souillac, where the angel holds the ram in the Sacrifice.[12]

But there is another series of examples that must be taken into account. The angel is shown bringing the ram to Abraham in several Moslem paintings executed since the sixteenth century (Figs. 4, 5, 6).[13] Although they are much later than the Irish and the continental Romanesque versions, and although the illustration of the Old Testament would seem to be an exotic element in Moslem art,[14] it is unlikely that the Persian, Arabic, and Turkish examples are derived from the West. In the story of the Sacrifice in the Koran (chapter 37), no angel is mentioned; but there is a literary tradition in Islam that accounts sufficiently for the pictorial conception. The Arab chronicler of the ninth century, Tabari, in describing the Sacrifice, tells how "God had Gabriel descend from heaven with a ram When Gabriel arrived on the mountain, holding the ram by the ear, he stationed himself behind Abraham."[15] This whole incident was of the greatest significance to Islamic imagination. It was argued that not Isaac, but Ishmael, the ancestor of the Arabs, was the son prepared for the sacrifice by Abraham;[16] and according to Tabari, the exclamations and words of Gabriel, Abraham, and Ishmael on this occasion form the takbir or prayers recited on the great feast of the Sacrifices.[17] Islam was regarded as the faith of Abraham, the builder of the Kaaba in Mecca and the ancestor of Muhammad. According to Moslem belief, Gabriel was the messenger of God in delivering the sacred black stone to Abraham and the Koran to Muhammad. Hence it was possible for Moslem artists to illustrate the Sacrifice at a period when miniature painting was an established art in spite of the prohibition of images.

These illustrations are rather infrequent, but the fact that in almost all that I have been able to discover the angel carries the ram, shows that this detail is essential to the Moslem type, in contrast to the exceptional character of the motif in Western art.

In the earliest of the Moslem images of the Sacrifice, a miniature of the fourteenth century in the Walters Gallery in Baltimore (Fig. 7), the angel stands behind the ram, without holding him. But even here there is reason to believe that the artist, in placing Gabriel directly behind the ram, had in mind the traditional account. For the painting illustrates a manuscript of the *World History* of Rashid al-Din, who tells how God sent Gabriel to bring a ram from Paradise, and how the angel, taking the sheep by the ear, came up to the mountain and stood before Abraham.[18]

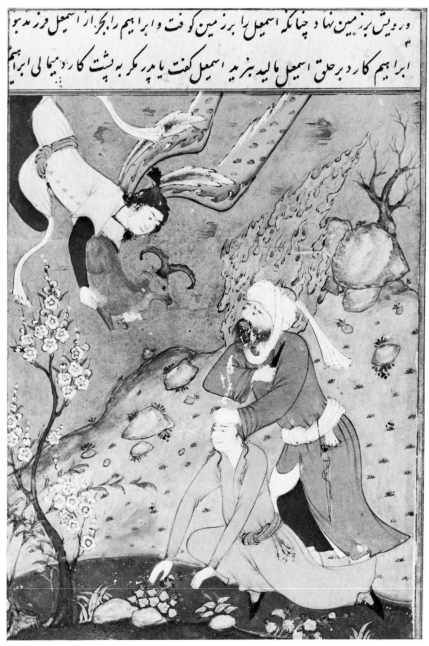

وریش بر زمین نهاد چنانکه اسمعیل را بر زمین کوفت و ابراهیم را بجز از اسمعیل ورز مده بو
ابراهیم کارد بر حلق اسمعیل مالیده ببرید اسمعیل کفت یا پدر مکر به پشت کارد بنمائی ابراهیم

Fig. 4 Paris, Bibliothèque Nationale: Ms. Suppl. persan 1313, fol. 40. Angel
Bringing the Ram to Abraham.

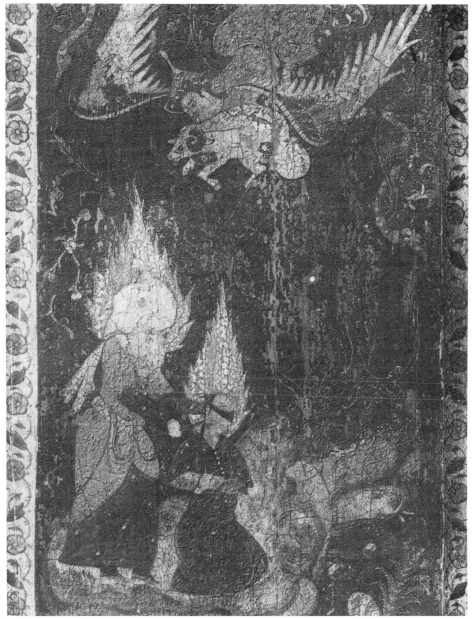

Fig. 5 Berlin, Islamisches Museum. Painted panel, Aleppo, dated 1603. Sacrifice of Abraham.

2.

What is the relation of the Moslem and the Western Christian versions of this peculiar detail? If there were only the continental examples, one could infer more readily that they depended on Moslem oral or literary tradition. They are concentrated chiefly in Spain and southern France and belong to a period rich in Moslem-Christian contacts which have left other traces in art. The text of Tabari and the Islamic miniatures come from the Eastern Moslem world, but there is also evidence that the motif was known in the Moorish region. The story of Gabriel bringing the ram, which had been browsing in Paradise, is told in a Morisco work of 1603, written in a Spanish dialect in Arabic script.[19] The oldest examples come from Ireland, however, and precede the first continental ones by a century or more. That an Arabic legend determined the conception of a biblical scene in Ireland in the tenth century is unlikely, although not impossible. There is an abundant Near Eastern material in the insular art of the early Middle Ages, derived apparently from East Christian art.[20] But the angel bringing the ram seems to be wholly foreign to East Christian painting and sculpture.[21]

It is not excluded, of course, that such an Arabic tale might have reached England and Ireland in the ninth or tenth century by other routes than the common connections with the East Christian world. In the Viking period, the commercial relations between the Moslem regions and Scandinavia were especially close, and the British Isles were among the chief objects of the Viking expeditions. Tens of thousands of Arabic and English coins have been found in Scandinavian burial places of the ninth and tenth centuries, a time when Irish and Anglo-Saxon works of art were imported to Norway and Sweden.[22] As early as the eighth century, before the period of most extensive communication between these regions, an Anglo-Saxon king, Offa (757–796), stamped a coin in imitation of an Arabic dinar, with Kufic writing.[23] But these are all secular objects, commercial and decorative; can one assume an equal facility in the transmission of Arabic religious tales? I know that Asín Palacios has given imposing arguments to prove that the *Divine Comedy* is based on Moslem conceptions, and that the eschatological fantasy of the earlier Middle Ages in Ireland, England, and the continent is heavily indebted to Arabic literature.[24] But much that he attributes to the latter existed already before Islam in early Christian writings or in mediaeval Latin literature prior to the ninth century.[25]

I may be permitted to adduce here a parallel situation in the history of the familiar epitaph: "What you are now, we were; what we are, you shall be" ("quod fuimus, estis; quod sumus, vos eritis").[26] It is the idea that underlies the macabre story of *The Three Living and The Three Dead*. Now this verse,

so common in Western epitaphs of the Middle Ages, has been traced literally to Arabic poems of the third and sixth centuries A.D.[27] To connect the latter with inscriptions in Italy and France in the eleventh and twelfth centuries does no violence to our knowledge of the historical relations of Islam and southwestern Europe in that period. But there is an older example in an Anglo-Saxon sermon which is dated in 971 and no doubt goes back to a Latin source. In the Blickling homily, "The End of This World is Near," the author tells the story of a man who returns to the tomb of his rich friend and hears from his bones: "O my friend and kinsman, be mindful of this, and convince thyself that thou art now what I was formerly, and after a time thou shalt be what I now am."[28] The same sentiment is expressed in the Latin epitaph that the Anglo-Saxon Alcuin (*ca.* 730–804) wrote for himself:

> Quod nunc es fueram, famosus in orbe, viator,
> Et quod nunc ego sum, tuque futurus eris.[29]

If the theory of the Arabic origin of the motif is correct, we would have a parallel to the history of the angel with the ram in Western and Moslem art: a transmission from the Arabic East to the far northwest, and thence to France and Italy. But the macabre verse exists also in substance in ancient literature—the same thought has been found in the book of Jesus Sirach (38:22)[30] and later in Ausonius[31]—and most probably both the Arabic and the mediaeval European examples in the north and south are derived from the older Hebrew and classical sources, although it must be admitted that neither the Hebrew nor the Roman versions are as close to those of the Middle Ages as the Arabic form of the third century A.D.[32]

The same possibility of a common source may be supposed for the Western and Moslem conception of the Sacrifice of Abraham.

It is well known that Koranic and traditional Moslem stories about the figures of the Old Testament are often based on Jewish legends.[33] In a Haggadic writing, the *Neweh Shalom* ("Dwellings of Peace"), Gabriel is described bringing the ram to the altar, a characteristically Semitic theme of angelic mediation.[34] The manuscript is a Spanish Hebrew writing of the fifteenth century;[35] but like other Haggadic tales, this one is probably of much more ancient origin.

Its antiquity is established by another account of Abraham's sacrifice as early as the first century B.C. A Greek writer of that time, Alexander Polyhistor, in his work *Concerning the Jews*, tells the story as follows: "But when he (Abraham) was about to slay him, he was forbidden by an angel who provided him with a ram for the offering." This text is preserved by Eusebius in his *Preparation for the Gospel*, an invaluable collection of Oriental history and traditions.[36]

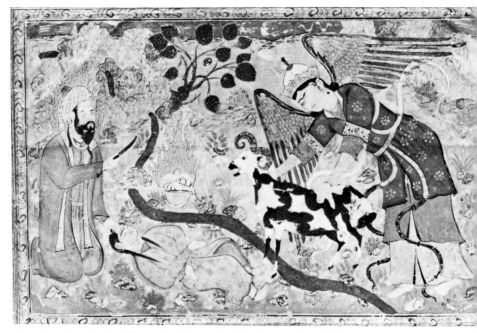

Fig. 6 London, India Office: Ethé Ms. 1342, Moslem painting, 1549.

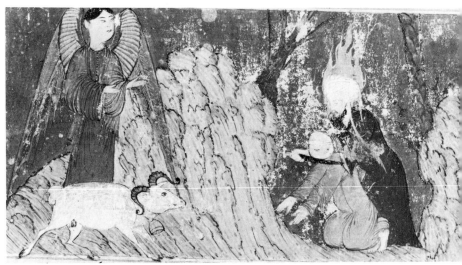

Fig. 7 Baltimore, Walters Art Gallery: Rashid ad din, *World History,* mid-fourteenth century. Sacrifice of Isma'il.

How the Jewish legend reached Ireland is obscure. Insular literature is amazingly rich in Jewish apocryphal elements and folklore. The elaboration of the stories of Adam and Eve, of Cain and Abel, of Lamech , of Nimrod, and of Solomon, in the literature of England and Ireland owes a great deal to Jewish tales.[37] In some instances this foreign matter may be traced to patristic writings; but the passage in Eusebius does not seem to have interested the early commentators on Genesis or to have influenced the Christian paraphrases of the story of the Sacrifice. The writers who recount the incident in chronicles or world histories, in which they draw sometimes on other works of Eusebius, are faithful to the biblical text. That is true of Sulpicius Severus, of Gregory of Tours, of Caedmon, and Peter Comestor. The *Jewish Antiquities* of Josephus, which was widely read in the Middle Ages, also adheres to the original story (I, 13, 4).

It is unlikely, moreover, that Jewish images suggested this exceptional type to Western artists, although one must observe that the Jewish pictorial remains of the fifth to the thirteenth century are too scant to allow a reliable judgment. But the fact that the surviving Jewish examples of Abraham's sacrifice generally correspond in iconographic type to the common Christian representations would exclude or weaken this possibility.[38]

The assumption remains that the legend was transmitted in the West by the Jews themselves, as in Islam. And of this there is interesting evidence in a text of the early Carolingian period.

In his *Interrogationes et Responsiones in Genesin*, the Englishman Alcuin asks:

Whence came that ram, who was sacrificed instead of Isaac? Was he suddenly created there out of the earth, or was he brought from elsewhere by the angel? Response: That ram is not to be considered imaginary, but a true ram. It is therefore supposed by the learned that an angel brought him from some other place rather than that God created him then and there from the earth, after the works of the six days.[39]

The two alternatives posed here are derived from the ones which appear in rabbinical tradition. Some Jewish writers say that a ram, created on the evening of the sixth day, had been browsing in Paradise, waiting for the occasion of Abraham's Sacrifice; others, that the angel brought the bellwether of Abraham's flock.[40] This last detail is actually rendered in the Persian miniature of the Sacrifice in the Walters Gallery (Fig.7).

The connection with extra-biblical Jewish tradition is strengthened by Alcuin's answer to the question that follows: "Why did Abraham call that place: *The Lord saw*, when there is nothing that the Lord does not see?" The reply alludes to "the saying of the Jews that when they are in difficulty and

wish to be helped by the Lord, they declare: God will see on the mountain, that is, will have mercy on us as on Abraham. Whence they are wont to give the sign of the ram by blowing on a horn."[41]

The explanation of the blowing on the shofar or ram's horn as a rite connected with Abraham's sacrifice follows Jewish literature. The rabbis say that when Israel has turned to sinfulness, it will be redeemed through the horns of the ram.[42]

But this second reference to Jewish legend comes directly from patristic question books. Alcuin simply reproduces here almost word for word corresponding passages of Jerome[43] and Augustine.[44] As several writers have observed, Alcuin's work is a compilation based on similar productions of the early Christian period.[45] But the question (no. 206) about the origin of the ram is not to be found in these older works, nor among the questions of Alcuin's mediaeval predecessors, Isidore[46] and Bede.[47] If we compare the questions of Alcuin with the corresponding series in Augustine's *Quaestiones in Heptateuchum*, the patristic book that corresponds most closely to this part of Alcuin's questions, we find the following: Augustine's qu. LVI is like Alcuin's qu. 200; qu. LVII is like Alcuin's qu. 201; qu. LVIII is like Alcuin's qu. 207; qu. LIX is like Alcuin's qu. 208.[48]

On the other hand, Alcuin's question (and answer) no. 206 is reproduced word for word in a later Carolingian question book by Angelomus of Luxeuil,[49] who copies other passages of Alcuin as well; and in the *Glossa Ordinaria* on the Bible, in the comment on *"arietem"* (Genesis xxii, 13), the author repeats Alcuin's answer.[50] That Alcuin himself had not merely copied some older Christian text is supported by the fact that in the *Glossa Ordinaria*, which names the patristic authors excerpted by Strabo, Alcuin is given as the source of this passage.

If this analysis is correct, one may suppose that Alcuin owed the particular question and answer to fresh information derived from contemporary Jewish sources. In the Carolingian empire the personal relations of Jews and Christians were often close; Agobard, the Bishop of Lyons, writing around 822, could attempt to summarize Jewish Midrashic and Cabalistic doctrines and complained of the growing influence of the synagogue in the Christian community.[51] The Haggadic conception of the angel and the ram in Ireland in the tenth century depends on the renewed intimacy with Jewish traditions during the Carolingian period, when trade and travel were revived and Jews became for a moment more important in economic and political life, serving also as interpreters and envoys on missions to the East. Alcuin himself, as a kind of minister of education to Charlemagne, and as a scholar occupied with the revision of the Latin text of the Bible, was undoubtedly aware of the value of Jewish learning; in his own writings there is occasional reference to the Hebrew

original of the Bible, although his own knowledge of Hebrew was probably very limited.[52] His most able pupil, Rabanus Maurus, in preparing a commentary on books of the Old Testament, inserted into this work the opinions of a learned Jew whom he consulted.[53]

From all this one may conclude that the Jewish legend of the angel and the ram, which is common to Persian and Western mediaeval art, was introduced into the Latin question literature at the end of the eighth century, and through the copies of Alcuin's text became known on the continent and was thus available to Western artists. How it reached Ireland and why it was especially favored there, I cannot venture to say. I have found no illustrations of the motif in England, although it turns up in the fourteenth century in miracle plays of the Sacrifice of Abraham.[54]

3.

Let us consider finally the possibility that in Western art the angel carrying the ram is a native variation independent of an Arabic or Jewish source. Such an abnormal departure is sometimes described as "accidental" and it is supposed that allowance must be made for chance in the production of iconographic varieties. But exceptional forms, no less than the common ones, presuppose determining interests and processes, even though they are more difficult to discover. A foreign model or text may underlie an isolated variant as well as a widespread type. To establish the independence of the motif of the angel with the ram one would have to show that it results from conditions in the West independent of the Moslem or Jewish examples. Of such conditions, the following may be entertained as possible: (1) a psychological process of condensation of existing images into a more compact form; (2) the imitation of a classic work with a similar motif; (3) the assimilation to other religious subjects in which an angel carries an object or instrument of salvation; (4) a desire to present the scene more rationally and naturally, in accord with new cultural standards. I shall take up these possibilities in turn.

1. Among the different ways in which an artist can imagine the scene, this type might suggest itself to a naive mind, unfettered by the biblical text and acquainted with the story mainly through other images. The angel is already mentioned in the Bible as calling to Abraham not to sacrifice Isaac, and in certain representations he points to the ram below or above him.[55] In placing the heaven-sent ram in the arms of the angel as the heavenly messenger, the artist unites more firmly and clearly two constant elements of the action, and gives them an obvious functional connection. In mediaeval art, one may observe often how an attribute or accessory of a saint, at first set beside him, is later brought into direct contact with his body or even placed in his hands. The lamb

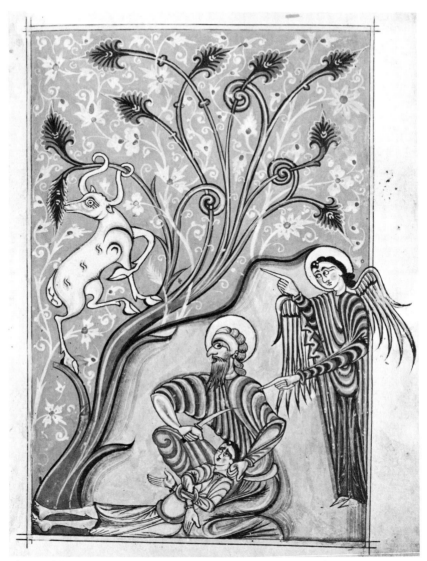

Fig. 8 Baltimore, Walters Art Gallery: Ms. 543 Four Gospels, 1455, Armenian. Abraham and Sacrifice of Isaac.

of God is set in the arms of John the Baptist, the symbols of the evangelists become seats of the writing figures, the apostles carry the instruments of their martyrdom. But the idea that the angel with the ram arose spontaneously from a process of imaginative condensation underestimates the compulsive force of traditional types in the Middle Ages and the theological importance of the text itself, which was too familiar to be disregarded, unless it could be replaced by another text or viewpoint, equally or more significant for the emotional, religious weight of the scene. The appearance of the ram *ex nihilo* in the thicket was an essential ingredient of the story for the Middle Ages. Not only did the ram turn up miraculously, but his entanglement in the bush, which the Hebrew writer perhaps derived from an old Sumero-Babylonian rite,[56] was interpreted by the Church as a prefigurement of the suspension of Christ on the Cross,[57] an analogy that is implied in the suspension of the ram by the horns from the branches of the bush in images of the twelfth and later centuries (Fig. 8).[58] The symbolic Christian sense of this detail would not operate in Islam; the account of the sacrifice in the Koran ignores completely the ram in the thicket.

A second objection may be brought against this explanation of the variant by an inherent process or tendency of the imagination: in some Western examples two angels are shown, one who arrests the sword of Abraham, another who brings the ram.[59] The second angel is only an addition to the usual form of the scene and implies that the artist has isolated the bringing of the ram as a distinct moment in the story.

2. Classical art offers a parallel in the related theme of the sacrifice of Iphigenia. In some examples of the Roman period, Artemis or a nymph is shown in the sky bringing a hind as a substitute for Agamemnon's daughter (Fig. 9).[60] Is the mediaeval angel with the ram a distant reflection of the classical image? This is improbable for several reasons: the mediaeval examples are all very late and exceptional and appear first in Ireland, a region least affected by classical art; and in the early Christian versions of the Sacrifice of Abraham, including the one on the Berlin ivory pyxis, which is closest to the style of classical art and in which the form of Abraham has recalled to some scholars the figure of Calchas in Timanthes' celebrated painting of the Sacrifice of Iphigenia, the ram is never carried by an angel.[61]

3. In the most impressive example of the motif, on the great pillar of Souillac (Fig. 3), one observes that the mediating angel appears also in the relief above, which represents the story of Theophilus.[62] It is in his arms that the Virgin descends from heaven to the repentant sinner in order to save him from the devil. On the portal of Beaulieu, another work of the same school, the angel appears again in this manner: on the tympanum, angels carry the instruments of the Passion of Christ; below, an angel carries Habbakuk to

Daniel.[63] On the stylistically related portal of Moissac, an angel bears the soul of the dying Lazarus to Abraham's bosom.[64] It may therefore be asked whether the artist who placed the ram in the arms of the angel in Souillac was not simply extending to a new theme a conception of angelic mediation already established in his school. On the south aisle portal of San Isidoro of León, the scene of the Sacrifice is surmounted by the Holy Lamb in a medallion held by two angels.[65] But in Souillac there is a deeper connection with the ideas underlying the main subject of the sculptures, the possibility of redemption through mediating persons like the Virgin, rather than through God, as in the story of Theophilus. By multiplying sacred figures between God and man, by introducing directly the lower agents of the work of salvation, the religion becomes more popular and human.

Since this pattern of mediation is unknown or less marked on the Irish crosses, it would not account for the oldest examples of the angel with the ram. The priority of the Irish versions reduces the importance of the third explanation; yet it is possible that in Souillac, the already existing but highly exceptional motif was adopted in spite of its inconsistency with the text of the Bible, because in this region the concept of mediation had a special value for religious thought at the moment. And this judgment would be supported by other aspects of the same sculpture.

The artist's independence of the text is more far-reaching than appears from the detail of the angel and the ram. For the bush in which the ram was caught, an element crucial for Christian exegesis, has been omitted, although the sculptor has taken pains to represent Isaac carrying the faggots and has shown this detail,[66] not symbolically, across Isaac's shoulder or in the form of the beams of the cross in analogy to Christ carrying the cross, but realistically, as a compact mass that a grotesque little Isaac, entangled in the twisted colonnettes framing the scene, holds before him like a torch. Instead of the familiar pairing of the Old Testament scene with the Crucifixion or with Christ carrying the Cross, there is carved on the other side of the trumeau the combat of an old man and a youth, in profane contrast to, or even parody of, the Sacrifice of Abraham in which the son submits to the father, as the latter to God.[67] The motif of the angel and the ram in Souillac is part of a conception of the story which breaks with its traditional religious sense and thereby conveys a new secular striving and consciousness of the individual. The main sculpture of the complex at Souillac, no longer centralized or hierarchically composed like most of the great Romanesque reliefs of the period, confirms and illuminates this tendency; for it represents the salvation of a particular sinner, not by Christ, but by the Virgin, who is carried by an angel and herself brings to the penitent Theophilus the concrete material means of his rescue, the document of his pact with the devil.

4. In deviating from the text, the sculptors who set the ram in the angel's arms replaced the spiritual significance of the ram in the bush by an image of the efficient cause of the miracle. The means of transportation becomes as interesting as the purpose of the event. This attitude is hardly unique in Romanesque art. In the church of San Isidoro of León, where there are two examples of this peculiarity, the Christ of the Ascension on the south transept portal[68] is shown being lifted bodily by two angels, a most unusual variation of the normal types. It contradicts the teaching of the commentators who distinguished the ascensions of Elijah and Christ by pointing out that whereas Elijah rose with the help of a chariot, Christ ascended by his own force.[69] The same type occurs also in southern France on the south aisle portal of St. Sernin in Toulouse.[70] This parallel to our own motif, so far as I know independent of any theological text, flows from an empirical trend in early Romanesque art to represent actions in a more consequential, episodically rich and natural manner, and would seem to support the conclusion that the European examples of the angel with the ram are a native invention, inspired by a new artistic viewpoint and unconnected with Jewish-Moslem tradition. The strength of this tendency in the West is much greater in the Romanesque period than is commonly realized—at least to judge from the books and articles which stress rather the theological and abstract character of Romanesque imagery; one could easily cite examples of a similar change toward concreteness and reality in many other themes. In the cloister of Moissac, on many capitals, the familiar biblical actions are preceded or followed by episodes of a purely preparatory or concluding character: Abraham and Isaac on the way to the sacrifice, Samuel seeking David in Bethlehem for the anointing, David conversing with Saul before the battle with Goliath, the descent of Christ and the apostles from Mount Tabor after the Transfiguration.

Yet this general trend is not enough to account for the invention of the angel with the ram. Most of the episodes I have mentioned existed already in pre-Romanesque art; what is distinctive in the eleventh and twelfth centuries is the unusual fullness of such episodic additions and the connection with a progressively naturalistic style, especially in stone sculpture. As in the previous explanation, the objection is at hand that the oldest examples belong to Irish art of the tenth century, a style which is not at all empirical in tendency and, on the contrary, reduces the traditional subjects to extremely brief, emblematic images. And this holds also for one of the oldest continental examples, the miniature in the Catalonian Farfa Bible, although not to the same extent.

A second difficulty lies in the distribution of the detail. It is found mainly in the southwest French and Spanish region, which shows in a pronounced way the iconographic realism in question. But the latter is a broader tendency that governs also large groups of Romanesque and Gothic works in which the

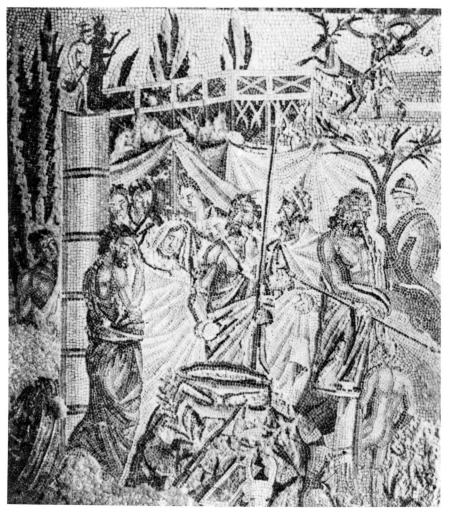

Fig. 9 Barcelona, Archaeological Museum: Pavement mosaic from Ampurias, second century. Sacrifice of Iphigenia.

traditional types of the Sacrifice are preserved. On the other hand, an angel with the ram appears in Romanesque art mainly in a part of Europe geographically close to Moslem (and Jewish) culture. Emile Mâle and others have brought together an impressive number of evidences of contact with Moslem art in southern France, especially in the region of Auvergne and Aquitaine; they include ornamental Kufic writing reproduced with an astonishing fidelity on capitals in Moissac and Le Puy and on the wood doors of the cathedral of the latter.[71] The communication between Moslem, Jewish, and Christian groups in Spain and southern France during the eleventh and twelfth centuries is too well known to require restatement. But I should like to add one fact that has a special interest for the present problem. The chronicler, Rodulfus Glaber, writing in the first half of the eleventh century, in a story about the capture of the Abbot of Cluny, Maiol, by Saracens while crossing the French Alps around 970, quoted the opinion of these Saracens that Christ descended from Abraham through Ishmael rather than Isaac.[72] It is possible that the divergent Jewish-Moslem account of the sacrifice also circulated in southern France and Spain.

In four of the examples a little detail seems to support the connection with an Arabic source. In the versions of Souillac, Parthenay, Capua, and the Farfa Bible, the angel holds the ram by the head at the ear or the horn. According to Tabari and Rashid al-Din, Gabriel carried the ram by the ear. The significance of this detail is not clear. It occurs in Ireland, too (Fig. 2), and among the Irish works there are other examples (Fig. 1) in which the ram is held by the hind parts. The method of carrying the sacrificial beast varies also in the pagan images of Iphigenia. In the painting in Naples and in a pavement in Ampurias in Spain (Fig. 9),[73] the hind is held by the horns, as in the statues of Artemis and the hind. But in most of the southern examples of the Sacrifice of Abraham with this particular motif, the ram is carried in the angel's arms, as in the Moslem images. The method of holding the beast does not help one, therefore, to trace a more precise stemma of relationships. Whether the story of Gabriel bringing the ram reached the south directly from Jewish or Moslem sources or by way of Alcuin's text or insular art remains an open question.

Yet even if the motif came to southern France and Spain from the north, it is worth considering the resemblance of the Moslem works and the examples in the Christian south as a kind of spiritual convergence. As the reception of Arabic science and philosophy by the Western world in the twelfth century presupposed a newly awakened native interest in secular knowledge and rational speculation, so the adoption of this little iconographic variant required a new attitude toward the basic text and its theological meaning, a readiness to disregard the crucial symbolism and weight of exegesis in favor of a more human, folkloristic, and in some respects more rational view, which approxi-

mates the Moslem and Jewish unsymbolic reading of this episode. The larger context of southern French and Spanish Romanesque art, and especially of the sculptures of Souillac, permits one, I think, to interpret the new type of the Sacrifice in this way. But I would not venture to propose this explanation for the older Irish examples, of which the spiritual milieu is much more obscure. It is worth noting, however, that the first literary record of the motif in the West belongs to the Carolingian period and to one of its leading humanists, Alcuin;[73a] this is the decisive moment when classical forms are reintroduced in the northwest after the prevalence of the abstract, unnaturalistic styles of the northern peoples with their heritage of old tribal cultures. In Alcuin's answer to the question about the ram one observes a naturalistic tendency, for he rejects the idea that God could have created the ram on the occasion of sacrifice, after his original labors of the six days—an idea that implies a perpetual creative action of God in nature—and prefers the less marvelous explanation that the ram was simply brought from another place.[74]

The survey and analysis of the available evidence yield the following results:

1. What appears to be an "accidental" variant in the West, unmotivated by the Bible text, occurs in Moslem art regularly as a direct illustration of a well-known legendary account of the sacrifice.

2. If this variant in Ireland is not inspired by Moslem oral, literary, or pictorial tradition, it may still be of Eastern origin, since the same idea appears earlier in Jewish folklore, although not in Jewish art, and since there is considerable evidence of elements of Jewish folklore and apocryphal literature in England and Ireland.

3. The Jewish legend had reached England by 800. It was interpolated by Alcuin in a series of questions about Genesis that otherwise corresponds closely to patristic writings.

4. On the continent the variant is concentrated in a region rich in contacts with Jewish-Moslem culture. In several examples it includes a minor detail, the grasping of the ram by the head at the ear or horn, that agrees broadly with Moslem literary accounts, but of which the significance is unclear.

5. The adoption of the Semitic variant in southern France and Spain, whether directly from Jewish or Moslem sources, or indirectly by way of Alcuin's text or Irish art, was possibly affected by native religious and artistic attitudes most evident in the sculpture in Souillac.

II

An Irish-Latin Text on the Angel with the Ram in Abraham's Sacrifice
(1967)

In a paper in *Ars Islamica* (X, 1943, 134–47) I investigated a variant of the mediaeval representation of the Sacrifice of Isaac, in which an angel is shown bringing the ram.[75] This variant not only ignores the text of Genesis xxii, 13 that tells of the ram appearing miraculously, "caught in a thicket by his horns"; but also excludes by implication the familiar symbolism of that miracle, the analogy with Christ on the Cross which is often brought out by commentators and illustrated in art.[76] I showed that this variant, exceptional in Christian art but typical in Moslem images of the Sacrifice, comes from early Jewish tradition.[77] The Jewish legend of the angel bringing the ram entered Latin question-books on Genesis through Alcuin who in speaking of the ram at the Sacrifice posed a problem that had engaged the thought of Jewish commentators: was the ram created then and there for the Sacrifice or was it an existing sheep brought by the angel?[78] In the first case one must suppose that God continued to create after the six days; in the second, the intervention of God is in accord with an already established order of nature. In the Hebrew *Sayings of the Fathers* (Pirke Aboth), the ram was included in a series of beings created by God on the evening of the sixth day in prevision of their future use;[79] and in the Midrash an angel was said to have brought this ram, browsing in Paradise since the sixth day, to the place of Sacrifice.[80] Another version identified the ram as the bellwether of Abraham's flock.[81]

In accounting for the acceptance of the variant by Romanesque sculptors, I pointed to a tendency in their art to introduce into biblical scenes some explanatory details and episodes that made the action more intelligible. These details referred to the efficient and material cause, to what preceded and prepared the action, as distinct from the final religious sense which, for the schooled believer, was implicit in the form of the story and was sometimes indicated by a symbolic device or a parallel typological image.[82]

This explanation would hardly fit the primitive character of the Irish stone sculptures of the tenth century at Arboe and Durrow (Figs. 1 and 2) which are the oldest known images of the angel carrying the ram.[83] I had first supposed that the motif in Ireland was based on Alcuin's book; but I have since found an Irish-Latin text of the seventh century that anticipates Alcuin. We can assume now that the variant in question could appear in Ireland as an illustration of the idea presented in that native text.

It is a passage in the book *De Mirabilibus Sacrae Scripturae* written in 655 by an Irish author who calls himself Augustinus.[84] Reflecting on the

nature of miracles in the Old Testament, he asks how the ram got to the place of Abraham's Sacrifice. He answers that according to some writers the earth brought forth the ram at that very hour in the same way that it originally begot sheep.[84a] But he knows a second and better explanation: since it cannot be said that God continued to create from the earth after the sixth day, he believes that an angel brought the ram from another place, just as an angel transported Philip from the eunuch to Azotus (Acts viii, 39) and as an angel is said to have brought Habbakuk to Daniel in the lions' den in Babylon (Daniel xiv, 35).[85]

The language of this Irish writer recalls in several phrases the text of Alcuin. The latter asks: "Was the ram suddenly created there out of the earth, or was he brought from another place by the angel? The learned suppose that an angel brought him from some other place rather than that God created him then and there from the earth, after the work of the six days."[86]

Since, as I have shown, Alcuin's question and answer are new in the type of question-book upon which he drew—for we do not find them in the question-books on Genesis by Jerome, Augustine, Isidore, and Bede, utilized by Alcuin[87]—the close resemblance to the Irish writer's text makes it probable that this was indeed, directly or indirectly, Alcuin's source. A scholar who has catalogued the surviving manuscripts of the Irish Augustine has already inferred Alcuin's acquaintance with this work from another passage in Alcuin's question-book that reproduces the text of the Irish author.[88] We do not have to assume then, as I did, a direct acquaintance of Alcuin with Jewish oral or written tradition for this detail, although it is ultimately of Jewish origin. The Irish text enables us to establish more fully, though not completely, the line of transmission of an attempted rationalistic account of the ram at the Sacrifice from its older Jewish sources to the Romanesque period. Alcuin, who went to school at York, of which he praised the exceptionally rich library, appreciated the learning of the Irish scholars in his native Hiberno-Saxon world.[89]

If the Irish sculptors who represented the angel bringing the ram on the stone crosses of Durrow and Arboe repeated an idea that had become part of native religious lore, it was for the writer of the seventh century a significant example of a theological principle which he illustrated by other scriptural incidents. His book is devoted to the explanation of the miracles in the Old and New Testaments. His aim, he says, is to show that whenever in the Bible something happens contrary to the everyday conduct of things, there God is not creating nature anew ("non novam ibi Deum facere naturam"), but is governing nature as He had established it in the beginning.[90] The miracles He performs are in accord with His laws and utilize existing means. So, in commenting on Joshua's miracle he remarks that the movement of the moon as well as the sun had to be arrested in order not to disturb chronology.[91] The change of Lot's wife into a pillar of salt, he explains, was effected by the spread

of the small quantity of salt, normally in the organism, throughout the whole body ("totum corpus infecit").[92] However fantastic the explanations of the miracles in this book—for they depend on the acceptance of supernatural forces—they show also a rationalistic temper which is indebted to classical thought and anticipates tendencies of the later Middle Ages.[93] The Irish Augustine is interested particularly in calendrical computation and in explaining rainfall and the tides. One cannot help noting that although he wrote in the seventh century and was known to Alcuin, the many surviving manuscripts of his book belong to the period of the twelfth to the fifteenth century.[94] It seems to have attracted attention again in the Romanesque period, a time when the interest in natural phenomena and rational explanation began to revive.

* * *

I take this opportunity to add several works to the previous list of examples of the angel carrying the ram in art.

In the Schocken Library in Jerusalem I have seen in a Haggada manuscript of the late fourteenth or early fifteenth century, written in northern Italy, a miniature of the Sacrifice with an angel bringing the ram (Fig. 10). Although he does not carry the ram in his arms, as in the clearest examples, he appears above it with one hand on the ram's shoulder. Since the ram is not near the tree, we may interpret this version as one that replaces the traditional literal type, in which the ram appears miraculously in the bush or beside it, by the physically more plausible variant. I do not know another example among the numerous Jewish representations. Like some other biblical pictures in Jewish manuscripts, it was probably based on a Christian model. In the same book there is a calendar with miniatures of the labors of the months, which include even the slaughtering of the pig.

Other examples are:

Nîmes, Musée Archéologique, Romanesque capital from the apse of the church of Les Saintes-Maries-de-la-Mer. The angel holds the ram by the horn. See V. Lasalle, "Fragment roman d'un Sacrifice d'Abraham au Musée Archéologique de Nîmes," *La Revue du Louvre et des Musées de France*, XV, 1965, p.176.

Parma, Duomo, capital. See H. Decker, *Romanesque Art in Italy*, New York, 1959, pl. 236.

London, Victoria and Albert Museum, French Romanesque capital.

Saint André de Bagé (Ain) in Burgundy, Romanesque capital; see P. Lavedan and S. Goubet, *Pour Connaitre les Monuments de France*, Paris, 1970, fig. 249.

Soissons, Musée Lapidaire, capital of mid-twelfth century from cloister of

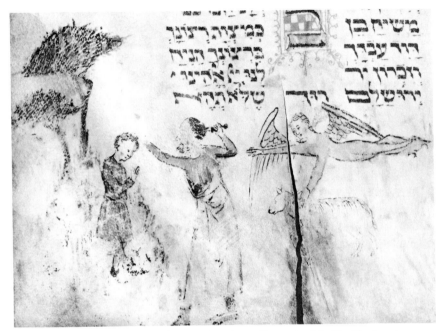

Fig. 10 Jerusalem, Schocken Library: Ms. 24087, Haggada, fol. 31. Abraham's Sacrifice with Angel Bringing the Ram.

Saint Médard; L. Réau *Iconographie de l'Art Chrétien*, II, 1, Paris, 1956, fig. 10, opp. p. 145; the scene is clearer in the Giraudon photo.

San Quirce (Burgos), Romanesque capital: J. Perez de Urbel and W. M. Whitehill, "La Iglesia románica de San Quirce," *Revista de Archivos*, Madrid, 1931, p. 20.

Paris, Bibliothèque Nationale, Ms. fr. 20125, fol. 35r, miniature. See H. Buchthal, *Miniature Painting in the Latin Kingdom of Jerusalem*, Oxford, 1957, pl. 150b—thirteenth century.

Bordeaux, St. Michel, tympanum of north transept portal, *ca.* 1500. On a second tympanum of the same doorway is the scene of Isaac with faggots and the ram on the altar.

Pietro Testa (1611?–1650), etching. One angel stays Abraham's arm; a second, flying, carries the ram. This work was kindly brought to my attention by Dr. Konrad Hoffmann of Tübingen University.

NOTES

1. See his *Crosses and Culture of Ireland*, New Haven, 1931, pp. 114, 115, and figs. 202, 205, 207. Other examples cited on the crosses of Kells and Donoughmore are unclear, and it is impossible to verify them on the photographs because of the weathered or mutilated condition of the relief. See also the illustrations in F. Henry, *La Sculpture irlandaise*, Paris, 1933, fig. 124, pl. 85, and also pls. 62, 63 (of the cross at Armagh). But Mlle. Henry in her detailed study of the iconography of the Irish crosses is unaware of this peculiar type of the Sacrifice.

I am able to reproduce figs. 1 and 2 through the kindness of Mrs. Arthur Kingsley Porter.

2. W. Neuss, *Die katalanische Bibelillustration*, Bonn and Leipzig, 1922, fig. 5.

3. On the tympanum of the south aisle portal of San Isidoro: M. Gómez-Moreno, *El Arte románico español*, Madrid, 1934, pl. LXVII, CXXVIII.

4. A capital of the porch of St. Seurin: J. A. Brutails, *Les Vieilles églises de la Gironde*, Paris, 1912, fig. 265.

There is another example in this region on a Romanesque capital in the abbey of Larreule: X. de Cardaillac, *Les Sculptures de l'abbaye de Larreule en Bigorre*, Tarbes, 1892, p. 30.

5. On the left, that is, north, side of the trumeau. For views of the whole and further details, see J. Baum, *Romanesque Architecture in France*, New York, 1928, pl. 241; A.K. Porter, *Romanesque Sculpture of the Pilgrimage Roads*, Boston, 1923, illus. 349–52; M. Schapiro, "The Sculptures of Souillac," in *Mediaeval Studies in Memory of A. Kingsley Porter*, Cambridge, Mass., 1939, p. 374, fig. 13, [reprinted in *Selected Papers, Romanesque Art, I*, New York, 1977, pp. 102 ff., fig. 13].

6. A capital from N.D.-de-la-Couldre: Porter, *op. cit.*, illus. 1046.

7. A capital in St. Lazare.

8. A capital in the nave of the cathedral; it is just barely visible in pl. 9 of C. Martin, *L'Art roman en Italie*, Paris, 1912.

9. On the portal of S. Marcello: E. Bertaux, *L'Art dans l'Italie meridionale*, Paris, 1904, fig. 205. The same motif appears in later Italian art in a Genoese painting of the seventeenth century in the Dresden Gallery (No. 753), brought to my attention by Professor Walter Friedlaender, and possibly in a painting of the vault of the Vatican Stanza of Heliodorus

by Guglielmo de Marsillac, to judge from the poor reproduction in A. Venturi, *Storia dell' arte italiana*, IX, 2, Milan, 1901, fig. 165, p. 237.

 10. On the south apse chapel of S. Isidoro: Gómez-Moreno, *op. cit.*, pl. CXXXIV, a.

 11. On the south door of the cathedral: *ibid.*, pl. LXXIX. It was not intended as an angel apparently, since another figure, who arrests the sword of Abraham, is winged.

 12. See his *Crosses and Culture of Ireland*, pp. 126, 127.

 13. Paris, Bibliothèque Nationale Suppl. persan Ms. 1313, fol. 40: a history of the prophets by Ishak ibn Ihrahim al-Nishapuri, sixteenth century; India Office Library, Ethé Ms 1342—Djami's Yusuf u Zulaikha: dated 1599, reproduced by T. Arnold, *Painting in Islam*, Oxford, 1920, pl. XXXI; a recent chromolithograph from Aleppo: Du Mesnil du Buisson, *Les Peintures de la Synagogue de Doura-Europos*, Rome, 1939, fig. 21; a painting on wood, dated 1603, part of the paneling of a room in Aleppo, now in the Berlin Museum: F. Sarre, "Bemalte Wandbekleidung aus Aleppo," *Berliner Museen, Ber. aus den preuss. Kunstsamml.*, XLI, 4, 1920, pp. 144–157 and fig. 50 [Fig. 5, p. 293, above]; a miniature in a Koran of 1816: R. Gottheil, "An Illustrated Copy of the Koran," *Revue des études islamiques* 1931, pp. 21–24, pl. V. For the last two references, I am indebted to the kindness of Dr. Ettinghausen.

 14. See T. W. Arnold, *The Old and New Testaments in Muslim Religious Art*, London, 1932, who ignores the representations of this theme.

 15. See *Chronique de Tabari, traduite par M. H. Zotenberg*, I, Pt. 1, Paris, 1867, chap. LIII, pp. 186. The same detail is reported by the commentator Al-Zamakh-shari (1075–1144), a Persian-born Arabic scholar, according to M. Grünbaum, *Neue Beiträge zur semitischen Sagenkunde*, Leyden, 1893, pp. 112, 113, and also in an unspecified Arabic version of the sacrifice recounted by G. Weil, *The Bible, the Koran and the Talmud*, New York, 1863, p. 88, "Gabriel stood before him with a fine horned ram."

 16. The Koran does not name the son; on the divergent interpretations, see I. Goldziher, *Die Richtungen der islamischen Koranauslegung*, Leyden, 1920, pp. 79 ff., and *Encyclopedia of Islam*, Leyden-London, 1927, p. 532, s.v. Ishak. In Morocco today, Isaac is still considered as the object of sacrifice: E. Westermarck, *Pagan Survivals in Mohammedan Civilisation*, London, 1933, p. 162.

 17. Tabari, *loc. cit.*.

 18. The text reads: "The Majesty of Glory (i.e., God) sent Jibra'il to bring a ram from paradise. Jibra'il took a white sheep, with black eyes, four legs, black feet and tall horns (?) by the ear; he came up to the mountain and stood there" The passage has been translated for me by Dr. Ettinghausen.

 19. See Grünbaum, *op. cit.*, pp. 245 ff., 250, after an English translation by Joseph Morgan, *Mahometism Fully Explained*, London, n.d., (*ca.* 1720).

 20. For a bold statement of the connections of insular and Near Eastern art, see J. Strzygowski, *Origin of Christian Church Art*, Oxford, 1923, pp. 230 ff. (this chapter: "Hiberno-Saxon Art in the time of Bede," was written for the English edition of the book). Strzygowski also finds close resemblances of insular and Moslem Art (p. 240). See also Porter, *Crosses and Culture of Ireland, passim*, and "An Egyptian Legend in Ireland," *Marburger Jahrb. f. Kunstwissensch.*, V, 1929, 1 ff. on Egypt and Ireland; J. Brøndsted, *Early English Ornament*, Paris, 1924, pp. 36 ff., 304 ff. For a summary of the literature on the problem, see P. Paulsen, *Studien zur Wikinger-Kultur*, Neumünster, 1933, pp. 1 ff., 15 ff.

 21. The early Christian representations of the angel in the Sacrifice of Abraham have been carefully studied by G. Stuhlfauth, *Die Engel in der altchristlichen Kunst*, Freiburg im Br., 1897, pp. 95 ff.

There appears to be an exception in the Cabinet des Médailles of the Bibliothèque Nationale in Paris, a gem which has been catalogued as a Christian Sassanian work prior to 340 A.D. It is described as follows by J. M. A. Chabouillet, (*Cataloque général et raisonné des camées et pierres gravées de la Bibliothèque impériale*, Paris, n.d., 1868?, p. 191, no. 1330): "Le patriarche est representé le couteau à la main et s'apprêtant à immoler son fils couché sur un autel en forme de pyrée. Abraham se retourne et aperçoit l'ange qui lui montre le bélier qu'il

retient par une de ses cornes." The description and attribution are repeated by Ernest Babelon in the latest edition of his guide to the Cabinet des Médailles, (*Le Cabinet des médailles et antiques de la Bibliothèque Nationale. Notice historique et guide du visiteur: I. Les antiques et les objects d'art*, Paris, 1924, p. 57, no. 1330), although the last sentence of Chabouillet is changed to read: "Abraham se retourne et aperçoit l'ange qui lui amène un bélier." If the description and attribution are correct, this work would have a considerable bearing on this problem, as well as on the history of early Christian art. But the only reproduction I have been able to find of this gem, on pl. 479 (no. 9) of Garrucci's *Storia dell' arte cristiana* (see also his text, VI, Rome, 1881, p. 123), shows no angel at all; Chabouillet and Babelon have apparently mistaken for an angel the bush, which is placed vertically across and above the body of the ram and is surmounted by the hand of God. One branch touches the horns of the ram, and it is not difficult to see the bush as a human figure presenting the ram. The early date assigned to the gem has been questioned by C. W. King, *Antique Gems and Rings,* I, London, 1872, p. 84.

Another work that seems to indicate the existence of the motif of the angel with the ram in early Christian art is an ivory pyxis from Nocera Umbra in the Terme Museum (A. Venturi, *Storia dell' arte italiana* I, Milan, 1901, fig. 406 and p. 534. It is described as follows by Alison Moore Smith (*The Iconography of the Sacrifice of Isaac in Early Christian Art*, Amer. Journ. Archaeol., Ser. 2, XXVI, 1922, p. 165): "The ram which is below a tree at Abraham's right appears again, with an angel added to the scene." This suggests that the artist, of the Alexandrian-Coptic school according to this writer, wished to show as a distinct episode the angel bringing the ram. But the angel to the left of the sacrifice is really the angel who brings Habbakuk in the adjoining scene of Daniel in the Lions' Den, and the second "ram" at his feet is a lion. This is clear from the description and the two illustrations in the study by A. Pasqui, *Necropoli Barbarica di Nocera Umbra*, Monumenti Antichi, XXV, Milan, 1919, pp. 209–314, figs. 61, 62.

22. See H. Shetelig and H. Falk, *Scandinavian Archaeology*, Oxford, 1937, pp. 271 ff.; T. J. Arne, *La Suède et l'Orient*, Archives d'études orientales, VIII, Upsala, 1914; G. Jacob, *Der nordisch-baltische Handel der Araber im Mittelalter*, Leipzig, 1887; and the works of Brøndsted and Paulsen cited in note 20 above.

23. It is reproduced in *The Legacy of Islam*, Thomas Arnold and Alfred Guillaume, ed., Oxford, 1931, p. 106, and discussed in the article in the same volume by A. H. Christie, "Islamic Minor Arts and their Influence upon European Work," pp. 113, 114. The coin reproduces the religious formula and the date (774) of the Arabic original. Christie also cited an Irish gilt cross of the ninth century with a glass paste center containing a Kufic inscription.

24. See his *La Escatología musulmana en la Divina Comedia*, Madrid, 1919, and *Dante y el Islam*, Madrid, 1927.

25. See T. Silverstein, *Visio Sancti Pauli,* Studies and Documents, IV, London, 1935, pp. 17–19.

26. For the Western examples, see W. Storck, "Der Spruch der Toten an die Lebenden," *Zeitschr. f. Volkskunde*, XXI, 1911, pp. 58 ff., and P. Deschamps, "Étude sur la paléographie des inscriptions lapidaires de la fin de l'époque mérovingienne aux dernières années du XIIe siècle," *Bull. monumental* LXXXIX, 1929, pp. 60, 61.

27. See K. Künstle, *Die Legende der drei Lebenden und die drei Toten und der Totentanz*, Freiburg im Br., 1908, pp. 29, 30; Storck, *op. cit.*, and his book *Die Legende von den drei Lebenden und den drei Toten und das Problem des Totentanzes*, Tübingen, 1910; and W. Stammler, *Die Totentänze des Mittelalters*, Munich, 1922, pp. 14 ff. The Arabic parallels are verses by 'Adi b. Zaid (sixth century A.D.) and Mudad b. 'Amr (third century A.D.), which have been kindly verified for me by G. E. Grunebaum: "As you are, so we have been—As we are, so you shall be," and "We were people as you are now, but—Time has changed us; and you shall be what we are now."

28. See *The Blickling Homilies*, ed. by R. Morris, Early English Text Soc., LXXIII, 1880, pp. 112, 113.

29. See *Poetae Latini aevi carolini*, I, 350, no. CXXIII, ll. 5, 6, Monumenta Germaniae Historica.

30. By L. Neubaur, "Zum Spruch der Toten an die Lebenden," *Zeitschr. f. Volkskunde*, XXII, 1912, p. 294. The Vulgate version reads, "Memor esto judicii mei; sic enim erit et tuum: mihi heri et tibi hodie."

31. Schenkl, ed., *ex sepulchro latinae viae*, p. 252; Monumenta Germaniae Historica, Auctores Antiq., V, 252; and for emended version, E. Rohde, *Psyche*, II, Tübingen, 1907, p. 395.

32. The Latin examples have been collected by B. Lier, "Topica carminum sepulcralium latinorum," *Philologus*, LXII, n.f. 16 (1903), pp. 591, 592.

33. See Weil, *op. cit.*, and D. Sidersky, *Les Origines des légendes musulmanes dans le Coran et dans les vies des Prophètes*, Paris, 1933.

34. Cited by L. Ginzberg, *The Legends of the Jews*, Philadelphia, 1925, p. 252, n. 245; another example from the *Midrash Yalkut* is cited by Weil, *op. cit.*, p. 88 note (it is a compilation made in Frankfurt in the thirteenth century).

35. Munich, Staatsbibliothek cod. hebr. 222 (*Sepher Ha-masim*); see M. Steinschneider, *Die hebraeischen Handschriften der k. Hof-und Staatsbibliothek in Muenchen*, 2d. ed., Munich, 1895.

36. See *Eusebii Praeparatio evangelica*, E. H. Gifford, ed., I, Oxford, 1903, p. 531, for the Greek text (IX, pars. 9, p. 421 b) and III, pars. I, p. 452 for the translation. According to J. Freudenthal (*Hellenistische Studien*, Breslau, 1875, p. 36 n.) the passage in question could not have been written by Alexander, since the language and style are closer to those of the Septuagint than are other passages about the Jews quoted by Eusebius from his treatise; but it was perhaps excerpted by Alexander from the writings of the chronographer Demetrius, who was more directly acquainted with Jewish literature and tradition.

37. On the influence of Jewish folklore on the biblical legends of the Christians, see L. Ginzberg, "Jewish Folkore: East and West," *Harvard Tercentenary Publications; Independence, Convergence and Borrowing*, Cambridge, Mass., 1937, pp. 89–108, esp. pp. 96 ff. On the relations with insular biblical legends in particular, see O. F. Emerson, "Legends of Cain, especially in Old and Middle English," *Publ. Modern Language Assn.*, XXI, 1906; St. J. Seymour, "The Book of Adam and Eve in Ireland," *Proc. Royal Irish Acad.*, XXXVI, 1922; R. J. Menner, "The Poetical Dialogues of Solomon and Saturn," *Modern Language Assn. Amer.*, 1941, pp. 21 ff., 45 ff., 59 ff.; M. Schapiro, "Cain's Jawbone That Did the First Murder," *The Art Bulletin*, XXIV, 1942, p. 205 ff. [reprinted here pp. 249–265]. On the respect for Jewish tradition and example in Ireland, see P. Fournier, "Le Liber ex lege Moysi et les tendances bibliques du droit canonique irlandais," *Revue celtique*, XXX, 1909, pp. 221–34.

38. In the early images in the synagogues of Dura and Beth Alpha (illustrated in R. Wischnitzer-Bernstein, *Symbole und Gestalten der jüdischen Kunst*, Berlin-Schöneberg, 1935, figs. 9,15), as in some of the oldest Christian versions, the angel does not appear at all. This agrees with Philo's account of the sacrifice in his work "On Abraham" (176), and with a Coptic retelling, published by O. von Lemm, "Kleine koptische Studien," *Mem. Imperial Acad. Sci. of St. Petersburg, Hist.-Philol. Class,* VIII, 1908, no. 12, pp. 17 ff.

A more developed early Christian type with the angel appears on an ironstone amulet of the fourth or fifth century with a Hebrew inscription in the collection of the late Edward Newell. It will be published in a book on Greco-Egyptian and Levantine amulets by Professor Campbell Bonner of the University of Michigan, who has generously put at my disposal some of his unpublished material. [See *Studies in Magical Amulets Chiefly Graeco-Egyptian*, Ann Arbor, 1950, p. 226 and pl. xviii, D. 343.]

For mediaeval and later Jewish images of the sacrifice similar to the contemporary Christian types, see Wischnitzer-Bernstein, *op. cit.*, figs. 16, 17; F. Landsberger, *Einführung in die jüdische Kunst*, Berlin, 1935, pl. 13, figs. 33 and 38; *Encyclopaedia Judaica*, VIII, s.v. Isaak, Berlin, 1931, pp. 481, 482. Alexander Marx has shown me an especially fine example in a

manuscript of about 1300 from Steiermark in the library of the Jewish Theological Seminary of New York.

39. Migne, Patrologia latina, C, col. 545, inter. 206: "Unde aries iste, qui pro Isaac immolatus est, venerit, solet quaeri: an (de) terra ibi subito creatus esset, vel aliunde ab angelo allatus?—*Resp.* Aries iste non putativus, sed verus esse credendus est. Ideo magis a doctoribus aestimatur, aliunde eum angelum atulisse, quam ibi de terra, post sex dierum opera, Dominum procreasse."

40. See Ginzberg, *Legends of the Jews*, I, p. 282, V, p. 252, n. 245; Weil, *op. cit.*, p. 88 n. The same alternatives occur in the Moslem literature: Grünbaum, *op. cit.*, p. 112, and Tabari, *loc. cit.*, p. 188.

41. Migne, Pat. lat., C, col. 545.

42. Ginzberg, *op. cit.*, I, p. 285, V, p. 252, n. 248; and *Bereshith Rabba*, LVI.

43. "Liber Hebraicorum Quaestionum in Genesim," Pat. lat., XXIII, col. 1021. The same passage is also found in Bede, "Quaestiones super Genesim," Pat. lat., XCIII, col. 319, and in Rabanus Maurus, Pat. lat., CVII, col. 568; cf. also Remigius of Auxerre, Pat. lat., CXXXI, col. 96.

44. "Quaestiones in Heptateuchum," Pat. lat., XXXIV, col. 563.

45. See K. Werner, *Alcuin und sein Jahrhundert*, Vienna, 1881, pp. 125, 126, and G. Bardy, "La Littérature patristique des 'quaestiones et responsiones' sur l'écriture sainte," *Revue biblique*, XLII, 1933, pp. 27, 28.

46. Pat. lat., LXXXIII, col. 249–51.

47. *Ibid.*, XCIII, cols. 318–20; he follows Jerome closely.

48. *Loc. cit.* Alcuin's qu. 207 is only in part like Augustine's LVIII; it repeats also part of Jerome's comment on Genesis xxii, 14 (*op. cit.*, col. 1021 A).

49. Pat. lat., CXV, col. 195.

50. *Ibid.*, CXIII, col. 139. Augustine and Jerome are cited by name in the following passage.
The *Glossa Ordinaria* is traditionally attributed to Walafrid Strabo (*ca.* 808–49), but the latter's authorship of this compilation has been questioned by S. Berger, *Histoire de la Vulgate*, Paris, 1893, pp. 133–36, who concludes, however, that the *Glossa Ordinaria* is at least in part a work by Walafrid (e.g., the Prophets); and by H. H. Glunz, *History of the Vulgate in England from Alcuin to Roger Bacon*, Cambridge, 1933, pp. 103–105. Glunz believed that the *Glossa Ordinaria* in its present form is a work of the twelfth century built (especially in the Pentateuch glosses) on compilations of Rabanus and Walafrid.

51. On Agobard's knowledge of Jewish doctrines, beliefs, and customs, see S. Katz, *The Jews in the Visigothic and Frankish Kingdoms of Spain and Gaul*, Cambridge, Mass., 1937, pp. 62–68. His writings "De iudaicis superstitionibus," and "De insolentia Judaeorum," are in Pat. lat., CIV, cols. 69 ff., 77 ff., and in Mon. Germ. Hist. Ep., V, 185 ff.

52. On Alcuin's knowledge of Hebrew, see S.A. Hirsch, *A Book of Essays*, London, 1905, pp. 8–10. On the relations of Christian and Jewish scholars in Alcuin's time there is an interesting passage in a letter of Alcuin's: "When I visited Rome as a youth and spent several days in Pavia, a certain Jew by the name of Lullus had a discussion with master Peter. This was the same Peter who taught grammar so brilliantly in your palace" (Ep. 271, quoted by M. Manitius, *Geschichte der lateinischen Literatur des Mittelalters*, I, Munich, 1911, p. 275).

53. For the texts, see Manitius, *op. cit.*, pp. 290, 294; and on the knowledge of Hebrew in the Carolingian schools, C. Singer, "Hebrew Scholarship in the Middle Ages," in *The Legacy of Israel*, E. R. Bevan and C. Singer, ed., Oxford, 1927, pp. 287 ff.

54. In the Chester Play, lines 433, 434 ("Therfore God hathe sent by me, in faye! A lambe,....") and the Brome Play, line 323 ("A fayr Ram yynder I gan brynge"); A. W. Pollard, *English Miracle Plays, Moralities and Interludes*, Oxford, 1890, pp. 28, 29, 175.
Alcuin's *Interrogationes* was translated into Anglo-Saxon by Aelfric, but his version does not go beyond question 201. See G. E. MacLean, *Aelfric's Anglo-Saxon Version of Alcuini Interrogationes Sigewulfi Presbiteri in Genesin*, Halle, 1883.

55. As in miniatures in the psalters of Saint Louis in Leyden and Paris, the York psalter in Glasgow, Latin Ms. 8846 in the Bibliothèque Nationale, Paris, the De Brailles psalter in the Beatty collection, the psalter French Ms. 5 in the John Rylands Library, Manchester, the Egerton Genesis in the British Museum, etc. For a Jewish example, cf. the Machsor of the fourteenth century in the Breslau University Library (*Encyclopedia Judaica*, VIII, 481).

56. As suggested by C. L. Woolley, *Abraham, Recent Discoveries and Hebrew Origins*, London, 1936, p. 162.

57. Cf. Rabanus Maurus: "Cornibus ergo haerentem arietem crucifixum Christum significat," *Commentarium in Genesim*, Pat. lat., CVII, col. 569; the same interpretation appears also in Isidore, *ibid.*, LXXXIII, col. 251; Bede, *ibid.*, XCIII, col. 320; Remigius of Auxerre, *ibid.*, CXXXI, col. 96; and other writers. The thorns or brambles are sometimes likened to Christ's crown of thorns.

58. Cf. the miniatures in the English Bible in Lambeth Palace (O. Saunders, *English Illumination*, I, Florence, 1928, pl. 39) and in a Regensburg manuscript of *ca.* 1170–85 in the Munich Library (Clm 14159, A. Boeckler, *Die Regensburg-Prüfeninger Buchmalerei des XII. und XIII. Jahrhunderts*, Munich 1924, pl. XXVII). There is an interesting example of 1455 in an Armenian gospels (fig. 8) in the Walters Gallery (Ms. 543, fol. 4).

59. As on the capital in Jaca cited on p. 289 and n. 11, and in a carving of the choir stall of Cologne cathedral (B. von Tieschowitz, *Das Chorgestühl des Kölner Doms*, Marburg, 1930, pl. 22a).

60. Cf. the painting in Naples (M.H. Swindler, *Ancient Painting*, New Haven, 1929, fig. 384), and for an example near the region of our Abraham type, a pavement mosaic from Ampurias, Spain (J. R. Mélida, *Arqueologia española*, Barcelona, 1929, fig. 197, p. 368), reproduced in Fig. 9.

61. For the Berlin pyxis, see O. Dalton, *Byzantine Art and Archaeology*, Oxford, 1911, fig. 115; on the early Christian types of the angel in this subject, see Stuhlfauth, *op. cit.*; and on the relation of Abraham to Timanthes' Calchas, see D. Ainalov, *The Hellenistic Foundations of Byzantine Art*, St. Petersburg, 1900 (in Russian), summarized by O. Wulff in a review in *Repertorium f. Kunstwissensch.*, XXVI, 1903, 45,—the observation is Graeven's. [Ainalov's book is now available in English: Rutgers University Press, New Brunswick, New Jersey, 1961—see p. 151 and fig. 71.]

62. Porter, *Romanesque Sculpture of the Pilgrimage Roads*, ill. 348; Schapiro, "The Sculptures of Souillac," p. 361, fig. 2. [reprinted in Selected Papers, I, *Romanesque Art*, 1977, p. 103, fig. 1.]

63. Porter, *op. cit.*, ill. 412, 419.

64. *Ibid.*, ill. 365, 366.

65. *Ibid.*, ill. 699, and Gómez-Moreno, *op. cit.*, pl. LXVII, CXXVIII.

66. Porter, *op. cit.*, ill. 352.

67. *Ibid.*, ill. 349–51; cf. my observations, *op. cit.*, p. 377. [reprinted in *Romanesque Art*, pp. 114–116.]

68. Porter, *op. cit.*, ill. 702.

69. Cf. Gregory, *Homiliae in Evangelia*, lib. II, hom. 29, Pat. lat., LXXVI, cols. 1216, 1217, and my comments in *"The Image of the Disappearing Christ,"* Gazette des beaux-arts, 6th ser., XXIII, 1943, 135 ff. [Reprinted in this volume, pp. 267–287]

70. Porter, *op. cit.*, ill. 308, 39.

71. Cf. E. Mâle, "Les Influences arabes dans l'art roman," *Revue des deux-mondes*, XVIII, 1923, 311–43, and A. Fikry, *L'Art roman du Puy et les influences islamiques*, Paris, 1934.

72. "They said that their Ismael begot Nabaiot; descending thence to their erroneous fiction which is, of course, as far from the truth as it is remote from holy and catholic authority"—*Rodulfi Glabri, Historiarum, lib.* I, cap. IV, 9 (ed. Prou, pp. 11, 12).

73. Cited in note 60 above.

73a. [For a correction of this statement, see the following article, "An Irish-Latin text on the Angel with the Ram in Abraham's Sacrifice," pp. 307–311.]

74. Dr. Ettinghausen has found another early example of the sacrifice of Abraham in Moslem art, a miniature in a manuscript of 1410–11 in the collection of Mr. Gulbenkian, formerly in the H. Yates Thompson collection. Here, as in the older example in the Walters Art Gallery, the angel does not carry the ram; but, considering the absence of the bush, the importance given to Gabriel and the other angels, and the difference from both the Biblical and the Koranic accounts, it is possible that the artist had in mind the traditional Jewish and Islamic legend discussed in this paper.

II

The footnote reference numbers, as they appeared in the original publication, are found in parentheses after each footnote in the second section.

75. "The Angel with the Ram in Abraham's Sacrifice: A parallel in Western and Islamic Art" (cited hereafter as S.). [Reprinted in this volume, pp. 289–306.] (1)

76. For some mediaeval texts see S., p. 315, n. 57; for the early Christian texts, see Isabel Speyart van Woerden, "The Iconography of the Sacrifice of Abraham," *Vigiliae Christianae*, XV, 1961, pp. 216 ff. and 239. (2)

77. S., p. 295. The oldest text is by Alexander Polyhistor ("Concerning the Jews"), a writer of the first century B.C. who perhaps excerpted the story from a work of the chronographer Demetrius. The text is preserved in Eusebius's *Preparation for the Gospel*, IX, 9, 421 b. (3)

78. *Interrogationes et Responsiones in Genesin*, Pat. lat., C, col. 545, inter. 206. (4)

79. *Pirke Aboth* 5:9—R.H. Charles, *Apocrypha and Pseudepigrapha of the Old Testament*, II, Oxford, 1913, p. 708. This passage was quoted in the eleventh century by Rashi of Troyes in commenting on Genesis xxii, 13, and through Rashi in the Christian *Extractiones de Talmud* (1248–55)—see M. Hailperin, *Rashi and the Christian Scholars*, Pittsburgh, 1963, p. 278, n. 63. (5)

80. See S., p. 314, n. 34. (6)

81. *Ibid.*, p. 297, n. 40. (7)

82. *Ibid.*, pp. 299–306 (8)

83. *Ibid.*, figs. 1, 2. (9)

84. Migne, Pat. lat., XXXV, cols. 2149 ff. In the prologue the author addresses the book to the clergy of "Carthage"—perhaps a copyist's error for an unfamiliar Irish place-name. On Augustinus, see M. Esposito, "On the Pseudo-Augustinian Treatise, De Mirabilibus Sanctae Scripturae, written in Ireland in the year 655," *Proceedings of the Royal Irish Academy*, XXXV, 1919, C, pp. 189–207. See also P. Duhem, *Le Système du Monde*, III, Paris, 1915, pp. 12 ff., 15, 16.

James F. Kenney, *The Sources for the Early History of Ireland*, I, New York, 1929, p. 777 (addendum to p. 276), notes the conjecture of P. Grosjean that "Carthage" refers to a monastery of Saint Carthach at Rathan or Liss-Mór. See Grosjean, "Sur quelques exegètes irlandais du VIIIe siècle," *Sacris Erudiri*, VII, 1955, p. 71, n. 1. (10)

84a. For the idea that the earth produced the bush and the ram, see the fourth-century theologian Ephraem Syrus, *Commentarii in Genesim et in Exodum*, R.M. Tonneau, ed., trans., Louvain, 1955, p. 69.

85. *Op. cit.*, I, 14, col. 2162. "Hunc in illa hora terra protulit, quomodo et in principio pecora gignit. An etiam, ne illud opus post diem sextam condidisse de terra Deus dicatur, istum aerietem detulisse angelum aliunde credimus, quomodo et Philippum angelus ab eunucho transtulit in Azotum, et ad Danielem in Babylonem Habacuc transtulisse ad lacum leonum fertur angelus." (11)

86. Pat. lat., C, col. 545, inter. 206: "Unde aries iste, qui pro Isaac immolatus est,

venerit, solet quaeri: an (de) terra ibi subito creatus esset, vel aliunde ab angelo allatus?—*Resp.* Aries iste non putativus, sed vero credendus est. Ideo magis a doctoribus aestimatur, aliunde eum angelum atulisse, quam ibi de terra, post sex dierum opera, Dominum procreasse." (12)

87. S., p. 298. (13)

88. Esposito, *op. cit.*, p. 201. (14)

89. For Alcuin on the Irish scholars, see the texts assembled by J.F. Kenney, *The Sources for the Early History of Ireland*, I, New York, 1929, pp. 534, 535. (15)

90. *Op. cit.*, col. 2151. (16)

91. *Ibid.*, col. 2175. Interesting for early mediaeval rationalism in this context is the question of Gunzo, an Italian writer of about 970, who asked whether, when the sun and moon stood still at Joshua's command, the other planets also stopped moving and the music of the spheres was changed. See M. Manitius, *Geschichte der lateinischen Literatur des Mittelalters*, I, Munich, 1911, p. 534. (17)

92. *Op. cit.*, cols. 2161–2. The rationalistic tendency of the Irish writer will be evident from a comparison with an example of folklore reasoning about the same episode. The anonymous fourth- or fifth-century author of the poem *De Sodoma*, following Jewish writers (Wisdom 10:7, Josephus, *Antiqu. Jud.*, I, 11, 4), describes the pillar of salt as still standing in the Palestinian plain, undissolved by rains or destroyed by winds; and to confirm the belief, he adds that the pillar, formed as an image of Lot's wife, menstruates (Pat. lat., II, cols. 1161–2). This legend reached the artist who painted the scene of the burning Sodom and Lot's wife in a thirteenth-century French manuscript of World History (British Museum, Add. Ms. 19669, fol. 20); a red cross is drawn over the place of the vulva in the whitened figure. The text says nothing of this detail, though it recalls the preceding verses of the ancient poem: ". . . devint une pierre salee ausi com se ce fust une ymaige com eut par grant diligence samblent ali tailliee et contrefaite" (fol. 22). (18)

93. The author refers in several places to the ancients and to learned literature: "duabus autem causis, ut sapientes aiunt" (I, 35); "ut multi magistri putant" (II, 15); "physiologi aiunt" (III, 2); "ut antiqui ferunt" (III, 8). All these are cited by Esposito, *op. cit.*, p. 206. (19)

94. Forty-two manuscripts are listed by Esposito, *op. cit.*, pp. 189 ff. (20)

The Beatus Apocalypse
of Gerona

(1963)

One of the great achievements of mediaeval art is the illustration of a commentary on the Apocalypse of St. John written by a Spanish priest, Beatus, toward the end of the eighth century at Liébana in Asturias. Twenty-two illustrated copies, dating from the early tenth century to the beginning of the thirteenth, have come down to us. Of these, two are in the Pierpont Morgan Library in New York; another, in the Bibliothèque Nationale in Paris, the Apocalypse of St. Sever, named after its origin in an abbey in southern France in the mid-eleventh century, has become well known through the frequent reproduction of some of its pictures. The publication of the copy in the treasure of the cathedral of Gerona, which was written in 975, supposedly in Távara in Asturias, and is one of the best preserved of all, makes available for the first time in facsimile a complete Beatus manuscript.* It contains over a hundred paintings of an extraordinary power of color and expression (Figs. 1, 2, and 3). I believe that this publication is an important event for artists and students of art who will find in the color facsimiles much to ponder and enjoy. The Urs Graf Verlag has maintained here a high standard of color reproduction, as in its facsimiles of the masterpieces of Hiberno-Saxon manuscript art. The introductory essays, while they say too little about the artistic character and problems, tell the story of the Beatus manuscripts as a group and of the Gerona codex in particular in relation to the history of religion and art in Spain.

Most of the surviving copies of the Beatus commentary were produced in the tenth and eleventh centuries in free Christian Spain, but are classed as works of Mozarabic art, on the assumption that their peculiar style depends on the art of the Christians in the parts of Spain under Moorish rule. The intense color, the brilliant decorative aspect and some details of represented architecture, like the horseshoe arches—to mention only one of several similarities to

* Jaime Marques Casanovas et al., *Apocalypse of Gerona*, Olten and Lausanne (Urs Graf Verlag), 1963.

319

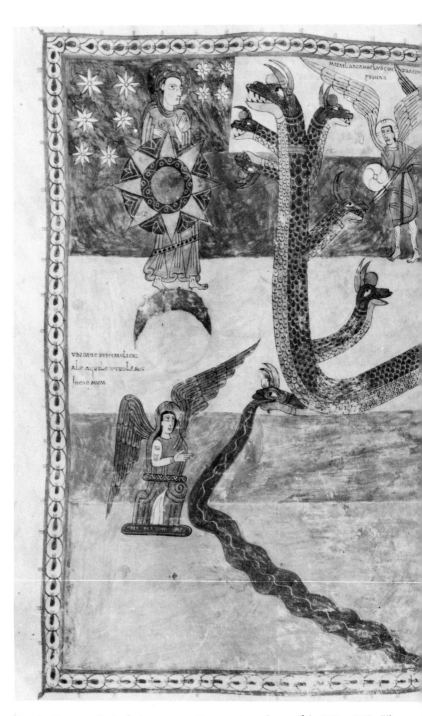

Fig. 1 Gerona, Cathedral treasure: Beatus Apocalypse, fol. 171v–172. The Woman Clothed in the Sun and the Seven-headed Dragon.

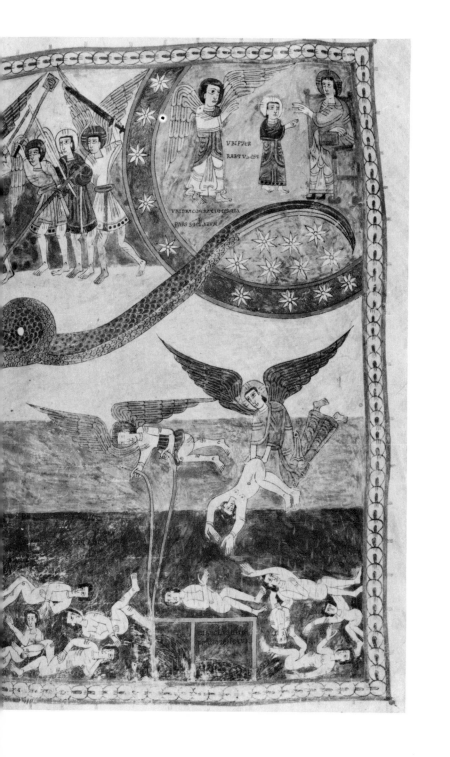

Moslem art—support this idea. But it has been known for some time that in the Christian Visigothic kingdom prior to the Moorish conquest the arts already showed considerable Oriental detail, including the horseshoe arch, so that the oriental appearance of the later arts of Christian Spain is not wholly a sign of Mozarabic influence. It may be, too, that certain simplified forms and groupings of color in this art, which resemble effects in East Mediterranean art, are spontaneous primitive solutions, common to many cultures of this level; the older heritage of classic and oriental forms, upon which the naive fantasy of artists of that isolated region of Spain worked, accounts for at least some of the similarities to Moslem art.

The paintings of the Gerona Beatus, like those of the other early copies, are an art of color bound to a visionary text. On great framed fields, divided into bands of contrasted color, are set the equally vivid figures who enact the Apocalypse of John with its grandiose revelations of last things: the splendors of heaven and earth, the coming end of the world, the wars of angels and demons, the trumpetings and scourges, the saved and the damned, the cosmic catastrophes and the final salvation. It is not an original visionary art in the sense of Blake, Goya, or Redon, with an atmosphere of mystery or sublimity. In a burning, heraldically bright color, the artist transposes the imagery of the canonical text in naive illustration of the single words. All is literal and crystal clear; the story is spelled out letter by letter. In one version the halos of the twenty-four Elders are inscribed each with a letter of their Latin designation and are set as complete circles above the twenty-four crowns. Where the author of the Apocalypse speaks of the half hour of silence in heaven at the opening of the seventh seal (viii, 1), there appears in the column of text a rectangle of golden yellow inscribed SILENTIUM. And to celebrate the omnipotence of God as the beginning and end of all things, the painter, authorized by the text, creates a gigantic Alpha and Omega, an intricate framework of complex forms, the Alpha embracing plants, figures, and beasts—a deeper sign of the essential bonds of this art with the Word.

Those who know the Apocalypse through Dürer's densely packed imagery, with its infinite detail, will be astounded by the simplicity of this Spanish art, the ease of passage between the natural and the supernatural, the evocative power of the barest forms—sometimes childlike in the innocence of conception. The knowledge of nature here is reduced to the most elementary distinctions between objects—that minimum of articulation needed for designating things. The drawing abounds in devices of archaic imagery—the frank repetition of objects in series, the fractioning of parts, two eyes in a profile head, limbs attached inorganically to the costume, falling houses simply inverted, map-like projections of space, and cross-sections of buildings with objects and figures visible through the open façade.

But though seemingly primitive in detail, the paintings disclose to longer scrutiny that they belong to a line of high development in art. Going back to the original set of illustrations of the end of the eighth century—probably works with much classic detail—these mediaeval copies retain many features of an advanced artistic culture. The two painters, a monk, Emeterius, and a nun, Ende, who have left their names in the colophon of the Gerona codex, inherited from classical art the idea of framing a picture on four sides; and they treat this constructed rectangular field, divided freely according to the content of each image, with that sense of the bounded space as a determining factor in the whole which marks the tradition of Western painting since that time. It is an art that preserves in vestigial yet potent form much of Roman style. It may reduce the modeled ancient figures to surprisingly rigid and flat elementary shapes; but it holds to the inherited idea of the closed, fully colored, dense image in which the background—through these colors—is an articulating force in the whole, like the figures themselves. In the Beatus manuscripts it is partitioned by bands that stratify into zones of distinct, strongly contrasted colors the more delicate, graded, and blending tones of the ancient atmospheric landscape. This near-barbaric art strives for richness, brilliance, elegance, and wonder, with means that ordinarily belong to an extremely simple domestic art. A strong will to perfection, a standard of completeness, raises the elementary forms to a high power of expression. In fusing the primitive and the advanced, this art is like the text of the Beatus commentary itself—a prophetic vision of world history edited in a small mountain village. The pages may be compared to a chessboard on which different positions of pieces represent different moments in the apocalyptic story. With every change in the pieces—in their number, place, and characteristics—the squares, too, change in color, but the whole is always a balanced field, a stasis; it is a unique historical instant that cannot be confused with another, and has a gripping simplicity and intensity through the color and arrangement. In some pages there are nearly a hundred figures, all legible and in groupings that possess an elemental shape, like a great emblem, which is never banal or repetitious. The variations in the repeated units are a joy to see, a marvelous game or conversation between neighboring equals.

If the painters have given up the late classic nuancing of colors by light and shadow tones, they have found an equivalent in the vari-colored points and lines traced in ornamental schemes on a single mass of local color. Beside the contrasts of large scale between neighboring background bands and of middle scale between figures, these minute oppositions within each figure and object fuse optically to produce unnameable subtle tones. It is a method of dosage of color that suggests an Impressionist flecking and breaking, but is related also to the play of colored points and threads in a woven fabric.

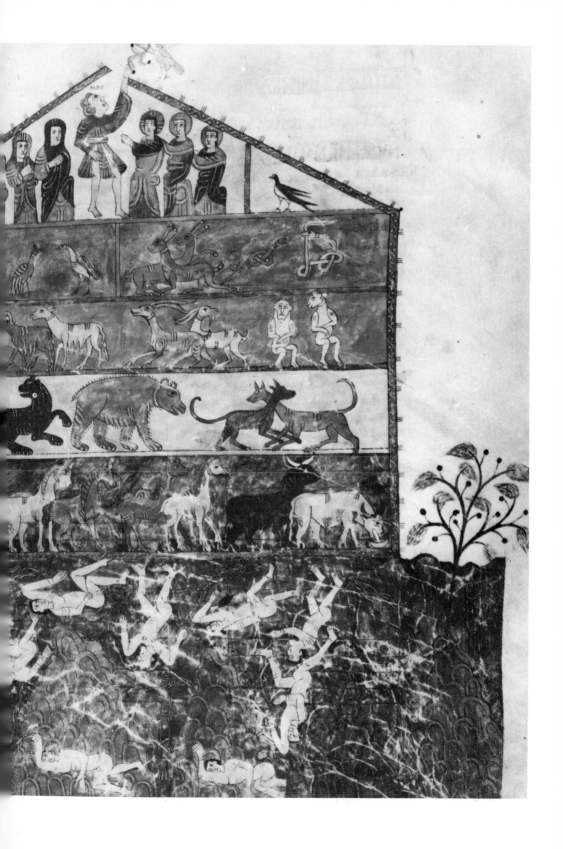

One must not forget that almost all these paintings in the Gerona Beatus are copies. We do not know what the original manuscript was like—from certain features of the copies we can surmise that it had more in common with postclassical painting of the seventh and eighth century and perhaps with Carolingian art, which continued or revived various features of classical style. The idea of Professor Neuss that the Beatus of St. Sever reproduces in its exceptional naturalistic forms the character of the original paintings is, in my opinion, mistaken—it is a Romanesque copy that owes its liveliness of movement and other un-Mozarabic qualities to its late origin in southern France. But here it is more interesting to note that art of such high quality was achieved in copying, however freely, a set body of existing works, just as a mediaeval monk transcribed the old text in the handwriting of his time. Can one imagine a painter today copying a hundred and twenty pictures by another artist with such freshness and delight and maintaining the distinctiveness of each image beside the next? The Beatus manuscripts make us realize how limited is our present conception of the artistic process, and how much it depends on the values of art and social life today. We are able, however, precisely through our own art and point of view, to appreciate these long-ignored mediaeval works as few observers could do during the last centuries before our time. I have had occasion to look at the older Morgan Beatus with painters and I have observed with satisfaction their strong response to this art. I do not think that I am fanciful in seeing in certain of Léger's works, painted during his stay in New York in the 1940s, the effects of his enthusiasm for this Spanish manuscript. A painting of Matta's, *Siempre Maltratada*, was directly inspired by the page representing the Woman of Babylon.

The stimulus to the writing and rewriting of the book—which is largely a compilation from older commentaries on the Apocalypse—was a dispute over the human person of Jesus: was he an adopted son of God or the incarnate Christ? How were the two natures in Christ related? In the text of the Apocalypse, Beatus found support for his own orthodoxy. Since the debate was between a rude, stuttering, vehement monk in the mountains of free Asturias, and the Archbishop of Toledo, Elipandus, who ruled his church under Moorish domination, and since it was the coarse provincial who accused the Toledan pontiff of the Adoptionist heresy, we suspect that the theological issues covered others, most likely political. Beatus got the support of the powerful Frankish court and its theologians, who at councils held in 794 and 799 denounced Elipandus. The formulations were so vague, the issues so unclear, it is hard to believe that one could fight over them—but perhaps that is why the fight was so bitter. In any case, the Apocalypse of John was often appealed to in the Middle Ages as an evidence in Christological disputes, and we owe to this doctrinal passion the commentary of Beatus on its text. (Another treatise by the

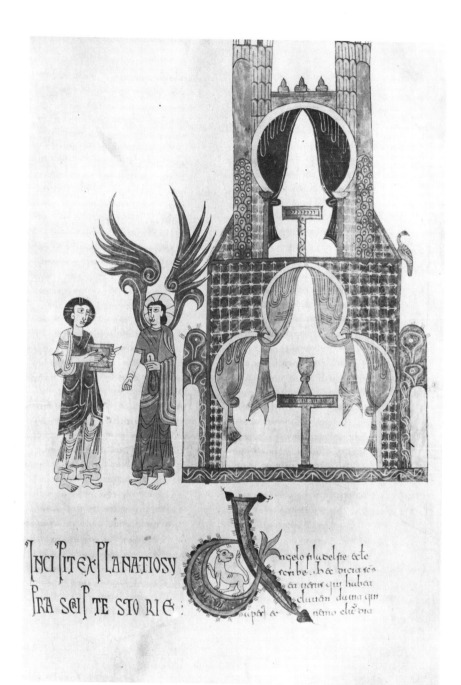

Fig. 3 Gerona, Cathedral treasure: Beatus Apocalypse, fol. 94. The Angel of Philadelphia.

Asturian priest, more purely polemical and without illustrations, was rarely copied.) It may be that what interested Christian Spain was the Apocalypse itself as an inspired book that foretold the victory over Antichrist, the destruction of Babylon (which was identified with the unbelievers), and the final triumph of God's people. The small mountain kingdom of Asturias, an outpost of Visigothic independence, felt itself to be engaged in a vast providential effort, while more civilized Toledo accepted Moorish rule and culture. The edition made by Beatus during the late eighth century, at a moment of revived resistance to the Moslems, possessed the value of a heroic national classic, a prophetic incitement of faith and will in a time of struggle. The illustrated text of Jerome's commentary on the Book of Daniel, which follows the text of Beatus in most manuscripts, confirms this interpretation; it prophesies the fall of the godless kingdoms and the restoration of captive Israel. This view of the political-religious sense of the Beatus manuscripts seems to me more plausible than the idea, which applies perhaps to some later apocalyptic imagery of the Middle Ages, that they are the products of millenary fears. All the copies of Beatus belong to the centuries of resistance and reconquest, and although the style has features of the Mozarabic art of Moorish Spain, the manuscripts were produced mainly in the Christian kingdoms. This origin explains the persistent element of drama in the paintings, unlike the Merovingian and Hiberno-Saxon arts of northern Europe, in which ornament and effigy replace action. On the level of formal fantasy common to the early arts of the new states established by the barbarian rulers of western Europe, this Spanish style is unique in its power of pictorial narration. Like these other postbarbarian styles, the Visigothic-Mozarabic has also a taste for great emblematic pages, transfigurations of ornament into arresting symbols; but the Spanish artists never lost the interest in history, the moving splendor of battles, resurrections, and redemptions. The fullness of episode and the heroic scale of the Beatus cycle make it a pictorial religious counterpart of the first Spanish epic, the poem of the Cid.

An Illuminated English Psalter
of the Early Thirteenth Century*
(1960)

Mr. William S. Glazier of New York acquired at the sale of the André Hachette library in Paris in December 1953 a Latin psalter with paintings of high quality which seem to have been completely unknown to students of mediaeval art.[1] These paintings, it will appear, form a unique series interesting also for their political meaning. The style of the miniatures and ornament, the handwriting, and the litany point unmistakably to England. What is more difficult to discover is the center where the book was made. Unlike most manuscripts of its kind, this psalter contains no calendar or inscription that permits us to infer the original owner.[2]

In content and format it resembles English psalters of the first half of the thirteenth century. The book has 182 leaves, 13 by 8⅝ inches, and is written in a large early Gothic hand, 20 long lines per page, on a script field 8³⁄₁₆ by 6 inches. Besides the psalms the text includes the nine canticles, the creed, the *Magnificat* and *Nunc dimittis*, the litany, several collects, and the office for the dead. After the six prefatory pictures, a magnificent illuminated *B* (Fig. 1) introduces the psalms. Smaller historiated initials precede Psalms 52, 101, and 109 (Figs. 2, 3, 4); and six other initials decorated with beasts and foliage complete the ten-part division of the psalter. The fable of the fox and the stork is represented in the *D* of *Dixi custodiam* (fol. 43). On every page of text still smaller initials, painted mainly gold, blue, or red, accent the beginning of each verse (Fig. 5); the empty spaces at the end of short lines are filled with colored pen scrolls of beasts and plant forms.

The six full-page paintings (Figs. 6, 7, 8, 9, 10, 11) depict: the Annunciation (fol. 1v), the Enthroned Virgin with the Child in her lap (fol. 2r), the Crucifixion (fol. 2v), Christ in Majesty (fol. 3r), David Playing for Saul (fol. 3v), the Coronation of David (fol. 4r). In the nine roundels of the Beatus initial (fol. 5v), we see David again playing before Saul, five musicians, two dancers, and David fighting with the lion. The initial of Psalm 52 (*Dixit*

* This article is the substance of a lecture given at the Warburg Institute in June 1957.

Fig. 1 New York, Pierpont Morgan Library: Ms. G. 25, Glazier Psalter, Psalm 1, fol. 5. Illuminated *Beatus* initial.

insipiens) shows four monkeys of whom two play instruments (fol. 57r); of Psalm 101 (*Domine exaudi*), Christ with two angels above three praying figures (fol. 107r); in Psalm 109 (*Dixit Dominus*), the *D* encloses God the Father seated beside Christ with the dove between them (fol. 121v) (Figs. 2, 3, 4).

In no other psalter with full-page prefatory paintings have I found the same choice. The first four scenes alone appear as a complete series in the related Amesbury Psalter in Oxford (All Souls College, Ms. 6).[3] In the Westminster Psalter (British Museum, Royal Ms. 2. A. XXII)[4] a cycle of five miniatures, we shall see later, offers some points of resemblance and in its subjects matches three of our scenes. The selection for the historiated initials is also singular, apart from the Trinity in Psalm 109, which is a common choice; it agrees, however, with many psalters of the late twelfth and early thirteenth century in the small number of figured initials.[5]

We shall understand better, I believe, the choice of the full-page pictures if we group the subjects in pairs, as they confront us in the open book: Annunciation—Virgin Enthroned (Figs. 6, 7); Crucifixion—Christ in Majesty (Figs. 8, 9); David Playing before Saul—David Crowned (Figs. 10, 11). In each of these pairs, an episode concerning a sacred figure is coupled with a scene of majesty. Mary, Christ, and David—members of one family line—are represented enthroned. The six paintings are images of a sacred dynasty, in action and in state.

Especially remarkable are the two scenes of David. The reader who is acquainted with Anglo-Saxon manuscript art will have observed already the resemblance of the first scene to the Nativity in the Benedictional of St. Ethelwold (Fig. 12), a work two and a half centuries older than our miniature. Saul assumes the posture of the Virgin; the servant behind him is like the midwife who adjusts the pillow behind Mary in the Nativity; and David replaces the figure of Joseph.[6] Not only the composition but something of the quality of the older drawing has survived in the new work, especially in the turbulence of the folds.

It is worth noting, too, that in other manuscripts the scene of David playing for Saul illustrates the psalm *Quid Gloriaris* (Psalm 51) and that Saul is often shown hurling the spear at David.[7] In the painting in Mr. Glazier's psalter, this element of violence is absent, although it is represented in the roundel with the same subject in the initial of Psalm 1 (Fig. 1). Like Rembrandt, centuries later, the artist has conceived the touching episode as a purely internal struggle of the feelings and their purgation by music. He has evoked the anguish of Saul in the constraint of his posture and perhaps also in the commotion of the folds of his bedclothes. One can imagine that the painter

Fig. 2 New York, Pierpont Morgan Library: Ms. G. 25, Glazier Psalter, Psalm 52, fol. 57. Illuminated initial.

Fig. 3 New York, Pierpont Morgan Library: Ms. G. 25, Glazier Psalter, Psalm 101, fol. 107. Illuminated initial.

Fig. 4 New York, Pierpont Morgan Library: Ms. G. 25, Glazier Psalter, Psalm 109, fol. 121v. Illuminated initial.

Nunc dimittis seruum tuū
domine: secdin uerbum
tuum in pace.
uia uiderunt oculi mei: salutare
quod parasti ante faciem tuū.
omnium populorum.
umen ad reuelacionem gencium:
et gloriam plebis tue israhel.
yrie eleyson. Xpe eleyson.
Xpe audi nos. Pater de
celis deus. miserere nobis.
ili redemptor mundi deus. misere
re nobis.
piritus sancte deus miserere nobis.
ancta trinitas unus ds miserere nob.
ancta maria ora pro nobis.
ancta dei genitrix ora p nobis.
ancta uirgo uirginum. ora p nob.
ancte michael. ora pro nobis.
ancte Gabriel. ora pro nobis.

Fig. 5 New York, Pierpont Morgan Library: Ms. G.
25, Glazier Psalter, fol. 172v. Litany.

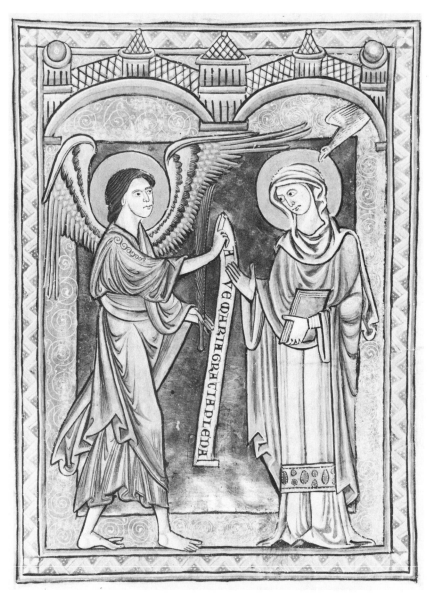

Fig. 6 New York, Pierpont Morgan Library: Ms. G. 25, Glazier Psalter, fol. 1v. The Annunciation.

Fig. 7 New York, Pierpont Morgan Library: Ms. G. 25, Glazier Psalter, fol. 2.
The Virgin and Child.

Fig. 8 New York, Pierpont Morgan Library: Ms. G. 25, Glazier Psalter, fol. 2v. The Crucifixion.

Fig. 9 New York, Pierpont Morgan Library: Ms. G. 25, Glazier Psalter, fol. 3.
Christ in Majesty.

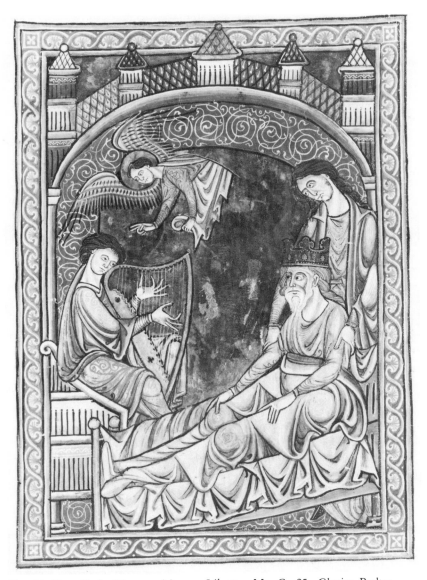

Fig. 10 New York, Pierpont Morgan Library: Ms. G. 25, Glazier Psalter, fol. 3v. David Playing Before Saul.

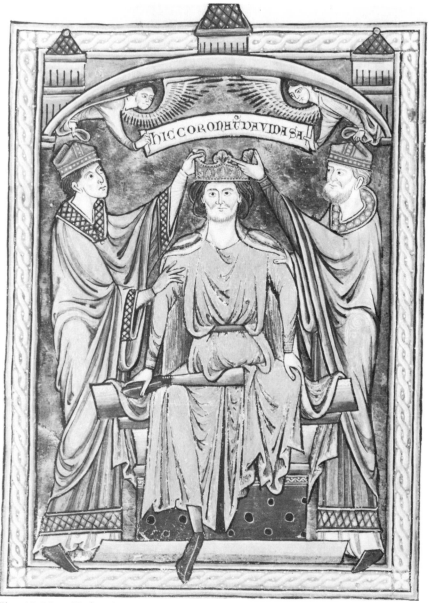

Fig. 11 New York, Pierpont Morgan Library: Ms. G. 25, Glazier Psalter, fol. 4. The Crowning of David.

found in the aspect of the woman after parturition a model for the depressed and suffering king, delivered of his passions by the psalmist's music.

Whatever his feeling for the pathos of the scene, the artist has been faithful in this choice of the moment to the text of I Sam. xvi, 14–16, which follows the episode of David's Anointing (I Sam. xvi, 13); the violence of Saul against David is told in later chapters (xviii, 10, 11; xix, 8). In the plan of illustration the crowning of David was evidently connected with Saul's possession by an evil spirit. The rejected ruler is contrasted here with the newly chosen king; in both scenes angels are set above David's head. Indeed, the divinely ordered replacement of Saul by David through the prophet Samuel was the most compelling biblical precedent for the assumed power of the church to depose an evil ruler.[8] As the page of Saul's illness recalls mediaeval ideas about the bad monarch, the following scene is saturated with political allusions.

The crowning of David (Fig. 11) is an image of the crowning of an English king. In representing this episode, the painter has not followed the text of the Bible; in the first book of Samuel (xvi, 13) Samuel anoints David, he does not crown him. The presence of two clerical figures beside the enthroned ruler is perhaps a "contamination" by the story of Solomon, who was anointed by the priest Zadok and the prophet Nathan (I Kings i, 34, 35). But there too we read nothing of a crowning. Clearly, the image pertains more to current English practice than to the Bible. The two figures in contemporary episcopal dress who crown the seated king correspond to the Archbishops of Canterbury and York, who claimed priority at the mediaeval rite. Without the inscription HIC CORONAT(ur) DAVID A SA(muele) it would not be easy to recognize the subject.

Ever since the Carolingian period, when Pope Stephen IV anointed and crowned Louis the Pious in Reims (816), calling him a "second David," the representations of anointings in the Old Testament became vehicles of the mediaeval notions about the sacredness of the king and the dependence of royalty on the church. In the ceremony of coronation in England, the anthem "Zadok the priest and Nathan the prophet anointed Solomon king" was chanted as a precedent for the church's role in the consecration of kings. Whereas in Byzantine art in the scene of the anointing David is always shown standing—a neutral posture that does not distinguish him from the attending figures—in Western art since the ninth century David often kneels before Samuel and still later is anointed while he sits on the throne. His posture expresses a local mediaeval view of the king's submission to the church or of the latter's authority in temporal affairs; it also reflects significant details of the *ordo* of coronation. In the twelfth and thirteenth centuries, during the conflicts between church and state, the anointing was an important issue; through this

sacramental rite the king was believed to become Christ-like, *sacerdos*, and could claim spiritual as well as temporal power. In opposition the papal party reduced the charisma of the rite by denying that the king could be anointed on the head like a bishop, by limiting the oil to the arms and shoulders, and prescribing for the ceremony the inferior oil of the catechumens rather than the chrism of the priests.[9] In England there are many images of the anointing of Saul, David, and Solomon, always on the head, and to these correspond pictures of a similar anointing of mediaeval kings. That is how the consecration of Edward the Confessor was represented on a wall of the Great Painted Chamber of the palace at Westminster under Henry III.[10] Two bishops anoint and crown the enthroned saintly king in the company of numerous clergy. But other pictures of coronations in English manuscripts show the mediaeval kings unanointed, precisely as in the Glazier Psalter.[11] In a copy of Matthew Paris's *Flores Historiarum* in Manchester (Fig. 13), Henry I, with legs crossed like the David in our miniature, is crowned by two bishops, but not anointed; while in another drawing in the same series a more spiritual and solemn figure of Edward the Confessor receives the holy oil (Fig. 14).[12]

In this manuscript, in which the crownings of kings are the only themes of illustration, one cannot infer too surely the significance of the anointing. Of the ten kings represented, two besides Edward receive the oil. The fact that the large majority are simply crowned and not anointed may reflect a reluctance to include the sacramental moment of the ceremony, if not indifference to it. But in representations of David in English psalters of the eleventh to the thirteenth century the anointing is so common that it may be regarded as essential; in very few works is David crowned without being anointed.[13] It is because of the frequency of the anointing of David in illustrations of the psalter (where the text, it should be recalled, speaks of his anointing), and because of the tendency to omit this important ceremonial detail in pictures of the coronation of mediaeval kings at this time, that the absence of the rite in the coronation of David in the Glazier Psalter may be regarded as significant.

It would be rash to suppose that in every instance the peculiarities of the rendering of a biblical scene of coronation express a contemporary attitude toward the anointing. Artistic types are often repeated indifferently and the foreign Byzantine image of David standing while anointed is too common in England during the twelfth and thirteenth centuries for us to seek a contemporary political meaning in all details of coronation imagery.

Nevertheless, the question can be raised in interpreting a work like the Glazier Psalter where the royal aspect of the whole series of miniatures is so pronounced and the enthroned David assumes a posture so distinct from the majesty of Christ and the Virgin. The same assertive worldly bearing is given to Alexander the Great in a contemporary drawing in Cambridge.[14] The leg set

Fig. 12 London, British Museum: Add. Ms. 49598, Benedictional of St. Aethelwold, fol. 15v. Nativity.

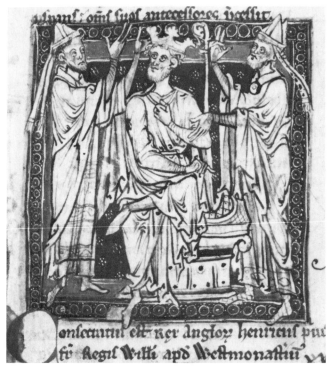

Fig. 13 Manchester, Chetham's Library: Ms. 6712, Flores Historiarum, col. 486. Coronation of Henry I.

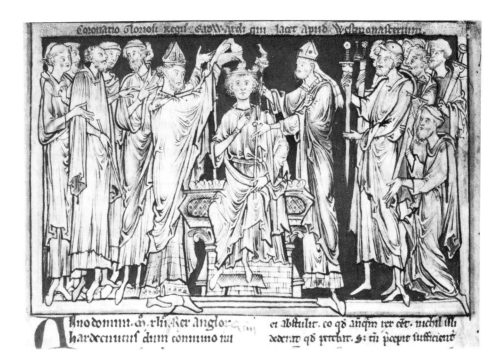

coronatio glonosi regis Edwardi qui Iaat apud Westmonasterium

Anno domini. dcxlii. Rex Anglo... et abstulit. eo qd aliquin rex cet. nichil illi
hardecnutus dum conuiuio tui dederat qd prebuit. S; tii precepit sufficiend

Fig. 14 Manchester, Chetham's Library:
Ms. 6712, Flores Historiarum, col. 433/
34. Coronation of St. Edward.

Sce Stephane. or ce quintine. or
ce clemens. or Sce albane. or
ce sixte. or ce osualde. or
ce corneli. or Sce eadmunde. or
ce cipriane. or Omnes sci martyres orate pnobis.
ce alexander. or
ce laurenti. or ce siluester. ij. or
Sce uincenti. or Sce hylari. or
ce georgi. or ce germane. or
ce fabiane. or Sce cuthberte. or
Sce sebastiane. or ce Benedicte. or
ce cristofore. or Sce leonarde. or
ce dionisi cu ce egidi. or
socus tuis. or Sce augustine. or
Sce eustaci cu ce gregori. or
socus tuis. or Sce swithune. or
ce ypolite cu ce dunstane. or
socus tuis. or Sce Remigi. or
ce mauricia ce audoene. or
cu socustuis. or Omnes sancti con

Fig. 15 New York, Pierpont Morgan
Library: Ms. G. 25, Glazier Psalter,
fol. 173v. Litany.

horizontally across the other knee is not true to nature, although it may approximate a real position. This physically impossible pose is an artistic type—perhaps a borrowing from Islam[15]—which justifies itself by its gestural force and is here made even more expressive through the closed knot formed by the hands grasping the ends of the extended leg. The perpendicular crossing of the legs was a variant of the widespread Romanesque convention of diagonally crossed limbs often applied to figures of pagan rulers, especially Pharaoh and Herod.[16] Although it seems appropriate to these malign personalities, the motif of the crossed legs is a general attribute of the ruler, whether good or evil; it isolates him from ordinary mankind, which sits or stands supported by both feet alike. Often what is significant is the contrast with the normal posture rather than an inherent expressiveness of the crossed legs as such. But in this contrast the posture may transmit something of the wilfulness of the despot and convey through nuances of form—through a particular tension or thrust—the spontaneity and arbitrariness of royal power. Its more general worldly sense is evident in the fact that some of the crowned musician elders of the Apocalypse on the tympanum of Moissac—figures who combine the sacred and the secular—sit like the David of our psalter with one leg placed horizontally across the other. In images of David the relaxed diagonal crossing is more common. In the Glazier miniature the rigid perpendicular form seems to be a posture of Superbia; the powerful, self-willed king bears himself erect and holds the extremities of his own limb like a scepter or sword, which bars the observer.

Shortly before Henry III ascended the throne in 1216, Pope Innocent III had affirmed the dissimilarity of the anointed king to the anointed Christ, and in England Stephen Langton, the Archbishop of Canterbury, who was to be a spiritual adviser of the young Henry, had written that the king is anointed not to the ministry, but to the service of the church.[17] During the first part of Henry's reign, when the psalter was painted, the meaning of the rite of anointment was still in question; an exchange on this point between Henry and Robert Grosseteste has come down, in which the philosopher-bishop restated the papal view that the consecration of the king by anointing does not give him the powers of a priest: "This privilege of anointing in no way places the royal dignity above or even on an equality with the priestly, nor does it confer power to perform any sacerdotal office."[18]

In a miniature in the Rutland Psalter, a book related to our manuscript, the artist has tried to picture the precise spiritual status of the consecrated monarch through various elements of David's coronation (Fig. 16).[19] One priest anoints, another crowns him, while Christ above holds in his veiled hand the disk of the sun, marked with the cross like a eucharistic wafer, in contrast to the moon on the other side. The artist seems to say with Robert Grosseteste

Fig. 16 Rutland, Belvoir Castle, Collection of the Duke of Rutland: Rutland Psalter
Anointing and Crowning of David.

that "the *sacerdotium* derived from heaven is greater than the *regnum* appointed for the earth," or with the theologian Honorius that the king, who receives his crown from the church, is to the priest as the moon to the sun.[20] In the Glazier Psalter, the king's claim to a priestly grace appears to be more drastically denied, since the anointing is ignored, and David is rendered in a thoroughly unpriestly posture in contrast to the royal figures of Christ and Mary on the preceding pages and contrary even to the aspect of Henry III on his seal, which the David image resembles in other ways.[21] I may quote here the words of Ernst Kantorowicz summarizing in another context the decree of Innocent III concerning anointment: the pope "expressly refused a Christlike representation to the Prince or the character of a Christus Domini."[22] It may be that the image conveys the point of view of a papal partisan who would limit the king's authority in ecclesiastical affairs and would at the same time derive the king's temporal power even more emphatically from his coronation by the church.[23] In the other paintings in the Glazier Psalter the primacy of the church as an earthly power is affirmed perhaps in the scepters given to the virgin and to Christ; in the picture of Christ in majesty, his eternity and absoluteness are spelled out: the traditional A and ω of his inscribed book is expanded—"Alpha et ω primus et novissimus, initium et finis, qui (est) A . ω " (Rev. xxii, 13).

It is possible to read these images in another sense, as an expression of the royalist view for which anointing is not indispensable to the legitimation of a king; the royalty of Christ himself precedes his anointing and is from all time ("ex eternitate divinitatis"). But it would be surprising for a defender of this view to connect the crowning of David by the priests with Saul's decline from grace.[24]

A detail of the litany may tell us more about the standpoint of the owner who ordered these paintings. The name Silvester, heading the confessors, is marked (*ii*) for double invocation (Fig. 15). Usually, such weighting of a name in a litany implies that the saint is the patron of the book's owner, whether an individual or a religious house. I have found no church or abbey dedicated to St. Silvester for which the psalter might have been written. But there were two outstanding English churchmen with that name in the first half of the thirteenth century: Silvester of Evesham, Bishop of Worcester from 1216 to 1218, and Silvester of Everdon, Bishop of Carlisle from 1246 to 1254. The first is mentioned by contemporary historians as among those present at Henry III's coronation in Gloucester in 1216.[25] It is tempting to associate the psalter with this Silvester. But he is an unlikely owner of the manuscript, which appears from its style to be later than his lifetime. Besides, the litany lacks the name specific to Worcester: St. Wulfstan, who was canonized in 1203.[26] The other Silvester was keeper of the great seal in 1244. In 1253 he was one of

three bishops who called upon Henry III to observe the liberties of the church; he was also among the bishops who in that year excommunicated the violators of the Magna Carta.[27] The litany seems to contain no features pointing to Carlisle; but since the manuscript is probably earlier than 1246, this is no serious difficulty for an attribution to the second Silvester.

The double invocation of the saint may refer, however, like the *ii* beside the name of Peter at the head of the apostles in the same litany, not to the vocable of a church or the name saint of an individual owner, but to the papacy as an object of special allegiance. For as Peter was the first pope, Silvester was the pope who in baptizing Constantine received the Roman empire from the converted ruler as the Church's property and marked—to quote Honorius again—the beginning of a new age in world history, the rule of the church.[28]

In the Westminster Psalter (British Museum Royal Ms. 2. A. XXII), with which the New York manuscript has much in common, both in the litany and the paintings, it is an English saint, King Edward, preceding Silvester, that heads the confessors in the litany and is invoked twice, like Peter. The choice of scenes anticipates by a generation the royal content of the series in the Glazier Psalter; the Virgin, Christ, and David are singled out in the same order in full-page paintings of their majesty.[29] But the idea is less clear-cut, less systematic, than in the later book: the Visitation as well as the Annunciation precede the enthroned Virgin and there are no episodes from the life of Christ or David. The latter is pictured crowned and on his throne, playing the harp; but the Virgin has neither crown nor scepter. Compared to this series, the paintings in the Glazier Psalter affirm in a more definite way the royalty of Christ and the Virgin while distinguishing it from the earthly and dependent character of David's kingship. If the litany of the Westminster Psalter stresses St. Edward, the name of the native royal saint—so dear to Henry III—is missing in the Glazier litany, which gives a greater importance to the papal and monastic elements. Germanus, Cuthbert, and Benedict are high on the list; following Silvester and Hilary among the confessors, they precede the secular saints and especially those of Canterbury: Gregory, Augustine, Dunstan.[30] The Glazier Psalter, I venture to say, was written in a monastic center in southeast England for a personality with a hierocratic point of view toward the monarchy.

To what historical moment it pertains is a delicate matter to determine, and not only because the date of the psalter is still unprecise—the style has suggested to different observers a time ranging from the end of the twelfth century to the 1240s.[31] Since the work is so largely a copy, what is politically significant in the miniatures and litany may refer to an earlier situation. The cycle in its present form might have arisen between 1208 and 1214, the period of sharpest conflict between the king and the church, when Pope Innocent III, who had declared his sovereignty over England, deposed King John at the

request of Stephen Langton and other bishops and ordered the French king to expel John and take possession of his throne. In those years could be conceived a series of pictures associating the replacement of Saul by David with the royalty of Christ. Later the pope was opposed by the English Church for supporting the king against his subjects and exacting burdensome levies. But the existence of a hierocratic viewpoint in the decades after 1214 is not excluded.

That the cycle of the Glazier Psalter was built in part on the Westminster Psalter (or a very similar book) is confirmed by the minute resemblance of details of the Christ in Majesty in the two manuscripts (Figs. 9, 17). The calligraphic ornaments of the text are almost identical. The same model of Christ in Majesty served another artist, contemporary with the master of the New York manuscript—the painter of the Lindesey Psalter (Society of Antiquaries, Ms. 59), which was made in London between 1220 and 1222. He apparently also knew the model of the Crucifixion in the Glazier Psalter: in his version the figure of Christ, the Italianate conception of the moon as a profile human head, and several other details are remarkably like our manuscript. Much in the latter recalls the art of St. Albans in the first half of the thirteenth century, where—according to some students—the Westminster psalter itself might have been executed toward 1200 for its royal owner.

In style of painting the Glazier manuscript is well advanced beyond the Byzantinizing phase of the Westminster Psalter with its compact massive figures. It announces the more articulated forms of the mid-thirteenth century and gives to the modeling and the lines, which retain a Byzantine aspect in many details, a restless, impassioned character, somewhat like the German painting of the same time (an art indebted to England). It is not clear to me whether the complexity of lines in our psalter, with the associated emotional note, is a new quality arising in reaction against the impassive solemnity of the Westminster paintings or simply continues with intenser modeling and natur-alistic detail a trend of expression already existing beside the other about 1200. Even that bold cast of the figures, which cross their frames and seem to project toward the observer, has precedents in earlier English art, although it owes its special force here to the painter's temperament. Byzantine (or Italo-Byzantine) types still dominate; they are obvious in the Annunciation, the Christ in the page of Majesty, [32] and in the Crucifixion (where the three nails are a new feature, purely Western), and are least evident in the two scenes with David, which have the strongest secular and contemporary reference. One may note as persisting Romanesque elements the gold inner background enclosed by a colored band and the vine scrolls drawn on the costume (Figs. 6, 9) as in several earlier psalters. [33]

At the same time the artist displays an advanced subtlety in color. In a

Fig. 17 London, British Museum: Ms. Royal 2 A XXII, The Westminster Psalter, fol. 14. Christ in Majesty.

scheme of dominant bright hues, he plays with small intervals and neutral tones. Grays and tans appear beside blue, red, and gold; a light blue is coupled with a light blue-gray. The many grays, warm and cool, and the varied contrasts of local hue with colored light and shadow—there are light blue or blue-gray shadows on a yellow field and a blue with yellow lights—lend a painterly freedom to the color; it is no longer a primitive filling of outlined areas despite the black contours. Even black and white work as colors and not simply as elements of drawing. In the Crucifixion John's yellow tunic is modeled with darks, the Virgin's orange-yellow tunic with olive-green. On faces the shadows are sometimes blue, sometimes the usual olive-green. In this choice of neutral and modulated tones, the painter continues and develops the art of the Westminster Psalter.

The style is less clearly of one piece than in works like the Lindesey or Amesbury Psalters. The master of the Glazier manuscript—a resourceful artist who employs more than one device in rendering the same element of nature—models by repeated lines as well as by solid shading. He is also surprisingly variable in the degree of finish and searching of forms. Often summary in marginal details and the accessories of the figures, especially the architecture, he allows himself some crudities of drawing—as in the Virgin's costume (Fig. 7) or the prominently dotted nipples of the crucified Christ (Figs. 8). The surface and decor of life interest him less than the human drama. His roughness in certain features suggests that in spirit he is no miniaturist—one might imagine him a mural painter who, having undertaken to work in a small format, is not perfectly at home with it. Yet he is capable of the minuteness and sustained invention of the great Beatus page (Fig. 1), an outstanding example in the series of such initials in English art. Compared to similar ones of the time, e.g., in the Lindesey Psalter, this *B* appears massive and architectural, like the plan of a huge tower or castle enclosing a world of living force.

In the variability of his forms we recognize not simply the mark of an individual, but also an unsettled stage in a historical transition, when new and old are incompletely fused in the same work. While retaining something of the severe forms of the previous art, he moves toward a more open play of lines. In emotional tendency as well as in types and details of composition, the Glazier painter is a forerunner of the Amesbury master, though less developed in the forms and lacking the elegance and sentimental pathos of that later generation, with its profuse curved detail. The Glazier manuscript, a more robust and rough-hewn work, appears closer to Romanesque art. It is not quite as advanced as the style of Matthew Paris, whose drawings, similarly bridging the Romanesque and Gothic, are of the second quarter of the century. Seen beside book paintings of the first quarter, the Glazier miniatures look more matured

in a Gothic sense than the Psalter, British Museum Royal Ms. I. D. X., which is dated before 1222; but they are not more modern than the Psalter of Robert of Lindesey, executed in London between 1220 and 1222.[34] They are also less consistently permeated by the new features of graceful line drawing in the miniatures of Trinity College, Cambridge, Ms. B. II. 4, probably of the 1220s.[35] The latter is one of a group of manuscripts attributed to that decade—including Cambridge University Ms. Kk. iv. 25, [36] the Castle Hedingham Roll (British Museum, Egerton Ms. 2849),[37] and the drawings in Emmanuel College Ms. 252[38]—which most resemble the miniatures of our psalter. (These have already been noted independently as members of the same family of styles by Dr. John Plummer.)[39] They share with the Glazier manuscript several themes and figure types (angel of the Annunciation, Crucifixion, the Virgin and Christ, the seated David) and minute elements of fold and contour. They are more slender, more linear, graphic cousins of the forceful Glazier style, and show a richer elaboration of the folds.

These works all belong to the St. Albans-London sphere. Since the Glazier master copied the Westminster Psalter (or its twin) and the undecisive litany is compatible with an origin in that region, the book can be localized there and perhaps in London itself. A date in the 1220s is the most consistent, it seems to me, with the known development of forms in the first half of the century. Further study, in fixing the time and place more exactly, will no doubt disclose some interesting connections with the later manuscripts and permit one to trace in a more accurate way the continuity of early and mid-thirteenth-century English art through the miniatures of the Glazier Psalter.[40]

NOTES

1. It was first described in the sales catalogue *Collection André Hachette, Manuscrits du XIIe au XVIe siècle,* Paris, Librairie Giraud-Badin, 1953, p. 20, no. 33, with a color plate (IX) of the miniature of the Annunciation. It is now G. 25 of the Glazier Collection—see the catalogue of the exhibition: *Manuscripts from the William S. Glazier Collection,* compiled by John Plummer, The Pierpont Morgan Library, New York, 1959, no. 17, pp. 14, 15, pl. 1, 3; and the account of the exhibition by Dr. Plummer in the *Burlington Magazine,* May 1959, p. 194. See also *The Glazier Collection of Illuminated Manuscripts,* catalogue and notes by Dr. John Plummer, The Pierpont Morgan Library, New York, 1968, pp. 22–23, with color plates I and IV.

2. On fol. I, a blank, is an old inscription: "121."

3. See Albert Hollaender, "The Sarum Illuminator and his School," in *The Wiltshire Archaeological and Natural History Magazine,* No. 179, L, pp. 230–62, pl. VI–IX.

4. See Eric G. Millar, *English Illuminated Manuscripts from the Xth to the XIIIth Century,* Paris and Brussels, 1926, pl. 62, 63.

5. For the choice of illustrations in psalter initials, see Günther Haseloff, *Die Psalterillustration im 13. Jahrhundert,* Kiel, 1938.

6. Cf. also the painting of the Dormition of the Virgin in the same manuscript

(fol. 102v) for a similar conception, with the added element of the angel overhead (G. F. Warner and H. A. Wilson, *The Benedictional of Saint Ethelwold, Bishop of Winchester 963–984*, Oxford, The Roxburghe Club, 1910). There is a related composition in the Bayeux Tapestry—the scene of the dying Edward (*The Bayeux Tapestry, A Comprehensive Survey by Sir Frank Stenton and others*, London, Phaidon Press, 1957, fig. 33). Cf. also the Nativity in the Sarum Missal of Henry of Chichester in the John Rylands Library, Manchester, Ms. Latin R. 24, fol. 149v (1252–64)—Hollaender, *op. cit.*, pl. II.

7. E.g., the psalter of the Duke of Rutland, fol. 55 (Eric G. Millar, *The Rutland Psalter*, Oxford, Roxburghe Club, 1937)—a full page painting that precedes an initial with a picture of a king slaying a bishop on fol. 55v (Saul commanding Doeg to slay the priests, I. Sam. xxii, 18).

8. Cf. Honorius, *Summa Gloria* (Migne, Patrologia latina, CLXXII, cols. 1259, 1260); Roger of Wendover, *Flores Historiarum*, ad 1166, for a letter of Thomas Becket to King Henry—translated by J. A. Giles, I, 1849, p. 551; the Song of Lewes (1264), line 446—Rex Saul repellitur, quia leges fregit (edited by C. L. Kingsford, Oxford, 1890). For the earlier texts and tradition, cf. Josef Funkenstein, "Samuel und Saul in der Staatslehre des Mittelalters," *Archiv für Rechts—und Sozialphilosophie*, XL, 1952–53, pp. 129–40. Saul and David are also cited as examples of kings elected and not hereditary by Archbishop Hubert of Canterbury in a speech at the coronation of John in 1199—Roger of Wendover, *op. cit.*, II, p. 18 (an added note attributed to Matthew Paris).

9. For the history of the coronation ceremony and of the associated ideas, I have followed particularly the books of Marc Bloch, *Les Rois Thaumaturges*, Paris, Strasbourg, 1924; Percy Ernst Schramm, *A History of the English Coronation*, Oxford, 1937; and Walter Ullmann, *The Growth of Papal Government in the Middle Ages*, London, 1955.

10. See E. W. Tristram, *English Mediaeval Wall Painting. The Thirteenth Century*, Oxford University Press, 1950, pl. 16 (after copies by Stothard and Crocker).

11. Cf. Pierpont Morgan Library Ms. 736, Life of St. Edmund.

12. For the whole series, see A. Hollaender, "The Pictorial Work in the 'Flores Historiarum' of the so-called Matthew of Westminster (MS. Chetham 6712)," *Bulletin of the John Rylands Library*, 28, Manchester, 1944, 361–81. It may be noted that the anointing is ignored in Matthew Paris's account of the coronation of Henry III in 1216 (*Chronica Majora*, Rolls Series, vol. 57³, pp. 1, 2) and in Walter of Coventry's *Memoriale* (Rolls Series, vol. 58², p. 233), though mentioned by Roger of Wendover (transl. Giles, II, p. 379).

13. There is an example in a psalter in the library of Durham Cathedral, Ms. A. II. 10, fol. 57.

14. University Library, Ms. Kk. iv. 25—see P. Brieger, *English Art 1216–1307*, Oxford, Clarendon Press, 1957, pl. 50. Cf. also the king, with hands touching knee and heel, who orders the martyrdom of John in the Anglo-French Apocalypse from St. Albans—Paris, Bibl. Nat., Ms. fr. 403, fol. 2 (L. Delisle and P. Meyer, *L'Apocalypse en Francais au XIIIe siècle*, Paris, 1900); a ruler in the Dublin manuscript of the Life of St. Alban, Trinity College, Ms. E. i. 40—Brieger, *op. cit.*, pl. 48a; and a related profile view of Pharaoh in Cambridge, Trinity College, Ms. B. 11. 4—Millar, *op. cit.*, pl. 68. For the posture in general, and its significance, see J. J. Tikkanen, *Die Beinstellungen in der Kunstgeschichte*, Helsingfors, 1912, pp. 163 ff. (Acta Societatis Scientiarum Fennicae, XLII).

15. For an early example in Islamic art in a Christian manuscript of 1180, see Paris, Bibl. Nat. Ms. Copte 13, fol. 1—a frontispiece portrait of Mark, the seventy-third patriarch of Alexandria. Related though not identical postures occur in the same manuscript in the pictures of Herod (fol. 104) and Pilate (fol. 131).

16. For an early example in the West, cf. a drawing of the biblical king Zedekiah, in Paris, Bibl. Nat. Ms. lat. 1822, fol. 42—early twelfth century, from Moissac.

17. For the text, preserved in Cambridge, St. John's College, Ms. 57, fol. 318v, see F. M. Powicke, *Stephen Langton*, Oxford, 1928, p. 109.

18. *Epistolae*, CXXIV (1245), ed. H. R. Luard (Rolls Series, XXV), pp. 350, 351. The translation is from Schramm, *op. laud.*, p. 129.

19. It precedes Psalm 26. ("Dñs illuminatio mea") of which the initial in many psalters contains an image of David's anointing. Alternative interpretations of the upper part of the Rutland miniature as illustrating "Dñs illuminatio mea" or Psalm 88—lines 21 and 38 refer to David's anointing and the eternity and perfection of his throne ("et thronus eius sicut sol in conspectu meo et sicut luna perfecta in eternum")—do not account for the special prominence of the sun held in Christ's veiled hand and its likeness to the eucharistic host, very different from the usual symmetry of sun and moon beside Christ in mediaeval art (or beside the enthroned king as on the seal of Richard I). The distinction between the higher and lower, the heavenly and earthly, seems to be implied here. Cf. also in Grosseteste's answer to Henry III his quotation of the words of Judah in the Testament of the Twelve Patriarchs: "Mihi dedit Dominus regnum et Levi sacerdotium; mihi dedit quae in terra, illi quae sunt in caelis; ut supereminet caelum terrae, ita supereminet Dei sacerdotium regno quod est in terra" (*op. cit.*, p. 350).

Professor Ernst Kantorowicz has kindly called my attention to Peter Lombard's gloss on Psalm 90, line 5 ("scapulis suis obumbrabit tibi")—abbreviated in the Canterbury Psalter interlinear gloss—which speaks of the sun as representing the divinity of Christ and the moon his humanity, and also the gloss on Psalm 88 in the same manuscript, with regard to the sun and moon: "dicit sol secundum animum, sicut luna secundum carnem." But these passages, too, seem to me less significant for the image in the Rutland Psalter, since they lack relevance to the sun-host.

20. *Summa Gloria*, Migne, Pat. lat., CLXXII, col. 1270: "sicut sol lunae, spiritus animae contemplativa vita activae, sic sacerdotium regno praeemineat."

21. Reproduced by Edward Edwards, *The Great Seals of England*, London, 1837, pl. IV, 2.

22. Ernst Kantorowicz, *The King's Two Bodies*, Princeton, 1958, p. 320.

23. Cf. Honorius, *op. cit.*, col. 1265—"ergo rex a Christi sacerdotibus, qui veri Ecclesiae principes sunt, est constituendus; . . . igitur quia sacerdotium jure regnum constituet, jure regnum sacerdotio subjacebit."

24. The omission of the anointing also makes it difficult to interpret the scene of David playing for Saul and healing his sickness of mind as an example of the consecrated monarch's thaumaturgic powers.

25. See Roger of Wendover, *op. cit.*, II, pp. 379, 380. The coronation took place in the presence of the papal legate; Henry did homage to Rome and to Pope Innocent before the altar and was then crowned and anointed. There was a second crowning at Westminster in 1220—*ibid.*, pp. 426, 427.

26. Roger of Wendover, *op. cit.*, II, p. 413, records Silvester's translation of St. Wulfstan in 1218 and his dedication that same year of a church of St. Mary at Worcester where he had been a monk and prior.

27. See *Dictionary of National Biography*, Supplement II, p. 196 (2nd edition, XXII, 621–622).

28. "Summa Gloria," cap. IV, Migne, Pat. lat., CLXXII, 172, col. 1264.

29. See Millar, *op. cit.*, pl. 62, 63.

30. The litany (fol. 172v–175r), after the apostles, evangelists, and disciples, reads: "Stephane, Clemens, Syxte, Corneli, Cipriane, Alexander, Laurenti, Vincenti, Georgi, Fabiane, Sebastiane, Cristofore, Dionisi cum sociis tuis, Ypolite cum sociis tuis, Quintine, Albane, Osvvalde, Eadmunde; Silvester ii, Hylari, Germane, Cuthberte, Benedicte, Leonarde, Egidi, Augustine, Gregori, Swithune, Dunstane, Remigi, Audoene; Maria Magdalene, Maria Egypciaca, Felicitas, Perpetua, Agatha, Agnes, Cecilia, Lucia, Katerina, Petronilla, Scolastica, Juliana, Margareta, Anastasia, Fides, Spes, Caritas."

The litany of Royal 2 A. XXII includes Thomas Becket, King Edward, and Alphege, and places Cuthbert, Benedict, Giles, and Leonard after Gregory, Augustine, and Dunstan—see J. Wickham Legg, *Missale ad usum Westmonasteriensis*, III, London, 1897, 1303 ff.

I have to thank Mr. Christopher Hohler of the Courtauld Institute for information about English litanies, which did not, however, yield a definite conclusion.

31. The early date is given in the auction catalogue cited in note 1; the later one was proposed by several scholars in the discussion following my lecture on the manuscript at the Warburg Institute.

32. Also Byzantine is the type of the Christ child in the Virgin's lap, with the exposed sole of his right foot.

33. E.g., the Canterbury Eadwine Psalter, the Copenhagen psalter (K. B. Thott 143, 2⁰), and the Westminster psalter; and later in British Museum, Royal Ms. I. D. X, Arundel 157, Munich Clm. 835, Cambridge, Trinity College Ms. B. 11. 4, Oxford, All Souls College Ms. 6 (the Amesbury psalter).

34. London, Society of Antiquaries Ms. 59—Millar, *op. cit.*, pl. 69, 70.

35. Cf. especially the initials of this psalter, fol. 100v, fol. 119v—Brieger, *op. cit.*, pl. 25; for the miniatures see Millar, *op. cit.*, pl. 68 and Brieger, *op. cit.*, pl. 23b, and the *Burlington Fine Arts Club Illustrated Catalogue of Illuminated Manuscripts*, London, 1908, pl. 37, no. 38.

36. See Brieger, *op. cit.*, pl. 41b, 50.

37. See *Burlington Magazine*, XXIX, 1916, pp. 189 ff., pl. II (Lethaby).

38. *Burlington Catalogue of Illuminated Manuscripts*, pl. 34, no. 35.

39. See note 1 above.

40. The lecture on the manuscript at the Warburg Institute was followed by a lively discussion. For a further interpretation of the six full-page miniatutes see the note by Professor Wormald, *Journal of the Warburg and Courtauld Institutes*, XXIII, 1960, p. 307.

On an Italian Painting
of the Flagellation of Christ
in the Frick Collection

(1956)

T he little picture of the Flagellation (Fig. 1) acquired by the Frick Collection in 1951 has called forth some sharply divergent opinions concerning its authorship. Like the Rucellai Madonna it has been ascribed to both Cimabue and Duccio. In this paper my chief concern is not to defend an attribution but to study certain elements of the painting historically in the hope that a fuller knowledge will help us to judge it better and to discern its place in Italian art.[1]

1.

Let us consider first the conception of the subject. Compared to other versions, what is most striking in the broad aspect is the sustained symmetry. The extended left arms of the flagellants form a horizontal line like the arms of a cross and—together with the long verticals of these strictly profiled figures, the paired background buildings, and the central column—give to the whole a static, arranged look, as if the scene represented a rite with a prescribed order. We may see it too as an emblem, even a monogram, reading the column as an I, the flagellants as an H, and Christ as an S enlacing the I, although this was hardly the painter's intention. At the opposite pole is the rendering of the subject in Duccio's *Maestà* (Fig. 2), where the action is conceived as a turbulent dramatic episode—here Pilate appears commanding the flagellation and a dense crowd clamors beside the figure of Christ.

In publishing the Frick panel, Millard Meiss observed a similar conception of the flagellants in two later paintings of the same theme.[2] One is on a crucifix in Perugia (Fig. 4), the other is part of a triptych in Berlin (Fig. 5). Although the position of Christ in front of the column distinguishes the first of these from our panel, we do not doubt there is some connection between the two works. Adapted to a narrower space, the postures of the flagellants in profile, raising

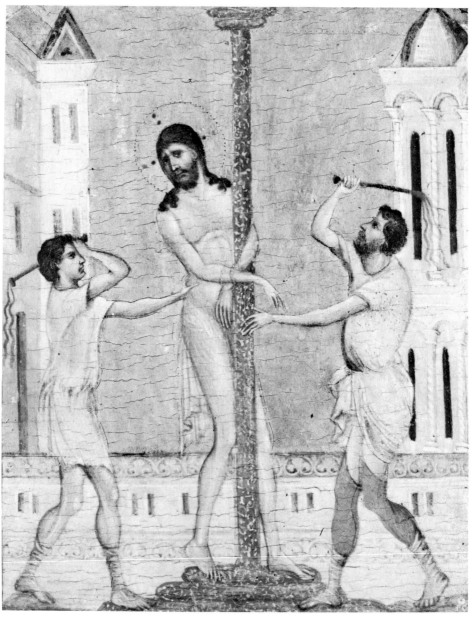

Fig. 1 New York, The Frick Collection: Tuscan School. The Flagellation of Christ.

their left arms to touch Christ's body (and other details, e.g., the unusual costumes), indicate a familial relationship of the Perugia version with the Frick panel. In the Berlin painting, too, there are obvious differences, but the connection with the picture in New York seems clear enough, especially if we take into account the varied representations of this subject. One detail will suffice: in both works the building at the left has a gable with a trefoil window.

There is a third example which has escaped Professor Meiss's attention and is particularly important because it is dated in 1260, some twenty-five to thirty years before our panel. It is a tiny miniature in the manuscript of the statutes of a confraternity of flagellants, the Battuti of Santa Maria della Vita in Bologna (Fig. 3).[3] Of unknown authorship, it has been ascribed conjecturally to the famous Oderisi of Gubbio whom Dante apostrophized as the leader in the art of illumination. Christ stands behind the column much like the figure in the Frick painting, and the two flagellants in profile—now mere silhouettes, their details having been effaced by some pious viewer's impulse of hate—extend their free arms to touch the body of the Savior. Beside this scene and within the same frame are painted a Cross with the instruments of the Passion and a half-figure of the Virgin holding the infant Christ.

This miniature is of extraordinary interest as a document of the nationwide epidemic of self-flagellation that broke out in Perugia in 1260. Prepared by the earlier preaching of the Joachimites and Franciscans, the movement seems to have been a defensive reaction of the despairing multitudes during the disastrous struggles of the imperial and papal factions in Italian civil life. According to old accounts, partly historical and in part legendary, the hermit Raniero Fasani, who led the movement in Perugia, also brought it to Bologna that same year. Immense processions of penitents marched half naked on the country roads and through the cities, scourging themselves and each other, with the memory of Christ's Passion in mind. This spontaneous outburst of flagellation had a lasting result in the establishment of confraternities devoted to penitence, prayer, and pious works. They inspired a new vernacular religious poetry and drama permeated by the intense feelings aroused during this social and religious crisis.[4] The great poem of Jacopone da Todi, *Donna del Paradiso*, which begins with the Flagellation of Christ, is a product of this movement.

> Donna del Paradiso
>> Lo tuo figliolo è priso.
>> Jesu Cristo beato.
> Accurre, donna, e vide
>> Che la gente l'allide:
>> Credo che llo s'occide,
>> Tanto l'òn flagellato.

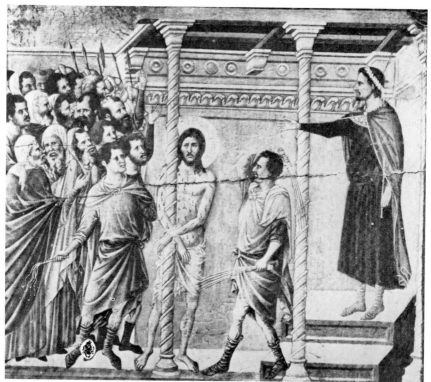

Fig. 2 Siena, Museo dell'Opera della Metropolitana: Duccio. Flagellation, detail of Maestà.

Fig. 3 Bologna, Biblioteca Communale dell'Archiginnasio: Statuto dei Battuti di S. Maria della Vita.

The connection of the Flagellation of Christ in the Bologna miniature with the flagellants, the so-called Battuti or Disciplinati, suggests the question whether this type of the scene owes its origin or at least its spread to these confraternities. In earlier art already the Flagellation of Christ is represented as a simple group of Christ and two scourgers, without Pilate or the Jews. Sometimes one of the scourgers extends a hand to Christ and breaks the regularity of the scene, so that the whole looks more episodic.[5] In a fresco of the Flagellation and Mocking in S. Urbano alla Caffarella near Rome, dated 1011, two scourgers touch Christ with their hands, but in decidedly asymmetrical gestures and as parts of a larger group of mocking and flogging men in the presence of Pilate.[6] Nowhere before the miniature in Bologna have I found in a Flagellation of Christ the distinctive symmetry of the extended arms, which in the Frick panel determines so evocative a cross pattern in the center of the field. This form arose perhaps from the sentiment of the contemporary penitents for whom flagellation was a frequently reenacted rite. The Flagellation of Christ was conceived like a Crucifixion, with the distinctness and concentrating order of an emblem or cult image. It might have been inspired by a picture of martyrdom where the saint is held by two symmetrical figures at his sides,[7] or even by a Byzantine Flagellation of Christ such as the miniature in the Paris manuscript, Bibliothèque Nationale grec 74, where Christ stands with arms outstretched supported on the shoulders of two men, while he is scourged by two others behind him.[8] But here the column is missing and the additional figures of Pilate and the Jews give the action a dramatic, historical note.

A more general connection of the new type of the Flagellation of Christ with the confraternities is indicated by the two other Italian examples already mentioned. The crucifix in Perugia is a double-faced processional cross, with the crucified Christ painted on the front and the Flagellation on the back.[9] The choice of the Flagellation as a unique scene on the back of a cross, a choice exceptional in Italian art, becomes intelligible if we assume that the crucifix was designed for a confraternity of flagellants. The assumption is confirmed by a banner of the fourteenth century, in the Metropolitan Museum of New York, painted by the Florentine Spinello Aretino for a confraternity of Battuti in Gubbio. On one side is the crucified Christ (held by Mary Magdalene); on the other is the Flagellation.[10]

In a similar way, on the Florentine tabernacle in the Berlin Museum (Fig. 5) the Crucifixion and the Flagellation are paired on the right wing as the only scenes from the Gospel. The whole is a triptych with the half-figure of the Virgin and Child in the center and four saints at the left. Here again the choice of the two Gospel themes points to a confraternity of flagellants.[11]

The fact that the oldest known example of the type of Flagellation in the Frick panel is found in the statutes of a confraternity of Battuti, and that the

Fig. 4 Perugia, Galleria Nazionale dell'Opera: Painting of the Flagellation, detail of a crucifix.

Fig. 5 Berlin, Staatliche Museen: Tabernacle, Flagellation (detail of Fig. 12).

two other examples of this type belong to works that strongly suggest a similar origin or association, permits us to suppose that the Frick panel, too, was made for such a group. Independently of these considerations, Professor Meiss has inferred from the treatment of the edges of the panel and its dimensions that it was originally in the lower right corner of a triptych, with a Madonna and Child.[12] This is the position of the same scene on the Berlin tabernacle.

2.

A singular detail of the Frick panel, not found in the other three examples, may reflect the religious moment.

In judging the work, the observer cannot help but notice the odd form of the base of the column. It is a primitive pedestal with two flat, round slabs, uniformly convex in profile and much broader than an ordinary base of the period. As if he were representing a distinct "order," the painter has designed a corresponding form of capital, with two smaller slabs of the same rustic character as those of the base. All these horizontal members have the reddish color of the column, but are in sharpest contrast to its slender proportions. It is surprising that the painter who drew the normal Romanesque capitals and bases of the colonnettes on the building at the right could lapse into so ungainly a form. We can hardly suppose that even an assisting apprentice would deform the canonical type of base in this degree, unless the deviant shape had some meaning in the scene. A similar base, with three broad, convex slabs, in a somewhat earlier version of the Flagellation on a triptych in Perugia[13] suggests that we are dealing here with a significant type rather than with the clumsiness of an unskilled painter.

It is possible that the painter's conception was influenced by the religious plays enacted by the flagellants. An inventory of the fourteenth century in Perugia lists a column and two scourges among the stage properties of a confraternity of Battuti.[14] A portable wooden column, painted to simulate a stone surface, with a wooden base broad enough to provide a support for both the column and the actor in Christ's role, might have been the model of the form in the picture.

In this article, as originally printed,[15] I had conjectured that the uncanonical form of the base was inspired by the broad flaring shape of the base of the truncated column of the Flagellation preserved in the chapel of San Zeno in the basilica of Santa Prassede in Rome (Fig. 7). According to a later tradition, it had been brought there from Jerusalem in 1223 by the Cardinal, John Colonna, who was at one time the papal legate in Perugia.[16] I had mistakenly supposed that the reddish color of the column in the Frick painting represented the color of the relic which was described in old guidebooks and in

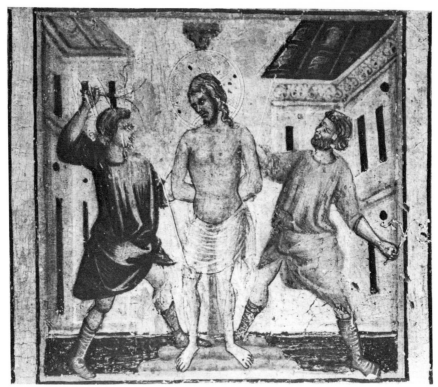

Fig. 6 Oxford, Christ Church Library: Detail of a tabernacle.

Fig. 7 Rome, Santa Prassede: Relic of the Column of the Flagellation.

a recent book on the churches of Rome as of blood jasper.[17] It is actually of "black jasper" and was first mentioned as in its present place in the fifteenth century.[18] The red color was perhaps suggested by accounts of the purported columns of the flagellation standing in the chapel on Mount Sion and in the court of the Holy Sepulchre. Saint Jerome in his *Encomium of Paula*, speaking of her pilgrimage to the Holy Land, mentions her seeing the column of the flagellation stained with the Lord's blood—"infecta cruore Domini."[19] According to the *Meditations on the Life of Christ* by the pseudo-Bonaventure, the original column showed traces of Christ's blood—a fact for which the author cited the testimony of unnamed historians.[20]

If the Frick panel were the only work in which the gesture of the extended arms of the flagellants occurred together with the broad-based column, the latter would be less significant for the history of the emblematic type of the Flagellation. But there is another painting which includes both these features: a panel in the library of Christ Church, Oxford, part of a tabernacle with numerous scenes from the life of Christ (Fig.6), surmounted by a half-length figure of the Virgin with the Child.[21] Here Christ is bound with his back to the column, as in the Perugia Crucifix (Fig. 4), which this scene recalls in other respects. The symmetry of the scourgers is less pronounced than in the Frick painting. The band of palmettes on the cornice of the right building is like the ornament on the wall in the background of the Flagellation in New York. The precise connections are uncertain, but one may conclude that the Oxford panel, painted some decades after the Frick and probably later than the Perugia Crucifix, reproduces a variant of the Bologna type which was also known to the painter of the Crucifix. The earlier occurrence of the broad-based column on the triptych in Perugia, the home of the Crucifix, suggests a local Perugian source of the motif. It was perhaps in Umbria that the latter detail was first combined with the type of the Bologna Flagellation.

3.

We turn now to an element of the picture which seems to be unique and independent of the religious content of the scene. It is the posture of the left figure who prepares to flog Christ with a backhand movement of the right arm. In attributing the panel to Duccio, Professor Meiss has insisted on this detail in particular as an original invention of great significance. "The Flagellation," he writes, "is a revolutionary work . . ." and the position of the left scourger's arm is for him its "most astonishing aspect" "This bold movement, involving foreshortening and a highly developed sense of space and bodily function, is unique in the painting and sculpture of the late Dugento, and uncommon, at least, in the early Trecento . . . This gesture, as well as the figure to which it

belongs and the one opposite, must be accorded a place among the most remarkable innovations of the *stil nuovo* in the late thirteenth and early fourteenth century. No other forms of the time disclose more clearly the appearance of the style and the mentality that, in the later phase of their development, we call Renaissance."[22] And since he has found a similar posture in classical works, this backhand stroke of the flagellant's arm becomes a support for Meiss's hypothesis that Duccio's style was inspired directly by antique art.

So extraordinary a form surely deserves a careful study, which must consider above all the approach to the form in earlier and contemporary works. But for a history of the form, it is necessary to distinguish the represented movement from the schema or manner of representation; this depends in part on the point of view of the artist-observer. Otherwise one can hardly interpret properly an archaic image or any rendering of natural forms where movement and depth are subject to conceptual constructions. It should be said at once, however, that we lack serious studies of posture and movement in the Italian art of this time. The following observations are far from complete.

The position of the left flagellant's arm in the Frick panel was not simply an element of style, but an actual stroke known to the Middle Ages; it was represented in pictures of battle scenes since the twelfth century[23] and described in literature. Clear examples occur in the psalter of Saint Louis which dates from the years 1253–1270 (Fig. 8).[24] The backhand blow from left to right of a weapon held in the right hand over the left shoulder was called the "coup de revers" in Old French[25] and "riverso" or "rovescio" in Italian. It is the "awk" or "awkward" stroke of the mediaeval English romances.[26] Malory wrote: "And therewithall sir Trystrames strode unto hym and toke his lady from hym, and with an awke stroke, he smote of hir hede clene."[27]

I cite these literary parallels not as proof of a mediaeval origin of the stroke, but only to show—what is perhaps obvious without the texts—that it belonged to experience as well as to art. The reverse stroke was also practiced in antiquity and in the Orient. What concerns us more, however, is the way in which it was represented.

In many works of the thirteenth century and earlier, particularly in scenes of martyrdom and sometimes in the Flagellation of Christ, it is shown frontally.[28] The head of the executioner may be in profile or three quarters, but the body faces the observer, and the raised arm, together with the weapon, is completely visible in front of the body.[29] Although the limbs are disposed parallel to the surface, this type is not without suggestion of depth; the whole figure is set in a balanced counterpoise of parts which betrays a classic ancestry. We would not expect this form in an old Oriental work. In Western mediaeval

Fig. 8 Paris, Bibliothèque Nationale: Ms. lat. 10525, Psalter of St. Louis.

art, it depends on a Byzantine type that recurs often in the Menologium of Basil II.[30]

The profile presentation of the movement, with the weapon partly covered by the head, is less rare in Dugento art than Professor Meiss has supposed. If it is unknown in earlier images of the Flagellation, it appears in other themes. In a miniature from Verona (Vatican Ms. latin 39), the figure of Christ driving the money-changers from the temple holds a rod over the left shoulder in the same way (Fig. 9).[31] The precise date of the manuscript is unknown, but it is surely earlier than the Frick panel. A related profile rendering can be found in the battle pictures cited above.[32] Here, too, we must admit a Byzantine source. Uncommon in Western art before the twelfth century, this profile view of the reverse stroke, with the overlapping of the weapon by the head, occurs throughout the tenth and eleventh centuries in Greek works of which several have been preserved in old Italian collections. Most often in these examples the head is turned back in profile in a direction opposite that of the arm (Fig. 10).[33] There are, however, Greek versions of the same stroke with a common profile of head and body, as in the Frick panel.[34] Since the costume of the two flagellants in the latter is unmistakably Byzantine, the dependence of the Italian form on Greek tradition seems even more probable.[35]

If all this is correct, it may still be asked whether the painter of the panel, in his search for visual truth and harmony of movement, has not gone beyond the Byzantine type by flexing the arm somewhat more acutely and inwardly.

Meiss, we have seen, regards this figure as an early instance of foreshortening which, together with the litheness of the body and the balanced structure of the limbs in action, anticipates the ideal of the Renaissance. But the distinction between the movement and the mode of representation is not altogether clear from his discussion. We are uncertain what aspect of the form he derives from a classic model. If it is the foreshortening of the forearm—a visual fact—we do not find this represented in the Greek example reproduced in his article, a vase painting of the early fifth century B. C.[36] There the forearm, largely covered by the head, is drawn parallel to the plane of the image, and the suggested sword stroke is as much downward as across. If it is the movement itself of arm and whip in a reverse stroke in depth normal to the picture plane, this is not convincingly illustrated by his other classical examples. Both are modern restorations: one contains no weapon and the other shows an arm bent parallel to the plane of the background.[37] The one instance he recalls of the reverse stroke in later Florentine art—in a Flagellation by a follower of Bernardo Daddi—also lacks foreshortening.[38]

In the Frick panel the foreshortening is only intimated, not realized. I do not see it as the "bold extension back into space" which Meiss has described. The painter wishes indeed to represent an arm receding in depth, but he draws

·cvs·

bic peccata nra.
tueniut rurfus ierllm̃a. Et
cũ ambulaueris inteplo acce-
duunt adeũ sũmi sacerdotes
scribe ⁊seniores ⁊dicunt illi. Inq̃
potestate hec facis. ⁊quis dedit ti
bi hanc potestat̃ ut ista facias.
Ihs aut Bene ait. ī́l. Interogabo
uos ⁊ego unũ ibũ ⁊respõdete m̃
⁊dicã uob inqua potestate hec facĩ.
Baptism̃u iohis decelo erat. An ex
hõibz. Respondebant m̃. At illi cogita
bant secũ dicentes. Sidixim decelo
dicet. Qr ⁊g nõ credidistis illi. Si
dixerim ̃ exhoĩbz timem̃ ⁊plin. Oẽs

cñi habebant iohm quia uere ꝓ
pheta erat. Et ꝑpndente dicunt. ihu
nescim̃. ⁊Bene ihc ait ill. neqʒ ego
dico uobis inqua potestate hec faciã.
t cepit illis imparabolis loqui
Vinea pastnauit hõ ⁊sepe cir
cũdedit eam. ⁊fodit lacũ ⁊he
dificauit turrī. ⁊locauit eam a
gricolis ⁊pegit pfectus ē. Et misit
ad agricolas inꝑ suũ ut abagri
colis acciper̃ defructu uinee. Qz ꝑ
prensũ cũ cederẽ. ⁊dimiser̃ uacuũ.
Et itm̃ misit aliũ seruũ ⁊illũ inca
pite uulnerauer̃. ⁊contumeliis fe
cer̃. Et rursũ aliũ misit ⁊illum

Fig. 9 Vatican City, Biblioteca Vaticana: Ms. lat. 39. Expulsion of Money
Changers from the Temple.

it in full length, with little if any perspective effect. It is drawn no shorter than the corresponding arm of the right figure which is silhouetted above the head in profile, parallel to the background.[39] This is an interesting example of the process of accommodating a new perception of depth to an older habit of surface design. To represent the arm bent inward across the body—a movement in depth—the painter has lifted the upper arm diagonally in the plane of the panel and drawn the forearm in profile in its actual length when flexed, keeping the parts as complete and distinct as possible; he has also brought the left shoulder forward to reveal the other arm fully, as in old Egyptian art. The elbows of the two arms are in a vertical line, although the arms are not extended at the same angle. For this movement of the limbs, the position of the right arm is impossible. There is a related solution in the Egyptian relief of the eighteenth dynasty from Memphis, showing the funeral of a priest (Fig. 11). The sculptor has devised a silhouette of a mourner's body in profile much like the left figure in the Frick panel, with the right arm and hand bent back and overlapped slightly by the head, the left upper arm extended horizontally.[40] But in that remarkable work, which belongs to the emancipating moment of the great Akhnaton, the shoulder is kept in strict profile; in this respect, the Egyptian sculptor was freer and relatively more advanced, one can say, than the Italian painter of the Frick panel.

By the time the panel was made—toward 1290—Italian artists had already begun to study seriously the play of foreshortened bodily forms in depth. The great master who painted in Assisi the frescoes of Isaac with Jacob and Esau created the most impressive solutions of this problem. There the foreshortening of arms and hands is powerful and constructive; it does not preserve the familiar silhouette of these parts but, in transforming the latter, accents the mass and the space, projecting the foreshortened modeled forms in strong relief forward and backward in depth. In another early fresco in Assisi, Joseph and his Brothers, attributed to the young Giotto, the stolen vessel held by the accusing servant is rendered in a decided perspective foreshortening.[41] Beside these fresh masterly realizations, the drawing of the Frick panel looks summary and unsure. Its author knows the new tendency—the movement of the arm might have been copied from a more advanced work—but his own style is not as searching, not as progressively oriented to the conquest of bodily movement and space. He is bound more to the surface network of lines and to delicate contrasts of color as the chief carriers of the religious values of the scene. The drawing of the bent arm, like the angular view of the building with which it coheres, creates a shallow bas-relief rather than a deep-set object in the round. The upper parts of the two buildings inscribed in the corners and touching the frame, the primitive silhouetted ground-plane so close to the lower edge of the panel,[42] provide a measure of the painter's interest in depth. From

Fig. 10 Milan, Castello Sforzesco: Byzantine ivory casket, tenth century.

Fig. 11 Berlin, Staatliche Museen: Egyptian relief from Memphis, Eighteenth Dynasty. Funeral of a priest.

the standpoint of natural articulation, his rendering of the reverse stroke is an archaic solution; the bent arm is attached to a body that is not organically adapted to the movement, although the outline of the figure forms a smooth arabesque. Hence the air of ceremonious deliberateness in the gesture, the stiff bearing of the whole body. Set in strict profile, with an arm extended forward to Christ, the flagellant is not a labile structure in free motion, but an element of the rigid framework of the three figures, the column, and buildings. This is an expressive parti-pris which must limit the naturalness of movement in the whole, while serving the religious effect.

Already before this time, Western artists less advanced than the painter of the Frick panel had sought in the figures of the flagellants a more active counterpoise of the limbs. Circling about Christ in contrasted positions, sometimes seen from behind, they swing the scourges across their bodies from side to side. Their limbs are not constrained to move in a plane parallel to the surface, but in big radial gestures sweep out a complex form in three dimensions. Their bodies possess three degrees of freedom—if one may use here the language of mechanics. In the Flagellation in Pistoia by Salerno di Coppo (dated 1274),[43] the two scourgers seem to rotate as they wield their weapons; and this rotation in depth is still more vehement on the triptych of Perugia which contains the broad-based column.[44]

4.

What can we conclude about the authorship of the panel from these observations?

From our study of the religious content, very little, although the connections with the Battuti point to the milieu for which the work was made or which inspired at least certain aspects of the conception. A Perugian link in the transmission of the type may be suspected. Whether it was a native artist or a Tuscan employed in Umbria who first combined the cross schema of the Bologna miniature with the relic-column, I cannot say.

But the study of the posture of the left flagellant permits us to gauge more clearly the painter's style in relation to the progressive art of the time.

The bent arm, we have seen, is a Byzantine motif, applied in the sense of the new Italian art of the 1280s, but without the energy of the foreshortenings in the works of the most advanced painters. It is like the perspective of the flanking towers, which the author of the Frick panel still renders in the old Byzantine manner, as if from a bird's-eye view, ignoring the eye level of the figures. By that time the painters in Assisi, building on older Romanesque art in Rome, had already employed the descending convergent roof line and created a deeper, more tangible setting for religious scenes.

A profound originality has been claimed for the tragic sentiment of the work;[45] but this, too, rests, I believe, on unconvincing comparisons. If the artist does not present a harassed, bleeding Christ, marked by the whips, it is not because he wishes to express a new vision of the nobly resigned, suffering figure who ignores his tormentors.[46] There is a nuance of anxiety in Christ's contracted brows and his unstable stance. As for the smooth, untouched, elongated body, it conveys rather the ideal aspect of Christ before the scourging begins, as described by the pseudo-Bonaventure: "Naked he stands before everyone, young and graceful and modest, beautiful in form among the sons of men."[47] The comparison with the impassivity of the crucified Christ on the *Maestà* in Siena seems to me far-fetched; there the figure is dead, and the limp suspension, without agony, is shared by the thieves. How Duccio conceived serenity in suffering we can see in the Christ of the Flagellation in the same work (Fig. 2).

The subtle gesture of the hand of the right flagellant extended to the column to steady the figure in movement, without touching Christ's body, is no invention of the painter, as Meiss has supposed.[48] The same gesture occurs in an older Romanesque miniature from Salzburg which was perhaps based on an Italian model.[49]

If these elements were revolutionary innovations of Duccio, a fundamental advance toward the art of the Renaissance, it is surprising that he abandoned them all when he came to paint the same subject about fifteen or twenty years later. I have remarked before how completely different is the dramatic, even realistic, conception of the scene on the *Maestà*. The special context of the Frick panel, possibly executed for a confraternity of flagellants or derived from such a work, might account for the accented symmetry or cult aspect of the image, exceptional in Duccio's smaller panels. The difference in date might also explain some significant changes in style. But since the attribution to Duccio rests in part on similarities to details of other scenes on the *Maestà*, it is permissible to compare our panel with Duccio's later rendering of the same subject (Fig. 2). In the corresponding parts, the Frick painting has a more languid, sinuous, ornamental rhythm of lines, a less varied structure in parallel or paired forms. In the *Maestà*, Duccio has forgotten the tall superhuman Savior and those gestures of the flagellants which have been judged so original and refined. His bleeding Christ is more detached and resigned than the Christ of the Frick panel, whose posture betrays fear of the awaited torment. Where he once followed the tradition that the column—a detail not mentioned in the Gospels—was a freestanding member in the praetorium of Pilate, he conceived it later according to another tradition, as a supporting column in the temple at Jerusalem.[50]

If Meiss is right in dating the panel shortly after the Rucellai Madonna

(1285)—and this seems to me plausible, although a date nearer to 1300 is not to be excluded—then it should be observed that Duccio already admits elements of Gothic architecture in the latter, while in the Frick panel the forms of the arches are still Romanesque. In comparing the tall arcature of the right building with that of the throne of the Rucellai Madonna, Meiss has ignored their great difference in style, particularly in the trilobed arches under an embracing archivolt on the second step of the throne and the pointed lancet forms on the side.[51] (Gothic details occur also on the Paliotto of Saint Peter in Siena, a work which Meiss regards as an immediate forerunner of Duccio's art.) The architecture alone would make us doubt Duccio's authorship of the panel.

On the other hand, the conception of the buildings has a more evident connection with the Florentine and Pisan schools. The cloister vault of the right building was at home in the architecture of both Florence and Pisa. The inclined roof and gable of the left tower, with the trefoil window which I have noted before in the Berlin triptych, appear in the mosaics of the Florence Baptistry[52] and in the work of Cimabue's following in Assisi.[53] The uncommon rendering of this roof and gable is perhaps more symptomatic; in the Frick painting the rising roof ridge, seen from above, starts well below the peak of the gable and, with the latter, is neatly inscribed in the corner of the panel— two features approximated in a Florentine drawing of the Annunciation in the Uffizi[54] and in the ancona of St. Catherine in Pisa,[55] a work of the later thirteenth century influenced by Florentine art. This design of the roof and gable is an extremely schematic treatment of a contemporary building form much used in Tuscany and Umbria. In the structure at the right, the painter attempts a stronger relief in the arcatures and the vault; but the angle of the two walls is awkwardly designed, even confused. All these details point to an artist in the Florentine or neighboring milieu who has not fully absorbed the newest inventions—the deeper, more modeled and elaborate background architecture—although the forms of his buildings harmonize with the figures and contribute to the whole.

Beautiful as the painting is—among the works with this type of Flagellation it is the most refined, the most considered in form—I do not share Meiss's high estimation of the artistic and spiritual level of its author. The comparison with the Rucellai Madonna and the Madonna with the Franciscans only convinces me of the lesser stature of this painter. His art is not of the precocious and epoch-making quality that Meiss has assumed in identifying him with Duccio. If he shows an affinity with the latter in line and color and in details of bodily form, and if, on the other hand, he recalls Cimabue, particularly in his figure of Christ, the question to be posed is not: Duccio or Cimabue? but by which of these men the artist was formed—if these were in

Fig. 12 Berlin, Staatliche Museen: Tabernacle.

fact the only masters capable of forming the author of the panel—whether he comes from Florence or Siena or from some neighboring center influenced by both.[56] The answer is not easy, since, in spite of the dominance of several great personalities, Tuscan art of this time is exceedingly mixed through the continual movement of artists and interchange of ideas. In pronouncing the name of the Sienese master, Meiss has recognized the softer, delicate note which is un-Cimabuesque, and the characteristic Ducciesque construction of the space, piece-meal and decorative, which often ignores consistency, setting forms in depth in naturally incompatible positions. But Meiss has also admitted the importance of the Florentine milieu for the Frick panel in placing it during or shortly after Duccio's stay in Florence. The Perugia crucifix and the Berlin triptych, on which he has found versions of the Flagellation related to the Frick panel, both depend on Cimabue's art.[57] And the example in Christ Church, Oxford, though it has Sienese and Roman-Umbrian characteristics, seems Florentine in its core. But none of these works is close enough to the Frick painting in style to determine our judgment, and all of them, particularly the first and the third, show how complex was the cross-breeding of types and styles during this period.

Though many details of our panel can be matched in Florentine works, they are all possible in the art of an assistant or pupil of Duccio active in Florence around 1290 or later. The type of halo, the curly hair of Christ falling widely on the shoulders, the elongation of the bodies (more pronounced than in the known works of Duccio, but not uncommon among his followers), the Cimabuesque folds of Christ's transparent loincloth, the clothes of the flagellants, the palmette ornament of the wall (as in the Madonna of the Servites in Bologna), all these familiar Florentine elements could be adopted by a member of Duccio's shop—perhaps one who painted some of the medallions on the frame of the Rucellai Madonna—without affecting essentially the Ducciesque core of his style. If the quiet, the sparseness and regularity of the forms suggest the goals of advanced monumental painting in the late thirteenth century, it is another sentiment of the whole that governs this work: not a search for the natural and the dramatic in austere, powerful shapes, which defines the effort of the great Florentines, but a more passive, intimate mood of religious meditation and a blander, decorative style. I believe Meiss is right in discerning basic Ducciesque qualities in the panel, granted the Florentine elements, although I cannot agree with his judgment of the painter's originality and value. Those more expert than myself in the study of Italian painting will be able, I hope, to demonstrate a more compelling attribution.

NOTES

1. This article arose from a question addressed to me by Millard Meiss concerning the figures of the flagellants and would not have been written without the stimulus of his searching study: "A New Early Duccio," *The Art Bulletin*, XXXIII, 1951, pp. 95–103. [See also "The Case of the Frick Flagellation," *Journal of the Walters Art Gallery*, XIX–XX, 1956–1957, pp. 43–63, for his comment on the present article.]

I wish to thank Mr. Franklin Biebel, director of the Frick Collection, for the opportunity to study the picture more closely and for the permission to reproduce the photograph (Fig. 1).

2. *Op. cit.*, p. 101.

3. Biblioteca dell'Archiginnasio, Ms. Fondo Battuti 42. For bibliography, see *Mostra Storica Nazionale della Miniatura*, Palazzo di Venezia, Roma. Catalogo, 2ª edizione, Florence, 1954, no. 169, pp. 124, 125, and in particular M. Salmi, *La Miniatura*, in *Tesori delle biblioteche d'Italia: Emilia e Romagna*, a cura del Prof. D. Fava, Milan, 1932, pp. 278, 279, and fig. 128.

4. On this whole movement and the events of 1260, see A. d'Ancona, *Origini del teatro in Italia*, I, Florence, 1877, pp. 98 ff.; V. de Bartholomaeis, *Le origini della poesia drammatica italiana*, Bologna, 1924, especially, pp. 225 ff.; Id., *Laude drammatiche e rappresentazioni sacre*, I, Florence, 1943, pp. xiii ff.; G. M. Monti, *Le confraternite medievali dell'Alta e Media Italia*, Venice, 1927, pp. 199 ff.

5. E.g., the cross of Master Guglielmo in Sarzana (1138). Cf. also a miniature in a Paduan psalter, Bologna, Bibl. Univers., Ms. 346, f. 285—*Mostra*, Rome 1954, *Catalogo*, pl. XXXIII a, no. 162.

6. J. Wilpert, *Die römischen Mosaiken und Malereien der kirchlichen Bauten vom IV. bis XIII. Jahrhundert*, II, Freiburg im Br., 1917, p. 859, fig. 400. The fresco was restored in the seventeenth century, but the Barberini drawings show the earlier state. Nearer to our type is a miniature in Cambridge, Trinity College, Ms. B. 11. 4, fol. 11v., English, early thirteenth century.

7. Cf. the martyrdom of St. Catherine on a window at Chartres: Y. Delaporte and E. Houvet, *Les vitraux de la cathédrale de Chartres*, I, pl. LXVIII, LXIX; the martyrdom of St. Eustace on a window at Sens: L. Bégule, *La cathédrale de Sens*, Lyon, 1929, p. 48, fig. 56. The schema goes back perhaps to a classical group, like that of Pentheus torn by the Maenads.

An odd and perhaps unconnected anticipation of the later schema of the two flagellants and Christ is the drawing in the Utrecht Psalter (and its copies), illustrating the penitential Psalm 31 (32), lines 9, 10; it shows two men flogging a horse or mule and grasping it by the head and tail: see *The Illustrations of the Utrecht Psalter*, edited by E. T. Dewald, Princeton, 1932, p. XXIX.

8. See the facsimile of the miniatures, edited by H. Omont, Paris, n. d., pl. 176. The same composition is repeated in the later Slavonic gospels of Elizavetgrad: N. Pokrovsky, *Monuments of the iconography of the evangiles* (in Russian), St. Petersburg, 1892, fig. 149, p. 305; but here the two men at the sides seem to hold the outstretched arms of Christ.

9. Galleria Nazionale dell'Umbria, no. 74. See *Catalogo della mostra giottesca*, Florence, 1943, no. 48, p. 154. It was probably made for the confraternity attached to the church of S. Francesco in Perugia, if we may judge by the two kneeling Franciscans at the foot of the Crucifixion.

10. See A. Burroughs, "The Flagellation by Spinello Aretino revealed by the X-ray," *Bulletin of the Metropolitan Museum of Art*, XXIII, 1928, pp. 274 ff. The painting has since been restored.

11. A Sienese triptych in the Fogg Museum, Cambridge, U.S.A., attributed to Duccio's workshop, also contains the Virgin and Child, the Crucifixion and Flagellation, and two scenes from the life of St. Francis: see B. Rowland, in *Art in America*, XXIII, 1934, pp. 47 ff. The Flagellation is quite damaged and vague, but is evidently different from the Frick type.

12. *Op. cit.*, p. 95.

13. See R. van Marle, *Development of the Italian Schools*, The Hague, I, 1923, fig. 236. I believe Meiss is mistaken in saying (*op. cit.*, p. 96) that "the blocks are not rounded."

14. A. d'Ancona, *Origini del teatro in Italia*, I. Florence, 1877, pp. 148, 149: "una colonda alla quale se lega Christo al tempo de la sua passione, e doie fruste." The document is in the archives of the confraternity of San Domenico in Perugia and dates from 1339.

15. *Scritti di Storia dell'Arte in Onore di Lionello Venturi*, ed. by M. Salmi, Rome, 1956, pp. 36–38.

16. On the history of the relic see Ch. Rohault de Fleury, *Mémoire sur les instruments de la Passion de Notre-Seigneur Jésus-Christ*, Paris, 1870, pp. 264, 265. Our illustration is taken from his pl. xxii. The relic in S. Prassede was perhaps regarded as the base or a fragment rather than as the whole of the original column. Supposed fragments of the latter are preserved elsewhere in Rome and in churches in Florence. In the Baroque period, painters showed Christ tied to the low truncated column (without a capital) in pictures of the Flagellation. See E. Mâle, *L'art religieux après le Concile de Trente, étude sur l'iconographie du XVIe, du XVIIe et du XVIIIe siècle*, Paris, 1932, p. 263, figs. 149–152.

17. M. Armellini, *Le chiese di Roma dal secolo IV al XIX*, Rome, 1942, p. 300 ("diaspro sanguigno"). In the Frick painting the color of the column is a red tending toward burnt sienna, with tiny white spots; the adjoining ground is an ochre yellow.

18. I owe this information to the kindness of Richard Krautheimer.

19. For the old descriptions, see A. Baumstark in *Byzantinische Zeitschrift*, XX, 1911, p. 183.

20. Bonaventura, *Opera Omnia*, XII, Paris, 1868, pp. 603, 604 (cap. LXXVI: "columna autem, ad quam ligatus fuerat, vestigia cruoris ostendit, sicut in historiis continetur").

21. See E. B. Garrison, Jr., "The Oxford Christ Church Library Panel and the Milan Sessa Collection Shutters," *Gazette des Beaux-Arts*, LXXXVIII, 1946, pp. 321–346.

22. All these quotations from *op. cit.*, pp. 102, 103.

23. Cf. miniatures in the Puiset Bible, Durham, late twelfth century (*Durham Cathedral manuscripts to the end of the twelfth century*, ed. R. A. B. Mynors, Oxford, 1939, pl. 52), the St. Louis Psalter (*Le psautier de Saint Louis, Bibliothèque Nationale latin 10525*, ed. H. Omont, Paris, n. d., pl. 42, 63), Bonn University Ms. 526, North French, dated 1286 (R. and L. Loomis, *Arthurian Legends in Mediaeval Art*, fig. 220).

24. See note 23.

25. See F. Godefroy, *Dictionnaire de l'ancienne langue française*, X, Paris, 1902, p. 571, *s. v.* "revers" (also VII, p. 170, 170b), and E. Littré, *Dictionnaire de la langue française, s. v.* "revers."

26. See *Oxford English Dictionary*, s. v. "awk."

27. Thomas Malory, *The Book of Sir Tristram de Lyones*, I, ed. E. Vinaver, Oxford, Clarendon Press, 1947, p. 415 (book VIII, 171 r); and earlier in the *Morte Arthure*, ca. 1360 (ed. E. Björkman, Heidelberg, 1915, line 2247: "he strykez awkwarde"). For the references to the English words and examples, I am indebted to my colleague, Professor Roger Sherman Loomis.

28. E.g., the Flagellation on the crucifix by Enrico di Tedice in S. Martino, Pisa (*Catalogo della Mostra Giottesca*, 1943, no. 20, p. 64; van Marle, *op. cit.*, V, p. 424, fig. 245), the triptych in Sta. Chiara, Assisi (van Marle, *op. cit.*, I, p. 412), the cycle of St. Cecilia at S. Urbano alla Caffarella (Wilpert, *op. cit.*, II, fig. 487—the Barberini drawing—and IV, pl. 230, 2—the painting), Martyrdom of John the Baptist, Paduan epistolary of 1259 (*Le miniature del epistolario di Padova del anno 1259*, ed. B. Katterbach, Vatican City, 1932, pl. XI). Flagellation in psalter, *ca.* 1280, from Liège, in the Morgan Library (Ms. 183, fol. 230 v), beheading of soldier in thirteenth century psalter from northeast France in the same library (Ms. 730, fol. 78), Flagellation in fresco in Andorra (Ch. Kuhn, *Romanesque mural painting in Catalonia*, Cambridge, Mass., 1930, pl. 51).

What might be interpreted as a frontal *riverso* in a rare representation of members of a confraternity of flagellants, nude to the waist and bearing a whip in the right hand across the left

shoulder, in a fresco of the Last Judgment in the apse of S. Bevignate in Perugia (assigned to the years just after 1270 when the church was founded), and therefore of the greatest interest for the possible connection of the Frick figure and the practice of the Battuti, is in my opinion not really an image of a reverse stroke, but a schema for symbolizing self-flagellation. For a reproduction, see U. Gnoli, in *Rassegna d'Arte*, 1914, pp. 274 ff.

It has nevertheless some interest for the psychological interpretation of the posture in the Frick panel as an analogous penitential, self-enclosing form, adequate to a passive, contemplative attitude, such as appears to characterize the artist of the Frick panel, in contrast to the more aggressive and realistic types of the Flagellation elsewhere.

29. There are, however, some earlier images of the Flagellation of Christ with a *frontal riverso* in which the head overlaps the weapon. Examples: in St. Gilles (A. K. Porter, *Romanesque Sculpture of the Pilgrimage Roads*, Boston, 1923, ill. 1322), and a psalter from Beauvais, *ca.* 1250, Morgan Library, Ms. 101 (*The Pierpont Morgan Library exhibition of illuminated manuscripts* held at the New York Public Library, New York, 1934, pl. 34). For examples in other subjects, cf. *Illustrations to the life of St. Alban in Trinity College*, Dublin, Ms. E, i, 40, ed. by W. R. L. Lowe, E. F. Jacob, and M. R. James, Oxford, 1924, pl. 10, 13 (first half of thirteenth century); Giovanni Pisano, the pulpit in the cathedral of Pisa (the soldiers whacking the thieves in the Crucifixion).

30. See *Il Menologio di Basilio II* (*cod. vaticano greco 1613*), Turin, 1907, pl. 33, 34, 69, 80, etc. For other Byzantine examples, see H. Omont, *Miniatures des plus anciens manuscrits grecs de la Bibliothèque Nationale du VIe au XIVe siècle*, Paris, 1929, pl. CXVIII, 7 (Coislin Ms. 237), pl. LIII (gr. 510); A. Goldschmidt and K. Weitzmann, *Die byzantinischen Elfenbeinskulpturen des X.–XIII. Jahrhunderts*, I, Berlin, 1930, pl. XIX, no. 32.

For this type in classic art, cf. S. Reinach, *Répertoire de reliefs grecs et romains*, I, p. 302, no. 32, p. 313, no. 76 (column of Marcus Aurelius), p. 415, no. 2 (Sidon sarcophagus).

31. It is a manuscript of the New Testament. The fragmentary calendar has a Lombard complexion and includes the Deposition and Translation of S. Zeno. The rod is not in accord with the text; John ii, 15 describes Christ as making "a scourge of little cords" to drive the merchants from the temple.

32. In note 23. For other examples in religious and secular themes in the thirteenth century, cf. Manchester, John Rylands Library, French Ms. 5, a picture Bible (*Bulletin de la Société française de reproductions de manuscrits à peintures*, Paris, 1923, pl. XXIV: Lamech killing his servant with his bow); Brussels, Bibliothèque Royale, Ms. 3634, 2, a cut-out miniature of the beheading of John the Baptist, from an antiphonary of 1290 from Beaupré, now in the A. Chester Beatty library (C. Gaspar and F. Lyna, *Les principaux manuscrits à peintures de la Bibliothèque Royale de Belgique*, Paris, 1937, pl. XLVIII); Pierpont Morgan Library Ms. 729, f. 258—figure fighting a lion—psalter from Amiens, *ca.* 1275; Morgan Ms. 183, page of calendar for December, peasant slaughtering an ox—psalter from Liège, *ca.* 1280. For an example from the twelfth century, cf. the thresher in the labors of the months on the pillar of Souvigny (J. C. Webster, *The Labors of the Months*, Evanston, 1938, pl. XLIX).

33. See A. Goldschmidt and K. Weitzmann, *op. cit.*, I, pl. III, no. 8 c (Milan, Museo del Castello, ivory casket), pl. LIII, no. 84a (Reims, Musée de la Ville, ivory carving). For a French Gothic parallel, cf. the ivory carving of the Flagellation in the Mège Collection, Paris (R. Koechlin, *Les ivoires gothiques français*, Paris, 1924, pl. LVII, no. 225).

34. A. Goldschmidt and K. Weitzmann, *op. cit.*, pl. XV, no. 30c (ivory casket in Liverpool); pl. XVII, no. 31c (ivory carving in Bologna, Museo Civico); pl. XXV, no. 44 (ivory carving in Leningrad, Hermitage).

35. As an example of the direct copying of a Byzantine ivory box by an Italian artist, cf. the scene of the Fall on the bronze doors of Pisa cathedral by Bonanus; it was copied from the fragment of a Byzantine ivory box in Pesaro, as was noted by H. Graeven, in *L'Arte*, II, p. 313 ff. See also A. Boeckler, *Die Bronzetüren des Bonanus von Pisa und des Barisanus von Trani*, Berlin, 1953, pp. 12, 13, n. 22.

Note on the Byzantine ivory box in Milan (Fig. 10) the soldier in profile whose posture, with sword raised over his head, corresponds to that of the right flagellant on the Frick panel.

36. *Op. cit.*, fig. 13.

37. For the history and restoration of the relief in the Casino Borghese, cited by Meiss, *op. cit.*, n. 35, see W. Amelung, "Zerstreute Fragmente römischer Reliefs," *Römische Mittheilungen des kaiserlichen archäologischen Instituts*, XXIV, 1909, p. 184 (a reference I owe to the kindness of Prof. Margarete Bieber); for the second relief, see C. Robert, *Die antiken Sarkophagreliefs*, III, Berlin, 1904, part 2, pl. LXII A, fig. 195.

38. It is in the National Gallery, Washington (R. Offner, *Corpus of Florentine Painting*, V, New York, 1947, pl. IV b). Note, however, in Daddi's Martyrdom of Lawrence (Toesca, *Florentine Painting of the Trecento*, pl. 85) in Sta. Croce, Florence, the figure in profile carrying fuel on his right shoulder, supporting it with the bent, foreshortened left arm. In Ambrogio Lorenzetti's Martyrdom of the Franciscans at Ceuta, in S. Francesco, Siena (1331), there is a true *riverso* seen from behind in the figure of the executioner (E. Cecchi, *Sienese Painting*, London, n.d., pl. CLXXXII).

An interesting variant of the *riverso* is the right figure in the Flagellation on a tabernacle in the collection of the Earl of Crawford and Balcarres (E. B. Garrison, Jr., *Italian Romanesque Panel Painting*, Florence, 1949, no. 351, p. 133: "Tuscan, provincial Sienizing, Cimabuesque, 1290–1300"); he holds the whip in his bent right arm across his head and left shoulder—a view from his right side would offer the appearance of the left figure in the Frick panel.

39. The handles of the whips are also of equal length, as if the left one, held in the foreshortened arm, were in the same plane as the other, parallel to the surface of the picture.

40. I refer to the second figure from the right in the lower zone; other mourners in the same relief offer interesting parallels to the silhouette of the flagellant.

41. See B. Kleinschmidt, *Die Basilika San Francesco in Assisi*, II, Berlin, 1915–1928, pl. 7a. Note also the pronounced foreshortening of the arms of the little carpenter in the lower right of the Building of the Ark (*ibid.*, fig. 36). And cf. the drastically foreshortened arm of the executioner in a painting of the late thirteenth century in the narthex of S. Lorenzo in Rome (Wilpert, *op. cit.*, II, fig. 460, p. 963).

42. This feature occurs, too, in the Paduan epistolary of 1259 (ed. B. Katterbach, *op. cit.*, pl. XI, XVI).

43. *Mostra giottesca*. p. 200, no. 59 b; Meiss, *op. cit.*, fig. 2.

44. Van Marle, *op. cit.* I, fig. 236. Cf. also the miniature in Morgan Library Ms. 101, cited in note 29, and the tabernacle of the Earl of Crawford and Balcarres (note 38 supra).

45. Meiss, *op. cit.*, p. 98.

46. In Byzantine art the martyr is often completely passive and seems to ignore his torturers; cf. the Vatican Menologium of Basil II (*loc. cit.*, pl. 149, 174).

47. Bonaventura, *Opera Omnia*, Paris, 1868, XII, pp. 603, 604, cap. LXXVI.

48. *Op. cit.*, p. 101.

49. G. Swarzenski, *Die Salzburger Malerei*, Leipzig, 1908–1913, fig. 351, pl. CIV (antiphonary in the Stiftsbibliothek St. Peter). It is perhaps worth mentioning here another miniature of the Salzburg school, in the Gumpert Bible in Erlangen (*ibid.*, pl. XLV, fig. 138), with the Flagellation, the Crucifixion, and an enthroned central Sophia in a single broad band, like the miniature of the Bologna Statutes. The gestures of the flagellants here are unlike those in Bologna, but recall Duccio's *Maestà*, while the Christ looks like a reversed image of the Christ of the Frick panel.If these two Salzburg miniatures of the twelfth century depend on Italian art, as do many of the types in the manuscripts of Salzburg, we can judge how fragmentary is the Italian evidence from which we try to reconstruct the history of the later types.

50. A serious, though not strict, objection to the idea of Duccio's authorship of the original composition of the Frick panel—if we suppose the latter to be a workshop copy or adaptation—is the fact that in two other Flagellations from the workshop or circle of Duccio, prior to the *Maestà*—Siena Gallery no. 35 and the Fogg tabernacle—the distinctive features of our panel are lacking.

51. *Op. cit.*, p. 100.

52. P. P. Muratov, *La peinture byzantine*, Paris, 1928, pl. 202.

53. E.g., in the painting of Peter Healing the Lame Man, and in the St. Gregory.

54. This drawing is cited by E. Sandberg-Vavalà, *Sienese Studies*, Florence, 1953, p. 42, note, as an evidence that the panel belongs to the school of Cimabue. Note, too, the similar awkward treatment of the angle of the two sides of the building.

55. A. Venturi, *Storia dell'arte italiana*, V, fig. 78.

56. The painting was attributed to Cimabue by R. Longhi in a letter to the Frick Collection. This name had already been inscribed in ink on the back of the panel during the nineteenth century, together with the number 17. Meiss, *op. cit.*, proposed the name of Duccio; Longhi, "Prima Cimabue, poi Duccio," *Paragone*, no. 23, Nov. 1951, p. 8 ff. defended his original view, arguing that the Ducciesque appearance was the result of excessive and arbitrary cleaning and restoration—an opinion I cannot accept after study of the panel; Meiss replied in *Paragone*, no. 27, March 1952, pp. 63, 64 ("Scusi, ma sempre Duccio"). The attribution to Duccio has been accepted by E. Carli, *Duccio*, Milan-Florence, 1951, introduction and pl. 20 ("ha qualche probabilità di essere un autografo duccesco") and approved tentatively by J. Pope-Hennessy, *Burlington Magazine*, 1952, p. 85 (who now considers the picture Cimabuesque). C. Brandi, *Duccio*, Florence, 1951, p. 156, n. 34 rejects Meiss's view; the painting is not Ducciesque or clearly Sienese in style, but Cimabuesque and Pisan. It is "definitely Cimabuesque," according to E. Sandberg-Vavalà, *op. cit.*, (note 54 above). Berenson, in a letter to the Frick Collection, regards the design as Cimabue's, the execution as by an assistant in the workshop.

57. If the Crucifixion on the Berlin tabernacle is clearly Cimabuesque, it should be noted that the Madonna and Child not only resembles Cimabuesque versions of this theme (the Servite Madonna in Bologna, the Madonna in the Coll. Contini-Bonacossi) but has Sienese parallels, especially in the work of Duccio and his circle (Fig. 12).

Fig. 1 Jerusalem, Bezalel National Art Museum: Ms. 180/57, Bird's Head Haggada, fol. 6v. The Eating of the Greens ("Karpas") and the Dividing of the Matzo.

Fig. 2 Jerusalem, Bezalel National Art Museum: Ms. 180/57, Bird's Head Haggada, fol. 26v. Lifting of the Cups in Praise of God.

The Bird's Head Haggada, An Illustrated Hebrew Manuscript of ca. 1300

(1967)

In the publication of the Bird's Head *Haggada* are united our interest in Jewish history and our love of art.[1] The festival in which the *Haggada* serves as an instrument is a tradition of ritual, poetry, and story-telling, where every gesture and word has a memorable meaning. The book with its pictures and ornament, as Dr. Jaffé brings out in his study, embodies a conception of history; here a people recall their past and affirm a common faith. The annual reading is a kind of sacred repetition, distinct from the liturgy of the Christian Easter which has no ethnic sense and says little about a communal destiny. The *Haggada* is not a book for the synagogue but for the assembled family at the Seder. As such it has no counterpart among the service books of mediaeval Christian ritual, which it parallels in its decoration. Though the pictures may delight the children, they were not designed to replace the written word for the illiterate, as a widely held theory would explain much of mediaeval art. They were addressed, I'm sure, to the already instructed reader of the text, and reenacted for his imagination both the historic and the present world referred to in the writing and, like the poetry and song in the same book, helped to save him from a merely intellectual grasp of a content steeped in feeling as well as thought.

Uniquely Jewish as it is, we cannot imagine the *Haggada* with this ornateness and lively illustration before the Middle Ages, when Christian art had created the psalters and liturgical books with pictures. It was not known in mediaeval Arab or Greek Jewry, only in the Latin-Christian milieu and later in neighboring countries in touch with the Western European world. The pictorial *Haggada* belongs to a time when the earlier practice of marginal imagery,

[1] *The Bird's Head Haggada of the Bezalel National Art Museum in Jerusalem*, edited by M. Spitzer, with contributions by E. D. Goldschmidt, H. L. C. Jaffé, B. Narkiss, and an introduction by Meyer Schapiro, L. A. Mayer Library, published for Beth David Salomons by Tarshish Books, Jerusalem, 1967.

found in Greek psalters and some Latin books, had undergone a great revival through the exuberant growth of ornament in the thirteenth and fourteenth centuries. The blank margins became then a field for an unconstrained fantasy which was often tied to the content of the writing on the page by subtle analogies, though without a religious sense.[2] The Jewish artists who represented the biblical and festive themes on the margins of the *Haggada* (Figs. 1, 2) surely knew the Christian books, religious and secular, with unframed marginal pictures in the same style. In the Bird's Head *Haggada* the details of buildings, the conception of Eden, Paradise, and Jerusalem, are clearly Gothic in form (Fig. 3). Knowing the churches of that time, we recognize at once the pointed arches, trefoils, crockets, pinnacles, lancet windows, and tracery, and are able to date and place the manuscript accordingly. The costumes and other everyday objects are also as in contemporary Christian work, an evidence of the common material culture of the two religious communities. Even the Hebrew script has a suggestive resemblance to the Latin writing of the time and place in the contrast of thick and thin strokes, the rhythm of letters, and the aspect of the page. The artist of the miniatures must have studied the German Christian art of his time and perhaps had worked together with Christian craftsmen, like the masons and stonecarvers of the synagogues who applied Gothic forms.

All this is significant as evidence of the intimate bond between Christian and Jewish culture in the Middle Ages, in spite of the separateness of the communities. The illustrations of the *Haggada* show that Jewry then could not escape the strong impress of the surrounding milieu; it accepted willingly a part of the Christian culture alien to its own past. And the acceptance strikes us as the more remarkable for being in the domain of visual art, where Jewish tradition seems closed to the achievements of neighboring peoples. But more than a style of representation and ornament was shared by the two communities. If the Christian artists formed certain images on the words of the Jewish Bible, the Jewish painters sometimes borrowed from Christian art the conception of the same subjects in illustrating the *Haggada* and *Mahzor*. The tendency to interpret Old Testament history in contemporary terms was common to the two religions; Christian art often represents the biblical rulers as mediaeval kings and alludes to the old texts as precedents for contemporary life. Yet in this common culture the illustrated *Haggada* has a character of its own, unmatched by any Christian books—qualities which, like the Yiddish language, have persisted long after the Gothic style ceased to be practiced. These pictures are quite obvious to us after more than six hundred years, and even the enigmatic birds' heads of the human figures (Fig. 2) seem familiar and typical, like a word that we recognize in its context even if we are uncertain of the exact

[2] See chapter on "Marginal Images and Drôlerie" pp. 196–198 above.

Fig. 3 Jerusalem, Bezalel National Art Museum: Ms. 180/57, Bird's Head Haggada, fol. 47. "Next Year in Jerusalem."

original sense. In our time Chagall has been able to insert them in his own pictures and to create with them a stronger sense of Jewish particularity.

Although I have seen too few of the examples in other manuscripts and can say nothing decisive about the meaning of the bird's head, I shall risk speculation on its origin. As a substitute for the human head it has been connected with rabbinic responses, summarized by R. Meïr of Rothenburg, forbidding representations of the human face. But why then the human faces of Pharaoh and of angels in the same *Haggada?* And why the choice of the bird's head among all possible animal substitutes? The task of explanation is complicated by the fact that in other German Jewish manuscripts of this period there occur Jewish figures with animal heads, and sometimes an angel with a featureless human face. The bird's head is not employed consistently and is hardly a canonical form required by an orthodox belief. This strange type of figure seems to be a local idea restricted to German Jewish manuscript art of the late thirteenth and the fourteenth century; it was not accepted widely or for long and was varied and perhaps misunderstood in the course of copying. But in the Jerusalem *Haggada* to which this feature has given its name the bird's head is so general in the representation of Jews that it may be regarded there as a symbol of the Jewish people.

What kind of bird is this? From the strong curved beak and the smooth profile of the head, I suppose that the bird is an eagle. A similar bird appears as an unmistakable eagle in the famous Heidelberg Manasse Codex. Now in Jewish literature the Jews are several times identified with the eagle. In Exodus xix, 4, a text most relevant to the feast of Passover, God says to Moses: "You have seen what I did to the Egyptians and how I carried you on eagle's wings and brought you to myself." The Jews as God's people are his fledglings, as Moses in his song reminds his hearers: "As an eagle stirs up her nest, flutters over her young, spreads her wings, takes them and bears them on her wings, so the Lord alone has led Israel" (Deuteronomy xxxii, 11, 12).

The eagle's head has possibly another and strictly contemporary meaning. The image of the eagle was one of the insignia of the German emperor in the period when the Bird's Head *Haggada* was produced. As a people placed under the ruler's protection, the Jews could be associated in Germany with the imperial eagle. In the same book, in the picture of the Pursuit Across the Red Sea (fol. 24v), an eagle appears in standard heraldic form as the emblem of Pharaoh.

The two connotations of the eagle's head—the Jews as God's fledglings and as the protected subjects of the emperor—are not incompatible. Like language, pictorial imagery abounds in metaphors and the same figure may carry several meanings. In mediaeval Christian art the eagle could be the symbol of Christ, of Saint John the Evangelist, of the Christian, of the Roman

empire, of evil, the sky, etc. The mediaeval artist, accustomed to translate concepts into pictures literally, often combining objects that have no natural organic connection, found nothing incongruous in the image of a human body with a bird's head. The Evangelist John was often represented in this way. Such a combination appears also in pictures illustrating Ezekiel's vision and had arisen in other contexts of the art of the ancient Near East with different unrelated meanings. It was as simple then for an artist to place an eagle's head on a human body as it is for us to call an aviator a "bird man" or a sports team the "eagles."

However we explain the image of the Jew with a bird's head, it is a fascinating figure that incites wonder, and reflection on the affinities of man and bird. Appearing throughout the book in so many scenes, it stamps the whole with its own strangeness and endows this copy of a common text with an unforgettable individuality. Here a fanciful idea, in a festive setting, gives a special charm to an art that, considered as sheer painting, was fairly commonplace in its time. The painter of this manuscript was not in the forefront of the artists of his generation, but like many craftsmen educated in the Gothic style he possessed a sure hand and taste at the service of tasks of real moment for the community whose beliefs and feelings he shared in conceiving the precious work.

This manuscript, now so exceptional, was in its day a piece of local everyday art with qualities of imagery and ornament inherent in the book-crafts of that time. It is impressive as a handmade object with continuously varied parts, a succession of pages each arresting and complete in itself as a field of calligraphy and painting, each a distinct unity for vision as well as thought. For the painter's logic, observe in the four figures on Fol. 47r (Fig. 3) how the colors have been contrasted, with a symmetry of the outer pairs and an inverted variation of the inner—an intuitive choice for gaiety, interest, and strength. The virtues of this devoted, modest art—directness, simplicity, clarity, a sweet naturalness and warmth—are as in much of Gothic popular art; they rest on command of a style that had been devised in the striving of greater artists for more intense effects in grandiose projects of monumental art. The freshness of the miniature paintings, even when conventional in the forms, is the marvel of the old hand-written books—more moving still when seen beside our own indifferent book arts. We hope that when the scattered remains of mediaeval Jewish art have been more fully studied and reproduced, we shall understand better both art and Jewish life of the past and see connections between them that are still ignored. But beside their value for understanding, the old manuscripts have an instant appeal to the eye, a charm that is reinforced by knowledge. They are priceless, too, as rare objects from a tormented past of which so much has been brutally destroyed; whatever is preserved must remind

us of our own survival. And as works of art they embody the faith in the life of the spirit. The beauty of the Bird's Head *Haggada*, we like to believe, had some importance for its survival.

Permissions

The author and the publisher would like to express their sincere thanks to the following institutions and individuals who kindly provided materials and granted permission to reproduce them in this volume.

Alinari/Editorial Photocolor Archives, Ravenna: Fig. 1, p. 34; Figs. 4 and 5, p. 41.

American Academy, Rome: Fig. 2, p. 73; Fig. 5, p. 76; Fig. 23, p. 112.

Archives Photographiques, Paris: Fig. 3, p. 246.

Bezalel National Art Museum, Jerusalem: Figs. 1 and 2, p. 380; Fig. 3, p. 383.

Biblioteca Ambrosiana, Milan: Fig. 2, p. 228.

Biblioteca Apostolica Vaticana, Rome: Figs. 1a, 1b, and 2, p. 48; Fig. 3a, p. 52; Figs. 3b and 4, p. 53; Fig. 8, p. 63; Fig. 20, p. 98; Fig. 1, p. 144; Fig. 4, p. 155; Fig. 13, p. 211; Figs. 6 and 7, p. 236; Fig. 3, p. 268; Fig. 5, p. 269; Fig. 9, p. 367.

Biblioteca Capitolare, Vercelli: Fig. 32, p. 126; Fig. 34, p. 129.

Biblioteca Communale dell'Archiginnasio, Bologna: Fig. 3, p. 358.

Biblioteca Medicea Laurenziana, Florence: Fig. 18, p. 218.

Bibliothèque Municipale d'Amiens, Amiens: Fig. 14, p. 183.

Bibliothèque Municipale de Boulogne-sur-Mer, Boulogne-sur-Mer: Fig. 5, p. 155.

Bibliothèque Municipale de Rouen, Rouen: Fig. 4, p. 269; Fig. 10, p. 283.

Bibliothèque Municipale, Verdun: Fig. 2, p. 196. (Photo: Dr. Lilian Randall)

Bibliothèque Nationale, Paris: Fig. 4, p. 75; Fig. 6, p. 77; Fig. 10, p. 82; Fig. 24, p. 113; Fig. 3, p. 116; Fig. 8, p. 159; Fig. 3, p. 201; Fig. 12, p. 211; Fig. 3, p. 233; Figs. 8a and 8b, p. 238; Fig. 9, p. 239; Fig. 6, p. 274; Fig. 4, p. 292; Fig. 8, p. 365.

Bildarchiv Preussischer Kulturbesitz, Berlin: Fig. 11, p. 369; Fig. 12, p. 373.

Bodleian Library, Oxford: Fig. 13, p. 89; Fig. 4, p. 254.

British Library Board, London: Fig. 28, p. 118; Fig. 13, p. 180; Fig. 2, p. 200; Fig. 5, p. 235; Fig. 6, p. 258; Figs. 1 and 2, p. 266; Fig. 7, p. 275; Fig. 9, p. 283; Fig. 12, p. 342; Fig. 17, p. 349.

Christ Church, Oxford: Fig. 6, p. 362.

Civiche Raccolte d'Arte Applicata ed Incisioni Castello Sforzesco di Milano, Milan: Fig. 10, p. 369.

(The) Duke of Rutland, Belvoir Castle: Fig. 16, p. 345.

Feofees, Chetham's Library, Long Millgate, Manchester: Fig. 13, p. 342; Fig. 14, p. 343.

Foto N. Sans, Gerona: Fig. 1, pp. 320–321.

(The) Frick Art Reference Library, New York: Fig. 2, p. 73; Fig. 5, p. 76; Figs. 7, 8, and 9, p. 80; Fig. 11, p. 84; Fig. 14, p. 91; Fig. 15, p. 92; Fig. 18, p. 94; Fig. 21, p. 100; Fig. 22, p. 102; Fig. 1, p. 356.

Galleria Nazionale dell'Opera, Perugia: Fig. 4, p. 360.

Islamiches Museum, Berlin: Fig. 5, p. 293.

Isobrazitelnoe Iskusstvo, Leningrad: Fig. 1, p. 200; Fig. 4, p. 201; Fig. 6, p. 204; Fig. 11, p. 211.

Kunsthistorisches Museum, Schatzkammer, Vienna: Figs. 16 and 17, p. 184.

Landesbibliothek, Düsseldorf: Fig. 31, p. 124.

The Metropolitan Museum of Art, New York: Fig. 1, *facing* p. 1; Fig. 2, p. 3; Fig. 6, p. 157; Fig. 1, p. 196.

Musées Royaux d'Art et d'Histoire, Brussels: Fig. 19, p. 98.

Museo della Opera della Metropolitana, Siena: Fig. 2, p. 358.

(The) National Library, Athens: Fig. 27, p. 118.

North Yorkshire County Council and Yorkshire Museum, York: Fig. 9, p. 208.

Office National Algérien du Tourisme, Algiers: Fig. 2, p. 245.

Charles Passela: Figs. 1–8, pp. 24–32; Fig. 16, p. 93; Fig. 2, p. 145.

Photographie Giraudon, Paris: Fig. 33, p. 129.

Pierpont Morgan Library, New York: Fig. 3, p. 13; Fig. 7, p. 159; Fig. 2, p. 250; Fig. 8, p. 276; Fig. 1, p. 330; Figs. 2, 3, and 4, p. 332; Fig. 5, p. 333; Fig. 6, p. 334; Fig. 7, p. 335; Fig. 8, p. 336; Fig. 9, p. 337; Fig. 10, p. 338; Fig. 11, p. 339; Fig. 15, p. 343.

Dr. Lilian Randall, Baltimore: Fig. 2, p. 196.

387

Royal Irish Academy, Dublin: Fig. 1, p. 228.

Pastor of the Church of Ruthwell, Ruthwell: Figs. 1 and 2, p. 150; Fig. 3, p. 152; Figs. 1 and 10, p. 162; Fig. 12, p. 180.

(The) Schocken Library, Jerusalem: Fig. 10, p. 310.

Soprintendenza per i Beni Ambientali e Architettonici di Ravenna, Ravenna: Fig. 2, p. 39.

Staatliche Museen, Berlin: Fig. 5, p. 360; Fig. 12, p. 373.

St. Bavo, Ghent: Fig. 1, p. 250.

(The) Master and Fellows of St. John's College, Cambridge: Fig. 3, p. 251.

St. Peter's, Vatican, Rome: Fig. 29, p. 121.

Stiftsbibliothek, Einsiedeln, Switzerland: Fig. 2, p. 145.

George K. Topouzis, Athens: Fig. 27, p. 118.

Trinity College, Dublin (Board of): Figs. 16 and 17, p. 216; Fig. 4, p. 235.

U.N.E.S.C.O., Paris: Figs. 1–8, pp. 24–32.

Victoria and Albert Museum, London: Fig. 7, p. 63.

(The) Walters Art Gallery, Baltimore: Fig. 7, p. 296; Fig. 8, p. 300.

Index